ITALIAN PAINTINGS
IN THE
MUSEUM OF FINE ARTS
BOSTON

Published with the assistance of the Getty Grant Program

ITALIAN PAINTINGS
IN THE
MUSEUM OF FINE ARTS
BOSTON

Volume I 13th – 15th century

Laurence B. Kanter

with an Introduction by Eric Zafran

Distributed by Northeastern University Press

MUSEUM OF FINE ARTS, BOSTON

For John Pope-Hennessey

This catalogue has been made possible by grants from the National Endowment for the Arts, a Federal agency, and from The Getty Publications Fund. Additional support was received from the Andrew W. Mellon Foundation Publications Fund.

ISBN NO. 0-87846-407-7

Library of Congress Catalogue Card No. 94-75917

Typeset by Carl Zahn in Monotype *Dante,* a design by Giovanni Mardersteig.

Designed by Carl Zahn

Edited by Troy Moss

Printed by Acme Printing Co., Wilmington, Massachusetts

Cover and jacket:
Fra Carnevale, *Presentation of the Virgin in the Temple* (?), (cat. 66)

Photographs were supplied by the Department of Photographic Services, Musuem of Fine Arts, Boston.

In the catalogue, dimensions are given in centimeters followed by inches.

CONTENTS

FOREWORD

As the director of the Museum of Fine Arts and a long-time admirer of early Italian paintings, it is a pleasure for me to present this catalogue of our collection. The brilliant analysis of the paintings is by Dr. Laurence B. Kanter, formerly assistant curator in our Department of Paintings. He very graciously continued his work on this project on his own time after moving to New York to assume the position of Curator of the Lehman Collection at the Metropolitan Museum of Art. We are immensely grateful for his erudition and dedication. The Museum of Fine Arts's collection of early Italian paintings, as documented in the introduction by our associate curator of European paintings, Dr. Eric Zafran, grew slowly over a century through both acquisitions and generous gifts which have continued to the present day. The result is that when our gold-ground paintings are seen in conjunction with those of the Gardner Museum and the Harvard Museums, the Boston area assumes a role as a major world center in this field.

This publication marks a milestone in the Museum's history, for it is the first scholarly catalogue to be published on our extensive painting collection. It sets a high standard for those we expect to follow on the later Italian schools, the French, and the Northern paintings. One of the special features of this catalogue is the attention given to the scientific examination of the paintings, and for this we have to thank Gianfranco Pocobene of the Harvard Museums and the members of our own paintings conservation staff, especially Brigitte Smith and Rhona Macbeth. The enormous task of editing and indexing the catalogue was performed meticulously by Troy Moss while the handsome design, using the photographs prepared by our department of photographic services under the direction of Janice Sorkow, was carried out by Carl Zahn.

This book makes a major contribution to the Museum, the profession, the public, and to scholarship in Italian art. We are truly thankful to the National Endowment for the Arts, a Federal agency, the Getty Grant Program, and the Andrew W. Mellon Foundation Publications Fund for making this publication possible.

Alan Shestack
Director

❧ ACKNOWLEDGMENTS

THE COLLECTION of Italian paintings at the Museum of Fine Arts, Boston, is one of the richest in any American public institution, both in quantity and quality. Taken together with the holdings of the Isabella Stewart Gardner Museum across the Fenway and the Fogg Art Museum in Cambridge, not to mention smaller museums such as those at Wellesley and Boston College, admirers of Italian painting can enjoy a wider range of experience in and around Boston than almost anywhere else in the Western Hemisphere, with only Washington and New York competing for the prize. Yet among its great sister museums in these cities – the National Gallery of Art, The Metropolitan Museum of Art, the Fogg and the Gardner – only the Museum of Fine Arts has never produced a catalogue of its Italian paintings. This volume is a first step towards redressing this lack. It is concerned only with works of the early Renaissance, produced prior to 1500, and among these it omits a small but important group of panels from Venice and the Veneto. These will be included instead in a projected second volume of the catalogue otherwise devoted to sixteenth-century paintings which, due to the combined accidents of Bostonian taste and collecting availability, are predominantly Venetian.

The information in this catalogue is in large part developed from the research and opinions of predecessors who worked in the Museum's Department of Paintings, including G.H. Edgell, W.G. Constable, Georg Swarzenski, Charles Cunningham, Thomas Maytham, and Scott Schaeffer, and of visiting scholars too numerous to mention by name who generously shared their expertises with the Museum's staff. Much of this material had been culled, organized, and amplified in two earlier attempts to assemble a catalogue of Italian paintings at the Museum of Fine Arts by Philip Hendy and Angelica Rudenstine, and without their extraordinary efforts, especially Mrs. Rudenstine's, this book would have been twice as long in preparation and much poorer in results. The most significant addition to their labors incorporated here is a more detailed study of the physical condition of each painting, for which the entire staff of the Department of Paintings' Conservation at the Museum of Fine Arts is to be thanked, but the singular contribution of two individuals must be acknowledged: Gianfranco Pocobene, then Assistant Paintings Conservator, the Fogg Art Museum, and Rhona Macbeth, Mellon Fellow in Paintings Conservation, the Museum of Fine Arts (1991-1992). A special debt of gratitude is owed to Everett Fahy, who systematically reviewed the collection of early Italian paintings at the Museum of Fine Arts in 1985, and who patiently answered endless questions of attribution as they arose over the years.

The first words of this catalogue were written at the urging of Peter Sutton, Mrs. Russell W. Baker Curator of European Painting at the Museum of Fine Arts in 1986. Its completion was made possible by the contributions of many people, among them a number of past and present members of the Department of Paintings: Monique van Dorp, Patricia Loiko, Marci Rockoff, Jane Hankins, Barrett Tilney, and Regina Rudser. The gathering of documentation for the catalogue, often a tiresome and thankless task, was aided by the participation of several talented research assistants provided in part through the generosity of the National Endowment for the Arts: Mary Ann Winklemas, Joseph Giuffrey, Randy Klebanoff, Tom McGrath, Bruce

Edelstein, and Andrew Noone. The enormous task of preparing and organizing the manuscript and photographs for publication was handled with great efficiency by Sydney Resendez, a Lee Fellow in the Department of Paintings. The editor, Troy Moss, did a remarkable job not only in checking and unifying the text and preparing the bibliography and index, but also in encouraging me to actually finish the project. A final debt of gratitude is owed to Alan Shestack, who authorized me to continue work on the catalogue after my departure from Boston in 1988, and Eric Zafran, who then oversaw the project, prepared the grants to keep it going, and successfully cajoled me into meeting all his deadlines.

Laurence B. Kanter

New York, September 1993

ON THE COLLECTING OF EARLY ITALIAN PAINTINGS IN BOSTON

Eric M. Zafran

VISITING the Academy of Fine Arts in Florence in 1858, the writer Nathaniel Hawthorne recorded in his *Notebook* that there the "procession of the art may be traced through the course of, at least, two hundred years. Giotto, Cimabue, and others of unfamiliar names to me, are among the earliest; and except as curiosities, I should never desire to look once at them, nor think of looking twice."[1] Hawthorne's prejudice against these "predellas and triptychs . . . shaped quaintly, in Gothic peaks or arches, and still gleaming with backgrounds of antique gold,"[2] and the rapture inspired in him by masterpieces of the Baroque painters Reni and Domenichino[3] is typical, not just of his own New England taste, but of America in general for most of the nineteenth century. Thus the collection of early Italian paintings at the Museum of Fine Arts, founded in 1870 and housed in its new Copley Square building in 1876, grew but slowly through donations and acquisitions to attain the eminent proportions documented in this catalogue.

That is not to say that paintings attributed to the famous Old Masters had not been seen at an early date in Boston. As the city's best-known art critic, William Howe Downes, wrote in 1888 of a typical painting auction of 1831:

> After the perusal of a catalogue of the collection of oil-paintings "lately arrived in this country from the galleries of Milan, Venice, etc." the reader wonders if any works by the old masters are left in those cities. A remarkable preface, full of rodomontade, explains how it is the most natural thing in the world that a Paul Veronese should have found its way to these shores, accompanied by choice specimens of the handiwork of Velasquez, Rubens, Tintoret, Guido, Murillo, Poussin, Ruysdael, Carlo Dolci, Giuliano Romano, Gerard Dow, Pietro da Cortona, Bassano, Netscher, Mengs, Le Brun, and Backhuysen. It is not fair to say that none of these were authentic works, but it is entirely safe to assume that most of them were counterfeits; and surely no one would have dared to offer such wares to any but a very ignorant and isolated community. It was between 1820 and 1850 that our fathers covered their parlor walls with those dreadful Salvator Rosas, Caraccis, Jan Steens, Ostades, and even Raphaels, and Correggios, in the genuineness of which they placed such implicit and touching confidence.[4]

Not only the auctions but also the annual exhibitions presented by the Museum's parent, The Boston Athenaeum, from 1827 on reveal that when it came to Italian art, the popular painters were those of the High Renaissance and Baroque eras. Supposed Raphaels, Leonardos, and Titians were not uncommon, and more frequently are found the names of Reni, Dolci, Rosa, Guercino, Giordano, and even Caravaggio.[5] One of the earliest exhibitors to rent the Athenaeum Gallery in 1829 was a Signor Antonio Sarti from Florence described as "proprietor of one of the most distinguished collections of valuable and rare paintings from the most ancient masters of Italy." Of Renaissance artists he presented works said to be by Raphael, Andrea del Sarto, and Correggio.[6] Likewise in 1835 when the Englishman John Watkins Brett held an exhibition there, among his primarily seventeenth-century wares were a *St. Jerome* by Leonardo and paintings by Titian and Tintoretto.[7] To an early charitable loan exhibition at the Athenaeum, the *Sanitary Fair Exhibition* of 1863, Peter Chardon Brooks, one of Boston's richest men and a distinguished collector, lent works supposedly by Ghirlandaio

and Andrea del Sarto. Other lenders provided paintings by Veronese, Schidone, Solario, and Palma Vecchio.[8] The *National Sailor's Fair Exhibition* of the following year included a Bellini and a Titian.[9] One of the few supposed authentic paintings of the Italian school that was in Boston as early as 1827 was a *Salvator Mundi* by Solario owned by the great print collector Francis Calley Gray.[10]

In 1874 the Museum received and exhibited at the Athenaeum its first major bequest of paintings, the collection formed by Senator Charles Sumner. Most of this was deemed of little value and quickly sold off. Still remaining in the Museum, however, is a sixteenth-century North Italian *Allegory of Redemption*.[11] The first special loan exhibition of paintings under the aegis of the Museum of Fine Arts was held that same year. It featured pictures belonging to H. R. H. the Duke de Montpensier, son of Louis Philippe. The Duke's paintings were mainly Spanish, but there were also a Sebastiano del Piombo and two Bassanos. Lent by local collectors as part of the same exhibition were a Cristoforo Allori *St. John in the Desert* from Abraham Bigelow and a *Madonna and Child* by Cima da Conegliano from Charles Shimmin.[12]

Of paintings from the Athenaeum's collection deposited with the new Museum in 1876, there were several seventeenth- and eighteenth-century examples but only one of the earlier period. This was a *Nativity*, thought to be of the School of Giotto (fig. 1) that had been purchased by a Mr. Folsom at a Boston auction in 1846.[13] It was later published by the scholar Osvald Sirén as a Taddeo Gaddi and remained at the Museum until 1977 when it was withdrawn and sold by the Athenaeum.[14] In addition to this the Dowse collection of watercolors, also transferred temporarily from the Athenaeum to the Museum, contained several copies of early Italians, including one of a fresco believed then to be by Giotto.[15]

The earlier Italian artists, the so called "primitives" or "pre-Raphaels," were clearly unappreciated and for the most part unrepresented in conserv-

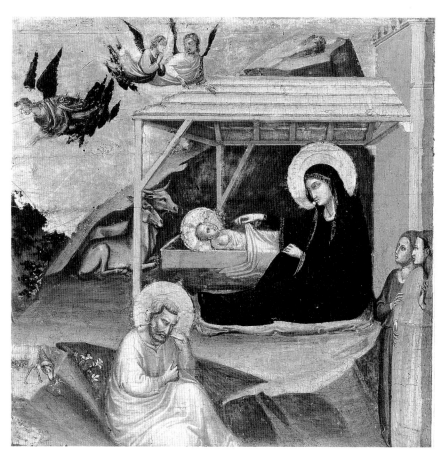

1. School of Giotto, *Nativity,* formerly Boston Athenaeum.

ative Boston. The one collection that could have ammeliorated this situation was rejected by the city's art lovers. This was the unfortunate and well-known case of the Jarves collection. Boston-born James Jackson Jarves (1818-1888), the son of the founder of the Sandwich glass company, had spent the years 1840-48 in Polynesia and first went to Florence in 1852. There, under the influence of the writers on art Alexis Rio and John Ruskin, he discovered the early Italian school.[16] Like the chief character in Edith Wharton's short novel *False Dawn*, an amalgam of Jarves and the New York collector Thomas Jefferson Bryan,[17] he began to proselytize in America for art in general and the early Italian school in particular. In his books and various articles, he passionately set forth his conviction about what he called, "the educational advantages of galleries and museums, and their conservative and refining influence on society."[18] He had a decidedly populist approach to art of the past and could declare in *Art-Hints* (1855) that "Giotto, Ghiberti, Brunelleschi, Angelico, Bartolomeo, Masaccio, Raphael Sanzio, and Michael Angelo Buonarotti, were artists of the people."[19] As Jarves later wrote the "favorable reception" of this book "was an additional encouragement for the continuance of a pursuit [the collecting of paintings] which, while so full of enjoyment to him individually, seemed also to be not without interest to his fellow citizens generally."[20]

"The historical and critical research" required for the preparation of *Art-Studies*, his next book published in 1864, led Jarves "to the conception of a gallery or museum of olden art for America, based upon a chronological and historical sequence of paintings, arranged according to their motives and technical progress."[21] With this in mind he contacted the distinguished Harvard professor of Fine Arts, Charles Eliot Norton. Jarves had first met Norton on a voyage to Europe in 1855 and given him a letter of introduction to Ruskin. Norton then visited Jarves's collection in Florence in 1857.[22] Norton, famed for his translations of Dante, became a trustee of the Boston Athenaeum, and Jarves wrote him from Florence on August 26, 1859:

> It has long been a pet scheme of mine to initiate in Boston a permanent gallery of paintings, with particular reference to the chronology, motives, and technical progress of Art, from the earliest development in Italy of the Christian idea, until its climax in the matured genius of its several illustrious schools. Masterpieces it was hopeless to expect to secure. Researches, however, made for my private studies, showed me that it was feasible for one on the spot to get together a valuable collection of pictures, covering the ground from the tenth to sixteenth century, characteristic of the great masters and their schools, illustrating the history of Art, provided it were gone about promptly, quietly, and diligently. Unwilling to lose the opportunity, I decided on taking the responsibility upon myself of making such a collection and of its subsequent adoption by my townsmen.[23]

Jarves's collection included works he identified as by Giotto, Leonardo, Fra Bartolommeo, Sodoma, Fra Angelico, Lorenzetti, Sassetta, and Lippo Memmi among others. He estimated the value of his thirty-eight paintings as "in round numbers $60,000," and he proposed "for $20,000, to deliver the collection with a descriptive catalogue, to make it finally the nucleus of a permanent gallery for Boston."[24]

Norton was enthusiastic about this proposal and published a pamphlet containing Jarves's proposition, letters of endorsement from European experts, and his own appeal that, "it is greatly to be hoped that such an opportunity of obtaining for Boston a gallery of specimens of the best Italian art may not be lost, and that Mr. Jarves's very generous proposition may be at once accepted."[25] Even the *Boston Courier* lent its support for the cultural benefits the proposed gallery of art would bring to the city:

> The possession of such a gallery, in combination with our public library, and the splendid museum of natural history which is destined to be reared at once in our immediate neighborhood, would give to Boston peculiar advantages for bestowing upon its citizens that finished education which includes science, literature, and the fine arts, and make it proportionally attractive to strangers.... A public gallery of works of Art would shed a benignant and beneficent influ-

ence over all that came within its sphere, and thus tend to correct the hardening and narrowing tendencies which so much beset us.[26]

The Athenaeum's trustees in October 1859 approved an appropriation of $5,000 toward the purchase and sought to raise the remaining $15,000 by subscription.[27] However, there was generally little enthusiasm for this, and some downright opposition, as reflected in an editorial in *The Crayon* (a New York based magazine on the arts):

> It is said that the collection of "old masters" got together in Italy by one Jarves, the author of a book called Art-Hints, is for sale, and that efforts are being made in Boston to purchase it. We hear that the Athenaeum has appropriated $5,000 toward the sum required. A pamphlet has been moderately circulated, setting forth the immense labor without regard to cost, the hair-breadth escapes from dirt, knavery and superstition, the self-sacrifice and intense enthusiasm of the said Jarves in his search for these canvases; with these "moving accidents by flood and field," is a collection of letters by Rio, Eastlake and the director of the Uffizi Gallery, written with a view to establish the originality of an unfinished Leonardo da Vinci and a very imperfect Raphael. What this gallery of pictures may be, how much of truth or of beauty it displays that would be of service in Boston, we cannot tell.[28]

Jarves's offer to include his collection in the Athenaeum's annual exhibition of 1860 was ignored and unable that summer to find in Boston any other place to exhibit it, he instead presented one hundred and forty-five paintings in New York City. They were shown in the winter of 1860-61 at what Jarves described as "the new marble gallery on Broadway," actually the Institute of Fine Arts at 625 Broadway between Houston and Bleecker Streets (also known after its proprietor Chauncy L. Derby as the Derby Gallery).[29] This exhibition received rather mixed reviews,[30] and the Athenaeum trustees in January of 1861 disbanded the committee on the subscription and decided definitively against the purchase in April. Nevertheless, recognizing the true value and quality of the collection, Norton and some other Bostonians wrote that same month to Jarves asking him to exhibit his collection in Boston.[31] Not, however, until January 1862 was he able to arrange for a portion of it to be shown there at Williams and Everett's Gallery on Washington Street. This group of thirty works included in addition to the Leonardo, Ghirlandaio, and Sano di Pietro, some of the better-known Baroque artists, Guido Reni, Domenichino, and Murillo.[32] The *Transcript* was supportive of the enterprise, encouraging the public to attend:

> We hope Mr. Jarves, by the interest the partial exhibition of his pictures has excited in this city, will be encouraged to let us see the rest of them from time to time, until that interest shall become strong enough to secure for them an abiding place here. It would require only a small expenditure to build or fit up a suitable place for the effective arrangement of the entire collection, and the gallery would be a needed and positive addition to the various educational institutions that are now characteristic of Boston.[33]

A series of articles followed, commencing on February 3, 1862, with the information that:

> The opening of this gallery in the midst of our city affords the opportunity so much coveted by numerous minds to see the art which has filled Europe with its fame through many centuries. . . . If we cannot afford the time and money to visit Florence and Rome . . . we have here the best substitutes. Though but a fragment of . . . the whole gallery, exhibited the past year at New York (let us hope the whole will soon be here) it serves well to give one the taste and appreciation of what the old art has been. . . . We see here Giotto in his stern dramatic power.[34]

After a long discussion on Giotto and his paintings, the anonymous writer continues in the next installment, "We think the merits we have pointed out may be surely recognized if we will give the patient attention the old works demand . . . if we will look at it until we grow beyond the quaintness."[35]

It was still not possible, however, to arrange a sale or establish a perma-

nent home for the Jarves collection in Boston, so in the spring of 1863, it was shown again in New York, this time at the Historical Society and remained there for three years.[36] Then in 1866, as the result of meeting a Yale professor on his return trip to Europe, Jarves agreed to deposit his collection, now numbering one hundred and nineteen items, at the recently opened gallery of Yale University in return for a loan of $20,000, the pictures serving as security. After three years, Jarves was unable to pay off the loan and a public auction was held at Yale. The collection was offered as a unit and there was only one bid, that made by the University Treasurer for $22,000 – the amount of the loan plus interest.[37] Yale thereby became the owner of what was eventually to be recognized as the first and certainly one of the most important group of early Italian paintings in America.

Jarves remained undeterred in his devotion to collecting. He used the money lent by Yale to buy additional paintings and sculpture in Italy,[38] and in 1883 was able to exhibit a second collection in Boston. He had been appointed commissioner for the Italian art section of the *American Exhibition of Foreign Products, Arts, and Manufactures* that opened in September of that year.[39] This exhibition is memorable in Boston primarily for the selection of Impressionist paintings displayed by the Parisian dealer Durand-Ruel.[40] Jarves's group of over sixty paintings included a Leonardo *Madonna and Child* and others ascribed to Giotto, Starnina, Fra Angelico, Piero della Francesca, and Luca Signorelli, as well as some of different periods and countries: Dürer, Rembrandt, Rosa, Reni, and Claude. In the introduction to the exhibition *Handbook* that he wrote, Jarves justified the presence of these Old Masters amidst a showing of contemporary works and vigorously defended their quality.[41]

Again no one in Boston expressed interest in acquiring these paintings, and the entire collection was purchased in 1884 by Liberty Holden of Cleveland, whose widow eventually gave it to The Cleveland Museum of Art.[42] Jarves continued to buy Italian paintings, and before he left America to return to Europe, he placed twelve paintings on loan to the Museum of Fine Arts. He wrote to General Loring, the Museum's director, on February 9, 1888, asking not only for a receipt but also for "a line telling me how they look hung and if they interest anyone." Those that can be documented of this group are a Timoteo della Vite, *Virgin Appearing to Saints Francis and Anthony*, Pellegrino Tibaldi's *Venus Anadyomene*, a Bellini *Portrait of a Man*, Antonello da Messina, *Ecce Homo,* and Sodoma *Magdalene in the Wilderness*. Then in 1893 the executor of the Jarves estate wrote Loring that "The Trustees under the will of the late James Jackson Jarves are desirous of selling the collection of the Old Masters now on exhibition at your museum. We should like very much to dispose of it to your institution, and would respectfully request that you lay the matter before the proper committee. By Mr. Jarves's private books we find that he valued the collection at about $17,000. The lowest figure at which we are permitted to sell by the beneficiaries under the trust is $10,000." Apparently the Museum Committee decided it did not wish to purchase the entire group but might be interested in individual examples, for the executor wrote the director again on March 2, 1893, "I will see if I can get the Trustees and beneficiaries under the trust to name prices for individual pictures and will then report to you. Meanwhile if your Trustees have any offers to make for any of the pictures, we should be glad to hear of them." Nothing seems to have been sold, and when the catalogue of the Museum's paintings, including both the permanent collection and loans, was published in 1921, it included as on deposit from the Jarves estate the Timoteo, the Tibaldi, and the portrait now listed simply as "Venetian School." Then in 1924 the heirs again offered for sale to the Museum the Timoteo della Vite, but this was refused, and in 1925 the pictures were returned,[43] so that no painting with a Jarves provenance is in the Museum's collection to mark the efforts of this truly pioneering collector.

Downes's study of art collecting in Boston mentioned previously appeared in serialized form in the *Atlantic Monthly* during 1888. He did not

mention Jarves, and wrote that with regard to the Italian school, there were to be found in Boston private collections "genuine paintings by Titian, Tintoretto, Giordano, Il Bassano, Guercino, and Andrea del Sarto,"[44] but unfortunately he does not relate what they were or who owned them. An indication that by this time taste had indeed begun to change was the presence in the eighteen-year-old Museum of Fine Arts of several early Italian paintings. Downes chose to describe two of these. He noted "a valuable and interesting specimen of the primitive art of the Renaissance . . . an altar-piece of the Sienese school of the fourteenth century representing the entombment and assumption of the Virgin." In addition there was a "Pietà, with paintings of saints on panels, by Bartolomeo Vivarini, who made the first oil-painting exhibited in Venice, signed and dated 1485. . . . The whole altar-piece is about six feet square, richly ornamented and gilded, and in a good state of preservation."[45]

Both of the paintings Downes discussed came from trustees of the Museum, and this group of distinguished men, despite their diverse backgrounds, were all infused with a love of art for its intrinsic as well as educational value. A respect for the early Italian paintings had been won in great part through the writings and lecturing of Jarves's chief local supporter, Charles Eliot Norton, who became a trustee of the Museum and whose lectures at Harvard inspired a whole generation of Bostonians.[46]

Of the gentlemen-collectors who created the Museum, perhaps the most venerable was its first president, Martin Brimmer. The son of a former mayor, he graduated from Harvard in 1849 and after travel in Europe, devoted himself to politics, art, and literature. Mr. Brimmer had a long association with the Museum – named as a trustee in the Act of Incorporation, February 4, 1870, Chairman of the first meeting of the Trustees that month, and President of the Museum from 1870-1896.[47] He formed a varied collection and to the Museum's loan exhibition of 1877 sent several paintings, including one by Agnolo di Donnino of *The Virgin and an Angel Adoring the Infant Christ*. This his widow left as a bequest to the Museum in 1906, but it was in poor condition and subsequently sold.[48]

Mr. Brimmer was always on the lookout for pictures for the Museum, and so when sent abroad for his health in 1882, he wrote from St. Moritz to the Museum's Director, General Charles Greely Loring, that he had investigated two collections in Rome. One belonged to a cardinal, but its sale to a foreigner was not possible.[49] The following year Brimmer was in Madrid, from where in April he wrote to Loring that he had "heard of the Toscanelli sale when I was in Florence, but could not get in to see it. Afterward I had some correspondence about it with Stillman[50] with a view to purchasing for the Museum and on receiving your letter I sent him credit for £400 where with to buy according to his judgement."[51] Then in June of 1883, Brimmer wrote General Loring from Paris: "Mr. Stillman has sent you two pictures, one from the Toscanelli sale marked 110 on the catalogue. Stillman says it is not by Bartolo, but is a good example of the Sienese school of the end of the 14th century, probably from the studio of Lorenzetti, and well preserved. I hope it is good for something and am sure it is big enough."[52]

The large painting listed in the Toscanelli sale catalogue as a Bartolo di Fredi[53] was the altarpiece, representing the entombment and assumption of the Virgin, described by Downes in his 1888 article. Now attributed to Niccolò di Ser Sozzo and Francesco Neri da Volterra (cat. 19), its size and condition have in recent years mitigated against its display, but at the Copley Square Museum it had a prominent place in the painting galleries (fig. 2). With its presentation by Brimmer in 1883,[54] it became the first early Italian painting in the Museum's permanent collection, launching the acquisitions of that school on a distinguished course.

The other large altarpiece seen in the 1902 gallery view (fig. 2) is the *Pietà* described in Downes's article. It also belonged to one of the Museum's greatest benefactors Quincy Adams Shaw (1825-1908). A graduate of Harvard in 1845, he went west, made his fortune in mining, and then traveled to Paris where he became interested in the Barbizon School, especially, begin-

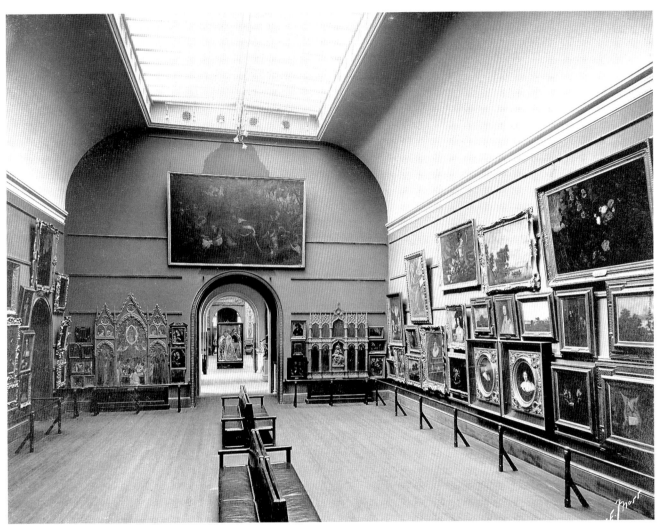

2. Museum of Fine Arts, Copley Square Galleries,
1902.

ning in the 1870s, Millet. Shaw formed the largest private collection of works by this artist and it eventually came to the Museum, but he also collected Italian Renaissance sculpture and an occasional painting.[55]

In 1875, Shaw lent the young Museum twenty-eight paintings and among them was the large altarpiece consisting of a center panel with a sculpted Pietà flanked by painted full-length standing saints, while above was the scene of the Ascension flanked by half-length saints. It was signed by Bartolomeo Vivarini and dated 1485. According to an 1899 letter to General Loring from Russell Sturgis of New York, it was Stillman who had bought this originally in Venice. When Mr. Shaw presented the work to the Museum in 1900, it was reported that it came from "a monastery near Venice."[56] Although the public remained impressed by this painting, the leading scholar of Italian painting, Bernard Berenson, found it second rate. He wrote, "the elaborate polyptych surrounding a carved *Pietà* dated 1485, and signed as these articles for export generally were, with the FACTUM VENETIIS PER BARTOLOMEUM, etc . . . is obviously a factory work, but, for a factory work, not a bad one. Discreetly lighted in the incense-laden atmosphere of a harmoniously colored chapel, it must have been effective."[57] Berenson thought more highly of another Vivarini in Mr. Shaw's collection. This was a bust-length *Magdalene* framed in similar fashion to the big altar by the Boston artisan Charles Prendergast.[58] That work (fig. 8) remained in the Shaw family until recent times.

Other of the Museum's early trustees had at least a passing interest in Italian painting – even if it was not their first love. A notable example was William Sturgis Bigelow (1850-1926). Appointed a trustee in 1891 he was renowned for his great collection of Japanese and Chinese art, which he gave to the Museum.[59] His acquaintance with other fields is evident in a cable he sent to General Loring in 1897 from Washington, D.C. which contained the following advice: "The market seems suddenly flooded with plausible old masters in imitation old frames. Berenson sold five Moronis last year. . . . I should go very slowly about buying."[60] The following year another cable from him to Loring asks for the address in New York where he can see a "Benozzo Gozzolo [*sic*]."[61] In fact several older Italian paintings came to the Museum from Mr. Bigelow, including in 1921 a Sienese primitive of *The Virgin and Child with Saints* now identified as by a follower of Cozzarelli (cat. 64). A large *Holy Family with Saints* by Bonifazio Veronese was bequeathed by Bigelow to the Museum on his death in 1926.[62]

One of the most significant Boston collectors and most generous donors to the Museum, with over 11,000 works of art donated in many different departments, was Denman Waldo Ross (1853-1935). First elected a trustee in 1895 he gave a group of Japanese objects in 1898 and continued making gifts until his death in 1935. A lover of textiles, manuscripts, pre-Columbian art, and Asian and Indian sculpture, he also presented the Museum with its first paintings by Monet. He was both an artist and a lecturer on the Theory of Design at Harvard, who acted as a freelance agent for the Museum, literally roaming the world seeking out suitable pieces.[63] As Matthew Prichard, the Museum's assistant director, wrote to him in September 1904, "It is most inspiring to hear of the work that you are doing for us. I do hope you will not imitate other collectors and ruin yourself."[64] Ross not only avoided ruin, but also had a clear vision of what he was doing. He defined it in a letter of 1912, "The Ross Collection is the expression of a life devoted to the study of works of art. It has a certain unity and consistency and, in the measure of its excellence, is a work of art. I don't ask that the various objects of the Collection should be exhibited together. I am willing that they should be put where they belong in our general arrangement and classification, but I want the words Ross Collection attached to every object or group of objects which has been given or loaned by me. By that means I shall be able to speak to the people of Boston long after I am dead, as in a book written or in a picture painted."[65] A celebration of Ross's many donations in 1932 prompted Bernard Berenson to write to the collector: "You have done more perhaps than all your other fellow

citizens put together not only to make a museum that counts among the museums of the world but to create a standard of taste and men to understand it and to try to work up to it. Mary and I congratulate you most cordially."[66]

During his extensive buying forays, Ross acquired a few paintings on behalf of the Museum. A letter of 1906 from him lists Japanese sword guards, a thirteenth-century manuscript, and "a small picture by Tiepolo (J.B.) bought of Fairfax Murray."[67] In 1907 he sent from abroad a collection of lace, Turkish embroideries, and a charming eighteenth-century Venetian painting of the frozen city.[68] While traveling during 1924, Ross reported, "I have seen very few good pictures here in Sicily; only two of the first order both of them by Antonello da Messina, who is a very great painter. However, we shall see pictures enough in Naples, Venice, Paris and London."[69] In 1924 based upon a letter from the director, Arthur Fairbanks, to Ross, it appears that the latter had urged the purchase of a painting "in the manner of Duccio" and the Museum Committee authorized the acquisition,[70] but no such work was actually added to the collection at this time.

Denman Ross's chief contribution to the collection of early Italian paintings came about in late October 1920 when in Florence he encountered Mrs. Thomas O. Richardson. She had earlier lent works to the Museum but now offered several significant Italian paintings as gifts. Ross gave the following account of what transpired:

> She suggested that I take them off her hands at once, I was unable to do so before leaving for Venice, so I asked Forbes [the director of the Fogg Art Museum] to see the pictures and start them along which he very kindly did. Mrs. Richardson was so much pleased with Forbes that she said "I am quite willing to give these pictures to you for the Fogg Museum." Forbes was loyal, however, and though he wanted the pictures very much, he advised Mrs. Richardson to carry out her first intention. So they are on their way. Both Forbes and Mason Perkins are much interested in these pictures and consider them an important acquisition. I saw them only in the late afternoon of a gray day, we were taking tea with Mrs. Richardson, so I have a very vague impression of the pictures. I am very glad to learn that they are "decidedly worth having." That is what Perkins said of them.[71]

Following their donation, Mrs. Richardson's gifts were listed in the *Bulletin* as: "Two Saints, Tuscan fifteenth century. Two paintings each representing a prophet with two angels, Tuscan fifteenth century. Three Saints, Umbrian School fifteenth century, Madonna and Child and Saints, Sienese school, fourteenth century."[72] The first of these panels are now identified as by Starnina and are among the finest gold ground paintings in the Museum's collection (cat. 31 a-d). Two other panels each representing three standing saints are now attributed to Niccolò Alunno (cat. 67a and 67b). Also notable was the *Madonna and Child with Saints*, now given to Niccolò di Buonaccorso (cat. 21). This had been on loan to the Museum since late in 1907, when Mrs. Richardson wrote to Mr. Fairbanks, that the picture, "Which I do not propose giving at present ... may be Sienese – more probably Umbrian as it came from Gubbio many years ago. It was then attributed to Lucas Cranach but I think wrongly."[73] In 1922 she added a small painting of the Virgin and Child enthroned in a landscape with the scene of the Coronation of the Virgin above. This is attributed here to Domenico Ghirlandaio (cat. 48). Following Mrs. Richardson's death in 1925, the Museum also received the lovely Costa *Portrait of a Lady* on loan from her since 1901.[74]

Further loans and donations during the late nineteenth and early twentieth centuries came from other long-time supporters of the Museum. The second early Italian painting to actually be given was a *Madonna and Child* thought to be by Spinello Aretino. It was presented by Mrs. C.B. Raymond in 1884[75] and is now attributed to Antonio Veneziano (cat. 6). The next notable gift of an Italian painting came from Mrs. Samuel D. Warren, Sr., in 1890. It was an *Entombment* then attributed to Cima da Conegliano[76] but later recognized as a Basaiti by Berenson, who described it as: "the earliest of

his works in our possession. ... It has something simple almost to the point of rusticity in the feeling, types and action; but the grouping, on the contrary, is carefully thought out and impressive, and the landscape has the characteristic charm of Basaiti at all times."[77]

The Felton family of Cambridge had lent pictures to the Museum since the early 1880s, and in 1902 Mr. and Mrs. Cornelius Felton gave a signed work of 1513 by Gaspare Negro.[78] Berenson described this as "an elaborate and rather pretentious work. ... It represents in the apse of a Venetian basilica the Blessed Virgin posed on a pedestal with the Dead Saviour in her lap and several Saints to right and left. It is a stiff stupid work but betrays acquaintance with Giorgione and perhaps Titian."[79]

In 1897 Miss Caroline Isabella Wilby bequeathed a *Madonna and Child with Angels* of the Sienese school[80] which is now identified as by Sano di Pietro (cat. 58). George Washington Wales, a trustee of the Athenaeum in 1870 and a member of the Committee on the Museum during 1876-1896, bequeathed in 1903 a group of eight paintings,[81] among which were those now attributed to The Argonaut Master and The Master of Bracciolini Chapel (cat. 47 and 32) as well as a Florentine School *Madonna and Child with Saints* here identified as by Lippo d'Andrea (cat. 33).

Catherine Sherwood presented in 1904 a work titled *Torture of a Saint* attributed to Jacopo Avanzi, but in the Museum's 1921 catalogue it was described as "North Italian School (Paduan School)."[82] Now it is attributed to Lorenzo di Niccolò di Martino (cat. 30). An anonymous Sienese *Madonna* given by Mrs. Josiah Bradlee in 1907 was soon identified as a Sano di Pietro (cat. 55). In 1910 a fourteenth-century Italian panel painting which had long been in Boston was made a gift to the Museum from the Massachusetts Historical Society. This was a standing figure of St. Lucy (cat. 4), but it had on the back an old label inscribed, "A representation of the Virgin Mary said to have been taken from a door of a church in Rome built A.D. 600. Gift of Messrs. John Low and Darius Chase, June 16, 1845." According to the Historical Society the gift was actually made on January 30, 1845, and the motion to transfer it to the Museum was approved in February 1918.[83]

In 1912 the Museum received what the scholar Osvald Sirén described in 1916 as, "the most important picture among those which I had the pleasure of seeing in the storerooms of the Boston Museum." He wrote further that it was "a large altar wing representing two kneeling and two standing saints, of which, however, one is almost gone. The picture is in a poor state of preservation, the paint beginning to peel off in parts; nevertheless its quality is so superior to any of the other picture here discussed that even in bad condition, it appeals with the strong voice of a great master. There can be no doubt that this beautiful ruin is an authentic work by *Fra Filippo Lippi*. ..."[84] This painting, however, was returned to the donor by a vote of the trustees in early 1917 and sold later that year to The Metropolitan Museum of Art.

Beginning in the late nineteenth century, the Museum also made acquisitions of Old Masters, including Italian ones, from well-known dealers. For example, at the Museum Committee meeting of April 1895:

> A photograph of a painting by Botticelli of the "Virgin and Child with St. John" was shown, offered by Agnew and Co. for £1150. A laudatory description of it was read from Dr. Waagen. ... Mr. Brimmer quoted the contents of a telegram from Dr. Edward Clifford speaking of it in high terms, and from Mr. Henry James in a more qualified manner, but calling it a fine second Botticelli. The Director was authorized to telegraph to Mr. Agnew, "Bigelow will take Botticelli at price named."[85]

On hearing this Agnew wrote to Mr. Bigelow, "We trust this work will give you the same satisfaction and pleasure as the Bonifazio you purchased last season. We ourselves think that it is a worthy companion, and that you have made a good purchase."[86] The Botticelli (cat. 52) formerly in the Barker collection, London, was purchased through the Sarah G. Timmins Fund, and in the same year Moroni's supposed *Portrait of Count Alborghetti*

and His Son was purchased from a private gallery in Bergamo with the Turner-Sargent Fund.[87]

The 1895 edition of the Museum's *Catalogue of Paintings and Drawings*, which included loans as well as permanent collection works hanging in the picture galleries incorporated the Botticelli and actually listed about thirty forteenth-, fifteenth-, and sixteenth-century works.[88] Among the notable examples were of course the gifts from Mr. Brimmer and Mrs. Warren. There was also the Vivarini *Pietà* lent by Mr. Shaw, as well as his Palma Vecchio *Annunciation*, Bassano's *Scourging of Christ*, Tintoretto's *Adoration*, and Veronese's *Marriage of St. Catherine*.[89] James Jackson Jarves still had eight works on loan by such distinguished names as Titian, Garofalo, Antonello da Messina, and Sodoma and from the Athenaeum there was the School of Giotto *Holy Family* (fig. 1). Several works were also lent by Denman Ross, including a Sienese *Madonna and Child*, which he gave in 1906 and is now considered to be by Cozzarelli (cat. 63).

The next year, 1896, saw the publication of the first account in a foreign journal of the Italian paintings in Boston and vicinity. This was an article by the young connoisseur Bernard Berenson, in the *Gazette des Beaux-Arts*.[90] A significant development since the time of Downes's article, in not only Boston but international collecting, was one that Berenson himself had a major hand in shaping – namely the then still-growing collection of Isabella Stewart Gardner. Berenson, who had come to Boston from Lithuania as a child of ten, was educated at Boston Latin, Boston University, and Harvard. Despite certain reservations, he always maintained an affectionate regard for his American hometown and especially for Mrs. Gardner, who had helped finance his first study trip to Europe and became his most important client when he turned to art advising as a profession.[91]

Berenson wrote that "Boston and its suburbs, Jamaica Plain and Cambridge, offered more of interest to the student of Italian art than did New York, but unlike that great city, it was in the private collections rather than in the public museum that one went to study them." Reflecting his own predilection, he continued, "the poverty of this last establishment [the Museum of Fine Arts] concerning paintings is more than compensated for by the magnificence of its collections of Chinese and Japanese art."[92] For Berenson the most important Italian painting in the Museum at this time was the small *Pietà*, given by Mrs. Warren, which the Museum assigned to Cima, but as indicated earlier, he attributed to Basaiti and described here as, "a work full of charm and emotion."[93] The *ancona* dated 1485 from the atelier of Bartolomeo was "only of archaeological interest," more interesting was an altar painting signed and dated 1513 by Gaspar Negro. A *Flight into Egypt* of Girolamo de Santa Croce was "inspired by prints of Dürer and Lucas van Leyden." The Venetian school was represented by an *Adoration of the Magi* attributed to Jacopo but probably by Domenico Tintoretto also the author of a head of a man attributed by the Museum to Annibale Carracci; a large *Sacra Conversazione* attributed to Titian seemed "no more than a copy by Beccaruzzi after Paris Bordone." He wrote further, "The other Italian schools are no better represented." These were he noted a *Madonna* dated 1561 by Alessandro Allori and another attributed to Pintoricchio, as well as a *Madonna in Glory* attributed to Timoteo della Vite but by Zaganelli. The Lombard School was represented by a *Madonna* attributed to Cima but actually of the school of Pavia, probably by Lorenzo of Pavia.[94]

Then, having ignored significant works in the collection, such as the Brimmer gift and the Botticelli, Berenson passes on to the private collectors of Boston and surrounding area. He mentions the following and the works they own: Quincy Shaw in Jamaica Plain – a half-length *Magdalene* on gold ground by Bartolomeo Vivarini and a *Madonna* by the youthful Cima, a *Madonna with Saints* by Bernardino Licino, and by Domenico Tintoretto a small *Annunciation* and a large *Nativity* begun perhaps by Jacopo Tintoretto, and of the Florentine school a *Madonna Adoring the Christ Child* by Mainardi; Professor Charles Eliot Norton of Harvard in Cambridge has a *Portrait of a Young Man* by Bernardo Licinio, and among several Venetian works *Head of*

a Old Man by Jacopo Tintoretto, and a painting of *Cardinal Grimani* by Domenico Caprioli. Denman Ross has a portrait by Tiberio Tinelli of Lorenzo Ghirardello, and a *Saint Sebastian*, a replica of the Raphael in the Lochis collection.[95] Berenson naturally reserves his most laudatory comments for "the collection of Mrs. John L. Gardner composed of works by Italian masters that all the European collectors would envy."[96] The paintings he describes in her collection were then attributed by him to Botticelli, Peruzzi, Catena, and Bonifazio.

Mrs. Gardner had on her own actually begun to collect Old Master paintings in 1888 and added several more (including her Vermeer) during a trip to Europe in 1892.[97] But by August 1st of 1894, when she next went abroad, she was being advised by Berenson, who sent to her on that date in England one of the first of many beguiling letters offering works of art for purchase. In this he inquired, "How much do you want a Botticelli?"[98] It was the *Death of Lucretia* belonging to Lord Ashburnham, and Mrs. Gardner did acquire it in December before sailing home. Over the next ten years she was to purchase the majority of her Italian, as well as other European, masterpieces that Berenson, with the assistance of Otto Gutekunst of Colnaghi's, was able to locate for her.[99] It was, however, only in 1896, she later claimed, with the acquisition of Rembrandt's *Self-Portrait* that she and her husband conceived the idea of building their own museum in Boston.[100] In a letter to Berenson of July 19, 1896, she writes, "Shan't you and I have fun with my museum?"[101] And indeed they did!

Major Italian paintings Mrs. Gardner purchased through Berenson included a Crivelli in 1897, a Sebastiano del Piombo (now Baccio Bandinelli) in 1899, Fra Angelico's *Dormition and Assumption of the Virgin*, and a Simone Martini polyptych in 1899, a Giotto and Raphael's *Pietà* in 1900, a Botticini in 1901, and Pintoricchio in 1902. Her museum, Fenway Court, opened in January 1903, but she continued to add sporadically to it for several more years. For example she bought her Giovanni di Paolo in 1908, when Berenson threatened that otherwise the Philadelphia collector John G. Johnson would "snap it up."[102] In 1917 Berenson tried to tempt her with another great masterpiece, the Bellini/Titian "*Bacchanal,*" as he called it, from the Duke of Northumberland's collection, but she was unable or unwilling to make the effort and this *Feast of the Gods* went to the eccentric collector Carl Hamilton in 1920 and then to P.A.B. Widener in 1922, who in turn gave it to the National Gallery of Art in Washington.[103] The Berensons did, however, convince Mrs. Gardner to purchase in 1921 what Mary Berenson described as "a severe yet radiant Madonna" by Giovanni Bellini.[104]

During the course of their relationship in forming the collection, there were some stormy moments. One of the issues was Mrs. Gardner's primacy among Berenson's American clients. In a letter of December 1895, to Berenson, she made it quite clear that she wanted first refusal of the treasures he discovered:

> I should only like to say first that in future and for all time, please don't let me and some one else know of the same picture at the same time. It may be only a prejudice of mine – but it is disagreeable to me to be put en concurrence in these things. So if you want to get pictures first for any one else, do so; and after that is all settled, have me in mind another time, when I am to be first – and wait until you hear from me before passing on the chance. Now I have said my disagreeable little Say, and I hope that you will be amenable and gentle with my "prejudice."[105]

Berenson certainly got the message and responded:

> Yes, I promise never to propose a picture to you at the same time that I am proposing it to someone else. But please believe that with the Giottino, at least, the case was not such. It was simply out of my reach before I knew it. I beg you to believe for the future that when such an accident does happen, it is not thro' fault of mine. Unless I take a picture over I can not of course prevent its being sold.[106]

Mrs. Gardner, especially, as she indicated in correspondence with

Berenson concerning the Loschi "Giorgione" of *Christ Bearing the Cross*, did not want to give the appearance of competing with the Museum of Fine Arts of which she was a patron and sometimes reluctant supporter.[107] On September 11, 1896, she informed Berenson, "if our stupid and impossible Art Museum does not get the Giorgione (the Christ head, you know) please get it for me. I have seen the photographs and like it, they won't move quickly enough to get it I fear." Berenson responded that General Loring had asked for his advice on this and been to see the painting with the painter Joseph Lindon Smith. Berenson advised them on price and told Mrs. Gardner, "I promised General Loring not to speak of the picture to anyone until he had refused it. If he does refuse, are you ready to pay as much as £4,000?"[108] The Museum did eventually "retire" from the quest, and she was able finally to obtain the painting in 1898, although it is now attributed to Giovanni Bellini.[109]

Berenson, judging from existing correspondence, refrained from offering works directly to the Museum until 1903. On that occasion it was a Perugino *Virgin and Child* that he himself had purchased and had proposed to Mrs. Gardner in June 1902. She turned it down[110] and he then felt free to approach the Museum. Of this, or another offer, Mrs. Gardner got wind and wrote sharply to Berenson in the fall of 1903 when he was traveling in America, "How we all change, also our points of view! This is what I judge by your being at Mr. Davis's[111] and by hearing you want to sell pictures to the Fine Arts Museum here! That you should be willing to do that after former decisions *is* a surprise!"[112]

Berenson replied to her on October 9, 1903, from Davis's home at Newport that he had to see that collector first due to his busy travel schedule and that "It is news to me that I am to sell to the Art Museum. Not that I should not be willing to, but I have heard nothing of it, and I have made no advances. You may rest assured that it could never occur to me to offer anything that I had not first offered to you – unless you have really stopped buying. In that case I should be guided by the principles which have always actuated me, to use all my influence to get pictures to America, and if possible to Boston."[113]

Having stated his case, Berenson (or actually Mrs. Berenson) wrote to the Museum's director, Edward Robinson, on December 1, 1903:

> I submit for the consideration of the Trustees of the Museum of Fine Arts a panel picture represented by the accompanying photograph. The subject is the Madonna with the Child. The author is Pietro Perugino . . . This panel shows Perugino at the beginning of his last phase, when his drawing had lost the precision but also the tightness of his earlier years, when his handling had attained its fullest freedom and his design had passed beyond its charm of the Quattrocento into the dignified largness of Classical art as developed by the elder Sansovino and Michelangelo, and adopted by Raphael, Fra Bartolomeo and Andrea del Sarto. Excepting the Villa Albani polyptych, I know of no work in private hands by Perugino of the merits of this one. Its condition is admirable. . . . Mr. Potter, your Keeper, upon seeing it three months ago, declared to my wife that he had never seen a more pleasant surface, or a picture in much better condition. . . . He added that he greatly desired that this picture should end in your Museum of Fine Arts. You may ask what guarantee I have for the statement that this panel is by Perugino. I have none but the guarantee of internal evidence. But that evidence I venture to say is so strong that I do not see how a scholar could dispute it. . . . The price of the picture is twenty thousand dollars. If it is what I have stated it to be, it is well worth that money, even allowing for the inevitable personal equation of my statement. It remains for me to add that the only person except Signor Cavenaghi [the restorer] and my wife and myself who have hitherto seen this picture is Mr. Potter; that it was offered (through a photograph) for sale but once, and that to Mrs. J. L. Gardner, who to my surprise and regret refused to purchase it.[114]

Mr. Robinson replied to Berenson on December 16, 1903, "Our Museum Committee met yesterday and took up once more the question of purchasing your Perugino. I am sorry to say that, in view of present conditions, it was decided that the Museum could not buy the picture, even should Potter

recommend it."[115] Only in 1909 was Berenson able to sell the Perugino to John G. Johnson of Philadelphia.[116]

One of Berenson's most difficult moments with Mrs. Gardner came about in 1896 due to his relationship with another art collecting family of Boston, the well-known and wealthy Warrens of Mount Vernon Street. Samuel Dennis Warren, Sr., a highly successful paper manufacturer was a trustee of the Museum from 1883 until his death in 1888. His wife, Susan Cornelia Warren, had begun collecting art about 1870.[117] She was a loyal supporter of the Museum and, among other things, had given it the Cima *Pietà* which Berenson correctly ascribed to Basiati. The Warrens sent to the Museum's summer loan exhibition of 1884 a group of twenty-five paintings, mainly French and American, but also one described on their list as "Andrea del Sarto, *Saint James Blessing Two Penitents.*"[118] Their eldest son, Samuel D. Warren, Jr., also became involved with Museum business, being elected a trustee in 1892 and then president from 1901 to 1907. Apparently a suit brought against him by his younger brother, the collector and aesthete, Edward Perry Warren (known as Ned), drove him to suicide in 1910.[119] The chief passion of Ned Warren, who early went to live in England, was for classical art, and he helped the Museum acquire many significant pieces in this field. Occasionally, through his friendship with Berenson, whom he had known at Harvard and whose first trip to Europe he had helped finance,[120] he was able to locate a significant painting. Thus in July of 1890 he wrote to Mr. Robinson:

> Berenson came across what he considered rather a find in Italy – at Venice I believe – and bought it as my agent. It is a Madonna and Child and seems to be by Bronzino. A copy of it – a bad one, he says - is at Hampton Court where it is referred to Bronzino. He tells me that it has been very little retouched – almost not at all – and is a genuine picture of the date it bears 1561. . . . In short I hope the picture though it does not represent the most interesting period of Italian Art is worthy of being accepted by the Boston Art Museum.[121]

The painting was accepted as Warren's gift and in the Museum's 1921 catalogue was attributed to Bernardino Lanini,[122] but it was later recognized that the original composition was by Pontormo. Many versions of it exist, and this one has been assigned to Francesco Morandini known as Il Poppi.[123]

In 1898, Berenson again advised Ned Warren, this time in his bargaining with the dealer Virzi in order to acquire paintings for Mrs. Warren from the Sant'Angelo family near Naples. This collection, he wrote Ned was "a bad pudding with few plums. The Filippino is genuine unquestionably authentic. In so far as I know his third best work in existance."[124] The work in question was Filippino Lippi's tondo of the *Holy Family with Saints*, but in order to obtain it, other pieces of lesser quality had to be purchased as well. Mrs. Warren thereby came into possession of one great Renaissance painting plus several lesser Italian works by Brusasorci, Catena, and Vecelli. There was also a large early German painting *The Death of the Virgin* by Michael Wohlgemut.[125] Otherwise Mrs. Warren's collection consisted mainly of nineteenth-century Barbizon and academic French paintings and English portraits.

Thus it was to Mrs. Warren that Berenson turned when he was desperately seeking to place another great Italian painting, Titian's *Rape of Europa*, in an American collection. As he explained apologetically to Mrs. Gardner, he had not offered it to her first, because she seemed to be on the point of acquiring for a considerable sum Gainsborough's famous *Blue Boy*. However, when that purchase fell through he wrote to her:

> I had no doubt I could get you The Blue Boy. I reasoned that you would not be likely to want to spend £20,000 on top of £38,000. But the Titian Europa is the finest Italian picture ever again to be sold—I hated its going elsewhere than to America, and if possible to Boston. So in my despair I immediately wrote to Mrs. S. D. Warren urging her to buy it.
> Now as you can not have The Blue Boy I am dying to have you get the Europa, which in all sincerity, personally I infinitely prefer. It is a far greater

picture, great and great tho' The Blue Boy is. No picture in the world has a more resplendent history, and it would be poetic justice that a picture once intended for a Stewart should at last rest in the hands of a Stewart.

But you have forbidden me to bring you into rivalry with any one else. Yet I have given you my reasons and I trust you will sufficiently consider the exceptional circumstances. I am under no obligation to Mrs. Warren. If you cable as soon as possibly you can make up your mind after receiving this, your decision will in a perfectly bona fida way come before Mrs. Warren's and then the Europa shall be yours. Cable, please the one word YEUP = Yes Europa, or NEUP = No Europa.[126]

Mrs. Gardner did not hesitate to cable "YEUP" and acquired a picture widely considered one of the finest Old Masters in America. If this actually engendered a rivalry between the two collectors, it is not clear. Mrs. Gardner maintained, for the time being, her friendship with both Sam and Ned Warren,[127] and in fact she did Ned Warren out of another painting when in 1900 she, through Berenson, beat him to a supposed Fiorenzo, later known as the "Master of the Gardner Annunciation."[128] This too did not seem to affect Ned's relationship with Mrs. Gardner, for in an undated extract from a letter he wrote to Edward Robinson, he says: "As nothing apparently has been done about pictures, I am left in doubt whether to have a signed picture of some importance examined for Mrs. Gardner or for the Museum. If genuine and untouched it should be a find."[129]

It is tempting to speculate that the painting to which Ned Warren refers was the signed Carlo Crivelli bought from the Panciatichi collection of Florence by his friend John Marshall in 1900.[130] In any case it is clear from the Isabella Stewart Gardner-Bernard Berenson correspondence that this painting, as Whitehill has suggested, was acquired by one of the Warrens for the Museum.[131] Berenson had written Mrs. Gardner about this painting already in 1900, stating it had, he believed, "an entirely new background – and in Crivelli the background is half of the whole."[132] Then following Mrs. Warrens's death in 1901, her collection was exhibited at the Museum from April through September of 1902. Although the Crivelli is not included in the published catalogue of the exhibition,[133] it must have been generally considered part of it, for Mrs. Gardner wrote to Berenson that the Warren pictures "do not interest me" and then goes on to state, "There is a Crivelli in the Warren Collection that is a sore pity. It is so done over by that man [the Milanese restorer Cavenaghi] that one really sees not one mite bit of Crivelli."[134] Berenson's response came to the defense of the restorer, Cavenaghi, if not the painting itself:

> The truth is I can not understand your feeling against Cavenaghi. It must be due to a misunderstanding. The only one of the Warren pictures that passed thro' his hands was the Crivelli. Well this Crivelli, altho' I admire it greatly as a work of art, is a picture I would let none of my friends who consulted me about it buy – and at least five different ones did consult me. My reason was that it was already restored, and that the gold ground was entirely new. The only one almost of my buying friends who did not consult me about it was Warren, and he bought it without my knowledge. He sent it to Cavenaghi, who would not have taken the picture at all, but for Richter's and my warm commendation. Cavenaghi did what he could. He removed what restorations there were on the flesh parts. These are now much better than they were.[135]

The subject of this Crivelli is a Pietà, and when it came to the Museum in 1902, its credit line was given as "purchased with an anonymous gift of money, aided by an appropriation from the James Fund."[136] A letter from Ned Warren to his brother Fiske that same year, however, declares, "What trouble I had to get the Crivelli into the Museum."[137] The Crivelli was hung in the Museum's First Picture Gallery with Shaw's Vivarini,[138] both coincidentally dated 1485.

The last round in the Warren-Gardner relationship was to concern the great Filippino Lippi tondo. The Museum was also an active, if inept, participant in these negotiations. By the terms of Mrs. Warren's will, her collection was to be sold at auction, but a sum of money was left to the Museum

to buy from her auction whatever works it desired.[139] The director thus solicited the Museum's counselors, including local artists and collectors, as to which pictures it should pursue.[140] None recommended the Lippi; the painter Edmund Tarbell, found it "muddled," and Joseph Lindon Smith thought it did not "possess to my mind the best characteristics of the master and compares unfavorably with the specimens in the National Gallery, London and the Badia in Florence." Rather surprisingly Denman Ross, it was noted, "does not want the Fillipo Lippo [*sic*], which he regards as the work of a third rate artist, and a third rate specimen of his work."[141] The result was that the Museum acquired ten paintings from Mrs. Warren's collection of which the most famous is probably Gérôme's *L'Eminence Gris*, and in her memory her four children donated the Wohlgemut *Death of the Virgin*.[142] They maintained possession of the Filippino Lippi and sought to sell it to the Museum, but during the settlement of the estate, Mrs. Warren's one daughter, Cornelia, who had felt most strongly about donating the work to the Museum, became worried about its condition and refused to consent to the sale unless the painting was exhibited in the unheated Print Room rather than the Painting Gallery and special steps taken to control the humidity. The Museum was unwilling to meet these stipulations, so the family decided to offer the painting to Mrs. Gardner.[143] Berenson, was apparently consulted by the Warren family at this time, as to the work's value and informed them that, if it was put up for sale at Christie's, they might be "agreeably surprised," but he added, "I have it very much at heart that the Filippino should remain in Boston."[144] Thus he wrote to Mrs. Gardner in May 1903, "I hope you have bought the Warren Filippino. It is a very beautiful picture, and I believe, his masterpiece."[145] But she replied, "I shall not take the Warren Filippino. It ought to go to the Fine Arts Museum. Sam Warren is President of that, and is part owner, as heir, of the picture. And they all adore it I believe."[146] Unfortunately they did not admire it enough, for the family and Museum could not come to terms. Ned and Cornelia Warren bought out their siblings's shares, and the painting was sent to Ned Warren's residence, Lewes House in England. After his death in 1929, his heir, Harry Thomas, sold it through Harold Parsons to the Cleveland Museum of Art.[147]

Although the Warren Filippino was lost to Boston, at least, what we can now justifiably call the Warren Crivelli remained and quickly became established as one of the highlights of the early Italian School at the Museum. Berenson himself ammended his view of the picture and wrote: "during the time when Crivelli had attained his greatest mastery and was more than ever magnificently ornate in his accessories, he painted the most original of all his treatments of this sublime subject [the Pietà], the famous *Pietà* of 1485, which years ago passed from the Panciatichi Collection in Florence to the Museum of Boston."[148] Crivelli's *Pietà* was also highly praised in an article of 1907 by William Rankin:

> ...a poem in form the Boston Pietà has distinction, dignity, concentration, architectonic design, beauty of line, of colour, of texture, symbolic imagination and reality. It is a literal rather than a spiritual interpretation, if you like, and Crivelli's dramatic gift is not a sheer or instinctive one perhaps, but there is a true humanity in his pathos, even if it be a little declamatory.[149]

Rankin concluded his survey of the Museum's collection by noting that, "Neither in the Boston collection nor at the Fogg Museum is there as yet a fair representation of even secondary early Florentine work. The student should go to New Haven and to private collections, for an impression of the wealth which Florence has sent us, even in the work of its more obscure and little regarded but still inspiring craftsmen."[150]

It is significant that Rankin mentions the Fogg Museum, for during the early part of the century the relationship between the Fogg at Harvard in Cambridge and the Museum of Fine Arts was extremely close. The former could well be characterized as a hotbed of activity in the field of early Italian painting. Opened in 1895 the Fogg quickly grew to prominence as both

a collecting and a teaching institution through the abilities, both financial and inspirational, of the director (from 1909), Edward W. Forbes, and the assistant director (from 1915), Paul J. Sachs. Both men also supported the Museum of Fine Arts; Forbes was still in his twenties when elected to the board of trustees in 1902 and served until 1969, while Sachs was appointed a trustee in 1932 and remained until 1965. By 1905 there were fifteen Italian primitives at Harvard, and this group was soon supplemented by four more from Forbes's aunt, Mrs. Edward Cary of Milton. The Society of Friends of the Fogg Art Museum was formed in June 1913, and the first painting they gave the next year was an *Annunciation* by the Sienese master Andrea Vanni.[151]

Evidence of the shared interest between the two museums was the willingness to display each other's paintings. In 1909, as the new Museum of Fine Arts building on the Fenway was in progress, some of its Italian primitives were placed at the Fogg Museum "side by side with the paintings already there" as Forbes wrote. He noted that, "In Mrs. Gardner's galleries, among her Italian pictures, perhaps better than anywhere in America, we can get into the spirit of the mediaeval life of Europe. Less known, but also very interesting to the lover of Italian art, is the collection in the Fogg Museum."[152] Then in 1913 when repairs were being carried out at the Fogg, a group of their primitives were lent for exhibition at the Museum of Fine Arts. In an article in the *Bulletin* again by Forbes, he detailed the additions to this collection since 1909. He could proudly mention among other works those by Agnolo Gaddi, Spinello Aretino, Ambrogio Lorenzetti, and a large altarpiece by Benvenuto di Giovanni successfully transferred from panel to canvas.[153]

A few years later in the *Harvard Alumni Bulletin* of January 1917, Forbes, discussing yet more recent gifts to the Fogg, felt compelled to answer the question, "Why does the Fogg Museum devote its main energy towards the acquisition of Italian primitive paintings?" He answers, "in the first place, it is not desirable to try to do just what the Museum of Fine Arts in Boston is doing; namely to have large and comprehensive collections in all fields of art. It is better for a small museum to specialize." But the chief reason he concludes is that, "the importance of early Italian painting in the history of art is fundamental. The paintings are not, as is so often supposed, merely curious and interesting historically. They are really beautiful, even though they sometimes need study before the beauty is perceived."[154]

In 1919 the Fogg published a detailed catalogue of its collection of early and High Renaissance paintings.[155] The sections on the Sienese and Umbrian paintings were by Professor George H. Edgell and the Florentine, North Italian, and Venetian by Professor Arthur Pope. In noting the other examples of the various schools to be found in America they gave special attention to Mrs. Gardner's and the Museum of Fine Arts's collections.

While the Fogg had a professional staff and scholarly faculty to advise on its quest for paintings, the Museum relied, at this time, as we have seen, primarily on its trustees and several freelance agents for locating Italian paintings in Europe. Some of the most important finds were those made by the painter Walter Gay (1856-1937). In 1928 he was described as an "artist and connoisseur" who for many years "has been a friend of the Museum and has acted in the capacity of European advisor to the Trustees."[156] Morris Gray, the Museum's president wrote to Mr. Gay in April 1915 asking him, "to be on the lookout for paintings that you think of great importance for the Museum and yet that you can buy at prices very substantially lower than those ruling hitherto."[157] The following month Gay wrote from Paris to Mr. Gray:

> I am sending you three photographs of pictures by Italian Primitives, that I have seen – any of which I can recommend as worthy of purchase by the Museum. Italian pictures of this period (14th century) are now extremely scarce as you know, and it is important to secure them when one can, as in a few years, there will be no more on the market.
>
> To go back to the pictures, the first is a cassone, or painting made for a mar-

riage chest, which I think is undoubtedly by Paolo Ucello. This opinion is shared by Friedlander of the Berlin Museum who saw it before the war. It is from the Butler collection, London – the latter had a sale in March 1911 though this painting did not figure in that catalogue, being bought at another time. It is owned by Bacri, and he will sell it at a great sacrifice – 22,000 francs.

The second picture is also a primitive – 13th-14th century – Adoration of the Magi. I can't give you the name of the painter … but the quality is extremely fine and it has a jewel like transparency. This picture was owned for many years by the family of Gérôme the painter who lately sold it to Wildensteins. The price is 30,000 francs.

The third picture is a very important one by Simone de Martini also-called Simone Memmi [*sic*] – Vasari says he was a pupil of Giotto, but Vasari was often uncertain on his facts and at all events he was a great man in his day. The Memmi is from the Barker Collection, London, and is an extremely striking and decorative conception, the background being old gold, and the figures showing dark against it. It represents the Marriage of St. Catherine. The picture is unusually large for a primitive – 140 centimeters high 110 wide. They ask 150,000 francs for it. These primitives were almost invariably painted on panels and I will call attention to a crack on the side of the halo near the head. This, I believe, can be remedied, or at least kept in abeyance by cradling. The rest of the picture is in good condition.[158]

Both the so-called Memmi and the unidentified *Adoration of the Magi* were the property of Wildenstein Gallery of Paris, and the Museum officials decided that they liked the former but could not buy such an expensive painting from a photograph and requested that the original be sent to Boston. Mr. Gay was able to arrange for this and wrote to Mr. Fairbanks on August 19, 1915, that Wildenstein, "will not take less than one hundred thousand francs for the picture, and it will be useless to offer less."[159] Mr. Fairbanks found the painting "to be finer than we had supposed on seeing the photograph," and he cabled Gay to agree to the offer on which he would receive a five percent commission. Gay in turn congratulated the Committee on their decision, adding, "the Museum will get a very rare picture."[160]

In response to a request for more information about the painting's provenance, Wildenstein wrote to Gay in December of 1915, that it had been bought from Captain Algernon Sartoris, "petit-fils du general U.S. Grant. … avec trois autres primitifs italiens qu'il avait herité d'un de ses oncles je crois et ce dernier les tenait tous de la collection Barker."[161] This "Memmi" is now attributed to "Barna da Siena" (cat. 16). The purchase of such a major work was made possible by funds left to the Museum by the painter Sarah Wyman Whitman.[162] A note in the Museum *Bulletin* on the acquisition stated, "If not from the hand of Lippo Memmi (d. 1356), it was plainly painted under his influence. … This picture is impressive both by its naive and dignified beauty and through the suggestion of the fear and hatred from which a work of consummate art has grown like a flower from the mire."[163]

Another sometime agent for the Museum in Europe was Richard Norton (son of Charles Eliot), who became a professor at and then director of the American School of Classical Studies in Rome. On the recommendation of Edward Forbes he acted for the Museum, and also, until they had a falling out, he advised Mrs. Gardner, who in 1899 had obtained through him a Mantegna.[164] In late 1907 the Museum's Mr. Fairbanks wrote to Norton in London that he would be "very glad to get a report on the sort of things which the Museum might wisely get to supplement its present collections."[165] Norton in one of a series of reports he sent, informed the director that the Renaissance collection was "the weakest department of the Museum … the pictures have more second and third rate specimens than first rate ones."[166] To improve this situation he arranged in 1907 for an anonymous donor to buy at the Nevin's sale in Rome a very fine Sano di Pietro triptych (cat. 57). This according to the *Bulletin* article Norton wrote, was made a gift to the Museum "by one who desires to remain anonymous, but to have the picture 'stand as a memorial of a pleasant friendship.'" He observed that it joined a Sano already at the Museum and one owned by

Professor C.E. Norton.[167] Mr. Fairbanks with his formal letter to Norton, sent one also for the donor which he thought might not be "florid enough," but, "so long as the donor desires his name to remain unknown, we are obliged to ask you to express in our behalf the interest we feel in this gift . . . may I ask you, then, to thank the donor for his generous impulse, as well as for the charming painting which has come to us?" He added that the work had "already attracted much interest among those who have seen it, and I am sure it will prove a most valuable addition to our collection," especially as he concluded "with the enlarged space of the new building soon to be ready, such gifts are doubly welcome at this time."[168]

Also suggesting pictures to the Museum during this era was Harold W. Parsons who would later act as an agent for several other museums notably those in Cleveland and Kansas City.[169] On August 8, 1915, Parsons wrote from Ponkapoag, Massachusetts, to Mr. Gray a typically detailed and self-righteous letter supporting the acquisition by the Museum's leading patron, Mrs. Walter Scott Fitz, of paintings by "Barnaba da Modena, Segna, Giovanni del Biondo, Simone Martini, and Ugolino da Siena," which all seem to have belonged to Langton Douglas and Philip Gentner.[170] All of these works were purchased and are included in the present catalogue (cat. 10, 29, 22, 11, 28). In 1916 Parsons from Italy offered a *Madonna* of the School of Duccio and a Mantegnesque *Christ Carrying the Cross*.[171] But Mr. Fairbanks replied, "the objects have been very carefully considered by Mr. Gray, Dr. Ross, and myself. . . . So far as paintings are concerned, I believe that sometimes it might be useful to get – if possible – the endorsement of Mr. Walter Gay in Paris. Several of our trustees have, and rightly, much respect for his opinion."[172] Parsons's response to this was to suggest that he would happily share his photographs with Gay if the latter were "willing to come down here." While acknowledging Gay's opinion of French and English paintings as authoritative, Parsons observed, "in the judgment of Italian pictures and sculpture it has little weight," and goes on to add that from photographs, "the so-called Paolo Ucello, the large 'Simone Martini,' and the 'Lippo Memmi,' recently given by Mrs. Fitz on his recommendation do not seem to be pictures of first-rate quality; and a number of important critics of Italian painting whom I have consulted are also of my opinion that they are not by the artists to whom attributed in the Museum *Bulletin*."[173]

After a Duccesque Madonna of his was rejected by the Museum in February 1920, Parsons asked that the photographs be sent to Edward Forbes at the Fogg and chastised the Museum's director Fairbanks, that "I am convinced that it is not possible to arouse interest by photograph with the Boston Committee, even in the case of such a really important and beautiful Sienese primitive as this."[174] In 1924 Parsons wrote to Mr. Hawes that "Holmes has agreed to see the marvelous Sterbini Daddi, either in Rome or in Northern Italy. Let us hope that this little masterpiece of Trecento Florentine painting will find its way into the Museum. It is a piece which we need to fill out our collection of Trecento painting, so weak in the great Florentine school. We have little in quality to equal it, nothing to surpass it, among our Italian pictures."[175] This work from the collection of Giulio Sterbini of Rome did not, however, go to Boston but to Mr. and Mrs. Robert Woods Bliss for their home Dumbarton Oaks, in Washington, D.C.[176]

It may have been in part from a desire not to have to rely on these ad hoc advisors that the Museum of Fine Arts announced in its *Bulletin* of 1911 that, "Certain friends of the Museum, realizing the importance of fostering the growth of its Collection of Paintings, have contributed a sum of money to pay the salary of a Curator during three years. The Museum has been fortunate in securing the services of M. Jean Guiffrey of Paris, to whom the French government has courteously granted leave of absence from his duties at the Louvre for this period."[177] The *Annual Report* added that "Mr. Guiffrey, in accepting the position of Curator of Paintings, asked that his department be given $100,000 a year to spend in developing the Museum's collection. Generous friends subscribed enough in addition to

the funds already in hand, or soon to come applicable to this purpose, to make a picture fund of $100,000 in 1911, and have promised like contributions in 1912."[178] Guiffrey, author of numerous publications, came to Boston in August and then returned to Paris to begin a quest for what he described as "works of the first rank."[179] With his contacts in the European art world, he was able to secure a number of these during his three-year appointment. Of the early Italian school he acquired two Milanese paintings, Andrea Solario's *Portrait of a Man* and Bramantino's *Virgin and Child* of which Roger Fry, when he first published it in the collection of P.M. Turner, noted, "it is something of an event to come upon an unknown primitive of such striking and original quality, and we cannot doubt that it will find its way before long into one of the many museums which compete for these treasures."[180] A cassone panel with scenes from the story of Psyche thought to be by Filippino Lippi was, according to Guiffrey offered in the summer of 1912 by the owner John Murray for 40,000 francs, but he persuaded him to accept 30,000 on condition that the cost of transportation, insurance, etc. all be charged to the Museum.[181] This painting is now attributed to Sellaio (cat. 50).

The Museum fortunately did not have to rely solely on purchases for the growth of the painting collection. Philanthropic donors continued to provide outstanding new additions. By far the greatest benefactors of the Museum's collection of early Italian paintings were a most generous mother and son combination. Edward Jackson Holmes (1873-1950) (fig.3) was the grandson of the poet Dr. Oliver Wendell Holmes and nephew of the Justice of the same name. His father, who inspired his interest in art, died when he was only eleven, and his mother, Henrietta Wigglesworth, then married Walter Scott Fitz, a successful partner in the China trade business. Holmes, after graduating from Harvard in 1895, traveled widely in Europe; during the voyage he met his future wife, and they married in 1897. Although he became a lawyer, he was able to devote most of his life to art, especially the Museum of Fine Arts, where he was elected first a member of the Visiting Committee of Chinese and Japanese art in 1907 and then in 1911 a trustee. From 1925 he served as director, until he resigned in 1934, at which time he was elected president.[182] His mother, until her death in 1929, contributed to the acquisition of art works of all sorts for the Museum including the famous Minoan *Snake Goddess*.

The first donation of an Italian painting by Mrs. W. Scott Fitz, was the exquisite Fra Angelico given in 1914 (cat. 36). This elicited from the trustees a "minute of recognition" published in the *Bulletin* stating, "it is a masterwork of its type; a delightful picture for which not only the Trustees, but the people of Boston, will be forever grateful."[183] A long article on the painting by the Harvard professor Chandler R. Post, noted, that "for almost thirty years it has hung in the collection of M. Edouard Aynard at Lyons, virtually unknown to the critics of Italian art. ... There can be no question, however, as to its authenticity; the picture speaks for itself, and to make assurance doubly sure, the greatest connoisseur upon Italian art, Bernard Berenson, includes it in the latest lists of the Florentine painters of the Renaissance, and Langton Douglas, the chief English biographer of Fra Angelico ... accepts it in a note ... in his recent edition of Crowe and Cavalcaselle."[184] Denman Ross was so impressed by the painting that he felt compelled to write a long letter to the editor of the *Boston Transcript*.[185] The very next year Lorinda Munson Bryant in her book *What Pictures to See in America* singled out the Fra Angelico as the only older painting of note in the Museum, writing, "No one can look at this exquisite little gem without feeling the sincerity of the artist."[186]

In 1915 the *Annual Report* could observe that to Mrs. W. Scott Fitz the Department of Paintings was, "again indebted for an important gift: three early Italian paintings – *Madonna and Child* by Barnaba da Modena, *Magdalene* by Segna di Buonaventura, *Saint Gregory the Great* by a follower of Simone Martini."[187] Of these works the Barnaba attribution has not changed (cat. 28), and the other two are now identified as Ugolino di Nerio

3. E. J. Holmes (on right) with George Reisner, curator of Egyptian Art, ca. 1927

(cat. 10) and Bartolo di Fredi (cat. 22). The taste for such early works must still not have been universal, for Harold Parsons, the gadfly dealer and connoisseur, who, as we have seen, was the middleman in their sale, in 1915 wrote to the director, Arthur Fairbanks, expressing annoyance that some people at the Museum were disappointed in Mrs. Fitz's gift. He points out:

> Of course Italian Trecento Art is only for the cultured and for the elite. I fancy that is why it is so eagerly sought for abroad, and so little appreciated at home. In the inner circle of art collectors at home the taste has developed, as the taste for all the greatest Art, such as the Han sculptures, the Greek archaic, and early Egyptian sculptures. The "average visitor" is intent on representation and the imitation of Nature. Such masters as Barnaba da Modena, and the almost as rare Segna, are beyond their ken. It is, by the way, Barnaba's masterpiece.
>
> I wonder if they will care more for the later Ugolino, which is to come from Florence; or for the Orcagnesque which will accompany it. To all who are familiar with Trecento Art, they will appeal – not as great masterpieces of great masters, for they are not that – but as beautiful pictures of a wonderful period. They are all in extraordinary preservation, and Mrs. Fitz was able to secure them at a most modest sum. They at least gave us the first breath of Trecento Art; for we had almost nothing before. And if the Simone, of which Dr. Ross writes me, is a really fine Simone, we shall have a jewel of rare quality set about with lesser, but equally pure gems.[188]

The works Parsons referred to as coming from Mrs. Fitz and given by her in 1916 were a second Ugolino di Nerio (cat. 11) and a supposed Giovanni del Biondo *Virgin and Child*. Sirén's attribution of this in 1920 to Niccolò di Pietro Gerini[189] was confirmed in 1951 when the modern frame was removed and the inscription and date discovered (cat. 29).

In April of 1916, Mrs. Fitz and her son also purchased from Kleinberger Galleries in New York a little *Crucifixion with the Virgin and St. John*. The dealer in his letter of sale wrote, "It is a remarkable work of Italian Quattrocento art and you are to be congratulated on this splendid acquisition. Its state of preservation is really unique, which adds a special charm to this masterpiece."[190] A letter from Professor Sirén identified, "this exquisite little picture which is in perfect state of preservation as a work by Lippo Memmi . . . evidently a comparatively late and mature creation," and he added, "it reveals an emotional expressiveness which makes it more interesting than most of Lippo's Madonnas and at the same time it has all the beauty of line and design which fascinates."[191] In a statement announcing the gift, the Museum director noted, "The picture by Memmi is an interesting companion to the lovely little Madonna by Fra Angelico, given to the Museum by Mrs. Fitz in 1914; that picture has been described as symbolizing 'Faith in Joy' whereas this crucifixion symbolizes 'Faith in Sorrow.'"[192]

This tiny picture evoked familiar but differing memories from two distinguished scholars. In September 1916 Bernard Berenson wrote to Mr. Fairbanks that he had seen the publication of the painting in the August *Bulletin*, and "If memory do not beguile me, it must be a picture I knew at Prof. Rocchi's in Rome years ago. I liked it very much and told the owner that it was by Lippo Memmi. But he called it Giotto and wanted a fabulous price. He then on my advice took it to London and Paris but returned chastened. Even then the price was too high. I am very glad it has come to you now, for it is a jewel."[193] Professor Frank Jewett Mather of Yale, during the course of a visit to the Museum, told the curator, Mr. Potter, "that the little 'Crucifixion' by Lippo Memmi was an extraordinarily good example of that master, that it was formerly in the collection of Prince Golinicheff-Koutouseff, personal secretary to the Dowager Empress Maria Feodorovna of Russia, and that it was brought to this country by Nicolas Riabouchinsky although it is not included in the catalogue of his sale in New York, April 26, 1916."[194] At present the painting is attributed to Naddo Ceccarelli (cat. 18).

In 1917 Mrs. Fitz "continued her long series of benefactions" with "a dodecagonal panel by Giovanni Boccati da Camerino representing on one side the Queen of Sheba and on the other a winged Cupid."[195] As the *Bulletin* of April 1917 noted "the panel is a salver used for the presentation of

marriage gifts"[196] Sirén was convinced it was by Boccati,[197] but Zeri later suggested Francesco del Cossa, so perhaps it is wisest to simply call it, as Berenson did, Ferrarese School.[198]

Once again in 1920 Mrs. Fitz presented the Museum with, what the *Bulletin* that year described as, an "important picture, remarkable both for its quality and its state of preservation."[199] This was a *Madonna and Child with St. Jerome* purchased from Durlacher Brothers of New York with an attribution to Fiorenzo di Lorenzo. Mr. Paff of Durlachers wrote to Mr. Fairbanks in April of that year, "I was fortunate enough to meet the man who was instrumental in bringing the picture by Fiorenzo di Lorenzo to this country. From him I learned the name of the family from which it came. The picture formerly belonged to Signor Bacchettoni, the Mayor of San Gemini, near Narni. Signor Bacchettoni now lives in Rome and it was there, I presume, that Mr. Forbes saw the picture 13 years ago. . . . My informant also told me that a member of this family was a cardinal and that he felt sure that the picture came, through him, from the Vatican. This, however, he only supposes to be so."[200] Berenson would later publish this work (cat. 68) correctly as an early Pintoricchio,[201] an opinion supported by Everett Fahy.[202]

The following year, 1921, Mrs. Fitz made yet another "welcome gift" to the Museum: a Bernardino Luini, *Salomé with the Head of John the Baptist*. Of this the *Bulletin* observed: "The subject was treated by Luini several times in varied ways (examples at the Louvre, Brera, Uffizi, and elsewhere)," and this one "ranks with the best of these pictures."[203] Later that same year she gave a *St. Peter and St. Paul* by the school of Simone Martini. These are now attributed to Andrea Vanni (cat. 23a and 23b).

Mr. and Mrs. Holmes in 1924 acquired for themselves from the Florentine dealer Luigi Grassi an extremely important early painting by Francesco di Giorgio. They lent it to the Museum in the following year and then repeatedly over the next nearly twenty years, finally giving it on December 11, 1941 (cat. 59). As Mr. Edgell observed of it at that time, "The painting is a real masterpiece by perhaps the most attractive painter of Siena in the fifteenth century. Its technical mastery within the self-imposed restrictions of the Sienese, its beauty, spirituality, and mysticism reveal the School of Siena at its best."[204]

Two years later Mr. Holmes contributed to the purchase of a *Saint Jerome* thought to be possibly by Carpaccio. In a memo the curator John Briggs Potter described it as follows:

> This is a picture of potent charm, and as for experts disputing the question of its authenticity, this could not affect the quality and perfections of the picture. To me, it is one of the rarest pictures of its kind that I have ever seen. Its technical merits are of a very high order. It is intriguing to the imagination, and I have never seen a picture of the School so carefully preserved in which the intervals and the intensities of the blues were so effectively related to the whole ensemble.[205]

The *Bulletin* article published upon the acquisition related that it is a work "in which the interest lies alike in its extraordinary composition and balance and the mastery of its execution. . . . The attribution of the panel is a subject for further study. . . . It has been attributed to Carpaccio . . . [but] the subject itself does not seem typical of the Carpaccio whom we know as a painter of Venetian life of his day. . . . The question of attribution will be, and rightly so, discussed at length, but it cannot diminish the rare quality and perfection of the picture."[206]

Mr. Holmes continued his generosity in 1928 with a thirteenth-century Italian *Crucifixion* (cat. 24) and a Riminese *Man of Sorrows* (cat. 26). The Dugento *Crucifixion* was given a new attribution in 1949 to the Bolognese school and specifically the painter of the Dugento *Crucifixion* in Faenza according to Gertrude Coor-Achenbach.[207] The painting remains a point of contention for specialists and is here given, following the idea of Todini, to the Master of the Blue Crucifix.

In 1944 Holmes presented to the Museum two paintings of saints by Girolamo di Benvenuto (now attributed to Benvenuto di Giovanni, cat. 62a

and 62b). Then in 1949 he sent to the Museum two paintings of the *Madonna and Child*, and these along with a late fifteenth-century North Italian *Apparition of the Virgin* were bequeathed to the Museum by his widow in 1964.[208] Through a bit of clerical confusion, only one of the Madonna and Child paintings, that by Cosimo Rosselli (cat. 44), was at first accessioned; the other, now attributed to the Master of the Johnson Nativity (cat. 43), was retroactively accessioned only in 1988 and is thus reproduced as a Museum painting for the first time in the present catalogue. In addition, Mrs. Holmes bequeathed the Museum a small altar pinnacle of an *Angel with the Instruments of the Passion* from the School of Duccio that had been in their collection since at least 1931 and on loan since 1934. It too, somehow, was overlooked at the time of the 1964-65 accessioning of the Holmes's bequest and was only formally added to the collection in 1978 (cat. 12).

Returning to a chronological survey of the early Italian paintings, it will be noted that in the first part of the century the Museum assembled a number of then-very fashionable cassone panels, the paintings from the fronts of marriage chests. Three came in 1906 as a bequest from Mrs. Martin Brimmer and are now all given to Marco del Buono and Apollonio di Giovanni di Tomasso (cat. 42a-c). In 1912 the Museum purchased the so-called Lippi cassone panel with the story of Psyche (cat. 50), which the *Annual Report* described as follows:

> It is a Florentine cassone, bearing the mark of Filippino Lippi and representing various episodes in the story of Psyche. It should be remembered that hitherto the Museum has contained no pictures from the Italian Renaissance except religious subjects and one or two portraits. It was desireable to show by an example with what grace these artists could portray successive subjects of the same story happily grouped within one frame; with what charm they could picture fables of mythology or memorable deeds of ancient history. This representation of the legend of Psyche seems to have had some celebrity. We know at least one replica with variations in landscape. It is preserved in the gallery of Mr. Brinsley Morley at London, and assigned to Jacopo del Sellaio, habitually the imitator of Lippi, Botticelli, Ghirlandaio, and several of their illustrious contemporaries.[209]

It was apropos of this picture that on New Year's Day 1913 Berenson wrote to Mrs. Gardner about the Museum, "What funny purchases of Hitalians they are making! That *Cupid and Psyche* cassone I hear they paid £40,000 for. Surely that can't be. When you and I worked together you refused to pay $2,500 for a pair far finer than this one alone, and by the same master Jacopo del Sellaio."[210]

Walter Gay, it will be remembered, recommended to the Museum in 1915 the supposed Paolo Ucello *Battle Scene* formerly in the Butler collection, London, that was purchased in 1915 (cat. 41). According to a *Bulletin* article of that year, it was of "very similar to the series of three large panels in the National Gallery, the Louvre, and the Uffizi [and]...is a typical example of the style of this rare and interesting master."[211] Now it is assigned to Apollonio di Giovanni and Marco del Buono. The same was true of another cassone panel of a *Triumphal Procession* purchased as Dello Delli in 1918 but deaccessioned in 1990. Still another supposed Ucello cassone was purchased in 1923. This and one acquired in 1930, both depict scenes from the story of King Solomon and the Queen of Sheba and are also now given to the productive shop of Apollonio (cat. 39 and 40).

If 1915 was an outstanding year for the purchase of the "Barna" and "Ucello" and Mrs. Fitz's various gifts, it was even more memorable for the opening of the grandiose Robert Dawson Evans Galleries for Paintings (fig. 4). In addition to the permanent collection, these new galleries housed a special inaugural exhibition of works lent by "friends of the Museum." The only Italian Renaissance paintings included were a *Madonna and Child* attributed to Raphael from Edward Andrews; a *Madonna and Child* by Alesso Baldovinetti from Mrs. Robert D. Evans; *St. John the Baptist* by Dominico Puligo from Mrs. Hubert A. Hawkins; *Portrait of a Man* by Moroni from Mrs. John M. Longyear; and from anonymous lenders a *Madonna and Child with*

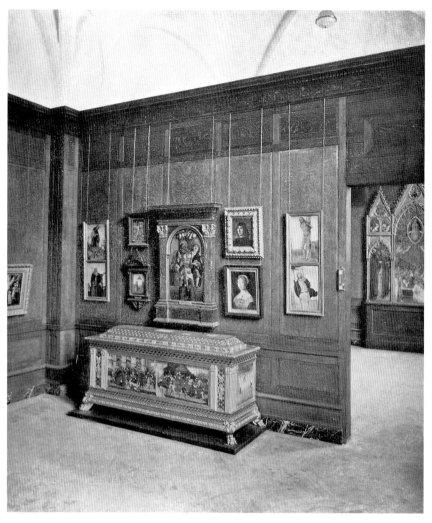

4. Italian Paintings Gallery, at the opening of the
Robert Dawson Evans Memorial Galleries for
Paintings, Museum of Fine Arts, 1913.

Saints of the school of Giovanni Bellini and a *Portrait of a Man* by Paris Bordone.[212] Two years later when Mrs. Evans died she bequeathed the Museum several Italian works of which one, a *Madonna and Child with Angel*,[213] now identified as by Bernardo di Stefano Rosselli (cat. 46) was a notable example of the earlier period.

The 1920s witnessed a continuation of significant early Italian gifts and acquisitions including those received from Mrs. Richardson, Mrs. Fitz, and Mr. Bigelow. To this distinguished company was added in 1922 gifts from the Henry H. and Zoe Oliver Sherman collection. According to the Museum's *Bulletin*, the Shermans had "for years been acquiring works of art, chiefly paintings with the intention of ultimately enriching the permanent public exhibition in and near Boston. After generous gifts to the Worcester Art Museum and the Fogg Museum of Art, they have given to this museum the larger part of the collection."[214] Although the Shermans retained ownership, they did at this time put on public view two of their finest Italian fifteenth-century panels, a *Descent from the Cross* by Cosimo Rosselli (cat. 45) and a brilliant little predella then attributed to Sassetta, but now named, after this very work, the Master of the Sherman Predella (cat. 35). Langton Douglas who had sold her the paintings, wrote Mrs. Sherman in June 1922, "I am glad that you have the 'Descent from the Cross.' My late friend, Lady Henry Somerset (to whom this picture belonged) very much prized it. . . . Her father bought this picture in Florence fifty or sixty years ago. I have been informed that the Sassetta came from the collection of the Prince of Pless. It was sold very privately."[215]

In 1922 the Museum also purchased for a mere $3,200 a Sienese panel of the *Annunciation and Crucifixion* attributed to Gregorio di Cecco from Durlacher Brothers. According to a later letter from the gallery's New York manager, Kirk Askew, it had come from the collection of the Earl of Haddington and was purchased in Edinburgh in 1912 as a Taddeo di Bartolo.[216] It is now given to the much rarer artist of Lucca, Giuliano di Simone (cat. 7). Also in September of that same year the dealer Lino Pesaro of Milan offered to the Museum a *Virgin and Child with an Angel* attributed to an even greater Italian master, Piero della Francesca. Mr. Hawes, the Museum's assistant director, was traveling in Europe and Mr. Gray cabled him in Vienna, "Buy Milan painting by Francesca if you deem wise under all circumstances." The dealer, however, would only make the sale for 800,000 lire in Vienna or Basel, and Hawes had to arrange for it to be sent to the latter city and then transported by ship from Antwerp to Boston.[217] After its arrival, Hawes noted in the *Bulletin*, "The rare and valuable painting acquired by the Museum is a panel, which like most of Piero's, has suffered damage. . . . The painting is assigned by the Italian authority Signor Venturi to the master's early period, probably before 1450."[218] The respected "art expert" Jean Paul Richter sent a letter noting that "the find of a Piero della Francesca is indeed an event in art history. . . . It is like the find of a Praxiteles." Berenson on reading of the acquisition was more dubious and wrote, in a facetious vein, to Mrs. Gardner, "I say, what a Piero della Francesca they have got for the B. M. F. A.? Don't you envy them?"[219] In 1926 he published the picture as an early Signorelli,[220] an attribution which Dr. Kanter has now reasserted (cat. 70).

In 1923 was purchased with the Helen Collamore Residuary Fund a *Crucifixion* by Bernardo Daddi (cat. 1). It had been bought during the war years by the Swedish expert Osvald Sirén from the German dealer Julius Böhler.[221]

The decade of the 1930s began with a great effort to secure one of the Museum's major treasures, a panel by the Sienese painter Giovanni di Paolo of the *Madonna of Humility* (cat. 53). It appeared in the sale of the famous collector Dr. Albert Figdor of Vienna which was to be auctioned in Berlin on September 29, 1930. The English scholar Philip Hendy, the Museum's curator of paintings from 1930-1933, in a memorandum recommending that the Museum purchase the painting, noted that in addition to the reproduction in Van Marle's authoritative book, he had personally seen the picture twice in Vienna in the summer of 1928 and "have since always considered it the best of Giovanni di Paolo's smaller works. It stands also for more than Giovanni di Paolo and for more than Sienese painting; for Gothic painting as a whole. It is a type which should be represented in a museum, and it would be difficult to find another example so exquisite or so complete." He continued, "Giovanni di Paolo's work is extremely popular with the American collectors of primitive pictures; Morgan, Sachs, Ryerson, Philip Lehman, Griggs and Blumenthal have small panels by him; and it consequently fetches high prices. This is an unusual example and its price with a London dealer would be from £7,500 to £12,500. There may be considerable competition at the Figdor sale, which has been planned for the keenest moment of the auction season, but the slump in trade may cause a drop in prices." He concludes: "I recommend bidding for this panel up to $60,000. I am unable to go to the sale myself owing to the difficulties over the immigration laws and the Museum would have to employ someone expert in pictures in case this has been damaged since I saw it two years ago. I wrote to ask Mr. Colin Agnew if he would be at the sale."[222]

On September 4th Edward J. Holmes cabled from Manchester, Massachusetts, to Hendy in Osterville: "Committee authorized $60,000 plus commission, Cheers."[223] Hendy in turn then cabled Colin Agnew who had returned from Venice to London and responded that he would personally go to Berlin. In a fuller letter to Agnew, confirming his cable, Hendy stated: "I don't want it bid for at all if any important area has been restored. I know from the photo that the sky has scaled a bit and the Virgin's robe has been

touched up. . . . I am authorized to ask you to bid up to $60,000, commission extra. I think it is an important picture, but I hope it won't have to cost as much as all that. I haven't found out yet how the Museum proposes to arrange the payment of the money, but presumably it will be enough to cable it to you when you cable us the result of the sale."[224] Agnew was able to acquire the painting reasonably for 135,000 marks ($33,750), and the purchase was actually made from the Maria Antoinette Evans Fund. The painting went on exhibit at the Museum on December 5, 1930.[225]

The next acquisition of an early Italian painting proved less fortunate. This was a *Virgin and Child* acquired in 1933 that Professor Giuseppe Fiocco supposedly accepted as by Mantegna, and of which the *Bulletin* article declared, "Aside from its beauty, the painting is an important document of Mantegna's early period, made all the more valuable because of the excellent state of its perservation. For more than a hundred and fifty years the painting has been in a German castle in Mark Brandenburgh."[226] Today the work is considered no more than a poor quality work by a follower of Mantegna.

In 1935 Mr. Holmes retired as director of the Museum and was made president. Chosen to succeed him was George Harold Edgell (1887-1954) (fig. 5) who had been serving as curator since 1934. Born in St. Louis and a graduate of Harvard in 1909, he had became a full professor of fine arts there in 1925. From his earliest studies, Mr. Edgell's interest was Sienese painting, and he wrote a classic book on the subject. His taste, however, ranged widely, and it was during his tenure that the Museum acquired its great Gauguin and most famous Renoir, *The Dance at Bougival*. He also encouraged significant donors such as Elizabeth Day McCormack (textiles), the Karoliks (American painting), and John T. Spaulding (French Impressionist painting).[227]

5. George Edgell and pet in the director's office.

Another staffing change, described as "of major importance" in *The Annual Report,* occured in 1937 when "the Trustees voted to call Mr. William G. Constable to come to Boston as curator of paintings. This position had been held previously by the Director and the arrangement was unsatisfactory."[228] Constable (fig. 6), known universally as "W. G.," who had previously been the Director of the Courtauld Institute of the University of London and Assistant Director of the National Gallery, London, brought, as was said at the time of his retirement in 1957, "a wealth of knowledge and experience."[229] His area of specialization in eighteenth-century Italian painting complemented the director's in early Italian. Over the succeeding years they established a gentlemanly relationship of internal memos that are models of courteous expertise and provide a detailed insight into the workings of the art world of the era. The assistant curator from 1934 to 1946 was Charles C. Cunningham; and when in 1942 Dr. Georg Swarzenski, former director of the Staedel Art Institute in Frankfurt, joined the staff as Fellow for Research in Medieval Art and Sculpture,[230] they were a formidable team.

The first major Italian painting purchased under the Edgell aegis was a quite extraordinary one – a work by the so-called Master of the Barberini Panels or Fra Carnevale (cat. 66). This picture of the *Presentation of the Virgin* and its companion, the *Birth of the Virgin*, which had been purchased by the Metropolitan Museum in 1935, had passed from the Barberini collection, Rome, to that of Prince Corsini also of Rome. Encouragement to purchase it came from Paul Sachs of the Fogg, who at the end of December 1936 wrote to Charles Cunningham:

> I am wondering also whether with the emphasis that we have placed upon modern pictures the time has not come when we ought to keep our powder dry for something really significant among the old masters; – for instance, the Carnevale (companion piece to the Metropolitan picture) would be "pretty swell," but I fear that even if we wanted it we could not have it because my guess is that the Frick Gallery will buy it. . . . It is that sort of thing that we ought now to aim for.[231]

When it appeared possible for the Museum to obtain the painting, Sachs again wrote to Cunningham that "it would, indeed, be a magnificent

acquisition and I am quite prepared to believe that it could be acquired 'within reason;' by which I mean somewhere between $60,000 and $75,000."[232] Following the decision to purchase the Fra Carnevale, Charles Henschel of Knoedler's, who sold it to the Museum, wrote to Mr. Edgell: "I congratulate you on having decided to purchase the Carnevale. It is a picture that I am tremendously enthusiastic about, as it has a combination of quality, condition, and attractiveness of subject. It is, to my mind, one of the very fine Italian pictures in this country. I had a telephone call yesterday from Dr. Richard Offner (he naturally does not know anything about your having the picture) saying that he was writing a very comprehensive article on this picture. . . . Dr. Offner told me he considered this one of the most extraordinary pictures he had ever seen."[233]

There was a good deal of activity in Italian works at the Museum in the late 1930s, and several came as gifts. In 1937 Dr. Eliot Hubbard gave a painting he had acquired in 1901 for $600 from Durand-Ruel of New York.[234] This was a panel of the Virgin and Child with a predella representing the Charity of St. Nicholas, the Crucifixion, and Christ and the Samaritan woman. Attributed to the School of Giotto, it had been part of the Cernuschi collection sold in Paris in 1900. It is now called Niccolò di Tommaso (cat. 5). Dr. Hubbard also gave a large thirteenth-century polyptych of the Italian Byzantine school from Apulia.[235]

In 1938 Mrs. Zoe Oliver Sherman formalized her gifts to the Museum. The Sherman predella was now to be given in memory of her father, Samuel Parkman Oliver, and a *Madonna and Child with St. John* by a follower of Gaudenzio Ferrari (22.636) in memory of her mother, Eliza Harrod Oliver. In addition she also now gave a "Giottesque Panel of about 1320"[236] in memory of her husband. This notable work had been bought by Mrs. Sherman in 1930 from R. Henniker-Heaton of London.[237] It is now attributed to the Maestro Daddesco (cat. 3).

John Templeman Coolidge, a trustee since 1902 and one of the members of the committee on the opening of the new museum in 1909, proposed in 1939 to donate two works, Neroccio's *Virgin Annunciate* (cat. 60) and Sano di Pietro's *St. Bernardino* (cat. 55) "bought many years ago from a dealer in Florence."[238] W. G. Constable wrote to Edgell in December 1939 that:

> I think both of these paintings would be very desirable additions to the Museum collection. The San Bernardino is unlike our other paintings by Sano di Pietro; and we have no example of Neroccio. Neither of the paintings are in very good condition, but I am sure Mr. Lowe [the Museum's paintings conservator] can do a good deal with them.[239]

Both works were accepted and subsequently published by Edgell.[240]

Purchases of these years included from Aldo Janoldo of Rome in 1936 "a very beautiful" *Madonna* by Lippo Memi (cat. 14), "fortifying the small but already excellent group of Sienese paintings."[241] It came with a certificate from Giacomo de Nicola, and in 1939 a letter from Berenson supported the attribution.[242] Then in 1939 was purchased the Ambrogio Lorenzetti *Madonna and Child* (cat. 15), a well-known work formerly in the possession of the Fratelli Griccioli at the Monastery of San Eugenio near Siena and later in the extensive collection of Dan Fellows Platt of Englewood, New Jersey. It had been discussed by the Museum's director in his 1932 *History of Sienese Painting*, although at that time it was in an altered state by the Sienese restorer Ioni.[243] Both *Art Digest* and *Art News* published the painting with headlines calling it "famous."[244]

Mr. Edgell, who was on good terms with Bernard Berenson, wrote him with the "good news" of the "happy acquisition" of the Lorenzetti, as well as that "Constable, as a Curator, is paying big dividends. Winlock is out of the Metropolitan and they have elected Francis Taylor, an excellent choice. I should not say so to anyone but you but I think I could have had the position at the Metropolitan. I preferred to remain a doorkeeper in the House of the Lord."[245] In what seems to have been his last letter to the Museum until after the war, Berenson responded, "I fear I must confess to very

6. W. G. Constable, ca. 1956

mixed feelings on hearing from you that you had refused the directorship of the Metropolitan Museum. As a Bostonian I am truly glad you are sticking to your post in the Fenway, but as an American I am very sorry." He concluded in typical fashion, "So glad you got Platt's Ambrogio. Please send a photo after its cleaning."[246]

In 1940 came a purchase that today seems odd but was much touted at the time – the so-called Piero della Francesco *Portrait of a Lady*. The dealer who sold it to the Museum, Mortimer Brandt, once much later indicated to the present writer that he knew the painting was questionable, but in any case in 1940 he provided a provenance for it, which Constable in turn related to Edgell:

> I have found out from Brandt a little more about the history of the Piero. He says – "It was bought from a noble old family at Città di Castello, Umbria many years ago. The family it was bought from has for many reasons asked that it should not be publicly mentioned. If the name is not to be published in the newspapers, the name of the family is Count Conestabile della Staffa." – It passed from this family to the Vigano family.[247]

The painting also came with authentication from A. Venturi, and a report of scientific examination by Dr. Colin Fink, Professor of Electrochemistry at Columbia University, asserting that "on the basis of all tests and evidence presented, we conclude that the painting is about 500 years old."[248] It was given the front cover of the October 1940 *Bulletin* and a long article by the Museum's director in which he described it as:

> A small painting measuring 12 x 10 inches, but in extrordinary condition, and stylistically so characteristic of the great Umbrian that, without hesitation, the attribution to his hand can be made at a glance. . . . The museum is singularly happy to have acquired one of the great profile portraits of the fifteenth century.[249]

Apparently doubts were expressed about the "Piero" quite soon, as a letter from Charles Cunningham to Paul Sachs at the Fogg of October 11, 1940, speaks of a "whispering campaign" that is "only logical, as the name of Piero della Francesca is certainly one of the most revered. To anyone who has seen the picture its great qualities just cry out. I know also that the boys in Detroit have been panning the picture. I suspect that this may be because we were skeptical here of the so-called Verrocchio Portrait which they bought."[250] Unfortunately Edgell and his staff had erred in their desire to possess a Piero, and the work was eventually recognized as a fake based on figures in Piero's Arezzo frescoes and a portrait in the Uffizi.[251]

A better sense of judgment was demonstrated at this time in the policy of "building up a collection of large-scale wall paintings."[252] Most of these purchases were made from the Brummer Gallery of New York, and the first and best was an enormous fourteenth-century *Crucifixion* of the School of Rimini (cat. 27). A memorandum from Constable to Edgell gave the reasons for the acquisition:

> I should be very much obliged if the Committee would consider seriously the acquisition of the big fresco of the School of Rimini which is offered to us by Brummer for $16,000. I have seen the fresco on several occasions and consider it very impressive and of good quality. It represents an important phase in Italian painting which is not only not represented in the Museum but is not well represented in America. I think I am right, also, in saying that there is no other example in the United States of a large scale fresco of this period. For a painting of this period it seems to me in good condition. About a foot of the right-hand side has disappeared entirely which throws the figure of the crucified Christ out of the centre; and some of the figures on the right have been damaged. The background, of course, has been a good deal broken, but the remainder of figures are in a good deal better state than a good many of the Giottesque frescos actually on the wall in Italy. This, I think, can be realized from the detail photographs which accompany this note.
>
> Swarzenski, without any prompting from me, has also seen the fresco and thinks very highly of it. . . . The price, I think, is moderate and I have reason to believe that it might be reduced somewhat.[253]

After its purchase the fresco was published in the *Bulletin* as the "only one of its type which can be seen outside Italy. It is large, measuring 133 inches high and 108 inches wide, the principle figures being somewhat smaller than life size. It is said to have been painted originally for the Church of Santa Lucia in Fabriano."[254] Brummer reported he had "bought it from the old professor Podio at his studio in Bologna, Italy in September, 1928" and sold it to William Randolph Hearst in late 1929. It remained in the collector's warehouse until it was repurchased by Brummer still in the original unopened case.[255] For many years this impressive work had an important place, set into the wall of the Museum's gallery of Italian Primitives (fig. 7).

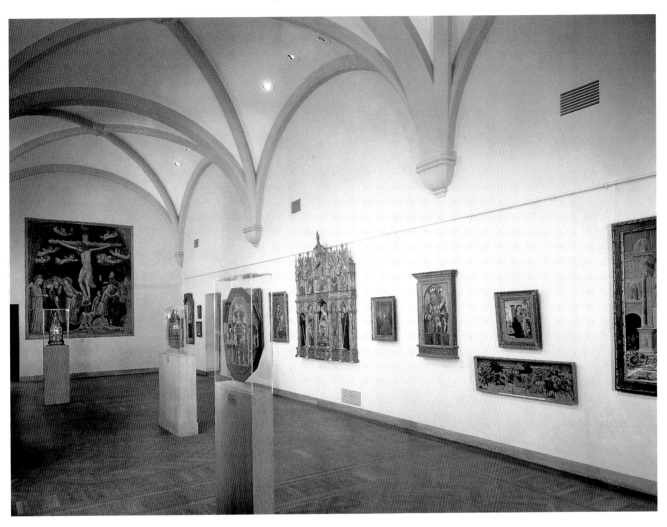

7. Italian Primitive Gallery, after renovation, 1963.

A group of frescoes was purchased during 1945. One set of five depicted scenes from the Passion, and according to the *Annual Report* "may with reasonable confidence be attributed to Paolo Zoppo, a little known painter of Brescia, in whose work may be seen the transition from the characteristically quattrocento work of Vincenzo Foppa to the developed Renaissance style of Romanino and Moretto."[256] A fresco of the *Annunciation* by an Umbrian painter active in the late fifteenth century was also purchased from Brummer in 1945. Berenson in a letter to Mr. Edgell, attributed it to Antonio di Viterbo,[257] but the Museum deaccessioned it in 1960. Three more frescoes were added in 1947; two of these had also been sold by Brummer to Hearst and remained in their unopened crates in a warehouse until repurchased.[258] The two still in the Museum's collection are the *St. Sebastian* by Bernardino di Lorenzo (cat. 69) and *Madonna and Child Enthroned* by Matteo da Gualdo (cat. 72).

Throughout the 1920s and 1930s, the Museum had been in regular contact with New York's most famous dealer, Joseph Duveen. In 1928 Sir Joseph

offered Boston a Giovanni di Paolo and a Filippo Lippi, but they were declined.[259] Two years later a Masaccio and two Masolinos were proposed by Duveen's right hand man, Bert Boggis, to Mr. Holmes.[260] Then in 1938 Mr. Edgell contacted the now Lord Duveen about seeing the great Allendale *Nativity* by Giorgione. The director, as Constable wrote to Paul Sachs, did go to New York, "saw it and was deeply impressed; but Duveen was ill and so nothing could be done. Bert said that the picture was on offer elsewhere, but I am inclined to think that this was just the usual dealer's talk."[261] This painting which caused a rift between Duveen and Berenson was in fact sold later that year to Samuel Kress who presented it to the new National Gallery.[262] Finally at the end of 1945, after Duveen's death and with the firm now being run by Edward Fowles, the Museum did make a major purchase of an Italian primitive. The work was a remarkable triptych by Duccio (cat. 9) that had been sold many years earlier by Langton Douglas to J. P. Morgan and was auctioned at Christie's in 1944.[263] Although Edgell was the Sienese expert, Constable, as curator, carefully laid out for him the rationale for the acquisition:

> You know as much as I do, and more, about the Duccio Triptych; but I should like to put on record that continuous study has more than ever convinced me that the center panel is by Duccio himself and is an outstanding example of his painting. Georg Swarzenski is wholly of the same opinion.
>
> The wings are certainly not by the same hand as the center panel; in other words, not by Duccio. But I am firmly of the opinion that they are not simply school pieces by an imitator of the great man but by an independent personality in whose work is reflected an influence of Gothic painting in Siena. I feel that quite a good case could be made for their being a work by Simone Martini; but since the Maestà seems to be the earliest work known to be by him and we can only guess at what his work was like before this, such a view is speculative. Again, Swarzenski, quite independently, had the same thought as myself.
>
> Arthur Pope, at my suggestion, has seen the painting at least twice and studied it with a good deal of care. He is enthusiastic and expresses the firm opinion that the center panel is certainly by Duccio and a very fine example. He also recognized, independently, the difference in character of the wings, and assented to the possibility, if not more, of their being by Simone Martini. . . . As you know, the price of the Duccio is $250,000, which seems high, but is, in fact, sensible for such a picture. As I suggested before, I think that a firm offer of somewhat less would get it. The matter, however, wants careful handling. If we offer too little, the picture will almost certainly be offered to Kress and he will be anxious to wipe our eye. In that case, he will certainly offer enough to get the picture. If we could feel our way and offer just enough to prevent Kress being brought into the question at all, that would, I believe, be the best thing.[264]

Just the right amount turned out to be $200,000 and after the purchase was approved, Mr. Edgell wrote Fowles immediately with the good news saying, "You can imagine what a personal satisfaction it is to me to know that this superb picture is to find a permanent home in the Museum."[265] In May of the next year Mr. Edgell arranged for a gala unveiling of the painting and wrote to Fowles again describing the event: "We had a very simple ceremony in the great Tapestry Hall which seats three hundred and fifty people. Mr. Holmes introduced me not as Director of the Museum but as an authority on Sienese painting: I spoke for twenty-five minutes and then the curtains were thrown open into the Stone Room where the painting had been put very beautifully on display. I had expected perhaps a hundred people but every seat was taken and fifty or sixty more were standing, with a couple of hundred in the rotunda who could not get in. The painting has received universal acclaim, and I think we can all be very proud of it."[266] In his *Bulletin* article on the painting, Edgell described it as "one of the most important acquisitions made in a decade by the Museum of Fine Arts."[267] *Art Digest* reported that "for some forty years the Morgans kept the painting quietly in a bedroom of their English home at Aldenham," and that it had never before been exhibited in America, where it now became the seventh Duccio in this country.[268]

In the 1940s some of the old Boston families continued to donate paintings. Mr. and Mrs. J. Templeman Coolidge in 1945 gave two fine works, a Florentine *Crucifixion* now ascribed to Agnolo Gaddi (cat. 8) and a reliquary diptych by Lippo d'Andrea (cat. 34). Quincy Adams Shaw, the son of the great collector, in December 1946 presented several works probably acquired by his father. Chief among these was a charming *Madonna and Child* by Bernardino di Mariotto which was published for the first time by Edgell who wrote, "there is no danger of the attribution to Bernardino ever being disputed by any serious student of Umbrian art."[269] Also given by Mr. Shaw was another *Virgin and Child* by Ghirlandaio (cat. 49), and a Tintoretto *Nativity*, which revealed such quality after cleaning that the donor requested it back and divided ownership of it between himself and the Museum before finally giving it in toto.[270]

A notable purchase was made in 1948 from Eugene Garbaty, a dealer/collector of New York City. He had had on loan to the Museum for a considerable time a large altarpiece by Zanobi Machiavelli (cat. 38). In 1948, as W. G. Constable explained in a memorandum to Mr. Edgell, Mr. Garbaty decided to sell it:

> because he has to give up his apartment in New York and can only take a limited number of his pictures to his home in Connecticut. ... Large quattrocento altarpieces are practically impossible to obtain and further examples are not very likely to come on the market. This Machiavelli was not, of course, one of the greater masters; and if we could get a Filippo Lippi or Botticelli, one would, of course, prefer to do so. That, however, we can assume is practically out of the question, and so a good example of a secondary master seems desirable."[271]

Constable could write to Garbaty after the purchase had been approved, that, "the picture is for us a notable acquisition which gives us an example of a large Florentine altarpiece, which makes a center for our quattrocento collections."[272]

The 1950s began with the purchase from the famous New York dealer in rare books, Walter Schatzki, of a Sienese Biccherna bookcover dated 1364. It is now attributed to Lippo Vanni (cat. 20). In a memo of January 1950 to Edgell, Constable observed:

> There is no need to emphasize how rare the Biccherna tablets are outside of Siena. This is an early one of large size and fine design, allied in conception and treatment to the great frescoes in the Palazzo Pubblico in Siena. Quite apart from its artistic treatment, however, it is an excellent example of an art that is peculiar and distinctly Sienese; and so would find a very suitable place in the Museum in which Sienese painting is so well represented. The painting is known and recorded in the literature on Biccherna panels.
>
> Admittedly, the condition is not good. Apart from the large perpendicular crack and minor blemishes, the group of figures on the left is almost entirely new. On the other hand, x-ray and other examinations show that the picture looks in rather worse condition than it actually is. This is also Mr. Lowe's opinion, who thinks that with careful cleaning and tinting of the most conspicuous breaks, the painting will prove surprisingly gay and attractive.
>
> Dr. Georg Swarzenski, who first found the panel in New York, is warmly in favor of its acquisition. Suitably framed it can hang very well either in the Painting Department or be exhibited in the Department of Decorative Arts, where it would, I am told, be heartily welcomed.[273]

In 1951 the Museum purchased two early Italian panels of saints. A *Bishop Saint* thought to be by Ambrogio Lorenzetti was bought from Arthur Nash of Washington, D.C. The condition was not ideal, and Constable wrote the director, "its acquisition seems to me a gamble, but one that I would certainly take were my own money involved."[274] The painting is now given to the Master of the Straus Madonna (cat. 17). The other, more important work, was a Simone Martini probably of Saint Andrew (cat. 13) that had been auctioned in the Carrie W. Meinhard sale at Parke Bernet Galleries in May 1951 for $6,500.[275] It was there acquired by the canny New York dealer Julius Weitzner, who offered it to the Museum. Although

Weitzner supplied authentication from Richard Offner, W. G. Constable consulted John Pope-Hennessy of the Victoria and Albert Museum in London, who replied, "I am inclined, from the photograph you send me, after cleaning, to think that it must be a Simone, but clearly a late work."[276] The Museum decided on the acquisition, and Weitzner wrote a revealing letter to the director on October 12, 1951:

> Having cleaned this painting twice I naturally had an advantage over your technical advisers and was convinced of the excellent state of preservation. . . . For your personal knowledge may I tell you that it took "a bit of fixing "at the Meinhard sale to purchase this beautiful painting at the price it was knocked down to me. I bought it with a little syndicate of dealers and had we not stuck together it would have fetched more than you are paying. In fact I quoted you a figure far below what my partners expected to achieve.[277]

Mr. Edgell died suddenly in 1954, and the Museum's curator of prints, Henry Rossiter served as interim director until Harvard educated Perry Rathbone, the director of the St. Louis Art Museum, was appointed to the position the following year. Under Mr. Rathbone the Museum made selective purchases of remarkably high-quality works. The first early Italian painting to be acquired was the *Expulsion from Paradise* by the Sienese master Benvenuto di Giovanni bought in 1956 from Dr. Alfred Scharf of London (cat. 61). Then in 1960 the beautiful double-sided reliquary, from the Heugel collection of Paris, was obtained from Knoedler's.[278] Considered then to be by Giovanni di Paolo, it had been published repeatedly by Berenson since 1909 and is now attributed to the unidentified, but splendid, Sienese artist known as the Osservanza Master (cat. 54).

In 1968 Perry Rathbone and the Museum trustee John Goelet visited the New York studio of the restorer Mario Modestini and saw being cleaned for Agnew's of London a panel depicting the *Archangel Michael* attributed to Gentile da Fabriano.[279] Much impressed they had it sent to Boston, where it was acquired and has since been identified as by Pellegrino di Giovanni (cat. 65). Other notable Italian paintings purchased during Mr. Rathbone's directorship were of course the Rosso, Lorenzo Lotto, a large Tiepolo allegory, and a miniature self-portrait of Sophonisba Anguisciola. Gifts included a portrait by Tintoretto from Dr. Rudolf Heinemann, a *Madonna and Child* by the Cremonese painter Boccaccio Boccaccino from the Fuller Foundation in memory of Governor Alvan T. Fuller, and several allegorical panels by Paolo Veronese from Mrs. Holmes.[280] From the estate of the New York artist Dana Pond came an anonymous Italian *Virgin and Child with Saints* now identified as by the Master of the Borghese Tondo (cat. 51).

In the era of Jan Fontein's directorship (1975-1987), and John Walsh's curatorship of the Painting Department, one early Italian painting, an *Enthroned Madonna and Child with Angels* by Neri di Bicci (cat. 37), was purchased from Colnaghi's. It was from an altarpiece originally in the Santissima Annunziata of Florence, and in recommending its purchase the curator observed: "The Museum has an outstanding if uneven collection of early Italian painting. We have a superb group of 14th century Sienese masters, fine late 15th century Venetian works... but strangely enough few Florentine pictures. . . . This Neri di Bicci by virtue of its being historically documented, in almost perfect state, of imposing scale, and superb quality, and above all a serious essay in the artistic issues of its crucial moment – is a compelling and worthy addition."[281]

More recently two notable early Italian paintings have been received as donations. In 1991 Louis Agassiz Shaw, the eldest son of Quincy Adams Shaw, died, and under the terms of his will, the paintings he had by descent from his father at his home in Topsfield were bequeathed to Harvard College for the use of the Fogg Museum with the stipulation that if they were declined, they would be offered to another museum.[282] The present writer was called in to examine a number of dubious works all in hideously overgilded frames that had been rejected by Harvard. Among them, however, was the Bartolomeo Vivarini *Magdalene* (fig.8) first documented in Boston by Berenson in 1894[283] and described as follows by him in 1916: "a

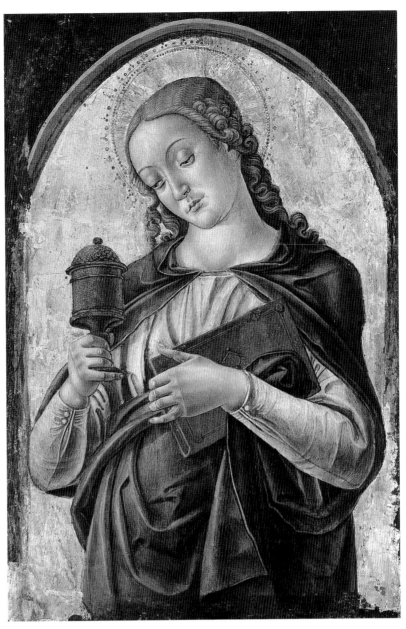

8. Bartolomeo Vivarini, *St. Mary Magdalen*, oil on panel, Gift of Louis Agassiz Shaw, 1991.691.

brief note taken so long ago as 1894 – since when I have not seen the picture again – refers to the *Magdalene* then at Mr. Quincy Shaw's in Boston as being of a quality equal almost to Crivelli's; and that is still the impression left in my memory."[284] This single saint has now happily been reunited with other distinguished works from the Shaw collection.[285]

The last of the great Boston collectors of Old Master paintings in the twentieth century was William Coolidge (1902-1992).[286] An investment banker who had graduated from Harvard, he formed a highly personal collection ranging from Memling, El Greco, Rubens, and Canaletto, to Corot, Sisley, Signac, and Andrew Wyeth. First appointed a trustee in 1961, to replace his brother, T. J., Mr. Coolidge lent all the major paintings from his collection to the Museum for many years. Following his death, it was learned that he had generously bequeathed the greater portion of these works to the Museum, including an unpublished *Virgin and Child* by Andrea del Sarto. The only exception was a remarkably well preserved little *Nativity*

panel from the School of Bernardo Daddi that he left to one of his oldest aquaintances. Fortunately this individual understands the importance of the total collection and has designated the Daddi a promised gift to the Museum (cat. 2). It thus becomes the most recent in a distinguished line of donations stretching back more than one hundred years to Mr. Brimmer's original gift of 1883.

Boston, August 13, 1993

*It was only possible to prepare a survey of the collecting of Early Italian paintings in Boston, because so much relevant material had been preserved in the Museum's archives and I am grateful to the Museum's Archivist, Maureen Melton, for making this so readily available and for sharing her wealth of knowledge on the history of the Museum and its personnel. I also made use of the research facilities at the Art Department of the Boston Public Library, the Archives of the Fogg Art Museum, the Massachusetts Historical Society, the Boston Athenaeum, and the Frick Art Reference Library. In the gathering of the relevant material I was greatly assisted by the researches of Sydney Resendez. Helpful suggestions on the content of this essay were made by Laurence Kanter, Cornelius Vermeule, Robert Simon, Efraín Barradas, and Everett Fahy. Regina Rudser prepared the manuscript and Troy Moss edited it. My thanks to all of them.

1. *Passages from the French and Italian Notebooks of Nathaniel Hawthorne* (Boston and New York, 1902), p. 318.

2. Ibid., p. 321.

3. Ibid., pp. 87, 89-91, 163, 165, 177-178.

4. William Howe Downes, "Boston Painters and Paintings," *The Atlantic Monthly* 12 (December 1888), p. 778.

5. In 1827 was presented the *First Exhibition of Paintings in the Athenaeum Gallery Consisting of Specimens of American Artists and a Selection of the Works of the Old Masters from the Various Cabinets in This City and Its Vicinity* (Boston, May 10, 1827) in which can be found works supposedly by Sirani, Domenichino, Maratti, Carracci, Cagnacci, and Batoni, as well as copies after Dolci and Reni.

6. Mabel Munson Swan, *The Athenaeum Gallery 1827-1873* (Boston, 1940), p. 89.

7. Ibid., p. 95.

8. *Catalogue of Pictures Lent to the Sanitary Fair for Exhibition* (Boston, 1863). On Peter Chardon Brooks see Eric M. Zafran, "Monet in Boston" in the exhibition catalogue *Monet and His Contemporaries from the Museum of Fine Arts, Boston* (The Bunkamura Museum of Art, Tokyo, 1992). A Fra Bartolommeo purchased in Italy for Brooks was donated by his descendents, the Adams, in 1911. See *Catalogue of Paintings* (Museum of Fine Arts, Boston, 1921), p. 5, no. 4.

9. *Catalogue of Paintings and Statuary Exhibited for the Benefit of the National Sailor's Fair* (Boston, 1864).

10. See Marjorie B. Cohn, *Francis Calley Gray and Art Collecting for America* (Cambridge, MA, 1986), p. 113.

11. The painting now tentatively attributed to Passerotti, is accession number 74.22 and when

given had a false Dürer monogram on it, so that it was attributed to that German master. On the Sumner collection see A. B. Johnson, "Recollections of Charles Sumner," *Scribner's Monthly* 10 (November 1874), pp. 109-110; W. G. Constable, "A Cranach from the Sumner Collection," *Bulletin* 41, pp. 64-68; and idem, *Art Collecting in the United States of America* (London and New York, 1964), p. 92.

12. *Catalogue of Pictures Belonging to H. R. H. The Duke de Montpensier and of Other Pictures Also Loaned to the Museum of Fine Arts* (Boston, 1874).

13. See the *Proceedings of the Opening of the Museum of Fine Arts with the Report for 1876* (Boston, 1876), p. 37. It is noted in Julia de Wolf Addison, *The Boston Museum of Fine Arts* (Boston, 1910), p. 58.

14. Osvald Sirén, "Trecento Pictures in American Collections, I," *The Burlington Magazine* 14 (1908), p. 12, and "Some Early Italian Paintings in the Museum Collection," *Bulletin* 14, no. 81 (February 1916), pp. 11-12.

15. Jonathan P. Harding, *The Boston Athenaeum Collection, Pre-Twentieth Century American and European Painting and Sculpture* (Boston, 1984), p. 106.

16. See Benjamin Rowland, Jr., ed., *The Art-Idea by James Jackson Jarves* (Cambridge, MA, 1960), p. xii. On Jarves, see also Theodore Sizer, "James Jackson Jarves, A Forgotten New Englander," *New England Quarterly* 6 (June, 1933), pp. 328-352.

17. Edith Wharton, *Old New York: False Dawn (The Forties)* (New York, 1924). See Van Wyck Brooks, *The Dream of Arcadia* (New York, 1958), p. 241. For Bryan see the *Catalogue of the Gallery of Art of the New-York Historical Society* (New York, 1915), pp. vii, 63-67, and Constable, 1964 pp. 29-30.

18. Quoted in Sizer, 1933, p. 329.

19. James Jackson Jarves, *Art-Hints, Architecture, Sculpture, and Painting* (New York, 1855), p. 264.

20. James Jackson Jarves, "Prefatory Remarks," *Descriptive Catalogue of Old Masters. . . . To Illustrate the History of Painting from A.D. 1200 to the Best Periods of Italian Art* (New York, 1860), quoted in Sizer, 1933, p. 337.

21. Ibid.; also reprinted in the auction *Catalogue of the Jarves Collection of Early Italian Pictures*, Yale College, New Haven, November 9, 1871.

22. Francis Steegmuller, *The Two Lives of James Jackson Jarves* (New Haven, 1951), p. 169.

23. Jarves's letter was published by Norton in the pamphlet *Letters Relating to a Collection of Pictures Made by Mr. J. J. Jarves* (Cambridge, MA, 1859), p. 5.

24. Ibid., pp. 11 and 13; also the "Introduction" to Osvald Sirén, *A Descriptive Catalogue of the Pictures in the Jarves Collection Belonging to Yale University* (New Haven and London, 1916). Jarves's

letter later printed in *The Crayon*, March, 1860, pp. 87-89 concludes:

> For a sum not exceeding $50,000, I can secure for Boston, including my own, a highly respectable gallery of Italian Art, consisting of from one hundred and fifty to two hundred genuine paintings. . .Boston pays $10,000 for a statue, and $8,000 for a picture of Copley's. Surely, then, it is not too much to hope that her large-minded men should be willing to contribute $50,000 to inaugurate a Public Gallery, beginning with some two hundred paintings, embracing a history of the Italian schools for five centuries; or, if that be too large an idea for the present, $20,000 for those that I possess.

25. Norton, 1859, p. 3.

26. Ibid., pp. 28-29.

27. Munson, 1940, pp. 105-106.

28. *The Crayon*, December 1859, p. 381.

29. Sizer, 1933, p. 342; Steegmuller, 1951, p. 182.

30. See Steegmuller, 1951, pp. 183-187. *The Crayon*, January 1861, p. 21, was again the most negative:

> As to the balance of the collection, we cannot see much value in it, inherently or relatively. We think it presumption, at all events, to attribute the pictures catalogued as by Fra Angelico, Raphael, Domenichino, Giorgione, Murillo, Velasquez, etc., to these article. We question the originality of the Rubens sketch and the Madonna of Da Vinci, both being, in any event, very poor specimens of these artists' genius. In our judgment, the value of a collection of "old masters" to this public depends entirely upon the best examples of old-master genius, not poor ones; and again, to meet the historical plea, a complete instead of an incomplete succession of them. We insist, furthermore, on the intrinsic excellence of pictures as a standard of acceptance, and repudiate any attempt to pass them off by the endorsement of conventional authorities.

31. See Swan, 1940, p. 108 and the exhibition catalogue *A Climate for Art, The History of the Boston Athenaeum Gallery 1827-1873* (Boston Athenaeum, October 3-29, 1980), p. 17. Also Rowland, ed., *Jarves*, 1960, p. 14; and Steegmuller, 1951, p. 189.

32. Announced in *The Evening Transcript* December 30, 1861; see Steegmuller, 1951, p. 202. In the *Art Idea* Jarves writes there were forty paintings. See Rowland, ed., *Jarves*, 1960, p. 14.

33. *The Evening Transcript*, January 24, 1862, in Steegmuller, 1951, p. 203.

34. *The Evening Transcript*, February 3, 1862, p. 1.

35. Ibid., February 4, 1862, p. 1. In the *Evening Transcript* of March 30, 1862, p. 1, Jarves reported that "one of the most rare and valuable of the Old Masters, Sano di Pietro's 'Coronation of the Virgin' at Williams & Everett's gallery, has been cut into by a visitor. . . . apparently to ascertain what material it was painted upon. Fortunately the injury is not extensive, but that such vandalism should exist in Boston is surprising. The picture is now protected by glass."

36. Steegmuller, 1951, pp. 211-214; Sizer, 1933, p. 342.

37. Steegmuller, 1951, pp. 232, 247-253; and also the exhibition catalogue, *Italian Primitives, The Case History of a Collection and Its Conservation* (Yale University Art Gallery, 1972).

38. Sizer, 1933, p. 348.

39. *The Official Catalogue Foreign Exhibition* (Boston, 1883), pp. 36-37 gives a brief biography of Jarves and his qualifications; see Sizer, 1933, p. 348; Steegmuller, 1951, p. 285.

40. See Zafran, 1992,

41. James Jackson Jarves, *Handbook for Visitors to the Collections of Old Art of the Foreign Art Exhibition* (Boston, 1883), pp. 3-5:

> A few words of explanation are necessary in regard to the several collections of antiquities and old art forming the Retrospective Art-Section of the Italian Department of the Boston Foreign-Art Exhibition. This section was not originally contemplated, but at my suggestion the Directors consented to my forming one. There were several reasons for this. The shortness of the notice given in Italy for the opening of the Exhibition, together with the competition of ten European contemporary exhibitions and the change in the American tariff, did not permit the securing of sufficient number of paintings and sculptures as would adequately represent all the best features of modern Italian art. . . . It is requisite that the critical public should understand, as regards the master-pieces of old masters, which give them their distinctive reputations, that it is within no one's power to obtain such except in the rare instances of the dispersion of some famous private gallery, or their cession by families which have inherited them from their ancestry, for tempting offers. A first-class gallery can still be obtained in Europe, but it must be diligently labored for and dearly bought. For prices of noteworthy examples steadily augment as they grow scarcer. The old masters now exhibited were secured many years ago, when circumstances for their acquisition were more favorable than at present. They are not presented as master-pieces, but as types of the greater men and their schools, fairly characterizing their motives, coloring, design and modelling; average representative examples of their minor work, but possessing some distinctive, recognizable qualities to those who have made study of them.

42. Stella Rubinstein, *Catalogue of a Collection of Paintings, etc., Presented by Mrs. Liberty E. Holden to the Cleveland Art Museum* (Cleveland, 1917), pp. 7-8; and Alan Chong, *European and American Painting in the Cleveland Museum of Art* (Cleveland, 1993), p. xiii.

43. Sizer, 1933, p. 351. Letter from Jarves to General Loring of February 9, 1888, in the Museum Archives, as are letters from the executor, Henry J. Bowen, of 1893. The Museum's *Catalogue of Paintings* (Boston, 1921) includes several loans from the Estate of James Jackson Jarves – the Timoteo della Vite, *Virgin Appearing to Saints Francis and Anthony*, Pellegrino Tibaldi, *Venus Anadyomene*, and a Venetian School, *Portrait of a Man*, nos. 54, 61, and 78. In addition, the Museum's loan cards record a supposed Antonello da Messina *Ecce Homo* and Sodoma *Magdalene in the Wilderness* also returned in 1925. The proposed sale is mentioned in a 1924 letter from the associate director, Charles Hawes, of December 19, 1924, to the trustee J. Templeman Coolidge. As Everett Fahy has pointed out in a letter of July 31, 1993, the pictures owned by Jarves's descendents were finally sold in auctions at Christie's, London, December 11, 1987, nos. 96-102, and December 11, 1992, no. 387.

44. Downes, December, 1888, p. 449.

45. Ibid., November, 1888, p. 654.

46. See the exhibition handbook by David Alan Brown, *Berenson and the Connoisseurship of Italian Painting* (National Gallery of Art, Washington, D.C., 1979), p. 38. Also "The Fine Arts, The Norton Era, 1874-1908," in Samuel Eliot Morison, ed., *The Development of Harvard University*; the "Introduction" to *Fogg Art Museum Harvard University, Collection of Mediaeval and Renaissance Paintings* (Cambridge, MA, 1919), pp. ix-x; and the exhibition catalogue *The Bostonians, Painters of an Elegant Age* (Museum of Fine Arts, Boston, 1986), p. 6; Brooks, 1958, pp. 122-128; and Constable, 1964, p. 44.

47. Walter Muir Whitehill, *Museum of Fine Arts Boston, A Centennial History* (Cambridge, MA, 1970), vol. 1, pp. 11-12; on Mr. Brimmer see, Edward Waldo Emerson, *The Early Years of the Saturday Club, 1855-1890* (Boston, New York, 1918), pp. 369-370; 1970; and the obituary in the *Annual Report* of 1895, pp. 304; and Carol Troyen and Pamela S. Tabbaa, in the exhibition catalogue *The Great Boston Collectors* (Museum of Fine Arts, Boston, 1984), p. 18.

48. Reported in the *Annual Report* of 1906, p. 98, and the *Bulletin* 4, no. 22 (October 1906), p. 1.

49. In a letter of July 7, 1882, from Brimmer to Loring in the Museum Archives. Could this have been the Massarenti collection bought later by Mr. Walters of Baltimore? See Eric Zafran, *Fifty Old Master Paintings from the Walters Art Gallery* (Baltimore, 1988), pp. 11-12.

50. Stillman was most certainly William James Stillman, a noted American painter and writer who spent much time in Europe. See David Howard Dickson, *The Daring Young Men: The Story of the American Pre-Raphaelites* (Bloomington, 1953), pp. 37-42.

51. A letter of April 26, 1883, from Brimmer to Loring in Museum Archives.

52. Letter of June 17, 1883, in Paintings Department files.

53. The Toscanelli sale took place in Florence April 9-29, 1883. The Bartolo di Fredi no. 110 was described simply as "Grand tableau d'autel." This may have been the largest work in Toscanelli's rich collection, but there were others of far greater importance by Sassetta, Lorenzo Monaco, Gaddi, and Filippo Lippi.

54. The donation is recorded in the *Annual Report* of 1883, pp. 7 and 18.

55. On Shaw see the "Introduction," in *Quincy Adams Shaw Collection*, exhibition catalogue, Museum of Fine Arts (Boston, 1918), pp. 1-4; and Troyen and Tabbaa, 1984, p. 19.

56. The Sturgis letter of April 4, 1899, is in the Paintings Department files. The donation is noted in the *Annual Report* of 1900, pp. 9 and 124; the altarpiece has the accession number 01.4.

57. Bernard Berenson, *Venetian Painting in America, The Fifteenth Century* (New York, 1916), p. 18.

58. Prendergast's description of his repairs and additions to the frame of the Museum's large Vivarini are given in a letter of September 7, 1905, in the Painting Department files.

59. For Bigelow see Whitehill, 1970, vol. 1, pp. 106-107.

60. Cable of March, 8, 1897, from W. S. Bigelow to General Loring in Museum Archives.

61. Cable of January 24, 1898, from Bigelow to Loring in Museum Archives.

62. For the Sienese work see the *Bulletin* 19, no. 115 (October, 1921), p. 62; the Bonifazio (26.768) was recently deaccessioned.

63. On Denman Ross see Whitehill, 1970, vol. 1, p. 15; and Troyen and Tabbaa, 1984, p. 21.

64. Copy of a letter of September 24, 1904, from Matthew Prichard to Denman Ross in Museum Archives.

65. Letter from Denman Ross to Morris Gray of August 15, 1912, in Museum Archives.

66. Letter from Berenson to Denman Ross of March 6, 1932, in the Museum Archives.

67. In a letter probably of 1904, in the Museum Archives. The Tiepolo was *The Apotheosis of a Poet* (06.118).

68. This is accession number 07.483.

69. In a letter from Ross to Morris Gray of April 13, 1924, of which a copy is in the Museum Archives.

70. Letter from Fairbanks to Ross of July 22, 1924, in the Museum Archives.

71. Letter from Denman Ross to Mr. Fairbanks of October 31, 1920, of which a copy is in the Museum Archives.

72. *Bulletin* 19, no. 111 (February, 1921), p. 19.

73. In a letter of November 24, 1907, from Mrs. Richardson to Arthur Fairbanks.

74. Accession number 25.227.

75. *Annual Report* of 1884, p. 13.

76. The gift is noted in the *Annual Report* of 1890, pp. 11 and 51.

77. Berenson, 1916, p. 235.

78. Accession number 02.681. The gift noted in the *Annual Report* of 1902, pp. 47 and 99; see also the *Annual Report* of 1903, pp. 102-103. See the *Annual Report* of 1882, p. 17 and of 1902, pp. 99-100 and *Bulletin* 14, no. 82 (April, 1916), pp. 12-13 and 17.

79. Berenson, 1916, p. 262.

80. See the *Annual Report* of 1897, p. 70.

81. On Wales see Whitehill, 1970, vol. 1, pp. 29 and 84.

82. 1921 Catalogue p. 32, no. 71.

83. According to a letter of December 12, 1963, from John D. Cushing, Librarian of the Massachusetts Historical Society to Mrs. Neil Rudenstine.

84. Sirén, 1916, p. 14.

85. Excerpts from the Committee records of April 1895 transcribed in the Museum Archives. Henry James's role as an expert on Italian painting might seem surprising, but he had looked long and hard in his earlier days at paintings in Florence and was especially fond of Botticelli, as indicated in the newspaper articles he published, collected in *Transatlantic Sketches* (Boston, 1875), pp. 288-289, and 300-301; and also in a letter to his father of January 14, 1879, for which see Leon Edel, ed., *Henry James Selected Letters* (Cambridge, MA, and London, 1987), p. 66.

86. Letter of April 3, 1895, from Thomas Agnew and Sons to Dr. W. Sturgis Bigelow in Museum Archives. The Bonifazio referred to must have been that bought privately by Mr. Bigelow and left to the Museum by him in 1926.

87. *Annual Report* of 1895, p. 15.

88. *Museum of Fine Arts Catalogue of Paintings and Drawings with a Summary of Other Works of Art Exhibited on the Second Floor* (Boston, 1895).

89. Most of these were eventually given to the Museum, accession numbers 01.5, 01.6, and 46.1430.

90. Bernard Berenson, "Les Peintures Italiennes de New-York et de Boston," *Gazette des Beaux-Arts* 15 (1896), pp. 195-214.

91. On Berenson's life and dealings with Boston see Ernest Samuels, *Bernard Berenson, The Making of a Connoisseur* (Cambridge, MA, and London, 1979), pp. 20-50; and also Rollin van N. Hadley, ed., *The Letters of Bernard Berenson and Isabella Stewart Gardner 1887-1924* (Boston, 1987), pp. 61, and 375.

92. Berenson, 1896, p. 204.

93. Ibid.

94. Ibid., pp. 204-206.

95. Ibid., pp. 208-214.

96. Ibid., p. 206.

97. Hadley, 1987, p. xix.

98. Letter of August 1, 1894, in Hadley, 1987, p. 39.

99. See Samuels 1979, pp. 219 and 247; also Donald Garstang, "Colnaghi's and Berenson," in the exhibition catalogue *Art, Commerce, Scholarship, a Window onto the Art World – Colnaghi 1760 to 1984* (P. & D. Colnaghi Co., London, 1984), pp. 21-23.

100. Hadley, 1987, p. xix.

101. Letter of July 19, 1896, in Hadley, 1987, p. 59.

102. Letter of July 8, 1908, in Hadley, 1987, p. 421.

103. Letter of January 7, 1917, in Hadley, 1987, pp. 593-595, See also Ernest Samuels, *Bernard Berenson, The Making of a Legend* (Cambridge, MA, and London, 1987), p. 210.

104. Barbara Strachey and Jayne Samuels, eds., *Mary Berenson, A Self-Portrait from Her Letters and Diaries* (New York and London, 1983), p. 238.

105. Letter of December 2, 1895, in Hadley, 1987, p. 43.

106. Letter of December 14, 1895, in Hadley, 1987, p. 44.

107. *The Annual Report* of 1891, p. 4 noted a donation from Mrs. Gardner to help offset the Museum's deficit. Later Mrs. Gardner was a member of the Committee for the New Museum of Fine Arts, but in November 1909, she described it as "really unfortunately bad." See Hadley, 1987, pp. 241 and 457.

108. Letter of September 11, 1896, in Hadley, 1987, p. 65; and letter of October 21, 1896, in Hadley, 1987, pp. 68-69.

109. In a letter of March 28, 1897, in Hadley, 1987, p. 80; also letter of February 25, 1897, in Hadley, 1987, p. 79 and note p. 65.

110. Letter of June 18, 1902, in Hadley, 1987, p. 290.

111. Theodore Davis of Newport was a collector of antiquities and paintings whom Berenson sometimes advised on his purchases. He gave Egyptian art to the Museum of Fine Arts and lent it paintings by Moroni, Catena, and Francia. He seems to have regarded Mrs. Gardner as something of a rival, see Hadley, 1987, p. 141. He gave his paintings to the Metropolitan Museum of Art. For information on Davis see also Samuels, 1979, pp. 181 and 204-205.

112. Letter of October 6, 1903, in Hadley, 1987, p. 323.

113. Letter of October 9, 1903, in Hadley, 1987, p. 323.

114. Letter of December 1, 1903, from Bernard Berenson (written by Mary Berenson) to Mr. Robinson in Museum Archives.

115. Copy of a letter of December 16, 1903, from Edward Robinson to Bernard Berenson in Museum Archives.

116. See Bernard Berenson, *Catalogue of A Collection of Paintings and Some Art Objects; Italian Paintings*, (John G. Johnson, Philadelphia, 1913), vol. 1, p. 84, no. 141, ill. p. 326; also Hadley, 1987, note p. 291; Samuels, 1979, pp. 380-381; and Strachey and Samuels, 1983, pp. 93-94, 149-150.

117. See Erica E. Hirshler, "Mrs. Gardner's Rival: Susan Cornelia Warren and Her Art Collection," *Fenway Court*, 1988, pp. 51-52.

118. List of "Mr. S. D. Warren's Pictures Loaned to Art Museum, Summer of 1884" in Museum Archives.

119. See Martin Green, *The Mount Vernon Street Warrens, A Boston Story, 1860-1910* (New York, 1989), pp. 10-11.

120. See Samuels, 1979, p. 50.

121. Letter of July 13, 1890, from E. P. Warren to Mr. Robinson in Museum Archives. This is undoubtedly the painting about which Berenson wrote his future wife in 1890; see Brown, 1979, p. 17.

122. Accession number 1890.165, the gift of the painting is noted in the *Annual Report* of 1890, p. 48; catalogue of 1921, pp. 13-14, no. 27.

123. See Janet Cox-Rearick and S. J. Freedberg, "A Pontormo (Partly) Recovered," *The Burlington Magazine*, 125 (September 1983), pp. 521-527. The attribution of the Boston painting to Il Poppi was made by Laurence B. Kanter in 1983.

124. An extract of Berenson's letter of June 6, 1898, to Ned Warren copied and sent to Boston is in the files of the Painting Department. See also the letter of Berenson to Mrs. Gardner of February 25, 1901, in Hadley, 1987, p. 249.

125. The contract between Mrs. Warren and the Sant'Angelos is in the files of the Painting Department.

126. Letter of May 10, 1896, in Hadley, 1987, pp. 55-56.

127. See Hadley, 1987, pp. 467-469.

128. Letter from Berenson to Mrs. Gardner of June 10, 1900, in Hadley, 1987, pp. 215 and 219 explains how Ned failed to go to Colnaghi's in time.

129. In the Museum Archives.

130. See Samuels, 1979, p. 358. The public auction of the Panciatichi collection in Florence did not take place until April 3, 1902.

131. Whitehill, 1970, vol. 1, p. 190.

132. Letter of 1900 in Hadley, 1987, p. 219.

133. The exhibition was entitled *Special Exhibition of Paintings from the Collection of the late Mrs. S. D. Warren* (Boston, April 1902).

134. Letter of June 30, 1902, in Hadley, 1987, p. 291.

135. Letter of July 12, 1902, in Hadley, 1987, p. 293.

136. *Annual Report* of 1902, p. 45.

137. The letter of July 22, 1902, is in the Department of Paintings file.

138. "The Collection of Paintings," *Bulletin* 1, no. 3 (July 1903), p. 18.

139. See the *Annual Report* of 1903, p. 102 and Whitehill 1970, vol. 1, p. 191.

140. Hirshler, 1988, pp. 51-52.

141. The letter and notes are preserved in the Paintings Department files. That of Denman Ross is dated July 30, 1902, Tarbell's August 24, 1902, and Smith's September 8, 1902.

142. *Annual Report* of 1903, p. 103.

143. Hirshler, 1988, p. 52; Green, 1989, p. 166.

144. Copy of an undated letter from Berenson to "Dear Warren" in the Paintings Department files.

145. Letter of May 3, 1903, in Hadley, 1987, p. 315.

146. Letter of May 19, 1903, in Hadley, 1987, p. 315.

147. The agreement between the family members stated in a letter of Fiske Warren to Samuel of October 23, 1903. See David Sox, *Bachelors of Art, Edward Perry Warren and the Lewes House Brotherhood* (London, 1991), pp. 223-225; also William M. Milliken, *Born Under the Sign of Libra* (Cleveland, 1977), p. 86; *The Cleveland Museum of Art, European Paintings before 1500* (Cleveland, 1974), pp. 76-78, no. 29; and Chong, 1993, p. xiii.

148. Berenson, 1916, p. 23.

149. William Rankin, "The 'Primitives' in the Boston Museum of Fine Arts," *The Scrip* 2, no. 4 (January 1907), p. 104.

150. Ibid., p. 108.

151. See "Introduction," *Fogg Art Museum Harvard University, Collection of Mediaeval and Renaissance Paintings* (Cambridge, MA, 1919), pp. xiii-xiv. Edgar Peters Bowron, *European Paintings before 1900 in the Fogg Art Museum, A Summary Catalogue* (Cambridge, MA, 1991), p. 15.

152. E. W. Forbes, "The William Hayes Fogg Art Museum . . . ," *Bulletin* 7, no. 39 (June 1909), p. 22.

153. E. W. Forbes, "The Fogg Museum of Harvard University," *Bulletin* 11, no. 64 (August 1913), pp. 35-39.

154. Edward W. Forbes, "Recent Gifts to The Fogg Art Museum and What They Signify," *Harvard Alumni Bulletin*, January 29, 1917, pp. 329-330.

155. See note 46.

156. In the *Bulletin* 26, no. 153 (February 1928), p. 13; on Walter Gay see the exhibition catalogue *Walter Gay: A Retrospective* (Grey Art Gallery and Study Center, New York University, New York, 1980).

157. Mr. Gray's letter to Gay is dated April 9, 1915.

158. The letter of Gay to Gray, May 7, 1915.

159. Letter of August 19, 1915, from Gay to Fairbanks in Museum Archives.

160. Letters of Fairbanks to Gay of October 27, 1915. Correspondence in Museum Archives.

161. Letter of December 28, 1915, from Wildenstein to Walter Gay in the Museum Archives.

162. For information on Sarah Wyman Whitman see *The Bostonians* (exh. cat. 1986), p. 229; and the *Annual Report* of 1906, pp. 50-81. On the Whitman bequest see the *Annual Report* of 1904, p. 39, and on the purchase the *Annual Report* of 1915, p. 114.

163. "A Sienese Primitive," *Bulletin* 14, no. 81 (February 1916), p. 2.

164. Letter of August 10, 1907, from E. W. Forbes to Richard Norton in the Museum Archives. See Hadley, 1987, p. 195, and on the possible source of their disagreement see Samuels, 1979, p. 416.

165. Letter of November 1907 from Fairbanks to Norton in Museum Archives.

166. In a letter of November 12, 1907, sent from London by Norton to Fairbanks in Museum Archives.

167. See the *Bulletin* 6, no. 33 (June 1908), p. 21.

168. Both the cover letter and other letter of Mr. Fairbanks to Richard Norton of November 4, 1907, are in the Museum Archives.

169. See Sox, 1991, pp. 211-232.

170. Letter of August 8, 1915, from Parsons to Mr. Gray in Museum Archives. A later letter from Parsons of June 10, 1921, to Mr. Hawes again takes credit for recommending these works to Mrs. Fitz.

171. Letter from Parsons to Mr. Fairbanks of 1916 in Museum Archives.

172. Letter from Fairbanks to Parsons of 1916 in Museum Archives.

173. Letter of October 28, 1916, from Parsons to Fairbanks in Museum Archives.

174. Letter from Parsons of June 10, 1921, in Museum Archives.

175. Letter from Parsons to Hawes 1924 in Museum Archives.

176. See Richard Offner, ed. M. Boskovits, *Corpus*, sec. III, part IV, 1990, pp. 78-81. Berenson and Mrs. Gardner had also visited the Sterbini collection; see Hadley, 1987, p. 292.

177. *Bulletin* 9 (June 1911), p. 22.

178. *Annual Report* of 1911, p. 17.

179. Ibid., p. 115.

180. Accession numbers 11.1450 and 13.2859. See *Bulletin* 9, no. 53 (October 1911), pp. 44-45; and 11, no. 67 (December 1913), pp. 67-68; and Roger Fry, "Bramantino," *The Burlington Magazine* 23 (September 1913), p. 317.

181. Letter from Guiffrey to Fairbanks of the summer of 1912 excerpted in the Museum Archives.

182. On Mr. Holmes and Mrs. Fitz see Whitehill, 1970, vol. 1, pp. 131-132, and also the Holmes obituary in the *Bulletin* 48, no. 274 (December 1950), pp. 87-88.

183. *Bulletin* 12, no. 70 (June 1914), p. 32.

184. Chandler R. Post, "Madonna and Child with Angels, Saints, and a Donor," *Bulletin* 12, no. 70 (June 1914), p. 28.

185. The text of Ross's letter is in the files of the Paintings Department. It says in part:

The painting by Fra Angelico which Mrs. W. Scott Fitz has just given to the Museum of Fine Arts is one of the most interesting and beautiful pictures that the Museum has acquired. . . . The surface of the painting is wonderfully preserved. . . . The painting of Fra Angelico was in no sense a business, it was religion. It was also the pleasure of life. . . . The value of the picture and its interest for us lies not only in the life of the master, but in the technical method of it, in which we see the consummation of a certain type of craftmanship. . . . It is particularly interesting that we should have in our Museum a picture in which the period of the Middle Ages is so beautifully summed up for us, – its Theology, its religious fervor, its vision of things unseen, its love of order, its sense of Beauty, its unsurpassed craftsmanship.

186. Lorinda Munson Bryant, *What Pictures to See in America* (New York, 1915), p. 56.

187. *Annual Report* of 1915, p. 115.

188. Parsons to Fairbanks, 1915.

189. Sirén, 1920.

190. Letter from F. Kleinberger to Mr. Holmes of April 12, 1916, in Paintings Department files.

191. Authentication letter from Osvald Sirén of December 2, 1915, in Paintings Department files.

192. Statment of 1916 in Paintings Department files.

193. Extract from a letter of September 26, 1916, from Berenson to Fairbanks transcribed in Paintings Department files.

194. From a note in the Paintings Department files dated Monday, September 25 [1916?].

195. Accession number 17.198. See *Annual Report* of 1917, p. 108.

196. See "A Renaissance Panel," *Bulletin* 15, no. 88 (April 1917), p. 9.

197. Ibid., p. 10.

198. The letter from Federico Zeri of 1952 is in the Paintings Department files. See Bernard Berenson, "Un Plateau de Marriage ferrarais au Musée de Boston," *Gazette des Beaux-Arts* 59 (October – December, 1918), pp. 447-466.

199. *Bulletin* 18, no. 106 (April 1920), p. 25.

200. Letter from A. Merriman Paff to Arthur Fairbanks of April 24, 1920, in Paintings Department files.

201. Berenson, 1932, p. 459.

202. Opinion given in the summer of 1985 and recorded in department file.

203. Accession number 21.2287. See *Bulletin* 19, no. 116 (December 1921), p. 72.

204. G. H. Edgell, "A Madonna, Saints, and Angels by Francesco di Giorgio Martini," *Bulletin* 40, no. 238 (April 1942), p. 21.

205. Memo of 1926 by J. B. Potter in Paintings Department files.

206. Accession number 26.141. A. C. J., "St. Jerome," *Bulletin* 24, no. 145 (October 1926), p. 66.

207. Gertrude Coor-Achenbach, "A New Attribution for the Dugento Crucifixion," *Bulletin* 47, no. 269 (October 1949), pp. 39-42.

208. Accession number 64.2085.

209. *Annual Report* of 1906, p. 108.

210. Letter of January 1, 1913, in Hadley, 1987, p. 500.

211. M. C., "Battle Scene, by Paolo Uccello," *Bulletin* 13, no. 78 (August 1915), p. 62.

212. Listed in the *Annual Report* of 1915, pp. 118-123.

213. *Annual Report* of 1917, pp. 19-20.

214. "The Henry Howard and Zoe Oliver Sherman Collection," *Bulletin* 20, no. 121 (October 1922), p. 57.

215. Letter of June 24, 1922 in Paintings Department files.

216. Letter of October 20, 1936, from Kirk Askew to James S. Plaut in the Paintings Department files.

217. Cable dated September 10, 1922, from Gray to Hawes and further correspondence of September 1922 through January 1923 is in the Museum Archives.

218. Charles Hawes, "Madonna and Child with a Angel," *Bulletin* 21, no. 126 (August, 1923), p. 48.

219. The Richter letter is quoted in extracts in the Museum Archives. Berenson's letter is of November 17, 1923, in Hadley, 1987, p. 665.

220. Bernard Berenson, "An Early Signorelli in Boston," *Art in America* 14 (April 1926), pp. 105-117. See Samuels, 1987, p. 340.

221. As reported by Sirén in a letter of October 12, 1936, to James S. Plaut.

222. Memorandum of Philip Hendy in Museum Archives.

223. Cable of September 4, 1930 in Paintings Department files.

224. Letter of September 10, 1930, from Philip Hendy to Colin Agnew.

225. P. Hendy, "Giovanni di Paolo," *Bulletin* 28, no. 170 (December 1930), p. 104.

226. Anne Webb Karnaghan, "A Virgin and Child by Andrea Mantegna," *Bulletin* 32, no. 140 (April 1934), p. 21.

227. On Edgell see the obituary in *Bulletin* 52, no. 290 (December 1954), pp. 82-83 and also Whitehill, 1970, vol. 2, pp. 443-444.

228. *Annual Report* of 1937, p. 42.

229. *Annual Report* of 1957, p. 45.

230. See Colin Eisler, "Kunstgeschichte American Style," in *The Intellectual Migration*, ed. by Donald Fleming and Bernard Bailyn (Cambridge, MA, 1960), p. 593; and the *Annual Report* of 1957, p. 5.

231. Letter of December 30, 1936, from Paul J. Sachs to Charles C. Cunningham in Museum Archives.

232. Letter of January 7, 1937, from Paul J. Sachs to Charles C. Cunningham in Museum Archives.

233. Letter of January 15, 1937, from Henschel to Edgell in Museum Archives.

234. According to a letter from Charles Durand-Ruel to W. G. Constable of June 28, 1952.

235. Accession number 37.410. See W. G. Constable, "A Polyptych from Apulia," *Bulletin* 40, no. 238 (April, 1942), pp. 21-25.

236. As it is referred to in documents.

237. The receipt executed at the Worcester Club in Worcester on January 11, 1930, and correspondence, is in the Paintings Department files.

238. George H. Edgell, "Six Unpublished Sienese Paintings in Boston," *Art in America* 28, no. 3 (July 1940), p. 97.

239. Memorandum of December 14, 1939, from W. G. Constable to Mr. Edgell in Museum Archives.

240. Edgell, 1940, pp. 97-98.

241. *Annual Report* of 1936, p. 34.

242. The authentication of Giacomo de Nicola is on the back of a photograph of the painting. The 1939 opinion of Berenson is given in a note in the Paintings Department files, but the original letter is unfortunately not there.

243. G. H. Edgell, "A Newly Acquired Panel by Ambrogio Lorenzetti," *Bulletin* 37, no. 223 (October 1939), pp. 70-73.

244. *Art Digest*, October 15, 1939, p. 9; *Art News*, October 7, 1939, p. 15.

245. Copy of a letter from Edgell to Berenson of January 16, 1940, in Museum Archives.

246. Letter of February 3, 1940, from Berenson to Edgell in Museum Archives.

247. Memo from Constable to Edgell of May 31, 1940, in Paintings Department files. The Conestabile provenance, as Cornelius Vermeule has pointed out, provided a cloak of respectability, since a famous Raphael *Madonna* now in The Hermitage, had come from the same source.

248. Report in the files of Paintings Department.

249. G. H. Edgell, "A Profile Portrait of a Lady by Piero della Francesco," *Bulletin* 38, no. 229 (October 1940), pp. 64-66.

250. Copy of a letter of October 11, 1940, from Charles C. Cunningham to Paul J. Sachs in Museum Archives. The Detroit Verrocchio was a bust-length profile *Portrait of a Woman* published by W. R. Valentiner, *Bulletin of the Detroit Institute of Arts* 16 (June 1937) as by Verocchio or Leonardo, which according to Everett Fahy is today considered either a fake or a much doctored panel.

251. According to an article of January 10, 1960, in the Sunday *New York Times*, a Museum spokesman said this work "had been withdrawn from the collection several years ago. . . .This work was under suspicion but had never been confirmed as a forgery out of deference to those involved in its acquisition. . . . After the deaths of some of the group, the picture was put away and no longer exists 'in art circles.'" The painting was, however, shown in the exhibition *Fakes and Forgeries* (The Minneapolis Institute of Arts, 1975), p. 91, no. 66 as "In the style of Piero della Francesca," with the information that "the panel is made from the wrong kind of wood, its grain runs vertically rather than horizontally, giving an uncharacteristic type of crackle, and the paint contains cadmium yellow, a modern pigment."

252. As noted in the *Annual Report* of 1945, p. 41.

253. Memorandum from Constable to Edgell of 1940 in Paintings Department files.

254. W. G. Constable, "A Fresco of the School of Rimini," *Bulletin* 39, no. 234 (August 1941), p. 48.

255. According to correspondence from the Brummer Gallery of May 3, 1940, and February 18, 1941, in the files of the Paintings Department.

256. These works still attributed to Zoppo are accession numbers 45.5-8 and 45.768. See the *Annual Report* of 1945, pp. 41-42.

257. Letter of February 27, 1946, from Berenson to Edgell quoted in Paintings Department files. Mr. Edgell was unconvinced.

258. According to letters from the Brummer Gallery dated March 28, 1947, and January 17, 1964, in the files of the Paintings Department.

259. Copy of a letter of January 6, 1928, from Mr. Holmes to Sir Joseph Duveen in Museum Archives.

260. Letter of January 25, 1930, from Bert Boggis to Mr. Holmes in Museum Archives.

261. Edgell's letter to Lord Duveen of May 21, 1938, and that of W. G. Constable to Paul J. Sachs are in the Museum Archives.

262. See Brown, 1979, p. 29. Samuels, 1987, pp. 432-436.

263. See Denys Sutton, "Robert Langton Douglas: Sunset at Fiesole," *Apollo* 110, no. 209 (July 1979), p. 55.

264. Memo of November 8, 1945, from Constable to Edgell in Museum Archives.

265. Copy of a letter of December 14, 1945, from Edgell to Fowles in Museum Archives.

266. Copy of a letter of May 29, 1946, from G. H. Edgell to Edward Fowles in Museum Archives.

267. Edgell *Bulletin* 44, no. 256 (June 1946), p. 35.

268. "Boston Acquires America's Seventh Duccio," *Art Digest* 20, no. 17 (June 1, 1946), p. 7.

269. Accession number 46.1428. G. H. Edgell, "A Madonna by Bernardino di Mariotto," *Bulletin* 45, no. 261 (October 1947), pp. 64-66.

270. The gifts were recorded in the *Annual Report* of 1946, p. 44. The correspondence between Quincy Adams Shaw and the Museum on the Tintoretto of March and April 1947 is in the Museum Archives. The final deed of gift was made in February 1949.

271. In a memorandum of April 8, 1948, from Constable to Edgell.

272. Letter of April 9, 1948, from Constable to Gabarty in Paintings Department files.

273. Constable's memo to Edgell of January 12, 1950, is in the Museum Archives.

274. Memorandum from Constable to Edgell of May 5, 1951.

275. Thomas E. Norton, *100 Years of Collecting in America, The Story of Sotheby Parke Bernet* (New York, 1984), p. 254.

276. Letter of December 3, 1951.

277. Letter from Julius Weitzner to Mr. Edgell of October 12, 1951, in Paintings Department files.

278. The purchase was confirmed in a letter of April 19, 1960, from Perry Rathbone to E. Coe Kerr, Jr., President of M. Knoedler and Co., a copy of which is in the Museum Archives.

279. Letter from Perry Rathbone to Geoffrey Agnew of November 30, 1967.

280. See the *Annual Report* of 1961, pp. 15 and 63-65.

281. Memo from John Walsh to Jan Fontein in the Paintings Department files.

282. Documents of gift in the Museum Archives.

283. Bernard Berenson, *The Venetian Painters of the Renaissance* (New York and London, 3rd ed., 1894), p. 149; and in his *Gazette des Beaux-Arts* article of 1896, p. 208.

284. Berenson, 1916, p. 16.

285. Accession number 1991.691. On Mr. Shaw and his family see the entry in *The National Cyclopedia of American Biography* (New York, 1939), vol. 27, pp. 484-485. A *Madonna and Child with St. John* by Tosini from the Shaw collection was given to the Art Museum of Boston College in 1988.

286. See the obituary in *Preview* (Museum of Fine Arts, Boston, September – October, 1992), p. 14.

❧ PART I:
Thirteenth and Fourteenth Centuries

I. FLORENCE

Bernardo Daddi

The Crucifixion

Tempera on panel
Overall: 39.8 x 28.6 (15¹¹/₁₆ x 11¼)
Picture surface: 36.5 x 28.6 (14⅜ x 11¼)

Helen Collamore Fund. 23.211

Provenance: Julius Böhler, Munich; Osvald Sirén, Stockholm

Literature: van Marle, vol. 3, 1924, p. 408 fn. 1; Comstock, February 1928, p. 94, March 1928, pp. 71, 73; Berenson, 1932, p. 165; Offner: 3, iv, pp. 61-63, pl. xxvii; Galetti and Camesasca, 1950, p. 774; Berenson, 1963, p. 52; Boskovits et al., 1964, p. 29; Fredericksen and Zeri, 1972, pp. 61, 564; Boskovits, 1984, pp. 345, 353; Boskovits, 1989, p.66; Boskovits, 1991, pp. 11, 20, 225-227, 245, 310.

Condition: The panel, 2.5 cm thick, has not been cradled though it is backed with a coating of wax resin. The engaged frame has been cut away and the panel trimmed to the edges of the picture surface at the two lateral sides. A slight lip appears on all four edges of the paint layer. The paint surface is unevenly preserved. The figures at the lower left have suffered only minor abrasion and pinpoint flaking losses whereas the four standing figures at the right have been nearly effaced. Local losses in the figures of Christ and the kneeling saint at the right have been liberally retouched. The robes of the two lower angels flanking the cross, originally blue, have been repainted green. The gilding remains largely intact, though somewhat worn.

BERNARDO DADDI was the most prolific and influential painter active in Florence in the generation following Giotto's, in the second quarter of the fourteenth century. The first preserved notice of him records his enrollment in the Arte dei Medici e Speziali, the painters' guild, sometime between 1312 and 1320, and in 1339 he was a founding member of the Compagnia di San Luca. From his earliest signed and dated altarpiece, a triptych formerly in the church of the Ognissanti (now in the Uffizi) of 1328, to the great Or San Michele tabernacle of 1347 (Daddi died in 1347 or 1348), he executed numerous important altarpieces and lavish private commissions, as well as overseeing the production of a large quantity of standardized devotional works of more modest quality. An unusual number of his paintings are signed and dated, but these evidence a wide range of quality in execution and invention, suggesting that a key factor in his commercial success was the efficient organization of a large workshop. The main thrust of scholars studying his work over the past sixty years has been twofold: the disentanglement of Daddi's artistic personality from the more anonymous production of his shop, and the identification of a body of works that might have been painted earlier than the 1328 Ognissanti altarpiece.

THE BODY OF CHRIST hangs on the cross, which rises the full height of the panel along its center, the titulus extending into the stamped and engraved border of the gold ground. Four angels, two clad in red and two in blue (repainted green), hover beneath the arms of the cross, weeping and collecting the blood that falls from Christ's wounds. Saint Mary Magdalene, dressed in red with long, unbound waves of hair falling down her back, kneels on the hill of Golgotha and embraces the foot of the cross. Behind her at the left the Virgin faints into the arms of three holy women, one dressed in mauve, one in orange, one in light green. Saint John the Evangelist, in a blue tunic and red cloak, looks sorrowfully at the Virgin, while another holy woman next to him, clad in purple, looks up toward Christ. At the right of the cross kneels an unidentified female (?) saint with a gold fillet on her head and violet robes bound at the waist with a looping sash. Behind her stand two soldiers, a centurion (? – he has no halo), and a bearded elder figure in orange robes who stare and gesture upward toward the figure of Christ.

Other than a manuscript opinion of Philip Hendy's (Museum files) describing this panel as a "typical early work" by Bernardo Daddi, the few notices it has

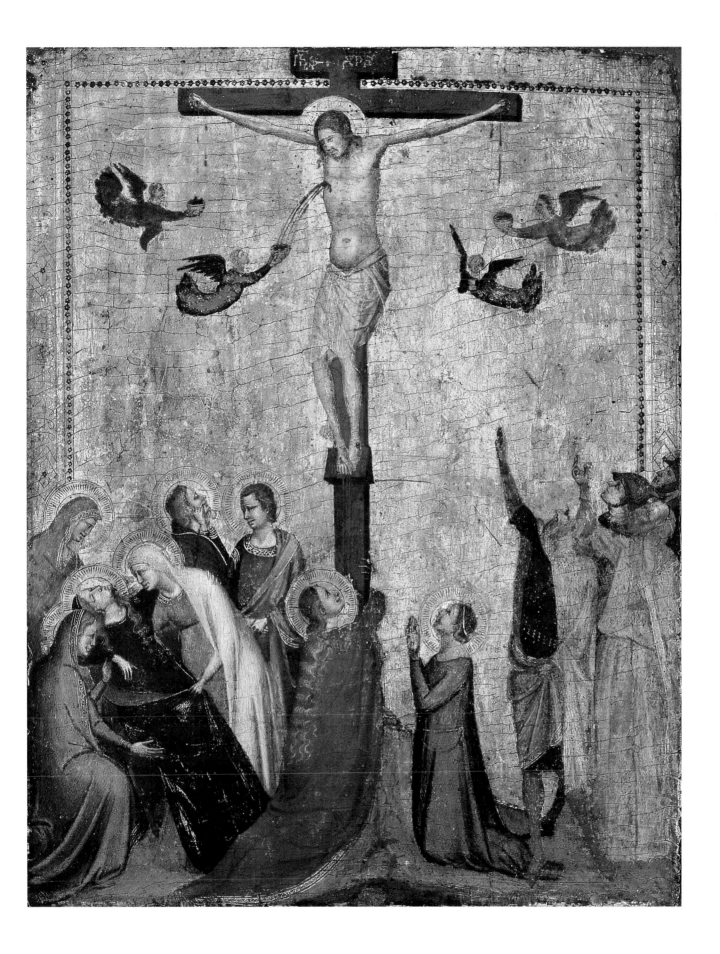

received mostly refer it to Daddi's workshop or a close follower in the latter half of his career. Comstock (1928), Offner (1934), and Boskovits (1964, 1984) discussed it in the context of a number of other representations of the Crucifixion by Daddi or from his studio which it loosely resembles in composition. The Boston panel, however, displays a number of peculiarities, notably in its shape, in the decoration of its gold ground, and in the originality and sophistication of some of its figural motifs, that distinguish it from other Daddesque Crucifixions.

The pronounced beard of gesso apparent on all four sides of the picture surface in this panel indicate that its present rectangular shape, highly unusual in Daddi's oeuvre, is original. The shape was favored more by earlier artists, such as the Saint Cecilia Master, and among Daddi's contemporaries is common only in the work of the Master of San Martino alla Palma. Both of these artists also preferred the system of border decoration used in this panel: a single course of simple rosette punches highlighting a margin engraved with sketchy, psuedo-cufic characters. This decoration is an anomaly in Daddi's oeuvre, appearing in approximately this form only in a panel of the Crucifixion recently identified in the Convento delle Oblate at Careggi (Boskovits, 1984, p. 339, pl. CLXVIA). Daddi's usual system of decorating haloes and the borders of gold grounds depends on the use of punching tools, though his putative early works do rely more on engraved patterns (Boskovits, 1984, pp. 70-71; Skaug, 1971, pp. 141-160).

As a rule, the many Crucifixions produced by Daddi or in his shop are all variations on a limited number of compositional themes, selecting and rearranging a fixed number of motifs which can all be identified in more than one panel. The Boston Crucifixion is an exception. It is, as Offner (1934, p. 69) pointed out, rare to find two kneeling figures in the foreground of Daddi's Crucifixions, but the presence here of a second kneeling saint[1] undoubtedly reflects some stipulation of the picture's original owner. More important, in no other Crucifixion does Daddi experiment with as dramatic a posture for the fainting Virgin or with such naturalistic gestures of support from the three holy women, reminiscent of the executioners in the fresco of the *Martyrdom of Saint Lawrence* in the Pulci-Berardi chapel in Santa Croce, Florence. The sophistication of these postures, of the figures' facial expressions, and of such details as the pull of the Virgin's cloak around her waist or the break in lighting on the hems of the robes of the Magdalene and the left-most holy woman as they fall forward over the lip of ground at the bottom of the panel reveal that this can only be an autograph work by Bernardo Daddi himself, and taken together with the observations concerning the panel's shape and decoration, imply that it dates from the earliest moments of his career, before the dated triptych of 1328 in the Uffizi (see Boskovits, 1991, p. 11).

Presumably, the Boston *Crucifixion* was not painted as an independent devotional panel. Probably it was originally intended as the right valve of a diptych, but the loss of its frame and the trimming of the wood support at both sides have destroyed any evidence of hinges or clasps that might have confirmed this supposition. No other panels are known which might plausibly be associated with the Boston *Crucifixion* as fragments of a single complex.

1. Boskovits (1991, p. 226) tentatively suggests identifying this figure as the Blessed Joan of Signa or, less probably, Santa Fina of San Gimignano. There is no evidence upon which either suggestion could be confirmed. The figure bears no attributes likely to lead to an identification.

2

The Nativity and the Annunciation to the Shepherds

Tempera on panel
38 x 18.4 (15 x 7¼)

Francis H. Burr Collection, Promised Gift.

Provenance: Philip Gentner, Florence; Eugenio Ventura, Florence; Knoedlers (Paris and New York); William Coolidge, Topsfield, Massachusetts

Literature: Offner, 3, viii, pp. 91-92, pl. XXI; Longhi, 1959, p. 35; Pope-Hennessy and Kanter, 1987, p. 52; Boskovits, 1989, pp. 80, 85, 354.

Condition: The panel support is exceptionally well preserved, evincing only a modest warp and no appreciable splits or cracks. It retains its original edges on all four sides and has been neither thinned nor cradled. The present surface of red paint on the reverse of the panel though much worn is not original; traces of an earlier pigment layer are visible beneath. Four hinges, two on each side, are visible where they have been sawn off at the edges of the panel, and as raised V–shaped channels of gesso where they penetrate the panel beneath the paint surface. Except for minor losses along these raised channels, especially in the face of the shepherd at the lower right, which has been almost entirely effaced, the paint layers are in a near-perfect state of preservation. The silver leaf of the sky is, however, much abraded, and a layer of red glaze which once covered it survives only in microscopic traces. The head and hands of the angel painted over this silver ground have been lightly reinforced, as has the bridge of Saint Joseph's nose at the bottom of the panel.

THE SCENE OF THE NATIVITY is set beneath the straw roof of a shed pitched against the side of a pink building pierced by two Gothic bifora. The Virgin, in a blue cape over a red dress, kneels at the left before a large wooden (?) manger filled with straw, into which she gently lowers the tightly swaddled figure of the infant Christ. Two angels, in yellow and brown robes glazed with blue and green shadows, kneel in adoration at the right, while six more, in red, blue, and brown robes, hover in an arch above. In the foreground, at the bottom of the panel, Saint Joseph, wearing a brown tunic and yellow robe, sits on a rocky outcropping resting his head in his hand, while before him a gray-clad shepherd tends a flock of three sheep, a ram, and a black goat. Above the roof of the shed another shepherd, playing an instrument resembling a bagpipe, is interrupted by an angel dressed in blue, flying downward and pointing to the Christ Child below.

This exquisite and beautifully preserved panel, in an exemplary state for a painting of the period, has been classed among the anonymous workshop productions of Bernardo Daddi since it was

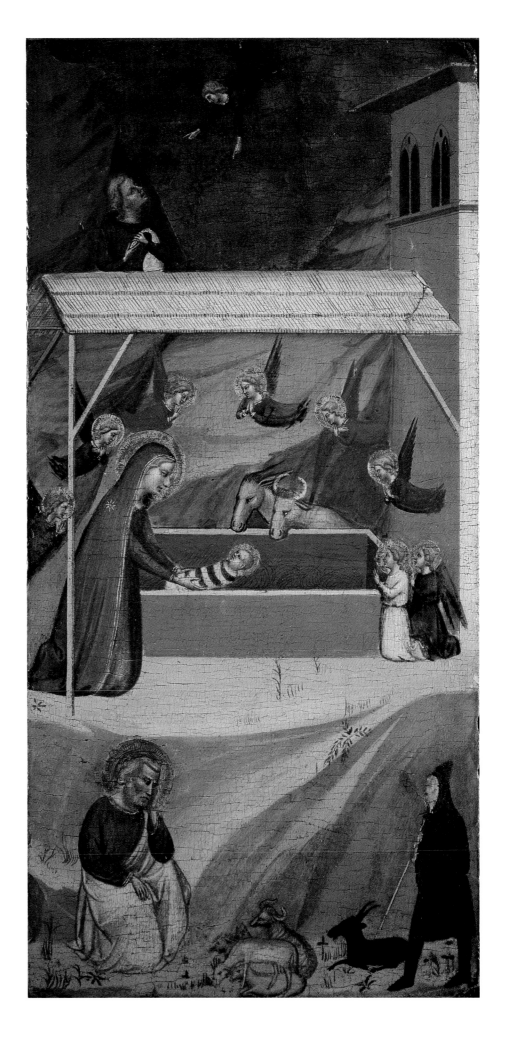

first published by Richard Offner (1958). The general outlines of its composition follow those of numerous other examples of the subject by Bernardo Daddi and his studio, including: 1) Florence, Museo del Bigallo, tabernacle dated 1333 (Offner, 3, iii, pl. VII); 2) Florence, Galleria degli Uffizi, predella to the altarpiece from San Pancrazio (Offner, 3, iii, pl. XIV, 24); 3) Altenburg, Lindenau Museum no. 15, tabernacle (Offner, 3, iii, pl. XII); 4) Siena, Pinacoteca Nazionale no. 60, triptych dated 1336 (Offner, 3, iv, pl. XLI); 5) London, Courtauld Institute Art Galleries, Seilern triptych, dated 1338 (Offner, 3, viii, pl. IV); 6) Edinburgh, National Gallery of Scotland no. 904, Bohler triptych, dated 1338 (Offner 3, iv, pl. XXXIV 3,4); 7) Berlin-Dahlem, Gemäldegalerie no. 1064, triptych (Offner, 3, iv, pl. XXXV.1); 8) Paris, Musée du Louvre no. 1667, triptych (Offner, 3, iv, pl. XLII); 9) Prague, Národní Galerie inv. no. 23,642, Konopiste triptych (Offner, 3, iv, pl. L); 10) London, Wallace Collection no. 549, fragment (Boskovits, 1984, pl. 189). All but one of these, the predella panel from the San Pancrazio altarpiece, occur as the left wing of a triptych, generally balanced by a Crucifixion in the right wing and completed above by a triangular gable with the Annunciation. Offner not unreasonably presumed such to have been the original function of the Coolidge Nativity as well, but identified no other panels from the same complex.

Several considerations militate against this reconstruction of the original context of the Coolidge Nativity. In the first instance, the panel preserves hinges on both sides, whereas the left wings of triptychs invariably had hinges on the right side only. Furthermore, the hinges were driven into the panel back to front, i.e. with their loops projecting at the back of the side edge of the panel, implying that it was meant to fold backwards over its neighboring panel(s) and possibly, therefore, that the Nativity was painted on the outside or reverse of its structure (which might also explain the unusual use of silver leaf glazed red in the sky, a technique for the inexpensive imitiation of gold rarely encountered in trecento painting). Finally, the panel, which is complete in its present form, was never enclosed in an engaged frame, as is almost without exception the rule in a conventional triptych or tabernacle structure. The likeliest explanation for these anomalies is that the Coolidge Nativity once formed a valve of a folding door from a custodia or reliquary cupboard.

One other panel, a Presentation of the Christ Child in the Temple in an Italian private collection (Boskovits, 1984, p. 365, pl. 193.b) shares all or most of these peculiarities with the Coolidge Nativity. Except for the addition of a flattened ogival arch at the top, it is to within a few millimeters the same size as the Boston panel (46 x 18.7 cm, overall, approximately 38 cm high to the spring of the arch), and it clearly shows evidence of hinges on both sides, driven back to front, with the protruding claws of the hinge hammered down flush with the panel surface, gessoed over, and now visible as raised V–shaped channels beneath the paint layers. Though the panel is said to have been altered in its overall shape (Boskovits, who appears to have known the panel in photograph only), this may be a misunderstanding of its highly unusual format, similar to Offner's belief that the Coolidge panel was mutilated by the excision of a triangular gable of the Annunciation. It also appears that the Presentation may be completed by a silver ground above the unorthodox projection of the roof tiles of the temple. Though Boskovits does not describe this ground as silver, its fine-veined craquelure visible in photograph corresponds to typical effects of silver leaf.

The subject of the Presentation of the Christ Child in the Temple is a logical companion to a Nativity in the context of a larger cycle of scenes from the infancy of Christ or the life of the Virgin, though they would be unprecedented as an isolated pair. How such a cycle of scenes – which may have included an Annunciation, an Adoration of the Magi, or a Dispute in the Temple – may have been disposed must remain a matter of conjecture, since no series comparable to this survives intact.[1] Assuming neither of the two known panels was altered in shape, it is possible: 1) that the Presentation in the Temple originally stood above the Nativity in a two- or three-tiered movable structure, as was the case later (ca. 1455) with Giovanni di Pàolo's scenes from the life of the Baptist, where arched-top panels (New York, Metropolitan Museum of Art, Robert Lehman Collection; Pasadena, Norton Simon Collection; Münster, Westfälisches Landesmuseum) stood above two tiers of rectangular panels (Chicago, Art Institute; Paris, Musée du Louvre); or 2) that the Presentation in the Temple stood to the right of the Nativity and was balanced in turn on its right by another rectangular panel. Either proposal allows for the presence of hinges on both sides of the panels. In favor of the second possibility is the fact that the hinges at the right of the Nativity and the left of the Presentation are at approximately the same heights (7.5 and 29 cm above the bottom edges of the panels), and that simple wire loop hinges of this type probably could not have held superimposed panels evenly in plane, resulting in greater damage along the top and bottom edges of the panels where they would have rubbed together than either panel presently evinces.

Stylistically consonant with each other, both the Nativity and the Presentation in the Temple present a number of incongruities, other than those of their physical structure discussed above, with respect to other works by Bernardo Daddi. The Presentation in the Temple is not a subject repeated in any other known work by Daddi. Though it employs that artist's stock figure types and such decorative devices as the fringed cloth of the altar frontal and the radial striations engraved in the haloes, the eccentric projection of the tiles of the temple roof is unprecedented in his work and the lack of visible supports for the roof "has no parallel in Trecento Florentine painting" (Boskovits, 1984, p. 365). The Coolidge Nativity differs from all other examples of that subject by the artist in a number of perhaps significant details: it is the only example in which the shed of the manger is viewed from the left rather than the right (it is centralized in the left wing of the Bigallo triptych) and from above rather than below, and it is the only example which includes a building as a support for one side of the roof. In both these respects, the panel follows the example of paintings by Taddeo Gaddi rather than Bernardo Daddi. In all of Daddi's other images of the Nativity, futhermore, the manger is not a plain, unincidented box, the ox stands on the left of the ass (except, again, in the Bigallo triptych), the angels are differently disposed, and the foreground shepherd(s) attends to the message of the annunciatory angel at the top of the panel.

These departures from the usual standardization of imagery within Daddi's highly regimented studio production imply that the details of the composition of the Coolidge Nativity were carefully devised for its specific context. The remarkable quality of its execution, in respect of both the sophistication of its technique and the vivacity of its expressive content, might argue for its completely autograph status, although the figure types do not correspond exactly to those in any other painting by Bernardo Daddi (or by any of his known followers or assistants). The panel was dated by Longhi (1959), in the course of discussing Daddi's debt to Taddeo Gaddi and Maso di Banco, a few years after the Bigallo tabernacle of 1333,[2] and this appears to be correct. The two Nativity compositions

by Daddi most closely related to the Coolidge panel are those of 1336 in Siena (no. 4 above) – where the figure of Saint Joseph is almost identically disposed and the ring of angels flying around the manger approximates the geometric regularity of those in the Coolidge panel – and of 1338 in Edinburgh (no. 6 above). It is likely that the Coolidge Nativity was painted close to 1336, the date also of the Maestà at S. Giorgio a Ruballa which, despite its radical difference of scale, it in many ways resembles.[3]

1. A custodia by Pacino di Bonaguida in the Kress Collection (K1717, Tucson, Arizona, University of Arizona) includes sixteen small scenes from the infancy and passion of Christ flanking a larger image of the Crucifixion.

2. Boskovits, 1989, p. 170, has observed that the inscription at the base of this tabernacle has been renewed and the last digits of the date may have been tampered with. A date around 1334, contemporary with or slightly later than Taddo Gaddi's "copy" of the composition at Berlin-Dahlem (cf. Longhi, 1959, pp. 34-36) would more comfortably fit the probable internal development of Daddi's style.

3. The Maestà at S. Giorgio a Ruballa was originally classified by Offner as "Close to Bernardo Daddi" (3, 4, pl. 20), but has recently come to be considered as probably an early work of Maso di Banco and possible evidence of Maso's training in Daddi's shop (cf. Boskovits, 1991, p. 178, with earlier bibliography). The argument is visually convincing, though it has not been universally accepted. It is possible that Maso's intervention may explain some of the peculiarities of figure style in the Coolidge Nativity as well, and perhaps in the Siena triptych (which is severely damaged and only incompletely legible), though neither relates compositionally to the Nativity painted later by Maso in the left wing of the triptych now in the Brooklyn Museum.

Maestro Daddesco

"Maestro Daddesco" is the conventional name assigned to a Florentine miniaturist first identified by Mario Salmi (1952, pp. 8-23), but whose oeuvre and stylistic development were only more recently clarified in studies by C. Bertelli (1970, pp. 14-30), A. Guidotti (1979, pp. 419-441), and M. Boskovits (1984, pp. 44-47, pp. 220-253). The Maestro Daddesco was a key figure in the development of early Gothic style in Florence, though the exact role he may have played is confused by disagreement over the precise period of his activity: the first third or the second quarter of the fourteenth century. A follower and sometime collaborator of the Master of the Saint George Codex, he was better able than any other painter of his generation to assimilate the influence of Bernardo Daddi (hence his sobriquet) and produce from it a strong and highly individual personal style. It was argued in the exemplary article by A. Guidotti (1979) that this influence from Daddi depends upon the elder Master's works of the 1340s, and that the Maestro Daddesco's earliest efforts are unlikely to significantly predate that decade. It is probable that the Maestro Daddesco remained active until or just beyond mid-century.

Center Panel of a Tabernacle: Madonna and Child Enthroned with Saint Lucy and a Bishop Saint; Crucifixion; Christ and the Virgin Enthroned

Tempera on panel
Overall: 57.1 x 34 (22½ x 13⅜); Original (minus bottom molding) 53.6 x 34 (21⅛ x 13⅜); Madonna and Child: 31.2 x 12.7 (12¼ x 5); Crucifixion: 31.2 x 13 (12¼ x 5⅛); Christ and the Virgin: 23 x 18.5 (9 x 7¼)

Zoe Oliver Sherman Collection. A Gift of Zoe Oliver Sherman in Memory of Henry H. Sherman. 38.1840

Provenance: R. Henniker-Heaton, London, by 1929/30; Zoe Oliver Sherman

Literature: Tatlock, 1930, pp. 224-225; Venturi, 1933, pl. 38; Offner, 3, i, p. 115; Meiss, 1951, pp. 99, 109; Schorr, 1954, pp. 159, 162; Offner, vol. 4, ii, 1960, pp. 50, 115; Fredericksen and Zeri, 1972, pp. 218, 564; Fahy, 1978, pp. 264, 267 fn. 7; Boskovits, 1984, pp. 24 no. 60, 46, 230; Bellosi, 1992, p. 30 fn. 14.

Condition: The panel, which is 0.8 cm thick, is built up with the addition of two superimposed layers of moldings to a maximum depth of 1.5 cm. A wax resin coating on the back has obliterated any evidence of thinning; the painting has not been cradled. Two small partial splits have been repaired on the back of the panel, one of which is visible on the front in the group of mourners at the left side of the Crucifixion scene. A pair of original metal hinges remain on either side of the panel, and all the engaged frame moldings are original. The gold ground and the decorative hatch marks that cover it are well preserved with few abrasions and losses, except for the area around the crucified Christ which is worn. The decorative shell gold patterns on the green fabric backdrops in the top and left scenes are also quite well preserved with some minor wear. The paint layers are in excellent condition, showing only tiny abrasions and pinpoint losses along the cracks that have been minimally retouched and light reinforcement of profiles along the edges of the gold ground.

The panel, which is complete with its original engaged frame, is divided into three distinct picture fields by a double-arched, trilobate arcade supported on pairs of Solomonic columns. Beneath the left arch is portrayed the Virgin and Child enthroned before a cloth of honor supported by three flying angels. The Child stands on his mother's lap—his right foot placed in her right hand—and pulls at the hem of her blue cloak. The throne, supported on a ring of pillars, is set on a three-stepped hexagonal dais, before which stand Saint Lucy, holding an unguent jar (?) and a martyr's palm, and a bishop saint. The right arcade shows the Crucifixion, with five mourning angels flying around the body of

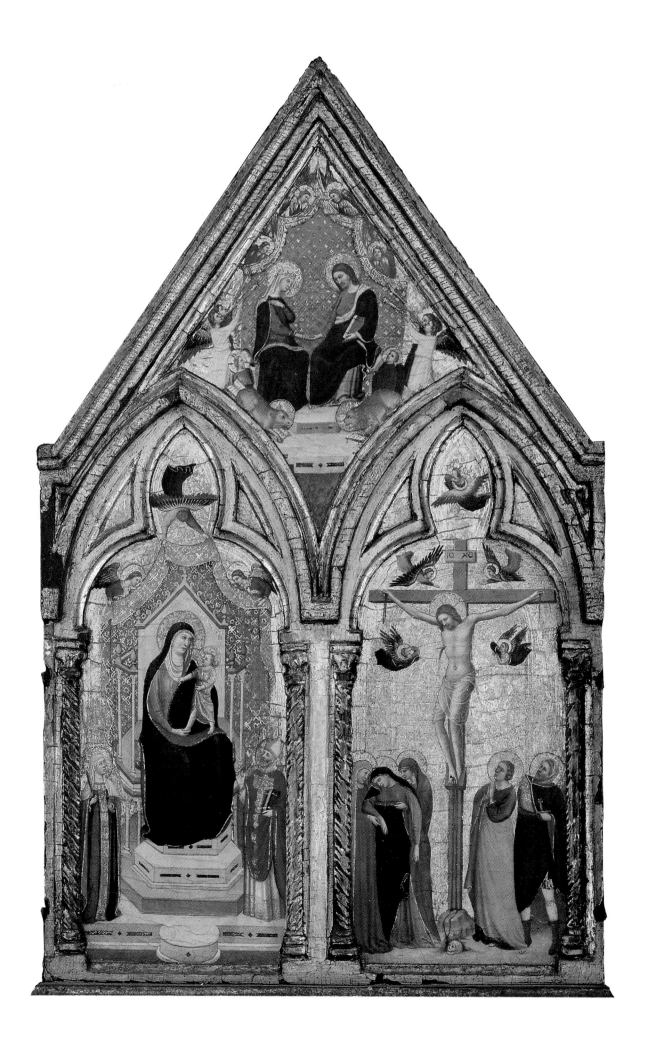

58 (cat. 3)

Christ on the cross. At the foot of the cross at the left the Virgin faints in the arms of two holy women. At the right are the mourning Saint John the Evangelist and the Centurion, both looking up and gesturing towards Christ. The borders of the gold grounds in both scenes are decorated with an engraved foliate pattern within bands of cross-hatching. The upper third of the panel, comprising the recessed area beneath the gable and above the arcade, is filled with a scene of Christ and the Virgin enthroned, clasping hands. Four seraphim hold up a fringed cloth of honor behind them; four angels, two at either side of the throne, blow trumpets; and symbols of the four Evangelists kneel on the dais in the foreground.

Surface damage to the arched surrounds of the two lower scenes and the presence of (original) hinges on the outer edges of the panel indicate that it was originally intended to function as the center of a portable triptych. When the now-missing wings were closed they would have folded over the two lower scenes and fit within the gilt moldings of the ogival arcade, leaving the scene of Christ and the Virgin in the tympanum exposed. Though far from common, such an arrangement is not unprecedented in the early trecento (see for example 45.880, below). Virtually unique, however, is the division of the covered surface into two distinct picture fields with independent framing arches, so that when open the tabernacle would have displayed four scenes side-by-side, in addition to the tympanum scene above.

Equally unusual is the iconography of the tympanum scene, which follows compositionally the traditional scene of the Coronation of the Virgin. In this instance, the Virgin is already crowned: Christ clasps her right hand in his, and in his left hand holds a book. The gesture was explained by Meiss (1951, p. 109) as a *dextrarum junctio,* "an action that commonly symbolizes marriage." Though the concept of the Virgin as the Bride of Christ, and thus symbolic of the Church, was common in the late Middle Ages, no earlier representations of Christ and the Virgin in *dextrarum junctio* are known.

Since it was first published by Tatlock in 1930, the Boston panel has been associated with most of the leading personalities in Florentine painting of the early trecento. Tancred Borenius (cited in Tatlock, 1930) and Richard Offner (1931, 1960) placed it in the circle of the Saint Cecilia Master. Lionello Venturi (1933) attributed it to Pacino di Bonaguida while Meiss (1951) described it as executed under the influence of Jacopo del Casentino.

Everett Fahy (1978) recorded a tentative attribution by Miklos Boskovits to the Master of the Saint George Codex in his earliest career, an attribution rejected by John Howett (oral communication, 1979), who instead proposed associating it with the Master of the Dominican Effigies. A convincing attribution to the so-called Maestro Daddesco was finally advanced by Boskovits in 1984.[1]

Though a complete corpus of works has not yet been agreed upon for the Maestro Daddesco, nor are the chronological limits of his activity a matter of consensus, there is no doubt that some at least of the illuminations grouped together under this name, particularly those decorating an antiphonary (Cor. B) in the Museo della Collegiata at Montevarchi and a gradual (Cor. 41) in the Biblioteca Laurenziana in Florence, were painted by the artist responsible for the Boston panel. In addition to their correspondence of color scheme and of spatial and narrative sense, they share close morphological similarities with the figures in the Boston panel, closer than exist between the Boston panel and any works by the various artists to whom it had formerly been attributed. Compositionally as well the Boston panel may be said to betray the hand of a miniaturist. The manner in which the irregular shapes of the picture fields are exploited for their full decorative and spatial potential, as in the case of the ingeniously foreshortened angels deployed in filling the cusps of the arches in the two lower scenes, or the carefully delineated lozenge of figures surrounding Christ and the Virgin in the gable, corresponds to the mise-en-page of the Maestro Daddesco in his historiated initials.

Alessandro Guidotti (1979, pp. 419-441) has established a convincing case for dating the Laurenziana manuscript (Cor. 41) by the Maestro Daddesco to the 1340s, and such a date, if not closer to or after 1350, seems appropriate for the Boston panel as well. A dating to the 1320s proposed by Boskovits (1984) is precocious, as is Bellosi's (1992) characterization of it as "un opera. . . quasi proto Giottesca," making no allowance for echoes of the late work of Bernardo Daddi and of the Master of San Martino alla Palma in the figure style; for the complex structure and sophisticated carpentry of the framing elements, which is unlikely to predate 1340 at the earliest and indeed looks forward to practices more common in the second half of the century; and for the spatial projection of the painted architecture. Details such as the circular extension to the marble pavement beneath the dais of the Virgin's throne in the lower left scene appear commonly in paintings of the late trecento but are virtually unknown in the first half of the century.

1. A proposal by Bellosi (1992, p. 24-30) to reattribute several key works by the Maestro Daddesco, including all the panel paintings assigned to him by Boskovits (1984), to other artists is in the main unconvincing. In particular, his attribution of the Boston panel to the Biadaiolo Illuminator is unacceptable. A comparison to the anconetta in the Robert Lehman Collection at the Metropolitan Museum of Art, New York (1975.1.99), a certain work by the Biadaiolo Illuminator, reveals the essential incompatibility of the two paintings.

Jacopo del Casentino

4

Saint Lucy

Tempera on panel
Overall: 91.6 x 35.5 (36¹⁄₁₆ x 14)
Picture surface: 87.6 x 33 (34½ x 13)

Gift of the Massachusetts Historical Society.
10.37

Provenance: John Low and Darius Chase,
Boston, until 1845; Massachusetts Histori-
ety, until 1910

Literature: Berenson, 1963, p. 101; Fredericksen
and Zeri, 1972, pp. 218, 563; Boskovits, 1984, pp.
58, 60, 315, pl. cxli.

Condition: The wood panel support, which is 3.0
cm thick, does not appear to have been thinned
down. There is a 33–cm long vertical split begin-
ning in the top left corner extending to the left of
the saint's head. With the exception of losses
along the split, and a 3-cm wide loss just left of
the saint's right elbow and a plug left of her right
shoulder, both caused by nail heads, the gilt
background and its punch tooling are in good
condition. The painted draperies are modern
(eighteenth-century?) and it is now impossible to
determine the state of any older paint layers that
may be preserved underneath. In the flesh tones
the original paint layer is somewhat more visible
beneath transparent layers of overpaint, and
though abraded are still fully legible. The black
lines in the halo and the brazier are modern
additions. The varnish layer is slightly discolored
and uneven.

THE FULL-LENGTH female saint clad in a
red cloak over a blue dress faces three-
quarters to the right. She holds a mar-
tyr's palm in her right hand and a flam-
ing brazier in her left. Based on these
attributes she has since her acquisition by
the Museum of Fine Arts been identified

PROBABLY trained in his native region of
the Casentino near Arezzo, Jacopo del
Casentino is first mentioned in Florence
in 1339, as a founding member of the
Compagnia di San Luca. He may have
been active as many as two or three
decades before this, though his earliest
extant dated painting is of 1333 (Florence,
Uffizi). In 1347, Jacopo del Casentino was
commissioned to paint the chapel of
Saint Martin in Sta. Maria Novella
(destroyed), and he was still active in
1349, when he is registered a second time
among the members of the Compagnia
di San Luca. According to Vasari, whose
information cannot be confirmed, he
died an octagenarian in 1358. The numer-
ous paintings plausibly attributed to
Jacopo del Casentino, a highly prolific if
slightly provincial artist, and his shop
evince little measurable internal develop-
ment or stylistic evolution, except that
some, putative later works, show the
marked influence of Bernardo Daddi
(q.v.) while others, putative early works,
can more meaningfully be linked to the
example of a painter of an older genera-
tion, the Saint Cecilia Master.

as Saint Lucy. There is no indication,
however, that the palm branch is not an
addition of the eighteenth-century (?)
restoration that reduced the panel to its
present state, and the original form of
the brazier, as indicated by faint incised
lines on the gold ground, more nearly
resembles an apothecary or unguent jar.
It is possible that the figure was original-
ly intended to represent Saint Mary
Magdalene.

The attribution of this panel to the
circle of Jacopo del Casentino was made
in the first instance by Angelica Rudens-
tine in 1963 (manuscript opinion in Muse-
um files) and was confirmed by Richard
Offner (letter dated 26 November 1963, in
Museum files), who identified three pan-
els in the collection of Dott. Vittorio
Frascione, Florence, representing the
Madonna and Child enthroned, Saint
John the Baptist, and Saint Catherine of
Alexandria as fragments of the same
altarpiece (Offner, 3, vii, p. 140, pl. XLVIII).
Its publication by Berenson (1963) as
Jacopo del Casentino was apparently for-
tuitous, since the panel he was referring
to, called "Saint Lucy with a Donor," is
that now on loan to the Instituut voor
Kunstgeschiedenis in Groningen (Rijks
Dienst inv. no. NK 1423), as indicated by
the mistaken annotation on its photo-
graph at the Villa I Tatti. Fredericksen
and Zeri (1972, p. 218) referred to it only
as anonymous Florentine, fourteenth
century.

Offner's association of the present
panel with those in the Frascione collec-
tion, which he labeled "Following of
Jacopo del Casentino," was based on
their correspondence in size and in the

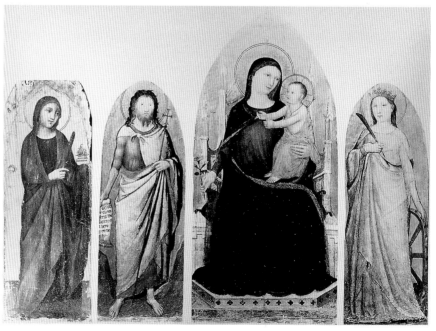

Fig. 1. Reconstruction of Altarpiece (Boskovits, 1984)
by Jacopo del Casentino

patterns of their halo and border decorations. His reconstruction was published for the first time by Boskovits (1984; fig. 1), who concluded that the panels were autograph works by Jacopo del Casentino from the last decade of his career, about 1340. Boskovits's estimation of the variable quality of Jacopo's oeuvre, much of which seems to have been produced for provincial patrons, and of its stylistic development over the artist's career seems on the whole to be accurate, and there is little to add to his evaluation of the Boston panel.

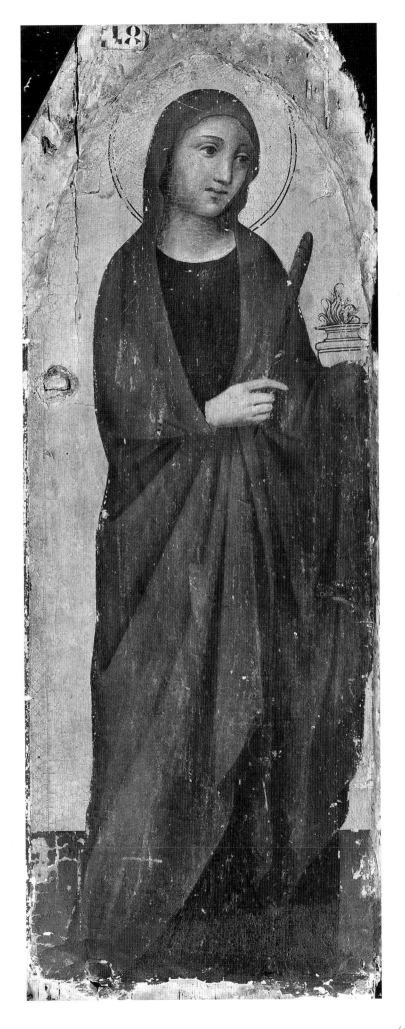

Niccolò di Tommaso

5

The Virgin and Child; Charity of Saint Nicholas; Crucifixion; Christ and the Samarian Woman

Tempera on panel
Overall: 100.7 x 69.7 (39⅝ x 27⅜)
Picture surface: Virgin and Child 78 x 52.5
(30¾ x 20⅝), predella
11.5 x 44.1 (4½ x 17⅜)

Gift of Dr. Eliot Hubbard. 37.409

Provenance: Cernuschi collection (sale, Galerie Georges Petit, Paris, 25-26 May 1900, lot 16); Galerie Durand-Ruel; Dr. Eliot Hubbard, 1901-1937

Literature: Offner, 1956, p. 190; Berenson, 1963, p. 161; Fredericksen and Zeri, 1972, pp. 150, 564; Maginnis 1981, suppplement, iv, p. 88.

Condition: The panel, which is 2.2 cm thick and has been neither thinned nor cradled, is in excellent condition except for a 25-cm long vertical crack starting above the predella and running up through the Virgin's right leg. The tabernacle frame is in part original but has been partially recomposed. The impost blocks, the sprial colonettes, the top center crocket and the bottom molding of the frame beneath the predella are modern additions. The remaining crockets are apparently original but have been regessoed and regilt. The row of free-standing cusps which lines the arch may be original, but if so has been regessoed and regilt. The original gilded surfaces and elaborate punchwork are slightly worn but otherwise well preserved. The paint surface is generally abraded, especially in the predella, and the Virgin's mantle has been heavily repainted. Both the retouching and uneven varnish layer are discolored.

A FAIRLY PROLIFIC master active in Florence in the third quarter of the fourteenth century, Niccolò di Tommaso registered in the Arte dei Medici e Speziali sometime after 1346. He may have trained in Orcagna's studio or more likely with Orcagna's brother Nardo di Cione, with whom he remained in close artistic association and whose testament he witnessed in 1365. A triptych in the Museo Nazionale di San Martino (Naples) bears Niccolò di Tommaso's signature and the date 1371. The following year he was paid for a fresco cycle in the convent of the Tau in Pistoia. Niccolò di Tommaso is last recorded on the Florentine tax registers of 1376. The reconstruction of his artistic personality on the basis of the signed Naples triptych and the Tau frescoes is in the first instance due to Richard Offner (1925, 1956), with significant additions to his oeuvre proposed by Boskovits (1975, pp. 202-203 n. 108).

THE VIRGIN is seated on an orange and gilt cushion before a gold ground inscribed with a pattern of radiating lines. She wears an ermine-lined blue cape over a rust-colored dress embroidered with gold sunbursts and ChiRho monograms. Her hair is bound in a loose gauze veil and her halo is inscribed: AVE GRATIA PL[ENA] DO. . . . She wears a gold band on the ring finger of her left hand, and two gold bands on the ring finger of her right hand, which is resting on a red book in her lap. The Christ Child, wrapped in a yellow cloth with blue shadows and embroidered with gold flowers, is seated in the crook of his mother's left arm. He raises his right hand in benediction and holds a finch captive in his left.

In the center of the predella Christ on the cross is mourned by the Virgin and Saint John seated on the ground. At the left is the scene of Saint Nicholas's charity: the saint, in a red cloak and bishop's mitre, drops a bag of gold through a window into a room in which three girls, in yellow, red, and green, are seated along-side their father, dressed in blue, who is unable to pay their dowries. Two of the maidens hold purses of gold in their laps, gifts from Saint Nicholas. At the right of the predella, Christ greets the Samarian woman at the well, while two disciples look on around the brow of a hill.

This tabernacle appeared, already reconstructed in its present form, at the Cernuschi sale as "School of Giotto." It entered the collection of the Museum of Fine Arts in 1937 as "Florentine School," and was first identified as a typical work by Niccolò di Tommaso by Hans Swarzenski (orally, 1953) and Richard Offner (1956). This attribution has not subsequently been questioned, although it is omitted from a list of the artist's works accepted by Miklos Boskovits (1975, p. 202). From his context, however, it is clear that Boskovits accepts Offner's attributions with only minor, specific exceptions, and the omission of the Boston tabernacle can only be considered an oversight. There is in fact no reason to reject the attribution, as the picture is entirely consistent in style with every other known work by the artist.

Though it is presumed that Niccolò's career covered at least three decades, it has not been possible to arrive at a satisfactory chronology for the development of his style, which seems to have been more than usually static. The present picture owes its composition, a curious cross between the Madonna of Humility and the Madonna in Glory, to the example of a small triptych in the Accademia, Florence, attributed to the Master of the Infancy of Christ (Marcucci, 1965, no. 63), an artist plausibly identified by Boskovits (1975, p. 323) with the early career of Jacopo di Cione. The Accademia triptych has been dated ca. 1355-60, a convincing terminus post quem for the Boston tabernacle.

Although mutilated, the form of the Boston tabernacle does not suggest that it was ever completed by shutters. The scenes of the predella need not have referred to images of saints now lost; a similar panel in the Accademia (Marcucci, no. 52) bears a predella with the martyrdoms of Saints Catherine and Agatha, but images of Saints Peter and Paul flank the Madonna in the main panel.

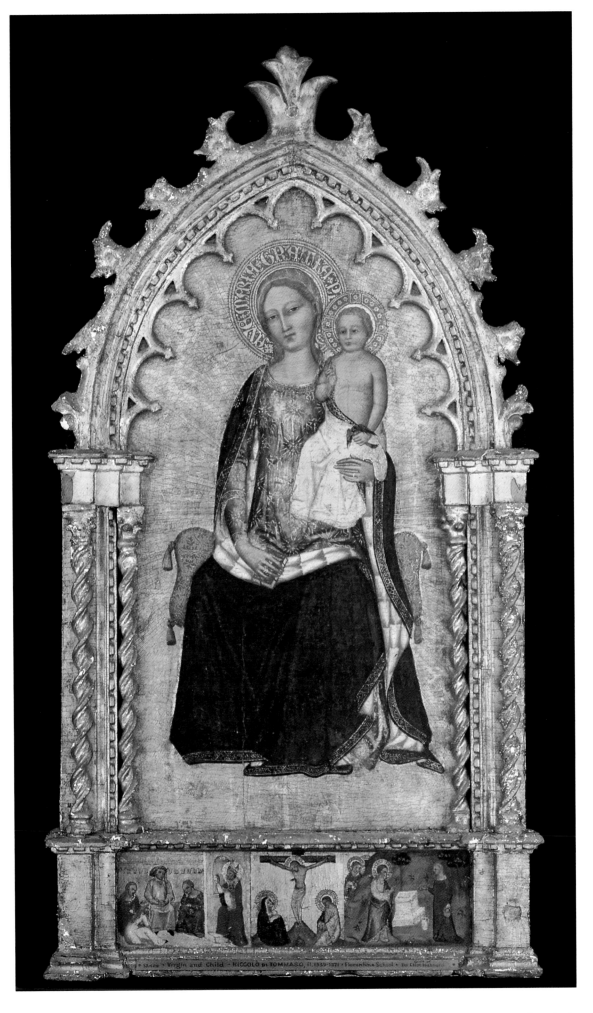

Antonio Veneziano

called Antonio di Francesco

FEW FACTS are known concerning the life of Antonio Veneziano, though Vasari dedicated a chapter to him in the *Vite* and his artistic personality has been clearly outlined following Richard Offner's initial studies of his work (1920, 1923, 1927). He is first mentioned in documents of 1369 and 1370, when he is recorded at work alongside Andrea Vanni (q.v.) in the Cathedral in Siena, and it was as Antonio da Siena that he matriculated, in 1374, in the Arte dei Medici e Speziali in Florence. Though this is the only notice of him in Florence, his painting style is firmly Florentine in origin, derived in large part from the example of Taddeo Gaddi and various Orcagnesque masters, and his sphere of influence was predominantly Florentine: he was reputedly the master of Gherardo Starnina (q.v.). From 1384 to 1386, Antonio Veneziano is recorded in Pisa working on the frescoes of San Ranieri in the Camposanto. No subsequent notices of his activity or of his death have been preserved. Boskovits (1975) advanced the not unreasonable hypothesis that he ended his career in Spain.

6

Madonna and Child with a Donor

Tempera on panel
56 x 37.4 (22 x 14¾)

Gift of Mrs. C. B. Raymond. 84.293

Provenance: Unknown; Mrs. C. B. Raymond, before 1884

Literature: Sirén, 1912, p. 12; Offner, 1920, pp. 98-103; idem, 1923, pp. 216-228; van Marle, vol. 2, 1924, pp. 449-452; Offner, 1927, pp. 67-81; Salmi, 1928-29, pp. 433, 438, 443; Venturi, 1933, pl. 59; Valentiner, 1933, no. 9; Antal, 1948, pp. 146, 205; Galetti and Camesasca, 1950, p. 132; Berenson, 1963, p. 16; Wagstaff, 1965, p. 16; Steinweg, 1965, p. 6; Keith, 1966, p. 7; Fredericksen and Zeri, 1972, pp. 11, 563; Fremantle, 1975, p. 236; Boskovits, 1975, pp. 153, 280-281; Cole, 1977, p. 47, pl. 98; Czarnecki, 1978; Tartuferi, 1987, pp. 32-35.

Condition: The panel, which has been cut to the edges of the picture surface on all sides, is 2.5 cm thick and is coated on the back with gesso. A partial split in the panel does not come through to the front. The picture surface is lightly abraded, especially along the edges of the unusually broad craquelure. The gold ground is moderately abraded with the pastiglia arch frame worn down to the gesso layer. The gold trim on the clothing of the Madonna and Child is well preserved with only minor abrasions.

THE VIRGIN is shown half-length wearing an orange robe with gilt collar and cuffs, a transparent veil over her head, and a blue cloak edged in gold with a dark green lining. She wears a gold earring in her right ear. She supports the Christ Child in her right hand and offers him her breast. The Child wears a yellow tunic, its shadows painted in red, with gold trim and a gilt floral pattern, and his legs are wrapped in a purple cloth edged in gold. He holds a finch in his left hand, which pecks at his thumb, while he gestures in benediction with his right hand towards the diminutive figure of a Dominican (?) nun kneeling in the lower left corner of the panel.

Formerly catalogued at the Museum of Fine Arts, on the suggestion of Osvald Sirén (1916), as by Spinello Aretino, this exceptionally refined image was first recognized as a rare work by Antonio Veneziano by Richard Offner (1920, 1923, 1927), whose attribution has never since been questioned. Offner said of the painting, "There are not many devotional pictures of the latter half of the fourteenth century at once so fresh, so temperate, so blissful, as the Virgin and Child at the Boston Museum of Fine Arts" (1927, p. 70), an opinion echoed in much of the subsequent literature on the period in which the painting has come to assume the status of a seminal object.

The Boston Madonna was clearly once the center panel of a small altar-

Fig. 2. Antonio Veneziano, *Saint Peter*. Formerly Loeser Collection, Florence

Fig. 3. Antonio Veneziano, *Saint Paul*. Formerly Loeser Collection, Florence

piece, and the diminutive figure of the Dominican (?) nun kneeling in the lower left corner must be understood as a "portrait" of the donor or patron of the chapel in which it once stood. Two lateral panels from the same altarpiece, representing Saints Peter and Paul (figs. 2-3), were recognized in 1923 by Richard Offner, when they entered the Charles Loeser collection in Florence, supposedly bought by Loeser from an English dealer. Two other lateral panels were also discovered outside Italy at an early date. One, representing Saint Andrew (some-

Fig. 4. Antonio Veneziano, *Saint Andrew*. Private Collection, Milan

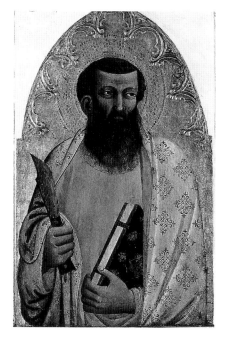

Fig. 5. Antonio Veneziano, *Saint Bartholomew*. Auckland City Art Gallery, New Zealand

times cited as Saint Philip), came from the collection of Ludwig van Burkel in Munich, and was first identified by Valentiner (1933). This panel (fig. 4) later passed through Drey in Munich to the Lanz collection in Amsterdam, and is now in a private collection in Milan (Tartuferi, 1987). The other (fig. 5), representing Saint Bartholomew and now in the Auckland City Art Gallery, New Zealand (Keith, 1966), was discovered by Hans Gronau in 1950 in the Eisler collection at Vienna (letter in Museum files), although it was first published by Berenson only in 1963. All five panels employ identical pastiglia decoration in the cusping of their arches and are closely related in size and style.

While there is no disagreement over the attribution of these panels or over the reconstruction of the altarpiece of which they formed part, there is a variety of opinion concerning their dating. Antonio Veneziano's documentable career is short and his dated works are few and largely concentrated in the middle or late 1380s. Offner, recognizing the affinities of the Boston Madonna with Antonio's frescoes in the Camposanto at Pisa (1384-86), nonetheless considered it unequivocally Florentine and therefore probably of the late 1370s. Steinweg (1965), Boskovits (1975), and Tartuferi (1987) preferred a date early in Antonio Veneziano's Pisan period, shortly before 1385, while Czarnecki (1978), emphasizing the Sienese characteristics of the composition and decoration of the Boston panel, dated it ca. 1370, placing it in relation to Antonio's documented presence alongside Andrea Vanni in the Cathedral in Siena.

Sienese characteristics, notable in the Lorenzettian composition and the heptalobate arch, are indeed apparent in the present panel, but are no less characteristic of all of Antonio Veneziano's work and must be considered intrinsic to his style. The decorative pattern of leaves and roses used in punching the gold of the Virgin's halo is derived from the example of Bernardo Daddi and the Cionesque painters in Florence, and might indicate a date in the middle or late 1370s, as Offner suggested. In addition, the Boston Madonna and the associated lateral saints are markedly attenuated – more Giottesque – than the figures in panels by Antonio that can more confidently be situated in his Pisan period, such as the Hannover Madonna and Child, the Berlin Annunciation, or the Göttingen Saint James. It is possible therefore, that the altarpiece was painted in Florence, where Antonio is documented only in 1374 but where he must have been active for some time afterwards, or

shortly after his arrival in Pisa, where he is first documented in 1384. A date around 1380 is not unreasonable.

The exceptionally intimate scale of this altarpiece and the somewhat unusual combination of saints in its lateral panels does not suggest an obvious source for its commission. The donor's habit appears to be Dominican, but it is not sufficiently detailed in rendering to distinguish it from the habits of Camaldolese, Carthusian, or Carmelite nuns (see F. Bonanni, S.J., *Catalogo degli Ordini Religiosi della Chiesa Militante*, 3 ed., vol. 2, 1723, passim). The absence of a Dominican or Benedictine saint in the lateral panels might suggest the probability of a Carthusian or Carmelite provenance – these orders were less obsessed with images of their own saints and blesseds in altarpieces – but equally it may not be coincidence that the convent of San Domenico in Pisa was founded on 29 August 1382 by Suor Chiara Gambacorta (cf. B. Giordano, O.P., *Oasi Domenicane*, 1987, pp. 30-32). Such a date is not incompatible with the possible date of Antonio Veneziano's arrival in Pisa.

Giuliano di Simone

7

Annunciation; Crucifixion

Tempera on panel
Overall: 82.2 x 47.5 (32⅜ x 18¹¹⁄₁₆)
Picture surface:
Annunciation: 25.4 x 31.1 (10⅟₁₆ x 12¼)
Crucifixion: 36.4 x 31.1 (14⁵⁄₁₆ x 12¼)

Seth K. Sweetser Fund. 22.403

Provenance: George Baillie-Hamilton, Earl of Tyninghame, Scotland, to 1912; Durlacher Bros., New York, 1912-22

Literature: Edgell, 1932, pp. 182-183, fig. 244; Berenson, 1932, p. 551; idem, 1936, p. 473; Edgell, 1944, pp. 53-56; Berenson, vol. 1, 1968, p. 201; van Os, 1969a, p. 51 fn. 49; Fredericksen and Zeri, 1972, pp. 29, 564; Boskovits, 1975, p. 247; idem, 1980, p. 20 fn. 36.

Condition: The panel support, which is 2.6 cm thick and has been neither thinned nor cradled, is in good condition, exhibiting only a slight convex warp. The original engaged inner and outer frames are less well preserved with extensive losses and worm damge along the sight and back edges, especially at the bottom. The gold ground is quite well preserved with only minor abrasions. The paint layers are more abraded and worn with tiny losses overall. Metal leaf, possibly silver, decorating the vase in the foreground of the Annunciation scene is completely lost, leaving only exposed bole and gesso.

A FOLLOWER of Spinello Aretino active exclusively in the region of Pisa and his native Lucca, Giuliano di Simone is known today on the basis of one signed and dated painting, a Virgin and Child Enthroned of 1389 (Castiglione di Garfagnana, S. Michele). As reconstructed by Meloni Trkulja (1971) and Gonzalez-Palacios (1971), the artist's activity would have begun in the years following Spinello's arrival in Lucca in the early 1380s, and extended possibly into the first or second decade of the fifteenth century. Boskovits (1975, p. 247 fn. 236) added several works to the artist's oeuvre, some of which he assumed were painted as early as the 1370s, indicating that Giuliano di Simone was an independent master before the arrival of Spinello, whose influence he absorbed alongside those of other local and Florentine artistic traditions.

WITHIN the ogival arch of an engaged Cassetta-style frame are two painted scenes, the Annunciation (below) and the Crucifixion (above), separated from each other by a raised, flat molding. The Annunciation takes place within a paneled room in which the Virgin is seated on a cloth-draped bench at the right. An open book rests on her lap and her hands are crossed in front of her chest. The Archangel Gabriel enters through an arched doorway at the left and kneels on the marble (?) pavement before the Virgin. He holds a lily stalk in his left hand and raises his right in a gesture of salutation. A gilt vase of roses and lilies rests on the pavement in the center of the room, separating the two figures. The dove of the Holy Spirit descends toward the Virgin along a burst of gilt rays emanating from a circular opening in the ceiling through which are visible three stars in a blue sky.

In the upper compartment is portrayed Christ on the cross with the mourning Virgin and Saint John the Evangelist at the left and right. Saint Mary Magdalene kneels and embraces the foot of the cross at the left, and behind her is a portrait of the donor of the tabernacle, kneeling, his hands clasped in prayer. The donor's wife (?) kneels in profile at the right. The cross is surmounted by a diminutive tree with a pelican feeding her young, a symbol of Christ's sacrifice. Two mourning angels fly beneath the arms of the cross, weeping over the body of Christ.

This panel was long thought, on the basis of the inscription "Taddeo Bartoli"painted at the lower left of the scene of the Annunciation, to be a work of the Sienese school of the early fifteenth century. An attribution to the workshop of Taddeo di Bartolo, specifically to his adopted son and heir, Gregorio di Cecco, persisted even after the inscription was found to be a later addition to the paint surface (Edgell, 1944). Angelica Rudenstine and Federico Zeri (correspondence in Museum files, 1963) were the first to associate the Boston tabernacle with late fourteenth-century Florentine, not Sienese, painting, grouping it with a small number of works close to the style of Spinello Aretino and Bicci di Lorenzo. The pictures in this group identified by Zeri – including Crucifixions in the Worcester Art Museum (1920.1; Davies, 1974, pp. 463-465), Yale University Art Gallery (Seymour, 1970, no. 8), and Musée Ingres at Montauban (no. 117) – are not strictly homogeneous, but they all share a close dependence on the compositional formulae of Spinello Aretino. The Boston tabernacle was correctly attributed to the Lucchese follower of Spinello, Giuliano di Simone, by Miklos Boskovits (1975, 1980), an attribution subsequently confirmed orally by S. Schaeffer (1982) and M. Frinta (1990).

Two works by Giuliano di Simone – in the Louvre and the Pinacoteca Nazionale, Parma – are particularly close in handling to the Boston tabernacle. These two pictures are nearly identical to each other in subject, with the Madonna and Child enthroned above a recumbent figure of Eve and the Serpent, four saints, and four angels. The Parma panel is complete with a small tympanum scene of Christ on the cross; a similar tympanum excised from the Louvre panel has been identified in a Crucifixion formerly in the Leegenhock collection (sold Christie's, London, 10 July 1987, lot 97; Gonzalez-Palacios, 1971, pp. 49-51). The Boston tabernacle differs from these only in the subject of its lower painted field and in the relatively dominant size and greater complexity of its tympanum scene, which fills well over half the overall picture surface. Such an arrangement is highly unusual among panel paintings of the period. The Boston tabernacle is also unusual in that it appears to have once been completed with folding shutters hinged to the sight edge, not the back edge of its frame.

Though a relative chronology for Giuliano di Simone's career has not yet

68 (cat. 7)

been established, it is possible to assert that the Boston tabernacle is likely to be nearly contemporary to the Louvre Madonna, with which it corresponds in every detail of figure style and compositional structure. Both works were probably executed within the last two decades of the fourteenth century, close in date to Giuliano's signed altarpiece of 1389 in Castiglione Garfagnana (Meloni Trkulja, 1971, pp. 61-64) shortly after the arrival of Spinello Aretino in Lucca in the 1380s. The Parma tabernacle, which is much more sophisticated in its spatial effects and accomplished in its figural modeling, is likely to be a work of the first decades of the fifteenth century.

Agnolo di Taddeo Gaddi

SON AND PROBABLY A PUPIL of the Giottesque master Taddeo Gaddi (d. 1366), Agnolo Gaddi is first recorded at work in the Vatican, probably as an assistant to his brother Giovanni, in 1369. He is documented in Florence from 1370 on, though he also worked at intervals in Prato, where he painted a series of frescoes in company with Tommaso del Mazza (formerly known as the Master of Santa Verdiana) for Marco Datini in 1385 and a fresco cycle in Prato Cathedral in 1392-95. Among Gaddi's most important Florentine commissions are the frescoes of the True Cross in the choir of Santa Croce, the high altarpiece of San Miniato al Monte (1393-96), and the designs for the sculptural decoration on the facade of the Loggia dei Lanzi. Besides his occasional association with independent masters such as his brother Giovanni Gaddi, Tommaso del Mazza, or Niccolò di Pietro Gerini (q.v.), Agnolo Gaddi operated a highly productive workshop which collaborated on nearly all his major commissions and which was responsible for a large number of modest, formulaic devotional panels painted loosely in his style. The decorative facility and narrative simplicity of Gaddi's paintings exerted a greater and more widespread influence than that of any of his contemporaries in Tuscany in the last years of the fourteenth century, strongly affecting even such painters as Lorenzo Monaco, who may have been employed briefly in his studio. Agnolo Gaddi died in 1396.

8

Christ on the Cross with the Virgin and Saint John

Tempera on panel
61.5 x 36.8 (24¼ x 14½)

Gift of Mr. and Mrs. J. Templeman Coolidge. 45.515

Provenance: Unknown; Mr. and Mrs. J. Templeman Coolidge, by 1945

Literature: Fredericksen and Zeri, 1972, pp. 76, 565; Boskovits, 1975, p. 296.

Condition: The panel, of a vertical wood grain and approximately 2.9 cm thick, has been neither thinned nor cradled. It has been cut along all four sides, with more of the picture field cropped along the top and right edges than along the left and bottom edges. The gold ground is well preserved, except for abrasion losses along the unusually broad craquelure at either side of the shaft of the cross, along a split at the top left corner of the panel, and through Christ's halo. The paint surface is lightly abraded throughout, more heavily on the body of Christ, with pinpoint flaking losses along the cusps of the craquelure. Larger retouched losses are visible in Christ's feet, the Virgin's mantle, and Saint John's pink robe, and losses from nail heads have been filled in Christ's chest and in the rocky mound beneath the Cross. The angels' bowls have been reinforced.

THE BODY OF CHRIST, wrapped in a transparent cloth around the waist, hangs on a heavy wooden cross which reaches the full height of the panel above a rocky mound at the bottom. At the foot of the mound lies a skull and a jawbone, and Christ's blood pours from his feet onto the rock. Two angels hover at Christ's sides, collecting the blood from the wounds in his hands in bowls, the angel at the left wearing a blue robe over a red tunic, that on the right a green robe over a blue tunic. At the foot of the Cross at the left stands the Virgin in profile, looking up at her son and wringing her hands in grief. At the right stands Saint John the Evangelist, looking back and up at Christ, wearing a pink mantle lined with green over a blue robe.

Known until 1952 only as "school of Giotto," this panel was at first assigned by Constable to the Bolognese school of the fourteenth century. Suida (note in Museum files, 1958) corrected this generic description to Florentine, early fifteenth century, noting resemblances to the early works of Lorenzo Monaco. An attribution to the school of Agnolo Gaddi was proposed by Zeri (notes in Museum files, 1963; 1972) and accepted initially by Fahy (note in Museum files, 1967), who remarked the painting's proximity to the style of Giovanni del Biondo.

70 (cat. 8)

Boskovits (1975) attributed the panel directly to Agnolo Gaddi, dating it ca. 1375-80, and latterly Fahy (letter in Museum files, 1988) described it as "a characteristic work by Agnolo Gaddi." The painting is not mentioned in the latest monograph on the artist (Cole, 1977).

The figure types employed in this panel are indeed typical of Agnolo Gaddi, but they are more finely rendered than is usual with that artist, while the ambitious foreshortening of Saint John the Evangelist in three-quarter lost profile and the strong plasticity of the draperies of all three principal figures, though slightly blunted by abrasion of the paint surface, are only rarely encountered even in Gaddi's best works. In these respects, the Boston Christ on the Cross more closely resembles a problematic series of panels from the workshop of Agnolo Gaddi (Paris, Musée du Louvre), convincingly identified as the predella to the Nobili altarpiece from Santa Maria degli Angeli, painted in 1387/88 and plausibly attributed to the young Lorenzo Monaco (cf. Gronau, 1950, p. 218, and Zeri, 1964, pp. 554-558, as Lorenzo Monaco; Cole, 1977, pp. 84-87, as Agnolo Gaddi). Though the Boston panel does not exhibit the precisely controlled draughtsmanship typical of other early works by Lorenzo Monaco, it must have been produced in Gaddi's shop at approximately the same moment as the Nobili altarpiece, in the late 1380s.

By its subject and shape, the Boston Christ on the Cross must be presumed to have been painted as the central pinnacle in a multi-tiered polyptych. This presumption is borne out by the pattern of worm damage visible on the back of the panel, and by the vertical alignment of two nail heads in the mound at the foot of the cross and in Christ's chest, indicating that it was originally secured to another panel beneath it by a vertical batten. That the polyptych of which it formed part could have been the Nobili altarpiece itself, the main panels of which, in Berlin, were painted by Agnolo Gaddi (Cole, 1977, p. 75) and which seems to be missing a pinnacle above the central Madonna, is ruled out by the presence of the Crucifixion among the panels of its putative predella. The central pinnacle, in this case certainly a Crucifixion, is also missing from another altarpiece by Agnolo Gaddi, now in the Museo della Collegiata at Empoli (inv. 19), the center panel of which, however, may be too small to have accommodated a pinnacle the size and shape of the Boston panel. Closely related in handling to the Boston panel is Agnolo Gaddi's Coronation of the Virgin in the National Gallery, London (fig. 6), which is truncated at the top,

Fig. 6. Agnolo Gaddi, *Coronation of the Virgin.* National Gallery, London

perhaps from excision of a pinnacle. While the London Coronation retains no traces of its original format and framing that could provide conclusive physical evidence for associating it with the Boston pinnacle, the two paintings are closely comparable in style and not dissimilar in scale to the proportions usually encountered between the main panel and pinnacle of a Gothic polyptych.

II. SIENA

Duccio di Buoninsegna

Pietro and Ambrogio (q.v.) Lorenzetti. Some of these narrative scenes remained the iconographic models for similar subjects painted in Siena as late as the end of the fifteenth century. The Maestà was removed from the high altar of the Cathedral in 1506, and only from that date on can Duccio no longer be considered an important influence in the history of Sienese art.

DUCCIO DI BUONINSEGNA was in effect the founder of the Sienese school of painting and, with his slightly younger Florentine contemporary Giotto, the first great artist of what is today known as the Italian Renaissance. He is first documented in Siena in 1278, though he may have been active there somewhat before that date. In 1285, he contracted to paint a major altarpiece for the Dominicans at Santa Maria Novella in Florence, the *Rucellai Madonna* (Florence, Uffizi), and it is possible that he was resident in Paris in 1296/97 (Stubblebine, 1979, p. 4), but he is otherwise recorded at fairly regular intervals in his native city. The great, double-sided Maestà for the high altar of Siena Cathedral, Duccio's only other documented painting, was commissioned in or just before 1308 – the contract of that year refers in the past tense to agreements already made, which may be codifications of verbal understandings or reiterations of a preceding contract which no longer survives – and was completed in 1311, when it was carried in triumph from the painter's studio to the Cathedral. Duccio is last mentioned in 1318.

Duccio's influence on his Sienese contemporaries was enormous. His style, derived from the emotional and physical pathos of Giovanni Pisano's sculpture and the narrative and calligraphic intricacies of French Gothic manuscript illumination, essentially defined the norm for Sienese painting during his lifetime, and some of his followers continued to work in a style clearly derived from his for a full generation after his death. The *locus classicus* for study of the dissemination of Duccio's style are the fifty-three surviving narrative scenes painted for the predella, pinnacles, and back of the Maestà, which show among themselves a wide range of quality in execution and which have been the subject of disputed attributions to most of the leading painters of the two generations following Duccio's own in Siena, including the Master of Badia a Isola, the Master of Città di Castello, Segna di Bonaventura, Ugolino di Nerio (q.v.), Simone Martini (q.v.), and

9

*Triptych: the Crucifixion;
the Redeemer with Angels;
Saint Nicholas; Saint Gregory*

Tempera on panel
left
Overall: 45.1 x 19.4 (17¾ x 7⅝)
Picture surface: 41 x 16 (16⅛ x 6¼)
center
Overall: 60 x 39.5 (24 x 15½)
Picture surface: 42 x 34 (16½ x 13⅜)
right
Overall: 45.1 x 20.2 (17¾ x 8¹⁵⁄₁₆)
Picture surface: 41 x 16.2 (16⅛ x 6⅜)

Grant Walker and Charles Potter Kling Funds. 45.880

Provenance: William Young Ottley, London, 1791/9-1836; Warner Ottley, London, 1836-1847; John Warner Ottley; R. Langton Douglas, 1904; J. Pierpont Morgan, Aldenham, Hertfordshire, 1904-1913; J. Pierpont Morgan, Jr., 1913-1944 (sale, Christie's, 31 March 1944, lot 118); Duveen Bros., New York, 1944-45

Literature: Waagen, vol. 1, 1837, p. 395, vol. 2, 1838, p. 123; Cust and Douglas, 1904, p. 350; Crowe and Cavalcaselle, vol. 3, 1908, pp. 19-20; idem, 1909, pp. 16-17; Cust and Douglas, 1911, p. 8; Weigelt, 1911, p. 261; Graves, 1912, p. 281; Breck, 1913 p. 112; van Marle, vol. 2, 1924, p. 9; Toesca, vol. 2, 1927, p. 515; Lehman, 1928, pl. xiv; Grieg, 1944, pp. 133-134; Edgell, 1946, pp. 107-112; idem, 1946a, pp. 34-41; Wolf, 1946, p. 7; Cecchi, 1948, pls. 57-59; Coletti, 1949, pp. 291-292, 308 fn. 4; Garrison, 1949, p. 350; Brandi, 1951, p. 147; Carli, 1952, n.p.; Sandberg-Vavalà, 1953, p. 91 fn. 2; Arb, 1959, pp. 191-198; Davies, 1961, p. 172; Stubblebine, 1964, p. 101; Berenson, 1968, p. 116; Contini, 1970, p. 104; Faison, 1970, pp. 23-24; Cattaneo, 1972, p. 95; Fredericksen and Zeri, 1972, pp. 67, 565; Stubblebine, 1973, p. 192; White, 1973, pp. 92-105; Maginnis, 1977, p. 284; Bronowski, 1978, pl. 28; Stubblebine, 1978, pp. 1-20; idem, 1978a, pp. 388-393; Sutton, 1979, p. 370; idem, 1979a, pp. 247-248 fn. 1; White, 1979, p. 45; Stubblebine, vol. 1, 1979, pp. 11, 12, 64, 68-71, 103, 104, vol. 2, figs. 145-149; Carli, 1981, p. 44; Shearman, 1983, pp. 94-95; Deuchler, 1984, pp. 25, 216; Pope-Hennessy and Kanter, 1987, p. 4; Bomford, 1989, pp. 90-97; Ragionieri, 1989, p. 138; Gardner, 1990, p. 394; Dunkerton et al., 1991, p. 220.

Condition: The center panel is composed of a single plank of wood with a vertical grain, 2.0 cm thick, to which a second piece of wood of the same thickness has been added to form the

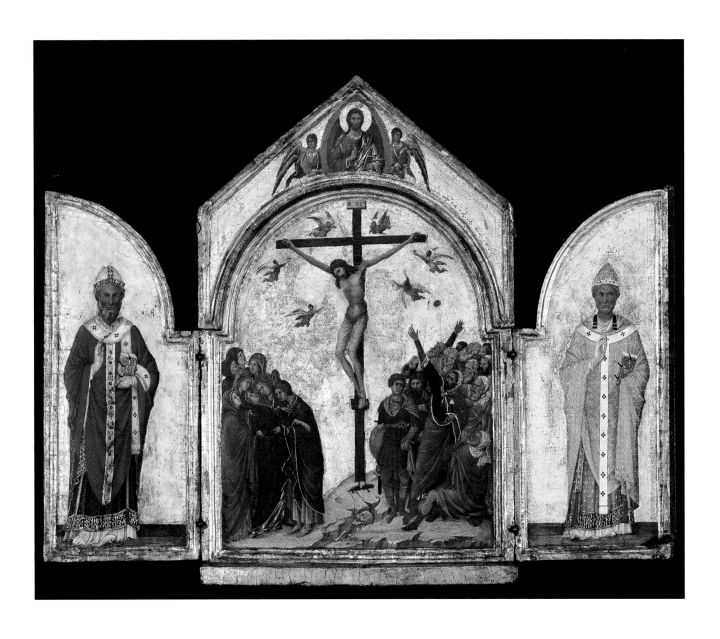

gable.[1] Its engaged moldings are original and extremely well preserved, with only minor wear on the gilding and some local regilding on the outer molding of the tympanum. The wings are 1.0 cm thick and are similarly in excellent condition. The metal hinges connecting the panels appear to be original. The gold ground of the main scene in the center panel has several large areas of abrasion that have been regilt, while the gold grounds in the tympanum and wings show only minor abrasions, notably alongside Saint Gregory's right arm and left shoulder in the right wing. The tooling of the borders along the edges of the gilt surfaces and the mordant gilt decoration of the draperies throughout are in excellent condition. Except for the center of Saint Gregory's pink robe in the right wing, and the angels around the crucified Christ in the main scene, which are slightly worn, the painted surfaces are in excellent condition. Tiny flaking losses have been minimally retouched.

IN THE CENTRAL PANEL beneath an arched frame is portrayed the Crucifixion. The limp body of Christ hangs from a slender wooden cross which extends nearly the full height of the panel against a gold ground. Six angels fly around the arms of the cross in mourning, three collecting the blood which flows from the wounds in Christ's hands and side; the blood from his feet flows down the shaft of the cross onto the hill of Golgotha and the skull and bones of Adam lying in a crevice below. At the left of the cross in the foreground is a group of six holy women, the Virgin, and Saint John the Evangelist. Saint John and three of the women support the Virgin, who faints as she looks sorrowfully up at her son. To the right of the cross is a crowd of fourteen male figures, including soldiers and Pharisees, some gesticulating towards the body of Christ. Behind this crowd rises the lance and the sponge of vinegar with which Christ was tormented.

The projecting tympanum above the Crucifixion scene is filled with the figure of Christ the Savior in a mandorla supported by two angels clad in robes of blue and red. Christ wears a purple tunic and a red cloak shot with gold highlights. He raises his right hand in benediction and holds a book in his left. To either side of the Crucifixion scene, painted on folding wings beneath half-arched frames meant to fit within the arc of the central tympanum when closed, are full-length figures of saints. At the left is Saint Nicholas of Bari, dressed as a bishop in white mitre and red chasuble over a purple dalmatic, with his name (S NICHOLA) inscribed against the gold ground at the level of his shoulders. On the right wing is Saint Gregory in a papal tiara, pink chasuble, and green dalmatic, his name (S GR . . .) partially legible against the gold ground behind him. Both saints are shown standing on a green pavement, their right hands raised in benediction, a

Fig. 7. Duccio di Buoninsegna, *Triptych* (closed). Museum of Fine Arts, Boston

green book clutched in their left hands. The backs of the wings are painted fictive porphyry with a raised surround and geometric Cosmatesque inlays (fig. 7).

Though part of the pioneering collection of Italian primitives formed by William Young Ottley at the end of the eighteenth century and first cited over 150 years ago by Dr. Waagen, this remarkably well-preserved tabernacle was little known to scholars of early Sienese painting until its acquisition by the Museum of Fine Arts in 1945. Prior to that, the few authors who discussed it did so largely on the basis of poor photographic reproductions, and all but Douglas – who, having sold it, knew the painting at first hand but whose unqualifiedly positive opinion may have been self-interested – considered it a work of secondary importance. In 1946, Edgell, then director of the Museum of Fine Arts, published the triptych fully for the first time, correctly noting a discrepancy of handling between the painting of the Crucifixion scene in the main panel and the two saints on the wings, and advancing the provocative theory that the

young Simone Martini may have been responsible for the latter. Edgell's hypothesis was based on a morphological comparison to some of the predella figures in Simone's Pisa polyptych, and on the peculiar woven fabric of Saint Gregory's tiara, which is not common but does reappear elsewhere in Simone's work. Coletti (1949) and Stubblebine (1978, 1979) both accepted and elaborated upon this attribution, which has elicited little positive reaction from other scholars.

Edgell's discussion of the Crucifixion in the center panel was largely based on a comparison of it to the same scene on the back of Duccio's Cathedral Maestà, which it follows closely in composition but simplifies in a number of details, such as the elimination of the two subsidiary crosses, a reduction in the number of angels mourning the crucified Christ and in the size of the crowds of spectators in the foreground, and in the suppression of the Virgin's and Saint John's haloes. For Edgell, who believed implicitly that the Boston tabernacle was painted by Duccio, these simplifications

suggested that it preceded the more fully developed version on the back of the Maestà, and he therefore assigned it a date ca. 1304-07. Most other writers have interpreted these differences either as implying a later date for the Boston tabernacle, after the completion of the Maestà in 1311, or as a disclaimer of Duccio's authorship. Arb (1959), for example, assumed that the Maestà Crucifixion represents the autograph standard of Duccio's work and concluded that the Boston Crucifixion was painted by an inferior workshop assistant. Garrison (1949) and Deuchler (1984) considered the triptych the work of Duccio's school or following, while Cecchi (1948) and Ragionieri (1989) considered it autograph. Stubblebine (1973, 1979) claimed that neither the Boston nor the Maestà Crucifixion was painted by Duccio himself, assigning them both to an artist he christened the Tabernacle 35 Master.

The only other in-depth study of the Boston tabernacle has been that of John White (1973, 1979; followed by Bomford et al., 1989, and Dunkerton et al., 1991), which carefully investigated the structure of the triptych in comparison to a closely similar example also attributed to Duccio in the National Gallery, London (fig. 8), representing in the center panel the Virgin and Child and in the wings standing figures of Saints Aurea and Dominic. White demonstrated that the carpentry of the two structures is identical, to within a few millimeters in all specifications (the London tabernacle is missing its original base and hinges and its frame moldings have been regilt, but none of these alterations vitiates White's findings), and concluded that as the backs of both triptychs are painted with identical porphyry and inlay patterns and both are decorated with similar engraved patterns on the margins of their gold grounds, both must not only have been made by the same carpenter but also designed and executed in the same artist's shop, i.e. Duccio's, probably not far from each other in time. Though Stubblebine discounted the importance of these physical observations, citing the paucity of extant examples (the Boston and London tabernacles are the only known Ducciesque triptychs surviving intact) as an inadequate sample group on which to base conclusions, he nonetheless attributed the London tabernacle to the supposed author of the wings of the Boston triptych, Simone Martini.

Both hands engaged in work on the Boston tabernacle – the crowds of figures at the base of the central Crucifixion were certainly painted by a different artist than were the two saints on the wings or the figure of the Redeemer and

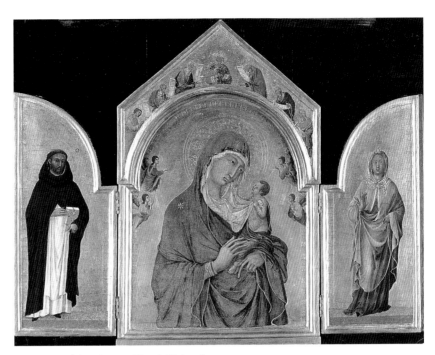

Fig. 8. Duccio di Buoninsegna, *Triptych: Virgin and Child, Saints Aurea and Dominic.* National Gallery, London

the two angels in the tympanum – may be found among the various narrative and non-narrative panels of the Maestà and on a number of the panels commonly attributed to Duccio. The compressed space and somewhat naive, doll-like figures with simplified drapery contours and repetitive gestures and expressions in the Boston Crucifixion may be recognized, as Stubblebine suggested, in the scenes of the Deposition and Entombment from the back of the Maestà, though his attribution of these and other works to a so-called Tabernacle 35 Master cannot be sustained.[2] The much more sophisticated ideation and rendering of the saints on the tabernacle wings are probably to be attributed to Duccio himself. Their softly rippled and subtly shaded draperies and the carefully studied bone structure of their hands and faces correspond to the same details in the London triptych, and both triptychs exploit the remarkable device of painting the saints' eyes turned outwards so as to fix on the viewer when the wings are opened at a 30– to 45– degree angle to the main panel. These figures are more mature efforts by the same artist, again almost certainly Duccio himself, who painted the recomposed tabernacle in the Queen's collection at Hampton Court (Shearman, 1983) and the Madonna of the Franciscans in the Pinacoteca Nazionale at Siena. The tympanum figures on the Boston tabernacle also relate convincingly to those on the tympanum of the central Madonna of the London triptych. Furthermore, the figure of the Crucified Christ in the central panel is

painted with an understanding of anatomy, subtlety of modeling and pathos of expression that may indicate the hand of Duccio himself. The rapid, calligraphic brushing of the draperies of the mourning angels may also betray Duccio's authorship.

While precise arguments of chronology for the restricted oeuvre directly attributable to Duccio are impossible, it does seem reasonable to assume that the Boston and London triptychs follow rather than precede work on the Cathedral Maestà, in the period that is between 1311 and Duccio's death in 1318. The suggestion (Cannon, 1980, pp. 270, 315 fn. 240) that the London triptych may have been painted for Cardinal Niccolò da Prato (d. 1321), a Dominican and Cardinal Bishop of Ostia, is plausible, and may indicate that it was commissioned during the Cardinal's journey from Avignon to Rome for the coronation of Henry VII as Holy Roman Emperor (May 1312) or on his subsequent return to Avignon. Such a provenance would also indicate that both the London and Boston triptychs represented a class of luxury goods which could be afforded only by the most exalted patrons, and were therefore not produced strictly for a local clientele.

1. See J. White, 1973, pp. 104-105, for exhaustive tables of measurements of the Boston tabernacle, not all of which agree exactly with those taken for this catalogue.

2. The series of panels on the Maestà grouped by Stubblebine under this name are not consistent among themselves, the Crucifixion scene, for example, being almost certainly a wholly auto-

graph effort by Duccio and most of the others showing varying degrees of participation by the master in their design and execution. The Tabernacle 35 itself (Siena, Pinacoteca Nazionale; Stubblebine, 1978, figs. 240-247) is a much damaged triptych probably of half a generation later than work on the Maestà, more closely related to the style of the Monteoliveto Master. The fragmentary Saint Peter in the collection of John Pope-Hennessy (ibid., fig. 239) is unquestionably by the Master of Monteoliveto and may have been cut away from a Madonna and Child formerly in the Ventura collection (ibid., fig. 226). The triptych in the Società di Esecutori di Pie Disposizioni (ibid., figs. 250-253) is too severely damaged to be compared to any other paintings, while the Madonna formerly in the collection of Humphrey W. Cook (ibid., figs. 248-249) is in its present state largely the work of Icilio Federico Ioni. The *Stoclet Madonna* (ibid., fig. 238), presently (1991) on loan to the Cleveland Museum of Art, also appears to have been completed in modern times.

Ugolino di Nerio

UGOLINO DI NERIO is recorded as a painter in Siena in documents of 1317, 1324-25, and 1327, none of which can be associated with a known work of art. The basis for reconstructing his artistic personality are the dispersed fragments (Berlin, London, New York, Los Angeles, Philadelphia, and elsewhere) from the former high altarpiece of Santa Croce, Florence, which is recorded by Vasari when still *in situ* as having borne his signature. These reveal him to have been an accomplished craftsman and inventive reinterpreter of Duccio's narrative and iconic formulae while remaining faithful to the general tenets of Duccio's style. They also permit the attribution to him of a number of important altarpieces and independent panel paintings which appear to range in date from about 1315 to nearly 1340 (Kanter, 1981-82, pp. 9-28), the later of which are heavily influenced by the emotional and dramatic as well as the decorative qualities of Ugolino's probably slightly younger contemporary Pietro Lorenzetti. Vasari, whose account of Ugolino in the *Lives* is somewhat confused, gave the date of his death as 1339 in his first edition (1550) and 1349 in his second edition (1568). The former is likely to be more nearly correct.

10

Saint Mary Magdalene

Tempera on panel
Overall: 40.7 x 29 (16 x 11⅜)
Picture surface: 35.5 x 24.7 (14⅛ x 9¾)

Gift of Mrs. W. Scott Fitz. 15.952

Provenance: Philip Gentner, Worcester; Mrs. W. Scott Fitz, 1915

Literature: "Recent Gifts," 1915, p. 83; Perkins, 1920a, p. 199, ill. p. 197; van Marle, vol. 2, 1924, p. 192, fig. 96; Weigelt, 1930, p. 72; Berenson, 1932, p. 523; Edgell, 1932, pp. 63-64; Berenson, 1936, p. 450; Coor-Achenbach, 1955, pp. 162-163, fn. 63; Berenson, vol. 1, 1968, p. 392; Whitehill, vol. 1, 1970, p. 328; Fredericksen and Zeri, 1972, pp. 206, 564; Amico, 1979, pp. 25, 30 fn. 14; Stubblebine, vol. 1, 1979, pp. 67, 161, 171-172; idem, 1985, p. 372 fn. 16; Laclotte, 1986; Pope-Hennessy and Kanter, 1987, p. 15; Laclotte, 1987, p. 56; Foucart, ed., 1987, p. 182.

Condition: The panel, of a vertical wood grain, has been thinned to a depth of approximately 1.7 cm and coated with a layer of wax resin. It has been cut on all four sides out of a much larger panel, and had modern frame moldings engaged to it all around. The gold ground and paint surface are extremely well preserved except for minor scattered abrasions and pinpoint flaking losses, with larger losses confined to the bottom edge and a 2-cm wide void in the saint's left shoulder. The losses are all minimally retouched.

THE BUST-LENGTH FIGURE of the Magdalene faces out of the panel towards the left. She is dressed in red with a red, green-lined (now decayed to brown) cloak and cowl bordered in gold. The top of her unguent jar, presumably held in her left hand, is cropped at the bottom of the panel, as are the upraised fingers of her right hand. The incised halo is cropped by the edges of the panel at the top and at the left, while above the Magdalene's shoulder at the right the initial letter M of her name is painted against the gold ground.

This beautiful but fragmentary panel was purchased for the Museum of Fine Arts with an attribution to Segna di Bonaventura, an attribution repeated, if with qualifications, by van Marle (1924), Edgell (1932), Berenson (1932, 1936, 1968), and Coor-Achenbach (1955). Perkins (1922) rejected the painting from his catalogue of Segna's works; Weigelt (1930) was the first to associate it with the circle of Ugolino. An attribution directly to Ugolino has been accepted by Boskovits (oral communication, 1978), Amico (1979), Polzer (letter in Museum files, 1979), Stubblebine (1979, 1985), Maginnis (oral communication, 1980), and Fahy (oral communication, 1985).

Weigelt related the Boston Magdalene to a panel showing the half-length figure

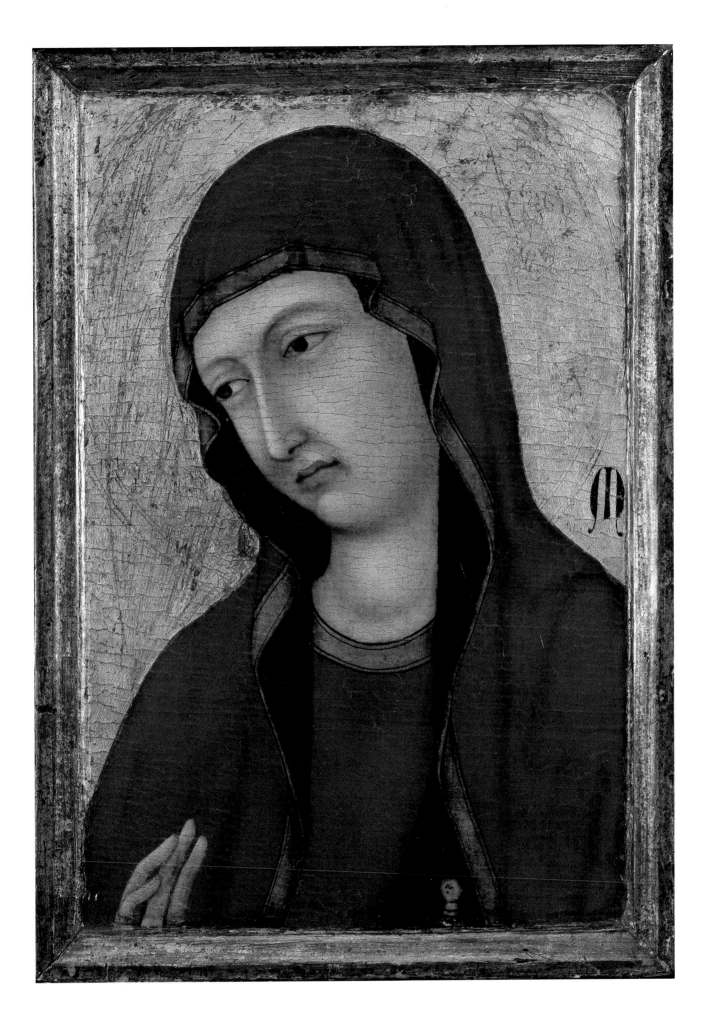

of Saint Catherine, then in the collection of the Countess van Francken-Sierstorpff, now in the Krannert Art Museum, Urbana, Illinois, as possibly parts of a polyptych formerly in the collection of Dr. Georg Martin Richter in Munich (the Richter polyptych cannot now be identified). Two further panels linked with the Boston and Urbana saints by Weigelt as probably by the same hand, showing half-length figures of Saints Mary Magdalene and Louis of Toulouse, have since entered the collection of the Fine Arts Museums of San Francisco. All subsequent discussion of the Boston Magdalene has been concerned only with the validity of Weigelt's grouping. Gertrude Coor-Achenbach (1955), for example, accepted the association of the three panels at Urbana and San Francisco as parts of a single complex, and her reconstruction is defended by Amico (1979), who denies any relation between these and the Boston saint. Zeri (1958a, p. 66) also accepted Coor-Achenbach's grouping, adding to it a half-length Saint Michael in the Czartorycki collection at the Narodowe Museum in Cracow. Laclotte (in Foucart et al., 1987) recognized the origin of the Urbana and Cracow saints in a single altarpiece, but denied any connection between them and either the San Francisco saints or the Boston Magdalene. Stubblebine initially (1979) accepted Weigelt's theory that the Boston Magdalene and the Urbana Saint Catherine originated from a single polyptych, and joined them with a Madonna in the Robert Lehman Collection, Metropolitan Museum of Art, New York. Later (1985), he joined the Boston Magdalene instead with the Cracow Saint Michael and with a half-length Saint Thomas in the Berenson collection at Villa I Tatti as Ugolino's earliest independent works, painted about 1315. For Stubblebine, the San Francisco saints could not be related to any other known panels by Ugolino, while Pope-Hennessy and Kanter (1987, p. 15) tentatively suggested that they may have stood alongside the Lehman Madonna in a single altarpiece complex.

From this tangle of interlaced arguments only two points are demonstrably clear: first, that the Boston fragment cannot have originated from the same complex as the San Francisco panels, since the Magdalene cannot have been portrayed twice in a single altarpiece; and second, that the Berenson Saint Thomas and the Cracow Saint Michael did not form parts of a single altarpiece. The Saint Thomas, though it has apparently been slightly reduced in height, is much larger than the Saint Michael, is differently inscribed, and employs a different pattern of incised decoration in its halo. The

Urbana Saint Catherine, on the other hand, corresponds exactly to the Cracow Saint Michael in size, in lettering style, and in halo decoration, and may be presumed to have come from the same altarpiece. It remains to be determined whether this pair should be joined to the San Francisco saints, as Zeri, and to a certain extent Coor-Achenbach and Amico, believed; whether they should be joined to the Boston Magdalene, as was in part suggested by Weigelt and Stubblebine; or whether there is no reason to group any of them together.

Pope-Hennessy and Kanter (1987) noted that the San Francisco, Cracow, and Urbana panels all form part of a group of works executed by an assistant of Ugolino within his shop, together with the Lehman Madonna, a Madonna at Montepulciano (to which the Berenson Saint Thomas is possibly to be joined), and an altarpiece in the Cleveland Museum of Art. This is not a priori evidence for their reconstruction in a single complex, since several of Ugolino's altarpieces betray a vacillating range of quality from panel to panel. There is, however, nothing that would argue strongly against their association, and Amico (1979) presented copious if not entirely convincing arguments to demonstrate a connection at least between the San Francisco and Urbana panels.

The Boston Magdalene is a fully autograph work by Ugolino from the earliest part of his career, around 1320, and despite its fragmentary state one of conspicuous quality. It cannot be associated with the San Francisco panels on iconographic grounds, as mentioned above, and similarly it is difficult to visualize any connection between it and the Urbana and Cracow panels, if for no other reason than that the resultant altarpiece would be the only known example in Ducciesque painting to align two female saints on the same side of the central panel. It is possible that the Boston Magdalene once stood alongside one of the surviving Madonnas by Ugolino. The *Tadini Madonna* in the Contini-Bonacossi collection, Florence, is particularly close to it in style, but physical evidence is lacking to support any hypothetical reconstructions.

II

Madonna and Child

Tempera on panel
Overall: 91.7 x 58.6 (36⅛ x 23¹/₁₆)
Picture surface: 81.5 x 52 (32⅛ x 20½)

Gift of Mrs. W. Scott Fitz. 16.65

Provenance: Rodolfo Calafranceschi, Rome; Philip Gentner, Worcester, 1915; Mrs. W. Scott Fitz

Literature: Perkins, 1920a, p. 200; van Marle, vol. 2, 1924, p. 147, fig. 99; Edgell, 1932, p. 62; Berenson, 1932, p. 582; Suida, 1952, p. 15; Coor-Achenbach, 1955, p. 162; Berenson, vol. 1, 1968, p. 437; Fredericksen and Zeri, 1972, pp. 207, 564; Maginnis, 1977, p. 283; Amico, 1979, p. 25; Stubblebine, vol. 1, 1979, p. 181; Kanter, 1981-82, p. 27 fn. 22.

Condition: The panel, of a vertical wood grain, is 2.9 cm thick and has been neither thinned nor cradled, though it has been trimmed on all three sides and along the arched top. The back of the panel is gessoed and painted red, the paint interrupted by three now-missing battens: horizontal battens at the bottom and just above the spring of the arch and a vertical batten at the top intended to secure a pinnacle superstructure. The mark of the lower horizontal batten is cropped at the bottom of the panel and is 6 cm wide. Old strips of wood 1.5 cm thick have been attached at each side of the panel with modern wire nails (the original panel is 55.5 cm wide) and the arched top has been trimmed to a flatter profile. These alterations were apparently effected to accommodate the wider radius of the modern (probably seventeenth- or eighteenth- century) frame moldings now engaged to the front of the panel. The gold ground has been entirely regessoed and regilt up to the profile of the figures. The paint layers are unevenly preserved. Though generally free of abrasions, there is a 3-cm wide loss in the Virgin's right cheek and losses at the top of her head and right shoulder. The toes of the Christ Child's left foot have been repainted, and the shadows of the Virgin's face and cowl have been much reinforced. The blue of the Virgin's mantle has similarly been much reinforced.

THE VIRGIN is shown half-length, turned in three-quarters profile to the right. She is dressed in blue robes lined with maroon and supports the Christ Child in the crook of her left arm. The Child is dressed in a sheer white garment and wrapped in a violet-red cloth decorated with a gilt quatrefoil pattern. He rests both his feet on the Virgin's right hand and wrist, and reaches up to pull her fringed veil across his chest. The back of the panel is painted red and inscribed: QUESTA MADONNA / DEL SOCCORSO RESTA / VRO IL PRETE ANGELO / SIRIGATTI LANNO / 1630 (this painting of the Madonna of Mercy was restored by the priest Angelo Sirigatti in the year 1630).

Since the time of its first publication by Perkins (1920), this Madonna has been recognized as one of a group of Ducciesque panels associated with the name of Ugolino da Siena. Perkins

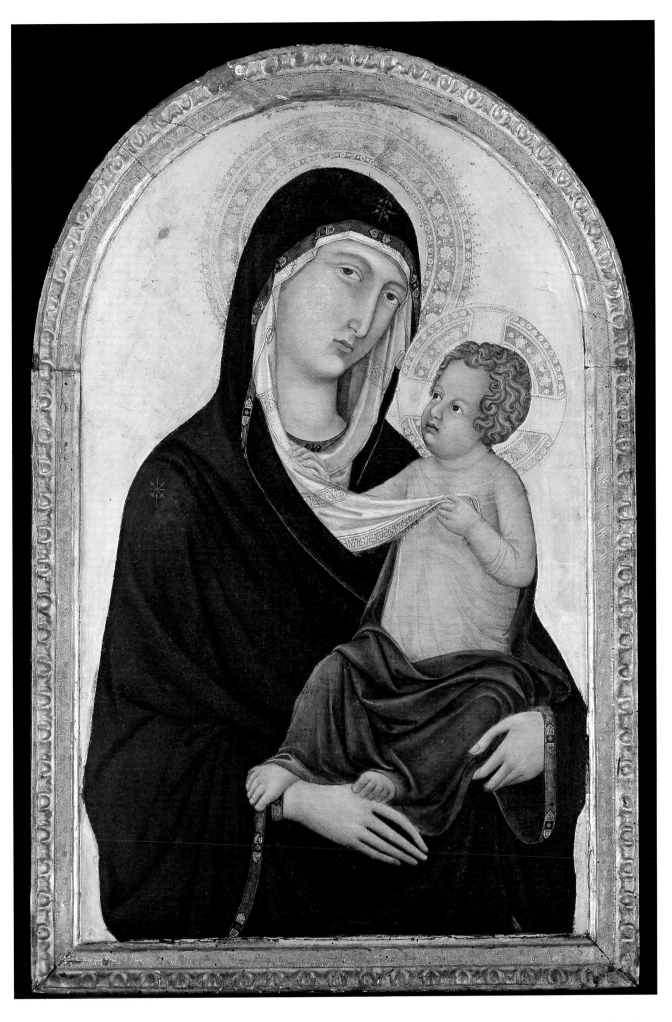

described the picture as Ugolinesque, likening it to two late works by the master: the Madonnas from San Casciano and from San Giovanni d'Asso. Van Marle (1924) attributed most of this group of pictures, the Boston Madonna included, to Segna di Bonaventura, a confusion which all later scholars have found unacceptable. Berenson (1932, 1968) considered the picture a product of Ugolino's studio, while Edgell (1932), Amico (1979), and Stubblebine (1979) assigned it to a follower of Ugolino. Coor-Achenbach (1955), Kanter (1981-82), and Fahy (orally, 1985) defended the picture's autograph status.

To a certain extent, judgments of the quality of the Boston Madonna have been compromised by the deadening effect of its modern gilding and by heavy overpaints that formerly obscured much of its surface. The panel was cleaned in 1942, but Coor-Achenbach still described it ten years later as "somewhat retouched," and Stubblebine published it as late as 1979 in its pre-War, overpainted state. Stubblebine attributed it to the painter he believed to have been responsible for an altarpiece in the Ricasoli collection at Brolio (Gaiole-in-Chianti), which was also heavily overpainted, and the specific points of similarity he cited between the two were all inventions of a modern restorer. For Coor-Achenbach and Kanter the Brolio altarpiece is a largely autograph creation by Ugolino, a judgment confirmed by a successful recent restoration (cf. L. Bellosi, in *Mostra di opere d'arte restaurate nelle province di Siena e Grosseto*, 1983, vol.3, pp. 30-33).

Coor-Achenbach related the Boston Madonna stylistically to Ugolino's polyptych no. 39 in the Pinacoteca Nazionale at Siena (Torriti, 1977, pp. 62-63), and it must fall chronologically in Ugolino's career somewhere between this work and the slightly later Brolio altarpiece. In this same period, which probably constitutes the years between 1325 and 1330, Ugolino must also have painted the panels showing half-length figures of Saint Andrew (formerly J. Paul Getty Museum, Malibu; sale, Christie's, New York, 21 May 1992, lot 26; fig. 9), and Saint John the Baptist (National Museum, Poznan; fig. 10), and the heavily repainted figure of a female saint, possibly Eustochium, formerly in the F. D. Lycett Green collection (sale, Christie's, London, 16 March 1956, lot 106). Kanter (1981-82) tentatively associated these three panels with the Boston Madonna as parts of a single altarpiece on the grounds of similarity in style and compatibility in size, but with the caveat that due to regilding, "any

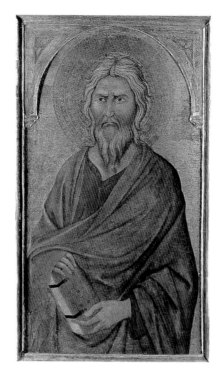

Fig. 9. Ugolino di Nerio, *Saint Andrew*. Formerly J. Paul Getty Museum, Malibu

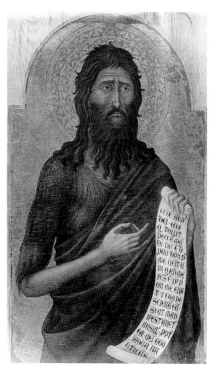

Fig. 10. Ugolino di Nerio, *Saint John the Baptist*. Muzeum Narodowego, Poznan

physical evidence of its (i.e. the Boston Madonna's) possible association with the Getty and Poznan panels has been lost." Slivers of original gilding do survive along the figures' profiles in the Boston panel, and traces of original tooling marks preserved there indicate that the present haloes, though reconstructed with modern tools, probably follow an original pattern preserved in the underlying gesso of concentric bands of decoration that are closely related to those in the Getty Saint Andrew. Furthermore, the outermost double-incised ring of the haloes in the Boston panel is filled with a course of tightly aligned small circular punches creating the effect almost of a beaded necklace, a peculiarity of design elsewhere encountered in Ugolino's work only in the Getty, Poznan, and Lycett Green panels.

Correspondence of punch-tooling cannot demonstrate the association of the Boston, Getty, Poznan, and Lycett Green panels in a single complex, it can only reinforce the evidence of style in asserting their approximate contemporaneity. Probably these four panels originated in a single altarpiece, but proof is still lacking. A fifth element grouped with them by Kanter, however, a pinnacle of the Crucifixion formerly in the Stoclet collection (sale, Sotheby's, London, 24 March 1965, lot 9), which he supposed to have fit above the Boston Madonna, is certainly extraneous to the group. It was painted rather earlier by the Ducciesque artist known as the Città di Castello Master, and may tentatively be proposed as the excised pinnacle from his Madonna now in the Museo del Opera del Duomo in Siena, the center panel to an altarpiece from the church of Santa Cecilia at Crevole, four additional panels of which are preserved in the Pinacoteca Nazionale, Siena (Torriti, 1977, p. 66).

The Goodhart Ducciesque Master (?)

12

Angel with Instruments of the Passion

Tempera on panel
Overall (including modern attachments):
30.5 x 20.9 (12 x 8¼)
Original panel: 27 x 17 (10⅝ x 6¾)
Picture surface: 26.2 x 16.6 (10⁹⁄₁₆ x 6½)

Bequest of Mrs. Edward Jackson Holmes.
1978.466

Provenance: Unknown; Edward Jackson Holmes,
Boston, by 1931

Literature: van Marle, 1931, pp. 57-58; Cooper,
1965, p. 163 fn. 7; Stubblebine, 1969a, p. 138; idem,
vol. 1, 1979, p. 155, vol. 2, pl. 535.

Condition: The wood panel is in excellent condi-
tion, has been neither thinned nor cradled, and
exhibits only a slight convex warp. The engaged
frame is a modern addition. The beard of the
original frame is clearly visible along the top
edge and less so along the left gable; the right
gable has been trimmed slightly further into the
picture field. The gold ground is moderately
worn especially around the halo and along the
bottom where the bole is revealed. The paint
surface has been evenly abraded in a modern
restoration, and tiny losses along the rather
extensive craquelure have been broadly
retouched.

THE AUTHOR of a restricted body of
works, probably executed between about
1315 and 1330, the Goodhart Ducciesque
Master was first identified by Offner (cit-
ed in Wehle, *The Metropolitan Museum of
Art: A Catalogue of Italian, Spanish, and
Byzantine Paintings*, 1940, p. 72, and Shorr,
1954, pp. 154-157), who named him after a
panel of the Virgin and Child Enthroned
with Donors then in the collection of
Mrs. A. E. Goodhart (now New York,
Metropolitan Museum of Art, Robert
Lehman Collection; Pope-Hennessy and
Kanter, 1987, pp. 6-7). Further attribu-
tions to the artist, of dubious validity,
were proposed by Coor-Achenbach (1955,
pp. 163-164, fn. 57), who characterized
him as a follower of Ugolino di Nerio,
and Stubblebine (1979, pp. 106-110), who
saw him instead as a direct follower of
Duccio active in the first quarter of the
century. The salient influence on the
Goodhart Ducciesque Master's style is
that of Duccio's follower, Segna di
Bonaventura (active by 1298–died before
1331), though he was undoubtedly a
painter of a slightly older generation
than either of Segna's sons: Niccolò
(active by 1332–ca. 1345) or Francesco
(documented 1328–1339) di Segna.

THE HALF-LENGTH FIGURE of an angel,
robed in purple with a green sash, is
posed frontally, filling the full height of
the picture field. He holds in his right
hand the column to which Christ was
bound, and in his left hand the flail of
Christ's flagellation.

This panel and another (fig. 11), of
identical shape and size now in the Frick
Art Museum, Pittsburgh (Hovey, 1975, pp.
35, 41-42) – representing an angel holding
two further instruments of the Passion,
the spear and the crown of thorns – once
stood together in the upper tier of an as
yet unidentified altarpiece. Both panels
have been presumed to have formed part
of Duccio's Maestà (Cooper, 1965; Hovey,
1975), though in all likelihood they origi-
nated from a different complex. The
Maestà is reasonably supposed to have
been completed by angel pinnacles, but
there is little agreement as to whether
these can be identified among surviving
Ducciesque examples (see Stubblebine,
1969a; White, 1979, p. 180 fn. 11).

The Boston and Pittsburgh angels
were attributed by Stubblebine (1979) to
a painter he dubbed the Master of the
San Sepolcro Resurrection, after an altar-
piece of that subject in Borgo San Sepol-
cro, and whom he characterized as a late
follower of Segna di Bonaventura, per-
haps an associate of Segna's son Niccolò.
The San Sepolcro altarpiece, however,

and the works plausibly associated with
it, including two angel pinnacles in the
Cleveland Museum of Art,[1] are by a later
and less refined hand than the Boston
and Pittsburgh panels, where the render-
ing of the angels' hair and features is
more delicate, the foreshortening of their
wings and hands is more sophisticated,
and the system of decorating their haloes
with engraved floral and acanthus pat-
terns is more archaic. Hayden Maginnis
(oral communication) observed of the
Boston panel only that it was likely to be
by an artist in the circle of Segna di
Bonaventura.

Of all surviving Ducciesque and
specifically Segnesque panels, the Boston
angel most closely resembles the small
body of works attributed by Offner to an
artist he called the Goodhart Ducciesque
Master, after a small devotional panel for-
merly in the A. E. Goodhart collection
(now New York, Metropolitan Museum
of Art, Robert Lehman Collection,
1975.1.24; see Pope-Hennessy and Kanter,
1987, pp. 6-7). The abraded surface of the
Boston panel precludes advancing a con-
fident attribution to this master, though
close parallels to its figure style and the
engraved patterns in its gold ground all
occur in his works. There is a particular-
ly striking correspondence of type and
composition between the Boston and
Pittsburgh angels and the angel pinnacles
in an altarpiece from Monterongriffoli,
attributed to the Goodhart Ducciesque
Master by Coor-Achenbach (1955, pp. 163-
164 no. 57), who mistakenly believed the
artist to be a follower of Ugolino rather
than of Segna. The Monterongriffoli
altarpiece is a flat, mechanical work of
uncertain attribution, but it is clearly
dependent in style on the Goodhart Duc-
ciesque Master.

The iconography of the Boston and
Pittsburgh panels is rare for this date, ca.
1320, and is elsewhere encountered in
Sienese painting of the early trecento
only in an altarpiece painted by Simone
Martini for the Servites in Orvieto
(Boston, Isabella Stewart Gardner Muse-
um).[2] In the pinnacles of this altarpiece,
two angels holding instruments of the
Passion (the Signs of the Son of Man –
Matthew 24:30) and two others blowing
trumpets, the summons for the Resurrec-
tion of the Dead (Matthew 24:31), flank
an image of the Redeemer exposing his
wounds. These overt references to the
Last Judgment are incorporated into a
conventional polyptych comprising half-
length figures of the Virgin and Child
and four saints, and such is likely to have
been the case with the Boston and Pitts-
burgh angels as well. It may be worth
noting, however, that Segna di Bonaven-
tura was responsible for several icono-

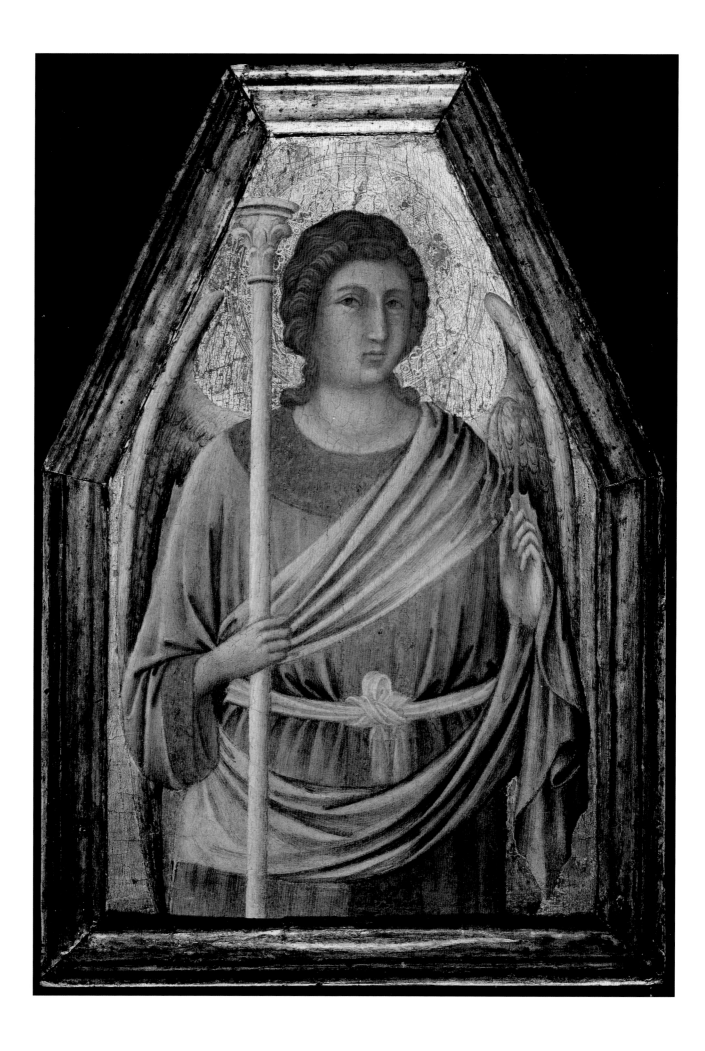

Simone Martini

Fig. 11. The Goodhart Duccesque Master, *Angel Holding Instruments of the Passion*. Frick Art Museum, Pittsburgh

graphically innovative altarpieces, including one employing the Man of Sorrows as its central panel (Stubblebine, 1969 pp. 1-8) and one based on the Last Judgment (Angers, Musée des Beaux-Arts; Stubblebine, vol. 2, 1979, fig. 331), and it is not impossible that the original context of the Boston and Pittsburgh angels followed one of these examples.

1. 62.257, 62.258. See Wixom, 1974, pp. 135-137. These two panels are probably the two angels "dipinta su tavola triangolare" lent by the Fratelli Pannilini of S. Giovanni d'Asso to the 1904 *Mostra dell'Antica Arte Senese* (Mostra, 1904, pp. 301, 302) and supposed to have formed part of Duccio's Maestà by Weigelt (1909, p. 212). They were accompanied in the 1904 exhibition by a pinnacle of the Redeemer, which would be the panel now in the Kress collection at Raleigh, North Carolina. The Fratelli Pannilini, who lent at least thirteen pieces to the 1904 exhibition, appear to have collected objects chiefly if not exclusively from the neighborhood of San Giovanni d'Asso, including the triptych by Ugolino from San Pietro in Villore, now in the Contini-Bonacossi collection. The Cleveland and Raleigh pinnacles, therefore, are likely to have originally formed part of the triptych still in the Pieve of San Giovanni d'Asso (Stubblebine, vol. 2, 1979, figs. 531-533), with which they agree fully in style.

2. For an aberrant discussion of the iconography of the Gardner polyptych, see Fehm, 1978, pp. 3-6.

WITH his slightly younger contemporaries Ambrogio and Pietro Lorenzetti, Simone Martini, born about 1284, was the dominant painter in Siena in the generation following Duccio's and one of the most innovative and influential painters in Europe in the first half of the fourteenth century. Probably trained in Duccio's studio and much influenced by the sculpture of Giovanni Pisano and Tino di Camaino, Simone's earliest career has not yet been convincingly reconstructed. His first certain work is a signed fresco of the Maestà in the Palazzo Pubblico, Siena, of 1315 (restored by the artist in 1321), and his other major commissions in Siena include an altarpiece for the Capella delle Nove (1326) and one for the tomb of the Beato Ambrogio Sansedoni, another fresco in the Palazzo Pubblico depicting the victorious Guidoriccio da Foligno, and an altarpiece of the Annunciation painted in 1333 for the Cathedral and signed jointly with his brother-in-law Lippo Memmi. Simone was also active in Naples, where he was employed by King Robert of Anjou around 1317, in Pisa, where he painted an altarpiece for the church of Santa Caterina in 1319, in Orvieto, where he painted three altarpieces probably in the early 1320s, and at an undetermined date in Assisi, where he decorated the chapel of Saint Martin in the Basilica of San Francesco. Simone Martini moved to the Papal court at Avignon around 1336/40, and he died there in 1344.

Praised by the poet Petrarch, Simone Martini expanded the sphere of Siena's artistic influence throughout Europe, first through his association with the Angevin court at Naples, his work at Assisi, and most decisively through his presence at Avignon, the example of which continued to provide models for Gothic painters as far away as Bohemia as late as the end of the fourteenth century. In Siena, Simone's workshop produced a number of major and minor masters working more or less faithfully in his style, including Lippo Memmi, "Barna," Naddo Ceccarelli, and the so-called Master of the Straus Madonna,

and his works, like Duccio's, remained influential until nearly the end of the fifteenth century. Simone's graceful, almost calligraphic figure style, his exquisite decorative sense – both in the rendering of painted details of fabrics or architectural settings and in the craftsmanship of punched and glazed decorations on gold grounds – and the psychological and expressive sophistication of his narratives were unrivaled in Italian art before the appearance of Fra Angelico in Florence eighty years after his death.

13

Saint Andrew (?)

Tempera on panel
Overall: 21.2 x 22.3 (8⅜ x 8¾)
Picture surface: 18.5 x 19.6 (7¼ x 7¾)

Charles Potter Kling Fund. 51.2397

Provenance: Morton Paul Bottenweiser, Berlin, until 1929; H. Meinhard, New York (sale Parke Bernet, New York, 28 April 1951, lot 305); Julius Weitzner, New York

Literature: Van Marle, 1929, p. 308, pl. iv; Berenson, 1932, p. 534; Edgell, 1953, pp. 7-8, 10; Paccagnini, 1955, pp. 158-159, 162, fig. 80; Rowlands, 1960, pp. 67-68; City Museum, 1960, p. 18; Berenson, 1968, vol. 1, p. 402; Contini and Gozzoli, 1970, p. 5; Fredericksen and Zeri, 1972, pp. 121, 565; Preiser, 1973, pp. 235-236, 416-417, figs. 229, 230; Boskovits, 1974, p. 367 fn. 9; Maginnis, 1977, p. 286; Caleca, 1977, pp. 70-71; Benedictis, 1979, p. 17; Volpe, 1983, p. 285, fig. 208; Martindale, 1988 pp. 30 fig. 6; 32, 34 fn. 8, 35 fn. 22, 186 cat. 10, pl. 58; Leone de Castris, 1989, pp. 84-85.

Condition: The panel, of a horizontal wood grain, has been thinned to a depth of 1.6 cm and backed with a thin veneer of wood with a vertical grain. Remnants of glue and slivers of wood attached to the face of this veneer suggest that further layers of wood reinforcement may have been removed at some time in the past. The engaged frame moldings are original and well preserved, though the gilding is worn along the outer edges. A horizontal split running the length of the panel through its center is visible in the paint surface and has resulted in minor flaking losses (retouched) in the saint's neck and shoulders and in some regilt losses in the gold ground. The gilding otherwise, including the mordant gilding on the saint's clothing and book, is only moderately worn, and the paint surface, except for small losses in the saint's green cloak, is exceptionally well preserved.

THE BEARDED FIGURE of the saint is shown bust-length filling the full height of the octagonal field. He wears a green robe over a red tunic and holds a red book in his left hand. He bears no other attributes that might aid in securely identifying him, and in most published citations he is referred to simply as an Apostle, or more generically as a bearded male saint. Preiser (1973, p. 236) suggested identifying him with Saint Matthias, comparing him to that figure in Simone Martini's Pisa polyptych, but in physical type he more closely resembles the figures of Saint Andrew in that altarpiece and in the panel by Simone Martini from the Blumenthal collection, Metropolitan Museum of Art, New York.

Since it was first brought to public attention by van Marle (1929), the attribution of this panel to Simone Martini has never been called into question, though opinions have varied widely regarding its dating and original function. Van Marle considered it an early

work, painted prior to the Pisa polyptych of 1319-20, but in a manuscript opinion preserved in the Robert Lehman Collection archives (Metropolitan Museum of Art, New York: certificate dated 21 March 1929), he proposed an earlier dating still, before the Palazzo Pubblico Maestà of 1315. Pope-Hennessy (letter in Museum files, 1951) and Rowlands (1970), followed by Preiser (1973), considered it a work of the 1330s, possibly later than the Uffizi Annunciation of 1333. Most other writers have placed it in the early 1320s, the presumed date of Simone's three Orvieto altarpieces, and this dating appears to be correct.

Rowlands (1970) published a panel (fig. 12) in the Birmingham City Art Gallery of identical proportions to the Boston Saint Andrew, representing a young male saint turned three-quarters to the right, which was exhibited alongside the latter at the Royal Academy winter exhibition of 1960 (Italian Art in Britain, cat. no. 265, pp. 101-102). Clearly originating from a single complex, Preiser (1973) was the first to propose that the two panels formed part of a predella, based on the horizontal wood grain in both and on the similarity of their octagonal picture fields to those of the narrative scenes in the predella of Duccio's Maestà. Preiser's proposed reconstruction of this predella assumed a series of eight similar figures of Apostles, two beneath each of the lateral panels of a pentaptych, flanking three panels of identical shape and size showing Christ as the Man of Sorrows with the mourning Virgin and Saint John the Evangelist. Martindale (1988) accepted the iconographic basis of Preiser's reconstruction, citing the tears shed by the Birmingham saint as proof that a Man of Sorrows stood at the center of the predella, but contends that the altarpiece must have been a heptaptych rather than a pentaptych, to accommodate all twelve Apostles in the predella, and that the center panel of the predella must have comprised a single elongated octagonal field rather than three separately framed figures, since no surviving altarpiece by Simone (other than the Uffizi Annunciation) has a center panel wide enough to accommodate three panels the size of the Boston or Birmingham saints beneath it.

To Martindale's observations it may be objected: first, that in the predella to Simone's Pisa polyptych, where a similar iconographic scheme is employed, the Man of Sorrows, Virgin, and Saint John the Evangelist in the center are separately enframed identically to the saints flanking them but are painted in narrower picture fields; and second, that there is

Fig. 12. Simone Martini, A Young Saint. Birmingham City Art Gallery

no a priori evidence for assuming the altarpiece to have been a heptaptych, since Saint John the Evangelist was himself an Apostle and three others could have been portrayed in the main panels or pinnacles above. Nonetheless, Martindale is probably correct in proposing the Monaldeschi altarpiece from San Domenico, Orvieto, as the original context of the Boston and Birmingham saints, noting that of Simone's surviving polyptychs it alone has lateral panels wide enough to have stood above two such units side by side. Additionally, the punched borders of the gold grounds in the Boston and Birmingham panels correspond exactly to those in the main panels of the Monaldeschi altarpiece, and the two sets of pictures are in full stylistic concordance.[1] Leone de Castris (1989) preferred to associate the Boston and Birmingham saints with Simone's altarpiece from San Francesco in Orvieto, a suggestion which cannot be disproved or dismissed but which, under the circumstances, seems the less likely.

1. The center panel of the Monaldeschi altarpiece is inscribed with a date, "MCCCXX..." the last digit(s) of which are illegible. Whether this date is to be read as 1321, 1322, 1324 or later is a matter of considerable scholarly debate, based primarily on measurements of the space available to accommodate one or more digits at the end of the inscription. In the total absence of documents or securely datable comparative material, this debate is certain to remain academic and irresoluble, though a date of 1324, shortly before the Malibu/New York altarpiece probably of 1326, seems most likely to this writer.

Lippo Memmi

LIPPO MEMMI was the son of the painter and miniaturist Memmo di Filipuccio, with whom he signed the large fresco of the Maestà in the Palazzo Pubblico in San Gimignano in 1317, his earliest certain work; brother of the painter Federigo Memmi, who is known from documents only but who is sometimes identified with the artist known as "Barna da Siena" (q.v.); and brother-in-law and collaborator of Simone Martini, with whom he signed the great Annunciation altarpiece of 1333 for Siena Cathedral (now in the Uffizi, Florence). Lippo's painting style is inextricably linked with that of Simone, to the extent that there has never been complete scholarly agreement on attributions of works between the two artists. Lippo has traditionally been regarded as an able but unimaginative imitator of Simone, an assessment that has been revised in recent years to reflect Lippo's relative importance in their joint workshop, partly on the basis of the mistaken assignment to him of the paintings once attributed to "Barna." In addition to numerous Sienese commissions, Lippo was apparently active in Pisa, where his influence lasted well into the second half of the century, and at Avignon, where a Madonna painted in 1347 jointly with his brother was recorded in the church of San Francesco. Lippo's late style, following the death of Simone Martini in 1344, has been little considered in art historical literature, but may be inferred from a damaged fresco formerly in the cloister of San Domenico, Siena, purportedly of 1356, to be coincident with that of the so-called Palazzo Venezia Master.

14

Virgin and Child

Tempera on panel
Overall: 75.4 x 55.5 (29¾ x 21⅞)
Picture surface: 65.6 x 46.8 (25⅞ x 18⅜)

Charles Potter Kling Fund. 36.144

Provenance: Paolini, Rome, 1919 (?); Grazzini, Florence; Aldo Jandolo, Rome

Literature: Bereson, vol. 1, 1968, p. 269; Fredericksen and Zeri, 1972, pp. 141, 564; Frinta, 1982, pp. 220, 222.

Condition: The wood panel, of a vertical grain, is 3.3 cm thick and moderately warped. A gesso layer coating the back fills a number of damages in the wood, indicating that it was added in relatively modern times. There are two partial, vertical splits through the middle of the panel. The overall dimensions of the panel have been increased by the addition of 2.5–cm wide strips around all the edges, underlying the engaged frame moldings but attached to the panel with modern nails. The engaged moldings, therefore, though old cannot be original to the picture (see also below, for further demonstration that they are not integral to the painted panel), and as they are gessoed and gilt continuously with the gold ground of the panel, that too cannot be original. The pronounced "fish net" craquelure of the gold ground does not extend into the painted areas, where less pronounced crack patterns more typical of fourteenth-century panel paintings are visible. The paint layers are worn and abraded, probably from overcleaning, with small losses in the area of the Virgin's nose and eyes and larger losses along the bottom. All losses have been retouched. Infrared examination reveals that in an old restoration the head of the Christ Child was significantly enlarged along the outer contours of the hair, perhaps to mask the irregular join between the paint surface and the new gold ground at that point.

THE VIRGIN, half-length, wears a red dress and white veil covered by a blue robe. She inclines her head to the left towards the Christ Child, whom she supports on her left arm, dressed in a white tunic and rose-colored lap-cloth. In his left hand he holds a scroll inscribed EGO SUM VIA VERITAS, and with his right hand he reaches across to play with his mother's thumb.

Ignored in most of the extensive literature concerning Lippo Memmi, Simone Martini, and the artists in their circle, this painting has been dismissed as an imitation of Lippo's style (Berenson, 1968; Fredericksen and Zeri, 1972) or as a modern forgery (Offner, Fahy, Boskovits, manuscript opinions). Loosely based on the composition of Memmi's *Madonna del Popolo* in Santa Maria dei Servi, Siena, the figure types, and especially the Christ Child, are actually closer imitations of those in Simone Martini's altarpieces of the mid-1320s. The motif punches used to decorate the gold ground all recur in other paintings from the workshop of Simone Martini and Lippo Memmi, but they are combined in patterns more reminiscent of their use in frescoes than panel paintings. The spacing of the leaves and flowers along the "vine" in the Virgin's halo, for example, is encountered in the Siena and San Gimignano Maestàs and in the much damaged fresco from the cloister of San Domenico, Siena, but among panel paintings only in Lippo's large Virgin and Child in the Gemäldegalerie Berlin-Dahlem.[1]

The physical state of the panel is also confusing. The broad crackle pattern in the gold ground resembles an induced craquelure more than a true stress crackle and it is uninterrupted by any of the punch strikes. In all other Simonesque panels, the strike of the punches themselves, the impressions of which are generally sharper than here, creates a crackle pattern radiating out from their edges. The gesso layer is thicker and much more uneven than in any other Simonesque painting, which could be the result of water damage except that no effects of water damage are apparent in the paint surface or in the wood of the panel itself. Furthermore, the vertical split in the panel visible in the gold ground to the right of the Virgin's halo must have been caused by warpage, yet the top and bottom frame moldings engaged across the wood grain are undamaged. Under normal circumstances they would either have split or disengaged, and their gilding would be discontinuous with that of the picture surface.

Conversely, the crackle of the paint surface is largely convincing, except in areas of obvious restoration, exhibiting fine and broad patterns not yet detected in any known forgeries nor, it would seem, possible to attain by any known methods of simulation. One possible conclusion might be that the painting is essentially "correct" but entirely regilt, the modern ground carefully (painstakingly) worked up to the edges of the painted figures, and that it had at one time been reduced to a state comparable to that of Simone's *Lucignano d'Arbia Madonna* in the Pinacoteca Nazionale, Siena (Torriti, 1977, pp. 86-87). In such a case it is necessary to ask whether a Virgin and Child of identical composition, formerly with the dealer Paolini in Rome, identified by Frinta (1982) as the work of Icilio Federico Ioni from a photograph in the Fototeca Berenson at the Villa I Tatti might not represent the present picture in an earlier, heavily repainted and differently regilt state. It would also be necessary to inquire whether the

The child holds a scroll inscribed: EGO SUM VIA VERITAS

painting as originally conceived was the work of Lippo Memmi, Simone Martini, the two artists in collaboration, or a third artist altogether. None of these questions is answerable at present.

1. No. 1067; see Boskovits, 1988, pp. 74-76. This panel cannot have formed the center of the San Casciano altarpiece as reconstructed by G. Coor-Achenbach (1961a, pp. 126-135) and Mallory (1974, pp. 187-202). It differs significantly in figure style and halo and spandrel decoration from the six lateral panels (see Maginnis, 1977, pp. 289-290 fn. 3), while the profile of its spandrels and the continuation of its stamped borders the full height of the panel (the stamped borders in the lateral panels end at the capitals of the framing colonettes) imply a completely different system of framing than may be presumed for the rest of that altarpiece.

Ambrogio Lorenzetti

WITH HIS BROTHER, Pietro Lorenzetti, and Simone Martini (q.v.), Ambrogio Lorenzetti was one of the foremost painters active in Siena in the decades between the death of Duccio and the Black Death of 1348. Though he may have been trained in Duccio's workshop, Ambrogio reveals more than any of his Sienese contemporaries a knowledge and understanding of Giotto's pictorial innovations in Florence, already evident in his earliest dated work, the *Vico l'Abate Madonna* of 1319. He may have maintained regular contacts with Florence, for he matriculated in the painters' guild there in 1327 and painted at least one altarpiece for a Florentine church, the San Procolo altarpiece now in the Uffizi. His sophisticated sense of modeling and of the rendering of space, perhaps the most advanced in Italy before the fifteenth century, as well as his bright palette and command of naturalistic detail, were highly influential in Siena, inspiring several generations of imitators after his own death in 1348 or 1349. Perhaps his best-known works today are the frescoes depicting Good and Bad Government in the Palazzo Pubblico in Siena (1338-1340), though undoubtedly more important for his contemporaries were his now-lost frescoes of scenes from the life of the Virgin on the facade of the Spedale della Scala, and his altarpiece of the Presentation of the Virgin, painted in 1342 for the Cathedral in Siena (now in the Uffizi, Florence).

15

Madonna and Child

Tempera on panel
75.5 x 45.3 (29¾ x 17⅞)

Charles Potter Kling Fund. 39.536

Provenance: Fratelli Griccioli, S. Eugenio, Siena; Dan Fellows Platt, Englewood, New Jersey

Literature: Burckhardt, vol. 2, 1884, p. 550; Berenson, 1897, p. 149; Heywood and Olcott, 1901, p. 341; Meyenburg, 1903, p. 40; *Mostra*, 1904, p. 307; Perkins, 1904a, p. 187; idem, 1904b, pp. 83-84; idem, 1904c, p. 582; Poggi, 1904, p. 44; Jacobsen, 1907, pp. 38-39, pl. XX; Sirén, 1907, p. 177; Crowe and Cavelcaselle, vol. 3, 1908, p. 119 fn. 4; Berenson, 1909, p. 187; Hutton, 1910, p. 155; Perkins, 1911, pp. 3-4; Gielly, 1912, p. 148; Sirén and Brockwell, 1917, p. 129; Perkins, 1920a, pp. 207, 209-210; van Marle, vol. 2, 1924, p. 398; Gielly, 1926, p. 117; Offner, 1927a, p. 78; Rowley, 1927, p. 211; Weigelt, 1930, p. 91; Venturi, 1931, pl. 66; Berenson, 1932, p. 290; Edgell, 1932, p. 131; Sinibaldi, 1933, pp. 95, 186-187; Edgell, 1939, pp. 70-73; Suida, 1952, p. 15; Rowley, vol. 1, 1958, pp. 42-43, vol. 2, pl. 29, 30, 38; Vermeule, 1960, p. 482; Offner, 1960, p. 235; Borsook, 1966, p. 20; Berenson, vol. 1, 1968, p. 215; Frinta, 1971, p. 307; Fredericksen and Zeri, 1972, pp. 109, 564; Skaug, 1976, p. 315 fn. 45; Torriti, 1977, p. 111.

Condition: The paint surface and gesso layer were transferred in 1939 to a new panel support; the painting's present shape is an invention of that restoration (see below). The gold ground, with the exception of the haloes which appear to be original, has been completely regessoed and regilt. The paint surface is in poor condition with losses and abrasions throughout, though the fleshtones are conspicuously better preserved than the draperies. There is a large, 5-cm wide loss in the bottom right corner. The painting has been extensively repainted and the contours strengthened overall.

THE VIRGIN is shown half-length in a vermilion dress covered by a blue mantle decorated with gilt stars. She holds the Christ Child on her left arm, his feet resting in the palm of her right hand. The Child, in a rose-colored tunic belted at the waist, wraps his arms around his mother's neck and presses his head to her cheek. The Virgin's halo is inscribed: AVE MARIA CHRASSIA [*sic*] P[L]ENA DOM.

Known traditionally as the *Sant'Eugenio Madonna*, after its provenance from the Griccioli collection at the Monistero di Sant'Eugenio, Siena, this painting has generally been discussed as a typical example of Ambrogio Lorenzetti's autograph style of the early 1330s. The first writer to doubt its attribution was Rowley (1927, 1958; followed by Weigelt, 1930), who associated it with Ambrogio's S. Petronilla altarpiece in the Siena Pinacoteca as the work of a separate master. Borsook (1966) also rejected the attribution of the Boston Madonna directly to Ambrogio Lorenzetti. Offner (1960) suggested that the three works given by

Rowley to his so-called Petronilla Master are in fact by three different hands, all probably working with Ambrogio in his workshop, while Torriti (1977), who mistakenly described the Boston Madonna as originally in S. Egidio [sic], Siena, found the isolation of a Petronilla Master "as enigmatic as it is absurd, taking from Ambrogio three of his certain and finest creations."

Of all the writers to have discussed or mentioned the Boston Madonna, only Borsook has seriously considered its deteriorated condition. Edgell (1939) published photographs of it in the state in which it was exhibited at the 1904 exhibition in Siena – at which time it had a rectangular shape with punched borders in its regilt ground, and had been heavily overpainted, probably in the early nineteenth century – as well as in the state to which it had been "restored" by Icilio Federico Ioni when it entered the Platt collection. Ioni had removed the old repaints and regilding, built up the panel to a gabled shape, added his own regilding and repaints, especially in the draperies, and supplied the picture with an elaborate and fantastic Gothic frame (fig. 13). All of these additions were removed in an ill-advised restoration when the panel entered the Museum of Fine Arts, reducing it to its present lamentable state. Nearly every aspect of this cleaning was misunderstood by Edgell, who mistakenly claimed that "completed the picture was revealed to be in an extraordinary state of preservation for a fourteenth century panel."

Though its condition precludes close stylistic analysis, there is no reason to doubt that the Boston Madonna was once an autograph production of Ambrogio Lorenzetti. It is not likely, however, to have been painted as early as is commonly supposed. The foreshortening of the Virgin's left hand and arm and what may be inferred of the volumes of both figures' bodies imply a dating close to the Sala della Pace frescoes in the Palazzo Pubblico, Siena, or the frescoed Maestà in Sant'Agostino: not earlier, that is, than the late 1330s, and possibly as late as the early 1340s. Such a dating has recently been supported by Erling Skaug's (1976) theory that a loose chronology for Ambrogio's panel paintings can be reconstructed from the use or absence of specific punch tools decorating their gold grounds. According to this theory, the Boston Madonna may be related to the 1342 Presentation in the Temple (Uffizi, Florence) and the 1344 Annunciation (Pinacoteca Nazionale, Siena). Though such evidence is not in its own right conclusive, it is not contra-

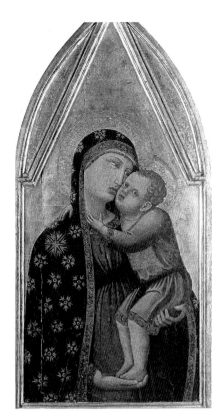

Fig. 13. Ambrogio Lorenzetti, *Madonna and Child* (as restored by Icilio Federico Ioni). Museum of Fine Arts, Boston

dicted by any other stylistic observations that may legitimately be drawn from the Boston Madonna.

"Barna da Siena"

THE IDENTITY of the artist conventionally known as "Barna da Siena" has become one of the most controversial topics in the modern study of early Italian painting. Vasari claimed that an artist named Barna was responsible for the frescoes of scenes from the New Testament in the nave of the Collegiata at San Gimignano, though Ghiberti, in his *Commentari*, had earlier described them as by a painter named Bartolo, perhaps confusing them with Bartolo di Fredi's Old Testament scenes on the opposite wall. In 1927, Peleo Bacci discovered an early graffito on the wall beneath the New Testament frescoes, claiming them as the work of "Lippo da Siena," and fifty years later G. Moran (1976) proposed discarding the name Barna altogether as a historical myth. Subsequent critical opinion has been divided between those favoring an attribution to "Lippo da Siena" (i.e. Lippo Memmi) for all the works formerly thought to be by Barna, and those who maintain a tangible difference in quality and expressive intensity between the paintings of Barna and the signed works of Lippo Memmi. Most writers concur in admitting a single stylistic milieu for all the paintings in question, and a convention for describing them all as "workshop of the Memmi," tentatively embracing the possibility that Barna might be Lippo Memmi's brother Federigo, has recently gained widespread acceptance.

The San Gimignano frescoes are among the most remarkable achievements of trecento painting in Central Italy. They are unmatched in their dramatic and expressive power by anything produced before Masaccio's frescoes in the Brancacci chapel, their spatial and compositional sophistication can be compared among contemporary works only to that of Ambrogio Lorenzetti, and their command of gesture and anatomical rendering is rivaled only in the paintings of Simone Martini and Pietro Lorenzetti. In all these respects they have little in common with the certain works of Lippo Memmi, other than morphological and decorative similarities which betray their origin in a common workshop experience. As there is no secure

Mystic Marriage of Saint Catherine

Tempera on panel
Overall: 138.9 x 111 (54⅝ x 43¼)
Picture surface: 134.8 x 107.1 (53⅛ x 42⅛)

Sarah Wyman Whitman Fund. 15.1145

Provenance: Robert McPherson, Rome, by 1858; William Blundell Spence, Florence, 1859; Alexander Barker, London (sale Christie's, London, 21 June 1879, lot 453); Captain Algernon Sartoris, Paris; Wildenstein, Paris

Literature: Gnoli, 1911, p. 339; "Sienese Primitive," 1916, p. 2; Fogg Art Museum, 1919, p. 106; van Marle, 1920, p. 125; idem, 1922a, pp. 41-44; Mather, 1923, p. 88; Edgell, 1924, pp. 49-52; van Marle, vol. 2, 1924, pp. 292-294; idem, 1925, pp. 43-45; idem, vol. 5, 1925, pp. 453-455; Brandi, 1928, p. 36; Weigelt, 1930, p. 84 fn. 65; idem, 1931, pp. 10, 12; Cecchi, 1931, p. 93; Berenson, 1932, p. 41; Edgell, 1932, p. 163; Venturi, 1933, pls. 92-95; Gabrielli, 1936, p. 127; Pope-Hennessy, 1946, pp. 35-37; Coletti, 1946, p. xxxi; Meiss, 1951, pp. 110-111; idem, 1955, p. 143 fn. 54; Zeri, 1957, p. 66; Volpe, 1960, p. 154; Carli, 1963, p. 36; Frinta, 1965, p. 261, fig. 31; White, 1966, p. 363; Berenson, vol. 1, 1968, p. 26; Laclotte, 1969, p. 13 n. 4; Delogu Ventroni, 1972, pp. 47-49; Fredericksen and Zeri, 1972, pp. 15, 564; Skaug, 1975, p. 150 fn. 4; Benedictis, 1976b, pp. 4, 9, 11; Maginnis, 1977, pp. 287-289; Caleca, 1977, p. 75; Torriti, 1977, p. 90; Lloyd, 1977, p. 16; Benedictis, 1979, p. 91, pl. 78; Fleming, 1979, p. 503 fn. 62; Polzer, 1981, p. 125, fig. 158; Previtali, 1985, pp. 29, 32, 112, fig. 45; Castris, 1988, p. 230 fn. 10; Martindale, 1988, p. 59; Boskovits, 1988, pp. 80, 114.

Condition: The panel, of a vertical wood grain, is approximately 2.5 cm thick and has been backed with a thick layer of wax resin. Three horizontal battens, 6.5 x 4 cm in section, are affixed to the back of the panel across the top, middle, and bottom, each secured with eight large, hand-cut nails. A vertical split in the panel extending its full height is visible through the figure of Saint Catherine, 27 cm from the left edge. The present engaged frame is a modern addition, though remnants of a gesso barb are visible along all four edges of the picture surface indicating that the original frame closely followed the present frame in placement. A network of cracks in the form of a large grid pattern, caused by the gesso underlayer covering an earlier image on the panel (see below), is plainly visible through the picture surface. The gold ground is very well preserved, with only minor scratches and abrasions, as is the gilt sgraffito decoration of Saint Catherine's robe and the tooled borders of the three small scenes below. The silver decoration of the border around the main scene has been reduced to bolus preparation, though the punch impressions there are clearly preserved, and the painted green and blue decoration in the border has blackened. The paint surface otherwise is extremely well preserved, except for retouchings in Christ's green robe and scars in the three small scenes at the bottom (the faces of Saint Margaret at the left and the conciliatory Angel in the center are substantially modern). The translucent glazes over the gilding in Saint Catherine's hair are intact.

THE UPPER THREE-QUARTERS of the panel are occupied by the full-length figures of Christ (right), wearing a blue mantle over a red robe and holding an orange book in his left hand, and Saint Catherine (left), wearing a red cloak lined with ermine over a white and silver (? now reduced to tarnished remnants and bolus) brocade dress with gold sleeves, cuffs, and collar. Saint Catherine, whose name is inscribed (SCA KATORINA) on the gold ground alongside her halo, holds a red book and a martyr's palm in the crook of her left arm, and extends her right hand to Christ, who places a wedding ring on her finger. Both figures overlap the silver (now red bolus), green, and blue border at the sides and top. Between them, seated on a throne or bench with Cosmatesque inlay, are the diminutive figures of the Virgin, in a blue mantle over a red dress, the Christ Child, in a gold brocade tunic and shawl, and Saint Anne, in plum-colored robes with a white headdress. The Child, who stands on the bench between the two older figures, holds a finch in his right hand and with his left reaches across to receive a rose offered him by Saint Anne. At the bottom of the panel are painted three small scenes in three distinct compartments separated from each other by thin painted strips and the punched borders of their gold grounds, but unified by a single continuous ground plane. At the left, Saint Margaret, wearing a red dress and wielding a hammer, subdues a demon, whom she holds by the horns with her left hand. The gold ground of this scene is inscribed SCA MARGARITA. At the right is Saint Michael, in a lavender cape over a white brocade robe, with a cross in his left hand and a sword raised in his right, subduing another demon. The exact subject of the center scene is not clear, but appears to be an angel or archangel, dressed in robes of blue and gold, presiding over the reconciliation of feuding enemies: two embracing warriors, that on the left clad in black, that on the right in pink, whose swords and shields lie discarded on the ground around them. Above this scene is a painted inscription: ARIGO DI NERI ARIGHETTI FECE FARE QUESTA TAVOLA.

This remarkable painting has been justly famous since its acquisition by the Museum of Fine Arts over seventy-five years ago, as much for its exceptional quality and beauty as for its unusual, if not unique, format and iconography and its endlessly disputed attribution. In scenes of the Mystic Marriage of Saint Catherine, the saint is usually wed to the infant not the adult Christ, as she is here. The group of Saint Anne, the Virgin, and the Christ Child (fig. 15) is one of the earliest such groupings extant, though it

basis for associating the historical name of Federigo Memmi with any known work of art, it seems prudent here to retain the conventional designation of "Barna," albeit in quotation marks (see also Volpe, 1982, pp. 186-187), to refer to paintings plausibly attributable to the author of the San Gimignano frescoes. The approximate period of this painter's activity is not possible to establish with confidence. The San Gimignano frescoes were traditionally thought to have been painted in the third quarter of the fourteenth century, though they are now more generally situated in the 1330s. None of the panel paintings related to them are likely to postdate the 1340s.

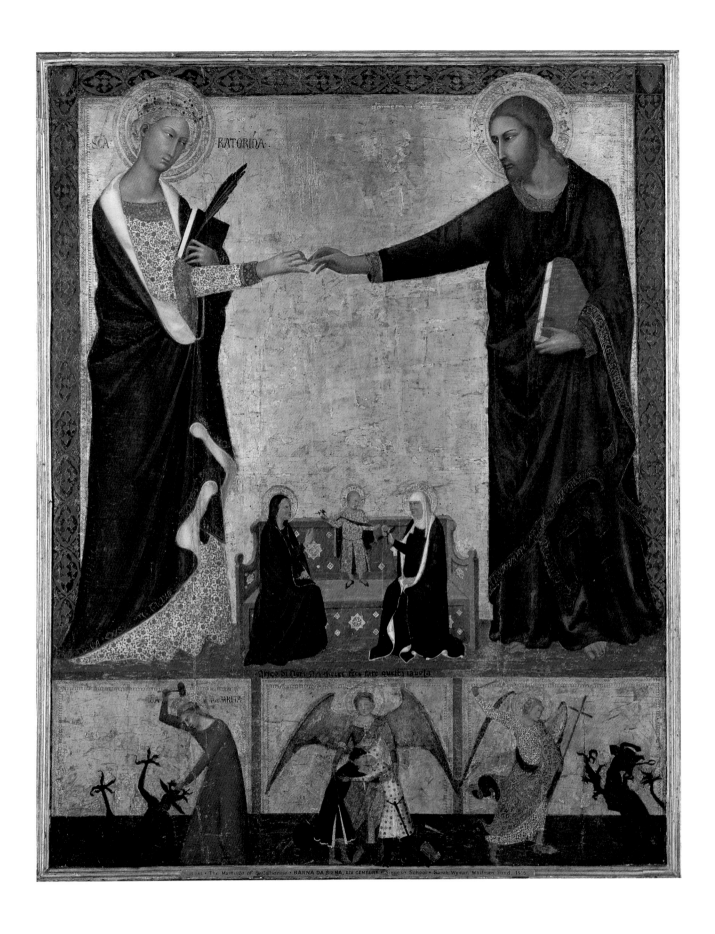

does not follow the form, known as the S. Anna Meterza of the Anna Selbsdritt, in which it would later become common, with the three figures seated on each other's laps (cf. Francesco Traini's version now in the Princeton University Art Museum). The scenes of Saint Margaret and Saint Michael in combat with demons at the lower left and right (figs. 14, 16) follow no known formal precedents in their highly sophisticated compositions, which were clearly designed for this specific context; and the central scene at the bottom, which lends the air of an ex-voto or commemorative offering to the entire picture, is of a topical immediacy unparalleled in fourteenth-century Italian painting, except perhaps in Simone Martini's fresco commemorating the exploits of Guidoriccio da Foligno. The inscription above this scene (there is no reason to believe this inscription is a later addition, as has frequently been claimed), recording the name of the picture's patron, undoubtedly relates to one or the other of the two warriors portrayed below, as must the now illegible coats of arms in the upper corners of the silver-gilt and painted border.

Though the style of the painting is unquestionably Sienese, an accumulation of circumstantial evidence suggests that it was not painted in Siena or for a Sienese patron. The name Arighetti is unknown in Sienese documents of the fourteenth century, yet the obvious expense of the commission, attested to by the lavish use of gold and silver on the panel, argues that its patron was a prominent citizen of his community. As has already been implied, the unusual iconography of the painting spawned no imitations in Siena or in any of the principal areas of Sienese influence, such as Pisa or San Gimignano. Finally, the painting is executed on a reused panel, which may be indicative of a provincial rather than an urban origin, where new, properly prepared panels might have been more readily available. Plainly visible beneath the present gilt and painted surface of the picture is the impression of an earlier composition, dividing the panel into a grid of twelve rectangular fields, four high by three across, covering approximately the right three-quarters of the panel, and a single vertical field extending the full height of the panel at the left, ending roughly at the cuff of Saint Catherine's extended right arm. Originally this panel was probably the right half of a dossal similar to that showing Saint John the Baptist Enthroned with scenes from his life in the Pinacoteca Nazionale at Siena (Torriti, 1977, p. 44), a type of altarpiece which must have been fairly common throughout Italy in the late

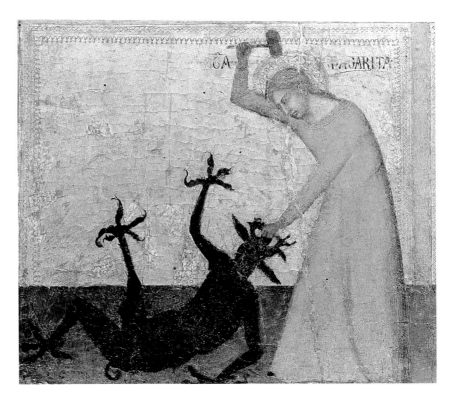

Fig. 14. Barna da Siena, *Saint Margaret Battling a Demon* (detail from the *Mystic Marriage of Saint Catherine*). Museum of Fine Arts, Boston

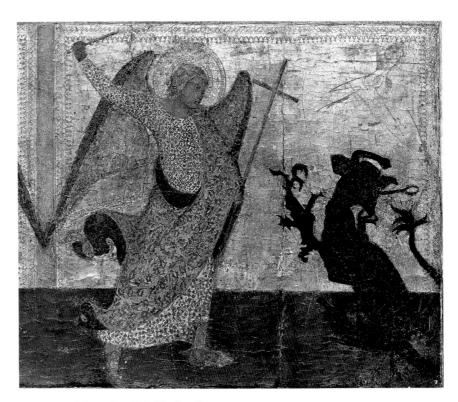

Fig. 16. Barna da Siena, *Saint Michael Battling a Demon* (detail from the *Mystic Marriage of Saint Catherine*). Museum of Fine Arts, Boston

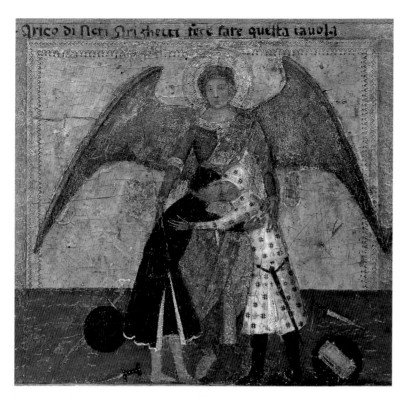

Fig. 15. Barna da Siena, *Saint Anne, the Virgin, and the Christ Child* (detail from the *Mystic Marriage of Saint Catherine*). Museum of Fine Arts, Boston

thirteenth and early fourteenth centuries.

As early as 1911 (Gnoli), the Mystic Marriage of Saint Catherine was recognized as belonging to a group of paintings produced in the orbit of Simone Martini, attributions for which have vacillated between Lippo Memmi, Barna da Siena, and the so-called Straus (see no. 51.783 below) and Palazzo Venezia Madonna Masters. For most scholars, beginning with van Marle (1920, 1922, 1924), the Boston panel has been a key work in reconstructing the artistic personality of Barna da Siena. Weigelt (1931) distinguished between the execution of Barna's San Gimignano frescoes and the Boston Mystic Marriage of Saint Catherine, and assigned the latter to a follower or assistant of Barna who also painted a Virgin and Child in the Percy Straus collection (now Museum of Fine Arts, Houston; fig. 17), christening him the Master of the Straus Madonna. Nearly all subsequent scholarship has been concerned with refining one or another of these two opinions. Pope-Hennessy (1946), for example, accepted the basic outlines of Weigelt's Straus Master; Meiss (1955) deleted the Boston Mystic Marriage of Saint Catherine from the list of paintings by the Straus Master; and Zeri (1957) reinserted it. Zeri renamed the painter the Master of the Ashmolean Crucifixion, after a painting first attributed to him by Offner (in Weigelt, 1931, p. 10), in an effort to minimize confusion with a later Florentine painter also

known as the Master of the Straus Madonna. Volpe (1960; followed by Boskovits, 1988) dismantled the oeuvre of the former Straus Master, assigning some of his works to Barna da Siena and the rest, including the Boston Mystic Marriage of Saint Catherine, to the so-called Master of the Palazzo Venezia Madonna, a follower of Lippo Memmi if not actually a phase of that artist's late career. Delogu Ventroni (1972) further fragmented these groupings, returning to an attribution to Barna for the Boston panel, while de Benedictis (1976, 1979) resurrected the Master of the Straus Madonna, whom she tentatively identified as Simone Martini's brother Donato, attributing the Boston Mystic Marriage to him along with a miscellaneous group of paintings selected from all previous lists of works by Barna, the Master of the Ashmolean Crucifixion, and Lippo Memmi.

More recent criticism, refocused from attributional debates onto the question of whether or not the Vasarian personality of Barna da Siena ever existed (Bacci, 1927, pp. 249-253; Moran, 1976a, pp. 76-80), assigns most if not all the works formerly grouped under Barna's name, including the Boston Mystic Marriage, to Lippo Memmi (see, for example, Caleca, 1977; Fahy, oral communication, 1985), or to the even more evasive rubric "Chompagno di Simone" or "Bottega dei Memmi," by which is intended any member of the anonymous team of artists working in the studio shared by Simone Martini and Lippo Memmi.

The case for conflating the personalities of Lippo Memmi and "Barna da Siena" is somewhat tenuous, resting largely on the interpretation of an early graffito beneath the frescoes at San Gimignano and on some undemonstrated assumptions concerning a small group of problematic pictures related to both artists' work. Seven panels (Altenburg, Palermo, Douai, and Pisa) generally thought to have been painted by Barna da Siena, for example, have recently been identified as the dispersed fragments of an altarpiece from San Paolo d'Arno, Pisa, reported by Vasari to have borne Lippo Memmi's signature (Mallory, 1975, pp. 9-20; Caleca, 1977), but the evidence for such an identification is purely circumstantial. Another of the linchpins of the argument identifying Barna with Lippo Memmi is an altarpiece in Casciana Alta (Pisa) which has been attributed to Barna (Bellosi, 1974, p. 94) and assumed without comment to be an autograph work by Lippo Memmi (Caleca). This altarpiece, which originally stood in the Chapel of Saint Stephen in the Duomo, Pisa, instead appears not to have been painted either by Memmi himself or by the so-called Barna, but by a Pisan master in conscious imitation of models by both these artists.[1]

Fundamental to an attempt at clarifying this situation is a more rigorous distribution of paintings on stylistic and technical grounds into groups that may be considered the work of a single artist. In this writer's opinion, only three panel paintings can with complete confidence be assigned to the same artist responsible for the Boston Mystic Marriage of Saint Catherine: a Madonna and Child in the Museo della Collegiata at Asciano, once the center panel of a polyptych no other members of which are known to survive; a small Crucifixion and Lamentation in the Ashmolean Museum, Oxford; and an Annunciation in the Staatliche Muséen, Berlin-Dahlem, which once formed a diptych with the Oxford panel. These paintings all share the same unusual figure style and canon, drapery forms, precision and delicacy of technique, sophisticated decorative sense (which, as Polzer, 1981, correctly points out, is markedly different from Lippo Memmi's, though the two artists share some punch tools between them), and highly charged emotive effects. These same characteristics, translated to a different medium and executed on a different scale, are also clearly discernible in the majority of the Passion frescoes in the Collegiata at San Gimignano,[2] traditionally attributed to Barna da Siena.

A small number of other panels share one or more characteristics with this

"core group" and may or may not be the work of the same artist, including: four full-length seated saints on faldstools now divided between Altenburg, Palermo, and Pisa, together with three pinnacle panels (Douai and Altenburg) reasonably supposed to have come from the same altarpiece; a double-sided panel (transferred to canvas with some attendant impairment of legibility) in the Louvre showing the Fall of the Rebel Angels and Saint Martin dividing his cloak; an Assumption of the Virgin in the Alte Pinakothek, Munich (the Louvre and Munich paintings in particular may be compared with the small scenes painted at the bottom of the Boston Mystic Marriage of Saint Catherine); and a diptych in the Museo Horne, Florence, showing the Madonna and Child and the Man of Sorrows. All the paintings in this last list show greater affinities to the recognized style of Lippo Memmi than do the panels and frescoes in the first group. While it has been claimed that they were painted by Lippo in an as yet undocumented stage of his career, it would be more reasonable to suggest, if only tentatively, that they were executed in Lippo's workshop perhaps by the author of the Boston Mystic Marriage of Saint Catherine, the putative "Barna da Siena," who in any event seems to have been trained there.

1. The Casciana Alta altarpiece may in fact prove to be an early work, possibly executed in Lippo Memmi's workshop, by Giovanni di Nicola da Pisa, whose mature style it closely resembles. A little known document (Archivio di Stato di Siena, Biccherna 390, memoriale from July to December 1326, f. 125r.) first published by Bacci, (1944, p. 149), establishes the presence of Giovanni di Nicola in Memmi's entourage: "anne a[v]uti per detto tenpo uno fiorino doro in mano di giovanni suo [i.e. Lippo's] disciepolo da pisa." See also G. Vigni, 1949, p. 319; and for further thoughts on the complex legacy of Lippo Memmi's workshop in Pisa, G. Chelazzi Dini, 1988, pp. 175-182.

2. Those scenes traditionally attributed to Giovanni d'Asciano, said by Vasari to have assisted Barna in this work, may well be slightly later restorations of Barna's frescoes rather than contemporary efforts by an assistant. They are clustered in groups that cannot be explained by reference to the usual working methods of teams of artists (cf. Faison, 1932, p. 286) but which could reflect the progress of damage from water seepage, and include random heads or parts of figures inserted into frescoes otherwise completely by the hand known as Barna. The style of these frescoes, furthermore, may more readily be explained by comparison to the later work of Bartolo di Fredi, after 1380. The artist responsible for them, certainly trained provincially and probably active not earlier than the last two decades of the fourteenth century, if not as late as the first third of the fifteenth century, may have been responsible for the graffito beneath the frescoes discovered by Bacci (1927), the primary basis for their reattribution to Lippo Memmi.

Master of the Straus Madonna

AN ANONYMOUS FOLLOWER of Simone Martini, Lippo Memmi, and "Barna," whose works are sometimes confused with those of the latter, the Master of the Straus Madonna was named by Weigelt (1931) after a picture in the Percy Straus collection, now in the Museum of Fine Arts, Houston. Attributions to the Master of the Straus Madonna have frequently been contested, and distinctions between his work and that of another Simonesque painter isolated by Weigelt, the Master of the Palazzo Venezia Madonna, have often been blurred. Zeri (1957) proposed renaming the painter the Master of the Ashmolean Crucifixion – after a painting attributed to him by Offner – to avoid confusion with a later Florentine artist also known as the Master of the Straus Madonna, but the Ashmolean Crucifixion and the Straus Madonna are not by the same hand (see no. 15.1145 above). The earliest works plausibly attributable to the Straus Master cannot be dated before 1340, and the affinity of his decorative vocabulary to that of Bartolomeo Bulgarini suggests that he remained active through the 1350s.

17

Bishop Saint

Tempera on panel
Overall: 34.8 x 30.5 (13¹¹⁄₁₆ x 12)
Picture surface: 30.8 x 26 (12⅛ x 10¼)

Charles Potter Kling Fund. 51.738

Provenance: Purchased in Italy before 1850 by Joshua Nash; Arthur C. Nash, Washington, D.C., 1951

Literature: Edgell, 1953, pp. 7-11; Meiss, 1955, pp. 142-145; Volpe, 1960, p. 154; Berenson, vol. 1, 1968, p. 404; Fredericksen and Zeri, 1972, pp. 109, 565; Benedictis, 1979, p. 91; Beatson et al., 1986, p. 626 fn. 85.

Condition: The wood panel support, 3.1 cm thick, has been cut along the bottom edge but is otherwise in excellent condition. The worn and abraded engaged frame that remains on either side of the panel is original; a beard of gesso along the bottom edge indicates that the picture field has not been cropped. The gilt background and the punch marks in the haloes are well preserved with only minor abrasions. The gilt decorations and punch marks in the vestments of the bishop are also in good condition but show more scattered flaking losses. The paint layer is fairly well preserved but there are numerous small retouched losses and abrasions overall, especially in the hands, books, and lower portions of the bishop's chasuble along the bottom edge where the panel was cut.

THE HALF-LENGTH FIGURE of a bearded episcopal saint, clad in a mitre and chasuble, faces three-quarters to the left. He looks upward and holds a red, a green, and an orange book between white gloved hands, the lower corners of the books resting against the bottom edge of the panel. The saint's chasuble is blue with a punched gilt floral design and red (formerly silver?) border. His orphrey is gilt and he wears a white pallium with a red floral design across his shoulders.

Aside from an old attribution to Ambrogio Lorenzetti which this panel bore at the time of its purchase by the Museum, an attribution defended by Edgell (1953) and repeated in Fredericksen and Zeri (1972, p. 109), it has always been considered in relation to the highly problematic group of works associated with the name of Barna da Siena (see 15.1145, above). Meiss (1955) proposed isolating a small Crucifixion in the Ashmolean Museum, Oxford (incorrectly discussed as in the Fitzwilliam Museum), and its pendant Annunciation in Berlin, a Madonna and Child in the Straus collection in Houston (fig. 18), and the present panel as works by a single hand distinct from those traditionally held to be by Barna. Volpe (1960) conflated Meiss's group, less the Straus Madonna, with the group of pictures generally identified as by the so-called Master of the Palazzo

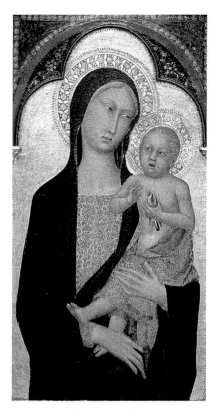

Fig. 17. Master of the Straus Madonna, *Madonna and Child*. Straus Collection, Museum of Fine Arts, Houston

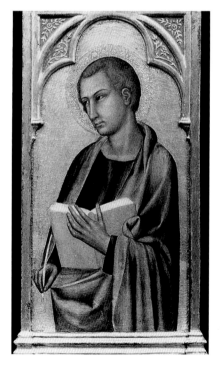

Fig. 18. Master of the Straus Madonna, *Saint John the Evangelist*. Griggs Bequest, Yale University Art Gallery, New Haven, CT

Venezia Madonna (Weigelt, 1931, pp. 1-13), adding to these the Boston Mystic Marriage of Saint Catherine (see no. 15.1145 above). Benedictis (1979) returned to Meiss's proposal, adding to his group the Boston Mystic Marriage of Saint Catherine and a miscellaneous selection of panels from the workshop of Lippo Memmi, primarily ancillary fragments of an altarpiece previously reconstructed by Mallory (1974, pp. 187-202).

Considering the relative merits of these and other arguments, it must be categorically affirmed that the two panels in Boston, the Mystic Marriage of Saint Catherine and the Bishop Saint, were not painted by the same artist. Though self-evidently produced in the same artistic milieu, they are conceived in radically different techniques: exceptionally precise and refined, decorative, and minutely attentive to the orderly regularity of detail in the Mystic Marriage; broad, approximate, and descriptive rather than decorative, with a haphazard concern for detail in the Bishop Saint. Of the group of pictures discussed by Meiss and Benedictis, only the Madonna and Child in the Straus collection is sufficiently like the Boston Bishop Saint in this way to suggest that they may be the work of a single artist. The Oxford/Berlin diptych instead shares its morphological details, its precision of technique, and its decorative sensibility with the Mystic Marriage of Saint Catherine, and like that picture relates more securely to the personality identified as Barna da Siena.

The Straus Madonna, like the Boston Bishop Saint, has been the subject of a confusing range of opinions and attributions, again centered around its possible relationship to the problematic Barna da Siena. Aside from questions of attribution, the most important contribution to the study of this panel is by Pope-Hennessy (1946, pp. 35-37), who correctly disassociated it from a half-length Saint Agnes in the Worcester Art Museum, previously connected with it by Weigelt (1931), and identified instead a half-length Saint John the Evangelist in the Griggs bequest to the Yale University Art Gallery (fig. 18) as a probable lateral panel from the same polyptych. The Griggs Evangelist corresponds closely enough to the Boston Bishop Saint in figure type (their difference in scale notwithstanding), painting technique, and punch tooling and patterns that it is tempting to identify the latter as the excised pinnacle once standing above the former. Though physical proof for associating them as fragments of a single altarpiece is lacking, they are clearly the work of a single artist.

At least two of the seven punch tools used to decorate the gold grounds of the Boston Bishop Saint, the Griggs Evangelist, and the Straus Madonna appear to be unique to this artist. They are found again in three further panels presently attributed to the Master of the Palazzo Venezia Madonna: two full-length saints in the Staatens Museum for Kunst in Copenhagen and a Mystic Marriage of Saint Catherine in the Pinacoteca Nazionale in Siena (Sani, 1985, pp. 107-109). All of these, and especially the Siena Mystic Marriage, are so closely related in style to the Boston, Griggs, and Straus panels as to permit the conclusion that they too are works by the same master who, for the sake of convenience but at the risk of confusion with the treatment of the name in earlier literature on Sienese painting, may be styled the Master of the Straus Madonna. This master must certainly have appeared first either in the workshop of Barna or of Lippo Memmi, hence the confusion of his works with theirs and with those of the so-called Palazzo Venezia Madonna Master (probably late works from Lippo Memmi's workshop), but the six panels discussed here can only have been produced as independent works by a personality distinct from theirs. The recent and largely convincing attempt to identify the Copenhagen saints as lateral panels to Bartolomeo Bulgarini's Nativity altarpiece in the Fogg Art Museum (Beatson et al., 1986), painted for the cathedral in Siena in 1351, may establish an approximate chronological vicinity for the activity of the Master of the Straus Madonna, as well as a partial explanation for the development of his decorative tastes away from the more purely Simonesque and towards those favored by Bulgarini in the third quarter of the fourteenth century.

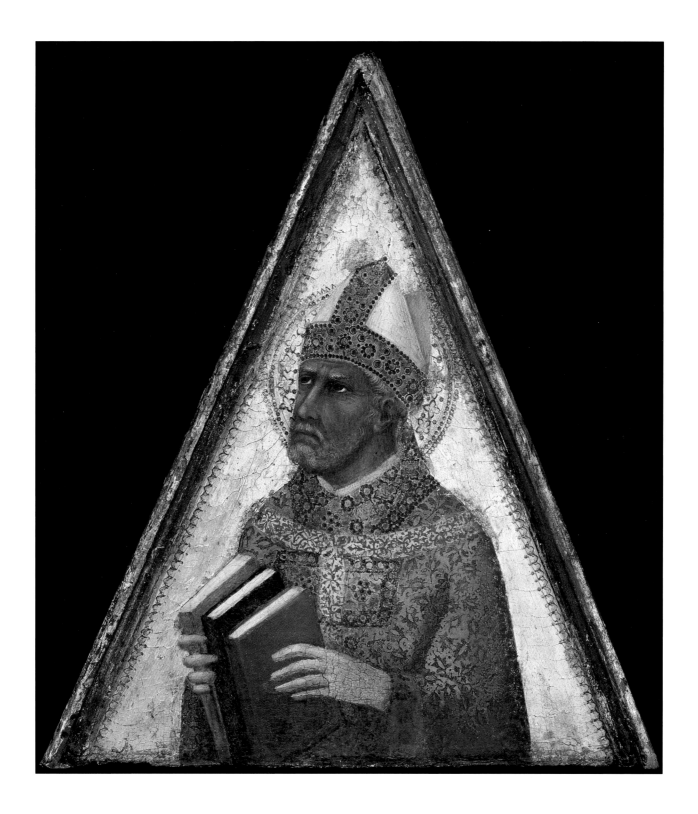

Naddo Ceccarelli

TWO SIGNED PAINTINGS by Naddo Cecca-relli – a Man of Sorrows in the Liechten-stein collection, Vaduz, and a Virgin and Child of 1347, formerly in the Cook col-lection, Richmond – and a number of other panels, primarily small-scale devo-tional works, which may be associated with these, reveal the artist to have been a follower of Simone Martini, probably trained in the latter's shop in Siena in the 1330s. He is commonly supposed to have accompanied Simone to Avignon around 1336, but like his contemporaries Bar-tolomeo Bulgarini and Jacopo di Mino del Pelliciaio, Ceccarelli was also much influenced by the paintings of Ambrogio Lorenzetti from the late 1330s and 1340s, especially by Ambrogio's palette and firm sense of modeled volumes. Cecca-relli was a highly refined technician, and his use of tooled gilt and silver decora-tion is among the most sophisticated of the Sienese trecento. Nothing is known with any certainty of the span of his career. He probably lived into the 1360s, when a leading painter of the following generation, Paolo di Giovanni Fei, seems to have been trained in his shop, but his name does not appear on the register appended to the statutes of the painters' guild in 1363.

Crucified Christ with the Virgin and Saint John the Evangelist

Tempera on panel
Overall: 21.9 x 15.2 (8⅝ x 6)
Picture surface: 18 x 11.5 (7⅛ x 4½)

Gift of Mrs. W. Scott Fitz. 16.117

Provenance: Della Genga, Assisi; Contessa Pucci; Mariano Rocchi, Rome, 1911; Prince Golinicheff-Koutouseff; Nicolas Riabouchinsky; Kleinberger Galleries, New York, 1916; Mrs. W. Scott Fitz

Literature: Perkins, 1907, p. 84; Stiavelli, 1909; Rocchi, 1911, pp. 38, 46; "Crucifixion," 1916, p. 27; Perkins, 1920a, pp. 273, 277; van Marle, 1920, p. 110; idem, vol. 2, 1924, pp. 272, 274; Berenson, 1926a, p. 300; idem, 1930a, p. 110; idem, 1932, p. 528; Edgell, 1932, p. 104, fig. 112; Schorr, 1940, p. 69 fn. 47; Meiss, 1951, p. 149 fn. 69; Berenson, vol. 1, 1968, p. 404; Fredericksen and Zeri, 1972, pp. 239, 564; Benedictis, 1979, pp. 28, 79, fig. 42.

Condition: The wood panel, of a vertical grain, is 7 mm thick and has been neither thinned nor cradled; the gesso and red-pigmented coating of the back is original. Exposed worm tunnels visi-ble along the left and right edges indicate that the panel has been trimmed at the sides. No such damage is visible along the top and bottom edges, though it is likely that the panel has been reduced in height as well. A diagonal hole stained black (from prolonged contact with iron) near the top left edge may indicate the removal of a hinge at that spot, though no corresponding hole is evident at the bottom of the panel. A continuous beard of gesso from the removal of an engaged frame is visible along all four edges of the picture surface. The gold ground and paint layers are extremely well preserved, with minimal abrasions and only a few scattered flak-ing losses.

THE CENTER OF THE PANEL is filled with the figure of Christ on the Cross, blood pouring from his hands, feet, and side and running in rivulets down the hill of Golgotha. Seated on the ground at the lower left is the mourning Virgin in a red dress and blue cape, her hands clasped before her. Opposite her on the right is Saint John the Evangelist, his chin on his right hand and his left hand on his knee. Both figures are painted on a much larg-er scale than the Crucified Christ.

Aside from an ascription to Giotto it bore in the Della Genga and Rocchi col-lections, this highly refined little panel has always been recognized as the work of a close follower of Simone Martini. It was acquired for the Museum of Fine Arts with an attribution to Lippo Mem-mi, supported by Perkins (1907, 1920), Sirén (letter in Museum files, 1915), Math-er (letter in Museum files, 1916), Beren-son (letter in Museum files, 1916) and van Marle (1920). The attribution to Lippo Memmi seems to have been questioned first by Max Friedländer (letter in Muse-

um files, 1924), and it was then repub-lished as by a follower of Memmi by van Marle (1924), and by Berenson (1926, 1930, 1932) as by a follower of Simone. Subsequent references have echoed these opinions without further elaboration, except that Benedictis (1979) considered it specifically the work of an Avignonese follower of Simone Martini, and Boskovits (letter in Museum files, 1978) thought it could be by Simone himself, contemporary to the large Crucifix at San Casciano Val di Pesa. Joseph Polzer (letter in Museum files, 1987) rejected an attribution to Simone, pointing out that none of the punch tools used to decorate the gold ground appear in any autograph works by that master, though several are to be found in the work of Naddo Ceccarelli.

In style the Boston panel depends strongly on the small-scale works of Simone Martini, especially the Orsini polyptych, and it must be presumed to have been painted by an artist intimately associated with Simone's shop in its later years. That this artist was Naddo Cecca-relli is suggested not only by Polzer's observations concerning the panel's punch tooling, but also by the almost identical spatial, emotional, and decora-tive sense evinced by that painter in all the smaller works plausibly attributed to him. Especially close is Ceccarelli's Cru-cifixion in the Walters Art Gallery, Balti-more (see Zeri, vol. 1, 1976, pp. 42-43, pl. 20), where the figure of Christ is visual-ized with almost identical facial features and anatomy, and the round, expressive head of Saint John the Evangelist relates (on a smaller scale) to that of his coun-terpart in the Boston panel. The some-what stiff, distinctive arabesque, traced in gold, of the falling drapery hems on the Boston panel may be compared to that in a small panel showing the Virgin Annunciate in the Stoclet collection (see Frinta, 1983, p. 233 fig. 13), or to the robes of the standing Virgin in a painted reli-quary also in the Walters Art Gallery (Zeri, vol. 1, 1976, pp. 43-44, pl. 21), while the unusually sophisticated device of aligning the knuckles of the Virgin's clasped hands in a fanlike pattern, accen-tuated by the light raking across them from the left, may be compared to the similarly decorative "isocephalism" of fingers in nearly all of Ceccarelli's paint-ings (Benedictis, 1974, pp. 139-154).[1]

Though an attribution to Ceccarelli for the Boston panel can be advanced with some confidence, it has not yet proven possible to deduce a chronologi-cal framework for that artist's career, and suggesting an approximate date for this picture would be little better than guess-work. Nor is it possible to be certain

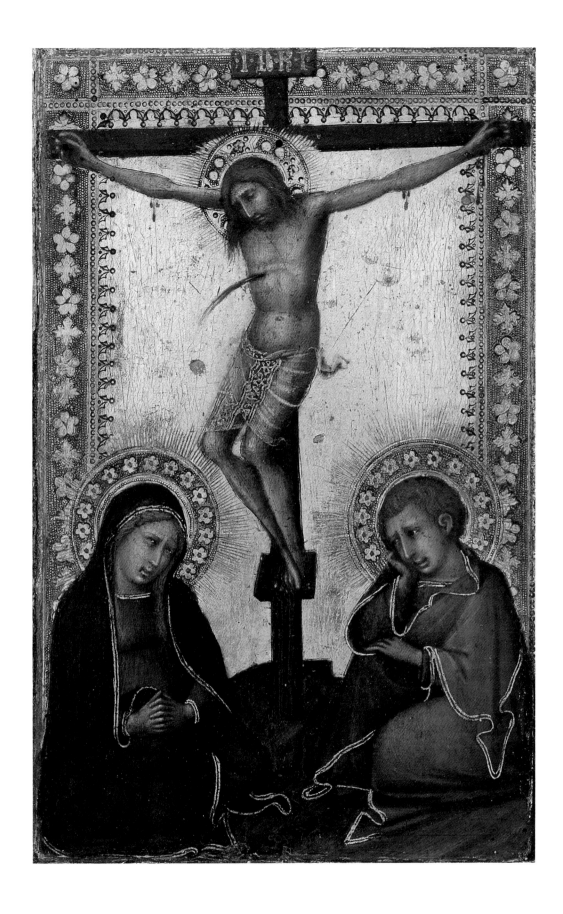

what purpose this little panel was origi-
nally meant to serve. Its size and format
suggest that it was painted as a valve of a
diptych, probably paired on the left with
a similar panel showing the Virgin and
Child. Evidence, however, that it ever
bore hinges which would have secured it
in such a complex is contradictory. Its
subject, the Crucified Christ attended by
the *seated* Virgin and Saint John, is rare in
trecento painting (see Berenson, 1926,
1930; Schorr, 1940) and is generally
encountered in altarpiece pinnacles or in
the painted gables of small devotional
panels, such as Francesco di Vannuccio's
triptych no. 183 in the Pinacoteca
Nazionale, Siena (Torriti, 1977, p. 162). It
is unlikely that the Boston panel once
stood in the pinnacle of some larger
structure: its shape would be highly
unusual if not unprecedented in such a
context, as would the relative thinness of
its panel support and the treatment of its
reverse. It may have been meant for use
as a pax, as is reasonably supposed to be
the case with a Head of Christ attributed
to the Master of the Orcagnesque Miseri-
cordia in the Metropolitan Museum of
Art, New York (1981.365.2), though too
few comparable objects survive to be
certain of such a contention.

1. Benedictis incorrectly attributes figures 4 and
15 in this article to Ceccarelli. Figure 10, now in
the collection of the Chrysler Museum, Norfolk,
Virginia, is too severely damaged and retouched
to allow certain attribution.

Niccolò di Ser Sozzo di Stefano

MISTAKENLY ASSUMED since the eighteenth
century to have been the son of the
noble Ser Sozzo di Francesco Tegliacci,
and therefore connected with a number
of documented political events and activ-
ities unrelated to his career as a painter,
Niccolò di Ser Sozzo was recently
(Moran, Fineschi, "Niccolò di Ser Sozzo
—Tegliacci or di Stefano?" *Paragone* 321,
1976, pp. 58-63) shown instead to have
been the son of a minaturist, Ser Sozzo
di Stefano, with whom he probably
trained. The earliest preserved notice of
Niccolò, unfortunately unconnected
with a work of art, is of 1348, though it is
generally assumed that he was active a
decade or more before this date. Niccolò
di Ser Sozzo's artistic personality, heavily
influenced by the example of Pietro
Lorenzetti, had traditionally been known
only on the basis of a single signed work,
an undated miniature of the Assumption
in the Archivio di Stato, Siena, until the
discovery (Brandi, "Niccolò di Ser Sozzo
Tegliacci," *L'Arte*, 1932, pp. 223-236) of his
signature, coupled with that of Luca di
Tommè, and the date 1362, beneath the
polyptych no. 51 in the Siena Pinacoteca,
permitting the attribution to him of a
number of large-scale paintings which
had previously been considered the work
of Bartolo di Fredi (q.v.). The exact divi-
sion of labor between Luca di Tommè
and Niccolò di Ser Sozzo on the 1362
altarpiece, and therefore the exact out-
lines of each painter's oeuvre, is still a
matter of scholarly debate. Niccolò di
Ser Sozzo first registered in the painters'
guild in 1363, the year of his death.

Francesco Neri da Volterra

THOUGH HE WAS BORN IN Volterra and is
documented working there in 1338, 1339,
and 1343, Francesco Neri must have
received his artistic training in Florence,
probably in the workshop of Bernardo
Daddi. By 1346 he is recorded in Pisa,
where in all likelihood he spent most of
the remainder of his career. He is last
mentioned there at work in the Cam-
posanto, from 1369 to 1371, and he died
sometime before 1386 (for a résumé of
the documents pertaining to Francesco
Neri, see M. Battistini, 1925, p. 110). His
artistic personality may be reconstructed
on the basis of one signed painting, a
Madonna and Child in the Galleria
Estense at Modena, and a small handful
of panel paintings closely related to it in
style. Roberto Longhi (1953) must be
credited with the rediscovery of
Francesco Neri as a leading influence on
Pisan painting of the second half of the
fourteenth century, as well as for recog-
nizing the essentially Florentine charac-
ter of his art. A fuller discussion of the
artist and his significance, as well as an
extended list of attributions to him, was
proposed by Boskovits (1967, 2, pp. 3-11).

19

Niccolò di Ser Sozzo

Triptych:

The Dormition and Assumption of the Virgin (center) *with Saints Augustine and Peter* (left) *and Saint John the Evangelist and a Deacon Saint* (right)

Tempera on panel
center:
Overall: 200.2 x 89.1 (78 ¹³⁄₁₆ x 35⁵⁄₁₆); Picture surface: 198 x 87.3 (78 x 34⅜)
left:
Overall: 137.8 x 54 (54¼ x 21¼); Picture surface: 122.5 x 50.5 (48¼ x 19⅞)
right:
Overall: 137.8 x 54.3 (54¼ x 21⅜); Picture surface: 122.5 x 50.5 (48¼ x 19⅞)

Francesco Neri da Volterra

Pinnacles to an altarpiece:
The Blessing Christ (center) *with King David, Saint John the Evangelist, and an Angel* (left) *and King Solomon, Ezekiel, and an Angel* (right)

Tempera on panel
center:
Christ Blessing (diameter): 20 (7⅞)
left:
Overall: 72.4 x 54 (28½ x 21¼)
King David: 29.5 x 19.6 (11⅝ x 7¾)
Saint John: 29.3 x 19.4 (11½ x 7⅝)
Angel (diameter): 19.4 (7⅝)
right:
Overall: 82.2 x 54.1 (32⅜ x 21¼)
King Solomon: 28.2 x 19.2 (11⅛ x 7½)
Ezekiel: 28.2 x 19.2 (11⅛ x 7½)
Angel (diameter): 20.6 (8⅛)

Gift of Martin Brimmer. 1883.175 a, b, c

Provenance: Giuseppe Toscanelli, Pisa (sale Florence, 20 April 1883, lot 110); Bought for the Museum of Fine Arts by Martin Brimmer and presented by him as a gift in 1883

Literature: Milanesi, 1883, pp. 28, 103-104, pl. xxvi b; Crowe and Cavalcaselle, vol. 3, 1885, p. 247; Reinach, vol. 1, 1905, p. 481; Perkins, 1905, p. 74; Crowe and Cavelcaselle, vol. 3, 1908, p. 125; Berenson, 1909, p. 139; Sirén, 1916, p. 38; van Marle, vol. 2, 1924, p. 493; Edgell, 1932, p. 167, fig. 215; Berenson, 1932, p. 312; Offner, sec. 3, VIII, 1934, pp. 155-157; Meiss, 1951, pp. 22, 169-170; Carli, 1955, p. 158, p. 158; Zeri, 1958b, pp. 9, 12; Klesse, 1967, p. 426; Berenson, vol. 1, 1968, p. 425; van Os, 1969a, p. 171; Bellosi, 1974, p. 97, figs. 214, 215; Benedictis, 1976, p. 118 n. 28; Frinta, 1976, p. 298; Maginnis, 1977, p. 296; Fehm, vol. 2, 1978, pp. 156, 163 fn. 2; Benedictis, 1979, p. 80; Skaug, 1983, p. 268; Fehm, 1986, p. 27; Boskovits, 1989, p. 78; van Os, vol. 2, 1990, pp. 141, 144 fig. 142, 221 fn. 108-110; Harpring, 1993, pp. 92, 95.

Condition: The framing elements uniting all six panels into a single structural unit are modern. None of the panels appears to have been altered in width to accommodate them to this structure, except that the right edge of the right pinnacle may have been trimmed slightly. All six panels were altered significantly in height. The center panel has been thinned to a depth of 1.7 cm and cradled. A vertical split extends the entire height of the panel just to the right of center and a partial split 17 cm from the left edge extends one-third the height of the panel from the bottom. The other five panels retain their original thickness and are generally well preserved. The left and right panels of the main register and the left pinnacle are composed of single vertical planks of wood; the right pinnacle is composed of three vertical planks, and the center pinnacle of two. The left pinnacle exhibits two vertical splits, one through each of the lower picture fields, and has been truncated and rebuilt with a 7-cm high triangular insert at the top and a 4.6-cm tall addition across the bottom.

The gilding in the pinnacles, both of the pastiglia spandrels and the ground within the picture fields, is well preserved. The paint surface of the four half-length figures is also well preserved, having suffered only minor abrasions. The glaze layers of all three angels, however, are badly worn, and the right half of the central angel has been effaced completely and repainted. The gold grounds in the three panels of the main register are extremely worn, with extensive local regilding and broad areas of exposed bolus. The paint surfaces in all three panels have also been severely abraded and are heavily retouched, especially the faces and hands of nearly all the figures, which are largely reconstructions. Exceptions are the faces of the risen Virgin and of the angels suporting her mandorla at the top of the center panel, which are mostly intact aside from losses along the split in the panel. The mordant gilt, punched, and sgraffito decorations in the robes of the four full-length saints in the lateral panels are almost entirely modern reconstructions, except that the silver gilt embroidery on Saint Augustine's robes in the left panel and the white and silver embroideries on the deacon saint in the right panel are well preserved: though the silver has blackened, they have suffered only minor losses and retouching.

THE LOWER HALF of the center panel is filled with a scene of the death of the Virgin. The body of the Virgin, wrapped in a black cloth and a white cowl, is laid onto a wooden bier by Saint John the Evangelist. Saint Peter, at her head, and the other Apostles circled around her read the office of the dead, while angels bearing candles and censers attend at the sides. Christ, in gilt robes, stands behind the bier and receives the Soul of the Virgin, in the form of a small child, into his arms. In the upper half of the panel is the figure of the Virgin enthroned in a blue mandorla, borne to heaven by a chorus of angels singing and playing instruments. An octolobe roundel in the pinnacle shows the half-effaced figure of Christ blessing.

The left lateral panel shows full-length figures of Saints Augustine, in bishop's mitre and cope, and Peter, in his traditional colors of yellow and blue and holding two keys, both looking up

toward the central scene of the Assumption of the Virgin. In the pinnacle above them, under a pair of ogival arches, are half-length figures of King David, holding a scroll inscribed "Elevata est magnificentia tua super caelos" (Psalm 8:2), and Saint John the Evangelist, holding a scroll inscribed "Signum magnum apparuit in celo mulies amicta sole et luna sub pedibus eius" (Revelations 12:1). Above these figures is an octolobe roundel with a half-length angel in profile, looking up in adoration at the roundel of Christ Blessing in the central pinnacle.

The right lateral panel shows full-length figures of a deacon saint holding a large red book and looking down toward the Death of the Virgin in the center panel, and Saint John the Evangelist, bearded, holding a pen and a book, and looking up toward the Assumption of the Virgin in the center panel. In the pinnacle above them, under a pair of ogival arches, are half-length figures of King Solomon, holding a scroll inscribed "Numeri decem – elevata est nubes de tabernaculo federis" (Numbers 10:11), and Ezekiel, holding a scroll inscribed "Elevata est altitudo eius super omnia ligna regionis" (Ezekiel 31:5). Above these figures is an octolobe roundel with a half-length angel in profile, looking up in adoration at the roundel of Christ blessing in the central pinnacle.

When it first appeared in the Toscanelli sale of 1883, Gaetano Milanesi attempted to identify this triptych with a documented alarpiece of 1389 painted by Bartolo di Fredi, Luca di Tommè, and Andrea di Bartolo for the Cathedral in Siena. Milanesi's attribution was based in part on the collaborative nature of the complex, the main panels and pinnacles being by different hands, and in part on the resemblance of the three principal scenes to paintings then believed to be by Bartolo di Fredi, notably the Assumption of the Virgin altarpiece from Monteoliveto di Barbiano at San Gimignano and the polyptych no. 51 in the Siena Pinacoteca. Milanesi did add the caution that "si à première vue on ne retrouve pas dans nôtre tableau les qualités du maître, on doit l'attribuée en partie à la mauvaise restauration...." An attribution to Bartolo di Fredi, as one of that artist's key works, persisted until 1932, when the signatures of Niccolò di Ser Sozzo and Luca di Tommè, and the date 1362, were discovered beneath the polyptych no. 51 in Siena. In that same year, Berenson changed his attribution for the Boston triptych to Luca di Tommè (to whom he also attributed the San Gimignano Assumption), and though Bartolo di Fredi's name has been mentioned in con-

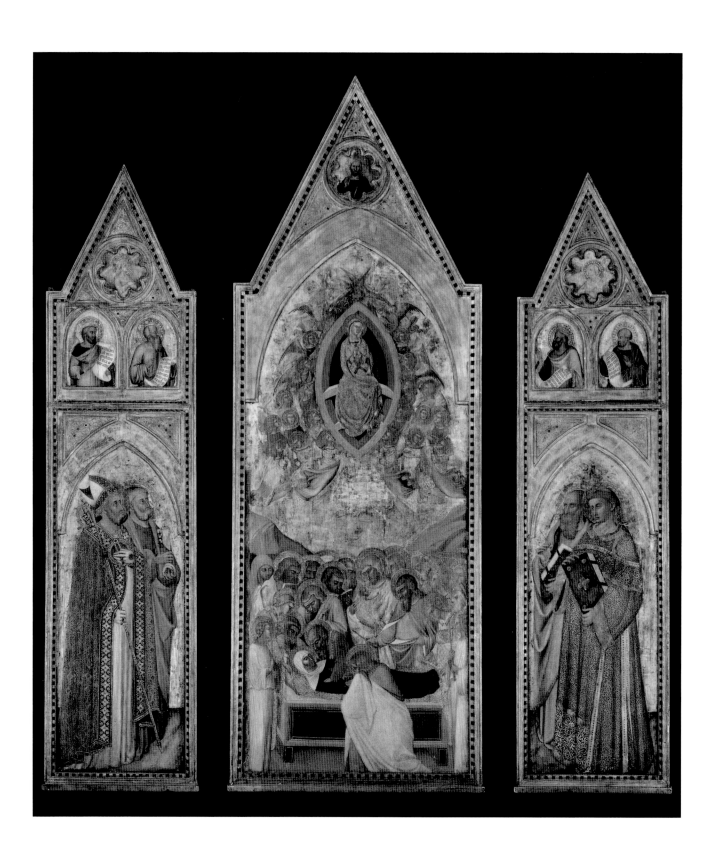

102 (cat. 19)

nection with the picture on occasion since then (Edgell, 1932; Carli, 1955; Benedictis, 1979 – this last is likely to be an editorial oversight, since the same author had earlier [1976] attributed the complex to Luca di Tommè), most subsequent discussion has vacillated between an attribution to Luca di Tommè, Niccolò di Ser Sozzo, the workshops of either master, or an unknown follower of either or both painters.

The first author to discuss the pinnacles separately from the main panels was Richard Offner (1934), who considered them the work of a Florentine master, a follower of the Assistant of Daddi. This distinction of hands has been recognized by almost all later writers, many of whom, however, ignored Offner's observation that the pinnacles were arbitrarily incorporated into the structure at a later date. Van Os (1990) devised an elaborate iconographic rationale for the inclusion of these half-length figures as witnesses to the Assumption of the Virgin, though their association with the complex is at best fortuitous, dating back not further than the mid-nineteenth century, and to a certain degree inappropriate in that Saint John the Evangelist is portrayed twice. The pinnacles were first correctly attributed to Francesco Neri da Volterra by Bellosi (1974), an attribution confirmed by Frinta (1976) and Boskovits (correspondence in Museum files).

As stated above, no such unanimity of opinion has emerged concerning an attribution for the main panels, in part due to the ravaged condition of the original paint surface and the extent of modern overpainting on faces, hands, and draperies. Those few figures that are relatively well preserved, especially the Virgin enthroned in the center panel and the angels supporting her mandorla from below, lead unmistakably to an attribution to Niccolò di Ser Sozzo in the period of his work at San Gimignano, probably the mid- or late-1340s. They all find exact parallels in type, attitude, or expression in Niccolò's illuminations for the choirbooks from the Collegiata (Museo d'Arte Sacra, Cod. LXVIII,1 and LXVIII,4) and in his altarpiece of the Assumption of the Virgin from Monteoliveto di Barbiano.[1] Especially close to the angels at the right of the Virgin's mandorla, and to the figure of the Virgin herself, are the figures in the illumination of the Pentecost (Cod. LXVIII,1 c. 56v.) from the Collegiata, which appears, however, to have been executed by an assistant of Niccolò di Ser Sozzo. The same assistant may be credited with the outermost panels of the Monteoliveto altarpiece, representing Saints Thomas and Bartholomew; with three panels from

another altarpiece, representing Saints John the Baptist (Hartford, Trinity College), Peter (London, Courtauld Institute Galleries), and Catherine (formerly New York, Roerich collection)[2]; and with most of the large figures in the present triptych, to the extent it is reasonable to assess their execution from what little of their original form remains.

Evidence for reconstructing the original format of this altarpiece as designed by Niccolò di Ser Sozzo – exclusive, that is, of its present pinnacles and modern frame – is contradictory. The unusually tall proportions of the center panel relative to the wings is unexampled among surviving Sienese altarpieces, as is the excessive difference in height for the spring of the framing arches between center and side panels. Both lateral panels show traces of a horizontal batten secured across the back approximately 130 cm up from the bottom edge. No traces of a batten or its securing nails are visible on the back of the center panel at this height, though three aligned nail heads are apparent beneath the paint surface approximately 181 cm from the bottom edge, just above the top of the Virgin's mandorla in the scene of the Assumption. If the batten nails in the lateral panels are aligned with those in the center panel, the spring of the framing arches in all three panels align as well, and the gazes of the four lateral saints are directed exactly, rather than approximately as they are in the present configuration, at the objects of their devotions: The enthroned Virgin in heaven and Christ holding the Virgin's soul on earth. Such an arrangement presupposes missing panels 50 or more cm tall (the center panel seems to have been cropped slightly at the bottom) beneath the lateral saints, perhaps half- or bust-length figures of further saints or predella style narrative scenes, though it is difficult to envision what such panels might have represented since no comparable examples are known. Additionally, it is clear that the altarpiece was also once provided with pinnacles. Vertical battens lap joined to the horizontal batten at the top center of each lateral panel were intended to brace an attached superstructure. Evidence of a similar vertical batten on the back of the center panel is lacking, and may have been destroyed when that panel was thinned and cradled.

The unusual format of this altarpiece was not imitated in any known Sienese structures of the later fourteenth century, though Zeri (1958a) and van Os (1990) have suggested that it may have been known near Pisa or Lucca. Both authors cite the Boston triptych as the probable model for Angelo Puccinelli's altarpiece

of the Dormition and Assumption of the Virgin in S. Maria Forisportam, Lucca, and Zeri postulates a Pisan period for Niccolò di Ser Sozzo to explain the evident influence of Francesco Traini on his mature style (see also Zeri, 1973, pp. 9-12). The fact that Francesco Neri was active primarily in Pisa (from 1346) and that part of the Toscanelli collection was formed in that area could indicate that the present hybrid structure was assembled from fragments with a common Pisan provenance.

If the two sets of fragments comprising this altarpiece did share a common provenance, however, which is plausible but not demonstrable, it is just as likely to have been San Gimignano as Pisa. The assistant employed by Niccolò di Ser Sozzo in the main panels is primarily known from works in San Gimignano, and Niccolò di Ser Sozzo's own contribution must be dated to the period of his activity there. Francesco Neri is documented as having painted an altarpiece for S. Agostino in San Gimignano, which was signed and dated 1352 (Nicola, 1919, p. 96 fn. 4), and though Niccolò di Ser Sozzo is not known to have worked for that church, it may not be coincidence that Saint Augustine is portrayed in the left lateral panel of the Boston triptych. While the evidence is nothing more than circumstantial, it is possible that the pinnacles to the Boston triptych are the surviving fragments of Francesco Neri's 1352 altarpiece, a possibility not contradicted by our present limited knowledge of that artist's stylistic development.

1. In addition to compelling stylistic similarities, Norman Muller (correspondence in Museum files) has pointed out that the Boston triptych shares with the Monteoliveto Assumption of the Virgin several distinctive punch tool marks, linking both paintings to the workshop of Niccolò di Ser Sozzo. See also Skaug, 1983.

2. The common authorship of these panels and their ascription to a distinctive assistant of Niccolò di Ser Sozzo was first proposed by S. A. Fehm, Jr. (1973, p. 29 fn. 15). They are defended as autograph works by Niccolò by C. Benedictis (1974, pp. 51-61), but there can be no doubt that they were produced by a separate artistic personality. The same artist may also have been responsible for a triptych of the Madonna and Child Enthroned with Saints Francis and Catherine (Benedictis, 1979, pls. 31, 33) and perhaps for a monumental crucifix in the church of Santo Spirito, Siena, frequently misattributed to Luca di Tommè. Benedictis (1976, pp. 103-120, and 1976a, pp. 87-95) identifies the hands of two associates of Niccolò di Ser Sozzo among seven graduals which she associates with his designs, made for the Collegiata at San Gimignano. Neither of these groups appears to be homogeneous (and neither can be associated with the work of Niccolò di Segna, as suggested by Benedictis); both include initials which may be attributable to the assistant discussed above. The date proposed by Benedictis for these graduals, 1340-42, is intuitive not documentary, and seems to be precocious.

Lippo Vanni

LIPPO VANNI is first mentioned in documents of 1344 and 1345 recording payments for the miniatures in a Gradual (Siena, Opera del Duomo, 98-4) painted for the hospital of Santa Maria della Scala. Among his major public commissions were three frescoes for the Palazzo Pubblico: a *Coronation of the Virgin* of 1352, which was completely repainted in the fifteenth century, and the *Battle of the Val di Chiana* and *Saint Paul Surrounded by Virtues* of 1363. Lippo's signature and the date 1358 appear beneath a painted reliquary triptych in the church of Santi Domenico e Sisto in Rome. A number of other miniatures, frescoes, and small-scale panel paintings have been attributed to him on the basis of these certain works, which reveal him to have been an artist of a distinctly personal and refined sense of narrative and of calligraphic line, and an important link in the transmission of the style of the masters of the first half of the century to the generation of painters born after 1330. The misattribution to Lippo Vanni of an altarpiece painted by Simone Martini in 1326 (New York, Metropolitan Museum of Art, and Malibu, J. Paul Getty Museum) and another by Niccolò di Segna (Coral Gables, Lowe Art Museum) have confused the outlines of his early development, which almost certainly occurred in close contact with Pietro Lorenzetti. Lippo Vanni is last mentioned in a document of 1375. The date of his death is unknown.

20

Biccherna Cover: The Tribute Offering

Tempera on panel
Overall: 44.5 x 33 (17½ x 13)
Picture surface: 31 x 33 (12¼ x 13)

Charles Potter Kling Fund. 50.5

Provenance: Commune of Siena, until at least 1724; J. A. Ramboux, Cologne, until 1867; Karl Anton Reichel, until 1931; Walter Schatzki, New York, 1949-50

Literature: Bichi, 1724, Ms. D 10; Ramboux, 1862, no. 21; Lisini, 1903, sub datum 1363; Crowe and Cavalcaselle, vol. 3, 1908, p. 112; Swarzenski, 1950, pp. 44-46; Carli, 1950, p. 122; Coor-Achenbach, 1956, pp. 120, 123 fig. 96; Borgia et al., 1984, pp. 24, 112-113.

Condition: The panel has split along a curving line from the top, above the left side of the throne, to just left of center at the bottom. Paint loss along either side of this split has been repaired, as has an almost total loss of paint in a strip 6-8 cm wide running the full height of the panel at its left edge, and a smaller strip covering the right side of the throne and the figure below. Scratches and abrasions are visible throughout the rest of the paint surface. The gold ground is modern, except for a small area at the top right edge, where some original gold remains. The band of five shields separating the painted image from the inscription has lost all its gilt surface, but the punch decoration is original.

A FIGURE, probably symbolizing the government or the state of Siena, wearing a red cap and robe lined with white fur, is seated in the center on a throne draped with a cloth of honor. He holds in his right hand a scepter of office and in his left a globe decorated with the colors of the Sienese Balzana, black and white. A pair of trumpeters, their instruments decorated with black and white flags, flank the throne on either side. Beneath them, around and before the throne, are ten figures of various ranks and stations presenting symbols of tribute to the seated figure, including (left to right): olive branches, keys, a fortified town or castle, a bag of money (?), candles, a flag, and a sword. The scene has been interpreted (Borgia et al., 1984, p. 112) as a symbolic affirmation of Siena's dominance over the cities and castles of the contada, perhaps in response to incursions by the companies of soldiers of fortune common at the time.

The inscription at the bottom of the panel, recording the names of the treasurer, comptrollers, and secretary of the office of the exchequer for the first semester of the year 1364, was badly damaged during an unfortunate modern restoration. It may be reconstructed with the aid of Galgano Bichi's 1724 inventory reference to this panel, to read:

[QESTO E] LIBRO DE L'ENTRATE ET DE L'ESCITE DE LA GENERALE [BICHERNA] DEL COM[UNO] DI SIENA AL TENPO DE' SAVI E DISCRETI HU[OMINI GHIN]O DI MA[RCH]OVALDO E DI SER PETRO LENCI E DI [MISSERE BON]INSEGNA [DI] MISSERE SANDRO DE' BANDI[NE]GLI E DI MA[RCHO DI CEC]CHO E DI M[A]NAIA DI GHUCCIO CHAMARLENGHO E [QUATRO DI B]ICCHERNA ADI PRIMO DI GENNAIO MILLE TRECENTO [LXIII INFINO A] CHALENDE [L]UGLIO MCCCLXII-II. BARTALOME[IO] DI SOCCO BARTAL]OM[EI] LORO SCRITTORE.

An exemplary article by Georg Swarzenski (1950) discusses at some length the significance of this panel within the tradition of decoration of the Sienese Biccherna covers. In particular he stressed the derivation of the panel's imagery from Ambrogio Lorenzetti's fresco of Good Government in the Palazzo Pubblico, Siena, and from the similar Biccherna cover of 1344 (Borgia et al., 1984, pp. 96-97) which has also been attributed to Ambrogio Lorenzetti (d'Argenio, 1982, pp. 152-153). In turn the Boston panel seems to have influenced the design of the Biccherna cover of 1385 by Niccolò di Buonaccorso (Borgia et al., pp. 116-117) and perhaps that of 1474 by Benvenuto di Giovanni (ibid., pp. 178-179). To Swarzenski's thorough discussion can only be added a consideration of the panel's authorship, which he situated generically in the following of Ambrogio Lorenzetti, an opinion shared by Enzo Carli (ibid., p. 24).

An attribution for the Boston panel can only be advanced with a disclaimer based on its seriously damaged condition. Those figures least affected, in particular the two trumpeters at the right, the knight directly beneath them, and the standard bearer and the man holding a bag of money (?) at the bottom, all indicate the hand of Lippo Vanni and may be compared favorably with his manuscript illuminations executed on a similar, reduced scale. Especially close, both in its drawing style and in its palette, is his large miniature of the Presentation in the Temple, from a gradual in the Opera del Duomo, Cod. 98-4 (Chelazzi-Dini, 1982, pp. 271-275), documented to 1345. The recovery of a dated painting from the middle of the artist's career adds, however, only marginally to an understanding of his development on account of its partial illegibility. It does provide an example of his work in a different medium and on a radically different scale from his only other documented commission of that decade, the *Saint Paul Surrounded by Virtues* and *Battle of the Val di Chiana* frescoes of 1363 in the Sala del Mappamondo in the Palazzo Pubblico in Siena.

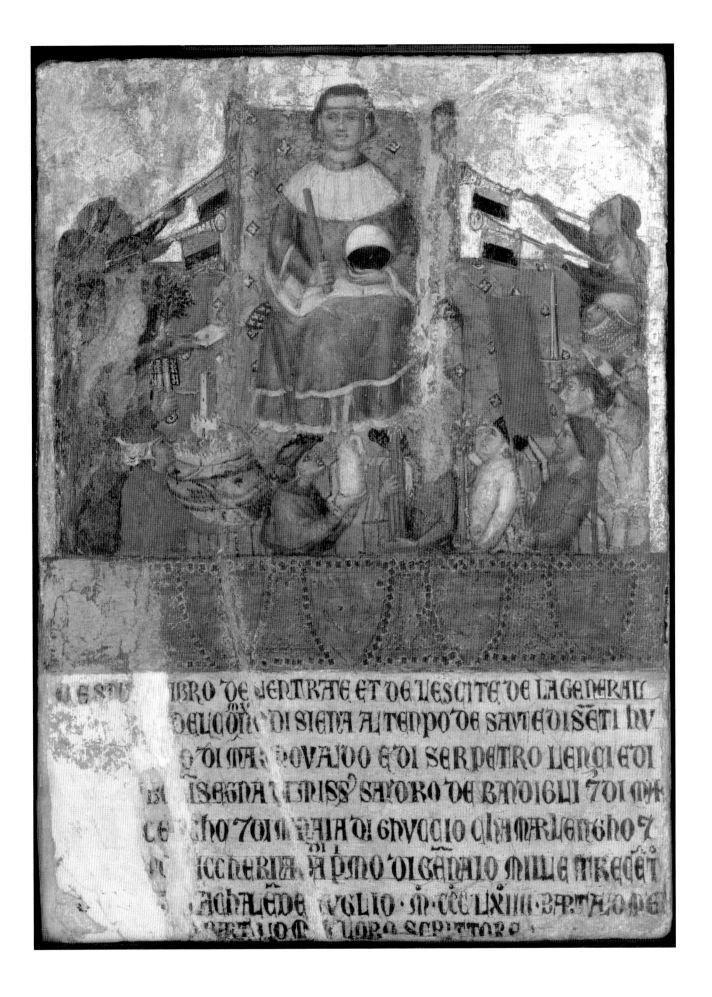

Niccolò di Buonaccorso

REASONABLY SUPPOSED to have been born in or around 1348 (Brandi, 1931, p. 431), Niccolò di Buonaccorso is first mentioned in a document of 1372 recording his election to public office in Siena, and his name is found on a register appended to the statutes of the painters' guild sometime between 1378 and 1386. He was paid in 1383 for a painting of Saint Daniel for the Cathedral, a work which is not known to survive, and he is the author of a biccherna cover of 1385, showing "Restored Government Restraining the Citizens" (Borgia et al., 1984, pp. 116-117), and of an altarpiece of the Virgin and Child with Saints of 1387, formerly in the church of Santa Margherita at Costalpino (Boskovits, 1980). He is primarily known as a painter of delicate, small-scaled works of which one, a Marriage of the Virgin in the National Gallery, London, is signed. These reveal him to have been an artist of extraordinary technical refinement and decorative sensibility. He was probably trained in the studio of Jacopo di Mino del Pelliciaio, one of the leading workshops in Siena in the 1360s, but the primary influence on his style, and in particular on his rich palette and sophisticated spatial effects, was the example of Ambrogio Lorenzetti earlier in the century. Niccolò di Buonaccorso died in 1388.

Madonna and Child Enthroned with a Bishop Saint, Saint John the Baptist, and Four Angels

Tempera on panel
Overall (excluding modern attached molding at top): 46.3 x 31.7 (18¼ x 12½)
Picture surface: 43.5 x 27.3 (17⅛ x 10¾)

Gift of Mrs. Thomas O. Richardson. 20.1860

Provenance: Marchese Ranghiasci-Brancaleoni, Gubbio (?); Mrs. Thomas O. Richardson, 1882

Literature: Perkins, 1920, pp. 116-118; van Marle, vol. 2, 1924, pp. 517-518; De Wald, 1930, fig. 64; Meiss, 1946, p. 5; Galetti and Camesasca, vol. 2, 1950, p. 1767; Berenson, 1932, p. 391; idem, 1968, vol. 1, p. 294; Fredericksen and Zeri, 1972, pp. 149, 564; Maginnis, 1977, p. 299; Muller, 1978, pp. 10-18.

Condition: The panel, of a vertical wood grain, is 1.7 cm thick and has been neither thinned nor cradled. The left, right, and bottom engaged moldings are original but have been partially regilt; the crocketed gable has been truncated, and the molding along the flat top edge is a modern addition. The gold ground and gilt pastiglia decoration of the spandrels is moderately worn, exposing small areas of red bole. Flaking losses in the throne have also exposed small areas of bole, easily confused with the layer of orange and red paint applied over the gold there before tooling. Except for the Virgin's mantle, which has suffered scattered small losses now covered with discolored retouches, the rest of the paint surface is in excellent condition.

THE MADONNA, wearing a blue robe over a white and gilt dress, is seated on a throne draped in an orange and gilt cloth of honor with a blue and yellow fringe, raised on a stone dais with red carved moldings. The Child, dressed in pink, is seated across her lap and holds in his left hand a small bird which pecks at the extended finger of his right hand. Standing on a marbleized pavement in the foreground at the left is Saint John the Baptist, wearing a pink cloak lined with blue over a hair shirt and holding in his left hand a scroll inscribed: ECCE AGNIUS DEI ECCE QUI. In the right foreground is an episcopal saint in a white alb and a yellow and gilt cope, with a border of alternating blue and red circles. He holds a bishop's staff in his right hand and a red book in his left, and looks up and back at the Christ Child. Behind the throne are four angels clad in blue and white, each contained within a lobe of the framing arch. The uppermost lobe of the arch is filled by the triangular gable of the Virgin's throne.

In a letter in the Museum's files dated 24 November 1907, Mary Richardson claimed to have purchased this panel in Gubbio twenty-five years earlier, with an attribution to Lucas Cranach. There is a strong presumption, therefore, that it formed part of the Ranghiasci-Brancaleoni collection at Gubbio, which was dispersed in 1882, though it cannot be positively identified with any item listed in the sale catalogue of 12 April that year (Piceller, 1882). Called an Umbrian work by A. Lisini (oral communication), possibly on account of its Eugubine provenance, the attribution of the present panel to Niccolò di Buonaccorso has not been doubted since it was first proposed by Perkins in 1920. It is in fact very closely related to Niccolò's signed Marriage of the Virgin in the National Gallery, London (no. 1109; Davies, 1961, pp. 384-385) and to the latter's two known companion panels: the Presentation of the Virgin in the Uffizi (Marcucci, 1965, p. 169) and the Coronation of the Virgin in the Robert Lehman Collection, Metropolitan Museum of Art, New York (Pope-Hennessy and Kanter, 1987, pp. 33-35). Not only are all four works unquestionably by a single artist, but also they must be nearly contemporary in execution. The London/Florence/New York complex has been plausibly dated ca. 1380 (Pope-Hennessy and Kanter,) on the basis of its similarity to Niccolò's dated works of 1385 and 1387 and its evident maturity by comparison to his putative early works of ca. 1370. A date around or just before 1380 seems appropriate for the Boston panel as well.

The shape of the Boston panel, formerly completed by a gable with gilt pastiglia decoration and possibly a glass inset bead or painted roundel, implies that it once formed the center of a small portable triptych with now-missing wings intended to fold over it as in the intact examples at Bloomington, Indiana (Cole and Gealt, 1977, pp. 184-187), or San Diego, California (Mongan et al., 1983, pp. 68-69). The present panel is more mature, less dependent on Jacopo di Mino del Pelliciaio's example than either of these, closer in this respect to the triptych by Niccolò di Buonaccorso from Konopiste (Meiss, 1946). It is also possible that it functioned instead as one valve of a diptych, on the model of a similar picture in Siena (Torriti, 1977, p. 142) possibly by Naddo Ceccarelli. One other diptych by Niccolò di Buonaccorso may be reconstructed that comprises gabled panels: the Madonna and Child with Four Saints in Siena (Torriti, 1977, p. 143, no. 222) and the Crucifixion now in the Chiaramonte Bordonaro collection, Palermo (Collection Toscanelli, 1883, pl. II).

The episcopal saint at the lower right of the Boston panel has traditionally been called Augustine. He does not, however, wear an Augustinian habit beneath his cope, nor does he bear any other attributes that could specify his identity.

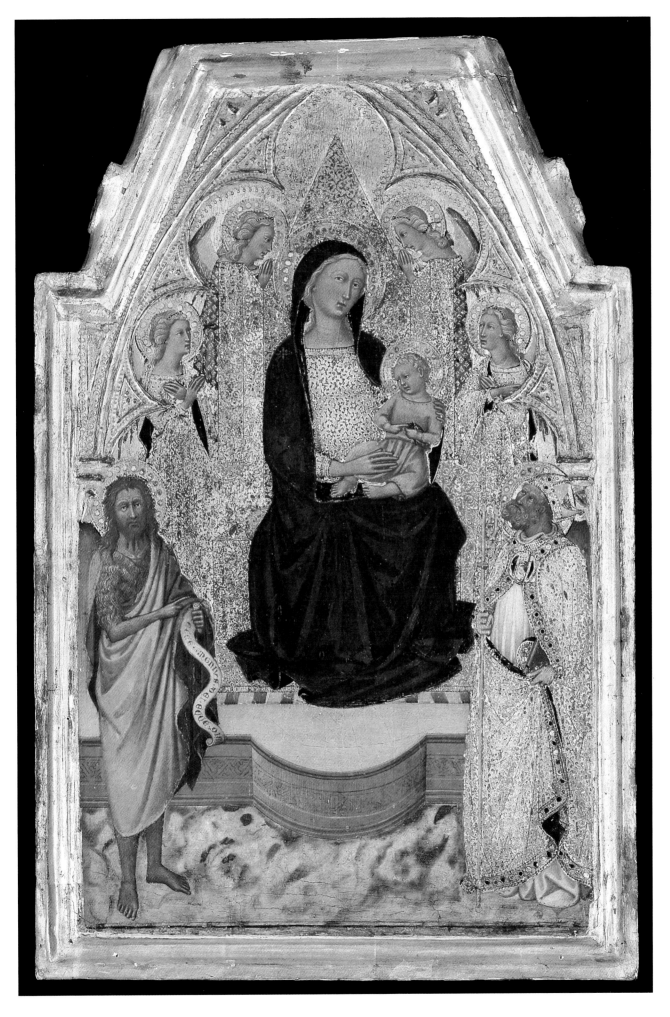

Bartolo di Fredi

BARTOLO DI FREDI was one of the most important and prolific painters of the second half of the trecento in Siena. His highly personal, almost naively eccentric style cannot be traced to the influence of any single artist, though his dramatic narrative and expressive formulae must have been indebted to the example of Pietro Lorenzetti. The first preserved notice of his activity dates to 1353, when he was sharing a studio with Andrea Vanni (q.v.). In 1367 he completed the frescoed scenes from the Old Testament covering the wall of the nave opposite "Barna's" frescoes in the Collegiata at San Gimignano, where he later supplied frescoes and at least one altarpiece to the church of Sant'Agostino (Kanter, 1983) and in 1374 painted an altarpiece for San Domenico (Traldi, 1977, pp. 50-54). Bartolo di Fredi is also documented at work in Volterra in the 1370s, and in the following decade he painted three major altarpieces for the church of San Francesco in Montalcino (Freuler, 1985, 1986). In 1389 he received the commission for the Calzolai altarpiece (lost) for the Cathedral in Siena, to be executed jointly with his son, Andrea di Bartolo, and with Luca di Tommè, and in 1392 he collaborated with Paolo di Giovanni Fei on another altarpiece for the Cathedral. Bartolo di Fredi's last known work (Chambery) was painted for the Malavolti chapel in San Domenico, Siena, in 1397. He died in 1410.

22

A Papal Saint (Saint Gregory the Great?)

Tempera on panel
Overall: 40 x 24.4 (15¾ x 8)
Picture surface: 36.5 x 16.8 (14⅜ x 6⅝)

Gift of Mrs. Walter Scott Fitz. 15.953

Provenance: Philip J. Gentner; Mrs. W. Scott Fitz, 1915

Literature: Whitehill, vol. 1, 1970, p. 328; Fredericksen and Zeri, 1972, pp. 239, 564; Moran, 1976, pp. 30-31; Muller, 1977, pp. 195-204; van Os, 1985, p. 56; Freuler and Wainwright, 1986, p. 327; Harpring, 1993, pp. 133, 134, 136, 158-159.

Condition: The panel, which has been thinned to a depth of 1.6 cm but is not cradled, has been cropped along the top and its shape altered by the attachment of a modern engaged frame (removed 1949/50) along the sides and bottom. The gilding and paint surface have been severely abraded and extensively retouched except on the saint's orphery, lappets, and tiara. A 3-cm wide strip of gold paint along the top is modern.

THE HALF-LENGTH FIGURE of a white-bearded saint wearing a papal tiara (cropped at the top of the panel) faces three-quarters to the left. He is dressed in a pale blue dalmatic hemmed in gold and writes with a white quill in a red-bound book propped up before him. When acquired for the Museum of Fine Arts in 1915, the lateral and bottom edges of the panel were covered by a modern engaged molding which was removed in a cleaning of 1949/50. At that time the punched decoration of the gold ground lining the pastiglia arch in the upper corners was found to continue the length of the panel on both sides, indicating it has not been altered appreciably in width. The top of the panel has been truncated, and the upper 3 cm of the present gilt surface are modern. Probably the panel originally terminated in a penta- or heptalobate arch, as in a panel by Bartolo di Fredi showing the Annunciate Virgin in the Yale University Art Gallery, New Haven (Seymour, 1970, p. 71; Moran and Mallory, 1972, pp. 10-15).

Originally ascribed to the school of Simone Martini and subsequently labeled more generically Sienese fourteenth-century, the present panel was first recognized as a work by Bartolo di Fredi by Norman Muller in 1977, on the basis of a correspondence between the punches used to decorate its gold ground and those commonly used by Bartolo. Reaffirmed by van Os (1985), and by Freuler and Wainwright (1986), this attribution is certainly correct, though Muller's proposal (1977, pp. 202-204) that it served as the pinnacle to a hypothetical lateral panel joined to the altarpiece of the Adoration of the Magi in the Pinacoteca Nazionale at Siena cannot be sustained. Van Os (1985) accepts Muller's reconstruction while Freuler (oral communication, 1986) rejects it outright. Freuler dates the Boston panel to the early 1380s, not 1368 as suggested by Muller and by Moran (1976, p. 30), and identifies a companion panel from the same complex, representing Saint Augustine, now in a private collection.

Bartolo di Fredi painted at least three altarpieces in the 1380s for the church of San Francesco in Montalcino. One of these, which included a Deposition dated 1382 and four scenes from the life of the Blessed Filippo Ciardelli (now in the Museo Diocesano at Montalcino), has recently been convincingly reconstructed (except for the supposed predella, which is by Andrea di Bartolo and belongs to a different altarpiece by that artist in the Pinacoteca Nazionale in Siena) by Freuler (1985, pp. 21-39). A second, much larger altarpiece constituting primarily scenes from the Life of the Virgin was commissioned in 1383 and completed in 1388, and has been reconstructed by Kanter (1983, pp. 17-28) and by Freuler (1985). Neither of these can have included the Boston saint and its companion Saint Augustine as pinnacles. A third Montalcino altarpiece has recently been identified by Freuler (1986, pp. 149-166) as including three panels in the Museo Civico at Lucignano, a pinnacle representing the Magdalene in the Westfälisches Landesmuseum in Münster, and, inappropriately again, a later predella by Andrea di Bartolo in the Pinacoteca Nazionale at Siena. It is probable that four panels showing full-length figures of Saints Peter, Paul, Francis, and Anthony of Padua now in the Museo Diocesano at Montalcino, brought there from the church of San Francesco, also formed part of this altarpiece, perhaps surmounted by pinnacles including the Boston panel.

Muller, presuming the Boston panel to have formed part of the Adoration of the Magi altarpiece and the latter to have come from the chapel of the Fornai in San Lorenzo in Siena, identified the saint as Sixtus II, "whose deacon was St. Lawrence" (1977, p. 204). Other than a papal tiara, the figure bears no attributes that could firmly specify his identity. His association by Freuler with a Saint Augustine makes it likely, however, that he is meant to represent Saint Gregory the Great and that he once formed part of a series of the four fathers of the Church.

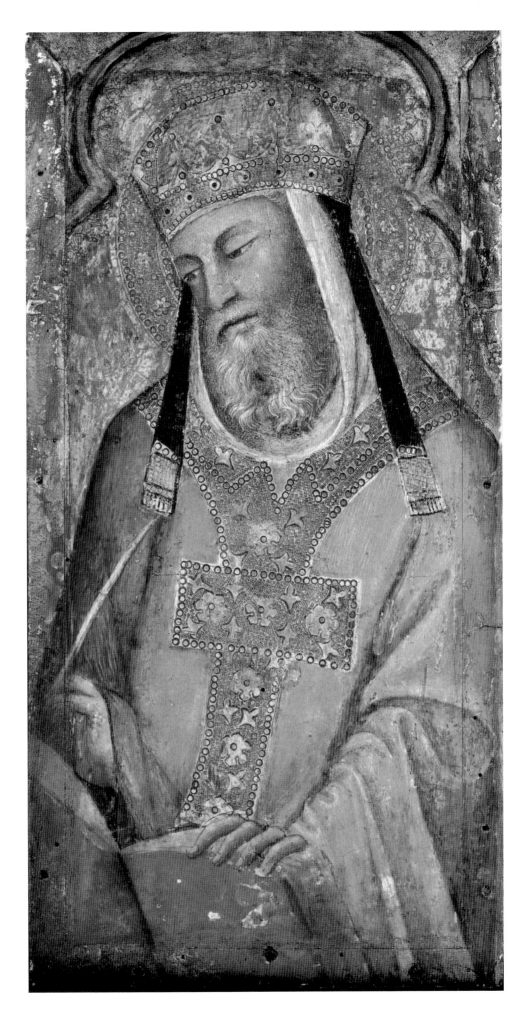

Andrea di Vanni d'Andrea

ANDREA VANNI's long career, spanning a known activity of sixty years, is perhaps better documented than that of any other painter of his time, but more for the many political offices he held in his native Siena than for his artistic production. He is first recorded in 1353, at which date he was sharing a workshop with Bartolo di Fredi (q.v.). Between 1367 and 1370, he was paid for decorating three chapels and the cupola in Siena Cathedral, some of this work carried out in conjunction with Antonio Veneziano (q.v.). His political career began with election to the Gran Consiglio of the Republic in 1370, an office to which he was reelected in 1372 and in 1380. In 1371 he was gonfaloniere for the Terzo di San Martino, in 1373 ambassador to Florence, and in 1376 Rector of the Opera del Duomo and an official of the office of the Biccherna. In 1379 he was appointed Capitano del Popolo. In 1382 he went to Avignon as ambassador from Siena to the Papal court, and from 1383 to 1385 he fulfilled the same mission in Naples. Securely dated paintings by Andrea Vanni are few, but include a fragmentary altarpiece painted for the church of the Castello di Casaluce (Naples) in 1365, a signed triptych in the Corcoran Gallery, Washington, of 1383-5, and an altarpiece in Santo Stefano in Siena, of 1400. Andrea Vanni is popularly remembered for his intimacy with Saint Catherine of Siena, whose portrait by him (San Domenico, Siena) is the only reliable likeness of the saint executed in her lifetime. Andrea Vanni died in 1413 or 1414.

23a

Saint Peter

Tempera on panel
Overall: 155.8 x 42.2 (61¼ x 16⁹⁄₁₆)
Picture Surface: 152.5 x 41.7 (60⁵⁄₁₆ x 16⅜)

Gift of Mrs. W. Scott Fitz. 22.3

Provenance: The Counts Griccioli, Monistero di S. Eugenio, Siena; Mrs. W. Scott Fitz

Literature: *Mostra*, 1904, p. 316, nos. 129, 130; Perkins, 1904, pp. 147-148; Berenson, 1909, p. 262; van Marle, vol. 1, 1922, pp. 230-233; idem, vol. 2, 1924, pp. 440-442; Berenson, 1932, p. 586; Meiss, 1951, p. 23 no. 40; Carli, 1955, p. 157; Meiss, 1955-56, pp. 46-47, 61; Ziff, 1957, pp. 138-142; Berenson, vol. 1, 1968, p. 440; Fredericksen and Zeri, 1972, pp. 208, 564; Boskovits, 1975, p. 218 fn. 101; Maginnis, 1977, p. 298; Benedictis, 1979, p. 96; Boskovits, 1988, p. 9.

Condition: The panel, of a vertical wood grain, has been thinned to a depth of 1.5 cm and cradled. Both the left and right edges of the panel appear to have been trimmed slightly, and the engaged, lancet arch frame at the top is a modern addition. Four vertical splits of varying lengths visible through the paint surface have resulted in flaking losses in the lower half of the panel. The gold ground and the mordant gilt decoration on the saint's robes and key are well preserved with only minor abrasions and small patches of regilding. The silver key, however, survives only as bolus preparation, and the heads of both keys have been repainted. The paint layers, aside from losses along the edges of the splits, are generally in good condition, except that the green lining of the saint's robe has been liberally retouched. The shield of arms at the lower left has been effaced.

THE SAINT is shown standing full-length in a blue robe and a yellow cloak lined with green. He holds a gold and a silver key in his right hand and a red-bound book in his left. A shield bearing a now-effaced coat of arms fills the lower corner of the panel.

Shown in the Sienese exhibition of 1904 as an anonymous Sienese work of the end of the fourteenth century, this panel and its companion (see below, no. 22.4) were identified by Perkins (1904) as by Andrea Vanni, and were described by him as examples of distinguished quality, notwithstanding their then heavily overpainted condition. A half-length Saint John the Evangelist now in the Fogg Art Museum, Cambridge (Meiss, 1955-56; fig. 19), was recognized as a third lateral panel from the same altarpiece by Tancred Borenius (quoted in the catalogue of the Parke Bernet sale, New York, 24 May 1944, lot 80). Undoubtedly cut from a panel that originally would have shown the saint full length, the Fogg Saint John the Evangelist corresponds closely to the Boston Saints Peter and Paul in style and approximately in the punched decoration of its gold ground.

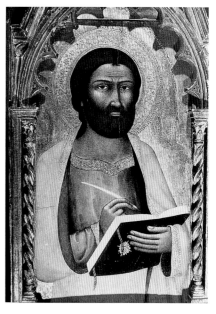

Fig. 19. Andrea Vanni, *Saint John the Evangelist.* Fogg Art Museum, Harvard University, Cambridge, MA

Meiss (1951) proposed identifying the missing central panel of this complex with a Madonna and Child in the church of San Donato in Siena, like the Fogg panel cut to a half-length format and like the Boston panels bearing a provenance from the monastery of S. Eugenio outside the Porta San Marco. The suggestion was accepted and amplified in a thorough discussion by Ziff (1957), who also accepted Meiss's proposal that an Annunciation diptych in the Fogg Art Museum (formerly in the Chigi-Saracini collection, Siena) stood in the pinnacles of the same altarpiece. Ziff added to Meiss's reconstruction three pilaster panels showing full-length female saints now in the Städelsches Institut, Frankfurt. Ziff's reconstruction was accepted without comment by Benedictis (1979), although Berenson (1968) did not connect the Fogg Annunciation, the San Donato Madonna, or the Frankfurt saints with the Fogg Evangelist and the two saints in Boston.

There is insufficient evidence, either stylistic or physical, to defend or reject the association of the Frankfurt pilaster saints with this altarpiece. It may, however, be positively affirmed that the Annunciation pinnacles in the Fogg Art Museum originate from a different complex. They are earlier in style than the three lateral panels and entirely different in the punched and molded decoration of their gold grounds. Furthermore, Ziff's reconstruction treating them as two of four similarly shaped lateral pinnacles is iconographically implausible, though it is paralled in one later Sienese altarpiece, Taddeo di Bartolo's Saint Christopher

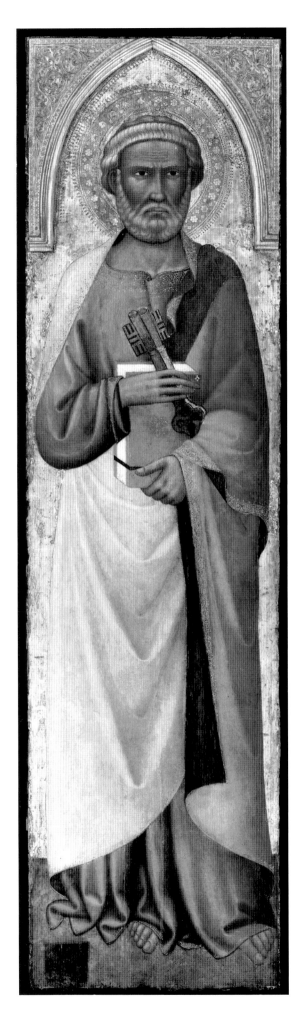
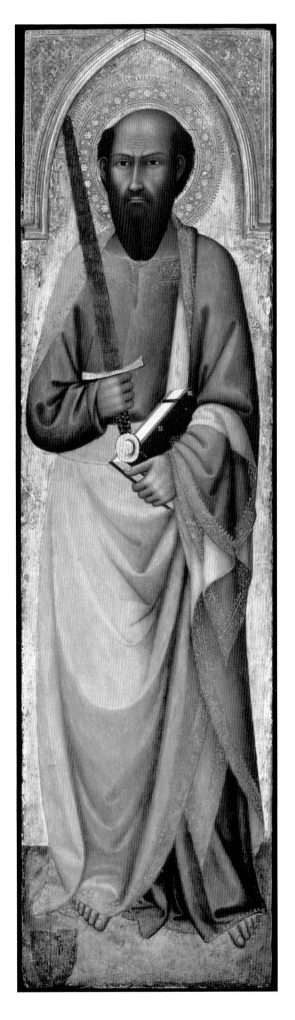

polyptych in the Museo Civico at San Gimignano (van Os, 1990, p. 43, fig. 14). The inclusion of the San Donato Madonna in this complex is also questionable. It too is much earlier in style than the lateral saints, and the tooling of the margin of its gold ground is significantly different. Its common provenance with the Boston saints is inconclusive evidence for a reconstruction, since the Counts Griccioli acquired Sienese paintings from numerous sources to decorate the monastery of S. Eugenio, converted in 1812 to their family villa.

The Boston saints are commonly considered early works by Andrea Vanni (especially van Marle, 1922, 1924), partly in recognition of their conspicuous quality and perceived superiority to the dated polyptych of 1400 in Santo Stefano alla Lizza. Boskovits (1975) noted, however, that they must postdate the surviving fragments of the Casaluce altarpiece (ca. 1365), and probably represent Vanni's reaction to the example of the Florentine painter Antonio Veneziano, with whom he collaborated in 1370 on work for the Cathedral in Siena. The Corcoran triptych, probably of 1383-85, still shows Vanni's style under the influence of his Sienese predecessors and contemporaries Niccolò di Ser Sozzo and Jacopo di Mino del Pelliciaio, and it is not until the following decade that he produced pictures that may be compared to the richer palette and brooding emotional tenor of the Boston saints. The latter are most closely related stylistically to the monumental Madonna and Child in the church of San Francesco, Siena, and to the Crucifixion pinnacle in the Siena Pinacoteca, both of which may be fragments of an altarpiece formerly signed by Andrea and dated 1396. It is not impossible that the Boston Saints originated from the same altarpiece, but proof is lacking.

Several commissions undertaken by Andrea Vanni in San Francesco in the last years of the fourteenth century are mentioned by Sigismondo Tizio in his *Historiae Senensis*, vol. 3 (Milanesi, vol. 1, 1854, p. 306). According to Tizio: "Tabulam quoque maioris are fratrum Minorum divi Francisci opera et sumptu Petri Bindi Ugurgerii, nec non Catherine uxoris eius et Bartolomei Malevolte equitis filie, hoc anno [i.e. 1400] erectam fuisse in eodem legimus codice, ab ipso quoque Andrea biennio prius [i.e. 1398] depictam. . . ." This information, supposedly derived from Andrea Vanni's own account book, is contradicted however by Mons. Fabio Chigi, who in 1625 saw "all'Arb[orino] di S. Francesco. La tavola che era la maggiore in S. Francesco de' Petroni. F.a Andreas Vannis 1396" (Bacci, 1939, p. 327). It is unclear whether Chigi was referring to an inscription on the altarpiece itself, or simply misquoted Tizio. The *Crucifixion* pinnacle now in the Siena Pinacoteca was brought there from the church of the Alborino outside the Porta Ovile, and is likely to have been part of the complex described by Fabio Chigi. The coats of arms appearing in the lower left corners of the two Boston panels are not now legible, but cannot easily be construed as having shown either those of the Petroni, the Ugurgieri, or the Malavolti. In the nineteenth century they were overpainted to represent the arms of the Griccioli (photograph published in Perkins, 1904).

23b

Saint Paul

Tempera on panel
Overall: 155.8 x 48.2 (61¼ x 18 ¹⁵⁄₁₆)
Picture surface: 153.5 x 42 (60⁷⁄₁₆ x 16⁹⁄₁₆)

Gift of Mrs. W. Scott Fitz. 22.4

Condition: The panel is 3.5 cm thick and has been neither thinned nor cradled. It is composed of two vertical planks, one 38.2-cm wide and one 4.7-cm wide joined to it on the left. Three wood dowels are visible on the left and right edges. The engaged, lancet arch frame at the top is a modern addition. The gold ground and mordant gilt decorations are in good condition, with only minor abrasions and local patches of regilding. The paint surface is also well preserved, with only minor pinpoint flaking overall and minimal retouching. The silver of the saint's sword is much deteriorated, and the shield of arms at the lower right has been effaced.

THE SAINT is shown standing full-length in a blue robe and a violet cloak lined with red. He holds a blue-bound book in his left hand, and in his right hand a silver sword with gilt pommel and hilt. An obliterated coat of arms fills the lower left corner of the panel.

See above, no. 22.3

III. SCHOOLS OUTSIDE TUSCANY

Master of the Blue Crucifix

24

Christ on the Cross with the Virgin and Saint John the Evangelist

Tempera on panel
Overall: 22.9 x 16.8 (9 x 6⅝)
Picture surface: 21 x 14.3 (8 ⁵⁄₁₆ x 5⅝)

Gift of Edward Jackson Holmes. 28.886

Provenance: Unknown; Edward Jackson Holmes, Boston, by 1928

Literature: Garrison, 1949, p. 100, no. 255; Coor-Achenbach, 1949, pp. 40-42; Bologna, 1962, p. 79; idem, 1964, p. 59; Fredericksen and Zeri, 1972, pp. 215, 564; Scarpellini, et al., 1980, p. 41, fig. 19; Todini, vol. 2, 1986, p. 376; idem, 1989, vol. 1, p. 125, vol. 2, p. 34.

Condition: The wood panel support is 1.2 cm thick and is uncradled. The picture surface was excavated to a depth of 1.0 cm, leaving a 2-mm-raised molding at the left and right; 2 mm thick cross-grain strips were affixed to the surface of the panel at top and bottom to complete the frame. The panel was then covered with paper front and back before gessoing, gilding, and painting. The original gesso surface of the back of the panel survives largely intact. An original hinge is preserved on the left side, 4 cm from the bottom of the panel, and damage from a missing hinge is noticeable on the same side, 4.2 cm from the top. The four sides of the panel appear not to have been trimmed, though exposed worm tunnels along the right edge imply that the paper and gesso ground once wrapped completely around that exposed outer side. The gold background is worn and abraded quite badly to the left of Christ and less so in other areas, but the gold mordant decorations in the draperies are quite well preserved. The paint layers have suffered tiny flaking losses throughout and are also abraded, especially in the faces and draperies and in the cross, which has been liberally overpainted. The red glazed inscriptions in the titulus of the cross and to the left of Christ are lost, and only fragments of blue (?) paint survive within the gilt disc of the moon at the upper right. The red paint of the sun at the upper left is broken by flaking losses but survives in large, intact areas.

PROBABLY trained shortly after the middle of the thirteenth century in Assisi in the circle of the Master of Saint Francis, the Master of the Blue Crucifix was an important link between the schools of Umbria and Emilia. He was first identified by Garrison (1949, p. 13), who named him for the striking palette of two Crucifixes attributable to him, and who characterized him as the most sensitive of the followers of Giunta Pisano working in the Perugia-Assisi region. The Master of the Blue Crucifix may have come directly under the influence of Giunta during a period of working in Bologna, but his primary activity seems to have been in northern Umbria, and does not appear to have extended much beyond the third quarter of the thirteenth century.

THE BODY OF CHRIST hangs limp on a darkened blue cross inscribed REX [GLORIAE], blood streaming from the wounds in his hands, side, and feet. Visible in the "sky," above the arms of the cross are the sun (left) and the moon (right). The Virgin, in a blue cloak trimmed with gold over a mauve dress and scarlet shoes, stands beneath the cross at the left, and opposite her stands Saint John the Evangelist, barefoot, wearing a mauve mantle over a blue robe. A faint, red-glazed inscription above Saint John's head reads ECE FILI TUA. Christ's sarcophagus fills the width of the picture field behind the three figures, and behind Saint John rises a green building with a red roof. The darkened roof of another building is visible behind the Virgin.

This much damaged but lyrically

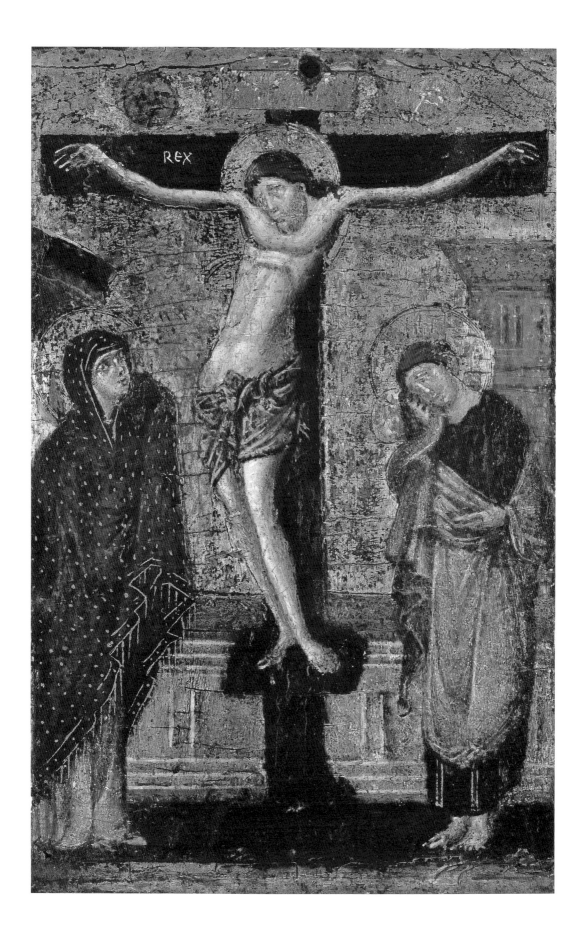

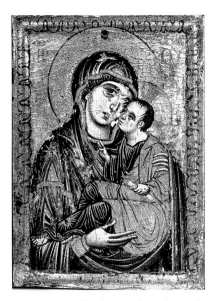

Fig. 20. Master of the Blue Crucifix, *Madonna and Child*. Private collection, Florence

account for the minor variance in their heights), and in having been pierced near the top center for a hanging device. Todini is almost certainly correct in asserting that these two panels were originally joined as a diptych; the exaggerated difference in their states of perservation is undoubtedly to be accounted for only by their divergent histories after being separated, probably early in this century. For Todini, the diptych is to be dated shortly after 1270, which is plausible.

beautiful panel entered the Museum of Fine Arts with a generic attribution to the Tuscan school of the thirteenth century. It was classified by Garrison (1949) as "Bolognese (?), or, less probably, North Umbrian (?)," and dated by him to the third quarter of the thirteenth century. Coor-Achenbach (1949) refined this classification by ascribing the panel to the author of a painted Crucifix in the Pinacoteca at Faenze, which she characterized as distantly inspired by the late works of Giunta Pisano at Bologna but more immediately and strongly influenced by the Master of Saint Francis and his followers in Assisi and Perugia. Coor-Achenbach assumed, on iconographic grounds, that the Faenza Cross (and the present panel) was Bolognese, or at least Emilian, though she specifically adduced comparisons to the work of an Umbrian follower of the Master of Saint Francis who has since come to be known as the Master of the Blue Crucifix.

Recent scholarship has recognized the Faenza Cross as itself the work of the Master of the Blue Crucifix, but the first author to extend such an attribution, correctly, to the Boston panel as well was Bologna (1964), followed by Scarpellini (1980) and Todini (1986, 1989). Todini, furthermore, published a beautifully preserved *Madonna and Child* in a private collection in Florence (fig. 20) which corresponds closely to the Boston panel in size – the Florentine panel measures 24.5 x 17.5 cm – and style, in the profile of its engaged frame (the Boston panel appears to have lost a cross-grain capping strip at the top, still engaged though visible as a split in the gilt surface of the frame in the Florentine panel, which could

Master of Le Palazze

AN ANONYMOUS Umbrian painter active around Spoleto in the late thirteenth or early fourteenth century, the Master of Le Palazze is named for a fresco cycle formerly in the convent church of S. Maria inter Angelos (Spoleto), commonly known as Le Palazze. These frescoes, of which 24.115 below is a fragment, and the few independent frescoes (all in Spoleto) that have been assigned to the same hand by B. Toscano (1974, pp. 3-23) reveal a talented provincial artist strongly influenced by Cimabue and the contemporary Roman school.

The Swaddled Christ Child
(fragment of a *Nativity*)

Fresco, transferred to canvas
44 x 50.5 (17³⁄₁₀ x 19⅞)

Gift of René Gimpel. 24.115

Provenance: S. Maria inter Angelos, Spoleto; Francesco Ciani, Spoleto, 1871-1908; Guglielmo Cianni, Spoleto, 1908-1921; Ernesto Bayet, Lieto Colle (?); Bernardo Bazzani, Bergamo (?); René Gimpel

Literature: Rowland, 1931, p. 224; Taylor, 1932, p. 78; Coor-Achenbach, 1953, pp. 11-15; Frederickson and Zeri, 1972, pp. 241, 564; Davies, 1974, pp. 465-475; Toscano, 1974, pp. 4, 17 fn. 6; Todini, 1989, p. 164; Cadogan et al., 1991, p. 260-261, fig. 54.

Condition: Two irregularly shaped fresco fragments, approximately 2 mm thick, have been transferred to a canvas support. Apart from minor cracks running through the plaster layers and small scattered losses, minimally retouched, the paint surface is in excellent condition.

THE CHRIST CHILD, swaddled in yellow cloth with black trim, is lying in a wood crib and looking up to the left. An ox and an ass, the latter cropped at the left edge of the fresco, watch the Child from behind the crib, while the lower right corner of the scene is filled with a fragment of the Virgin's yellow and red mantle.

This fragment formed the upper left corner of a Nativity, part of a much-discussed fresco cycle from the Church of S. Maria inter Angelos, commonly known as Le Palazze, near Spoleto. The original disposition of the nine frescoes (now dispersed) known to have been painted there is thoroughly discussed by Davies (1974). A photograph of the complete Nativity fresco prior to its removal from the south wall of the church around 1921 was published by Taylor (1932) and Coor-Achenbach (1953). Surviving fragments of this fresco, other than the Boston Christ Child, include a St. Joseph (Worcester Art Museum, 1932.1), a Shepherd with one hand of the reclining Virgin (Fogg Art Museum, Cambridge fig. 21), and the youngest magus. The rest of the figure of the Virgin and the arm of the angel announcing the birth of Christ to the shepherds have not been recovered.

Most discussions of the frescoes from Le Palazze in the extensive literature referring to them (see Davies, 1974, for a complete summary) are concerned with the reconstruction of the cycle and its iconography. Most authors concur in situating them late in the thirteenth century and in considering the author a product of a local Spoletan "school."

Gertrude Coor-Achenbach dated them to the early fourteenth century "on the basis of composition and iconography." Bruno Toscano, the author to have most closely investigated their stylistic links to contemporary painting in Umbria and Rome, cited their dependence on Cimabue's Passion frescoes in the Upper Church at Assisi as evidence for a date after ca. 1290. The paucity of comparable material from other sites around Spoleto renders a more concrete judgment impossible for the present.

Fig. 21. Master of Le Palazze, *Shepherd with One Hand of the Reclining Virgin*. Fogg Art Museum, Harvard University, Cambridge, MA

Master of San Pietro in Sylvis
(Pietro da Rimini ?)

NAMED after a fresco cycle decorating the apse of the church of San Pietro in Sylvis at Bagnacavallo (Forlì), the Master of San Pietro in Sylvis has been regarded as one of the founders of the Riminese school of the fourteenth century, alongside Giovanni and Giuliano da Rimini.

The San Pietro in Sylvis frescoes were traditionally thought to have been the work of Giuliano da Rimini, and were first attributed to an independent master by Salmi (1931-32, p. 253-256). Toesca (1951, p. 726) identified their author as Pietro da Rimini, otherwise known from a signed Crucifix in Urbania and thought to have been a painter of uneven accomplishment active primarily in the second quarter of the fourteenth century. Toesca's suggestion has met with both wide acceptance (e.g. Zeri, 1958, p. 50; Pasini, 1990, pp. 95-99) and uncompromising disdain (Volpe, 1965, pp. 21-23), a range of opinion based in part on the lack of agreement over most attributions to Pietro da Rimini, who has been assigned a confused and vacillating corpus of paintings from the time of Cavalcaselle on. If the Master of San Pietro in Sylvis is to be identified with Pietro da Rimini, his works would constitute Pietro's early career, possibly from as early as ca. 1310 until the end of the first quarter of the fourteenth century.

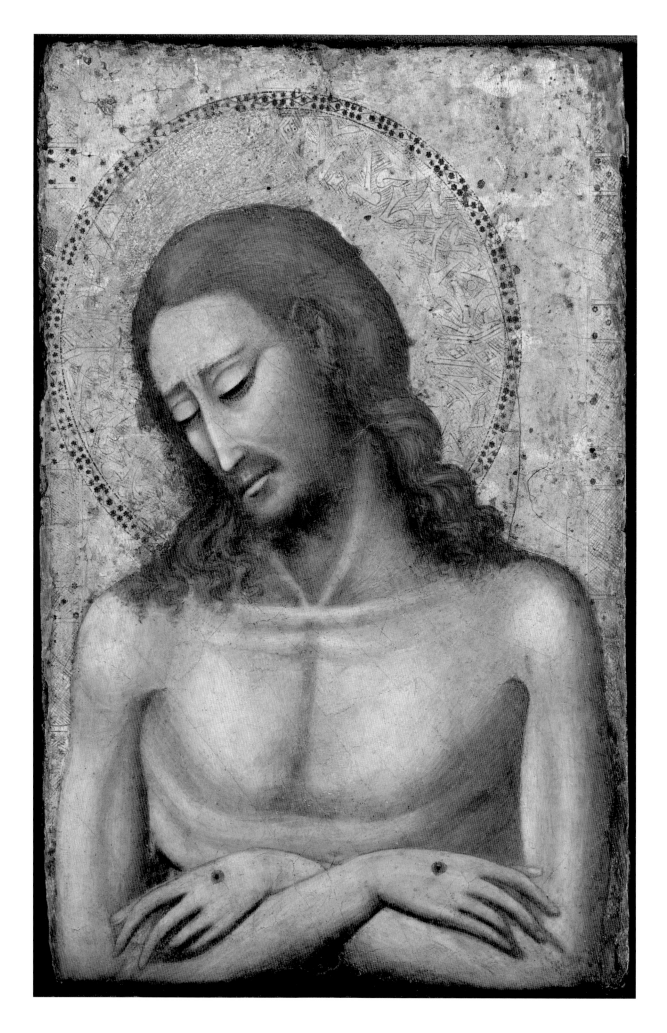

118 (cat. 26)

Man of Sorrows

Tempera on panel
26.7 x 17 (10½ x 6⅝)

Gift of Edward Jackson Holmes. 28.887

Provenance: Unknown; Edward Jackson Holmes, Boston, by 1926

Literature: Van Marle, 1935, p. 5; Salmi, 1935, p. 329; Berenson, vol. 1, 1968, p. 356; Fredericksen and Zeri, 1972, pp. 236, 564; Pasini, 1990, p. 56; Stefaniak, 1992, pp. 693, 694 fig. 2.

Condition: The panel support, of a vertical wood grain, has been thinned to a depth of 1.0 cm and cradled. All four edges appear to have been trimmed slightly. The gold ground is fairly well preserved except for a loss above Christ's head. The paint surface has suffered numerous minor flaking losses, but has not been extensively abraded. Larger losses are visible in Christ's chest, left shoulder, temple, and hair. There are also numerous small losses along the edges of the picture, especially at the bottom, all of which have been restored and liberally inpainted.

THE FRONTAL FIGURE of Christ, cropped above the waist, is shown with his arms crossed before him, exposing the wounds in his hands and side. His head is inclined to the left, the punched border of his nimbus overlapping the engraved border of the gold ground along the left edge of the panel. The inner ring of the nimbus is engraved with a pseudo-cufic pattern against a cross-hatched ground. Christ's eyes are closed and his brows are knit in pain.

Since this panel was first made known to scholars, it has been considered a product of the Riminese school (Perkins, letter 15 June 1926 in Museum files; Salmi, 1935; Berenson, 1968; Fahy, verbally, 1985), and more specifically it has been associated with one of the salient personalities of that school, Pietro da Rimini (van Marle, 1935; F. Zeri, letter in Museum files, 1951; W. Suida, verbally; M. Laclotte, verbally, 1987). By and large it has been discussed only peripherally, however, and modern studies of the Riminese school omit mention of it altogether.

The problematic attribution of this highly refined little panel to Pietro da Rimini rests on its similarities to a large Crucifix in the Galleria Nazionale delle Marche at Urbino, traditionally assumed to be a cornerstone of the artist's oeuvre. The type of Christ, the means used to delineate the details of his anatomy, and the tenor of his pathetic expression are virtually identical in these two paintings, and it can only be concluded that both pictures are by the same artist. That this artist might be Pietro da Rimini, author

of a Crucifix in the Chiesa dei Morti at Urbania, has recently been called into question, however, and the Urbino Crucifix has been related instead, along with a small number of independent panel paintings, to the frescoes in the apse of the church of San Pietro in Sylvis at Bagnacavallo. The figure of the crucified Christ between the Virgin and Saint John at San Pietro in Sylvis is particularly close to the Urbino Crucifix and to the Boston Man of Sorrows, and it seems acceptable to christen their author the Master of San Pietro in Sylvis.

The frescoes at San Pietro in Sylvis have themselves in the past been regarded as works by Pietro da Rimini. An inscription on them was recorded in the eighteenth century identifying their patron and the artist, but the latter was unfortunately fragmentary even at that date, with only "... DE ARIMINIO" preserved. Recent criticism (Bottari, 1958, pp. 136-138; Volpe, 1965, pp. 21-23) has succeeded in identifying the patron and establishing a terminus ante quem for the frescoes of 1332, with a likely period of execution around 1320. As such, they can have been painted by Pietro da Rimini only if they are considered youthful works. If the Master of San Pietro in Sylvis is not to be conflated with Pietro da Rimini, he must be considered a talented contemporary investigating parallel stylistic possibilities (Gnudi, vol. 1, 1977, pp. 120-136; idem, 1978, pp. 61-65). Given the scarcity of surviving documentary material concerning Riminese trecento culture and the fragmentary nature of surviving visual evidence, the problem does not at present seem resoluble.

The original function of this panel is unclear. Its vertical wood grain seems to disallow its placement in the predella of an altarpiece, where images of the Man of Sorrows are commonly found, and the sides of the panel retain no evidence of hinges that might have established it as part of a diptych or triptych. There is no surviving indication of how the panel was originally framed, or whether its present proportions are original: the engraved border of the gold ground along the left and right sides implies that the picture surface was never substantially wider than it is now, but the border does not continue across the top, and the bottom of the panel, where Christ's arms are cropped, is severely damaged.

Master of the Urbino Coronation

A RIMINESE PAINTER first identified by Salmi (1931-32) and named for a triptych in the Galleria Nazionale delle Marche at Urbino representing the Coronation of the Virgin, the Master of the Urbino Coronation was active primarily in the Marches and in Umbria – at Fabriano – between about 1340 and 1380. Whether he was an itinerant Riminese or a Marchigian who absorbed Riminese influences is a matter of some debate (Volpe, 1965), though the principal sources of his art are indisputably the works of Giuliano and Pietro da Rimini and the still anonymous Riminese Master of the Life of Saint John the Baptist.

27

The Crucifixion

Fresco, transferred to canvas
338 x 277 (133 x 108½)

Augustus Hemenway Fund. 40.91

Provenance: S. Lucia del Mercato, Fabriano (?);
Tartuferi, Bologna; Palazzo Corsini, Rome, 1894-
1916; Convento S. Antonio, via Merulana, Rome;
Castel Sant'Angelo, Rome; Prof. Publio Podio,
Bologna; Brummer Gallery, New York, 1929;
William Randolph Hearst; Acquired from Brum-
mer Gallery, New York, 1940

Literature: Salmi, 1931-32, pp. 238-242; Molajoli,
1934, vol. 16, no. 4, pp. 319-335; Brandi, 1935, pp.
124, 196 fig. III; Constable, 1941, pp. 48-54; Zeri,
1950, pp. 36-40; Volpe, 1965, pp. 50-52; Berenson,
vol. I, 1968, p. 356; Zampetti, 1971; Fredericksen
and Zeri, 1972, pp. 137, 564; Carpegna, 1973, p. 40;
Peters, 1988, p. 43, fn. 1.

Condition: The plaster layers, approximately 2
mm thick, show extensive cracks over the entire
surface, mostly caused by the procedure of trans-
fer to canvas, but these do not seriously impair
the legibility of the image. There are also
numerous damages and losses of varying size
scattered over the entire surface and broadly
inpainted. The paint layers that remain are in
fairly good condition, however, retaining a con-
vincing sense of modeling and a dependably
accurate sense of the fresco's original palette.

THE BOSTON *Crucifixion* formed part of a
cycle of frescoes reputedly removed from
the church of Santa Lucia del Mercato at
Fabriano in the nineteenth century
(Brandi, 1935), two other surviving frag-
ments of which have so far been identi-
fied. These represent the Birth of the
Baptist (Rome, Galleria Nazionale del
Palazzo Barberini; fig. 22) and the
Annunciation to Zacharias (Rochester,
New York, Memorial Art Gallery of the
University of Rochester; fig. 23), and
were recognized as parts of a single com-
plex by Robert Longhi (cited in Santan-
gelo, 1974, p. 6) and Federico Zeri (1950).
The Roman fresco came, like the Boston
picture, from the Palazzo Corsini in 1916;
the provenance of the Rochester picture
is unknown.

The reputed Fabrianese provenance
of the cycle is important to any discus-
sion of its authorship and significance.
The Boston Crucifixion is grouped by
Salmi (1931-32) with a small number of
panel paintings and a fresco in Fano
around the triptych in the Galleria
Nazionale delle Marche at Urbino repre-
senting the Coronation of the Virgin, a
Riminese picture of distinguished quality
presumably datable around the middle of
the fourteenth century. The essential
validity of Salmi's group has never been
questioned, though a controversy, at
times descending to the level of polemic
(Volpe, 1965), has arisen over the fixed

Fig. 22. Master of the Urbino Coronation, *Birth of
the Baptist*. Galleria Nazionale del Palazzo Barberini,
Rome

Fig. 23. Master of the Urbino Coronation,
Annunciation to Zacharia. Marion Stratton Gould
Fund, Memorial Art Gallery of the University of
Rochester, Rochester, NY

boundaries of this group. In particular, a
fresco in the church of S. Agostino at
Fabriano and a fresco formerly in the
convent of S. Emiliano there have been
the subjects of heated discussion (B.
Molajoli, 1934; P. Zampetti, 1971a). For
some, these are certainly works by the
Master of the Urbino Coronation, distin-
guished from the other pictures in the
group only by differences imputed to
chronological development. For others,
the Fabriano frescoes are products of an
indigenous school strongly influenced by
the painters of Rimini and especially by
the Master of the Urbino Coronation.

There is little doubt, and none has
been expressed in the literature cited
above, that despite their Fabrianese
provenance the Boston, Rome, and
Rochester frescoes belong firmly in the
group of pictures assigned to the Master
of the Urbino Coronation. All the other
known works by the artist come from
Urbino or its immediate vicinity (Pesaro,
Fano), and it may therefore be that the
undeniably powerful influence he exert-
ed in Fabriano (assuming the Fabriano
frescoes to be in fact indigenous and not
Riminese) is to be imputed directly to
the cycle of which the present fresco
formed part, formerly in Santa Lucia del
Mercato.

The extremely precocious dating pro-
posed by Volpe (1965) for the Fabriano
frescoes is unacceptable. None of the
known paintings by the Master of the
Urbino Coronation can have been exe-
cuted earlier than the second quarter of
the fourteenth century, if not indeed
after 1350. The Fabriano frescoes must be
among the Master's last works. They are
dated by Zeri (1950) to the decade of the
1360s, in part following Molajoli's report
(1936) of the construction of Santa Lucia
del Mercato around 1365. Though the
exact date of construction of the church
cannot be confirmed, a date around 1370
for the Boston fresco is plausible on styl-
istic grounds.

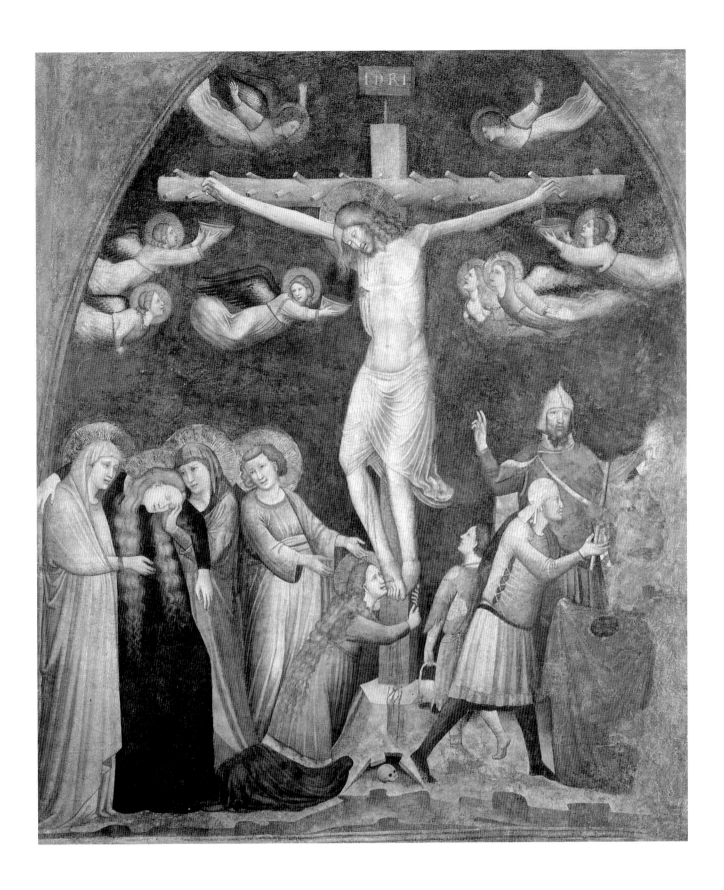

Barnaba da Modena

BORN IN Modena and in all likelihood trained either there or in nearby Bologna, Barnaba da Modena spent the greater part of his career in Genoa, where he is first mentioned in a document of 1361. The following year he is described as a citizen and resident of Genoa, implying that he may have settled there as much as a decade earlier. Barnaba's first signed and dated work, a Madonna and Child of 1367 in Frankfurt, includes the epithet IN JANUA (in Genoa) after the artist's signature, and he is recorded there at regular intervals until 1380, when he returned briefly to Modena before being called to Pisa. By 1383, the date of the last preserved notice referring to Barnaba da Modena, he had returned to Genoa. The date of his death is unknown. Barnaba da Modena successfully combined the highly expressive styles of Vitale and Jacopino da Bologna with formal characteristics of the Sienese and Byzantine schools popular with conservative Genoese taste to produce a highly individual style of his own. His influence was particularly forceful in Pisa, where in addition to his importance for painters of the local school, he made a lasting impression on a leading Sienese artist of the next generation, Taddeo di Bartolo.

28

Virgin and Child

Tempera on panel
Overall: 100.3 x 63.4 (39½ x 25)
Picture surface: 88.6 x 59.7 (34⅞ x 23½)

Gift of Mrs. W. Scott Fitz. 15.951

Provenance: W. Fuller Maitland, Stansted Hall (?); R. Langton Douglas, London; Philip Gentner, Worcester

Literature: Perkins, 1915, pp. 222-223; van Marle, vol. 4, 1924, pp. 371-372; Berenson, 1932, p. 42; Venturi, vol. 1, 1933, pl. 118; Berenson, 1936, p. 36; Galetti and Camesasca, vol. 1, 1950, pp. 201-202; Wagstaff, 1965, pp. 18-19; Berenson, vol. 1, 1968, p. 27; Pesenti, 1968, pp. 25, 27 fn. 19; Malvano, 1969, pp. 340-341; Faison, 1970, pp. 27-28; Pesenti, 1970, pp. 52, 73; Fredericksen and Zeri, 1972, pp. 15, 564; Padovani, vol. 1, 1972, p. 351, fig. 342; van Os, 1983, p. 72; Algeri, 1989, pp. 194, 204 fn. 24.

Condition: The panel, the sides and back of which have been coated with wax resin, has not been cradled and retains three of its original engaged moldings; framing pilasters at left and right have been cut away leaving a raised beard of gesso and gilding. The arched molding above the Virgin's head and the simple horizontal molding at the bottom of the panel are intact, though the latter has been regilt at either end. The dentil molding and corbels at the top have been more extensively repaired and regilt. The gold ground and tooled decoration otherwise are in excellent condition, except for local repairs in the haloes (see below). The mordant gilding in the Virgin's mantle is well preserved, while that in the Child's garments is somewhat abraded. The paint surface is extremely well preserved, suffering only mild abrasions overall.

THE VIRGIN is shown half length in a blue mantle, decorated with a dense pattern of gilt striations, over a pink dress. She turns in three-quarters profile to the right, and holds the Christ Child in the crook of her left arm. The Child, dressed in a scarlet and gilt robe with a green lining over a yellow and gold embroidered tunic and wearing a necklace of coral, rests his right arm on his mother's shoulder, gazes up at her face, and toys idly with her veil in his right hand.

This Virgin and Child was first recognized by Osvald Sirén in 1914 as a characteristic work by Barnaba da Modena (letter to R. Langton Douglas in Museum files), and all subsequent references to it have been concerned with highlighting its exceptional quality and with determining its approximate date relative to the artist's first known work, the Virgin and Child of 1367 in the Städelsches Kunstinstitut, Frankfurt. Along with two loosely related compositions in the Philips de Jongh collection, Eindhoven (van Os, 1983), and formerly in the Crespi-Morbio collection, Milan (Algeri, 1989), the Boston painting is generally thought to have preceded the dated work in Frankfurt, though Sirén and van Marle (1924) thought it could have been painted as late as 1370. More recently, Pesenti (1968, 1970) has pointed out the iconographic relationship between the Boston painting and an earlier Virgin and Child in the Museo di S. Maria di Castello in Genoa, attributed to an unknown Sienese or Pisan painter working in Liguria. Both works follow closely similar cartoons derived from the example of Pietro Lorenzetti in the first half of the century. Pesenti's conclusion that the Boston painting is likely to be one of Barnaba da Modena's earliest surviving efforts seems to be correct.

The engaged framing members of the Boston Virgin and Child indicate clearly that it was painted as the center panel of a conventional polyptych, not, as is contended by Malvano (1969, where the Boston painting is confused with a wholly unrelated Virgin and Child by Barnaba da Modena in Tortona), as an independent devotional image. At some point in its history, probably after it was separated from its lateral panels, it came to be venerated as an independent object, as is attested to by the repaired damages in the gold ground – six in the Virgin's halo and three in the Child's. These repairs cover the points of attachment of two silver crowns, commonly added to paintings of special devotional significance. Under these circumstances, the likelihood of any associated lateral panels surviving is far less than if the altarpiece had simply been dismantled for sale in more modern times.

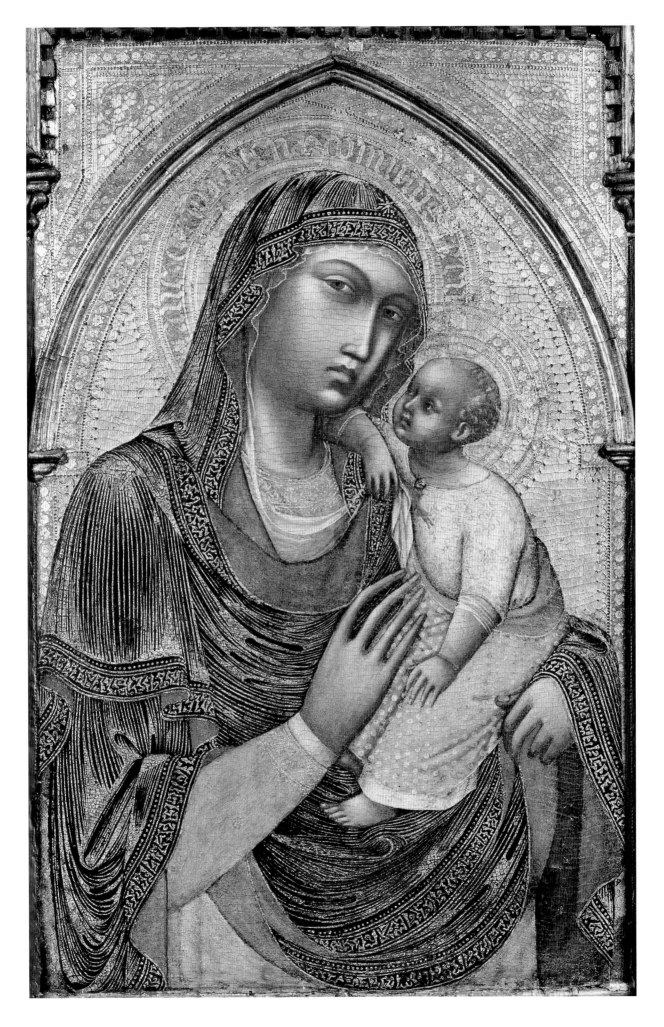

PART II:
Fifteenth Century

Niccolò
di Pietro Gerini

Niccolò DI PIETRO GERINI's long and pro-
lific career is unusually well documented
from the first notice of his activity in
1368, when he enrolled in the Arte dei
Medici e Speziali, to his death in 1414 or
1415. Possibly a student of the Master of
the Orcagnesque Misericordia or of
Jacopo di Cione, he became one of the
prime exponents of the Orcagnesque
style in Florence over the last third of the
fourteenth century and one of its last
and most faithful interpreters in the first
decade and a half of the fifteenth. His
earliest dated work, an altarpiece of 1375
in the Collegiata at Impruneta, was
painted in collaboration with Pietro Nel-
li, and other documented collaborations
with heads of independent studios are
recorded in 1383 (Jacopo di Cione), 1386
(Ambrogio di Baldese), 1391 (Agnolo
Gaddi), 1397 (Ambrogio di Baldese), and
1399-1401 (Spinello Aretino and Lorenzo
di Niccolò). In addition to Florence,
Gerini is documented working on monu-
mental decorative campaigns in Volterra
(1383), Prato (1391-1401), Pisa (1392), and
Empoli (1404), an index of the high repu-
tation he enjoyed among his contempo-
raries, confirmed by the frequency of
records referring to him and the great
number of works by him which survive.

29

Virgin and Child Enthroned

Tempera on panel
Overall: 161.5 x 77 (63⅜ x 30¼)
Picture surface: 146 x 70.5 (57½ x 27¾)

Gift of Mrs. W. Scott Fitz. 16.64

Provenance: Rodolfo Calafranceschi, Rome (?)
(sale, Jandolo and Tavizzi, April 5-20, 1907, lot
312); Joachim Ferroni, Rome (sale, Galleria San-
giorgi, April 14-22, 1909, pl. 3); Philip Gentner,
Florence; Purchased by Mrs. Fitz on behalf of
the Museum of Fine Arts in 1916

Literature: Sirén, 1920, p. 466; Offner, 1921, pp.
148-152, fig. 2; van Marle, vol. 3, 1924, p. 638, fig.
361; Offner, 1927a, pp. 83, 89, 91; Lazarev, 1928, p.
39; Berenson, 1932, p. 394; Galetti and Camesasca,
1950, p. 1066; Boskovits, 1962, p. 24 fn. 9, 26;
Berenson, 1963, p. 158; Marcucci, 1965; Frederick-
sen and Zeri, 1972, pp. 81, 50; Fremantle, 1975, pp.
323, 330, fig. 683; Boskovits, 1975, p. 404; Cole,
1980, pp. 70, 73 fn. 8; Maginnis, 1981, p. 72.

Condition: The panel support has been neither
thinned nor cradled, and its engaged frame
moldings above the spring of the arch are sub-
stantially original though heavily regessoed and
regilt. The topmost molding strip and the
engaged moldings along the sides and bottom of
the panel are modern additions. The gold
ground is reasonably well preserved, with local
repairs along a partial split in the panel between
the heads of the Virgin and the Child, in the Vir-
gin's halo, and along the edges of the throne.
The mordant gilding on the throne and on the
Virgin's dress and mantle is largely intact. The
paint surface has been mildly abraded through-
out, with minor flaking losses minimally inpaint-
ed. Losses in the Virgin's blue robe have been
more heavily overpainted, and the bottom edge
of the panel, including sections of the dais of the
throne, is badly damaged and much restored.

THE VIRGIN is shown full length and
frontally, wearing a white dress embroi-
dered with dark blue and gold beneath a
blue mantle lined with ermine. She is
seated on a marble throne decorated
with carved acanthus finials and crockets
and with Cosmatesque inlay on the riser
of its dais and on the armrests, draped
with an orange-red cloth of honor. She
supports the Christ Child, wrapped in a
yellow robe, in the crook of her left arm.
The Child holds two fingers of his moth-
er's right hand in his left, reaches his
right arm around her neck, and rests his
head against hers. The picture is
inscribed across the lower left and right
corners: ... D[OMI]NI M/CCCCIIII/DEL MES
[E] DI LUGLIO.

Through most of its early critical his-
tory, the inscription at the bottom of the
Boston Virgin and Child Enthroned, dat-
ing it to July 1404, was covered by an
elaborate modern frame, removed dur-
ing cleaning only in 1951. When it first
appeared at auction in Rome in 1907 (and
again in 1909) it was attributed to

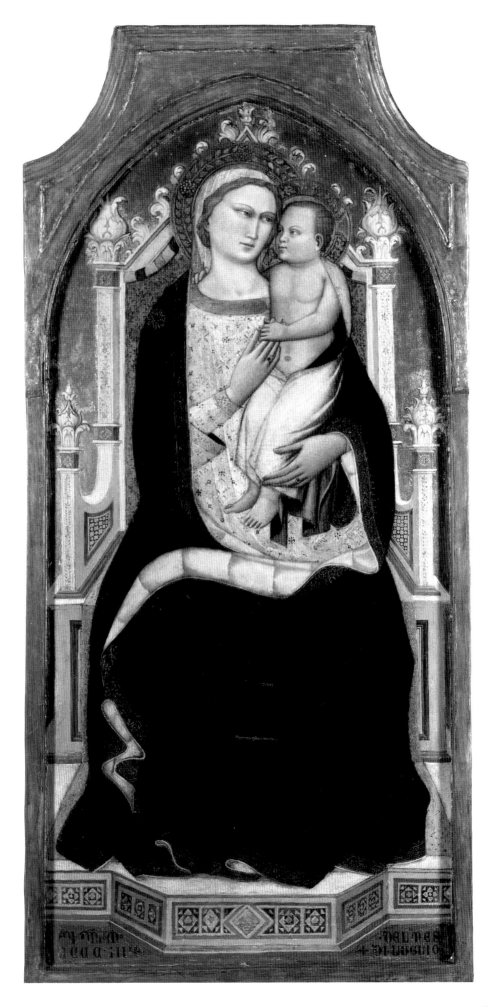

Ambrogio Lorenzetti (d. 1348/9), and it was acquired by the Museum of Fine Arts in 1916 as a work by Giovanni del Biondo (d. 1399). Osvald Sirén (1920) first recognized the painting as by Niccolò di Pietro Gerini, an attribution endorsed by Richard Offner (1921, 1927a), who proposed dating it to ca. 1392 on the basis of comparison to other securely datable works by Gerini from that decade, particularly the frescoes in the sala capitolare at San Francesco, Pisa (documented to 1392). Offner remarked the dependence of Gerini's style in the Boston picture on the example of Bernardo Daddi and the Cioni, modified by contact with Agnolo Gaddi, with whom he had collaborated on commissions in Prato in 1391. For van Marle (1924), the influence not of Agnolo Gaddi but of Spinello Aretino was dominant in this picture, and he attributed it instead to Lorenzo di Niccolò, a pupil and sometime collaborator of Niccolò di Pietro Gerini. Fremantle (1975) associated the painting with a group of works isolated by Berenson under the rubric "Master of the Arte della Lana Coronation," an artist characterized as a close follower of Niccolò di Pietro Gerini, perhaps identifiable with the young Lorenzo di Niccolò.[1] All other writers who have discussed the Boston painting have followed Offner in treating it as a prototypical work of Niccolò di Pietro Gerini, and it has frequently been adduced as a standard against which to confirm other attributions to that artist.

Any lingering doubts over the attribution of the Boston panel to Niccolò di Pietro Gerini must strictly be due to the picture's late date. After the Santa Felicità altarpiece of 1401 (Florence, Accademia), on which he collaborated with Spinello Aretino and Lorenzo di Niccolò, Niccolò di Pietro gravitated noticeably away from the severe style influenced by Orcagna and Nardo di Cione in which he had begun his career, and towards the example of Agnolo Gaddi and his followers. This softer late style is clearly evident in two works by Gerini closely similar to the Boston painting in composition, figure style, and handling: a Madonna and Child with Saints John the Baptist and Zenobius in the Pinacoteca Comunale at Pistoia (Marcucci, 1965, p. 113) and the altarpiece of the Madonna and Child with Saints Anthony Abbot, John the Baptist, Lawrence, and Julian in the Accademia, Florence, also dated 1404 (Fahy, 1978a, fig. 13). Both of these pictures have in the past been incorrectly attributed to Lorenzo di Niccolò or another anonymous follower of Niccolò di Pietro (cf. Chiti, 1931, p. 47; Berenson, 1932a, p. 14).

The size and shape of the Boston Virgin and Child Enthroned suggest that it originally served as the center panel of a polyptych. On the analogy of other polyptychs by Niccolò di Pietro Gerini, and particularly the Accademia altarpiece of 1404 (which the Boston panel closely resembles in the manner of its framing), the ground plane of the lateral panels, which would undoubtedly have represented two or more standing saints, would have been notionally continuous with that in the center, and it is reasonable to assume that the extensions of the dais of the Virgin's throne cropped at the lower left and right edges of the Boston panel would have appeared at the inside edges of the lateral panels. No independent images of standing saints attributed to Niccolò di Pietro Gerini are known with fragments of this dais cropped at their inner edges, so reconstructing the original context of the Boston painting must remain a matter of conjecture.

1. The paintings first attributed to the Master of the Arte della Lana Coronation by Berenson (1963, p. 138) and by B. Cole (1968, pp. 215-216) have been recognized by Boskovits (1975, p. 227 fn. 73) and E. Fahy, (1978a, pp. 375-376) as not forming a stylistically coherent group, and have been convincingly reassigned by them to Niccolò di Pietro Gerini and three other artists. The Boston Virgin and Child Enthroned is not among the works discussed by any of these authors; only Fremantle seems to have favored an attribution for it to the supposed Master of the Arte della Lana Coronation.

Lorenzo di Niccolò di Martino

LORENZO DI NICCOLÒ was not, as is commonly believed, the son of Niccolò di Pietro Gerini (q.v.), though he was associated with the older artist as an apprentice or a partner in the earliest preserved documents referring to him, of 1392 and 1395. In 1400-1401, he collaborated with Gerini and Spinello Aretino on the high altarpiece of Santa Felicità (Florence, Accademia), which is signed by all three painters, and the following year he signed and dated a triptych showing Saint Bartholomew enthroned and scenes from his life (Museo Cìvico, San Gimignano), his earliest, securely datable, independent work. In 1402, Lorenzo di Niccolò contracted to paint a large altarpiece for the church of San Marco in Florence, which now stands on the high altar of San Domenico, Cortona. The same date appears on an altarpiece attributable to him in the church of San Martino at Terenzano, while another, in the Cini collection, Venice, is dated 1404. All his works through this date reveal Lorenzo di Niccolò to have been an able follower of Niccolò di Pietro Gerini, softening the latter's marmoreal figure style somewhat and adding a dimension of pictorial space entirely lacking from Gerini's intentionally flat, hieratic images. By 1410, however, the date inscribed on a polyptych now in the Medici chapel in Santa Croce, Lorenzo di Niccolò's artistic allegiances had shifted decidedly to the orbit of Lorenzo Monaco. This phase of the artist's career is little documented. Lorenzo di Niccolò was dead by 1422.

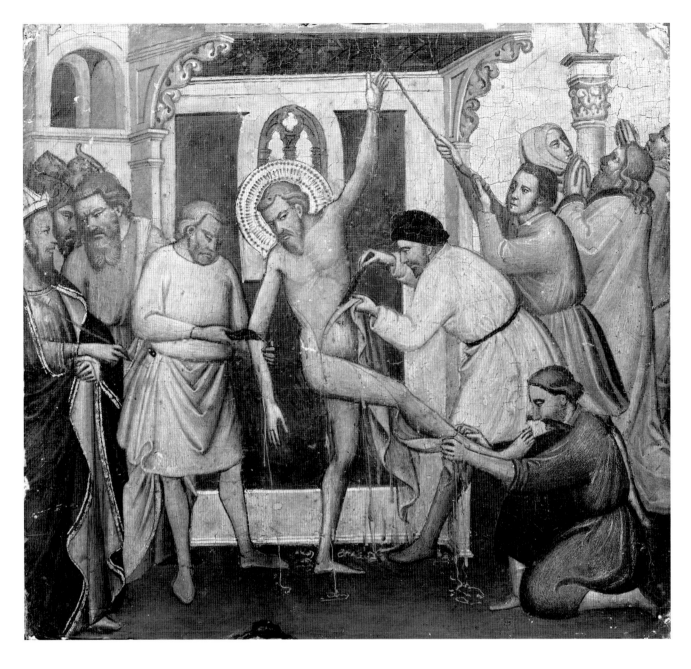

30

Martyrdom of Saint Bartholomew

Tempera on panel
28.8 x 31 (11⅜ x 12¼)

Gift of Miss Catherine Sherwood. 04.237

Provenance: Unknown; Miss Catherine Sherwood by 1904.

Literature: Fredericksen and Zeri, 1972, pp. 80, 563.

Condition: The panel has been thinned to a depth of 2.2 cm but has not been cradled. A horizontal split running the length of the panel along its center has not broken the paint surface. The gold ground is fairly well preserved, except for small losses along the punched pattern in the saint's halo. The paint surface has suffered extensive pinpoint flaking losses along the edges of the craquelure, coarse overpainting of which is now moderately discolored. No barbs of gesso are apparent at any of the panel's four edges, indicating that it has been reduced in height and width by some indeterminate amount.

THE SAINT is shown standing on one foot, naked, within a Gothic alcove in the center of the panel. Three executioners cut the skin from his body with knives, while a fourth holds his left arm raised with a rope and pulley. King Astrages, who ordered Bartholomew's execution, stands at the left, with a counselor and three soldiers. Three men at the far right worship an idol set atop a free-standing Corinthian column.

This little-known panel was attributed to Lorenzo di Niccolò by Richard Offner (note in Museum files, 1936), an attribution supported by comparison to the same scene in the artist's signed and dated Saint Bartholomew altarpiece of 1401 at San Gimignano. The principal group of the saint and his four executioners, in a virtually identical arrangement, appears in both. In the panel at San Gimignano, the entire scene is closed off behind by an architectural backdrop. Three soldiers enter through a doorway at the left, but the figure of King Astrages and the idol worshippers at the right are omitted. The latter do appear in the sinopia of a fresco of the Martyrdom of Saint Bartholomew by Spinello Aretino in the Cortigiani chapel in San Michele Visdomini, Florence, the altarpiece of which was painted by Lorenzo di Niccolò (cf. Cohn, pp. 42-43; Tartuferi, 1983, pp. 3-18). Spinello's fresco is reasonably supposed to predate 1401 and to have been the source for Lorenzo di Niccolò's portrayal of the scene in the San Gimignano altarpiece; it is even closer than the latter to the composition of the scene on the Boston predella panel.

That the Boston panel is not merely an anonymous replica of Lorenzo di Niccolò's composition may be deduced by comparison to other small-scale figure paintings by him, such as the half-length figures in the predellas to two paintings of the Madonna and Child, in the Hermitage, Saint Petersburg (Lazarev, 1928, fig. 9), and at Santa Maria delle Grazie, Stia, in the Casentino (cf. Fahy, 1978a, fig. 15). The Boston panel is close to these in figure style but is looser in handling and is likely to be of a slightly later date. In this respect it more closely resembles the predella of the altarpiece by Lorenzo di Niccolò in the sacristy of Santa Croce, Florence. This altarpiece was probably painted after the still slightly Gerinesque Cini altarpiece of 1404, but perhaps not as late as the Cappella Medici altarpiece, also in Santa Croce, of 1410, which shows the precocious influence of Ghiberti and Lorenzo Monaco in its design. A date between 1404 and 1410 is plausible for the Boston panel as well.

Though Lorenzo di Niccolò's altarpiece in the Cortigiani chapel in San Michele Visdomini included a figure of Saint Bartholomew, it is unlikely that the Boston panel once stood in a predella beneath it since the same scene was frescoed on the right wall of the chapel. Two other predella panels by Lorenzo di Niccolò – a fragmentary Adoration of the Magi (29 x 40 cm; Alberto Saibene collection, Milan, 1962) and a Beheading of the Baptist (dimensions unknown; private collection, Florence, cf. Maginnis, 1981, fig. 152) – are loosely related in style and in scale to the Boston panel. The cropping of the latter along all four of its edges, however, precludes positive identification of any other panels from the same predella.

Gherardo di Jacopo Starnina

SUBJECT of a laudatory biography in Vasari's *Vite*, where he is said to have been the pupil of Antonio Veneziano and in turn the teacher of Masolino da Panicale, Starnina was long known to art history through documents only, with no works of art that could be securely attached to his name. He was first recorded in Florence in 1387, when he enrolled in the Compagnia di San Luca. Vasari claims that he spent many years in Spain, and he is in fact mentioned in documents from Valencia and Toledo between 1398 and 1401. By 1404 he had returned to Florence, where he painted a fresco cycle in the chapel of Saint Jerome in the Carmine, only scattered fragments of which survive. In 1409 he was paid for a fresco cycle in Santo Stefano, Empoli, fragments of which have recently been recovered. Starnina died in or shortly before 1413.

Various proposals to attribute independent panel paintings to the author of the fragmentary remains of frescoes in Empoli and at the Carmine had been largely inconclusive (Procacci, 1933, pp. 151-190; 1935, pp. 333-384; 1936, pp. 77-94; for a summary of the documents and the earlier literature pertaining to Starnina) until J. van Waadenoijen (1974, pp. 82-91) demonstrated his identity with a painter otherwise known as the Master of the Bambino Vispo. This painter, first isolated by Sirén (1904, p. 349; see also G. Pudelko, 1938, pp. 47-63, for the most thorough discussion of this artist), was long recognized as a leading exponent of the International Gothic style in Florence, but had been regarded as a follower of Lorenzo Monaco probably active in the second and third decades of the fifteenth century. It is now possible to recognize in his work, nearly all of which must have been produced between ca. 1404 and 1413, the catalyst for Lorenzo Monaco's, and perhaps Lorenzo Ghiberti's as well, own early experiments with an International Gothic style, and an important influence on the succeeding generation of painters in Florence, including Rossello di Jacopo Franchi, Giovanni dal Ponte, and Alvaro di Pietro Pirez.

31a

Saint Vincent

Tempera on panel
67.5 x 34.6 (26¼ x 13⅝)

Gift of Mrs. Thomas O. Richardson. 20.1855a

Condition: The panel, 3.1 cm thick and neither thinned nor cradled, is composed of two vertical-grained pieces of poplar with a join located 3 cm from the left edge. It has been cut on all four sides to its present shape. Marks from horizontal battens (one near the top, the other near the bottom) and two nails near the bottom edge and a nail hole at the top edge are visible on the back. The panel has an uneven, vertical, partial split 9 to 11 cm from the right edge that was caused by the insertion of dowels at the top and bottom. The original pointed arch has been truncated, leaving a 12 cm-long flat profile at the top of the panel. The gesso, paint, and gilt layers are in excellent condition with only minor losses and abrasions. The outer edges of the arch have been regilt beyond the beard of gesso remaining from the removal of the original engaged frame.

THE YOUNG DEACON saint is standing full-length on a tiled pavement, facing three-quarters to the viewer's right. He wears a pink dalmatic over a white alb, and holds a blue book in his left hand. His right hand, holding a martyr's palm, rests on a millstone, and the rope with which the stone was tied to Vincent's neck trails and loops on the floor before him. Several pentimenti are plainly visible in the design of the rope.

See 20.1857 below

31b

Saint Stephen

Tempera on panel
67.4 x 33.3 (26⅝ x 13⅛)

Gift of Mrs. Thomas O. Richardson. 20.1855b

Condition: The panel, 2.9 cm thick and neither thinned nor cradled, is composed of two vertical-grained pieces of poplar joined at 15.2 cm from the left edge. It has been cut at the bottom, left, and top sides to its modern shape; the right edge appears to be an old cut. Marks from two horizontal battens (one near the top, the other near the bottom) and four nails and a nail hole (three nails near the bottom edge and a nail and nail hole at the top edge) are visible on the back. The original pointed arch has been truncated, leaving a 12.5 cm-long flat edge at the top. The outer edges of the arch have been regilt beyond the beard of gesso remaining from the removal of the original engaged frame, and there is an incised line in the gold ground along the right vertical edge of the panel. The gesso, paint, and gilding are generally in excellent condition with only minor losses and abrasions. There is some

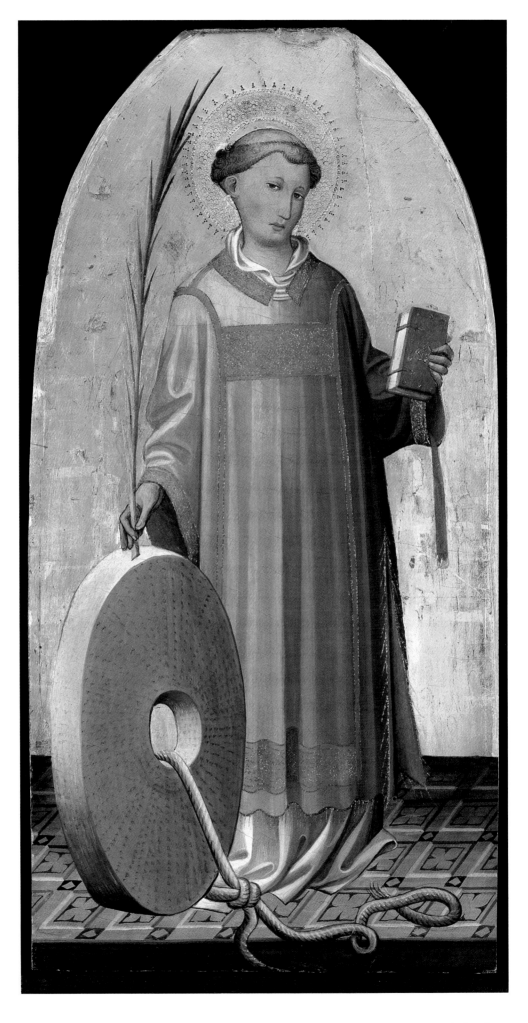

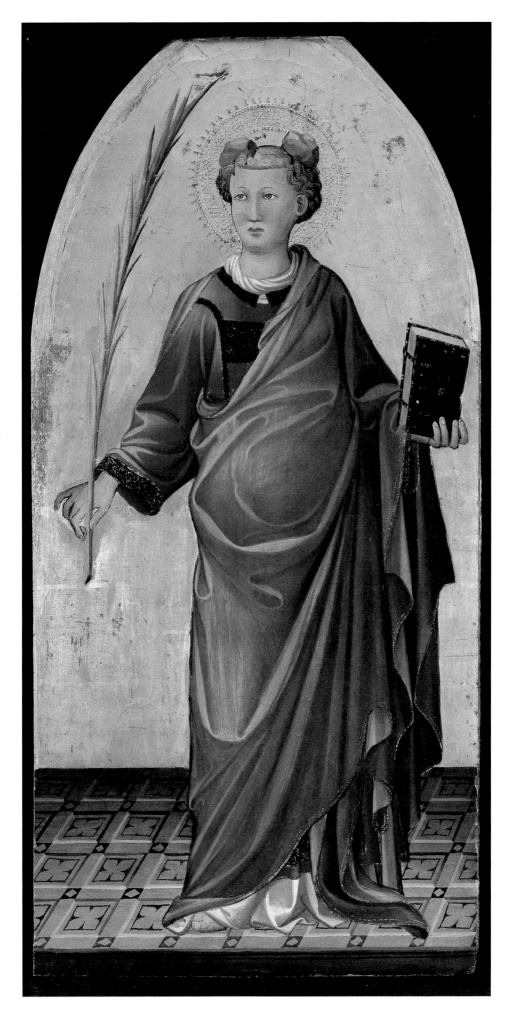

132 (cat. 31b)

retouching in the cheek of the saint, in his blue cloak, the palm leaf, and in the bottom right corner of the panel.

THE SAINT is shown full-length standing on a tiled pavement, his body posed three-quarters to the viewer's right and his head turned back towards the left. He wears a red dalmatic over a white alb and is wrapped in a blue cloak with vermillion lining. In his left hand he holds a black book and in his right hand a martyr's palm. Two large stones, symbolizing his martyrdom, rest atop his head.

When this and the preceding panel entered the collection of the Museum of Fine Arts they had been joined together into a single panel with a strip of wood separating them of sufficient width to allow the pavement tiles to form a continous pattern. They appear thus in old photographs, and are sometimes (e.g. Syre, 1979, pp. 121-124) still discussed as if they formed a single panel. Raimond van Marle, (vol. 9, 1927, pp. 198, 205 fig. 132) knew them as a single panel, but mistakenly published a photograph of an altogether different picture – two deacon saints in the Maitland Griggs collection – incorrectly labeled as the panel in Boston.

See 20.1857 below.

31C

Isaiah with Two Angels

Tempera on panel
31.8 x 74.1 (12½ x 29⅛)

Gift of Mrs. Thomas O. Richardson.
20.1856

Condition: The panel, of a vertical wood grain, has been thinned to a depth of 1.5 cm and cradled, and is composed of three (or four ? – the cradle covers the joins on the back) planks joined side by side. It appears that the top and right edges are original, but that the left has been slightly trimmed. A remnant of a dowel is visble along the bottom edge 25.5 cm from the left corner. There are three vertical splits in the support, the left-most split (27 cm from the left edge) has come through to the front while the other two (43 and 60 cm from the left edge) are partial splits. Along the bottom edge, the arch tops that belonged to two panels postioned below this panel were cut away and replaced with arch-shaped wood fills. The gesso layer exhibits numerous losses along the edges, especially along the bottom where the arch tops were detached and along the top where a corbel frieze frame originally existed. The painted figures and central areas of gilt background are fairly well preserved with small scattered abrasions and losses overall. The faces and hair of the figures, especially the angel on the left have been minimally retouched and the contours reinforced. The bottom part of the right angel's robe has been more heavily repainted.

THE PROPHET is seated in the center of the panel facing three-quarters to the viewer's right, holding a banderolle inscribed ISAIA PROF ETA. He wears a blue turban and a blue robe covered by a green cloak with a red lining. At the left edge of the panel, facing right, kneels an angel with red wings and a red tunic covered by a blue cloak lined with yellow; at the right is an angel with blue wings and a blue tunic covered by a red cloak lined with green.

See 20.1857 below.

31d

Jeremiah with Two Angels

Tempera on panel
31.8 x 74 (12½ x 29⅛)

Gift of Mrs. Thomas O. Richardson.
20.1857

Provenance: Unknown; Mrs. Thomas O. Richardson

Literature: Perkins, 1922, pp. 44-45, 49-51; van Marle, vol. 9, 1927, pp. 198, 207; Berenson, 1932, p. 339; Pudelko, 1938, p. 57, fn. 24; Longhi, 1940, p. 184; Santangelo, 1948, p. 36; Galetti and Camesasca, 1950, p. 1452; Berenson, 1963, p. 139; Gonzalez-Palacios, 1971a, no. 3, p. 9 fn. 9; Fredericksen and Zeri, 1972, pp. 125, 564; Palumbo, 1973, p. 24; Fremantle, 1975, pp. 447, 450; Boskovits, 1975, p. 10 fn. 8; Sricchia Santoro, 1976, pp. 11-29; Syre, 1979, pp. 121-124, fn. 306; van Waadenoijen, 1983, pp. 38-39, 67-68, 79, fig. 19; Zeri, 1988, pp. 32 (ill.), 35.

Condition: The panel, of a vertical wood grain, has been thinned to a depth of 1.3 cm and cradled, and is composed of several planks joined side by side (the cradle on the back makes it difficult to determine the exact number of joins). Two vertical splits in the panel (32 and 54 cm from the left edge) divide the work into three roughly equal sections. Two triangular wood fills have been inserted along the bottom edge where the tops of subjacent panels projected into this panel. The top, left, and right edges do not appear to have been trimmed. An incised line and a gesso beard are visible along the left edge. Gesso losses are extensive along the top and bottom edges but these have been restored. The painted figures and central portions of the gilt background are generally well preserved with minor losses and abrasions overall. The faces and hair of the figures, especially Jeremiah and the angel on the right have been retouched and contours heightened. The bottom sections of the robes of all three figures have been lightly retouched to cover losses from cutting as have the outlines of the scroll and a 2.5 cm-wide loss at the top of the scroll where the original frame adhered.

THE PROPHET, identified by a banderolle inscribed GIEREMIA PROFETA which he holds in his left hand, is seated in the center of the panel looking to his right. He wears a dark green robe, visible only at his shoulder and chest, and a violet cloak with a blue lining. At the right

edge of the panel is a kneeling angel in three-quarters profile with violet wings and a violet tunic covered by a green cloak with red lining. At the left edge of the panel is a kneeling angel in full profile with blue wings and blue tunic, only the sleeves of which are visible, draped in a red cloak with violet lining. Both angels follow the direction of Jeremiah's gaze, towards the viewer's left.

Since entering the collection of the Museum of Fine Arts in 1920, this and the three preceding panels (20.1855a, 20.1855b, 20.1856) have been almost without exception recognized as characteristic works by the so-called Master of the Bambino Vispo, recently identified with the Florentine painter Gherardo Starnina. Longhi (1940) removed them from the Master's corpus, calling them "cosa senese-pisana, affine a Martino di Bartolomeo," and Syre (1979) associated them with a number of other panels traditionally attributed to the Master of the Bambino Vispo but given by her instead to an artist in the Master's workshop or close following. Neither suggestion has gained general acceptance, even among those authors who believe the corpus of the Master of the Bambino Vispo is not homogeneous.

While there is general agreement as to their attribution, there is some confusion over the reconstruction of the complex of which the four Boston panels formed part. Michael Rinehart (letter in Museum files, 1960) first recognized a full-length Saint Lawrence in the Perkins collection at Assisi (fig. 24) as a third lateral panel from the same altarpiece as the Saints Stephen and Vincent (20.1855a, b); his opinion was subsequently published in Berenson's lists of 1963, and was accepted by, among others, Gonzalez-Palacios (1971a) and Palumbo (1973). The Saint Lawrence is the same size (65.2 x 33.2 cm) as the Boston saints, is cropped identically to them across the top (though a little higher into the picture field at the bottom), and includes a pavement that corresponds in every detail to that in the Boston panels except for being adapted to viewing on the right side of the altarpiece. Filippo Todini (oral communication, 1987) recognized a fourth lateral panel from this altarpiece in a full-length Saint Anthony Abbot formerly on the Florentine art market, first attributed to the Master of the Bambino Vispo by Luciano Bellosi and published by Fiorella Sricchia Santoro (1976, fig. 31), without reference to any reconstruction of its original context. The Saint Anthony Abbot self-evidently forms a pair with the Assisi Saint Lawrence, and would have stood alongside it on the extreme right of the altarpiece.

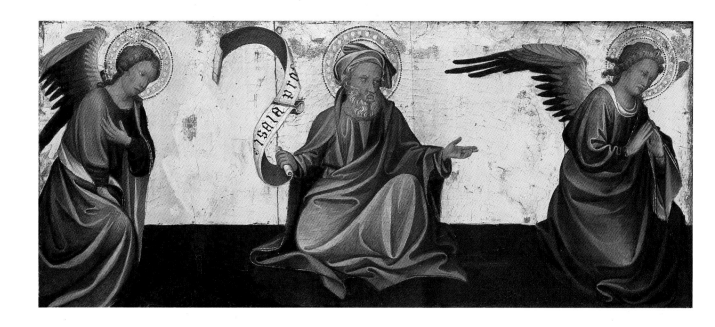

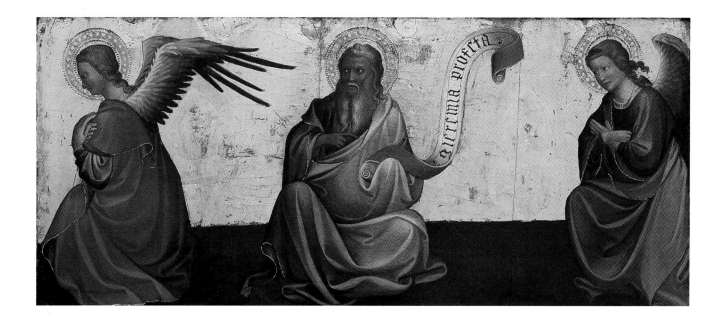

Syre (1979), who did not include the Saint Anthony Abbot in her catalogue of works by or related to the Master of the Bambino Vispo, denied the association of the Assisi Saint Lawrence with the Boston saints, proposing instead two panels formerly on the Dutch art market, representing Saints John the Baptist and Nicholas (?), as the missing panels from the right side of the Boston altarpiece. The size of these panels is unknown, but their pavement includes one extra row of tiles receding into depth and the projection of the orthogonals implies that they originally stood on either side of a central image in an altarpiece rather than together to one side. Because of the greater depth of the pavement in these panels, their association with the Boston saints is difficult to envi-

sion. If they did originate from the same altarpiece it must necessarily have been a heptaptych rather than a pentaptych, as Zeri (1988) assumed, though it seems more likely that they formed part of a different complex.

The two panels in Boston showing prophets seated between pairs of kneeling angels (20.1856, 20.1857) have almost without exception been considered parts of the predella to an altarpiece. Only Philip Hendy (manuscript note in Museum files, 1930) correctly recognized them instead as parts of the spandrels that stood above the lateral panels, a suggestion rejected or ignored by all later writers. The excised tops of the arches of subjacent panels are plainly visible, however, incorporated into the paint surface at the bottoms of both sets of spandrels,

and the incised outlines of the fleur-de-lys finials which once surmounted the frames of these lower panels may be seen at their points of attachment in the gold grounds of the spandrels between the angels and each prophet. The panel showing Isaiah, therefore, originally stood above, not beneath, the Boston Saints Stephen and Vincent, while that with Jeremiah originally stood above the Saints Lawrence and Anthony Abbot. In this position (fig. 25), furthermore, the glances and gestures of the kneeling angels are focused on the subject of the missing central panel.

At the top of both spandrel panels in Boston are marks left by an attached corbel frieze which must have supported an entablature or string course in the now-missing frame. Such a corbel frieze is

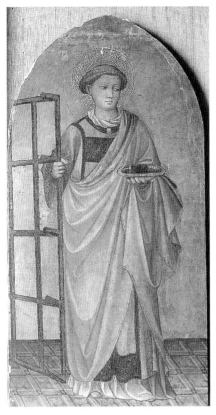

Fig. 24. Gherardo Starnina, *Saint Lawrence*. Perkins Collection, Sacro Convento di San Francesco, Assisi

Fig. 25. Reconstruction of altarpiece showing the placement of the Boston panels

Fig. 26. Gherardo Starnina, *Hosea*. Museo di Palazzo Venezia, Rome

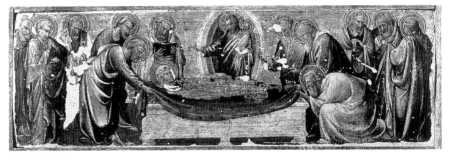

Fig. 28. Gherardo Starnina, *Death of the Virgin*. Gift of Ray Winfield Smith, Class of 1918 and Mrs. Smith; Hood Museum of Art, Dartmouth College, Hanover, NH

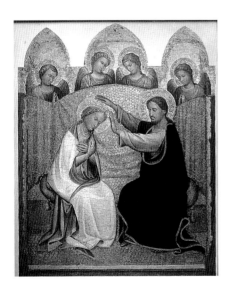

Fig. 27. Gherardo Starnina, *Coronation of the Virgin*. Galleria Nazionale, Parma (Photograph: Soprintendenza per i Beni Artistici e Storici, Parma)

normally used in Tuscan altarpieces only beneath a further tier of painted panels, in this case pinnacles. Two panels portraying the Virgin and the Angel of the Annunciation (45.5 x 51 cm each), formerly in the Chiaramonte Bordonaro collection, Palermo, have been convincingly proposed by Filippo Todini (oral communication, 1987) as the excised pinnacles from this altarpiece. The missing central pinnacle has not yet been identified.

A fragmentary panel in the Museo di Palazzo Venezia in Rome, representing the bust-length figure of the Prophet Hosea (fig. 26) and clearly excised from the spandrels of an altarpiece, has been associated with the Boston prophets on stylistic and iconographic grounds by A. Santangelo (1948), who, however, assumed that the Boston panels originat-

ed not from the same set of spandrels but from a predella. The Hosea, which preserves the fragmentary lobes of two gables in its lower corners, cannot have stood alongside the Boston spandrels, unless it stood directly above the central panel of the altarpiece and that panel terminated in something other than a simple arch. Such a panel, representing the Coronation of the Virgin (fig. 27), is preserved in the Pinacoteca Nazionale at Parma (no. 440: 78 x 57 cm; Quintavalle, 1939, p. 181). Terminating in three gables cropped in a manner similar to the tops of the lateral panels in Boston, Assisi, and Florence, the Parma Coronation corresponds closely to them in style and in the punched decoration of the haloes, and is of an appropriate size to have once stood between them. The Prophet Hosea, fur-

thermore, fits exactly above the Parma panel, between the center and right gables, continuing the profiles of the interrupted arches and accounting for a total height of the main panel and its spandrel(s) equal to that of the Boston lateral panels and spandrels, allowing for minimal losses due to the thickness of the saw blades used to cut the panels apart. Final proof, however, allowing for the reintegration of the Parma Coronation and the Palazzo Venezia Hosea with the Boston/Assisi/Florence altarpiece is lacking. The Parma panel does not continue the pavement pattern of the lateral panels since its foreground is entirely covered by the elaborate cloth of honor draped over the Virgin's throne.

A panel representing the Death of the Virgin formerly in the Ray W. Smith collection, Cologne, and now in the Hood Museum at Dartmouth College, Hanover, New Hampshire (fig. 28), undoubtedly once stood in a predella beneath the Parma Coronation of the Virgin. Its subject is complementary to the Parma panel, and the two are exactly the same width. No other scenes from the Life of the Virgin are known that might have stood alongside the Dartmouth panel in a predella, nor are any scenes from the lives of Saints Vincent, Stephen, Lawrence, or Anthony Abbot recorded that might have completed this altarpiece.

Opinions regarding the date of the altarpiece to which the present panels belong have varied with the critical fortunes of the Master of the Bambino Vispo. When he was considered an attractive but derivative follower of Ghiberti and Lorenzo Monaco, the Boston panels were grouped among pictures thought to have been executed in the 1420s or early 1430s (van Marle, 1927; Pudelko, 1938). Subsequent to his identification with Gherardo Starnina, this date was pushed forward to between 1404 and 1409 (Boskovits, 1975a; van Waadenoijen, 1983; Zeri, 1988), i.e., shortly after the artist's return to Florence from Valencia but before his documented frescoes at Empoli. Syre (1979), as has been mentioned, considered the Boston panels the work of a follower of Starnina, while she dated the Assisi Saint Lawrence, judged by her an autograph work, to the artist's earliest career in the late 1380s. Sricchia Santoro (1976) also considered the Boston prophets, together with the Palazzo Venezia Hosea, as early works, presumably of the 1390s, reflecting the influence of the Valencian painter Andres Marzal de Sas.

The evident influence of Valencian painting on these panels and the Italian provenance of most of them argue for a dating of the complex sometime after Starnina's return to Florence in about 1404. It is difficult to establish a coherent pattern of development for the artist over the decade following that date, up until his death around 1413, but it is probable that the Boston panels are to be situated later rather than earlier in that period. They are much less reminiscent of Spanish culture than such pictures by Starnina as the Ryerson *Death of the Virgin* in Chicago or any of the panels of the Saint Lawrence altarpiece from the Certosa, painted around 1406. A date around 1410 seems reasonable.

Master of the Bracciolini Chapel

A PROVINCIAL Tuscan, probably Pistoiese, painter active in the first third of the fifteenth century, the Master of the Bracciolini Chapel is named for a cycle of frescoes in San Francesco al Prato, Pistoia, showing the Marriage and Death of the Virgin, the Conversion of Saint Paul, and the Glorification of Saint Augustine. These frescoes were first discussed and joined to other paintings by the same hand by Offner and by G. Brunetti (1935, pp. 221-244). The Master of the Bracciolini Chapel may have trained in the shop of Agnolo Gaddi, the dominant influence on his early style, or locally in the studio of Giovanni di Bartolomeo Cristiani. In his later works, including the Pistoia frescoes, the Master of the Bracciolini Chapel shows himself to have been fully aware of Lorenzo Monaco's technical and stylistic innovations, possibly through the example of the latter's altarpieces in Prato and Empoli. The most complete discussion of the artist's work is to be found in De Marchi (1992).

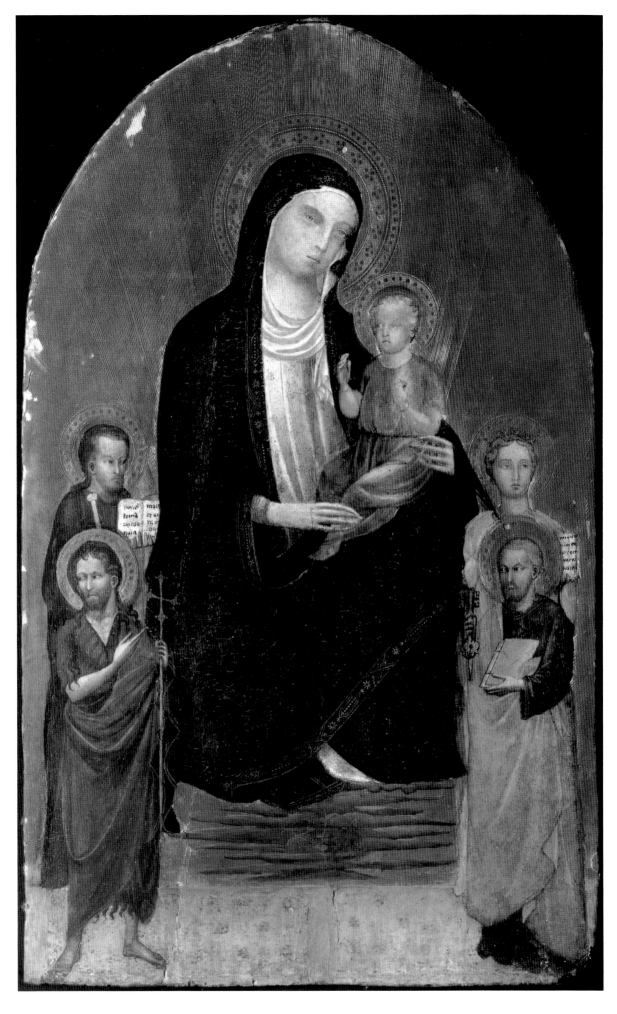

32

Virgin and Child with Saints John the Baptist, James, Peter, and a Virgin Martyr (Catherine?)

Tempera on panel
76 x 47.5 (29⅞ x 18¾)

Bequest of George Washington Wales.
03.563

Provenance: Unknown; George Washington Wales, by 1903

Literature: Sirén, 1920a, p. 78; Berenson, 1963, p. 5; Fredericksen and Zeri, 1972, pp. 138, 563.

Condition: The back and sides of the panel have been coated with a thick layer of wax resin, obscuring evidence of cutting or thinning. A vertical split running the full height of the panel along its center is visible through the paint surface, as is another, partial split running through the Virgin's right shoulder and alongside the figure of the Baptist. The gold ground has been entirely regessoed and regilt, except that the haloes may have been regilt over traces of the original gesso preparation. The paint surface is badly abraded throughout, with the faces of the Virgin and Child especially worn. The four saints are in fair condition. The blue of the Virgin's mantle has deteriorated to black and has been extensively overpainted, as have the clouds above which she floats. The red foreground and its gold and white decorative motifs are heavily worn.

THE VIRGIN, wearing a blue (now black) mantle over a rose-colored tunic and white veil, is seated frontally above a bank of clouds, holding the Christ Child on her left knee. The Child, dressed in a crimson tunic over an orange- sleeved shirt, holds a partially effaced bird in his left hand and raises his right in benediction. At either side of the panel are two diminutive figures of saints. In the foreground are Saints John the Baptist (left), wearing a dark red robe over his hair shirt, holding a reed cross and gesturing back toward the Christ Child; and Peter (right), wearing a yellow mantle lined with orange over a blue robe and holding a book in his left hand and two keys in his right. Behind them stand Saint James the Greater (left), holding a book and a pilgrim's staff, and an unidentified female saint (right), wearing a crown and holding a book and a martyr's palm. Though her traditional attribute of a spiked wheel is absent, the palm, book, and crown could indicate that this figure represents Saint Catherine of Alexandria.

This severely damaged panel has in the past been attributed to various Tuscan painters active in the first decades of the quattrocento: Lorenzo di Niccolò (Sirén, 1920), Andrea di Giusto (Berenson, 1963), and the Master of 1419 (Zeri,

1972). Its format and composition, with the Virgin seated on a bank of clouds accompanied by saints standing on a solid ground plane, is quite common at that period, and is known in examples by Lorenzo Monaco, the Master of Santa Verdiana, the putative Ambrogio di Baldese, the Master of Sant' Jacopo a Muciana, the Master of the Straus Madonna, etc. A closely similar panel undoubtedly by the same hand, though in a much finer state of preservation, was identified by Everett Fahy (note in Museum files) at the Denver Art Museum (1947.29). Fahy attributed both the Denver and Boston paintings to the Master of the Bracciolini Chapel, the anonymous author of a cycle of frescoes in San Francesco al Prato, Pistoia, to whom he also assigned related panels showing the *Coronation of the Virgin* (Sotheby's, Monaco, 7-8 December 1990, lot 2) and the *Virgin and Child with Four Saints* (Turin, Giancarlo Gallino; cf. De Marchi, 1987, no. 7), and others. This attribution appears to be correct.

The condition of the Boston panel makes its legibility only tenuous, but the figures of the four saints are well enough preserved to allow favorable comparisons to the Pistoia frescoes, and particularly to the frescoes of the Dormition of the Virgin and Saint Augustine Enthroned. The characteristic features of each saint – their high foreheads, sharply arched brows, down-turned mouths, thin, straight noses, round eyes, and small hands – all find parallels at Pistoia, while the artist's distinctive brushing technique using dotted highlights is fully in evidence there as well.

The date of the Bracciolini chapel frescoes is undocumented though they are presumed, not unreasonably, by Brunetti, (1935, pp. 221-244) to have been painted around 1430, after the artist's dated triptychs of 1424 in the Duomo at Fiesole and 1426 in Budapest, Szépmüvészeti Múzeum. Even closer in style to the Boston panel than any of these three works is a miniature of God the Father (?) blessing and David sounding the harp in an initial "B" from a Benedictine psalter (Pistoia, Biblioteca del Seminario episcopale, Cod. N, c. 2v.) documented to the years 1414-1416, attributed to the Master of the Bracciolini Chapel by L. Bellosi (1985, pp. 25-27). Both the Boston panel and the illumination show more clearly the influence of Agnolo Gaddi than do any of the certain or putative later works by the Master of the Bracciolini Chapel. A date for the Boston panel in the second decade of the fifteenth century is plausible.

Lippo d'Andrea di Lippo

BORN IN 1370 or 1371, Lippo d'Andrea was probably active as an independent master as early as the last decade of the fourteenth century, though he enrolled in the Compagnia di San Luca only in 1411. That same year he received a commission, together with Niccolò di Pietro Gerini (q.v.), Ambrogio di Baldese, and Alvaro di Pietro for the fresco decoration on the facade of the Palazzo del Ceppo in Prato. In 1435/36, on the occasion of the consecration by Pope Eugene IV of the newly completed dome of the Cathedral in Florence, Lippo d'Andrea was selected along with his almost exact contemporary Bicci di Lorenzo and two younger painters, Giovanni dal Ponte and Rossello di Jacopo Franchi, to paint frescoes of the Apostles in the tribune chapels. Lippo d'Andrea was still active as late as 1437, but by 1442 he had ceased painting and in 1447 he declared himself unable to earn a living by his trade. He died before 1451.

Two of the Apostles, Saints Simon and Thaddeus, painted by Lippo d'Andrea in the tribune of the Cathedral survive, and represent the basis for attributing to him the majority of the paintings formerly classified under the name of the "Pseudo-Ambrogio di Baldese." The "Pseudo-Ambrogio di Baldese" was first reconstructed as an artistic personality by Sirén (1908-09), who thought him a late trecento master. Van Marle (1924) and Offner (1927) recognized him to have been active instead in the first third of the fifteenth century, in close rapport with Bicci di Lorenzo. An attempt to identify him with the little- known Ventura di Moro (Carli, 1972), based on a signed painting in the Pinacoteca Nazionale, Siena, failed to recognize the heterogeneous character of many of the attributions to the master, some of which can in fact be assigned to Ventura di Moro. The correct identification of the "Pseudo-Ambrogio di Baldese" with the Lippo who painted the Cathedral Apostles was first proposed by Padovani (1979, pp. 55-56), and this artist was subsequently shown by Procacci (1984) to have been Lippo d'Andrea.

33

Virgin and Child with Saints Mary Magdalene and John the Baptist

Tempera on panel
80.5 x 50.3 (31 ¹⁵⁄₁₆ x 19 ¹³⁄₁₆)

Bequest of George Washington Wales.
03.564

Provenance: Unknown; George Washington Wales, by 1903

Literature: Sirén, 1916, p. 61; van Marle, vol. 9, 1927, p. 88; Pudelko, 1935, p. 88; Fredericksen and Zeri, 1972, pp. 124, 563; Fremantle, 1975, p. 424.

Condition: The panel, which has been thinned to 2.2 cm, exhibits two vertical cracks; one, to the right of the Virgin, runs the full height of the panel; the other, to the left, extends 20 cm from the top edge. The paint surface has been heavily abraded throughout, obscuring the definition of all but the contours of the figures (the outlines of the Virgin's and the Child's hands have been reinforced), and large areas of repaint covering local losses interrupt the continuity of modeling in all the draperies. The gold ground is modern, and the mordant gilding on the hems of the Child's, St. John's, and the Magdalene's cloaks has been reconstructed. The gold border of the Virgin's mantle is original.

THE VIRGIN is seated upon a raised dais, supporting the Christ Child on her knee. She wears a blue cloak lined with green over a red and gilt brocade dress; the Child is loosely wrapped in a pink cloth decorated with gold. He holds a small bird in his left hand, which pecks at the fingers of his right hand. In the foreground at the left, smaller in scale than the Virgin and Child and looking back and up at them, stands Saint Mary Magdalene, clad in a red dress and cloak and holding a white ointment jar. Opposite her at the right stands Saint John the Baptist in a hair shirt and vermillion robe. He holds a thin gold cross and a scroll, the lettering on which has been obscured and improperly reconstructed.

This much-damaged painting entered the Museum of Fine Arts in 1903 with an attribution to Bicci di Lorenzo. It was first identified by Osvald Sirén (1916) as forming part of a group of works which he had earlier attributed to the late trecento Florentine painter Ambrogio di Baldese (1908-09, p. 326); the author of the group was later christened by van Marle (1927) the Pseudo-Ambrogio di Baldese in recognition of the later dating, i.e. the first third of the fifteenth century, of all of its members. It was included by Pudelko and Fremantle in their compendia of works by the Psuedo-Ambrogio di Baldese, but has not elicited discussion or critical comment from any scholar who has dealt with this artist since van Marle.

The wholly convincing identification of the so-called Psuedo-Ambrogio di Baldese with Lippo d'Andrea, a Florentine painter active between about 1395 and 1442, has not addressed the question of the lack of homogeneity among the works attributed to him. It is clearly necessary to distinguish a number of minor hands within the corpus of paintings assigned to his name, but the Boston Madonna is fully consistent in style and handling (insofar as it can be discerned in the panel's present condition), with the majority of pictures that form the nucleus of his output. Probably it was painted in the first half of the artist's career, but all such judgments are rendered academic by the painting's deteriorated state.

34

Reliquary diptych: Christ on the Cross with Saints Francis and Onophrius; The Virgin and Child with Saint Lawrence

Tempera on panel
Left wing: Overall: 18.4 x 12.9 x 3.2 (7¼ x 5�⁄₁₆ x 1¼); Picture surface: 10.9 x 6.6 (4⁵⁄₁₆ x 2⅝)
Right wing: Overall: 18.4 x 12.9 x 3.4 (7¼ x 5⁄₁₆ x 1⁵⁄₁₆); Picture surface: 11 x 6.6 (4⁵⁄₁₆ x 2⅝)

Gift of Mr. and Mrs. J. Templeman Coolidge. 45.514

Provenance: Unknown; Mr. and Mrs. J. Templeman Coolidge, by 1945

Literature: Swarzenski, 1950, p. 44; Fredericksen and Zeri, 1972, pp. 224, 565; Huter, 1975, pp. 13-14, 16 fn. 10; Land, 1978, p. 585 fn. 3.

Condition: The diptych is extremely well preserved, retaining all its original moldings, metal hinges, and the glazed gesso decoration on its outer surfaces. The relics and any fragments of glass that may have protected them in their compartments are lost, but their wax mounts and some labels remain. The gold ground, which covers the front face of both panels entirely, is also extremely well preserved, exhibiting only modest wear along the front edges of the moldings and partial regilding on some of the raised dividers between relic compartments. The painted surfaces are intact with the exception of a small loss at the bottom of St. Lawrence's red robe and some abrasion in the glazes over the Christ Child's draperies, though no retouchings are in evidence.

EACH WING of the diptych contains fourteen rectangular cavities surrounding a central gilt and painted image. The left wing portrays Christ on the cross with Saint Francis holding a book and pulling aside a vent in his brown habit to reveal the stigmata, and Saint Onophrius leaning on a crutch, clothed in his long curling hair and beard, accompanied by a

diminutive lion crouching at his feet. In the right wing are the Virgin, in a blue cloak over a red and gold brocade dress, suckling the Christ Child, who is dressed in a gold robe, and Saint Lawrence, who wears a red deacon's robe and holds a book and a martyr's palm. The grill of Lawrence's martyrdom can be seen behind him at the left edge of the picture field. The outside of both wings of the diptych is painted "marmo finto," and the upper edges of both wings are cut through with slots to receive a carrying strap.

This rare surviving portable reliquary diptych – a similar example is preserved in the Fogg Museum of Art, Cambridge, attributed to an Umbrian painter known as the Master of Offida (Bologna and de Castris, 1984, p. 297) – was previously identified in this Museum only as "Italian, fourteenth century." Carl Huter (1975) corrected the dating to the early fifteenth century, but inexplicably located the artist's workshop in Venice, with a tentative attribution to Cristoforo Cortese. The present attribution was suggested in correspondence with Keith Christiansen (1985) and Everett Fahy (1988), and may be defended on the grounds of a general similarity of figure types and palette to other works traditionally given to the so-called Pseudo-Ambrogio di Baldese (see above, no. 03.564), now recognized as Lippo d'Andrea. Fahy specifically calls attention to the resemblances between this diptych and a small devotional diptych in the Museo di Capodimonte, Naples (no. 956: Vitalini Sacconi, 1968, fig. 56, as Arcangelo di Cola; Boskovits, 1975, p. 350, as Lorenzo Monaco), representing the Virgin and Child with a Donor and Christ on the cross with Saint Mary Magdalene, which he attributes to Lippo d'Andrea. Close to the present panel as well are the pinnacle figures in Lippo d'Andrea's triptych from San Pietro a Cedda near Poggibonsi.

Lippo d'Andrea's career covered some fifty years of active production, from the early or middle 1390s to about 1442. The present diptych probably dates to the later part of his career, close in time to his documented frescoes of 1435-36 in the Duomo, Florence. Contemporary works by the Master of Borgo alla Collina and Bicci di Lorenzo share some of the technical and stylistic peculiarities of this loosely drawn and painted image, suggesting a date for it between 1430 and 1440.

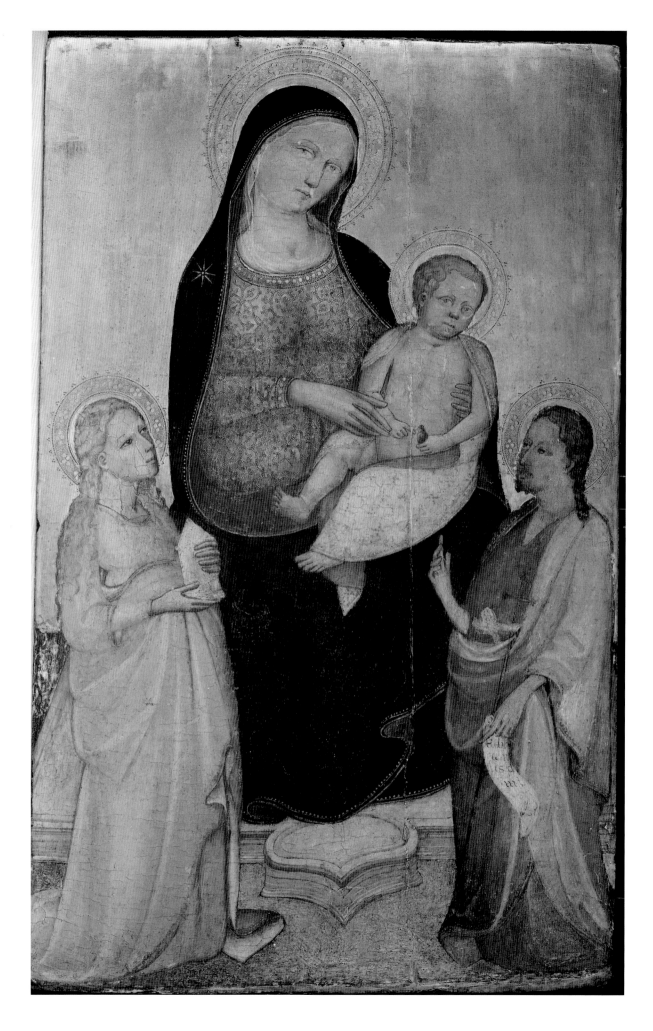

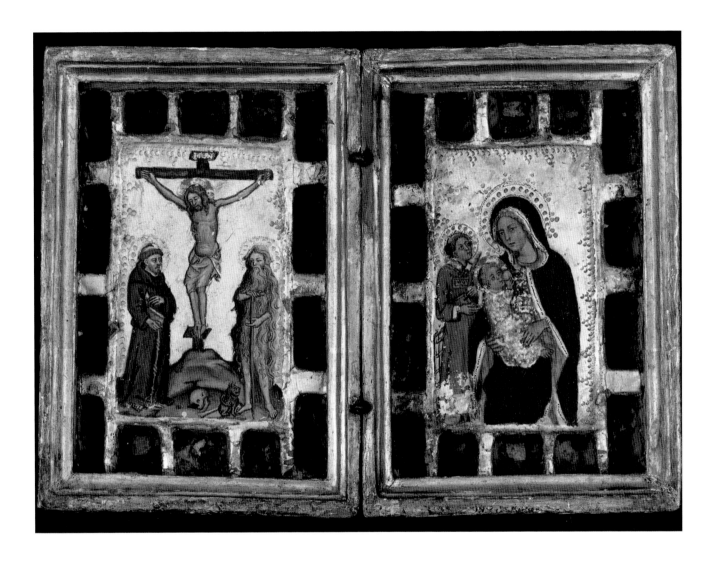

Master of the Sherman Predella

A FLORENTINE PAINTER active probably in the second quarter of the fifteenth century, the artist was first identified by Pope-Hennessy (1939, p. 184) and named for the panel now in the Museum of Fine Arts, Boston, a gift of Zoe Oliver Sherman. Further pictures by the same hand were identified by R. Longhi (1940, 1948, 1967), who characterized the Master as a contemporary of Masolino and a principal exponent of the emerging Renaissance style in Florence. For Pope-Hennessy, the Master of the Sherman Predella was instead a follower of Fra Angelico and Domenico Veneziano, much influenced by the Gothic narrative style of Lorenzo Ghiberti and Masolino, and therefore a full generation younger than the artist envisioned by Longhi. Formal similarities to paintings by Fra Angelico of the 1430s, as well as to works by Sassetta and the Osservanza Master in Siena of about the same date, suggest that the later proposal may be more nearly accurate. The scarcity of identified works by the Master of the Sherman Predella coupled with the fact that one of them was found in Arezzo (Longhi, 1948), that he engendered no appreciable following in Florence, and that he seems to have enjoyed a more than casual awareness of contemporary Sienese painting suggests that the Master of the Sherman Predella may have been primarily active in provincial centers in eastern Tuscany.

35

Martyrdom of a Female Saint (Saint Agnes ?); Flagellation of Christ; Saint Jerome in the Wilderness [The "Sherman Predella"]

Tempera on panel
Overall: 28.6 x 52.5 (11¼ x 20⅝)
Picture surface:
left: 21.6 x 13.1 (8½ x 5⅛); center: 21.6 x 26.8 (8½ x 10⅝); right: 21.6 x 13.1 (8½ x 5⅛)

Gift of Zoe Oliver Sherman in Memory of Samuel Parkman Oliver. 22.635

Provenance: Prince of Pless, Silesia; R. Langton Douglas, London, 1922

Literature: "Sherman Collection," 57; Berenson, 1926a, pp. 369, 383 fn. 11; van Marle, vol. 9, 1927, p. 331, fig. 207; Berenson, 1930a, p. 129, fig. 149; idem, 1932, p. 511; L. Venturi, 1933, pl. 142; Pope-Hennessy, 1939, pp. 184, 203 fn. 136; Longhi, 1940, p.185, n. 22; idem, 1948, pp. 161-162, fig. 181; idem, 1967, pp. 38-40; Fredericksen and Zeri, 1972, pp. 137, 564; Fremantle, 1975, no. 1263; Sutton, 1979, p. 224; Freuler, 1991, p. 234.

Condition: The panel, which is 1.9 cm thick and of a horizontal wood grain, has been neither thinned nor cradled. The gilt borders framing the painted scenes are well preserved except along the outer edges, where some losses and regilding have occurred. The haloes and the mordant gilt decorative motifs in the draperies of the figures are also in good condition. The painted surface, except as noted below, is well preserved: though evincing extensive pinpoint flaking throughout it is minimally abraded. The blue of the skies in all three scenes has been almost completely overpainted except along the horizons in the left and right scenes, where a brighter band of the original ultramarine blue is visible. This overpaint covers numerous small losses. Other notable losses occur to the left of Christ's head (possibly a nail head), in a horizontal crack through Saint Agnes's (?) shoulders, and in the tree behind Saint Jerome. Retouching in these damages is minimal and confined to the losses.

THE PANEL is divided by flat gold strips, decorated with engraved crosshatching and center and subcenter discs, into three distinct scenes, those on the outsides set in rocky landscapes, that in the center in an architectural interior. In the left scene, a female saint, dressed in a blue robe covered with gilt stars over an orange dress, kneels between two piles of burning faggots and raises her arms toward an angel flying down to her from above. Behind her stand three soldiers in varicolored armor, one holding a sheathed sword, one a spear, and one visible only by his helmet. Between the saint and the group of soldiers, an executioner raises a dagger to be plunged into the neck of the saint. In the right scene Saint Jerome, dressed in a coarse white robe knotted with a rope at the waist

and holding a rosary in his left hand, his cardinal's beretta lying on the ground before him, kneels in the wilderness among wild grasses and reptiles and beats his bared breast with a stone. The center scene takes place on a polished marble pavement, closed off by four arched bays and aediculae of a classical building behind. The left two bays are filled with the figure of Christ bound tightly to a column and whipped by two executioners. In the right two bays, separated from the group of the flagellation by an arched doorway, are five holy figures, including the Virgin in a swoon on the floor, the Magadelene in red hovering over her, and Saint John the Evangelist, his hands clasped in grief and concern, at the far right.

For most of its earliest history, this picture was considered a particularly exquisite, probably early, work of Sassetta (Berenson, 1926, 1930, 1932; van Marle, 1927; Venturi, 1933), and was represented as such to Mrs. Sherman by R. Langton Douglas – who may be credited, along with Berenson, with the rediscovery of Sassetta as an artistic personality some twenty years earlier – when he sold it to her in 1922, as well as by Giacomo de Nicola (letter in Museum files). Only in 1939, with the publication of his monograph on Sassetta, did Pope-Hennessy remove it from the Sienese master's oeuvre, properly recognizing it as Florentine through its affinities with the paintings of Masolino and Paolo di Stefano, and proposing a date for it in the 1440s in response to the influences of Fra Angelico and Domenico Veneziano. Pope-Hennessy named the artist of this picture the Master of the Sherman Predella, but identified no other works by the same hand.

The characterization of the Master of the Sherman Predella as Florentine has not subsequently been questioned, but Roberto Longhi (1940, 1948, 1967), the only other author to have seriously considered the identity of this painter, doubted the late date for his activity suggested by Pope-Hennessy. For Longhi, a dating after 1440 implied a retardataire or conservative style, which he equated with mediocrity and which in turn he found contradicted by the very evident quality of the Sherman predella. Additionally, he identified three other works by the same artist, all of which he felt betrayed the influence of Lorenzo Monaco in the 1410s rather than of Masolino a half-generation later, tempered by experience of the earliest works of Fra Angelico (which he believed were earlier than is presently thought to be the case), and familiarity with the architectural innovations of Brunelleschi. For Longhi, the Master of

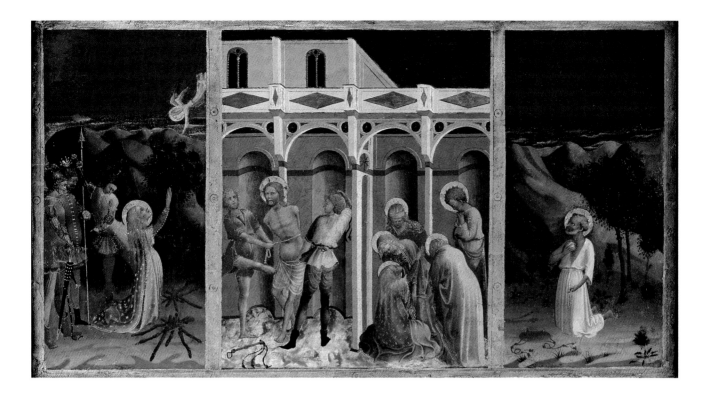

the Sherman Predella was himself a powerful innovator, as demonstrated by the highly naturalistic rendering of the recession of banks of clouds in the skies above the two lateral scenes in the Boston panel (see its reproduction prior to cleaning in 1950 in Berenson, 1926 and 1930a), whose likely span of activity covered the decades of the 1420s and 1430s.[1]

Longhi's contention that artistic quality presupposes innovative or progressive style, though widely accepted, has not proven historically accurate, and there seems otherwise to be insufficient evidence to view the Master of the Sherman Predella in the precocious light in which Longhi cast him. Very little tangible relation to Lorenzo Monaco is in fact apparent in any of the handful of works attributable to the Master of the Sherman Predella, whose figure style and highly refined palette can more profitably be compared to that of Fra Angelico in the early 1430s. The curiously archaic conception of "classical" architecture implied by the edifice depicted in the center of the Boston panel does relate to that in the background of Lorenzo Monaco's fresco of the Meeting of Anna and Joachim in the Bartolini chapel in Santa Trinita (early 1420s). Both structures are less reminiscent of Brunelleschi, however, than they are of Lorenzo Ghiberti, from whom the Master of the Sherman Predella also derived his narrative structure and conception of space. Longhi's observation on the precocious naturalism of the skies in the lateral scenes of the Boston panel was based on a misunderstanding of their almost completely repainted condi-

tion and is belied by the schematic rendering of hills, trees, and crevices in the middle- and foregrounds of the same scenes; they are probably instead to be regarded as later reflections of painted effects achieved by Fra Angelico and Domenico Veneziano. Pope-Hennessy's dating for the Boston panel after 1440 is, on balance, likely to be only slightly conservative if not wholly accurate. Certainly the picture is unlikely to predate the last years of the 1430s.

The iconography and original function of the Boston panel are matters of some debate. The female saint in the martyrdom scene at the left is usually thought to be Catherine. She was tentatively identified as Agnes by Longhi (1967), and this identification is likely to be correct. Saint Agnes, a virgin martyr, refused to marry the son of the prefect Sempronius or to renounce Christianity and was burnt at the stake. The flames of her martyrdom parted, however, and refused to harm her, whereupon she was stabbed in the neck and throat. The stars that decorate the dress and mantle of the saint are not likely to be iconographically significant: the same dress and mantle, with colors reversed, are worn by the Magdalene kneeling at the foot of the cross in a panel of the Crucifixion by the Master of the Sherman Predella formerly in the Pinacoteca Nazionale at Arezzo (Longhi, 1948).

The scene of the Flagellation in the center of the Boston panel is highly unusual for including the swooning Virgin attended by Saint John and the Holy Women. According to the apocryphal

Gospel of Nicodemus, Mary went to the hill of Calvary in the company of Saints John, Mary Magdalene, Mary Salome, and Martha, and fainted when she saw her son stagger beneath the weight of the cross. Depictions of this episode are not uncommon in Italian painting, but there are no known parallels or precedents for the present scene. Associating the Virgin's swoon with the Flagellation may be meant to call to mind the *Meditationes vitae Christi* of Thomas à Kempis, in which the reader is exhorted to suffer along with Christ through each stage of the Passion just as his mother did. Furthermore, the Flagellation is one of the five sorrowful mysteries of the Virgin – along with the Agony in the Garden, the Crowning with Thorns, the Via Crucis, and the Crucifixion – contemplated in devotions of the Rosary (see Beissel, 1909), and it may be that the Boston panel was painted for a confraternity of that dedication.

Though it is universally referred to as the Sherman Predella, it is not clear that the present panel was indeed meant to function as a predella. The thickness of the panel, which is intact, is significantly less than customary for predellas painted on independent horizontal planks of wood, and smaller predellas included in devotional tabernacles (see no. 37.409 above) are generally painted directly on extensions of the vertical planks supporting the main image (the wood grain in the present panel is horizontal). Though it may have been trimmed slightly along its outer edges, there is no indication that it has been stripped of an engaged frame,

and its gilt divider strips and continuous border of uniform width and decoration cannot be explained by reference to the example of any other known predella. Furthermore, the particular pattern of pinpoint flaking visible throughout the picture, caused by shattering from compression along the raised cusps of the craquelure, is the result not of abrasion but of warpage towards rather than away from the painted surface. This condition is commonly found in panels set into walls, where moisture is absorbed rather than lost through the back. It may be that the Sherman "predella" was in fact part of a piece of liturgical furniture or the decoration of a room – possibly an oratory or, as was suggested above, confraternal chapel whose dedication might explain the peculiar iconography of the painted scenes – but once again no precedents are known that could aid in securely demonstrating such a contention.

1. The attribution of a small triptych of the Crucifixion and saints, now in a Swiss private collection, to the Master of the Sherman Predella as an early work (Longhi, 1967) has recently been rejected by Freuler (1991, p. 234) on the grounds that it seems to have been painted in the 1430s. Freuler's dating of the triptych ca. 1430 is justified, as is Longhi's characterization of it as an early work by the Master of the Sherman Predella.

Fra Angelico

BORN GUIDO DI PIETRO, probably in the last decade of the fourteenth century, and first recorded as a painter in 1417, Fra Angelico – known to his contemporaries as Fra Giovanni da Fiesole – entered the Dominican order sometime between 1418 and 1423. He may have received his artistic training as a miniaturist, possibly in the workshop of Lorenzo Monaco, from whom he inherited at least one incomplete commission in the early 1430s. His earliest dateable painting, an altarpiece from the convent of S. Pietro Martire in Florence (Florence, Museo di San Marco), is of 1429. Three of Angelico's greatest paintings, the Cortona Annunciation, the Linaiuoli tabernacle, and Lamentation for the Compagnia del Tempio, were painted in the following decade, at the end of which Angelico was engaged in painting the high altarpiece and cell frescoes in the newly consecrated monastery of San Marco in Florence. Angelico remained resident at San Domenico in Fiesole, where he served as vicario of the community, until 1441, when he transferred to San Marco. Around 1445, Angelico was summoned to Rome by Pope Eugenius IV, and he remained there until 1449/50, painting the chapel of Saint Nicholas in the Vatican for Eugenius's successor, Nicholas V. From 1450 to 1452 he served as Prior of the convent of San Domenico at Fiesole. At some uncertain date after that he returned to Rome, where he died in February 1455.

Fra Angelico is, with Masaccio and Fra Filippo Lippi, acknowledged as one of the dominant artistic personalities of the first half of the fifteenth century in Florence. In the nineteenth century, his works were highly prized for their apparent devotional sincerity; their light, clear palette and meticulous decorative sensibility becoming standards for a modern revival of spirituality in art. In recent decades, he has come to be admired more for the complex intellectual content of his art, and for his role in the rediscovery of classical style and illusionistic pictorial space, hallmarks of what is today considered the Renaissance. Notwithstanding his active role in conventual life and Dominican politics – Angelico is believed to have been instrumental in promoting the election of Fra Antonino Pierozzi as Bishop of Florence in 1446 – he was a prolific and dedicated painter, a friend and sometime collaborator of Lorenzo Ghiberti, and the teacher of artists such as Benozzo Gozzoli and perhaps Zanobi Strozzi. In addition to his commissions in Rome, Angelico's works were in demand in cities as removed from the normal sphere of Florentine influence as Brescia, Perugia, and Orvieto, though he is perhaps best remembered today for his decorations of the convent of San Marco in Florence, where he lived for some years in the 1440s, and which has been turned into a museum displaying paintings by him brought there from churches throughout the dioceses of Florence and Fiesole.

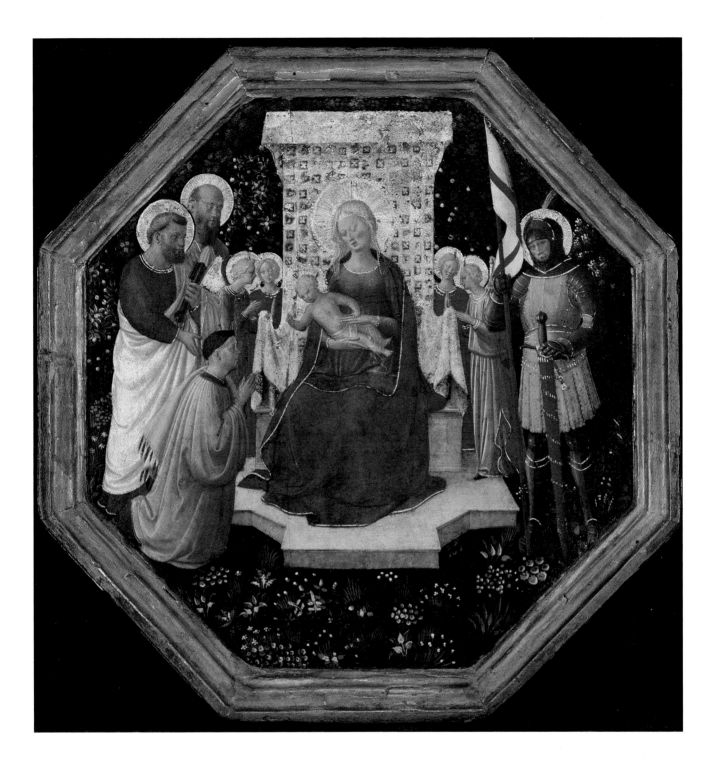

36

Virgin and Child Enthroned with Saints Peter, Paul, and George (?), Four Angels, and a Donor

Tempera on panel
Overall: 29.7 x 29.1 (11¾ x 11½)
Picture surface: 25.8 x 24.8 (10⅛ x 9¾)

Gift of Mrs. W. Scott Fitz. 14.416

Provenance: Baron Triqueti, Paris, by 1869; Mme. Lee-Childe, Paris (sale, Hôtel Drouot, Paris, 4 May 1886, lot 1); Edouard Aynard, Lyon (sale, Galerie Georges Petit, Paris, 4 December 1913, lot 35); Kleinberger, New York

Literature: Crowe and Cavalcaselle, vol. 2, 1869, p. 164 fn. 78; idem, vol. 2, 1883, p. 396; Berenson, 1909a, p. 107; Crowe and Cavalcaselle, vol. 4, 1911 p. 104; Post, 1914, pp. 27-32; Schottmuler, 1924, p. 22; van Marle, vol. 10, pp. 156, 164; Muratoff, 1930, p. 59; Berenson, 1932, p. 20; Venturi, 1933, pl. 180; Berenson, 1936, p. 17; Galetti and Camesasca, vol. 1, 1950 p. 94; Pope-Hennessy, 1952, p. 197; Salmi, 1958, p. 105, pl. 40a; Berenson, 1963, p. 11; Berti, 1963, p. 38, n. 108; Orlandi, 1964, pp. 63-64; Baldini, 1970, p. 95; Fredericksen and Zeri, 1972, pp. 9, 564; Pope-Hennessy, 1974, pp. 222, 239, fig. 64; Boskovits, 1983, pp. 11, 12, 14, 23 fn. 4, fig. 5; Fallani, 1984, pp. 51, 174; Venchi, 1984, p. 16; Corsini, 1984, pp. 16-19; Tartuferi, 1990, pp. 45-48.

Condition: The panel has been thinned to a depth of 5 mm, backed with a new panel 7 mm thick, and cradled. A vertical split runs the full height of the panel just to the left of the Virgin

and Child, and a 6-cm long vertical split interrupts the profile of the kneeling donor. The engaged frame appears to be original but is badly damaged and poorly restored. The gilding of the haloes and of the baldachin behind the Virgin is slightly worn, allowing the red bole to show through in spots (easily confused with red glazing over the surface of the gold). The paint surface is extremely well preserved though lightly abraded. Scattered pinpoint losses and small losses along the two splits described above have been minimally inpainted.

THE VIRGIN, in a red dress and blue mantle, is shown seated upon a marble throne and dais backed by a gilt cloth of honor and canopy, engraved and glazed red. She holds the Christ Child across her

right arm, while he reaches to the left to bless the kneeling figure of a donor, wearing a pink surplice and the ermine scarf (almucia) of a canon. The canon is presented to the Virgin and Child by Saints Peter, wearing a yellow robe over a blue tunic and holding two keys, and Paul, his hands clasped in prayer and adoration of the Christ Child. Balancing this group on the right is a warrior saint in full armor covered by a pink tabard, standing a sheathed sword against the ground with his left hand and holding a banner of a red cross on a white field in his right. At either side of the Virgin's throne stand a pair of angels, those in front dressed in blue and those behind in red. The composition is filled out to the edges of the octagonal picture field by a meadow of grasses and flowers and a hedge of fruit trees.

The warrior saint at the right of the painting is universally presumed to represent Saint George, though he conspicuously lacks the attribute of a subdued dragon and he could have been intended instead to represent Saint Maurice. Orlandi (1964), assuming his identification as Saint George, explained his visual prominence, standing alone to anchor one side of the composition, as a reference to the church of San Giorgio sulla Costa in Florence. San Giorgio sulla Costa was ceded to the Dominican community of Fiesole (of which Fra Angelico was then vicario in the absence of the prior) in 1435 upon its renunciation by the parrocco, Tonnero de' Castellani. It was occupied by the Dominicans only until 1436, when they were awarded the convent of San Marco. Angelico himself was not among those of the community who transferred to San Giorgio, but according to Orlandi's thesis, he would have executed the Boston panel in commemoration of the event, portraying Tonnero de' Castellani in the guise of the kneeling donor at the left. Accepted by Baldini (1970) and Fallani (1984), and tentatively by Pope-Hennessy (1974), Orlandi's thesis must be discounted on two grounds. First, the donor is presented by Saints Peter and Paul, who must be presumed to be either his name saints or patrons of one of his benefices, neither of which can be demonstrated for Tonnero de' Castellani, who retained the incumbency of Sant'Andrea at Mosciano after relinquishing that of San Giorgio sulla Costa. Neither is Tonnero de' Castellani known to have been vested with the dignity of canon. Second, Orlandi's thesis establishes a precise date for the painting, 1435, but this date cannot be reconciled with Fra Angelico's other known works of that time.

Of the various writers to have discussed the Boston panel, only van Marle (1928), Muratoff (1930), and Pope-Hennessy (1952, 1974) have doubted its attribution as an autograph work by Angelico. For Pope-Hennessy, "The closest point of reference for the style of the attenuated figures occurs in the *Sposalizio* in the predella of the Montecarlo *Annunciation*," a painting which he dates close to 1450 and attributes in large part to Zanobi Strozzi (1412-1468), a miniaturist who is often thought to have been a pupil if not a collaborator of Angelico. He also attributes to Zanobi Strozzi a *Virgin and Child Enthroned with Saints Dominic and Catherine of Alexandria and Nine Angels* in the Vatican Pinacoteca, which is closely related stylistically to the Boston panel, and correctly relates it to two paintings by Angelico which must be dated after 1450: the Bosco ai Frati altarpiece in the Museo di San Marco and the Pontassieve Madonna in the Uffizi. The latter provide a reasonable frame of reference for the Boston panel as well, both for its spatial structure – the dais of the Virgin's throne, though designed to echo the octagonal shape of the picture field and therefore not exactly like any other painted by Angelico, is projected from an identical viewing point to those in the Pontassieve and Bosco ai Frati altarpieces – and figure style. Like them it must be considered wholly autograph and dated within the last decade of Angelico's career, between 1445 and 1455.

It should also be noted that while the facial types of Saints Peter and Paul in the Boston panel do not correspond closely to those two figures in any work by Angelico plausibly dated to the 1430s, they are replicated almost exactly in the *Vision of Ezekiel* from the Annunziata Silver Chest (ca. 1451), where a close parallel for the detailed realism of Saint George's (?) armor is also to be found in the scene of the Massacre of the Innocents, and where the types of the Virgin and Child recur in the *Flight into Egypt*. The Boston Saints Peter and Paul, especially the latter, also correspond to their counterparts painted in the predella of the Bosco ai Frati altarpiece (1450-1452), and on the framing pilasters of Angelico's Perugia altarpiece. Though the latter is traditionally believed to be a documented work of 1437, Andrea De Marchi (1990, pp. 94-97) has recently proposed, not unconvincingly, that it can only have been painted after 1445 and was perhaps executed as late as 1447, after the accession to the papacy of Nicholas V. Post (1914) observed a close parallel of figure types between the saints in the Boston panel and those in the Saint Stephen and Saint Lawrence frescoes painted by Angelico in

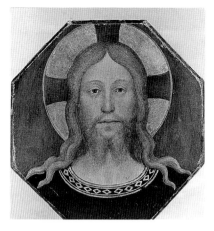

Fig. 29. Fra Angelico, *Face of Christ*. Formerly Triqueti collection, Paris

1447/48 in the Chapel of Nicholas V in the Vatican, noting as well (though dismissing with "it perhaps means nothing") the exact correspondence between the donor's robes in Boston and those of the clerics at the right in the *Ordination of Saint Lawrence*.

If a Roman provenance could be demonstrated for the Boston panel – Angelico spent the years 1446-1449, the period in which this picture was most likely executed, in Rome – the presence in it of Saints Peter and Paul might refer not to the donor's name but to his dependence on papal patronage, while the warrior saint opposite could be either his name saint or the titular saint of his benefice. A Roman provenance might also help to explain the unusual format of the panel, which is virtually unprecedented in Tuscan painting. Originally the picture was double-sided, with a head of Christ painted on the reverse (fig. 29). The two pictures, already sawed apart, were seen together in the Triqueti collection by Crowe and Cavalcaselle (1869), and were reproduced side by side in the catalogue of the Lee-Childe sale of 1886, after which the head of Christ disappeared to be rediscovered only recently by M. Boskovits (1983; see also Corsini, 1984, and Tartuferi, 1990). Though painted in a broader manner than the Boston panel, with little of the meticulous realism of details and none of the sophisticated spatial and compositional effects which distinguish it, there is no reason to suppose that the two images were not conceived and executed contemporaneously, as the head of Christ can be compared favorably with numerous heads in the Chapel of Nicholas V.

Double-sided panels of octagonal shape, painted with secular or allegorical subjects, were commonly presented in Florence as gifts to new mothers (desco

da parto), but such cannot have been the function of the present complex which is decidedly smaller than the typical deschi da parto and neither secular nor allegorical in subject. The reverse, with the head of Christ, was unprotected by a frame (its size, 29.5 x 29 cm, corresponds to the overall dimensions of the Boston panel and it is painted to the edges on all sides), which is also typical of deschi da parto, and its relatively good state of preservation, damaged only by minor scratches and nicks, suggests that it may have been hung against a wall. Unfortunately, any evidence of a hanging strap which might have been present at the top edge would have been destroyed when the panels were sawed apart and thinned.

Neri di Bicci

BORN IN 1419, Neri di Bicci inherited from his father, Bicci di Lorenzo, and grandfather, Lorenzo di Bicci, one of the most successful and longest continually operative commercial workshops in Florence. Neri's earliest signed and dated work, at Canneto in the Val d'Elsa, is of 1452, the year of his father's death, but he may have been the actual if not the titular head of the family workshop for as much as a decade before that. His style essentially appealed to the conservative Gothic taste among Florentine patrons which had accounted in large part for the success of his family's workshop since the end of the fourteenth century, though he introduced decorative and architectural motifs into his compositions derived from the leading artists of his time, such as Michelozzo, Fra Filippo Lippi, and Fra Angelico. Neri di Bicci's last dated painting, an altarpiece in the Pinacoteca Nazionale, Siena, is of 1482. He may have continued to paint for a decade or more after that, but no notice of him later than 1491 has been preserved.

From 1453 to 1475, Neri maintained a workshop diary (*Libro di Ricordanze*) which documents an astonishing number of commissions for altarpieces and frescoes as well as painted household and luxury goods such as candelabra, coats of arms, wooden angels and crucifixes, stucco madonnas, tapestry designs, shop signs, etc., and lists no fewer than nineteen assistants who worked for him. The *Libro di Ricordanze* is an invaluable source of information on the system of Florentine workshop production in the fifteenth century, on the procedures of art consumption, and on the nature of the Florentine art market at the time. Art historians have traditionally regarded the *Libro di Ricordanze* as Neri di Bicci's most important work. His numerous surviving paintings, however, reveal him to have been an exceptionally accomplished craftsman and an able draughtsman and colorist, if not an artist of singularly inventive inspiration.

37

Virgin and Child Enthroned with Four Angels

Tempera on panel
Overall: 155.9 x 93.6 (61⅜ x 36⅞)
Picture surface: 154.5 x 88.9 (60⅞ x 35)

Charles Potter Kling Fund. 1983.300

Provenance: Cappella Villani, SS. Annunziata, Florence; Private collection, France (cf. Zeri, 1980); P. & D. Colnaghi, London, by 1980

Literature: Zeri, 1980, pp. 131-133; Matthiesen, 1983, p. 49; Sutton, 1983, p. 99; Dalli Regoli, 1989, p. 29, fig. 30.

Condition: The panel, 3.5 cm thick and uncradled, is composed of three vertical planks of approximately equal width glued together. The original engaged frame and spandrel decoration has been removed and the exposed wood of the spandrels regilt, but a gesso beard is preserved around the entire perimeter of the painted surface. The gold ground is well preserved, with only minor local abrasions through which the red bolus has been exposed. The mordant gilt decoration on the draperies is mostly lost. The paint surface is extremely well preserved, suffering only pinpoint flaking losses and slight abrasions. A scratch through the tip of the Virgin's nose has been repaired. The ultramarine blue of the Virgin's mantle is in exceptional condition.

THE VIRGIN, dressed in a blue mantle lined with yellow over a red tunic, is seated frontally on an elaborately carved marble throne which terminates in a shell niche at the top. The Christ Child, seated on his mother's left knee, reaches up to a pomegranate which she proffers with her right hand. Two childlike angels with varicolored wings rest on the arms of the throne; that on the right, dressed in green, glances sidelong at the Christ Child while that on the left, dressed in yellow, looks casually out at the spectator. Two further angels, dressed in blue with rose and yellow highlights, stand at either side of the throne, leaning on its seat. Resting their chins in their hands, the angel at the right peeks through the arm of the throne at the Child and that on the left looks back over his shoulder out of the picture towards the left.

Federico Zeri (1980) first attributed this painting to Neri di Bicci and recognized it as the missing center panel from the altarpiece formerly in the Villani di Stoldo chapel in SS. Annunziata, Florence. The lateral panels of this altarpiece, showing at the right Saints Francis, Philip, Catherine, Albertus Magnus (?), and Jerome (Florence, Accademia, no. 3470), and at the left, Saints John the Baptist, Margaret, James Major, Bernard, and Matthew (Oberlin College, Allen Memorial Art Museum, no. 61.78; Stechow,

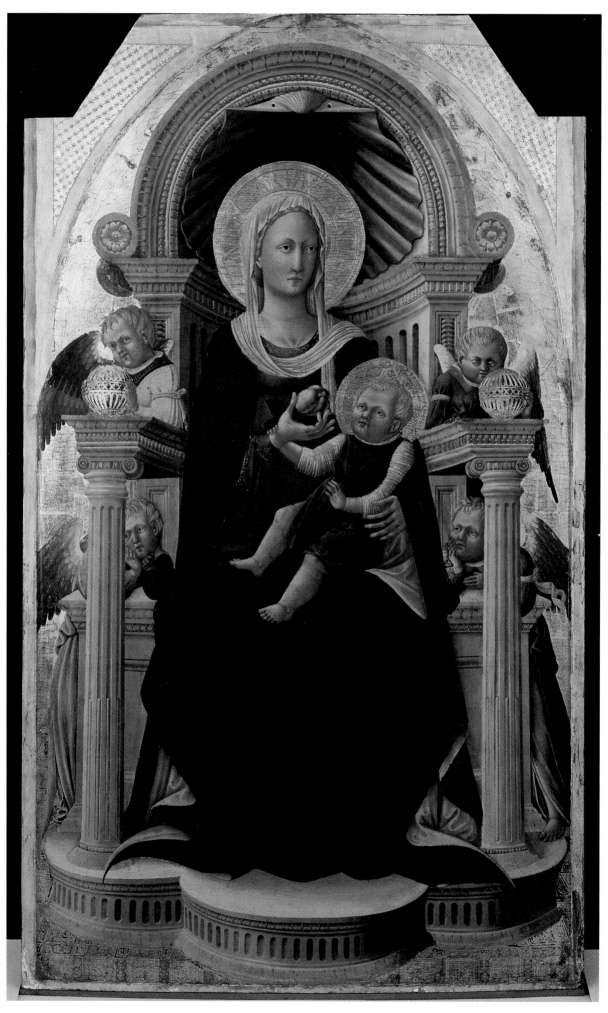

148 (cat. 37)

1967, pp. 116-118, for a full bibliography of references to this altarpiece; fig. 30), were identified by W. Cohn (1956, pp. 61-65) on the basis of seventeenth-century descriptions of the complex *in situ* and of the testament of Jacopo di Giovanni di Matteo Villani (1454). A coarse drawing of 1675 showing the elevation of the chapel (Casalini, 1962, p. 68) indicates the altarpiece, conforming in shape and composition to the Oberlin, Boston, and Accademia panels, filling the width of the altar niche (ca. 290 cm) and installed beneath and in front of a sculptural group of the Crucified Christ with the Virgin and Saint John the Evangelist. The altarpiece is described still in the chapel by Del Migliore (1684, p. 282), but was removed shortly after 1688, when litigation with the Guadagni family for possession of the chapel was finally resolved (Casalini, 1962, pp. 61-62). The altarpiece was first moved to the Capitolo de' Macinghi, where it remained until 1700, and then successively to a room next to the upper sacristy (until 1702), the stanza della Barberia, one of the new dormitory rooms (until 1706), and finally the stanza del Professato (ibid., pp. 62-63). It is not recorded among the "quadri antichi raccolti per il convento" moved in 1789 to the Gallery established in the atrium of the Annunziata library (ibid.), and probably its three panels had been dispersed before that date.

Jacopo Villani's testament refers to the chapel of Saint James "in qua est immago et figura Domini Nostri Iesu Christi Crucifixi in tabernaculo super altare," but does not mention a painted altarpiece. Casalini (1962) supposed that the altarpiece indicated in the 1675 drawing was instead the original high altarpiece of the Annunziata, described in Ghiberti's *Commentari* (1947, pp. 34-35) as a work of Taddeo Gaddi, which would have been moved to the Villani chapel in 1449, when the high altar was rebuilt. Alessandro Parronchi (1964, p. 131), suggested that the Accademia and Oberlin panels could be the surviving fragments of the new high altarpiece commissioned in 1449 from Ventura di Moro,[1] moved to the chapel of Saint James in 1505 to make room for the Deposition altarpiece by Filippino Lippi and Pietro Perugino. Villani's testament, however, obliged his heirs to endow the chapel, which he had had built and decorated ("fatta fabricare e adornare . . .") and to have mass said there on the feasts of Saints James, Francis,[2] and Catherine, all of whom are represented in the foreground of the Oberlin and Accademia panels. Given the correspondence of the other seven saints portrayed there to the name saints of Jacopo Villani's wife (Margherita) and six

Fig. 30. Neri di Bicci, *Saints John the Baptist, Margaret, James Major, Bernard, and Matthew*. Allen Memorial Art Museum, Oberlin College, Oberlin, OH

sons (Giovanni, Matteo, Bernardino, Filippo, Girolamo, and Alberto), and the exact correspondence of the width of the complete altarpiece to that of the altar niche in the chapel of St. James, it is inconceivable that it could have been painted for any other chapel in the Santissima Annunziata.

The chapel of Saint James originally served as the sacristy of the Santissima Annunziata until a new sacristy was constructed between 1438 and 1441. Jacopo Villani acquired rights to the chapel in 1444 (Tonini, 1876, p. 132), though at what time after this he, or his heirs, might have commissioned the altarpiece is unclear. Clearly painted by Neri di Bicci, it is not mentioned in the artist's account books (*Libro di Ricordanze*), which begin in the year 1453, when Neri inherited control of the family studio from his father, Bicci di Lorenzo (d. 1452); it may therefore be presumed to have been executed while Neri was still a member of his father's shop, and may even have been a commission not to Neri di Bicci but to Bicci di Lorenzo (Frosinini, 1987, p. 7). Stylistically, the altarpiece is less mature, more indebted to the example of Bicci di Lorenzo than either the fresco of S. Giovanni Gualberto enthroned (Santa Trinita, Florence) of 1450 or the Cederni altarpiece in Parma of 1448-53 (Kent, 1989, pp. 378-379). It is reasonable, therefore, to date the Villani altarpiece between 1444 and 1450, and probably to situate it at the earlier end of that period. Zeri (1980) noted the dependence on Brunelleschi and Michelozzo for the design of the throne in the Boston panel

as well as figural and compositional quotations from works by Fra Filippo Lippi, all typical of Neri di Bicci's early style.

1. For Ventura di Moro, who was known to Parronchi only through documents, see Procacci, 1961, pp. 52-53, fn. 99. Ventura di Moro is now known as the author of a signed devotional panel of the Madonna and Child in the Pinacoteca Nazionale di Siena (no. 389), on the basis of which Enzo Carli (1972a, p. 109) assigned to him all the paintings formerly attributed to the artist known as the Pseudo-Ambrogio di Baldese. While this conclusion has since been proven untenable (see catalogue nos. 33 and 34 above), some of the heterogeneous group of pictures that once bore that attribution, such as the altarpiece no. 22 in the Yale University Art Gallery, appear in fact to be the work of Ventura di Moro.

2. Cohn, 1956, incorrectly says the feast of Saint Mark. The relevant text of Villani's testament is published in Casalini, 1962, p. 67 fn. 33: "Et similiter faciant quolibet anno in perpetuum in dicta cappella festum sancti Jacobi maioris appostoli quod celebratur de mense julii cuiuslibet anni in die dicti festi faciendo ibidem cantari vesperos cum organis et salmis et canticis solemniter secundum rituum Ecclesiae. Et similiter faciant quolibet anno in perpetuum in dicta cappella die quarto mensis ottobris festum Beati Francisci et die vigesima quinta novembris quolibet anno festum Sancte Caterine." Archivio di Stato di Firenze, Conventi Soppressi, SS. Annuntiatae de Florentia, anno 1454 die 1 aprilis, Testamentum Jacobi de Villanis, redato da ser Giovanni di ser Taddeo da Colle.

Zanobi di Jacopo di Piero Machiavelli

ZANOBI MACHIAVELLI was born in Florence in 1418, and is recorded living there in 1457 and in 1469. There is some disagreement over whether he trained under Filippo Lippi, Pesellino, or Fra Angelico, though paintings plausibly attributed to him as early works betray the marked influence of Pesellino, and a document of 1452 recording the association of the latter with a certain Zanobi may refer to Machiavelli. In the 1460s he is documented at work in the Badia at Fiesole (1464/5), and as Benozzo Gozzoli's assistant in San Gimignano and Pisa. He remained active through the 1470s in Pisa, where he painted two altarpieces for the Franciscan monastery of Sta. Croce in Fossabranda, one of which is dated 1472 and both of which are strongly impregnated with the style of Benozzo Gozzoli. Zanobi Machiavelli died on 7 March 1479.

38

Virgin and Child Enthroned with Saints Sebastian, Andrew, Bernardino (?), Paul, Lawrence, and Augustine

Tempera on panel
Overall: 234.3 x 219.7 (92¼ x 86½)
Picture surface: 234.3 x 205.9 (92¼ x 81)

Charles Potter Kling Fund. 48.297

Provenance: Gabrielli, Florence, until 1868; Joseph Spiridon, Paris (sale, Berlin, Cassirer and Helbing, 31 May 1929, lot 46); Marczell von Nemes, Munich (sale, Munich, Muller, Cassirer, and Helbing, 16 June 1931, lot 15); Dr. M. Garbaty, New York, by 1939; Eugene L. Garbaty, New York, until 1948

Literature: Fischel, 1929, cat. no. 46; Kreplin, vol. 23, 1929, p. 514; van Marle, 1929a, p. 182; idem, vol. 11, 1929, p. 624; Berenson, 1932a, p. 699; idem, 1963, p. 124; Fredericksen and Zeri, 1972, pp. 114, 565; Matteoli, 1972, pp. 142-143.

Condition: The panel support has been thinned to 2.5 cm and cradled, resulting in numerous vertical splits visible through the paint surface. The joins between the planks comprising the support are disguised by the cradle, but the presence of three horizontal battens once securing them in place may be deduced by a series of plug holes aligned along the bottom, center, and top of the panels. The left and right sides of the panel are unpainted to a width of 7 cm, the picture surface terminating in a thin gold border with a raised barb, indicating the removal of an engaged frame. No such border appears at the top or bottom of the picture, though a 6 cm strip along both those sides is modern and may be presumed originally to have been covered by a frame as well. The paint surface has been severely abraded, especially areas of green in the foliage and background, and local retouching over minor paint losses has discolored. The gilt haloes and the gold embroidery on the draperies are well preserved.

THE VIRGIN, wearing a blue mantle lined with green and hemmed with gold over a red dress, is seated on a marble throne with a porphyry dais in the center of the composition. She faces three-quarters to the left and holds the naked Christ Child, who presses the fingers of his right hand to his mouth, on her lap. Standing on the grassy creviced foreground on either side of the throne are six saints. To the left are Saints Sebastian, wearing red leggings, a pink tunic with blue trim, and a violet cape with blue trim and holding an arrow; Andrew, wearing a red robe and green mantle, both hemmed with gold, and holding a large wooden cross; and Bernardino (?), wearing a brown habit and holding a red cross and a book, a crown at his feet. At the right of the throne stand Saints Augustine, wearing a bishop's mitre and a red and gold cope with a blue hem over a black habit and

holding a crozier and book; Lawrence, dressed in red deacon's robes and holding the grill and palm of his martyrdom; and Paul, dressed in a red mantle over a green robe, holding the sword of his martyrdom in his left hand and in his right a packet of letters (epistles), the first of which is inscribed AD ROMANOS. The Virgin's throne is backed with a purple niche and white marble entablature supported on fluted Corinthian pilasters, and behind this, closing off the foreground, a low marble wall runs the full width of the picture field. Above the wall can be seen a line of five fruit trees.

Since its first publication at the time of the sale of the Spiridon collection (1929), this altarpiece has been recognized as a fully characteristic work by Zanobi Machiavelli, closely comparable to his signed altarpieces in Pisa, Dublin, and Dijon. What little notice it has engendered, other than Berenson's (1932) remark that it may be Machiavelli's most significant effort, has been largely concerned with establishing the identities of the six saints flanking the Virgin, and particularly of the rearmost saint at the left and the foremost saint at the right. The latter has been called Zenobius (who, however, is never portrayed with a monastic habit beneath his cope), Bernardo degli Uberti (who was a cardinal, not a bishop), and Augustine. Augustine is likely to be correct, given the leather belt closing the dark habit at the waist. The monastic saint at the left has variously been considered Bernardino and John Gualbert. Though neither identification can be accepted with absolute certainty, the figure's habit does appear to be Franciscan. Nothing is known of the original location that might contribute to the firm identification of the saints.

Matteoli (1972) is almost certainly correct in dating the Boston altarpiece to the mid- or late 1460s, when Machiavelli may reasonably be supposed to have gravitated closest to Benozzo Gozzoli in his style, overcoming the earlier influences of Pesellino and Fra Filippo Lippi. Machiavelli is documented as Gozzoli's assistant at San Gimignano (1463-68) and Pisa (from 1468). The style of his Pisan works is well documented from his altarpieces in Dijon and Pisa, which were painted for the church of Santa Croce in Fossabranda there. That the present picture, which is less schematic and more clearly reminiscent of Fra Angelico as well as Gozzoli, predates these is only inference, as there are no known securely datable works by Zanobi earlier than the Pisa altarpiece (now in Dijon) of 1472, but nothing about its style or iconography clearly contradicts the assertion.

Marco del Buono di Marco

and

Apollonio di Giovanni di Tommaso

MARCO DEL BUONO (1402/3-1489) and Apollonio di Giovanni (1415/7-1465) are listed in a tax return of 1457 as partners in a joint studio the account books of which, running from 1446 to 1463, are preserved today (Callmann, 1974, app. 1). These account books list a sequence of commissions for the painting and gilding of cassoni or linen chests intended for presentation on the occasion of important Florentine marriages, a production in which the shop specialized. One of the chests listed there was identified by Stechow (1944, pp. 4ff.) with a cassone panel now at Oberlin College, enabling the reattribution to this shop of a number of similar works which had previously been grouped under various provisional names: the Compagno di Pesellino, the Virgil Master, the Dido Master, and the Master of the Jarves Cassoni.

There is no tangible evidence in the form of an independently signed or documented work to indicate the role either artist played in the partnership. Though Marco del Buono is named first in the account ledger and claimed the studio as his property in the 1457 tax declaration, his prominence may have been due only to seniority, and prevailing opinion considers Apollonio di Giovanni the principal designer and painter of the shop. The wide range of quality and technical accomplishment within a generally uniform stylistic idiom characteristic of the many cassoni – as well as deschi da parto, portraits, and private devotional panels – painted in this shop implies a complex but efficient system of production which obviates the identification of individual personalities among the artists working there. The list of the shop's clients, on the other hand, which numbers most of the principal families of Florence, as well as the evident material expense involved in painting many of the cassoni, which are lavishly embellished with minutely detailed gold and silver decoration, suggest the importance of this category of commercial artistic production in Florence in the third quarter of the fifteenth century.

39

Journey of the Queen of Sheba

Tempera on panel
Overall: 41.6 x 134.8 (16⅜ x 53¼₆)
Picture surface: 39.1 x 132.5 (15⅜ x 52½)

Herbert James Pratt Fund. 23.252

Provenance: Unknown

Literature: *Bulletin of the Museum of Fine Arts* 21 (1923), p. 57; Offner, 1927, p. 30, fig. 22 G; van Marle, vol. 10, 1928, pp. 550-551; Shapley, 1966, p. 98; Fredericksen and Zeri, 1972, pp. 12, 564; Callmann, 1974, pp. 43 fn. 21, 62, 65-66 cat. no. 28, pl. 149.

Condition: The wood panel support, comprising two horizontal planks of roughly equal height glued together, is 3.2 cm thick and has not been thinned or cradled. Engaged frame moldings have been detached from all four sides but a gesso barb is preserved along the entire perimeter of the picture surface. The gilt and tooled decoration is in good condition, exhibiting only moderate wear, while the paint surface has suffered only minor pinpoint flaking and scratches. The sky is slightly abraded, as are a few of the faces in the procession. A short horizontal split in the bottom left corner has resulted in gesso and paint losses which have been restored. A layer of yellowed varnish has been removed from the left half of the picture but, inexplicably, retained in the right half.

THE JOURNEY of the Queen of Sheba is represented as a triumphal procession, with the Queen enthroned on a gilded triumphal car drawn by a pair of caparisoned chargers ridden by black pages in the center of the panel. Behind and before her, her retinue, including camels laden with chests of gifts and provisions, walk and ride through a mountainous landscape toward the city of Jerusalem in the right background.

The subject is a common one on painted wedding cassoni, and is known in at least three versions from the shop of Marco del Buono and Apollonio di Giovanni: in the Kress Collection at Birmingham, Alabama (Shapley, 1966, p. 98); formerly in the Merton collection at Maidenhead Thicket (sale Christie's, London, 11 April 1986, lot 58); and the present panel. The first two of these may be identified as having formed pairs with panels representing the Meeting of Solomon and the Queen of Sheba (see Callmann, p. 43). Though it may be presumed that the Boston panel too once formed part of such a pair, and though additional panels from the shop of Marco del Buono and Apollonio di Giovanni representing the meeting of Solomon and the Queen of Sheba are known (see no. 30.495 below), none of these can be firmly associated with ours as part of a suite.

The Journey of the Queen of Sheba

was acquired by the Museum of Fine Arts as a work of Paolo Uccello, and was first attributed by Offner (1927), followed by van Marle (1928), to the Virgil Master. Though not discussed by Stechow (1944) in his study identifying the Virgil Master as either Apollonio di Giovanni or Marco del Buono, it has never been doubted as an integral member of the body of works grouped under their names. Accepted as a product of the workshop by Callman (1974) and as autograph by E. Fahy (manuscript in Museum files), it is a typical if not especially distinguished example of their commercial production, notable primarily for its relatively good state of preservation.

40

Meeting of Solomon and the Queen of Sheba

Tempera on panel
Overall: 46.8 x 178.5 (18¼₆ x 70¼)
Picture surface: 44.5 x 176.5 (17½ x 69½)

Bequest of Mrs. Harriet J. Bradbury. 30.495

Provenance: Unknown; Mrs. Harriet J. Bradbury, by 1916

Literature: Sirén, 1916, p. 92; Offner, 1927, p. 30; Fredericksen and Zeri, 1972, pp. 12, 564; E. Callmann, 1974, pp. 14 fn. 32, 32 fn. 32, 34 fn. 35, 43, 64-65 cat. no. 25, pls. 10, 146, 243, 258; Cole, 1987, pp. 23, 51, fig. 20.

Condition: The panel support has been thinned to an indeterminate depth and marouflaged. Several horizontal, partial splits have opened at either end of the panel. Both the gesso ground and paint surface are abraded and worn with scratches, typical of cassone panels, overall and larger losses along the edges. The gilt and tooled surfaces are also worn and scratched. Most of the blues and greens have deteriorated to an almost black color.

THE PANEL shows, at the left, the retinue of the Queen of Sheba winding across a hilly landscape and through the gates of the walled city of Jerusalem. The Queen's triumphal car stands empty in the left foreground, with horses and servitors milling around it. At the right the Queen of Sheba, followed by her ladies-in-waiting and courtiers, greets King Solomon, attended by his court, before the arches of the Temple. The composition may be said to be a free derivation from Ghiberti's relief of the same subject on the Porta del Paradiso of the Florence Baptistry, spread out to an elongated frieze appropriate to the shape of the picture field of a cassone front.

The meeting of Solomon and the Queen of Sheba concludes the narrative

Fig. 31. Marco del Buono and Apollonio di Giovanni
di Tommaso, *Journey of Sheba*. Kress Collection,
Birmingham Museum of Art, AL

of the journey of the Queen of Sheba, as represented on no. 23.252 above, and thus the two scenes were frequently represented on pairs of cassoni. Callmann (1974, pp. 43, 64-65) reconstructs two extant pairs produced in the shop of Marco del Buono and Apollonio di Giovanni: one comprising a Journey of the Queen of Sheba formerly in the collection of Sir Thomas Merton at Maidenhead (sale Christie's, London, 30 November 1979, lot 35; ibid., 11 April 1986, lot 58) and a Meeting of Solomon and the Queen of Sheba formerly in the Woodburn and Butler collections (untraced); the other comprising a Journey of the Queen of Sheba in the Kress Collection at Birmingham, Alabama (Shapley, 1966, p. 98; fig. 31), and the present panel. The Birmingham and Boston panels are closely comparable in size, in spatial conception, and in decorative details, and there is little reason to doubt their reconstruction as a pair. Additionally, Callmann records two further representations of the Meeting of Solomon and the Queen of Sheba from the shop of Marco del Buono and Apollonio di Giovanni, one in her own collection and one in the Jarves collection at Yale University.

The Boston Meeting of Solomon and the Queen of Sheba and the Yale version of the same subject formed part of Sirén's and Offner's original lists of works by the Virgil Master, all of which have since been recognized as products of the workshop headed by Marco del Buono and Apollonio di Giovanni. The Boston panel is one of the more ambitious works to emerge from that shop, not only for its great size and the lavishness of its elaborate decorative details but also for the complexity and clarity of its spatial organization. Callmann (1974, p. 65) convincingly argues for a late dating, after 1460, for this panel and its pair at Birmingham, which is borne out by the extraordinary architectural conceit of the Temple of Solomon with its flanking colonnades projecting forward at the sides, constructed of Corinthian piers and ionic columns, a faceted entablature frieze, and winged putti supporting wreaths atop the cornice. Colonnades surmounted by putti and wreaths are also to be found flanking the Temple in the Yale panel, but they are represented parallel to the picture plane and much simpler in detail, while the entire structure is simplified even further in the other known versions of the scene. Projecting colonnades of this form, though without the mixture of Corinthian and Ionic orders and without the elaboration of the entablatures, reappear in only one other, probably later panel from the workshop, an Abduction of Helen in a private collection (Callmann, pl. 175). Though not at present susceptible of proof, there is some reason to believe that the Boston Meeting of Solomon and the Queen of Sheba may have been among the last cassoni painted in the shop before the death of Apollonio di Giovanni in 1465.

41

The Battle of Pharsalus and Beheading of Pompey

Tempera on panel
41 x 131 (16 x 51¼)

Francis Bartlett Fund. 15.910

Provenance: Charles Butler, Warren Wood, Hatfield, Herts.; Captain H. L. Butler, Warren Wood, Hatfield, Herts.; Bacri, Paris

Literature: "Battle Scene," p. 62; Pope-Hennessy, 1950, pp. 25-26, fig. 18; Fredericksen and Zeri, 1972, pp. 12, 564; E. Callmann, 1974, pp. 46 fn. 36, 74 cat. no. 54, pls. 136, 207.

Condition: The panel support has been thinned to a depth of 1.4 cm and cradled, forcing several horizontal, partial splits to open at either end. The gesso ground and paint surface is lightly abraded throughout and is interrupted by numerous scratches and small flaking losses, typical of painted cassone fronts. Losses have been heavily restored with many of the retouchings now discolored. The areas of gilt decoration are somewhat better preserved.

A BATTLE between two armies of mounted lancers and swordsmen fills the left two-thirds of the picture field, with three downed horses and two knights in the center foreground, two lance engagements above them, and advancing phalanxes of horsemen on either side. All the knights wear silver armor, many sport gold wings or gold and colored plumes from their helmets, and most of the horses bear gold trappings. At the right of the panel, before a dense wooded landscape, seven knights circle around the decapitated body of another, a knight at the left holding the head in his left hand and a sword in his right.

The panel, excised from the front of a cassone, illustrates Caesar's defeat of Pompey at the Battle of Pharsalus, as recounted by Plutarch. After the battle, Pompey fled to Egypt where he was granted asylum by Ptolemy but treacherously murdered. Ptolemy sent Pompey's head to Caesar hoping to win the latter's gratitude, but Caesar wept upon receiving the grisly trophy. According to Plutarch, the murder took place on a boat on the Nile, whereas it is here represented in a dark wood, and the scene of Pompey's head presented to Caesar is omitted.

Callmann (1974, p. 74), who interprets the scene at the right of the Boston panel as the presentation of Pompey's head to Caesar, compares it to three later, and more complete, Florentine representations of the Battle of Pharsalus on cassoni: one in the Lee collection at the Courtauld Institute Galleries, one formerly in the Gambier-Parry collection, and one in a private collection (ibid., pl. 206). She also records a version of the subject presumably made in the workshop of Marco del Buono and Apollonio di Giovanni, though known only from its description by van Marle (vol. 10, 1928, pp. 554-555). Reproducing a cassone by Marco del Buono and Apollonio di Giovanni painted with scenes of the assassination and funeral of Julius Caesar, van Marle described a companion chest in the same collection portraying a battle, beheading, and presentation of the head. This can only have been meant to represent the Battle of Pharsalus and its aftermath, and its association with a chest showing the death of Caesar suggests that the Boston Battle of Pharsalus may also once have had a pendant with that subject. A panel showing the assassination and funeral of Julius Caesar, painted by Marco del Buono and Apollonio di Giovanni and of similar size to the Boston panel, is preserved in the Ashmolean Museum, Oxford (Lloyd, 1977, pp. 8-10, pls. 9-11), but there is no evidence the two were ever associated with each other.

The Battle of Pharsalus was acquired for the Museum of Fine Arts, apparently through the intermediation of the American painter Walter Gay, as the work of Paolo Uccello. This attribution rested on the authority of Max Friedländer, and was based on the picture's evident dependence on Uccello's scenes of the Rout of San Romano. An attribution to Uccello or his shop was first definitively rejected by Pope-Hennessy (1950), and the correct attribution to the workshop of Marco del Buono and Apollonio di Giovanni was advanced by Fredericksen and Zeri (1972) and Callmann (1974). The latter, who imposes a restrictive, Offnerian view on the productions of this workshop inappropriate to their commercial nature, specifically attributed the Boston panel to the assistant responsible for a much-damaged cassone painted with a battle scene in the Cincinnati Art Museum. An approximate terminus post quem for the execution of the panel is provided by the probable date of Uccello's San Romano panels, ca. 1455/56, and there is no reason to suppose that it was painted after the death of Apollonio di Giovanni in 1465 (see no. 06.2441 below).

42a

42b

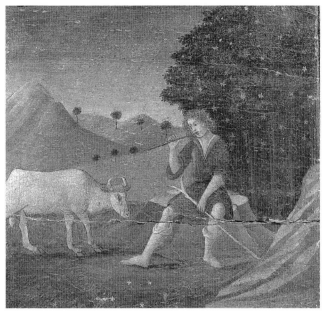

42c

42a

Scenes from the Aeneid (?)

Tempera on panel
38 x 140 (15 x 55⅛)

Bequest of Mrs. Martin Brimmer. 06.2441a

Provenance: Unknown; Mrs. Martin Brimmer, Boston, by 1906

Literature: Sirén, 1916, p. 85; Fredericksen and Zeri, 1972, pp. 12, 564; Callmann, 1974, pp. 29 fn. 21, 41, 69 cat. no. 36, pl. 178.

Condition: The chest into which this panel is incorporated and all its engaged moldings appear to be original (with the exception of the lid, which has been at least partially rebuilt), though all its surfaces have been regessoed and regilt. The main painted panel shows no splits or cracks, and there are only minor abrasions and scratches scattered over its painted surface which have been minimally retouched.

THE PICTURE is divided into two distinct scenes by the crenellated wall of a city, set slightly to the right of center. At the left, a battle or tournament of swordplay between mounted knights fills an open piazza in the foreground, while a crowd of elegantly dressed young men and women watch from the windows of a large palazzo behind, leaning on oriental carpets draped from the window ledges. At the right, a man and a woman are seated on a gilded triumphal car drawn by two richly caparisoned horses ridden by two young boys. They are accompanied by a retinue of courtiers and mounted and foot soldiers, all moving away from the city.

The scenes are traditionally identified as the tournament celebrating Aeneas's victory over Turnus and the wedding procession of Aeneas and Lavinia, an identification accepted by Callmann (1974, p. 69) and E. Fahy (manuscript opinion in the Museum files). If correct, they could have been meant to form a suite with a cassone front similar to one in the Musée de Cluny, Paris (acc. no. 7505), which shows Aeneas defeating Turnus as Latinus, Lavinia, and Amata watch, and the wedding of Aeneas and Lavinia. Conversely, the Cluny front could have been completed on its chest by end panels such as those formerly in the Toscanelli collection showing a tournament and procession (Callmann, pls. 117, 120), which might then be interpreted as replicating the subjects of the Boston cassone front.

The Boston panel is set into a chest which appears to be original except for having been completely regilt and perhaps altered slightly in the form of the lid. The inside of the lid is painted with an imperfectly preserved textile pattern, again apparently original, but the outside of the lid seems to have been rebuilt, perhaps to replace damaged upper members. A nearly identical chest, complete with paired Corinthian pilasters hung with escutcheons at the sides and a gilt, punched, and painted ribbon-and-stick frieze across the top and bottom, appeared at Christie's, London, 28 June 1923, its front panel painted with the same scenes in closely similar composi-

tions as on the Boston chest. To judge only from the poor photograph in the auction catalogue (reproduced also in Callmann, pl. 177), this second chest seems to have been in all essentials finer than the Boston version. The tournament in the left foreground is more freely movemented, and the horses more ably rendered and more convincingly foreshortened. The crowds at the windows (four instead of three) are less schematic, while the receding street at the far left, overhung by a balcony from a neighboring palazzo, is rendered with a perspectival accuracy more typical of Pesellino than of even the most accomplished efforts of Marco del Buono and Apollonio di Giovanni. The scene of the wedding procession at the right shows in a similar degree a greater sophistication than the corresponding scene on the Boston chest, with a more extensive landscape and naturalistic frieze of figures.

Given the absolute conformity of figure types and decorative vocabulary in both these chests to all the known works attributable to Marco del Buono and Apollonio di Giovanni, it can only be concluded that both chests were produced in that workshop. Whether differences between them are to be imputed only to a difference in the assistants employed in their execution, or whether they might have been produced at different dates, must remain a matter of open conjecture. Everett Fahy (letter in Museum files) suggests that the Boston chest was painted by an independent artist influenced by Apollonio di Giovanni, and it is perhaps worth speculating whether it might have been painted after the death of Apollonio di Giovanni (1465), when the shop was inherited by Marco del Buono's son, Antonio di Marco (see cat. no. 06.2441b, c below).

42 b, c

Rape of Ganymede; Io and Mercury
(end panels of a cassone)

Tempera on panel
each: 38 x 40 (15 x 15¾)

Bequest of Mrs. Martin Brimmer.
06.2441 b, c

Provenance: Unknown; Mrs. Martin Brimmer, Boston, by 1906

Literature: Fredericksen and Zeri, 1972, p. 21; Callmann, 1974, p. 69; Saslow, 1986, pp. 40-41, 213 fn. 60, fig. 110.

Fig. 32. Marco del Buono and Apollonio di Giovanni di Tommaso, Cassone with *Scenes from the Aeneid*, *Rape of Ganymede*, and *Io and Mercury*. Museum of Fine Arts, Boston

Condition: The panels are set into the ends of a cassone (see 06.2441a above) and appear to be integral to it. The Rape of Ganymede (06.2441b) is split horizontally approximately one-third the distance from its bottom edge. Io and Mercury (06.2441c) is similarly split horizontally, one-third the distance from its top edge. Both panels have been heavily abraded and suffered numerous flaking losses and scratches which have been extensively restored.

BOTH SCENES are set in vague, hilly landscapes. In one, Jupiter, in the guise of an eagle, carries off the young Ganymede, in contemporary Florentine dress, while two similarly attired youths look on in amazement. The youths were identified as Ganymede's brothers Ilos and Assarakos by E. G. Budde (letter in Museum files), following an indication of Homer (Iliad 20,231). In the second panel, Mercury, dressed as a shepherd, is seated on a rock playing a pipe and holding a staff. Grazing nearby is Io, changed into a white heifer by Jupiter to protect her from the jealous wrath of Juno. This panel has always been referred to as Io and Argus, but Argus, a servant of Juno, had a hundred eyes. He was lulled to sleep by Mercury playing his pipe, and it must be Mercury, not Argus, who is portrayed here.

The panels are incorporated in the ends of a cassone of which the front is painted with the scenes from the Aeneid catalogued above (06.2441a; fig. 32). The chest seems to be integral, and there is no reason to suppose, as did Fredericksen and Zeri (1972) and Callmann (1974), that the end panels are by a different artist. Fahy (manuscript opinion) regarded all three panels as by a single hand which, given their differences in figure scale and condition, seems to be the case.

The idiosyncratic simplification of figure types and gestures in these two panels, derived from examples produced in the shop of Marco del Buono and Apollonio di Giovanni, is exactly paralleled in a cassone front of a battle and triumph in the Musée du Cinquantenaire, Brussels (Callman, pl. 271), and the three panels are probably to be attributed to a single artist. Callmann (p. 38) makes the not unreasonable suggestion that the Brussels cassone may be the work of Antonio di Marco del Buono, who inherited Apollonio di Giovanni's workshop upon the latter's death in 1465, but the suggestion is not yet susceptible of proof.

Master of the Johnson Nativity

A PROLIFIC Florentine craftsman active in the last third of the fifteenth century, the Master of the Johnson Nativity was first identified by Everett Fahy (1966, p. 28; 1976, pp. 172-173), and named after a panel in the John G. Johnson Collection, Philadelphia Museum of Art. The corpus of works attributed to the artist, nearly all of them private devotional panels of a somewhat formulaic repetitiveness, was expanded recently by Gemma Landolfi (in Dalli Regoli, 1988, pp. 243-327). The Master of the Johnson Nativity was probably trained in the workshop of Domenico di Michelino, with whom he collaborated on an altarpiece for the Chellini chapel in San Jacopo e Lucia, San Miniato, though he was able to assimilate characteristics of many of the most fashionable painters of his time, including Filippo Lippi, Alesso Baldovinetti, Francesco Botticini, and Sandro Botticelli, in arriving at a style that enjoyed, to judge from the number of his works that survive, a not inconsiderable commercial success. An attempt (Bernacchioni, 1990) to identify the Master of the Johnson Nativity with a certain Domenico di Zanobi, an assistant of Domenico di Michelino documented in the latter's shop in 1467, is plausible but based entirely on circumstantial evidence.

43

Virgin and Child

Tempera on panel
Overall: 78.5 x 50.2 (30⅞ x 19¾)
Picture surface: 72.5 x 45 (28½ x 17¼)

Bequest of Mrs. Edward Jackson Holmes, Edward Jackson Holmes Collection. 64.2379

Provenance: Unknown; Edward Jackson Holmes, Boston, by 1935

Condition: The panel has been thinned to a depth of 7 mm and is cradled. Though the panel has presumably been trimmed slightly at the edges, a beard of gesso survives along the entire perimeter of the paint surface. The gilt haloes of both figures have been partially resurfaced, but the paint layers are otherwise well preserved. Tiny flaking losses throughout, as well as minor damages along several partial, vertical splits in the panel have been minimally retouched. The Virgin's left hand and the profile of the Child's leg, damaged by one of these splits, hs been more extensively overpainted. The Virgin's ultramarine mantle has blackened, and a thick, nearly opaque yellow varnish presently obscures the true colors and tonality of the picture. Infrared examination reveals the presence of extensive underdrawing beneath the paint layers.

THE VIRGIN, wearing a red dress with slit sleeves and a transparent veil covered by a blue (now black) mantle, is shown half-length turned slightly to the right. She supports the Christ Child, naked but for a coral necklace, standing on the ledge of a short parapet before her to the right. The Child holds a finch in his left hand, and raises his right in a gesture of benediction. Behind the two figures is a curved marble niche with porphyry revetment and a red architrave and cornice, above which rise the tops of a row of cypress trees. A garland of alternating white and red roses is strung from the corners of the niche to the top center of the panel.

Though on continuous loan to the Museum of Fine Arts since 1935, this beautifully preserved picture is unpublished and virtually unknown. It was correctly attributed to the Master of the Johnson Nativity by Everett Fahy (manuscript note in Museum files, 1985). A fragmentary replica of the composition formerly in the collection of Carl von Weinberg, Frankfurt, was published as the Master of the Johnson Nativity by Fahy (1976, p. 172) and is reproduced by G. Landolfi (1988, fig. 238, cat. no. 27, p. 320). The von Weinberg picture (fig. 33), which includes the garland of roses and probably also included the niche behind the figures, though this is cropped out in the panel's present, fragmentary state, differs from the Boston version only slightly in that the Virgin's right hand is positioned above rather than below the Child's left

Fig. 33. Master of the Johnson Nativity, *Madonna and Child*. Formerly von Weinberg Collection, Frankfurt

hand and that the Child inclines his head in the opposite direction.

The form of the niche in the present painting, which ultimately derives from mature works of Filippo Lippi such as the Saints Cosmas and Damian altarpiece in the Uffizi or the Virgin and Child in the Palazzo Medici Riccardi, is repeated in another composition by the Master of the Johnson Nativity formerly in the Mead collection, Florence (Landolfi, 1988, fig. 230), and appears in a varied form in pictures by the same Master in Rutland, Massachusetts, State Hospital (ibid., fig. 261), the Bearsted collection at Upton House, Edgehill (ibid., fig. 262), and the collection of Queen Helen of Romania at San Domenico, Fiesole (ibid., fig. 263). This last is one of the few paintings by the Master of the Johnson Nativity which approaches the Boston panel in refinement and delicacy of execution, and both may perhaps be considered early works, closer to the example of Lippi

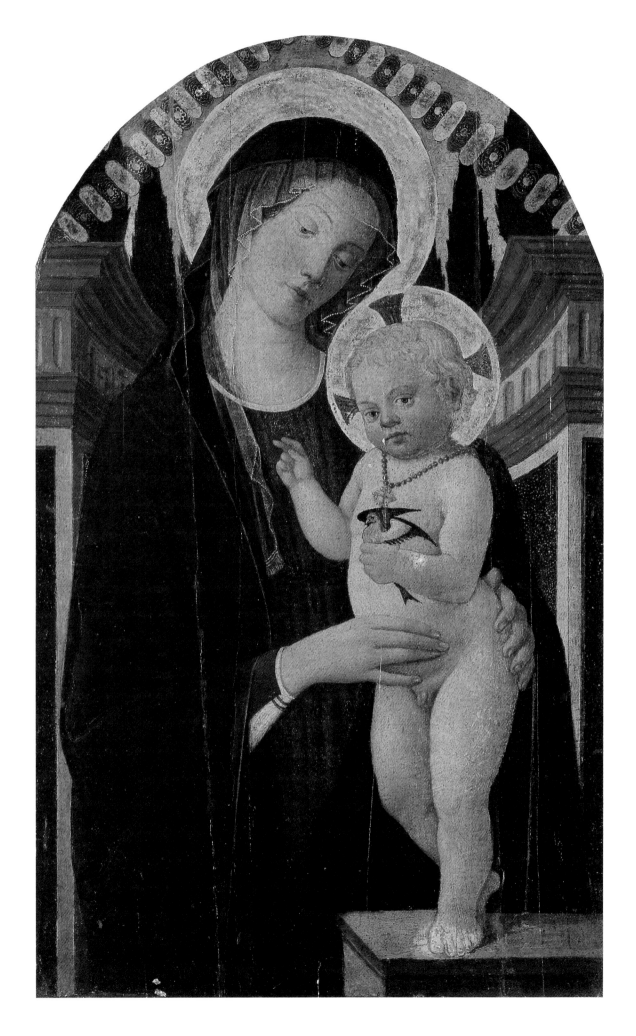

158 (cat. 43)

(d. 1469) and of Fra Diamante. A possible terminus post quem for the Boston panel is suggested by its general resemblance to Luca Della Robbia's Virgin and Child in the stemma of the Arte dei Medici e degli Speziali on Or San Michele of ca. 1465. A date ca. 1470 for the present picture seems reasonable.

The aedicula frame in which the Boston panel is now housed, typical of devotional pictures of this type from the third quarter of the fifteenth century, especially from the workshops of Neri di Bicchi and the so-called Lippi-Pesellino imitators, is old and may be original. It has not been cut or enlarged to fit the panel, only adapted to accommodate the cradle. Its painted and gilt surface is modern but probably faithful to its original design, as most frames of this type have the sloping frieze painted blue and decorated with either sgraffito or mordant gilt stars (though not of the shape of the present stars). The honeysuckle crocket at the top center of the frame has been lost, and those at the spring of the arch at either side are modern replacements. The sight edge, which would have been lost in cutting the frame away from the painted panel to which it was engaged, is a reconstruction.

Cosimo Rosselli

MUCH UNDERESTIMATED by writers from the time of Vasari on, Cosimo Rosselli was born in 1439 and apprenticed at the age of fourteen, in 1453, to Neri di Bicci (q.v.). He left the latter's studio in 1456 and may have attached himself to the workshop of Alesso Baldovinetti, by whom his earliest paintings are strongly influenced. In 1468/9, Rosselli painted an altarpiece for the German confraternity of Saint Barbara in Florence (Florence, Uffizi), and he seems to have enjoyed the patronage of the German community there throughout his career. A series of distinguished commissions for frescoes in the forecourt of the SS. Annunziata (1476), the Sistine Chapel at the Vatican (1481-2, where he painted alongside Perugino, Botticelli, and Ghirlandaio), and in the chapel of the relics in Sant' Ambrogio (1486) span the period of his greatest artistic success. In the 1490s and the early years of the sixteenth century, Rosselli adopted a more luminous though compositionally static style, influenced by the mature works of Domenico Ghirlandaio (q.v.) and by the presence in Florence of numerous paintings by Netherlandish artists, perhaps accessible to him through his German patrons. From this period date an altarpiece of the Virgin and Child with the Young Baptist and Saints James and Peter in the Accademia, Florence (1492), and a Coronation of the Virgin in Sta. Maria Maddalena dei Pazzi (ca. 1505). Rosselli died in 1507.

44

Madonna and Child with an Angel (?)

Tempera on panel
Overall: 73.7 x 54.3 (29 x 21⅜)
Picture surface: 73 x 53.4 (28¾ x 21)

Bequest of Mrs. Edward Jackson Holmes. 64.2077

Provenance: Unknown; Edward Jackson Holmes, Boston, by 1933

Literature: Venturi, 1933, pl. 241; Berenson, vol. 1, 1963, p. 191.

Condition: The panel, of a vertical grain, is 1.5 cm thick and has been backed with a wax resin layer. It has been trimmed slightly along the edges, and shows a 10 cm-long vertical split in the top right corner. The paint surface is extremely well preserved with only very small losses and scratches scattered over the surface, most notably in the Christ Child's cheeks and along the bottom edge of the picture. The drawn profile of an arched window opening beginning 6.6 cm to the left of the present rectilinear opening is now plainly apparent beneath thinning layers of pigment, and the top half of the sky visible through the window has been extensively overpainted. The mordant gilt haloes are moderately worn.

THE VIRGIN, wearing a red dress and blue robe, is seated frontally on a low stool. With her left hand she supports the Christ Child standing on her leg, and in her right hand she holds a white rose. The Child, scantily clad in a transparent cloth, embraces his mother's neck with his right arm and presses his face against her cheek. Behind these figures at the right stands an angel (?) wearing a red diadem and a yellow robe over a green-sleeved tunic, holding a bouquet of white, pink, and red roses in a fold of cloth at its waist. A window in the upper left corner of the picture opens onto a deep hillside landscape.

Though largely ignored in the summary literature concerning the artist, this beautifully preserved panel is a fine example of Cosimo Rosselli's early style, undoubtedly painted prior to his commission for the fresco of the *Vision of Saint Filippo Benizzi* in the forecourt of the SS. Annunziata, Florence (1476). Everett Fahy (note in Museum files) dated it ca. 1475, probably on the basis of its close relationship to the Saint Barbara altarpiece in the Uffizi traditionally thought to have been painted at that time. As the composition of the two principal figures closely parallels that in a documented altarpiece of 1468 by Cosimo Rosselli and assistants formerly in the church of San Pier Scheraggio, Florence (first identified by Baldini, 1953, p.

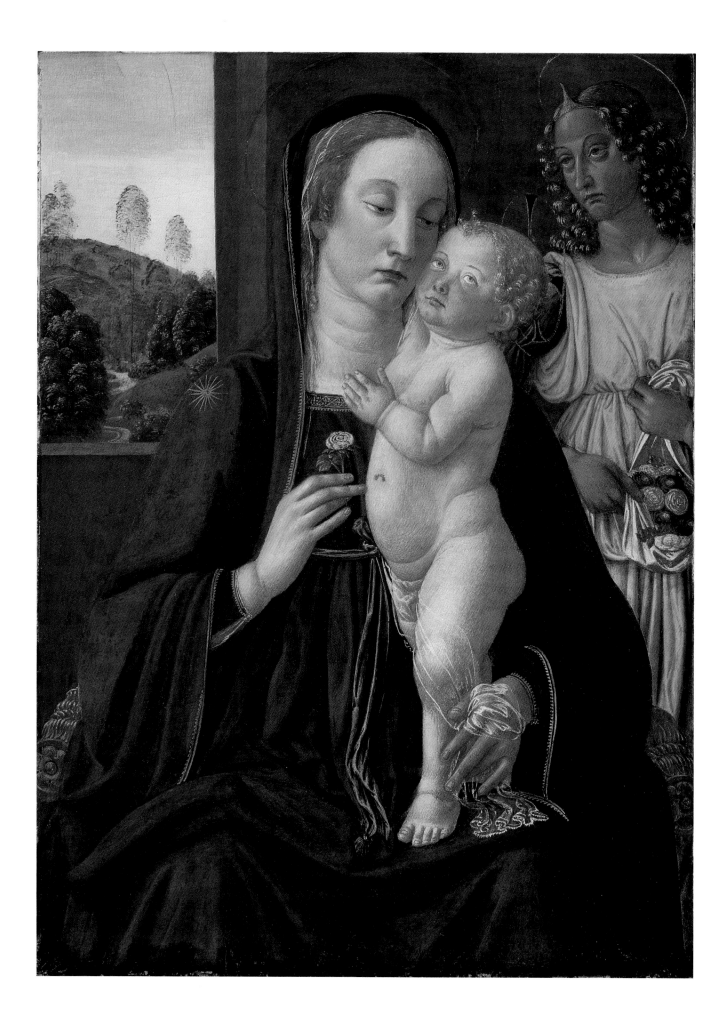

279; the attribution and dating of this altarpiece have been questioned by Nuttal, 1985, pp. 367-372), and as the Saint Barbara altarpiece has recently been shown on the basis of documents also to date to 1468-69 (Nuttal, 1985; Padoa Rizzo, 1987), there is a strong likelihood that the Boston Madonna was painted around or before 1470.

The figure in the background of the present picture has always been identified as an angel, which may be correct, but it is painted without wings and may have been intended instead to represent Saint Elizabeth of Hungary. Though such an identification is at best tenuous, based not on the figure's appearance but on the attributes of a princess's diadem and a bouquet of roses, it is perhaps worth noting that one of Cosimo Rosselli's principal patrons at precisely this moment was the German Confraternity of Saint Barbara (for whose chapel he executed the Saint Barbara altarpiece in 1468-69). Saint Elizabeth of Hungary was styled *gloria Teutoniae* and adopted as the patron of the Cavalieri Tedeschi (Réau, vol. 1, 1958, p. 418), raising the possiblity that the Boston Madonna was painted as a private commission for a member of the Compagnia di Santa Barbara or another confraternity of the "nazione tedesca" in Florence (see also no. 22.651 below).

Typical of Cosimo Rosselli's paintings of the Madonna and Child, the present picture was painted up to an engraved line denoting the borders of the picture field on all four sides. The gesso preparation of the panel is continuous beyond this engraved line, as are some of the picture's underdrawing and random strokes of paint. Such a practice is more common in Venice than in Florence, and was intended to allow the fully painted panel to be fitted into an independently constructed frame. In Florentine workshop practice, the painter generally worked on a prepared panel supplied to him already complete with an engaged frame. Cosimo Rosselli's studio appears to have been almost unique in Florence in preferring the North Italian technique. The source of this preference and the reasons for it are unclear.

45

Descent from the Cross

Tempera on panel
Overall: 50.8 x 36.0 (20 x 14⅛)
Picture surface: 49.37 x 34.29 (19⁷⁄₁₆ x 13½)

Zoe Oliver Sherman Collection. 22.651

Provenance: Giovanni Rosini, Pisa, by 1839 (?); Charles, Third Earl Somers, ca. 1865; Lady Henry Somerset, Reigate Priory; R. Langton Douglas; Zoe Oliver Sherman, 1922

Literature: Rosini, vol. 2, 1839, p. 110; Berenson, 1909, p. 179; Venturi, vol. 7, i, 1911, p. 696; van Marle, vol. 11, 1929, p. 591, fn. 359; Pigler, 1947, pp. 81, 87; Musatti, 1950, p. 108; Busignani, 1962, pp. 42, 45 fn. 8; Fredericksen and Zeri, 1972, pp. 178, 564; Sutton, 1979, p. 196, fig. 10.

Condition: The panel support, a single plank of wood, has been thinned to a depth of 1.1 cm and cradled, and exposed worm tunnels along the left and right edges suggest that it may have been reduced in width as well. The paint surface is well preserved, though it has been unevenly cleaned with much greater abrasion, especially of the greens and the flesh tones, in the lower half than in the upper. Scattered flaking losses, especially in the figure of Christ and in the faces and hands of several figures at the bottom of the panel, have been retouched and are now slightly discolored.

THE LIMP BODY of Christ is lowered from the cross by five saints: two younger men standing on ladders and three older, bearded men receiving the body on a shroud below. In the foreground at the left, the Virgin faints in the arms of five holy women, all sitting around her on the ground. Next to them, in the bottom center of the composition, an elderly male saint kneels and looks back at the scene of the Deposition. A further group of four figures stands in the foreground at the right, distinguished by their Eastern garb and nimbi. The foremost of these holds the crown of thorns and three nails, and gestures with his right hand back toward the body of Christ. A deep mountainous landscape completes the scene behind.

Except for its publication by Rosini (1839) as by Gherardo Starnina, this well-known panel has always been discussed as a typical early work by Cosimo Rosselli. This attribution is not open to doubt, though a determination of the painting's approximate date is complicated on the one hand by its unevenly abraded condition and on the other by the traditional misdating of a handful of iconographically related works by Cosimo Rosselli with which the Boston panel has always been compared, specifically the *Lamentation* in the John G. Johnson Collection, Philadelphia, and the *Disrobing of Christ* and the *Via Crucis* formerly in the Mount Trust,

Oxfordshire. As was recognized by Anna Padoa Rizzo (1977, p. 10 fn. 8) the Philadelphia and Mount Trust paintings are actually late works by the artist, dating not earlier than the last decade of the fifteenth century.

The best preserved portions of the Boston *Descent from the Cross*, the middle-distance and background landscape and the two figures on ladders lowering the body of Christ from the cross, suggest a possible dating for this panel in the mid-1480s, close in time to Rosselli's fresco in the chapel of the relics in the church of Sant'Ambrogio, Florence (1486), though not as late as his more thoroughly Ghirlandaiesque panels plausibly assigned to the 1490s. The structure and rendering of the landscape and the modeling of the two young male saints resemble comparable details in a panel of the *Visitation* by Cosimo Rosselli (ex-collection Lord Ponsonby of Shelbrede; sold Christie's, London, 10 July 1987, lot 102) of very similar format and nearly identical dimensions to the Boston *Descent*. Though the possibility cannot be excluded, there is no evidence beyond the coincidence of their far-from-usual format and their general stylistic similarity that these two panels were once paired in a single complex. It is possible that Cosimo Rosselli specialized in the production of small-scale narrative panels for private devotion (such must have been the function of the Philadelphia / Mount Trust triptych as well) throughout this period in the latter half of his career.

Certain as yet unexplained iconographic peculiarities in the composition of this *Descent from the Cross* are worthy of note, specifically the identities of the six saints surrounding the body of Christ and of the beati or saints standing at the right, and the apparent emphasis placed on the shroud on which Christ's body is lain and the nails and crown of thorns displayed as trophies by one of the beati at the right. Most of these details are embellishments of similar details in Fra Angelico's altarpiece of the *Descent from the Cross* from Santa Trinita, Florence, where, however, only the canonical figures of Nicodemus, Joseph of Arimathea, and John the Evangelist are identified as saints. Though no program underlying the peculiarities of Cosimo Rosselli's panel has yet been discovered, a fruitful avenue of research may lie in the artist's earlier patronage by the Compagnia di Santa Barbara and the German community in Florence (see no. 64.2077 above). Another German confraternity in Florence was the Compagnia di Santa Maria della Pietà, also known as the Compagnia del Chiodo (i.e. the confraternity of the Holy Nails; cf. Battistini, 1931, p. 12).

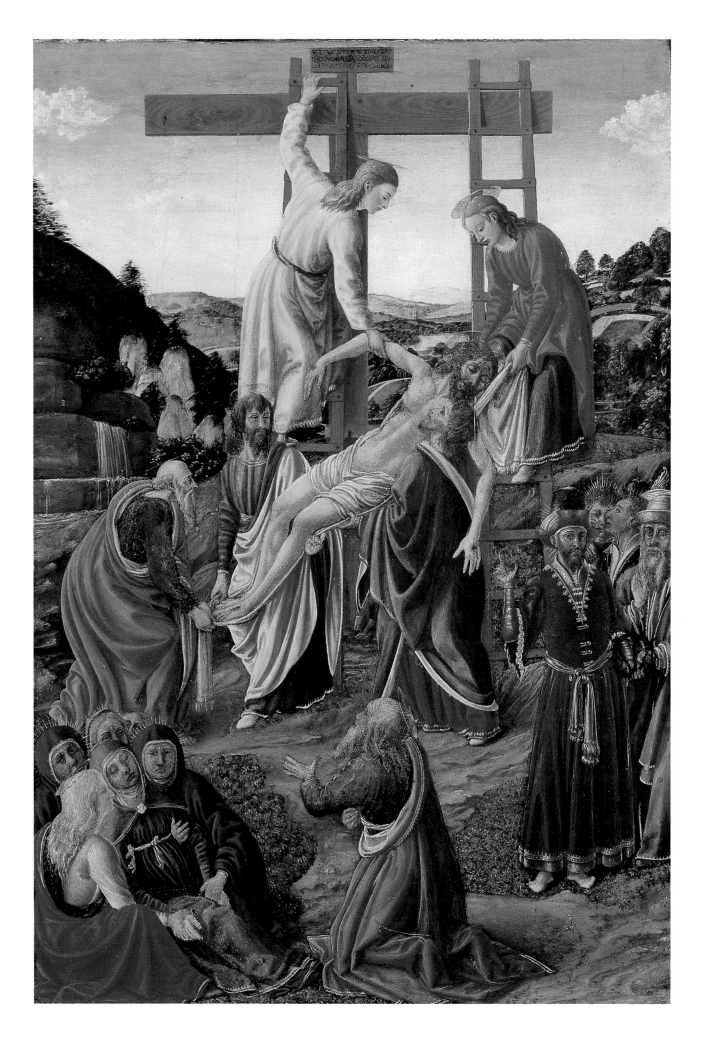

It is possible that the present panel and perhaps some related works, such as the Philadelphia/Mount Trust triptych or Bernardo Rosselli's *Deposition* in Avignon (Laclotte and Mognetti, 1977, no. 265), were commissioned by members of that confraternity.

Bernardo di Stefano Rosselli

BERNARDO DI STEFANO ROSSELLI was born in 1450, and apprenticed in the workshop of Neri di Bicci (q.v.) in 1460. He was active as an independent illuminator by 1470, when he contributed a miniature of Christ Disputing with a Doctor of the Law to the choirbooks in Siena Cathedral (Libreria Piccolomini, cod. 25.10, c. 7). A series of altarpieces, mostly for provincial patrons, frescoes, and devotional panels attributable to Bernardo Rosselli have recently been identified by Anna Padoa Rizzo (1986, pp. 5-15; idem, 1987, pp. 3-18; idem, 1987a, pp. 20-27). While these reveal a lingering impression of Neri di Bicci's commercial practice in their technique and, to a lesser extent, composition, the salient influence on Bernardo's style derives from the paintings of his cousin, Cosimo Rosselli (q.v.). Bernardo Rosselli died in 1526.

46

Madonna and Child with an Angel

Tempera on panel
Overall: 59.8 x 46.3 (23⅛ x 18¼)
Picture surface: 57.5 x 44.5 (22⅝ x 17½)

Bequest of Mrs. Robert Dawson Evans. 17.3223

Provenance: Mori, Paris

Literature: Berenson, vol. 1, 1963, p. 145; Fredericksen and Zeri, 1972, pp. 135, 564; Dalli Regoli, 1988, fig. 65; Fahy, 1989, pp. 295, 299 fn. 48.

Condition: The panel, of a vertical wood grain, has been thinned to a depth of 1.4 cm, backed with an auxiliary panel support and cradled. Ruled incisions in the gesso demarcating the edges of the painted composition along all four sides indicate that the panel has not been reduced significantly in size; similar incisions visible along the contours of the figures imply that the composition was transferred to the panel by stylus tracing off a full-scale cartoon. A vertical split in the panel running through the Virgin's neck has resulted in modest paint loss, as have several scratches in the Christ Child's right leg. The painted and gilt surfaces are otherwise exceptionally well preserved, with all the colored glaze layers intact. An extremely yellow, discolored varnish obscures the true tonality of the painting.

THE MADONNA, wearing a blue cloak and gold and red brocade dress tied with a blue-green sash, is shown cropped at the waist behind a stone parapet. She is turned three-quarters to the left, her hands clasped before her in adoration of the infant Christ. The Child, seated on the parapet on a cloth of honor and propped on a gilt cushion, is wrapped in a green-gray cloth and wears a coral necklace and bracelets. An adoring angel with darkened wings, clad in a red gown, hovers in the air above the Christ Child. A deep river landscape unfolds behind the three figures.

This painting and no. 03.562 in the Museum of Fine Arts collection (see below) have traditionally been attributed to the Master of San Miniato, a prolific aritst first recognized by Berenson (1913, pp. 23-24), but assigned a large and heterogeneous body of works by scholars over the past eighty years. A sub-group of these attributions, including the two Boston panels, was isolated by Offner under the designation "Master of the Via Romana Lunette."[1] Though refinements of attribution have been applied to various aspects of Berenson's and Offner's groupings (especially Dalli Regoli, 1988), no writer has yet questioned the association of the two Boston panels as by a single hand, notwithstanding their very different tonalities and facture.

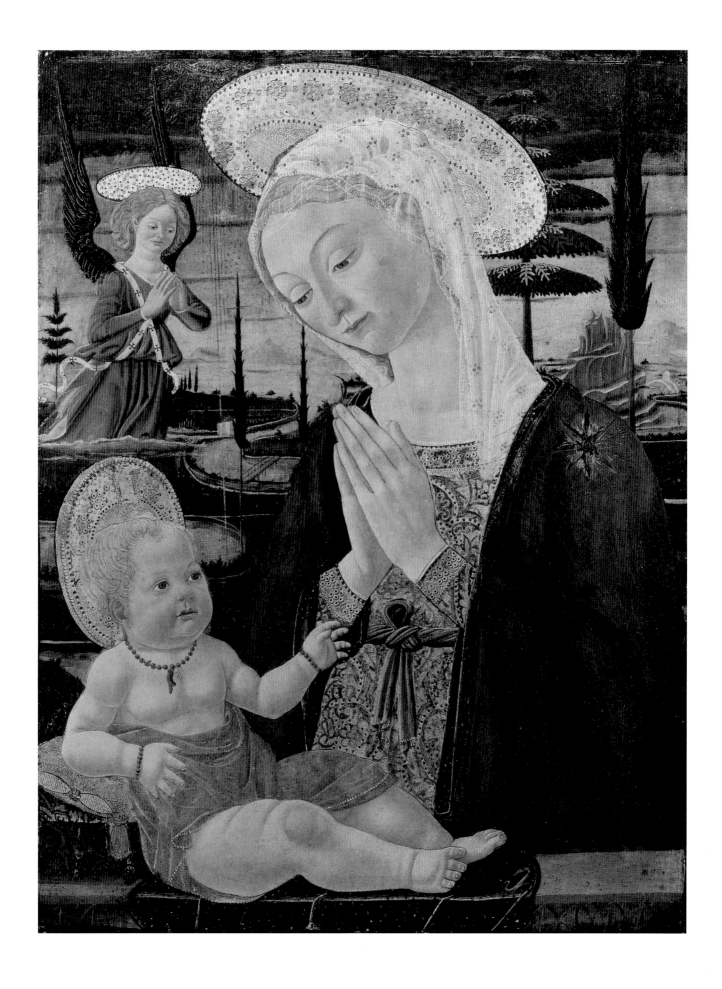

Accepting the common authorship of the Boston panels, Everett Fahy (1989) identified Offner's Master of the Via Romana Lunette with an anonymous assistant of Biagio di Antonio who had previously been christened the Argonaut Master (q.v.) In doing so, however, Fahy isolated a handful of pictures from Offner's group which he recognized as the work of Bernardo di Stefano Rosselli. Included among these are two, a *Madonna and Child* in the Musée Bonnat, Bayonne (no. 887), and another formerly with Pedulli in Florence, that establish an attribution to Bernardo Rosselli for the present picture as well. The three works may be compared in such decorative details as the glazed patterns on their painted fabrics and the punching of gilt haloes, as well as in figure types, landscape elements, and drawing style.

Among the rather large group of works plausibly attributed to Bernardo Rosselli, the present picture can be related most closely to paintings assigned to the late 1470s or early 1480s, such as the altarpiece from S. Piero a Sieve (1484) now in the Princeton University Art Museum. The harder, more linear handling of the Boston Madonna and its thinner, more nervous figure types suggest a slightly earlier date, as does its loose relationship to prototypes by Cosimo Rosselli (e.g. the *Adoration of the Child* in the Schlesisches Museum, Breslau; Musatti, 1950, p. 121). Also derived from Cosimo Rosselli (see no. 64.2077 above) is the artist's practice of painting on a panel gessoed to the edge, prepared to be inserted into an independently carved frame.

A coarse replica of the Boston painting was formerly in the Petreni collection (Dalli Regoli, 1988, fig. 74, as Bernardo Rosselli), and another is at Locko Park (Fahy, 1989, p. 295; *Locko Park* 1968, no. 8). Bernardo Rosselli seems to have made a commercial practice of repeating his compositions with minimal variation, judging from the unusual member of such replicas that survive.

1. Offner's unpublished attributions to the Master of the Via Romana Lunette are recorded in manuscript notes at the Frick Art Reference Library, New York. It should be noted that Offner never saw the two Boston panels side-by-side. Mrs. Robert Dawson Evans's 1917 bequest of the present picture to the Museum of Fine Arts was subject to life interest of her sisters, the Misses Hunt, and it was at their home that Offner studied it.

The Argonaut Master

THE Argonaut Master is the conventional name assigned by Schubring (1915) to the author of two cassone or wainscotting panels in the Metropolitan Museum of Art, New York (09.136.1; 09.136.2), showing scenes from the story of Jason and the Argonauts, and a group of related works first isolated by Werner Weisbach (1901, pp. 115-125). As Everett Fahy (1989) pointed out, however, the two panels in New York were designed and painted by different artists, one of whom can confidently be identified as Biagio di Antonio (1446-1504). Fahy retained the name Argonaut Master for the author of the other, and assigned an expanded corpus of work to him. These comprise mostly narrative cassone panels and private devotional images previously attributed to Pesellino and to various artists active in the last third of the fifteenth century, especially Jacopo del Sellaio (q.v.) and a follower of the Master of San Miniato known as the Master of the Via Romana Lunette (see 17.3223 above). The Argonaut Master, a modest but prolific painter, was tentatively identified by Oberhuber (1973, p. 53 fn. 22) with Cosimo Rosselli's brother, the engraver and illuminator Francesco Rosselli (1448 - before 1513).

47

The Adoration of the Christ Child with the Dove of the Holy Spirit

Tempera on panel
85.6 x 47.4 (33¹⁵/₁₆ x 18⅝)

Bequest of George Washington Wales. 03.562

Provenance: Unknown; George Washington Wales, by 1903

Literature: Sirén, 1916, p. 13; van Marle, vol. 13, 1931, pp. 434, 454 fn. 1; Berenson, 1932, p. 829; idem, 1963, p. 145; Fredericksen and Zeri, 1972, pp. 135, 563; Dalli Regoli, 1988, pp. 98, 113 fn. 35, fig. 72; Fahy, 1989, pp. 294-295, 299 fn. 47.

Condition: The panel, of a vertical wood grain, is 2 cm thick and has been backed with a thick coating of wax resin. A vertical split 36 cm long extends from the bottom edge through the Christ Child's legs. The gilt haloes and the paint surface generally are well preserved, except that the flesh tones have been unevenly abraded. Pinpoint flaking losses have been minimally retouched, while larger losses in the grass foreground and in the green robe of the angel at the right have been more coarsely inpainted.

FOLLOWING a compositional formula common in representations of the Nativity, the Virgin is shown kneeling in three-quarter profile to the left, her hands joined in a gesture of adoration, her long blue cloak spread out around her in looping folds on the flower-strewn ground. The Christ Child, naked and holding a finch in his right hand, reclines on one long pleat of his mother's robe, propped against a bundle of hay. A half-ruined shed at the right and a wattle fence at the left close off the foreground meadow from a deeper landscape reminiscent of the Arno valley, including a winding river, farmland and *podere*, and a partial view of a walled city (Florence ?). Fitted beneath the arched top of the composition are two hovering angels, dressed in tunics of pink (left) and green (right), their arms crossed before them, while the Dove of the Holy Spirit floats above the Virgin's head, descending along a glory of golden rays emanating from the top center of the panel.

First identified by Sirén as the work of a follower of Pesellino, this painting was also associated with the studios of Pier Francesco Fiorentino (van Marle, 1931), Sellaio, and Baldovinetti, until Berenson (1932) placed it in the following of the Master of San Miniato, the name under which it has largely been known ever since. Offner included this picture in the nucleus of works he assigned to the Master of the Via Romana Lunette (see no. 17.3223 above), a grouping accepted by

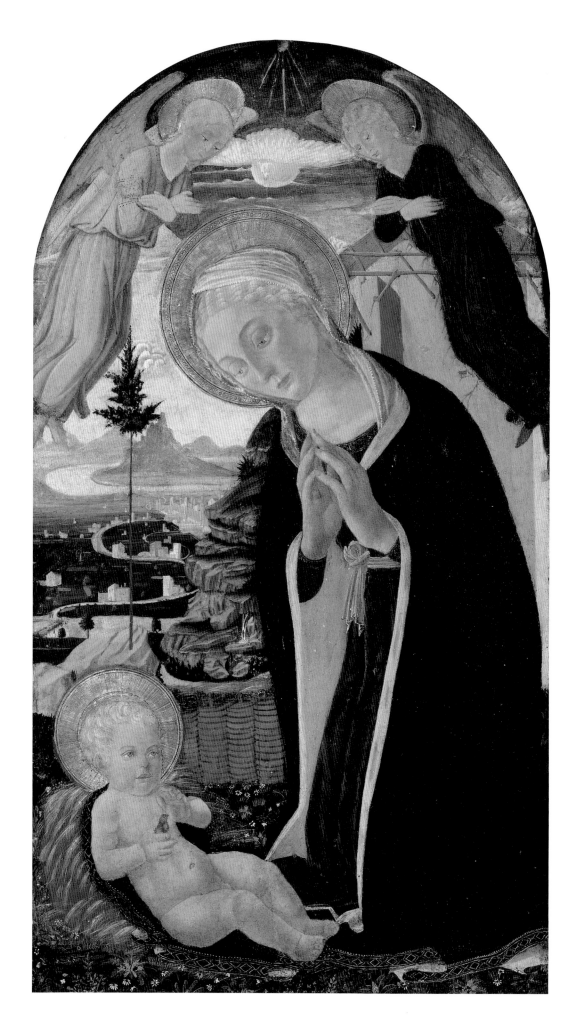

166 (cat. 47)

Dalli Regoli (1988, where it is labeled, together with the other pictures by this Master, "ignoto fiorentino") and Fahy (1989), who identifies the Master of the Via Romana Lunette with the slightly better-known and highly prolific Argonaut Master.

Though the complete homogeneity of the Argonaut Master's oeuvre as reconstructed by Fahy is not wholly convincing, several works ascribed to that Master offer striking parallels of composition and handling to the present picture and support the validity of the attribution. A half-length *Madonna and Child in a Niche* at the Honolulu Academy of Arts (Dalli Regoli, 1988, fig. 70) is particularly close to the Boston panel in tonality and figure types, while similarities of composition and spatial structure to an *Adoration* in the Yale University Art Gallery, plausibly attributed by Fahy (1989, fig. 8) to Biagio d'Antonio, underscore the origins of the Argonaut Master in that artist's shop.

Domenico di Tomaso Bigordi,
called Domenico Ghirlandaio

BORN ABOUT 1448 in Florence, Ghirlandaio is said by Vasari to have been a pupil of Alesso Baldovinetti, though his early style betrays the strong influence of Verrocchio and he may have passed part at least of his apprenticeship in the latter's shop. By 1475 he was working in partnership with his brother David, painting in the Library of Sixtus IV in the Vatican, where he returned in 1481 to paint the walls of the Sistine Chapel alongside Perugino, Botticelli, and Cosimo Rosselli. Though he also worked in Pisa and in San Gimignano, his primary sphere of activity was Florence, where he emerged as possibly the most sought after monumental decorator of the last quarter of the fifteenth century. Ghirlandaio died in 1494.

Domenico Ghirlandaio is best known for his fresco cycles in the Sassetti chapel in Sta. Trinita and in the apse of Santa Maria Novella, in which he successfully blended the drama of religious narrative with an acute observation of contemporary life in Florence for an effect of topical immediacy much admired and much imitated by his contemporaries. His own brilliantly descriptive technique is, however, often confused within the miscellaneous output of his large and well-organized workshop, which included collaborators and subcontractors such as his brothers David and Benedetto, his brother-in-law, Sebastiano Mainardi, Bartolomeo di Giovanni, and Biagio di Antonio, as well as pupils in the conventional sense, among whom may be numbered Fra Bartolommeo, Francesco Granacci, and the young Michelangelo Buonarroti.

48

Virgin and Child; Coronation of the Virgin

Tempera and oil on panel
Overall (including original frame): 43.8 x 27 (17¼ x 10⅝)
Picture surface: *Virgin and Child:* 16 x 12.6 (6¼ x 5); *Coronation of the Virgin:* 7 x 14.8 (2¾ x 5¾)

Gift of Mrs. Thomas O. Richardson. 22.5

Provenance: Unknown; Mrs. Thomas O. Richardson by 1922

Literature: Fredericksen and Zeri, 1972, pp. 82, 564.

Condition: The main panel of the tabernacle is a single piece of wood, 2.6 cm thick with a vertical grain, to which the architectural moldings have all been engaged. Their gilt surfaces are quite well preserved with the only significant loss the returns of the predella: that on the left is missing, that on the right a repair. There is no evidence that the structure was ever completed with an antependium. The lunette is constructed of a separate carved panel approximately 2.8 cm thick into which the picture surface has been excavated. This panel, of a horizontal wood grain, is backed with another panel 1.6 cm thick. The two are gessoed and painted continuously along the seam between them. They have at some point been broken free of the main panel beneath them and are currently reattached by means of four modern screws. This reattachment has obscured the cut-away from an old iron hanging strap at the top center of the main panel. The paint surface in both the main picture field and in the lunette is in extremely poor condition from severe abrasion throughout and large flaking losses especially in the figures, which have been liberally retouched. The landscape background in the main panel, the carpet beneath the child's feet, and one of the cherubs' heads in the lunette are somewhat better preserved.

WITHIN a carved and gilt tabernacle frame of fluted Corinthian pilasters supporting a stepped entablature with an unornamented frieze, the Virgin and Child are portrayed in front of a deep landscape of Florence and the Arno valley. The Virgin is shown half-length behind a marble parapet draped with a red carpet. She wears a blue mantle over a red dress, and a red cloth of honor hangs behind her. The Christ Child stands naked on the parapet, raises his right hand in a gesture of benediction and holds a pomegranate in his left. In the lunette of the tabernacle, framed in the same leaf-and-dart molding that surrounds the main scene below, is represented the Coronation of the Virgin. Seated on a bank of clouds with seraphim behind and above them, Christ, at the right, wearing a blue cloak over a red tunic, places a crown on the head of the Virgin, at the left, wearing a white

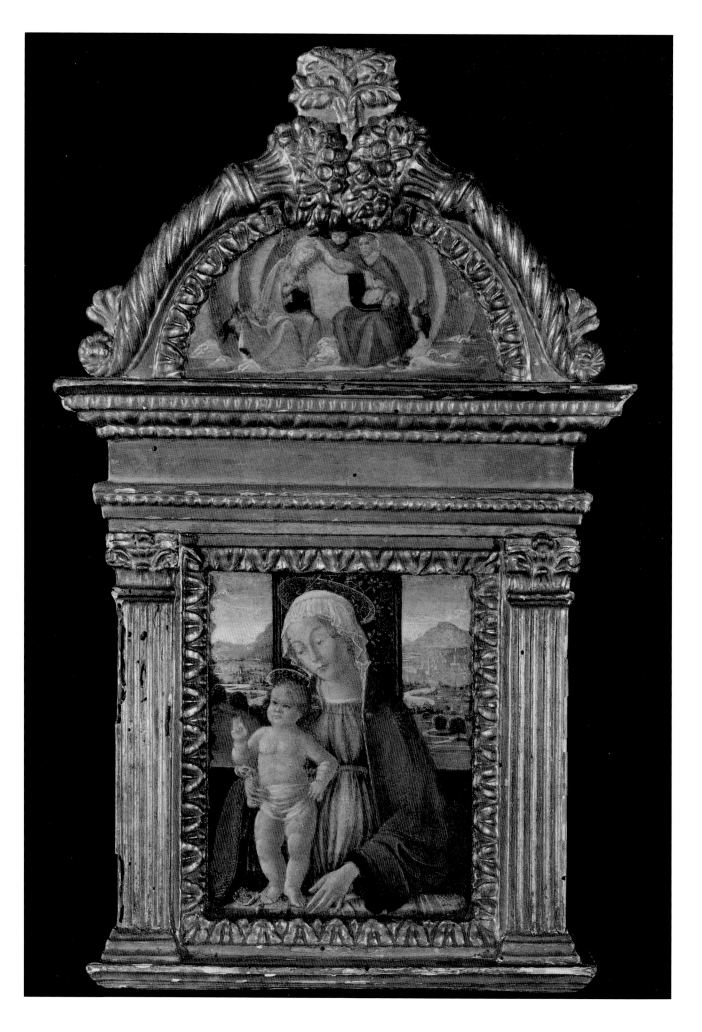

168 (cat. 48)

mantle lined with blue over a red dress. The tympanum of the lunette is formed of heavy carved cornucopias with honeysuckle corners and a heraldic oak at the top center.

This little-known painting is remarkable more for its beautifully preserved frame than for its pictorial qualities, which have been so compromised by abrasion as to render the images only partially legible and to make certain attribution impossible. Philip Hendy (note in Museum files, 1930) tentatively proposed Sebastiano Mainardi as its author, while Fredericksen and Zeri (1972) and Fahy (correspondence in Museum files, 1979) attributed it more generically to the workshop of Domenico Ghirlandaio. Wilhelm Suida (note in Museum files, 1958) suggested that it might have been painted in the workshop of Andrea del Verrocchio, and indeed the composition of the Virgin and Child group derives from a model popularized by Verrocchio and his immediate followers, among whom was Domenico Ghirlandaio, in the 1470s. An example particularly close to the Boston painting in style as well as design is Ghirlandaio's early fresco of the Virgin and Child Enthroned with Saints Sebastian and Julian at Brozzi (ca. 1475) and, as Fahy observed, the same artist's grisaille lunette of 1482/84 in the Palazzo Vecchio, Florence. Fahy also pointed out the dependence of the lunette in the Boston tabernacle on that of Ghirlandaio's altarpiece of 1478-79 from the Sala Grande of the Opera del Duomo, Pisa (Denver Art Museum, Kress Collection, K1726; Shapley, 1966, p. 126), concluding that the painting was executed in the artist's studio in the early 1480s, but that its condition precluded identifying the hand of the assistant responsible.

A date in the early 1480s accords well with the style of the tabernacle frame of the Boston painting, and specifically with the presence at its top of a heraldic oak tree unmistakably referring to the Della Rovere. In 1481 and 1482, Domenico Ghirlandaio was employed by Pope Sixtus IV Della Rovere in the decoration of the walls of the Sistine Chapel at the Vatican, and the Boston tabernacle may possibly have been a minor commission to the artist at this time, either on behalf of the Pope or of one of his nephews, Cardinal Domenico or Cardinal Girolamo Basso Della Rovere. Such distinguished patronage might argue for an attribution of the Boston panel to Ghirlandaio himself rather than to an assistant in his shop, but too little remains of the paint surface to confirm or deny the plausibility of the argument.

The provenance of the Boston tabernacle is unrecorded prior to Mrs. Richardson's gift of it to the Museum of Fine Arts in 1922. Mary R. Richardson acquired a number of paintings in 1882 in Gubbio, including a Virgin and Child with Saints by Niccolò di Buonaccorso (20.1860) and two sets of pilaster panels by Niccolò da Foligno (20.1858, 20.1859), and it may be that she acquired the present painting there as well. Gubbio, long a dependency of the Montefeltro of Urbino, became a feudal dominion of the Della Rovere upon the death of Guidobaldo da Montefeltro in 1508. It is possible, though the evidence is no more than circumstantial, that the Boston tabernacle might have come there, presumably from Rome, sometime after 1508 and before the extinction of the Della Rovere succession in 1624. As the incidence, outside the decoration of the Sistine Chapel, of Della Rovere patronage of Florentine painters in the fifteenth century is exceedingly rare, this hypothetical provenance cannot be ruled out.

49

Virgin and Child

Tempera on panel
Overall: 54.1 x 36.6 (21 ¼ x 14⅜)
Picture surface: 53 x 35.7 (20⅞ x 14¹/₁₀)

Gift of Quincy A. Shaw. 46.1429

Provenance: Unknown; Quincy Adams Shaw, Boston, by 1932

Literature: Berenson, 1932, p. 321; idem, 1936, p. 286; 1963, p. 126; Young, 1970, p. 98; Fredericksen and Zeri, 1972, pp. 117, 565; Fahy, 1974, p. 15, fig. 7; idem, 1976, p. 215; L. Venturini, in Gregori, 1992, p. 156 fn. 18.

Condition: The panel has been thinned to a depth of 6 mm and cradled. Several vertical partial splits running from the top and the bottom of the panel, possibly caused by cradling, interrupt the picture surface but have not resulted in appreciable paint loss. The paint surface is well preserved but for moderate overall abrasion, more pronounced in the figure of the Christ Child, and minor flaking losses. The landscape, sky, and fleshtones of the figures have been slightly overcleaned sometime in the past, while the darker areas of paint retain an earlier layer of discolored varnish and old discolored inpaints.

THE VIRGIN, wearing a blue mantle over a red gown, her hair draped in a transparent veil, is shown half-length at the right side of the painting. She turns three-quarters to the left and clasps her hands in adoration of the naked figure of the Christ Child, seated on a brown cushion on a stone ledge at the lower left. The Child holds a globe in his left hand and raises his right in benediction. Behind the two figures is a deep landscape showing a river winding through a plain to a bay, on the far shore of which spreads a fortified city with numerous towers. The landscape is closed off in the distance by a range of dimly seen mountains, and at the left by a rocky cliff from which grow several reedy trees.

Commonly considered a prototypical work by Domenico Ghirlandaio's brother-in-law, Sebastiano Mainardi, this much admired composition is recorded in at least eight known versions:
(i) Bowes Museum, Barnard Castle, County Durham; (ii) Strossmayer Gallery, Zagreb; (iii) Wawel Castle, Cracow; (iv) formerly collection Mrs. Edgar Speyer, New York; (v) formerly with Salocchi, Florence; (vi) formerly collection Paul Bottenweiser, Berlin; (vii) formerly collection of the Hon. Mrs. Donald Forbes; and (viii) the present panel. Except for the panel at Zagreb (van Marle, vol. 13, 1931, fig. 101), in which the composition has been adapted to fit a tondo format, all these replicas differ from each other only in minor

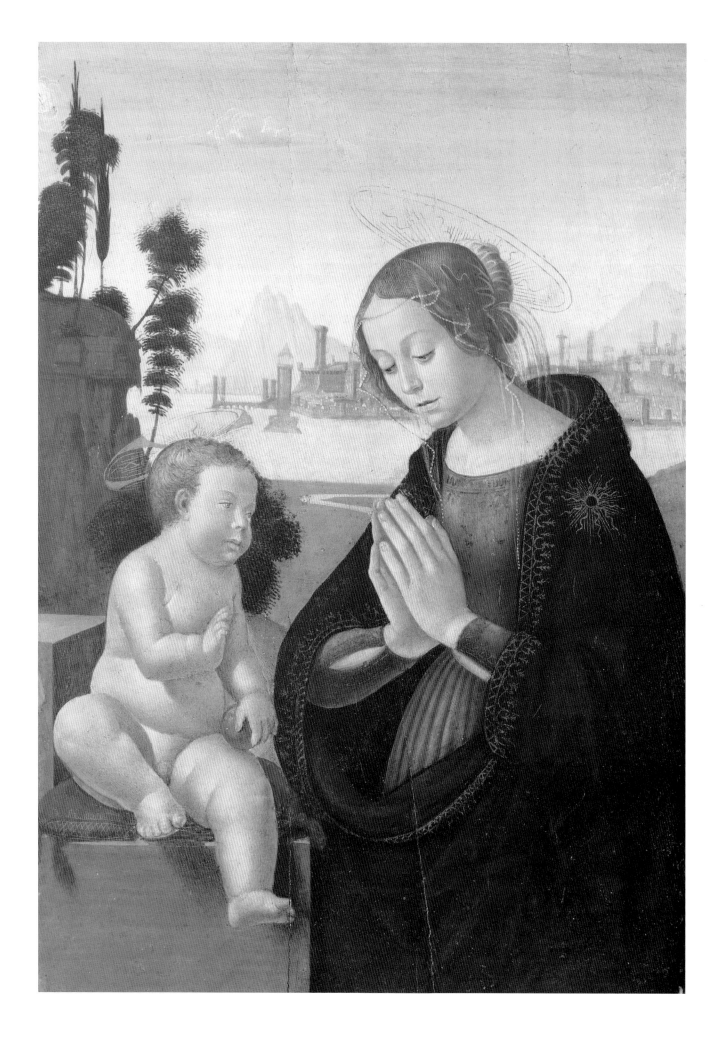

170 (cat. 49)

Fig. 34. Workshop of Domenico Ghirlandaio, *Madonna and Child*. Bowes Museum, Barnard Castle, County Durham

details of landscape, in the rendering of the ledge on which the Child is seated, in the decorative borders of the Virgin's draperies, or in the projection of the two haloes.

The attribution of these paintings to Mainardi, accepted by all modern critics except van Marle (vol. 13, 1931, p. 156, discussing the Zagreb and Bottenweiser versions), and Venturini (in Gregori, 1992), was first proposed by Francovich ("Sebastiano Mainardi," *Cronache d'Arte*, iii, 1927, p. 191), who knew only the version formerly in the Bottenweiser collection, Berlin. The poses of the Virgin and of the Child derive loosely from compositions by Domenico Ghirlandaio of the 1480s (Fahy, 1974), and were reused with slight alterations in numerous paintings from Ghirlandaio's shop, most of which have also been commonly attributed to Mainardi. The Virgin in a similar pose is shown full-length in a fresco of the Nativity at Brozzi and in variants of the same composition on panel in the Vatican; Dresden; the Fitzwilliam Museum, Cambridge; formerly in the Harrach collection, Vienna; etc. The pose of the Child is repeated in tondi in the Louvre; Naples; the Liechtenstein collection, Vaduz; the Merton collection, Maidenhead; the Kress Collection, Birmingham, Alabama; etc. Both of these compositions, like that of the Boston painting, were apparently devised by Domenico Ghirlandaio, not Mainardi, and were intended to be easily replicable for commercial production. That Mainardi may have been among the many assistants employed in executing these replicas but

was not, as is conventionally assumed, responsible for their ideation was first recognized by Zeri (in Zeri and Natale, 1984, pp. 29-30) and has been more recently elaborated by Venturini.

The Boston panel is unquestionably the finest in quality, the best preserved, and probably the earliest of the eight known versions of its composition, and it is regarded by L. Venturini as the prototype from which the rest of the series derives. It is indistinguishable in style and in handling from a pair of small panels – a Nativity (Pinacoteca Vaticana) and a Resurrection (Kunstmuseum, Copenhagen) – frequently attributed to Mainardi but tentatively regarded by Venturini (op. cit., p. 195) as autograph works by Domenico Ghirlandaio. The Boston panel can also be compared favorably to the tondo of the Virgin and Child with Angels in the Louvre, the prototype, partly painted by Ghirlandaio himself, for another series of replicas conventionally ascribed to Mainardi. All of these paintings can probably be dated to the late 1480s or early 1490s, the likely date of the Boston panel as well. Most of the replicas of the Boston composition, on the other hand, are relatively coarse in execution and some of them may possibly have been painted as late as the second decade of the sixteenth century. The version at Barnard Castle (fig. 34), though crudely repainted in parts, is of sufficient quality to be considered an early work within the series, probably produced under Ghirlandaio's direct supervision rather than as a distant workshop reflection of his designs only. The Boston panel was certainly produced under similar circumstances, if not actually worked on in part by Ghirlandaio himself.

Jacopo d'Arcangelo del Sellaio

BORN IN Florence in 1441 or 1442, Jacopo del Sellaio was inscribed in the Compagnia di San Luca there in 1472. The following year he is recorded working in partnership with a certain Filippo di Giuliano, whose independent works have not yet been positively identified, and with whom he is again recorded working in 1480/81. An altarpiece of the Annunciation in S. Lucia dei Magnoli (ca. 1473) is documented as a product of this partnership. In 1483/4, Sellaio painted an altarpiece of the Pietà for the church of San Frediano in Florence, now in Berlin, and an altarpiece of the Crucifixion still in San Frediano, which must have been painted about 1490, is traditionally ascribed to him. Sellaio died in 1493.

The many works attributed to Sellaio on the evidence of these three altarpieces were undoubtedly painted not by a single artist but by a fair-sized commercial workshop, implying that Sellaio's partnership with Filippo di Giuliano may have been continuous rather than ad hoc. These paintings share many technical and stylistic features but they vary widely in quality and borrow eclectically from the leading Florentine painters of the time, notably from Botticelli, Filippino Lippi, and Domenico Ghirlandaio. The greater part of the paintings attributed to Sellaio are private devotional panels of repetitive design and uninspired execution, though a number of very fine cassone panels have also been ascribed to him or to his shop.

50

Story of Psyche

Tempera and oil on panel
Overall: 43.8 x 152.8 (17¼ x 60⅛)
Picture surface: 42 x 151.8 (16⅞ x 59¾)

Picture Fund. 12.1049

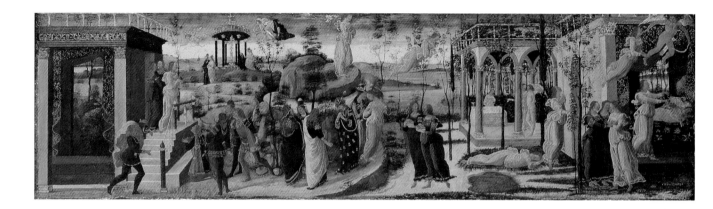

Provenance: Alexander Barker, London (sale, Christie's, London, 20 June 1879, lot 487a); Charles H. Butler, Warren Wood, Hatfield, Herts. (sale, Christie's, London, 25 May 1911, lot 45); Charles Fairfax Murray, London, 1911; John E. Murray, Florence, 1912

Literature: Burlington House, 1880, no. 227; New Gallery, 1893-94, no. 146; Foerster, 1895, pp. 219, 221; Burlington House, 1896, no. 150; Mackowsky, 1899, pp. 199, 278; Berenson, 1909, p. 83; Perkins, 1913, p. 104; Schubring, 1915, pp. 303-304, no. 356; Constable, 1925, pp. 282, 287, pl. ııh; idem, 1927, p. 54; van Marle, vol. 12, 1931, pp. 392, 407; Berenson, 1932, p. 525; idem, 1936, p. 451; "Lorenzo il Magnifico," 1949, sala ıx, no. 15; Berenson, vol. ı, 1963, p. 196; Goodison and Robertson, 1967, p. 155; Fredericksen and Zeri, 1972, pp. 186, 563; van Os, 1974, p. 61; Vertova, 1979, p. 115, pl. 35a; Horne, 1987, Appendix ıx, p. 28.

Condition: The panel, 3.5 cm thick, has been neither thinned nor cradled, and does not appear to have been trimmed along the edges. The paint surface, which is unevenly preserved, retains a raised beard of gesso along all four sides. Extensive pinpoint flaking scattered throughout the picture surface does not interrupt the legibility of the figures or setting except within a semicircular area at the top center of the panel, which is heavily disfigured. Damage in this area was undoubtedly caused by scraping from the keys for the cassone – part of a cutout to accommodate the lock mechanism is preserved in the back of the panel at this point. An area approximately 22 x 15 cm in the lower left corner of the panel, including the landscape seen through the curtains in the building at the left, is heavily restored, but the paint surface is otherwise in good state, showing only minor abrasion in the flesh tones and in the figures silhouetted against the sky. The mordant gilding, though slightly worn throughout, is almost everywhere intact.

THE FIRST HALF of the story of Psyche, as recounted by Apuleius (*Golden Ass*, 4:28ff.) and Boccaccio (*Genealogia deorum* 5:22ff.), unfolds in continuous narrative across the length of the panel. At the left, Psyche, dressed in a flowing white gown, appears on the steps of a palace attended by her two older sisters, while six suitors rush forward to praise her beauty above that of Venus. In the sky above the suitors, the jealous Venus instructs her son Cupid to strike Psyche with love for a man of vile estate, but Cupid instead falls in love with Psyche himself. In the distance at the left, Psyche is brought by her parents to the shrine of Apollo at Milesia to consult the oracle concerning her future marriage. The oracle instructs Psyche to be left at the summit of a mountain where she will encounter her husband, who will be terrible but of divine birth. In the center foreground, Psyche's weeping parents lead her up the path to the mountain, and at the top center she is shown alone and afraid at the summit. As she waits there, Zephyr blows her gently down into the valley, where she sleeps among the flowers and grasses. Waking, she sees a marvellous palace but no servants. She dines, bathes, and is wed to Cupid, whom she is not permitted to see. She pleads with her husband to permit her to visit her sisters once again, and though he warns her against their jealousy he causes them to be brought to the palace by Zephyr. Psyche's sisters, in the foreground at the far right, convince her that she is in fact wed

not to a god but to a serpent. To the right of center in the foreground the sisters are each given a small box of treasure from the palace and returned to their own husbands. That night, defying his instructions not to try to learn his identity, Psyche holds an oil lamp above the sleeping Cupid and sees that he is indeed a god. A splash of hot oil from the lamp burns Cupid, who is shown fleeing in the top right corner, Psyche clinging to his ankle and he pushing her away in anger at her faithlessness.

A cassone panel by Jacopo del Sellaio with a nearly identical choice and arrangement of subjects as the present panel, though significantly larger than it (58.4 x 178.8 cm) is preserved in the Fitzwilliam Museum, Cambridge (Marlay Bequest; Goodison and Robertson, 1967; fig. 35). Each of the narrative episodes represented in the Boston panel is repeated in a slightly simplified composition in the Cambridge version, except that the latter adds at the left the conception of Psyche by Apollo and Endilichia (or the birth of Psyche?) and the infant Psyche attended by her older sisters. The corresponding area of the Boston panel is void and has been completely repainted, so that it is possible that one or both of these scenes once figured within the architecture of the structure at the left. A pendant to the Cambridge panel, representing the concluding scenes of the story of Psyche, was formerly in the E. Proehl collection, Amsterdam (van Os et al., 1974; presently [?] Fellowship of

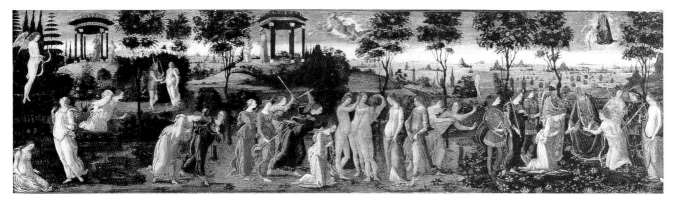

Fig. 35. Jacopo del Sellaio, *Story of Psyche*. Fitzwilliam Museum, Cambridge

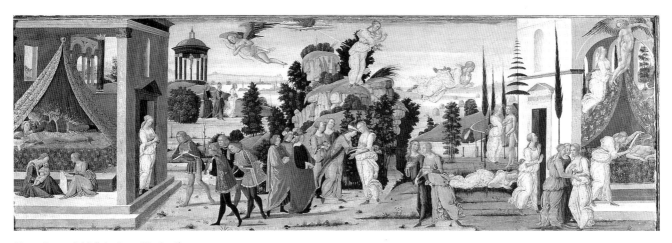

Fig. 36. Jacopo del Sellaio, *Story of Psyche*. Abegg-Stiftung, Riggisberg, Inv. no. 14.123.72

Friends, Renaissance, California: cf. Young, 1985, p. 373). Two variants of this panel are known, one in the Abegg collection at Riggisberg (Freuler, 1991, pp. 290-291) and one sold at Parke Bernet, New York, 8 January 1972, lot 180. According to Ellen Callmann (letter in Museum files), neither is likely to have been a pendant to the Boston *Story of Psyche*. The Riggisberg panel is however, closely related in size (42 x 158.5 cm; fig. 36) and style to the Boston panel, and the possibility that they derive from a single pair of chests cannot be excluded.

In his discussion of painted representations of the legend of Cupid and Psyche, R. Foerster (1895) treated the Boston and Fitzwilliam cassone panels, then in the Butler and Marlay collections, respectively, as by two different artists, and the Boston (Butler) panel was exhibited at the Royal Academy in 1896 as by Filippino Lippi. Both panels were attributed to Jacopo del Sellaio by Mackowsky (1899), and this attribution has since been doubted only by Angelica Rudenstine (manuscript notes in Museum files), who objected that Sellaio's documented and reasonably attributed works are invariably more "hard-edged" as well as spatially clearer and less complex, more dependent on the example of Bar-

tolomeo di Giovanni, than the looser, more fluid composition and figure style evident in the Boston panel. She proposed instead a tentative attribution to the young Filippino Lippi in the period around 1475, the moment of his closest approximation to Botticelli's style, but qualified her opinion as uncertain in the light of what she mistakenly assumed to be the irretrievably damaged state of the panel. F. Gamba (letter in Museum files, 26 February 1964) agreed with her that while the Cambridge Story of Psyche could confidently be attributed to Jacopo del Sellaio, the Boston panel, and particularly the right half of the painting, more closely resembled the earliest work of Filippino. She added, however, that the left half of the painting was difficult to reconcile with any known stage of Filippino's development. Both Rudenstine and Gamba considered the Boston *Story of Psyche* a work of the period 1475-1480.

An attribution to Filippino Lippi or any other immediate follower of Botticelli and a date around 1475 for the Boston *Story of Psyche* are impossible to sustain. Everett Fahy has recently (letter in Museum files, 1991) reaffirmed the traditional ascription of the Boston panel to Sellaio, explaining the very evident differences between it and the Fitzwilliam panel as a

function of date, the latter being an early work, presumably of the 1470s. The grouping of the figures in the left foreground of the Boston panel appears to derive from Botticelli's fresco of Moses and the Daughters of Jethro in the Sistine Chapel (1481-82), which it must therefore postdate, while its palette, fluid brushwork, and confused spatial structure more closely approximate the late Crucifixion in San Frediano (after 1490?) than any other work documented by or attributed to Sellaio. A date for the Boston panel around or just before 1490 is reasonable, making it one of the latest known painted cassone panels from Tuscany, the fashion for which had largely been eclipsed there almost a decade earlier.

Master of the Borghese Tondo

AN ANONYMOUS FOLLOWER of Domenico Ghirlandaio, the Master of the Borghese Tondo was active in and around Florence in the last years of the fifteenth and at the beginning of the sixteenth centuries. The artist is named for a tondo of the Holy Family with the Infant Saint John the Baptist in the Galleria Borghese, Rome (inv. 352; Della Pergola, vol. 2, 1959, no. 35), which was first associated with other works by the same hand and attributed to the otherwise unknown Jacopo del Tedesco by G. de Francovich (1926-27, pp. 535-540). Though some of the pictures identified by Francovich are homogeneous in style, there are no grounds for associating any of them with the name Jacopo del Tedesco. Fahy (1976, pp. 167-168) christened the artist the Master of the Borghese Tondo and listed twenty-four paintings in his oeuvre, including an altarpiece of the Mystic Marriage of Saint Catherine from San Jacopo in Campo Corbolini, Florence, now in the Museo del Cenacolo di San Salvi (Padovani, Meloni Trkulja, 1982, pp. 18-20) dated 1501. Numerous additions to his oeuvre, including dated paintings of 1494 (formerly Galleria Bellini, Florence), 1503 (Sant'Andrea a Doccia), 1505 (Sant'A-gata, Florence), and 1511 (Sant'Angelo, Legnaia; S. Pietro a Monticelli, Florence), have recently been proposed by L. Venturini (in Gregori, 1992, pp. 282-289), along with a doubtful identification of his hand among Pintoricchio's assistants in the decoration of the Borgia apartments at the Vatican (1492-94).

51

Virgin and Child with Saints Dominic and Thomas Aquinas (?)

Tempera on panel
Overall: 37.8 x 31.6 (14⅞ x 12⅜)
Picture surface: 36.7 x 30.5 (14⁷⁄₁₆ x 12)

Estate of Dana Pond, New York, 1963. 63.3053

Provenance: Unknown

Condition: The panel support, 1.4 cm thick and neither thinned nor cradled, is composed of two vertical boards joined 8 cm from the right edge. It has been trimmed at the left and right, and possibly along the top and bottom. A gesso beard from the removal of an engaged frame is evident along the top edge only. The paint surface, partially obscured by an uneven layer of opaque, yellowed varnish, is well-preserved except for minor scattered pinpoint flaking losses, some lifting along the seam in the panel, and slightly larger damages along the edges of the composition.

THE VIRGIN, dressed in a blue mantle lined with yellow over a red gown, stands full length before a red cloth of honor. The Christ Child, naked, lies across his mother's arms and turns to his right to bless the figure of Saint Dominic, kneeling in the left corner of the picture, and to accept the lily offered him by the saint. In the right corner kneels another Dominican saint, possibly Thomas Aquinas, holding a red book in his left hand and gazing in adoration at the Christ Child. The composition is closed off behind a stone parapet, with two basins of carnations (?) resting on its ledge.

This unpublished painting was correctly attributed to the Master of the Borghese Tondo by Everett Fahy (letter in Museum files, 1986). The attribution may be confirmed by comparison to the Borghese Tondo itself or to an Adoration of the Child with the Infant Saint John the Baptist, Saint John the Evangelist, and Saint Francis in the sacristy at San Lorenzo, Florence. A putto to the right of God the Father in the latter repeats the peculiar distortion of the Christ Child's face in the Boston painting, and the figures of Saint Thomas Aquinas (?) in one and Saint John the Evangelist in the other are interchangeable. Among the dated paintings attributable to the Master of the Borghese Tondo, the Boston panel most closely resembles the altarpiece of 1503 at Doccia. Its loose relationship, furthermore, to Ghirlandaiesque compositions of the late 1490s makes a date for it in the first few years of the sixteenth century likely.

Both kneeling saints are clad in Dominican habits, and the saint on the left is clearly identifiable as Dominic by his lily. The saint on the right bears no distinguishing attribute other than a book. He may be Saint Vincent Ferrer, but is perhaps more likely to be Thomas Aquinas. The presence of two Dominican saints is the only clue to the original function of this panel, as an independent object probably commissioned by a member of the Dominican community or a lay member of the third order of Saint Dominic. As the panel bears no traces of the removal of battens, dowels, or hinges, it is unlikely to have been part of a larger complex.

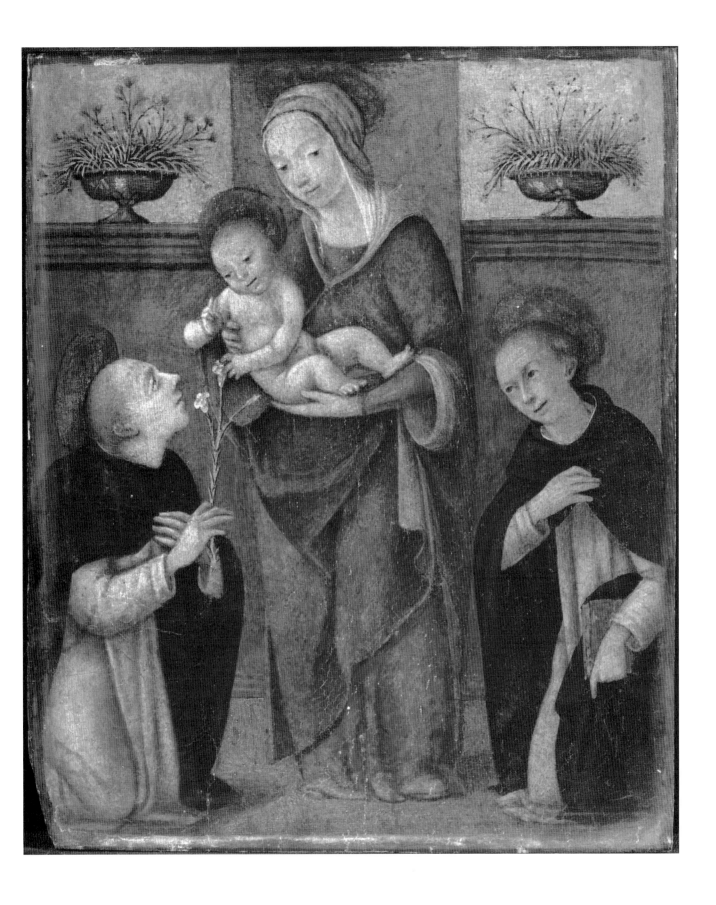

Sandro Botticelli

PERHAPS the best-known painter of the Florentine quattrocento, Sandro Botticelli was born Alessandro di Mariano Filipepi in either 1444 or 1445 (his father declared him to be thirteen years old in 1458). He was apprenticed around 1464 to Fra Filippo Lippi, in whose shop he remained until 1467, after which he may have worked for a brief time with Verrocchio. Botticelli had established an independent workshop by 1470, and in 1472 he registered for the first time in the Compagnia di San Luca, the painters' guild, with Filippino Lippi registered as his apprentice. For nearly two decades afterward he enjoyed a regular series of prestigious public commissions, including the assignment in 1481 to paint three frescoes on the walls of the Sistine Chapel in the Vatican, alongside Perugino, Ghirlandaio, and Cosimo Rosselli. He also enjoyed the patronage of the Medici, for whom he executed the so-called *Primavera* and the *Birth of Venus* and a series of illustrations to the *Divine Comedy*, as well as many other of the principal families of Florence.

Botticelli was profoundly influenced by the preachings of Fra Girolamo Savonarola and apparently much moved by his death in 1498. From that date to his own death in 1510, Botticelli seems to have avoided the secular and classical subjects of many of his earlier works, and his characteristically graceful, lyrical style was replaced by a harder, more expressive draughtsmanship and a palette of sharp, contrasting colors. This late style of Botticelli has been widely misunderstood in modern criticism, which conventionally, but incorrectly, assigns only about half a dozen paintings to the last decade of this otherwise prolific artist's career. Additionally, the highly efficient organization of Botticelli's workshop and its large commercial production, especially of images of the Madonna and Child, has been only superficially investigated.

52

Virgin and Child with Saint John the Baptist

Tempera on panel
123.8 x 84.4 (48¾ x 33¼)

Sarah Greene Timmins Fund. 95.1372

Provenance: M. Joly de Bammeville (sale Christie's, London, 12 June 1854, lot 51) (?); Alexander Barker, London, by 1857-after 1864 (?); Earl of Dudley (sale Christie's, London, 25 June 1892, lot 19); Charles Fairfax Murray, London; Thos. Agnew & Sons, London, 1895

Literature: Waagen, 1857, p. 72; Crowe and Cavalcaselle, vol. 2, 1864, p. 427; J. LaFarge, ed., *Noteworthy Paintings in American Private Collections* (New York, 1907) p. 400; Horne, vol. 11, 1911, p. 266; Yashiro, vol. 1, 1925, p. 246; van Marle, vol. 12, 1931, p. 266, fn. 1, 268 fig. 171; Hendy, 1932, pp. 229-230; Berenson, 1932, p. 101; idem, 1936, p. 87; Galetti and Camesasca, vol. 1, 1950, p. 418; Salvini, vol. 4, 1958, p. 75; Mandel, 1967, p. 100; Fredericksen and Zeri, 1972, pp. 33, 263; Bo and Mandel, 1978, p. 100; Lightbown, vol. 2, 1978, p. 139; Horne, 1987; Appendix III, no. 4.

Condition: The panel support is composed of four planks of wood nailed and glued together: two vertical planks extending from the top of the picture to the level of the Virgin's knee and the front edge of the table; a horizontal plank beneath these extending their combined width; and a narrower vertical plank running the full height of the panel at the right, joined to the others approximately through the center of the vase of flowers. The development of the composition and the pattern of plugged nail heads apparent only around the edges of the horizontal plank at the bottom suggest that it and the rightmost vertical plank may have been added to the structure after preliminary design work on it had already begun. The planks, which do not apear to have been planed, are all of a thickness of 3.2 cm, and are braced by two horizontal battens inserted into grooves cut in the back. The paint surface is well preserved except for small losses along the joins between the planks and light, overall abrasions from overcleaning. The mordant gilt haloes of all three figures have been nearly obliterated. Underdrawing and pentimenti are clearly visible beneath thinning layers of paint, especially in the areas of the figures' hands and above the vase of flowers.

THE VIRGIN, in a red dress with slit sleeves and a blue cloak with a gilt hem and gold embroidered green lining, is seated in three-quarter profile to the left. She looks down and clasps her hands in adoration of her son, seated on a cushion on her right knee. The Christ Child, loosely wrapped in a purple cloth, looks up at his mother and toys idly with an open book in his lap. Behind the Child and gazing adoringly at him is the young Saint John the Baptist, his hands crossed on his chest holding a staff with a cross. The Virgin is cropped at the knees by a low marble parapet, and behind her the composition is closed off by an articulat-

ed marble wall or pier projecting aggressively forward in space at the right. A marble ledge fills the lower right corner of the composition, on top of which are set an open book and a finely wrought enamel (?) vase filled with roses, both casting shadows to the right.

The early history of this painting is confused in all published sources referring to it. It may be one of two paintings of similar subject – a Virgin and Child with Saint John the Baptist – listed by Crowe and Cavalcaselle (1864) in the collection of Alexander Barker, London. One of these, formerly in the Beckford collection (most recently sold at Christie's, London, 1 July 1966, lot 54), was described by Waagen in his first account of the Barker pictures (vol. 2, 1854, p. 127). The other, possibly 95.1372, was purchased at or after the Joly de Bammeville sale of 1854, and was therefore not seen by Waagen on his first visit to the Barker collection, but was then included in his supplement of 1857 (p. 72). Waagen's description of this second picture agrees in all essentials with the Boston painting except that the Virgin is said to be standing, probably a confusion on Waagen's part since in none of his compositions of the Virgin and Child with Saint John the Baptist did Botticelli portray the Virgin standing. Only the first of Barker's two Botticellis appeared at the sale of his collection (Christie's, London, 6-8 June 1874, lot 91). Presumably the other was sold privately sometime after 1864, when it was described as still in the Barker collection by Crowe and Cavalcaselle, possibly to the Earl of Dudley. In 1864, Crowe and Cavalcaselle list a Nativity as the only painting by Botticelli in the Dudley collection, but a picture unequivocally identifiable as the Boston painting is visible in a photograph of the picture gallery at Dudley House in 1890 (Robinson, 1979, p. 165, fig. 6). It subsequently appeared in the Dudley sale of 1892, where it was purchased by Charles Fairfax Murray, perhaps for Agnew's, and shortly thereafter sold to the Museum of Fine Arts.

Though admired by Waagen and by Crowe and Cavalcaselle, the picture was omitted by Ullman (1893) and Horne (1908) from their biographies of the artist, and therefore remained little known until its publication by Yashiro (1925) as a workshop replica of a tondo in the Lanckoroncki collection, Vienna (fig. 37). Though Hendy (1932) argued that the Boston painting was an autograph work by Botticelli, all other published sources either treat it as a replica of the Lanckoroncki tondo (e.g. Salvini, 1958) or consider both these works to be studio replicas of a lost original (e.g. Lightbown,

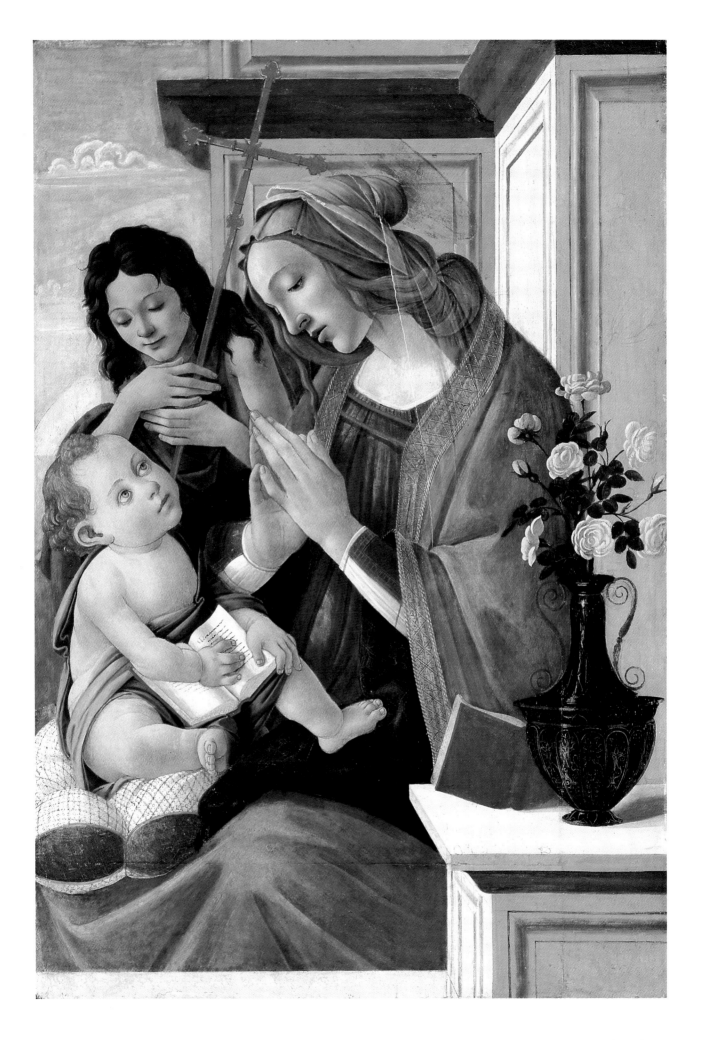

(cat. 52) 177

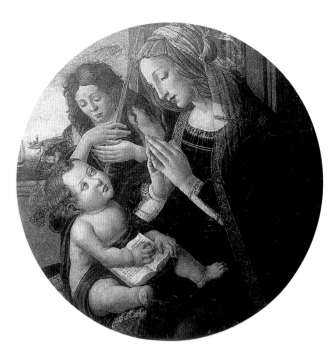

Fig. 37. Sandro Botticelli, *The Virgin and Child with the Young Saint John the Baptist*. Formerly Lanckoroncki collection, Vienna

Fig. 38. Sandro Botticelli, *The Virgin and Child with the Young Saint John the Baptist*. Formerly Hay Collection, Washington, D.C.

1978). Only Federico Zeri and Everett Fahy, in manuscript opinions, have expressly classified the Boston painting as an autograph work. In his manuscript notes for an appendix to his 1908 monograph ("Catalogue of the works of Sandro Botticelli, and of his disciples and imitators, together with notices of those erroneously attributed to him, in the public and private collections of Europe and America"), published only in 1987, Horne also listed the Boston painting as a school piece, but compared its composition not to the Lanckoroncki tondo but to that of a tondo in the collection of the Hon. John Hay in Washington, formerly in the Nistri collection, Prato (Crowe and Cavalcaselle, vol. 2, 1864, p. 425; fig. 38). The Hay tondo, recently in a private collection, Washington (sale Sotheby's, New York, January 14, 1994, lot 4), is not discussed in any modern literature on Botticelli. It more closely resembles the Boston painting than does the Lanckoroncki tondo in that it includes a vase of roses on a ledge at the lower right.

The primacy of the Boston, Hay, or Lanckoroncki versions of this composition is impossible to establish without physical examination of the Lanckoroncki tondo. From photographs alone it might be argued that the Boston and Lanckoroncki paintings were developed as enlargements of a single drawing (they differ in scale by 10-20 percent, so it is unlikely that a full-scale cartoon was employed to transfer the image from one to the other), a practice apparently common with Botticelli's more commercial productions. The figures in the Boston panel were drawn in with firm, precise outlines (suggestive of a mechanical means of transfer ?), with minor freehand corrections in areas like the Child's left foot or the palm of the Virgin's right hand. No such "corrections" are visible in reproductions of the Lanckoroncki tondo. The architectural details in the Boston painting, which are of an eccentric and original invention, were ruled directly on the panel, constructed around orthogonals converging on a vanishing point in the area of the Virgin's right sleeve, and the vase of flowers at the right was freely drawn on the panel's gesso preparation. The vigorous underdrawing, now clearly visible through thinning layers of paint, indicates that as originally conceived, stalks of lilies were meant to rise above the spray of roses nearly the full height of the panel. As finally realized, the artist suppressed the lilies and largely ignored his own underdrawing in brushing in the forms of the rose petals, leaves, and the meticulously rendered enamel vase.

The free invention of the architecture and vase of flowers in the Boston painting, which can only be imputed to Botticelli himself, is undoubtedly to be explained by the need to adapt a pre-existing design for the three-figure group to an enlarged format, roughly corresponding to the planks of wood added at the bottom and right sides of the panel (see condition notes above). Exclusive of these additions, the figural composition resembles that of the *Virgin and Child with Saint John the Baptist* in Dresden, and is likely to have evolved in close temporal proximity to it, probably in the early 1490s. The enlargement of the composition and the execution of the Boston painting, however, are likely to date from somewhat later, closer to 1500. The paint surface bears all the hallmarks of Botticelli's autograph late style, of the period of the Saint Zenobius panels in London, New York, and Dresden, or of the London *Mystical Nativity*. The style of the Lanckoroncki tondo is impossible to judge in photographs, as it appears to have been restored or reinforced at a later date. The Hay tondo follows quite literally nearly every detail of the Boston panel, including drapery and fabric patterns and the particular arrangement of roses in the vase (though the handles of the vase are suppressed). There can be no doubt that in all essentials it is a later replica of 95.1372, adding to it only those details, such as the landscape at the left or the slightly shifted position of the Baptist's cross, as were necessary to readapt the composition to a tondo form.

II. SIENA

Giovanni di Paolo
di Grazia

THE DATE of Giovanni di Paolo's birth is unknown. He is first recorded as an artist as early as 1417, when he was paid for some illuminations in a Book of Hours, and 1418, when he painted an image of the Blessed Catherine of Siena. Both of these were Dominican commissions, an order with which he was to be regularly associated throughout his career. Three altarpieces painted in the 1420s for chapels in San Domenico, Siena, reveal the combined early influences on his highly original style of Gentile da Fabriano, who passed through Siena in 1425/6, French and Lombard manuscript illuminations, with which he undoubtedly came into contact in the second decade of the century, and a native Sienese tradition exemplified by Taddeo di Bartolo, who may have been his first teacher.

Giovanni di Paolo produced a large number of altarpieces, private devotional panels, and illuminated manuscripts over an active career covering more than six decades. Some of the most memorable narrative formulations associated with Sienese fifteenth-century painting may be credited to him, such as the Creation and Expulsion (New York, Metropolitan Museum of Art, Robert Lehman Collection) from the predella of the Guelfi altarpiece of 1445, or the scenes from the life of Saint John the Baptist now divided between museums in Chicago, New York, Pasadena, Münster, and Avignon (see Strehlke, in Christiansen et al., 1988, pp. 192-200, 214-218). Around or shortly after 1461, he painted a series of scenes illustrating the life of the recently canonized Saint Catherine of Siena (ibid., pp. 218-242) that codified that saint's iconography and which have more recently become some of the most discussed works of the Tuscan quattrocento.

In the last two decades of his life – he died in 1482 – Giovanni di Paolo's work became increasingly exaggerated in its figural distortions, palette, and draughtsmanship, and many of his more extreme paintings from this period have been attributed to a supposed collaborator of the artist, Giacomo del Pisano, or to anonymous members of his shop. There is no certainty, however, that he employed assistants in other than subordinate technical capacities, nor little likelihood that any of them could have created the remarkably powerful, almost tormented images associated with Giovanni di Paolo's name from 1465 on.

53

Madonna of Humility

Tempera on panel
Overall: 62 x 48.8 (24⅜ x 19¼)
Picture surface: 55.5 x 42.2 (21⅞ x 16⅝)

Maria Antoinette Evans Fund. 30.772

Provenance: Eugene von Miller Aicholz, Vienna[1]; Albert Figdor, Vienna (sale, Cassirer, Berlin, 29 September 1930, lot 9)

Literature: Berenson, 1909, p. 180; van Marl, vol. 9, 1927, pp. 407-408; von Baldass, 1929, p. 466; Friedländer, 1930, no. 9; Hendy, 1930, p. 104; Perkins, 1931, p. 30; Berenson, 1932, p. 245; Gengaro, 1932, p. 233; Venturi, 1933, vol. 1, pl. 155; Berenson, 1936, p. 211; Pope-Hennessy, 1937, pp. 27-28, pl. IX; Brandi, 1941, p. 243; Pope-Hennessy, 1947, p. 26, pls. XXII-XXIV Brandi, 1949, p. 98; Sandberg-Vavalà, 1953, p. 291; Carli, 1956, p. 64; Berenson, vol. 1, 1968, p. 175; van Os, 1969, pp. 128-139, fig. 80; Faison, 1970, pp. 27-28, 30; Hartt, 1971, p. 312, fig. 373; Torriti, 1977, p. 312; S. Wilk, "Bugiardini's *Holy Family with the Young St. John the Baptist*," *Perceptions* (1982) p. 9, fig. 11; Cole, 1985, pp. 82-83, fig. 53; Pope-Hennessy and Kanter, 1987, p. 123; Alessi, 1987, p. 319; Pope-Hennessy, 1988, pp. 22-23; Christiansen, 1989, pp. 266-268, 270 fn. 23; De Marchi, 1992, p. 211 fn. 37.

Condition: The panel, of a vertical wood grain, is 1.9 cm thick and has been neither thinned, cradled, nor modified in any way. It preserves two horizontal battens, possibly original, on the reverse, which is gessoed and painted light green with a dark surround. The engaged frame moldings are original and well preserved, with two holes (intended for a hanging cord or strap) drilled in the top edge. The paint surface is exceptionally well preserved, with only scattered tiny flaking losses and minimal retouching. The gilt haloes and cloth beneath the Christ Child are also extremely well preserved, the latter retaining its orange overglazes intact. The gilding of the pillow beneath the Virgin and of the rays surrounding the dove is somewhat worn, and the red glazes covering the former are broken through, with red bolus exposed in a few areas.

THE VIRGIN, wrapped in a flowing blue mantle, is seated on a gold cushion in a field of wildflowers and strawberries. She is turned three-quarters to the left; her long braided hair is wound tightly with a blue ribbon and tied up around her head. She holds the naked Christ Child before her on a gold cloth, bearing his weight on her right hand while his left leg rests lightly on her left arm. The Child looks out over his right shoulder, but reaches back to play with his mother's chin with his left hand and with his right the transparent veil that falls over her head. Behind the two figures is a dense thicket of fruit trees and behind (i.e. above) this is a panoramic landscape of cultivated fields of grain, groves of trees, hills, fortified towns, stony roads, a river, and a lake, ending in a sharply curved horizon. Floating in the sky, which shades from white at the horizon to a deep saturated

Fig. 39. Giovanni di Paolo, *Madonna of Humility*. Pinacoteca Nazionale, Siena (Photograph: Soprintendenza per i Beni Artistici e Storici, Siena)

blue, at the top center of the panel is the dove of the Holy Spirit surrounded by a burst of gilt rays.

Giovanni di Paolo's interpretation of the Madonna of Humility, one of his best-known and most admired images, is recorded in two extant versions: the present painting and a nearly identical replica in the Pinacoteca Nazionale, Siena (no. 206; fig. 39). The two paintings differ only modestly in size (the Siena panel measures 62 x 47.5 cm overall), in the composition of their landscapes, and in the general disposition of the two figures. The Siena version, which is considerably damaged in comparison to the near-perfect state of preservation of the Boston panel, lacks the dove of the Holy Spirit and slightly alters the actions of the Christ Child, who no longer toys with his mother's chin, and of the Virgin, who holds her son's foot rather than his leg with her left hand. The Siena version is commonly agreed to be the later of the two panels, though the distance of time separating them has been a matter of some debate, with proposals ranging from nearly two decades (Pope-Hennessy, 1937) to virtual contemporaneity.

A valid point of reference for the Boston *Madonna of Humility* is provided by Giovanni di Paolo's work of the early 1440s. Close parallels for the projection of its landscape are to be found in a predella with scenes from the life of the Virgin, now divided between the Cleveland Museum of Art, the National Gallery of Art, Washington, the Metropolitan Museum of Art, New York, and the Vatican Pinacoteca, convincingly dated ca. 1440 (Zeri and Gardner, 1980, pp. 27-28); in the illuminations in an antiphonary of

1442 painted for Lecceto (Biblioteca Comunale degli Intronati, Siena, Cod. G.I.8; cf. Strehlke, 1988, pp. 180-189); and in the predella to the Guelfi altarpiece of 1445, the two surviving panels of which are now in the Metropolitan Museum of Art, New York (Zeri and Gardner, 1980, pp. 20-21; Pope-Hennessy and Kanter, 1987, pp. 115-117). So close is the conception and rendering of landscape details and the agreement of figure style between the Boston panel and the Lecceto antiphonary that it is necessary to assume a date for the former around or just before 1442. The Siena *Madonna of Humility*, on the other hand, was undoubtedly painted somewhat later, probably shortly after 1450. Its landscape is more regular in its patterning (the rows of wheat in the Boston panel are sketched freehand and frequently do not align with the edges of the fields in which they are contained) and is projected with a greater vertical emphasis than in the Boston panel, and its figures are thinner, more wiry and sharper-featured. In all these respects it approaches the style of Giovanni di Paolo's Saint John the Baptist predella in the National Gallery, London, of 1454.

Since it first came to the attention of scholars shortly before the sale of the Figdor collection, the Boston *Madonna of Humility* has been noted for its evident dependence, singularly unusual in Giovanni di Paolo's oeuvre, on the example of Sassetta. Keith Christiansen (1989) has reasonably proposed a specific, now-lost prototype by Sassetta representing the Madonna of Humility in a rose garden, a replica of which is to be seen in Sano di Pietro's painting of that subject in the Museo d'Arte Sacra at Montalcino. Sassetta's painting would have been contemporary to or shortly after his large *Madonna and Child with Two Angels* (Pinacoteca Nazionale, Siena, no. 325; Torriti, 1977, p. 246) of 1438, in which the artist introduced the two-figure composition developed in all the later variants. Perhaps significantly, the movement of the figures in the Boston *Madonna of Humility* closely parallels that in Sassetta's painting of 1438 (which was prominently installed in the entrance hall of the Palazzo Pubblico), with the Child reaching towards his mother's chin and the Virgin cradling her son's leg in her left arm, while the later version in Siena instead follows the formula recorded in Sano di Pietro's painting, in which the Virgin holds the Christ Child's foot in her left hand.

Though the image of the Madonna of Humility was introduced to Sienese art in the early fourteenth century by Simone Martini (Meiss, 1951, pp. 132-156), her representation in an enclosed garden

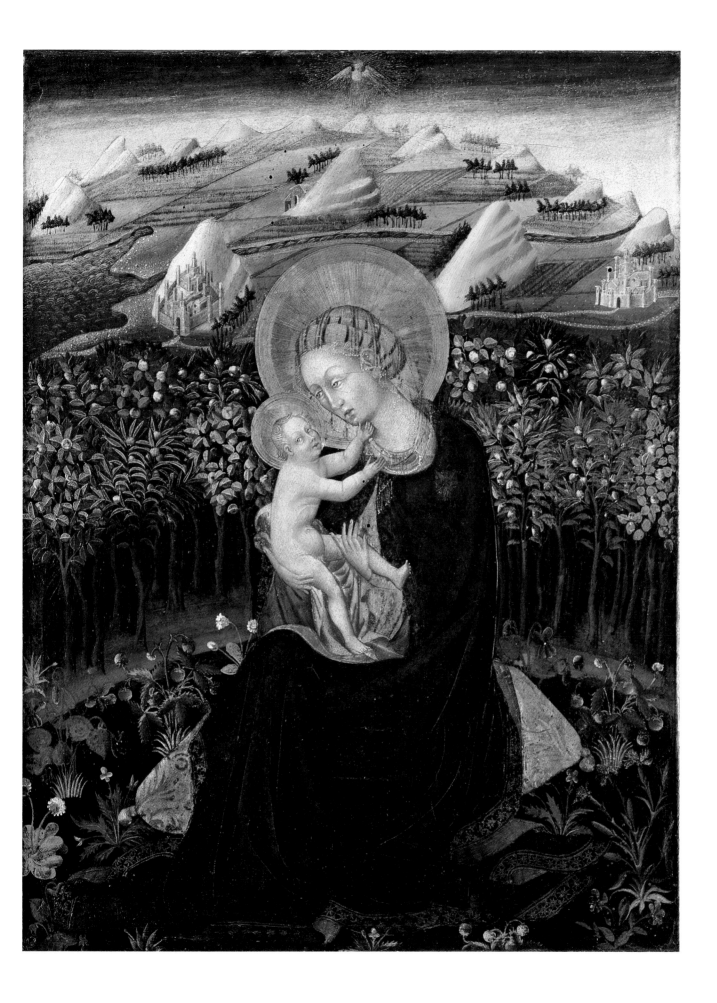

is of North Italian origin and appears to have been brought back to Siena in the early fifteenth century by Andrea di Bartolo (van Os, 1974, pp. 19-27, where, however, proposals for dating Andrea's pictures range from twenty to thirty years too early). The summary "landscapes" in Andrea di Bartolo's paintings are all bound by a curved horizon, a convention he absorbed from Venetian examples. Christiansen (1989, p. 267) suggests that Giovanni di Paolo's more panoramic landscape may derive from the Veronese miniaturist who collaborated with the artist on the Lecceto antiphonary of 1442, but if so the influence is likely to depend upon some earlier acquaintance if not collaboration of the two painters. Strehlke (1984, pp. 381-390) discusses the inclusion of the dove of the Holy Spirit in representations of the Madonna of Humility, as well as other aspects of the development of the iconographic type in Siena in the first half of the fifteenth century, without, however, specific reference to either of Giovanni di Paolo's two versions of the subject.

1. According to Berenson, 1909; the painting does not appear in the sale of the Aicholz collection (Galerie Georges Petit, Paris, 18-22 May 1900).

The Master of the Osservanza

ONE OF THE dominant personalities of Sienese painting in the second quarter of the fifteenth century, the Master of the Osservanza has also been one of the most controversial subjects of modern art history. Until 1940, the three major complexes of paintings now commonly recognized as his work were all attributed to Sassetta, as the products of a hypothetical "Gothicizing" or archaizing moment of his career in the 1430s. First recognized as an independent artist by Longhi (1940, pp. 188-189, fn. 26) and his pupil Graziani ("Il Maestro dell'Osservanza," *Proporzioni*, ii, 1948, pp. 75-88), he was named by the latter after a triptych in the church of the Osservanza outside Siena, painted probably between 1436 and 1441 for the now suppressed church of San Maurizio.

Opposition to Longhi's and Graziani's theory at first took the form of dividing the proposed Master's oeuvre into works retained for Sassetta, including a number of panels from a famous series illustrating the life of Saint Anthony Abbot (Christiansen et al., 1989, pp. 104-123), and works presumed to be early efforts by Sano di Pietro (q.v.), including the Osservanza triptych itself and an altarpiece of the Birth of the Virgin in the Museo d'Arte Sacra, Asciano. While it is now universally conceded that the Osservanza Master is wholly distinct from Sassetta, though heavily influenced and perhaps trained by him, attempts to identify him with the young Sano di Pietro persist. Another proposal (Alessi and Scapecchi, 1985, pp. 13-37) to identify him with the painter Francesco di Bartolomeo Alfei (active 1453-1483) is entirely improbable. Christiansen's suggestion (1989, p. 100) that the works attributed to the Master of the Osservanza are the products of a studio or consortium of artists, such as that known from documents to have been headed by the otherwise mysterious Vico di Luca (active 1426-1449), and with which the young Sano di Pietro may have been associated, is the most compelling in view of the visual evidence presented by the works themselves.

54

Reliquary

Tempera on panel
Overall: 70 x 37.5 (27½ x 14⅞)
Picture surface (recto and verso): 22.5 x 8.5 (8⅞ x 3⅜)

Charles Potter Kling Fund. 60.536

Provenance: Eugene von Miller Aicholz, Vienna (sale, Galerie Georges Petit, Paris, 18-22 May 1900, lot 368); Henri Heugel, Paris, by 1908; Mme. Henri Heugel; Jacques Heugel; M. Knoedler & Co., New York, 1960

Literature: Berenson, 1909, p. 178; van Marle, vol. 9, 1927, p. 452; Berenson, 1932, p. 247; idem, 1936, p. 212; Pope-Hennessy, 1938, p. 178; Brandi, 1947, p. 122; Zeri, 1965, p. 256; Berenson, 1968, vol. 1, p. 179; Fredericksen and Zeri, 1972, pp. 183, 536.

Condition: The structure of the reliquary, except for the base which is a modern addition, is original and well preserved. The glass roundels on the recto appear to be original and their gilt gesso surrounds are undisturbed; the glass roundels on the verso are of later, though not modern, manufacture and their gesso surrounds have been repaired and regilt to accommodate them. The outer framing pilasters on the verso have also been repaired (they may be replacements) and regilt. Other than these repairs, the gilt surfaces throughout are exceptionally well preserved, as are the painted and glazed surfaces. The figure of a deacon saint in the tympanum of the verso is moderately worn, and has suffered local losses where it abuts the repaired surround of the relic compartment below it. Small flaking losses elsewhere have been minimally retouched.

RECTO: In the center, the crucified Christ hangs from a cross with a red titulus, blood streaming from his wounds onto the ground. His hands and the arms of the cross are cropped at the punched border of the inset central panel. At the foot of the cross stand the mourning Virgin in a pale blue cloak over a red dress, her hands raised and her head thrown back, and Saint John the Evangelist in a rose-colored cloak over a pale blue fringed tunic, his face buried in his hand. At the top, above a trilobate compartment labeled *Zaccaria*, is the half-length figure of the Baptist wearing a blue cloak over his hair shirt, holding a red cross in his left hand and gesturing upwards with his right thumb.

VERSO: A monastic saint in a mauve habit belted by a rope with three knots is seen from behind kneeling on a gray-green pavement. He looks up in adoration at a vision of the Celestial Host, rendered in pale blue as half-length figures floating above a bank of clouds. Christ, the Virgin, and Saint Peter are visible in the front of the group, with the tips of five haloes receding behind them. At the top, above an unlabeled trilobate compartment, is the half-length figure of a

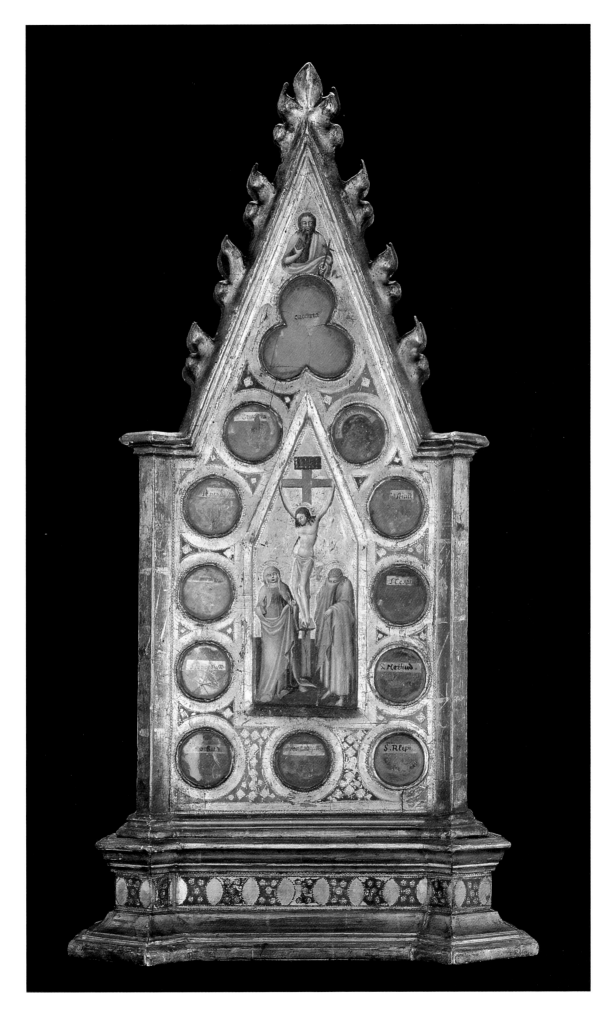

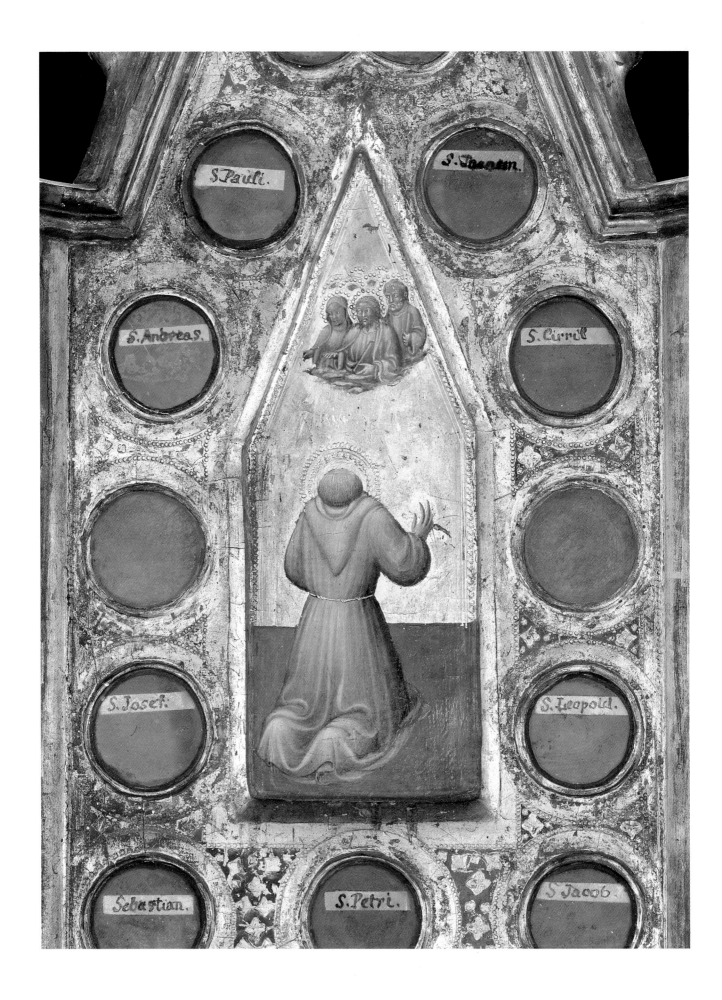

184 (cat. 54, verso)

young deacon saint in red, a blue book in his left hand, a martyr's palm in his right.

The identity of the deacon saint must once have been established by one of the relics contained within the circular compartments below. These have been changed at least twice, however, and were finally removed entirely. The labels affixed to the glass roundels on the verso were probably inserted in the last century and refer mostly to prominent saints (e.g., John, James, Peter, Sebastian, Joseph, Andrew, and Paul, though also Leopold and Cirril). The labels on the recto are older, possibly seventeenth- or early eighteenth-century, and are affixed to what appear to be the original fifteenth-century glass roundels. They refer mostly to obscure, undoubtedly local saints (aside from Saint Roch, three compartments are dedicated to Saint Pentady, Martyr, one to Saint Methud, and one to Saint Cesara), two of whom are of primarily Venetian association: Zaccharias (two compartments, including the principle, trilobate cell at the top) and Alypius. One compartment contains what appears to be an older label still. It is arched to follow the profile of the roundel, where all the others run straight across the glass, and it is lettered in a decidedly older, perhaps fifteenth-century script: DE OS[SIB]US SCI GERARDI, possibly refering to the Blessed Gerard of Villamagna.

Similarly, the exact significance of the main scene on the verso may once have been explained by reference to one of the relics contained in the reliquary. The monastic saint has quite reasonably been identified as a Franciscan, though probably not Francis himself given the lack of stigmata. The apparition of the Celestial Host appears in none of the more familiar Franciscan legends, though it must have been a specific incident in the life of one of the Franciscan saints or blesseds.

Devotions to the Blessed Gerard of Villamagna, who in the fifteenth century was referred to as Saint Gerard, were common to the Servites, the Templars, and the Franciscans, though his cult was chiefly promoted by the latter, who claimed him as a tertiary. Franciscan altarpieces incorporating images of "Saint" Gerard are not uncommon in the regions of Pisa and Siena in this period (cf. Dinora Corsi, "Gherardo da Villamagna. Storia di una leggenda," *La terra benedetta. Religiosità e tradizioni nell'antico territorio di Ripoli*, 1984, pp. 47-86), but no scenes from his life comparable to that on the Boston reliquary are recorded.

It is reasonable to assume that the Boston reliquary was commissioned for a Franciscan community, and that it contained a relic of (among others) the Blessed Gerard of Villamagna, Saint John the Baptist, whose image appears on the verso, and possibly of the True Cross (in relation to the image of the Crucifixion), a large fragment of which was donated by Fra Elia to the convent of San Francesco in Cortona. When it appeared at the von Miller Aicholz sale in 1900 it was inappropriately built into a triptych structure incoporating two narrative panels by Neri di Bicci representing the Baptism of Christ and a Miracle of San Bernardino. Two predella panels by Neri di Bicci with these subjects were until recently also in the Heugel collection, Paris (sale, Palais d'Orsay, Paris, 14 December 1979, lot 19). There is no evidence that they were removed from the same church as the Boston reliquary (Saint Bernardino was the founder of the Franciscan Reform movement), but if they were it could imply a provenance in the diocese of Arezzo, where both Neri di Bicci and the Osservanza Master are known to have worked.

Though known to specialists since the early part of this century, the Boston reliquary appears in none of the extensive literature on the Osservanza Master or related problems in Sienese quattrocento painting. It was attributed to Fra Angelico at the von Miller Aicholz sale (1900), an attribution accepted, hesitantly, by Richard Offner (note on a photograph at the Frick Art Reference Library, dated 1925). Berenson (1909, 1932, 1936, 1968) included it in his lists of the work of Giovanni di Paolo, and he was followed by van Marle, who probably did not know the piece in the original. It was listed in monographs on Giovanni di Paolo by John Pope-Hennessy (1938) among "pictures which I have been unable to identify or to examine" and described as a diptych, and by Cesare Brandi (1947), without comment. Pope-Hennessy later (1960, oral communication) firmly rejected any connection with Giovanni di Paolo, expressing doubt that the reliquary was Sienese at all.

The reliquary was first associated with the circle of Sassetta and Sano di Pietro by Zeri (letter in Museum files, September 1960; 1965, p. 256), who linked it with an artist responsible for four predella panels in the Vatican pinacoteca and two triptychs, one in the Pienza Gallery and one in the Kress collection at El Paso, Texas. This artist, called by Zeri the pseudo-Pellegrino di Mariano, was characterized by him as a pupil of Sano di Pietro much influenced by the Osservanza Master. Zeri's attribution was accepted provisionally by Millard Meiss (letter in Museum files, March 1961) and wholly by Everett Fahy (oral communi-

cation, 1985), while a direct attribution to the Osservanza Master, whom he considered to be identical with the young Sano di Pietro, was proposed by Miklós Boskovits (oral communication, 1978). The most recent discussion of the pseudo-Pellegrino di Mariano, also known as the Pienza Master, considers his paintings early works by the Osservanza Master but makes no mention of the Boston reliquary (Alessi and Scapecchi, 1985, pp. 19, 20, 35, fn. 87).

The identification of the pseudo-Pellegrino di Mariano with the Osservanza Master is to be categorically rejected on stylistic grounds. While the Pienza triptych is closely related to the Osservanza Master in style, the Kress triptych (which is certainly by the same hand) reflects the influence of Sano di Pietro's work of the 1450s. These pictures parrot the forms and compositions of the Osservanza Master without approximating the vitality of his draughtsmanship or the sophistication of his spatial experiments. By the same token, the Boston reliquary must be disassociated from the group of works attributed by Zeri to the pseudo-Pellegrino di Mariano. Meaningful stylistic comparisons can be made only with works by the Osservanza Master, specifically with the triptych in the Chigi-Saracini collection, Siena; with the five-part Passion predella divided between Kiev, Philadelphia, Detroit, Cambridge, and the Vatican; and above all with those scenes from the much-disputed Saint Anthony series for which he was responsible. There is an exact correspondence of figure types between the Death of Saint Anthony in Washington and the verso of the Boston reliquary, between the God the Father in the Chigi triptych and the Saint John the Baptist in Boston, and between the Kiev and Boston scenes of the Crucifixion. In addition, the painter of the Boston reliquary used the same freely brushed strokes of color to model his forms as the author of all the Saint Anthony panels save the Saint Anthony Beaten by Devils in New Haven, a technique uniquely personal to the Osservanza Master which is the basis for identifying him as an artistic personality distinct from Sano di Pietro (Seymour, 1952-53; Carli, 1957).

The Saint Anthony panels by the Osservanza Master and the Boston reliquary may be approximately contemporary, but there is no certain basis for assigning a date to either. The only securely dated work by the Osservanza Master, a Pietà of 1432/3 in the collection of the Monte dei Paschi, Siena (von Erffa, 1976, pp. 4-7), shows few compelling similarities to the Boston reliquary. It could be argued, however, that the composi-

tion of the scene on the verso of the Boston reliquary depends from Sassetta's *Saint Francis Adoring the Crucifix* now in Cleveland, originally the back pinnacle of the Borgo San Sepolcro altarpiece painted between 1437 and 1444. In that case it would be necessary to date the Boston reliquary after the middle of the 1440s, probably close to 1450 as one of the Osservanza Master's latest works. The question does not at present seem firmly resoluble.

Sano di Pietro

SANO DI PIETRO, the most prolific and probably the most admired Sienese artist of his time, was born in 1405 and first registered in the guild of painters in 1428. He is reasonably supposed to have trained in the workshop of Sassetta, with whom he is associated in documents of 1428 and 1432, and to have worked extensively in collaboration with the Osservanza Master (q.v.), with whom he is frequently confused. Nothing certain is known of his career, however, prior to 1444, when he signed the altarpiece of the Beato Colombini, painted for the convent of the Gesuati in San Girolamo, Siena (Siena, Pinacoteca Nazionale). From that date to his death in 1481, Sano was the recipient of a steady stream of important public commissions, both communal and ecclesiastical, for frescoes, altarpieces, commemorative panels, biccherna covers, and manuscript illuminations, at the same time producing unprecedented quantities of votive and devotional works for the private market. His style has been criticized as static and uninspired by modern critics, but this is a misunderstanding of the restrictions placed upon him by the highly efficient, entrepreneurial structure of his large workshop, in which many of the leading talents of Sienese painting of the later fifteenth century trained, and by the conservative taste of the market to which he catered, especially that of the Franciscan Observant movement and its expanding cult of devotions to Saint Bernardino. In his autograph works, among which may be numbered the four paintings attributed to him in the Museum of Fine Arts, and especially in his manuscript illuminations, Sano is revealed as an artist with a clear, simple narrative sensibility and sincere, sometimes moving religious sentiment, and as a craftsman of great refinement and impeccable technique.

55

Madonna and Child

Tempera on panel
Overall (including original engaged frame):
38 x 26 (15 x 10⁄₁₆)
Picture surface: 33.8 x 21.8 (13¼ x 8⅝)

Gift of Mrs. Josiah Bradlee. 07.78

Provenance: Unknown; Mrs. Josiah Bradlee, by 1907

Literature: Gaillard, 1923, p. 203; van Marle, vol. 9, 1927, p. 528; Fredericksen and Zeri, 1972, pp. 181, 563; Pope-Hennessy and Kanter, 1987, p. 144.

Condition: The wood panel, 1 cm thick, has developed a considerable convex warp and has been backed with a layer of wax resin. A vertical split running the length of the panel through the Virgin's face and left hand and two smaller vertical splits in the lower left quadrant were caused by an ill-conceived and unsuccessful attempt to flatten the panel's warp in 1952-53. The left and right engaged frame moldings are original; the bottom molding and right half of the top molding are also original but have split away from the panel and have been restored and reattached; the left half of the top molding is modern. The gold ground and paint surface are extremely well preserved, retaining some remnants of transparent surface glazes in depressions like the punched border of the Virgin's gown. Pinpoint losses scattered across the figures and along the split in the panel have been lightly retouched.

THE VIRGIN, wearing a blue cloak lined with green over a yellow dress with gilt collar and cuffs, is shown half-length turned slightly to her right. She holds before her the Christ Child, wrapped in a red blanket and white swaddling clothes, catching up a fold of her cloak with her left hand where she supports the Child's knees. The Child holds a banner, inscribed *diligite giv* . . . , in his right hand, and with his left toys with his mother's fingers at his chest. Both figures gaze out of the picture towards the left.

This painting was attributed to Sano di Pietro by Osvald Sirén in 1916 (oral communication) and was published as such by Gaillard (1923, citing Sirén's authority). It was mentioned by van Marle (1927) but does not appear in any edition of Berenson's lists. It is a typical early work by Sano di Pietro and one of unusually high quality. Its composition derives from a *Madonna and Child* in the Pinacoteca Nazionale in Siena, no. 236, variously dated between ca. 1447 and ca. 1452 (Brandi, 1933, p. 253; Torriti, 1977, p. 270), differing almost exclusively in the placement of the Child's left arm. The design of the Child, wrapped in swaddling clothes with the soles of both his feet visible, reappears with slight variation in the Scrofiano altarpiece of 1449 (Siena, Pinacoteca Nazionale, no. 246), but in very few later works. The close

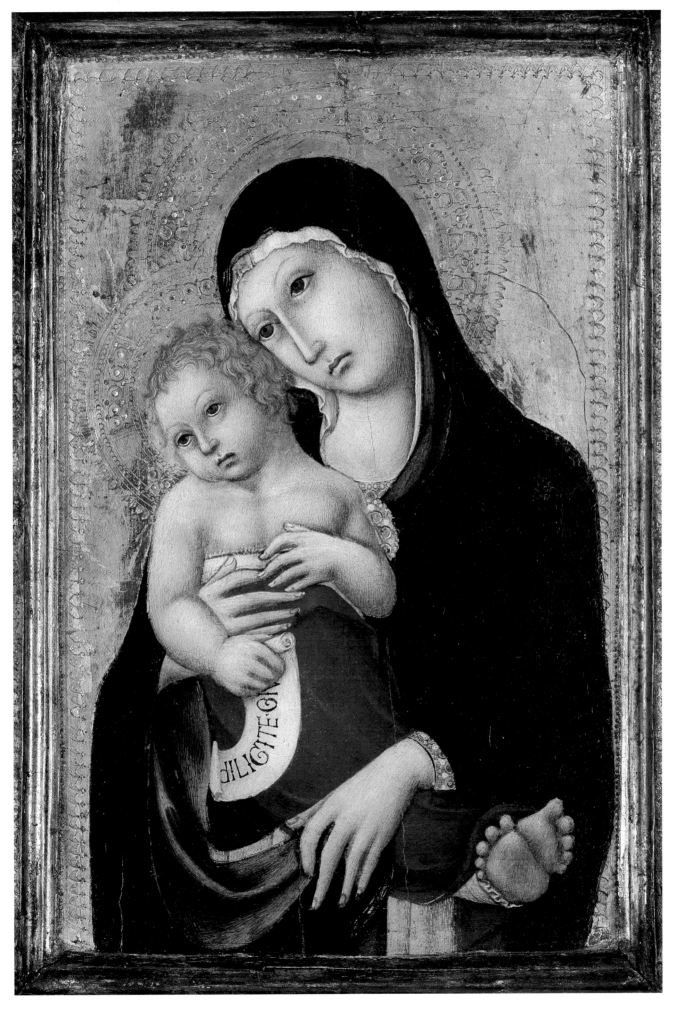

similarity of handling between the Boston panel and the Scrofiano altarpiece or the Saint Bartholomew altarpiece of 1447 (Siena, Pinacoteca Nazionale, no. 232), argues for dating the former shortly before 1450. Pope-Hennessy and Kanter (1987) list a number of small-scale variants of this composition, including a roundel in the Robert Lehman Collection at the Metropolitan Museum of Art, New York, of closely comparable quality.

56

Saint Bernardino

Tempera on parchment (?), laid on panel
Overall (including original engaged frame): 44.9 x 25.4 (17⅞ x 10)
Picture surface: 40 x 20.3 (15¾ x 8)

Gift of J. Templeman Coolidge. 39.801

Provenance: Costantini, Florence, 1902; J. Templeman Coolidge

Literature: Edgell, 1940, pp. 94-97; Berenson, vol. I, 1968, p. 374; Fredericksen and Zeri, 1972, pp. 181, 564.

Condition: The parchment on which the painting is executed has begun to detach from its panel support and bulges out along the bottom edge, bottom left corner and top right corner. The panel and its engaged frame are old and apparently original. The left and right outer edges of the panel show evidence of once having been engaged to a larger structure. The paint layer is much abraded with tiny losses overall. There is extensive retouching of the damages and over this a thick uneven layer of natural resin varnish. The gold halo of the saint is especially worn as is the gilded decoration in the border which is now barely visible.

THE SAINT is shown standing full-length facing three-quarters to his right. In his left hand he holds a book bound in red open to the inscription: PATER MANIFES-TAVI NO[M]EN TV[V]M HOM[INI]B[US]. Above his outstretched right hand is a gilt sunburst with the monogram of Christ: YHS. He stands upon a globe, marked with red towns (?), dark green trees, and light green rivers, surrounded by a wide band of light green probably meant to represent ocean. The saint is framed within a vermillion arch decorated with a faintly legible gilt pattern. Beneath the arch and above the saint's halo, in white letters against the blue background, is repeated the inscription: MANIFESTAVI NOMEN TUUM OMINIBUS [*sic*].

Berenson lists fourteen independent images of Saint Bernardino, excluding fragments of altarpieces, by Sano di Pietro besides the present panel. These fall into two general compositional groups. In one the saint presents a closed book held in both hands, with the sunburst monogram embossed on its cover. In the other, of which the present panel is an example, he holds the sunburst in one hand and an open book in the other. Inscriptions, invariably present, vary from image to image, and occasionally two angels are introduced supporting the saint above the globe, as in a large panel in the Pinacoteca Nazionale, Siena (no. 253) or in a panel formerly in the collection of Count P. Piccolomini, with Langton Douglas in 1923. The latter repeats

the inscription MANIFESTAVI . . . , beneath the framing arch as in the present panel. For further discussion of images of Saint Bernardino painted by Sano di Pietro, see K. Christiansen, 1991, pp. 451-52.

The Boston *Saint Bernardino* was accepted as a work of Sano di Pietro by Edgell (1940) and Berenson (1968), though E. Fahy considered it not good enough for Sano (oral communication, 1985). The painting is certainly by Sano di Pietro, though its curious technique, painted on parchment, and its ruinous condition make any finer judgments of quality or dating impossible.

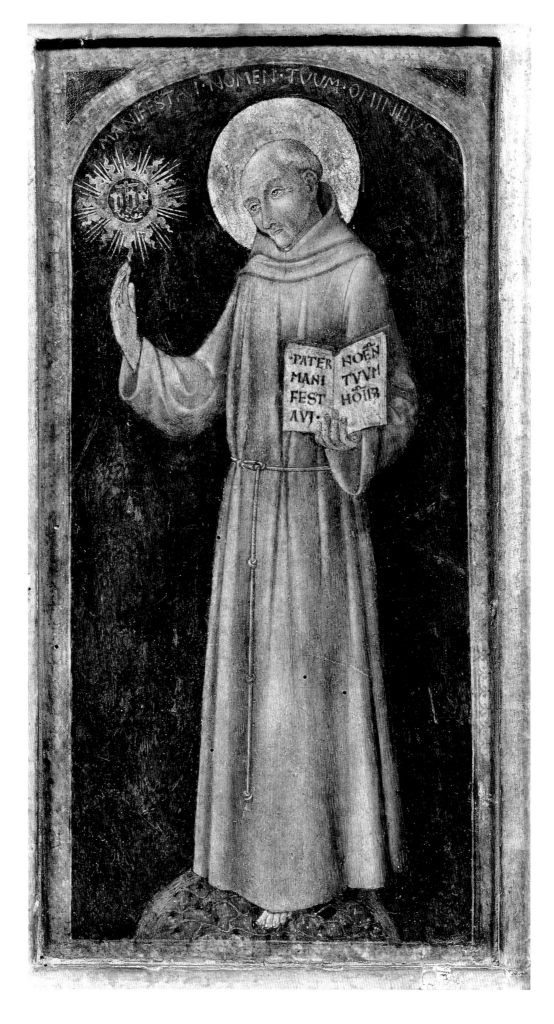

Triptych:

The Virgin and Child with the Blessing Christ, Two Angels and a Donor; Saint Jerome; Saint Catherine of Siena

Fig. 40. Sano di Pietro, *Pietà*. Formerly Tucher collection, Nürenberg

Tempera on panel
Left:
Overall: 95 x 51 (37⅜ x 20⅛)
Picture surface: 81 x 45.6 (31¼ x 17½)
Center:
Overall: 122.3 x 70.6 (48⅛ x 27¾)
Picture surface: 99 x 63.2 (39 x 24⅞)
Right:
Overall: 101 x 52.5 (39¾ x 20⅝)
Picture surface: 81 x 44.5 (31⅞ x 17½)

Anonymous gift, 1907. 07.515

Provenance: Count Carlo Vicoli-Caccialupi, San Severino Marche; Count Gaetano Alovisi Caccialupi, San Severino Marche, by 1828; Laura Antinori, San Severino, 1839-1860; Padre Zucchi, curate of S. Pietro, Gubbio; Mons. Badia, Pesaro; Count Augusto Caccialupi, Macerata, after 1870-ca. 1893; Reverend Robert Nevin, Rome (sale, Galleria Sangiorgi, Palazzo Borghese, April 22, 1907, lot 39)

Literature: Ricci, vol. 1, 1834, p. 203, fn. 51; Rossi, 1875, p. 372; Aleandri, 1908, pp. 136-138; Norton, 1908, pp. 21-22; Gaillard, 1923, p. 203; van Marle, vol. 9, 1927, p. 528; Berenson, vol. 1, 1968, p. 374; Fredericksen and Zeri, 1972, pp. 18, 563; Pacciaroni, 1984, pp. 33-35.

Condition: All three panels are composed of vertical planks 3.5 cm thick. The two lateral panels are each built from a single plank, with a 4-cm wide strip of wood, corresponding to the width of the engaged frame molding, fixed across the grain at the bottom of the panel and secured in place with three spikes; that on the left panel is heavily damaged and repaired. The center panel comprises three planks sawed through at the bottom, with the lower frame molding affixed to the surface and no cross-grain cap-strip. The gold grounds of all three panels and the mordant gilding on the draperies in the center panel are very well preserved, with minimal abrasion and only minor local losses that have been regilt. The paint surface of the right hand panel is exceptionally well preserved. The center panel is in good state but has suffered minor scattered flaking losses which have been restored. The left panel is less well preserved, with scattered flaking losses throughout and larger losses across the lower edge of the picture surface.

IN THE CENTER PANEL, the Madonna is shown half-length turned three-quarters to the left. She is cloaked in a blue mantle lined with green, over a gilt tunic glazed with red visible at her throat, cuff, and waist; in the decorated frieze of her halo is the angelic salutation: AVE * GRATIA * PLENA * DOMIN[US TECUM]. She cradles the Christ Child, clad in a pink cloak over a white tunic glazed with blue shadows, on her right arm while he pulls at the hem of her cloak with both his

hands. Cropped at the lobes of the frame on either side are two adoring angels clad in green, pink, and yellow. In the lower left corner of the panel is a diminutive figure of a female donor in the black habit of a Dominican nun or tertiary, her hands clasped in prayer and her eyes raised to an apparition of God the Father which fills the upper arch of the panel. God the Father is portrayed half-length floating on a bank of clouds and is represented as the Blessing Christ, with a cruciform nimbus and holding a blue book under his left arm. The left panel is filled with a half-length figure of Saint Jerome turned three-quarters to the right, wearing cardinal's robes (but without a beretta) and writing with a quill in a large book which he supports on his left arm. Across the bottom of the panel runs a white strip with a partially preserved (later) inscription which reads: ...NS...SAVTA CACIALU...COMES ET ADVOCATS...TO.... The right panel is filled with a half-length figure of Saint Catherine of Siena turned three-quarters to the left, wearing a Dominican habit and holding a stalk of lilies in her right hand and a red book with a blue clasp in her left.

The frames surrounding all three panels are original and largely intact, suffering only minor damage and repairs along the bottom edges and some of the upper crockets. The fact that each of the panels is separately and completely enframed, and that the hinges joining them are either original or replacements for original hinges, indicates that the altarpiece was from the first, notwithstanding its size, intended to be portable. The side panels were not meant to fold over the center panel as in a traditional portable triptych: they are too large and of an inappropriate shape relative to the center panel, their backs are unfinished, and their hinges are set at the back edge, not the front edge, of their frames. The hinges were provided as a simple means of detachment for greater ease of transport.

The partially effaced inscription running across the bottom of the left panel permits the identification of this triptych

with a painting recorded in the early nineteenth century in the collection of the Counts Vicoli-Caccialupi in San Severino Marche. At that time it was attributed to Lorenzo d'Alessandro da San Severino, and the figure of Saint Jerome was thought to be a portrait of the celebrated jurist Giambattista Caccialupi (1437-1496). The inscription, then complete, was read as: IOANNS BAPTA CACIALVPVS COMES ET ADVOCAT S CONCISTOR LI. Though enjoying a certain local notoriety in the first half of the century, all trace of it had been lost by 1875 (Rossi), and it was only reidentified after it appeared in the Nevin sale, under its correct attribution to Sano di Pietro, in 1907 (Aleandri, 1908). Ironically, the full publication of the picture's history at that time was not registered by scholars, and the Caccialupi triptych was once again "lost" until its quite recent identification with Sano di Pietro's altarpiece in the Museum of Fine Arts, Boston (Pacciaroni, 1984).

In the Caccialupi collection, the triptych was described (Rossi, 1875) as complete with a predella showing Christ as the Man of Sorrows with the mourning Virgin and Saint John the Evangelist in three circles (fig. 40). The predella, which measures 21.5 x 77 cm and has the Caccialupi arms (di rosso alla fascia doppiomerlata d'argento accompagnata in capo da una stella di otto raggi d'oro) painted in the lower left and right corners, was offered separately from the triptych in the Nevin sale (lot 137), and was sold to Baron Tucher in Nürnberg. It reappeared at public auction in 1972 (Christie's, London, 8 December 1972, lot 21) but its present whereabouts are unknown.

The identity of the kneeling donor in the center panel is unclear, but it has been proposed that she could be the mother, wife (Bianchina Procacci), or sister (Lucrezia Grassi) of Giambattista Caccialupi (Aleandri, 1908, p. 138). While the inscription on the left panel is later than the painting itself, it could accurately record the circumstances of its commission, even though the fragmentary last word should be completed as "CON-

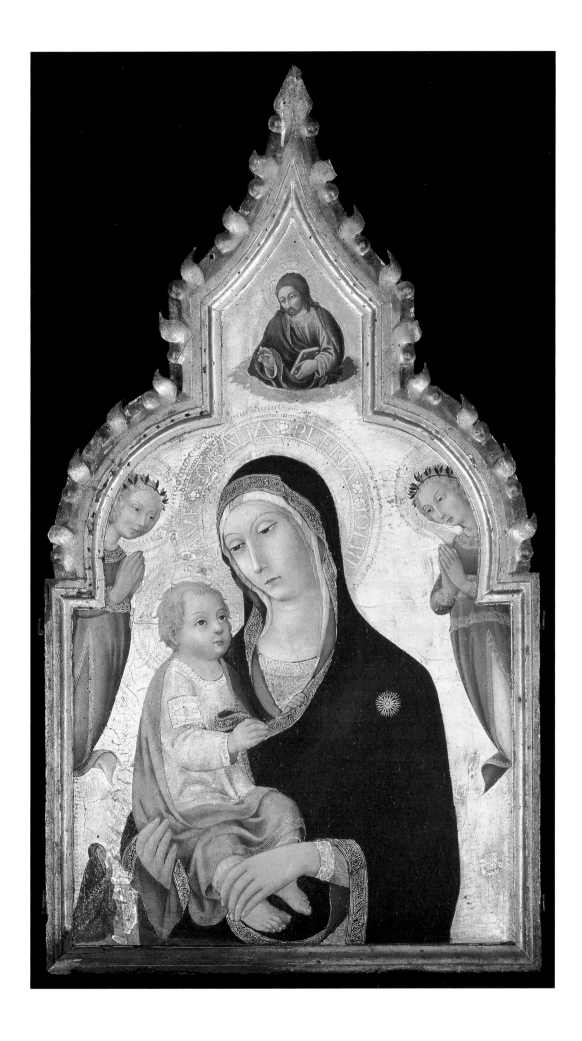

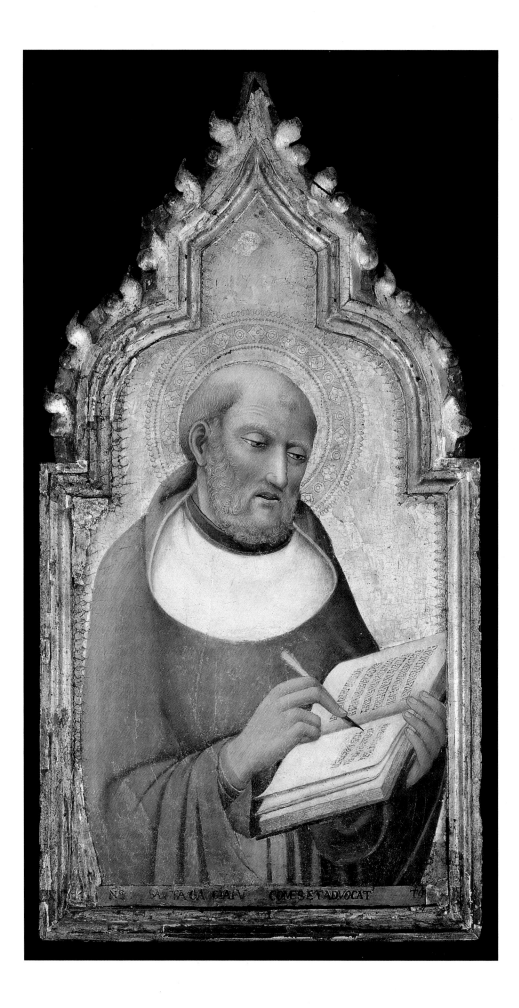

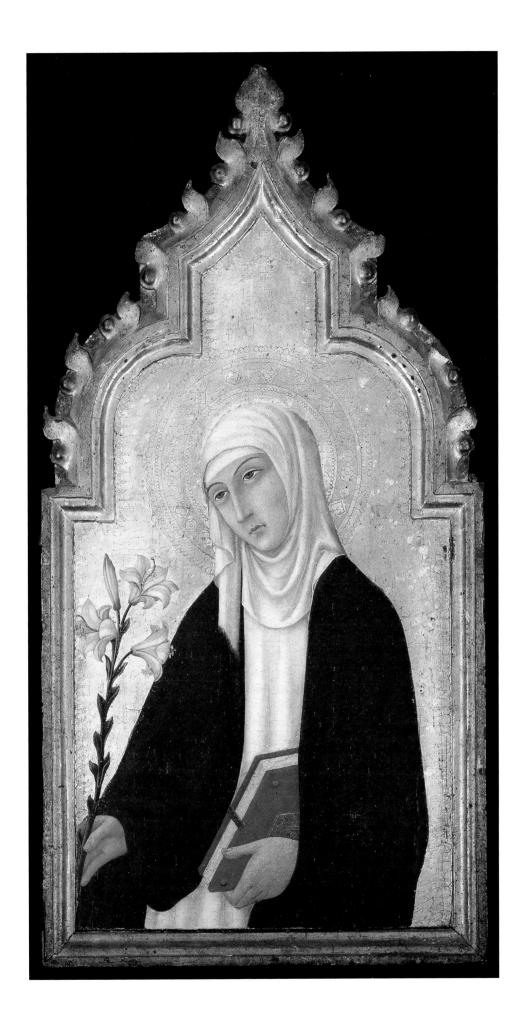

CISTORIALI" rather than "HOC OPUS F[ECIT] F[IERI]" as Aleandri supposed. Giambattista Caccialupi taught at Siena from 1460, where he held the office of Giudice delle Riformanze in 1464 before moving on to the University in Pisa (Zdekauer, 1894, p. 85). Caccialupi could have commissioned the altarpiece from Sano di Pietro during his residence in Siena: a terminus post quem of 1461 is established by the presence of Saint Catherine of Siena, who was canonized in that year. It is also possible that Caccialupi, if he were the patron, could have ordered the painting after his transfer to Pisa. It is tempting to date the altarpiece on stylistic grounds to the later 1460s or around 1470, close in time to the Badia a Isola altarpiece of 1471, which corresponds to the Boston triptych not only in its figure types but also in the form of its predella. Such a date for the Boston triptych might also explain some minor compositional novelties in Sano di Pietro's largely static repertoire of figural types by reference to Simone Martini's Pisa polyptych, where similar motifs occur.

58

Madonna and Child with Four Angels

Tempera on panel
Overall: 65.4 x 47.2 (25¾ x 18½)
Picture surface: 57.1 x 38.5 (22½ x 15⅛)

Bequest of Caroline Isabella Wilby. 97.229

Provenance: Unknown; Caroline Isabella Wilby, by 1897

Literature: Perkins, 1905, pp. 74-75; Berenson, 1909, p. 237; Gaillard, 1923, p. 304; van Marle, vol. 9, 1927, p. 528; Berenson, 1932, p. 398; idem, vol. 1, 1968, p. 374; Fredericksen and Zeri, 1972, pp. 181, 563.

Condition: The panel, of a vertical wood grain, is 3.2 cm thick. It has been backed with canvas and a wax resin layer, but apparently has not been thinned. The engaged frame moldings are original and are largely intact, though the top and bottom moldings have split at their centers from the warpage of the panel and all four show minor repairs and local regilding. A vertical split 16.5 cm long extends from the top center of the panel to the level of the Virgin's left eye. Losses in the gold ground and paint surface along this split have been retouched, but the gilding and paint layers otherwise are in excellent state, showing only scattered pinpoint flaking losses, a 1-cm wide loss in the Virgin's left cheek, and negligible abrasion.

THE VIRGIN is shown half-length, turned three-quarters to the left, wearing a blue (now darkened to black) robe over a red dress with gilt collar and cuffs. She holds the Christ Child, wearing a pink tunic with green sleeves, before her at the left. The Child presses his cheek to his mother's brow, and clutches at the hem of her robe with his right hand. Squeezed into the upper corners of the composition are two pairs of angels robed in yellow and red, their hair bound with garlands of flowers and their hands crossed on their chests in adoration.

Regarded without comment as a work by Sano di Pietro since its first publication by Berenson (1909, mistakenly as a Madonna and two angels), the present picture is a fully autograph work produced probably in the last decade of the artist's life. Though its general composition reflects a common type in Sano's oeuvre, the precise design of the two principal figures is not repeated in any other Madonna and Child, implying that their cartoon was invented for this work. In type these figures most closely resemble those in the Assumption altarpiece of 1479 in Siena (Pinacoteca Nazionale, nos. 259, 260) and slightly less closely those in the Augustinian altarpiece of 1471 at Badia a Isola. The four angels, executed with a concern for detail unusual among Sano's late works, may also be compared

with pictures certainly or purportedly of the 1470s, such as the two altarpieces mentioned above, the anconetta no. 261 in the Pinacoteca Nazionale at Siena, or two panels of the Madonna and Child with two saints and four angels: one in the Kress collection at El Paso, Texas (no. K522; Shapley, 1966, pp. 145-146), and one in the Pinacoteca Nazionale, Siena (no. 228; Torriti, 1977, p. 287).

Though the present panel omits the pair of saints flanking the Virgin in the Kress and Siena Madonnas and is rectangular rather than arched in format, it shares with them one peculiarity missing from any of Sano's earlier works: the nimbi of the two foremost angels are interrupted by the heads of the two behind. This spatially irrational device is repeated in the Assumption altarpiece of 1479 but not in earlier works, such as the Saints Cosmas and Damian altarpiece (Siena, Pinacoteca Nazionale, no. 233), datable to the late 1460s. The Boston Madonna employs a more crowded composition than the Siena or Kress Madonnas, pressing all the figures closer together and cropping the uppermost pair of angels at the level of their noses. In this respect the composition compares only to a little-known and much damaged Christ Crowned with Thorns by Sano in the Chigi-Saracini collection, Siena (Bellosi and Angelini, 1986, pp. 49-50), which, given its close resemblance to the signed and dated Lamentation of 1481 in the collection of the Monte de' Paschi, Siena, may be considered one of Sano's last works.

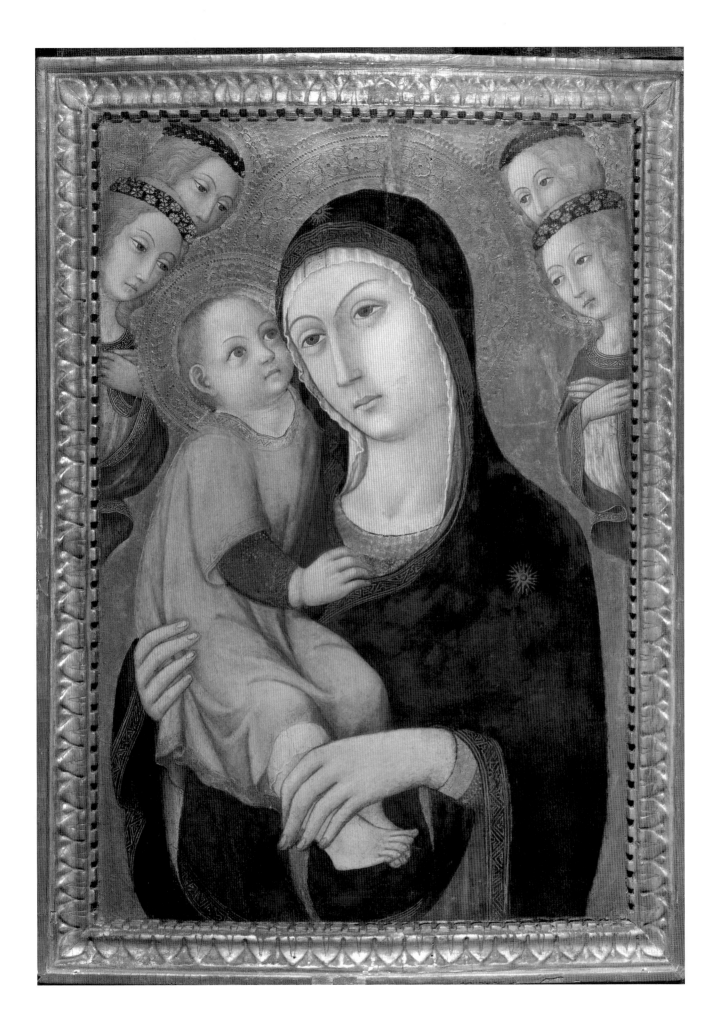

Francesco di Giorgio Martini

59

Madonna and Child with Saint Jerome, Saint Anthony of Padua, and Two Angels

Tempera on panel
Overall: 71 x 53 (28 x 20⅞)
Picture surface: 68.5 x 49.5 (27 x 19½)

Gift of Edward Jackson Holmes. 41.921

Provenance: Luigi Grassi, Florence, 1924; Edward Jackson Holmes, Boston

Literature: Perkins, 1928, pp. 66-68; Comstock, 1928a, pp. 34, 36; van Marle, vol. 16, 1931, p. 173; Berenson, 1932, p. 202; Venturi, 1933, pl. 303; van Marle, 1937, p. 270-271; Edgell, 1942, pp. 20-21; Weller, 1943, pp. 88-90; Coor-Achenbach, 1961, pp. 47, 85, 118, 123; Berenson, vol. 1, 1968, p. 140; Fredricksen and Zeri, 1972, pp. 73, 565; Torriti, 1977, p. 400; Toledano, 1987, pp. 58-59; Angelini, 1988, p. 18; Christiansen et al., 1989, pp. 322, 330; Bellosi et al, 1993, p. 287.

EQUALLY ACCOMPLISHED as a painter, sculptor, and architect, Francesco di Giorgio was one of the dominant artistic personalities of Central Italy in the last third of the fifteenth century. He was born in Siena in 1439, and was trained there probably in the studio of Sano di Pietro, whose compositions, palette, and decorative motifs he exploited in his earliest paintings of the Madonna and Child. He may also have worked briefly with the sculptor Antonio Federighi or even Donatello, who was resident in Siena between 1457 and 1459. Francesco di Giorgio's first securely datable works, a cassone panel of the Triumph of Chastity (J. Paul Getty Museum, Malibu) and a life-size polychrome wood sculpture of Saint John the Baptist (Opera del Duomo, Siena), were both executed in 1464. In 1468 he painted a biccherna cover now in the Archivio di Stato, Siena. His only other securely datable paintings are the monumental altarpiece of the Coronation of the Virgin from Monteoliveto Maggiore of 1471-72, and the Nativity altarpiece of 1475 from the Olivetan monastery at Porta Tufi, both now in the Pinacoteca Nazionale, Siena.

More than any other Sienese artist, Francesco di Giorgio was influenced by the Mantegnesque style of the Lombard miniaturists Liberale da Verona, who was active in both Siena and at Monteoliveto Maggiore from 1467 to 1476, and Gerolamo da Cremona, who arrived in Siena in 1470. Furthermore, from 1469 to 1475, Francesco shared a workshop with the painter and sculptor Neroccio de' Landi (q.v.). Distinguishing between the works of all four masters at this period has been a matter of limited consensus among scholars. Most of the surviving paintings attributable to Francesco di Giorgio can be dated before the dissolution of his partnership with Neroccio and the departure of Liberale from Siena. By 1477, Francesco had taken up residence at the court of Federigo da Montefeltro, Duke of Urbino, for whom he worked as a sculptor, architect, and military engineer, and to whom he dedicated a treatise on architecture. Thereafter Francesco appeared only intermittently in Siena, where his services were more in demand as a diplomat and a civil and military engineer than as a sculptor or painter. In the last decades of his career he did undertake to rebuild the high altar of the Cathedral in Siena, for which he cast a pair of bronze angels, and to decorate the Bichi chapel in S. Agostino (1488-91) in collaboration with Luca Signorelli (q.v.). A hybrid altarpiece of the Nativity in San Domenico, Siena, also dates from about this time. Francesco di Giorgio died in December 1501 or January 1502.

Condition: The panel support, which has not been thinned or cradled, has a coarse, knotty wood grain, predominantly vertical in direction but with pronounced diagonal swirls along the left side. A 21-cm long diagonal break across the top left corner of the panel, repaired with old butterfly joins, follows the direction of the grain at that point and is visible also as a crack in the paint surface. The linen, gesso, and paint layers are delaminating from the panel support, possibly due to the unusual pattern of contraction and expansion caused by the swirling wood grain. The edges of the painting, including most of the head of the angel seen in profile at the right, are much damaged and repaired, though traces of the original gesso barb from an engaged frame remain along the left and right sides. The gold ground is badly abraded and has been heavily restored, though the gilt decoration of the Virgin's collar is well preserved. The paint layers have suffered only pinpoint flaking losses and light overall abrasion, with the exception of the head of the angel in profile at the right, which is largely renewed, and the blue of the Virgin's mantle, which has turned black and is heavily overpainted. An old layer of discolored varnish covers the painting except for the Virgin's face, which has been cleaned and strengthened around the mouth and through the shadow of the nose, giving her a brighter and slightly falsified appearance relative to the other figures.

THE VIRGIN, wearing a high-waisted red dress with a gold collar, a transparent white veil, and a blue (now black) cloak lined with green, is seated facing left on a gold stool, one leg of which is visible at the lower right corner of the panel. Her hands are joined in adoration as she gazes down at the naked figure of the Christ Child lying diagonally across her lap. In the background at the left are Saint Jerome, wearing a rose-colored tunic open at the chest to expose the wound he has inflicted upon himself with the stone he holds in his right hand, and Saint Anthony of Padua, dressed in a Franciscan habit and holding a heart in

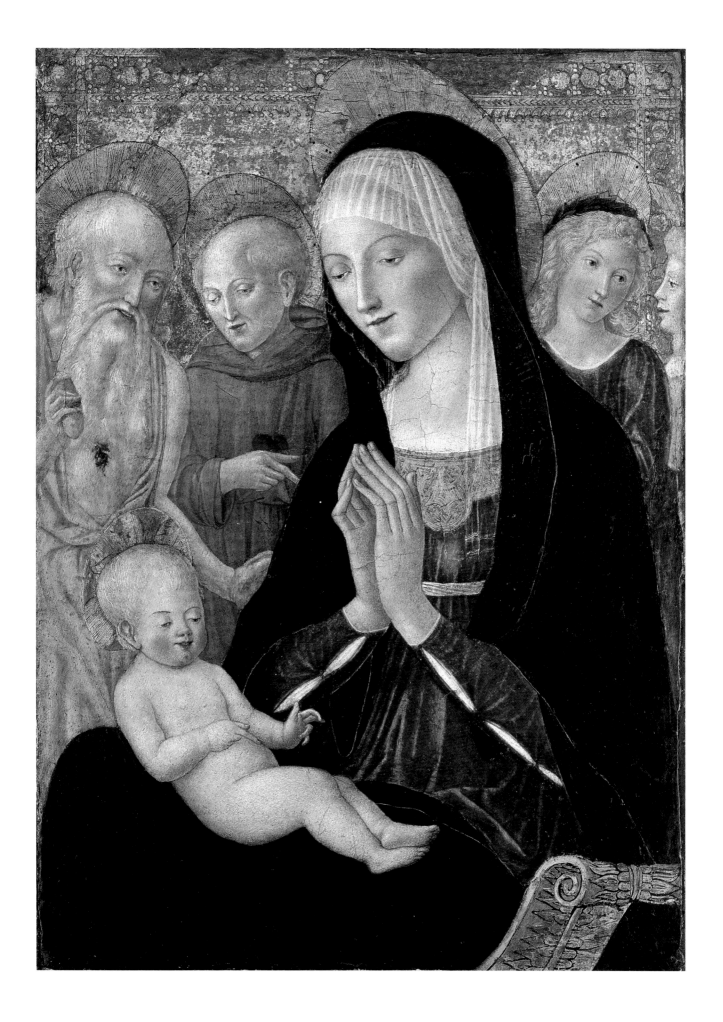

Fig. 41. Francesco di Giorgio, *Madonna and Child with Saint Jerome, Saint Anthony of Padua and Two Angels*. Museum of Fine Arts, Boston (detail, infrared reflectograph)

his right hand. Behind the Virgin at the right are two blond-haired angels, one wearing a red tunic and a laurel wreath, the other, cropped in profile at the right edge of the panel, a pink tunic. All six figures have haloes rendered as foreshortened gold discs with engraved radiating striations. The gold ground is decorated with a stamped border.

This work belongs to a class of devotional objects, rectangular or arched panels, representing the Madonna and Child with pairs of saints and/or angels, produced in great quantities in Siena in the fifteenth century, especially in the workshops of Sano di Pietro and, among Francesco di Giorgio's contemporaries, Matteo di Giovanni. The Boston Madonna is unusual among such pictures for the asymmetrical disposition of the figures, two saints to one side and two angels to the other, rather than in corresponding pairs flanking the Virgin. This innovation was little followed in Siena except in later paintings by Francesco di Giorgio himself (Siena, Pinacoteca Nazionale, no. 288) and by Neroccio de' Landi (Siena, Pinacoteca Nazionale, no. 295), with whom Francesco di Giorgio shared a workshop between 1469 and 1475. The motif of the reclining Child in the Boston Madonna, which was also later adopted by Neroccio, has been cited as deriving from the marble reliefs attributed to the so-called Piccolomini Master (Weller, 1943), but perhaps more relevant are such works as Donatello's *Piot Madonna* in the Louvre (Pope-Hennessy, 1976, pp. 172-191), or other Donatellesque

relief sculptures Francesco could have known in Siena (cf. Giancarlo Gentilini in Bellosi et al., 1993, pp. 176-191). There is some confusion over the identity of the Franciscan saint in the present panel, who was initially thought to be Saint Bernardino (van Marle, 1931), then Saint Francis (Venturi, 1933), before being recognized as Saint Anthony of Padua (Edgell, 1942). Weller (1943) doubts this identification, incorrectly.

Traditional scholarship has long been concerned with the many Madonna and Child paintings attributable to Francesco di Giorgio primarily from the point of view of their relative chronology within his career, and therefore of the visual evidence they provide of his relationships with his contemporaries and sometimes associates Neroccio de'Landi and Liberale da Verona. Thus, the Boston Madonna was published as an early work, dating from the beginning of his association with Neroccio about 1469, by Toledano (1987); as painted probably between 1470 and 1472, an example of Francesco di Giorgio's incipient interest in the works of Liberale da Verona and Gerolamo da Cremona, by Kanter (in Christiansen et al., 1989); as predating 1472, by Van Marle (1937) and Edgell (1942); and as dating from the end of Francesco di Giorgio's association with Neroccio, between 1472 and 1475, by Weller (1943), Coor-Achenbach (1961), and Torriti (1977). Venturi (1933) called it a mature work without specifying a date, and Boskovits (orally, 1978), suggested a possible dating close to 1490. More

recently, Alessandro Angelini (1988, and in Bellosi et al., 1993) has begged the question of dating Francesco di Giorgio's Madonna and Child compositions by assigning the execution of nearly all of them to a supposed collaborator of the artist, christened the Fiducario di Francesco and possibly identifiable with the sculptor Giacomo Cozzarelli, hypothetically employed by Francesco virtually as an amanuensis throughout his career, from the 1460s through his death in 1501/2.

Angelini's thesis, though compromised in part by an incomplete familiarity with Francesco di Giorgio's works outside Italy and by some tenuous assumptions of chronology,[1] has the merit of elucidating the commerical nature of the workshop operated by the artist before his departure for Urbino between 1475 and 1477. In addition to important commissions for monumental sculpture and painted altarpieces, this workshop was responsible for the virtual mass-production of painted cassone as well as carved and modeled reliefs and paintings of the Madonna and Child for a flourishing domestic market. Francesco di Giorgio's role as a designer in this process and the extent to which he shared the duties of execution with his associates, among them Neroccio de' Landi and possibly Giacomo Cozzarelli, lies at the heart of all questions of attribution and dating concerning these works. There can be little doubt, for example, that the innovative composition of the Boston Madonna and its ambitious spatial devices (contradicting the flat gold background of the panel) must be due to a design by Francesco di Giorgio, but it is equally true that the schematic modeling of drapery folds in the Virgin's dress or in the robes of the two saints at the left and the unimaginative rendering of the body of the Christ Child are not equal to the high standards apparent elsewhere in the artist's work.

Infra-red reflectographic examination of the Boston Madonna (fig. 41) reveals at least two artists involved in its conception and realization. All six figures were in the first instance blocked in with quick, forceful strokes delineating their general contours and establishing their relative positions in space. Two of the figures, Saints Jerome and Anthony of Padua, were then worked up in broad, sculptural planes of dark wash intended to remain visible as modeled shadows through translucent layers of paint on the surface, a technique also exploited in Francesco di Giorgio's altarpiece of the Coronation of the Virgin for Monteoliveto Maggiore (Siena, Pinacoteca Nazionale, no. 440; cf. Bellosi et al., 1993,

pp. 300-305). The Virgin, the Christ Child, and the two angels at the right were instead completed by a fine-lined, elegant draughtsmanship with no attempts at indicating volumes or transitions of light and dark in the underdrawing. It is reasonable to conclude that the first artist, responsible for planning the composition and constructing the figures of the two saints at the left, was Francesco di Giorgio, and that the second artist was a completely distinct personality with a radically different sense of working procedure. Whether this second artist was responsible for the entire paint surface of the panel is a matter of conjecture, as is the question of his identity, but considering the probable date of the painting, ca. 1470, a suggestion that he may be identifiable with Neroccio de' Landi cannot be dismissed.

1. Angelini accepts the traditional dating of 1463 for Francesco's illuminated frontispiece in a manuscript of *De Animalibus* (Siena, Museo Aurelio Castelli), but like his illuminated Nativity in an antiphonary from Monteoliveto Maggiore (Chiusi, Museo della Cattedrale, codex B, fol. 3v.), traditionally dated 1458-61, it must instead have been painted a decade later, between approximately 1471 and 1474 (Kanter, in Christiansen et al., 1989, pp. 322-324). Accepting *De Animalibus* as a "documented" early work necessarily confounds the attribution of other paintings datable to the middle or late 1460s. Further confusing the artist's origins are the debatable attributions to Francesco di Giorgio's earliest career, ca. 1458-60, of panels by Vecchietta (Preaching of Saint Bernardino, Liverpool, Walker Art Gallery; Marriage of Saint Francis with Poverty and the Imposition of the Yoke of Obedience, Munich, Alte Pinakothek; Two Flagellants, Chantilly, Musée Conde; Two Flagellants, Bayonne, Musée Bonnat; Susannah and the Elders, Siena, Pinacoteca Nazionale), Benvenuto di Giovanni (Saint Anthony of Padua and the Mule, Munich, Alte Pinakothek; A Miracle of Saint Louis of Toulouse, Rome, Pinacotecta Vaticana), and Matteo di Giovanni (the biccherna cover of 1460 showing the consecration as Cardinal of Francesco Todeschini-Piccolomini by Pope Pius II, Siena, Archivio di Stato), proposed in Bellosi et al., 1993. Though Francesco di Giorgio was clearly much influenced by Vecchietta, a more convincing case was made by Kanter (in Christiansen et al., 1989, p. 316) and by Christiansen (1990, p. 212) for placing his training and earliest development in the workshop of Sano di Pietro.

Neroccio di Bartolomeo de'Landi

BORN IN 1447, Neroccio is commonly believed to have been apprenticed to the sculptor and painter Vecchietta, though it is also possible that he spent some time at least in the studio of Sano di Pietro (q.v.). He is first documented as an independent artist in 1468. Shortly after this date he entered into a commercial partnership with Francesco di Giorgio (q.v.), which was legally dissolved in 1475. Nearly all of Neroccio's certainly attributable works postdate his separation from this joint studio, and all of them bear the unmistakable impress of Francesco di Giorgio's influence in their style and technique. As an independent master, Neroccio specialized in the production of devotional paintings and sculpted reliefs of the Madonna and Child, catering to a domestic market abandoned by Francesco di Giorgio after 1475. Neroccio also painted monumental altarpieces of 1476 (Siena, Pinacoteca Nazionale, no. 282), 1492 (Siena, Pinacoteca Nazionale, no. 278), 1496 (Montisi, Santissima Annunziata), and of uncertain date (Washington, National Gallery of Art, and Magliano in Toscana, Santissima Annunziata), and undertook major sculptural commissions, such as the monument of Bishop Tommaso Testa Piccolomini in Siena Cathedral, of 1485.

Neroccio was one of the principal figures in the late nineteenth-century revival of taste for Sienese art of the Renaissance; his distinctively elegant and graceful style, unencumbered by any obvious spiritual sincerity, made him a favorite among English and American collectors. In the first two decades of the twentieth century, his pictures commanded higher prices than those of any other fifteenth-century Sienese painter except Matteo di Giovanni, and consequently numerous forgeries of his style appeared on the market and figured in early studies of Sienese fifteenth-century painting. An acurate image of his artistic accomplishment is also clouded by the great number of studio works that pass under his name in public collections throughout the world, an index of the facility with which his technique was imparted to assistants and of the entrepreneurial nature of his workshop.

60

The Virgin Annunciate

Tempera on panel
Overall: 68.3 x 29.5 (26⅞ x 11⁵⁄₈)
Picture Surface: 62.2 x 24 (24½ x 9⁷⁄₁₆)

Gift of J. Templeman Coolidge, Jr. 39.802

Provenance: Costantini, Florence, 1902; J. Templeman Coolidge, Jr., Boston

Literature: Berenson, 1909, p. 205; Edgell, 1940, pp. 97-98; Coor-Achenbach, 1961, pp. 77-78, 163, fig. 53; Berenson, vol. 1, 1968, p. 291; Fredericksen and Zeri, 1972, pp. 148, 564.

Condition: The panel (2.5 cm thick) has not been thinned nor cradled. The engaged frame is original but has been restored, regessoed, and regilt. Two dowel holes are visible in the left edge. A vertical, partial split in the panel runs from the bottom edge to the middle, approximately 10 cm from the right edge. There is also a 17-cm-long vertical split to the right of the Virgin's head and a 4-cm split to the left of her head. The paint surface has been severely abraded and extensively restored.

THE VIRGIN stands full length in a red dress and a blue mantle lined with green, a single star on her right shoulder. She holds a purple-bound book with gilt clasps open in her hands, and inclines her head gently to the left. Behind her is a deeply receding landscape with a fortified tower in the right middle distance; the ground beneath her feet is strewn with white pebbles of varying sizes.

The attribution of the present panel to Neroccio (Berenson, 1909; Edgell, 1940) was not questioned until 1957, when Ellis Waterhouse (oral communication) dismissed it as a modern forgery. W. Suida (oral communication, 1958) and Coor-Achenbach (1961) reaffirmed its authenticity and its attribution to Neroccio, while F. Zeri (oral communication, 1963) described it as "very fine and certainly Nerocciesque but suspicious, puzzling." E. Fahy (oral communication, 1985) also tentatively considered it a modern forgery. All these reservations expressed over the picture's authenticity must in fact be due to its ruinous state of preservation, to the extensive retouching of the paint surface, and to the modern regilding of its original engaged frame. The picture certainly dates to the fifteenth century and was certainly painted by Neroccio. It is situated by Edgell early in the artist's career, before 1476, and by Coor-Achenbach in the late 1480s. Precise judgments in this regard are rendered impossible by its gravely deteriorated condition, but what little can be reconstructed of the Virgin's figure type implies a date for the panel in the late 1470s or around 1480.

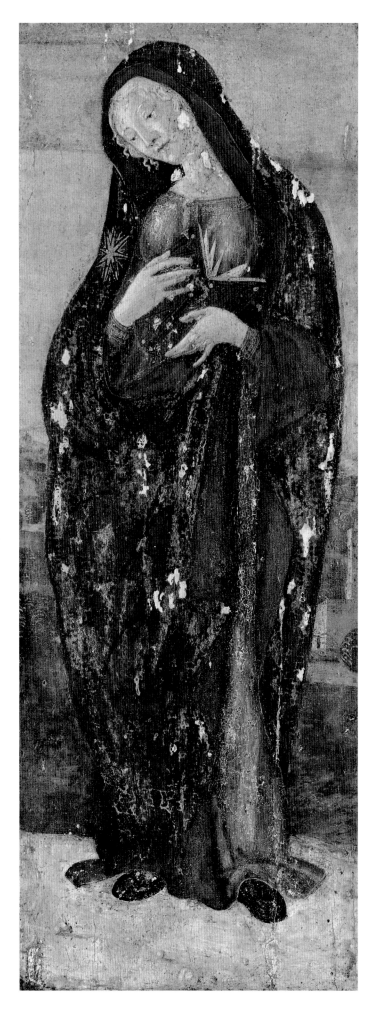

Coor-Achenbach, noting the presence of hinge marks along the left edge of the panel, posited the existence of a separate panel showing the Angel of the Annunciation and supposed that both may have formed the wings of a triptych, possibly with a Madonna and Child, painted or sculpted, between them. It should also be noted that the left frame molding on the Boston panel is 1/2 inch narrower than the other three moldings, implying its contiguity to another framed panel immediately to its left. If the outer panels in this hypothetical triptych were designed to close over the central panel, the latter would have had framed dimensions on the order of 27 x 23½ inches and an image size of approximately 24½ x 21½ inches, corresponding to none of the surviving Madonnas by Neroccio. There is no firm evidence, however, that the central image was a Madonna and Child, that it was painted or modeled by Neroccio, or that the wings were intended to be movable. The hinge marks noticed by Coor-Achenbach are two drilled holes which could have received dowel pegs to hold the side panels in a fixed position, in which case the central panel could have been of any width. In addition, two claw nails set into the panel about four inches from the top may have been intended to affix a horizontal batten (any other marks confirming the presence of such a batten have been obliterated by the thick coat of wax that covers the back of the panel) which should have been continuous across the length of the complex, serving to hold it rigid. Existing evidence permits no further deductions as to the panel's original disposition within a larger complex or to the possible identification of other fragments from such a complex.

Benvenuto di Giovanni di Meo del Guasta

THE FIRST MENTION of Benvenuto di Giovanni as an artist occurs in a document of 1453, when he was at work with Vecchietta on the frescoes in the Siena Baptistry, and it is reasonable to assume that he had earlier been apprenticed to the older master. The influence of Vecchietta on his early style is noticeable through his works of the 1460s – in particular in an altarpiece of the Annunciation in S. Girolamo, Volterra (1466), and a biccherna cover of 1468 – but was quickly supplanted by a fascination with the Mantegnesque classicism of the Lombard miniaturists Liberale da Verona and Gerolamo da Cremona who arrived in Siena in 1466 and 1470, respectively. Benvenuto successfully blended his own narrative and coloristic sensitivity with the exuberant fantasy of Liberale and the exquisitely detailed naturalism of Gerolamo to produce a series of masterpieces, on both a monumental and an intimate scale, through the decades of the 1470s and 1480s, including the Montepertuso altarpiece of 1475 (now in Vescovado di Murlo) and the Expulsion from Paradise discussed below.

Benvenuto's late style, commencing with his Ascension altarpiece of 1491 (Siena, Pinacoteca Nazionale) and the Passion predella which originally stood beneath it (Washington, National Gallery of Art), has been characterized as dull and stiff by comparison to his early works, and is frequently confused with that of his son and sometime collaborator, Gerolamo di Benvenuto (1470-1524). The eccentricity of these late works, with their exaggerated figural elongations, prismatic rendering of draperies, and mannered simplifications of landscape, has found little favor with critics, but implies a natural evolution from the miniaturist tendencies of his early works and represents perhaps the last and most original statement of quattrocento style in Siena. Benvenuto's last dated painting, the altarpiece of San Martino in Sinalunga, was produced in collaboration with his son Gerolamo in 1509. He is known to have died by 1518.

61

Expulsion from Paradise

Tempera on panel
25.8 x 34.5 (10⅛ x 13⅝)

Charles Potter Kling Fund, 1956. 56.512

Provenance: M. F. Engel-Gros, Ripaille, Switzerland (sale, Galerie Georges Petit, Paris, 30 May 1921, lot 2); M. and Mme. Emile Paravicini, Paris (sale, Galerie Jean Charpentier, Paris, 6 December 1952, lot 1); Dr. Alfred Scharf, London

Literature: Weigelt, vol. 14, 1921, p. 183; Ganz, vol. 1, 1921, pp. 114, 128, vol. 2, 1921 pl. 62; Catroux, 1921, pp. 270-274; Gaillard, 1922, pp. 125-130; Berenson, 1932, p. 77; idem, 1936, p. 66; van Marle, vol. 16, 1937, pp. 407-409; Ragghianti, vol. 1, 1953, p. 80; Bologna, 1954, p. 19 fn. 3; Maytham, 1957, pp. 44-46; Fredericksen and Davisson, 1966, p. 23; Berenson, vol. 1, 1968, p. 39, vol. 2, pl. 845; Fredericksen and Zeri, 1972, pp. 25, 565;Bandera, 1974, pp. 11-13, 16 fig. 31; idem, vol. 1, 1977, p. 31.

Condition: The panel support, of a horizontal wood grain, has been thinned to a depth of 3 mm, backed with a 1 mm wood veneer, and cradled. The paint surface is well preserved, except for scattered pinpoint losses, a small loss on the left side of the angel's halo, a loss in Eve's right forearm, and minor abrasions in her right thigh, abdomen, and left breast. Minor losses have also occurred along a diagonal crack which runs through Eve's chest, and along the edges of the panel, all four of which have been cut.

UNLIKE TRADITIONAL representations of the Expulsion from Paradise, in which Adam and Eve are shown walking shamefully out of Eden with the angel behind them, this composition is centralized, with all three figures portrayed frontally, nude, the angel standing between the first parents. Eve, at the right, raises her hands as if to remonstrate or explain as she turns walking to the right and the angel pushes her along by the right shoulder. Adam, at the left, braces his legs stiffly against the ground and raises his eyes imploringly to heaven, as the angel pulls at his left arm. The figures stand upon a bare strip of ground dotted with a few plants and stones, while a wooded rocky landscape rises steeply behind them.

This remarkable panel is justly regarded as one of Benvenuto di Giovanni's most exquisite and accomplished efforts, though it was first attributed to him only in 1932 (Berenson). It had initially been ascribed by Gustavo Frizzoni to Benvenuto's son and sometime collaborator Gerolamo di Benvenuto (see Ganz, 1921; Weigelt, 1921; Catroux, 1921), and was thought by Gaillard (1922) not to be Sienese at all but rather Ferrarese and probably by Cosimo Tura. Gaillard's attribution was based on the undeniably Mantegnesque character of the scene, and was supported by four wax seals of

the Belle Arti of Ferrara on the back of the panel. Subsequent writers (e.g. Bandera, 1974) have cited the Boston panel as a prime example of the Mantegnesque character of Benvenuto's style, mediated by the Lombard miniaturists Liberale da Verona and Gerolamo da Cremona, as well as of the artist's awareness of contemporary Florentine art through the prints of Antonio Pollaiuolo (Bologna, 1954).

No writers have yet attempted to identify the complex of which the Boston Expulsion formed part: the format and composition of the scene do not correspond to those of any other known works by Benvenuto di Giovanni. The panel has been cut on all four sides, and while it may safely be presumed on the basis of its composition alone that very little has been lost at the bottom edge, there is no concrete evidence as to whether or how much further it might have extended at the sides and top. The eccentric, almost irrational cropping of the landscape at these edges does imply that the composition was once significantly larger. Possibly the scene was meant to fill the upper corner of a narrative altarpiece, as in Fra Angelico's Annunciation altarpiece in Cortona, where a small scene of the Expulsion is included in the middle distance. The scale of the plants and stones in the foreground, however, and the horizontal wood grain of the panel suggest instead that it occupied the center of a predella. The figures in the Boston Expulsion are painted on approximately the same scale as those in two other predellas by Benvenuto di Giovanni – the Passion predella in the National Gallery of Art, Washington,[1] and the putative predella to the San Domenico altarpiece[2] – the individual panels of both of which are much larger overall than is the Boston panel.

It is the San Domenico altarpiece that provides the most compelling stylistic context for the Boston Expulsion, though it is unlikely that the latter formed part of a series with the three panels, in Avignon and Capesthorne, so far identified as comprising its predella. Not only are they incongruous in subject, but they differ in the manner of rendering haloes, foreshortened in the present panel, engraved flat in the other three. Also related stylistically to the Boston Expulsion, and presumably close to it in date, are the Biccherna cover of 1474 showing an allegory of Good Government, and the Annunciation altarpiece of 1470 in Sinalunga. Given the direct relationship of subject between the Expulsion – the first fruits of original sin – and the Annunciation – the moment of redemption from original sin – together with the

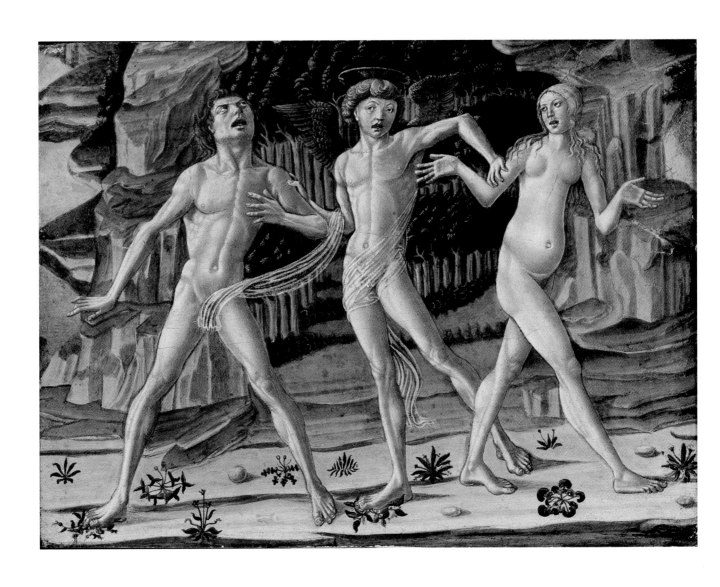

precedent of Fra Angelico's inclusion of scenes of the Expulsion in the background of his Annunciation altarpieces, and Giovanni di Paolo's inclusion of a scene of the Expulsion in the middle distance of his predella panel of the Annunciation now in the National Gallery of Art, Washington, it may tentatively be suggested that the Boston *Expulsion from Paradise* once stood in the center of the predella to the Sinalunga Annunciation. Unfortunately, no other small-scale narrative panels of this date by Benvenuto di Giovanni survive that might be adduced in support of this hypothesis, nor can any other fragments of the same predella be at present identified.

1. See Kanter in Christiansen et al., 1989, pp. 305-311, for a full discussion of this predella and its association with the Ascension altarpiece of 1491 from S. Eugenio. The center panel of the Passion predella measures 41.2 x 52.9 cm.

2. See Laclotte and Mognetti, 1977, nos. 28, 29, for the association, following a suggestion of Federico Zeri, of a *Massacre of the Innocents* and a *Martyrdom of a Bishop Saint* in Avignon, together with a *Miracle of Saint James* formerly at Capesthorne, with the San Domenico altarpiece. Traditionally associated with a document of 1483, the San Domenico altarpiece has recently been shown (Seidel, 1989, pp. 71-138) to have been completed and installed before 1478. Probably it was painted even before the Montepertuso altarpiece of 1475, as stylistically it may more plausibly be situated between that work and the Annunciation altarpiece in San Bernardino, Sinalunga, signed and dated 1470, than between the Montepertuso altarpiece and dated paintings of 1479 (London, National Gallery) or 1481 (Siena, Monte dei Paschi).

62a

Male Saint

Tempera on panel
Overall (including added strips): 28.5 x 28.3 (11¼ x 11⅛)
Original picture surface: 24.4 x 20.2 (9⅝ x 8)

Gift of Edward Jackson Holmes. 44.831

Provenance: see 44.832 below

Literature: see 44.832 below

Condition: The panel, whose wood grain is horizontal, has been unevenly thinned to a depth ranging from 2.1 to 2.4 cm and backed with a layer of wax resin. It has been enlarged by the addition of modern strips at the left (2 cm), right (6 cm), top (2.3 cm), and bottom (1.8 cm) edges, all integrated with the paint surface. The figure of the saint and the background within the circle are fairly well preserved though lightly and evenly abraded. Small local losses have been minimally inpainted. Both the pink circle and black outline have been heavily reinforced.

THE TONSURED and bearded saint is shown in half-length facing to his right,

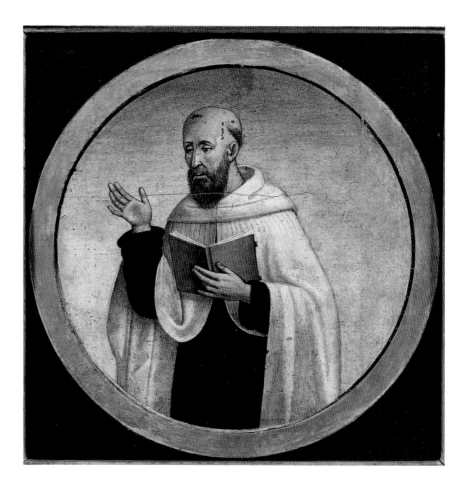

his right hand raised and his left hand supporting a red book open before his chest. His habit comprises a white scapular over a black tunic. The sky behind the figure shades from blue at the top to nearly white at the bottom, and the whole is framed within a pink circle lined with black.

The saint was traditionally identified at the Museum of Fine Arts as Augustine until it was published by Fredericksen and Davisson (1966) as an unknown Carmelite (?) saint. Van Os (1971) labeled the figure a Carmelite without qualification. A note in the Museum's files from W. G. Constable suggests that the habit may be that of the Premonstratensian order. If so, the figure could be intended to represent Saint Norbert, founder of that order. The only other recorded image of Saint Norbert in Central Italian art occurs in a fresco in the abbazia of SS. Severo e Martirio near Orvieto (Kaftal, 1965, c. 832). There exists evidence, in the form of an altarpiece now in the National Gallery, London (Kanter, 1983a, pp. 53-54), that Benvenuto di Giovanni worked in Orvieto, and also at Bolsena in the Diocese of Orvieto, where he painted the predella attached to an altarpiece by Sano di Pietro. There is no direct evidence, however, that the present panel might have come from SS. Severo e Martirio while oblique evidence exists that it

may have originated in a specifically Dominican context (see below).

For further discussion of this panel and its companion see below, no. 44.832

62b

Saint Vincent Ferrer

Tempera on panel
Overall (including added strips): 28.5 x 28.3 (11¼ x 11⅛)
Original picture surface: 23.1 x 21.7 (9⅛ x 8½)

Gift of Edward Jackson Holmes. 44.832

Provenance: Purchased by Edward Jackson Holmes in Florence around 1930 (oral communication recorded in Museum files).

Literature: Fredericksen and Davisson, 1966, pp. 30-31; van Os, 1971, pp. 72-73; Fredericksen and Zeri, 1972, pp. 92, 564; van Os, 1989, p. 86.

Condition: The panel, whose wood grain is horizontal, has been unevenly thinned to a depth ranging from 2 to 2.7 cm and backed with a layer of wax-resin. It has been enlarged by the addition of modern wood strips at the left (2.7 cm), right (3.9 cm), top (2.9 cm), and bottom (2.5 cm) edges, all integrated with the paint surface. The ground and paint layers in the saint and sky are much better preserved than those in its companion (44.831 above), but the pink circular "window" has been heavily reinforced.

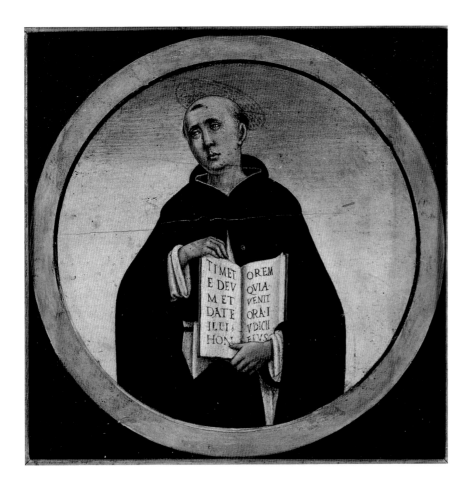

THE TONSURED, beardless saint is shown frontally, in half-length, glancing to his right. He wears a Dominican habit and holds an open book before him inscribed: TIMETE DEVM ET DATE ILLI HONOREM QVIA VENIT ORA IVDICCI EIVS. The sky behind him shades from blue to white. The whole is framed within a pink circle drawn in perspective, the receding inner edge of which is shaded at the top and lit at the bottom.

The saint was traditionally identified at the Museum of Fine Arts as Thomas Aquinas until it was shown by Fredericksen and Davisson (1966) to be Vincent Ferrer, citing the inscription, exclusively associated with that saint, which appears on the open book. Though it was labeled by van Os (1971) simply a Dominican saint without further comment, there can be no doubt that the figure is meant to represent Saint Vincent Ferrer.

In the reserves at the Szépmüvészti Múzeum in Budapest is a roundel showing another Dominican saint, Peter Martyr (fig. 42), that corresponds to both Boston roundels in size and in style and which undoubtedly formed part of a single predella with them. This connection was first noticed by H. Defoer and was published by van Os (1971, p. 72; and 1989; mistakenly as in the Kunsthistorisches Museum, Vienna), who also associated a roundel showing Saint

Fig. 42. Benvenuto di Giovanni, *Saint Peter Martyr.* Szépmüvészeti Müzeum, Budapest

Fig. 43. Benvenuto di Giovanni, *Saint Jerome.* J.H. Van Heek Collection, s'Heerenbergh

Jerome in the J. H. van Heek collection, 'sHeerenbergh, with the group (fig. 43). The Saint Jerome is slightly smaller than the Boston roundels, having been trimmed closer to the circle on all four sides, and has black spandrels and a lightly traced floral decorative motif within the circle on the horizontal axis. Vestiges of such a motif are also visible, beneath modern repaints, on the Boston panels, whose present gold spandrels were clumsily painted over the original black ones in 1954/55 as "less obtrusive and more harmonious with the frames" (note in Museum files).

Van Os identified the Saint Jerome and Saint Peter Martyr with two lots in the Ramboux sale (Cologne, 1867, nos. 207, 208), there attributed to Giacomo Pacchiarotto. They were accompanied in that sale by a third panel representing a Man of Sorrows (present whereabouts unknown) which must have been the central image of the predella. The Boston roundels do not figure in the catalogue of the Ramboux sale and are not known to have come from his collection. It is therefore not clear if five panels comprised a complete predella or if another pair of unrecorded saints, or perhaps the mourning Virgin and Saint John the Evangelist, may be missing from the present reconstruction.

Since their acquisition by the Museum of Fine Arts both panels have been attributed to Benvenuto di Giovanni's son, Gerolamo di Benvenuto. Fredericksen (1966) accepted this attribution, with reference, however, to Benvenuto di Giovanni's signed and dated altarpiece of 1498, then in the Metropolitan Museum of Art, New York (sale Sotheby's, New York, 1 June 1978, lot 133). An attribution to Gerolamo di Benvenuto and a dating around 1508 was advanced for the van Heek Saint Jerome by van Os (1969, no. 12) before that author was aware of its association with the Boston and Budapest panels. The resemblance of the Saint Jerome to figures in Benvenuto's altarpiece of 1498 is even more pronounced than for the Boston panels, while the drawing style and handling of paint in all three, as well as in the Budapest Saint Peter Martyr, are typical of Benvenuto, contrasting markedly to Gerolamo di Benvenuto's signed altarpiece of the Assumption, also of 1498, in the Museo Diocesano at Montalcino.

Though most scholars decline to distinguish confidently between the styles of Benvenuto di Giovanni and Gerolamo di Benvenuto, especially in works plausibly dated between 1498 and 1509, such a distinction is patent and manifest even within collaborative works such as the Saint Martin altarpiece of 1509 in Sinalun-

ga. The two pilaster bases of this altar-piece both show scenes of Saint Martin dividing his cloak, similar in composition to each other though reversed in orientation, one of which is quite clearly by Benvenuto and one by Gerolamo. A desco representing the Choice of Hercules in the Galleria Franchetti at the Ca d'Oro in Venice, painted to celebrate a marriage in 1500 between the Tancredi and de Vieri families, can only be a work by Benvenuto di Giovanni despite a generally accepted attribution for it to Gerolamo. The same is true of a Crucifixion in the Galleria Nazionale del Palazzo Barberini in Rome, usually attributed to Gerolamo di Benvenuto but actually painted by Benvenuto di Giovanni, to name just one other example. The Boston, Budapest, and van Heek roundels relate closely to the Franchetti desco of 1500 and, as has been said, to the 1498 altarpiece by Benvenuto formerly in the Metropolitan Museum, and must have been painted by that artist at about that time. Their resemblance to Gerolamo's work is limited to those superficial aspects of form which the younger artist strove to imitate in his father's work. An attribution to Benvenuto di Giovanni for these panels was also recognized by Strehlke (1991, p. 200).

The presence of two Dominican saints, Peter Martyr and Vincent Ferrer, in this predella implies that it may once have stood in a Dominican church and possibly beneath an altarpiece with other, more prominent Dominican saints represented, such as Dominic, Thomas Aquinas, or Catherine of Siena. No such altarpiece by either Benvenuto di Giovanni or Gerolamo di Benvenuto is known, however. Those which can be documented as having come from a Dominican context have known predellas or are incompatible in date, while those altarpieces of an appropriate date are incompatible iconographically. Either the Boston/Budapest/van Heek predella was removed from an altarpiece not known to survive today, or they did not belong to a Dominican complex, and the presence of two Dominican saints among them is strictly fortuitous.

Guidoccio di Giovanni Cozzarelli

LITTLE IS KNOWN about the life and artistic career of Guidoccio Cozzarelli, except that he was born in 1450 and must have spent much of the decade of the 1470s in the workshop of Matteo di Giovanni. For most historians of Sienese art, he is little more than a servile imitator of Matteo's style, whereas in fact his works can be divided into two distinct types. A series of dated altarpieces (Siena, Pinacoteca Nazionale and Sinalunga, San Bernardino) and manuscript illuminations (Siena, Libreria Piccolomini) of the early 1480s reveal him to be a highly talented if not especially inventive or original follower of Matteo di Giovanni, while a signed and dated altarpiece of 1495 (Siena, Pinacoteca Nazionale) is instead dependent on the example of his slightly younger contemporary Pietro di Giovanni degli Orioli. Many of Cozzarelli's finest works still pass under the name of one or the other of these two artists. Cozzarelli's style of the early years of the sixteenth century – he shares with Benvenuto di Giovanni (q.v.) and Bernardino Fungai the unusual distinction of being one of the few important painters in Siena active in the fifteenth century to survive into the sixteenth – is undocumented. He is known to have died by 1517.

63

Madonna and Child with Two Angels

Tempera on panel
Overall: 44.2 x 31.6 (17⅜ x 12⁷⁄₁₆)
Picture surface: 42.4 x 29.5 (16¾ x 11⅝)

Denman Waldo Ross Collection. 06.121

Provenance: Unknown; Denman Waldo Ross, Cambridge, Massachusetts, by 1893

Literature: Perkins, 1905, p. 75; Berenson, 1909, p. 158; Addison, 1910, p. 59; Berenson, 1932, p. 157; idem, 1936, p. 136; Galetti and Camesasca, 1950, p. 733; Berenson, vol. I, 1968, p. 98; Fredericksen and Zeri, 1972, pp. 58, 563.

Condition: The panel has been thinned to a depth of 8 mm and is cradled. The cradle has caused two vertical splits to form at the bottom edge. The one on the left, rising through the body of the Christ Child, is 14 cm long, the one on the right, passing through the Virgin's left hand, is 28 cm long. The engaged frame has been cut away, although a barb of gesso remains on all four sides, indicating that the picture surface has not been reduced. The gilding is heavily worn and has been locally repaired, especially in the upper right corner of the panel. The paint surface has suffered extensive pinpoint flaking but is otherwise largely intact with only scattered minor losses across the face and neck of the Virgin and in the Child's left hand.

THE MADONNA, in a red and gold brocade dress covered by a blue mantle, is turned three-quarters to her right looking down at the naked figure of the Christ Child before her, who plays absently with the fingers of her left hand. Behind the Virgin are two angels with their hands cupped in adoration, one in a blue tunic with a red collar, looking down at the Christ Child, the other in a red tunic with a blue collar, staring out at the viewer.

Though first brought to public attention by Perkins as early as 1905, and included in every edition of Berenson's lists as the work of Guidoccio Cozzarelli, this painting is discussed by no other author to have treated this artist. Zeri (oral communication, 1963) reaffirmed its attribution to Cozzarelli, while E. Fahy (oral communication, 1985) judged it of insufficient quality to be by him, labeling it instead "workshop of Matteo di Giovanni." The composition, figure types, and decoration of the gold ground in this picture do derive from Matteo di Giovanni's Madonnas of the late 1470s, but in exactly the same fashion as do all of Guidoccio Cozzarelli's early paintings. Its supposed lack of quality is purely a function of its damaged state.

The general lines of the composition of the Boston Madonna are repeated in at least four other pictures by Guidoccio

206 (cat. 63)

showing the Madonna and Child with two angels. One, now in the Allen Memorial Art Museum, Oberlin (Berenson, 1918, fig. 52), and another in Montalcino (Carli, 1972, pp. 57-58), appear to date from the mid-1480s, given their close resemblance to the two altarpieces by Guidoccio in Sinalunga. A third Madonna, formerly in the Kaufmann collection, Berlin (Friedländer, 1917, no. 26) was certainly painted later, probably at the end of that decade. The last in the series, now in the Brera, Milan (Malaguzzi-Valeri, 1903, p. 43), must have been painted around or after 1495, the date of Guidoccio's Saint Sebastian in Siena (Pinacoteca Nazionale, no. 296). By this date the artist had decidedly shifted his stylistic allegiance away from Matteo di Giovanni to the orbit of Pietro Orioli.

The Boston Madonna may be presumed to be earlier than any of these paintings. It corresponds most closely in its figure types to the *Madonna and Child with Saint Jerome and the Beato Colombini* in Siena (Pinacoteca Nazionale, no. 367), signed and dated December 1482. The figures of the Virgin in these paintings are virtual repetitions of each other, and both panels are painted in a similarly broad, loosely brushed technique. By 1484, the date of a Madonna in the Palazzo Pubblico, Siena, Guidoccio's technique assumed the strong linear character usually associated with his style, and it can only be concluded therefore that the Boston Madonna is one of his earliest surviving works, painted around or shortly after 1480.

64

Follower of
Guidoccio Cozzarelli
Madonna and Child with Saints Jerome and John the Baptist

Tempera on panel
Overall: 71.7 x 48.9 (28¼ x 19¼)
Picture surface: 66.1 x 43 (26 x 16⅞)

William Sturgis Bigelow Collection.
21.1460

Provenance: Unknown; William Sturgis Bigelow by 1921

Literature: Edgell, 1934, pp. 205-207; idem, 1935, pp. 88-90; van Marle, vol. 16, 1937, p. 381; Fredericksen and Zeri, 1972, pp. 58, 563; Laclotte and Mognetti, 1977, no. 55.

Condition: The panel, which is 2.9 cm thick, has been neither thinned nor cradled and retains its original engaged moldings at the top and sides. The bottom molding is a modern replacement, and the entire frame has been regilt. Two holes pierced through the top and back of the panel originally accommodated a hanging strap. The paint surface and the gilding of the panel are very well preserved with only minor paint loss along scratches in the area of the Virgin's left eye, across the Virgin's chest and the Child's right hand, across the Virgin's left hand, and both the Child's feet and ankles. Irregular areas along the bottom margin of the panel have been repainted to cover losses caused by the splitting away of the lower frame molding.

THE VIRGIN is shown half-length in a red dress with gold collar, cuffs, and sash, and a blue mantle with green lining. The Christ Child, wearing only a coral bracelet and a pearl and coral bead necklace, strides across her lap towards the right, looking back over his right shoul-

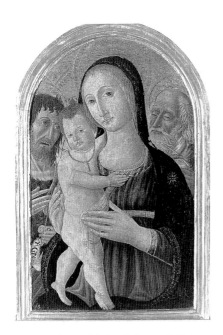

Fig. 44. Follower of Guidoccio Cozzarelli, *Madonna and Child with Saint John the Baptist and Saint Jerome.* Musée du Petit Palais, Avignon (inv. 20200)

der. Behind the Virgin are Saint Jerome, holding a stone to his bared breast, and Saint John the Baptist, wearing a hair shirt and holding a reed cross and a scroll inscribed: ECC[E A]GN[US DEI].

Given to the Museum of Fine Arts as an anonymous work of the Sienese school, the present painting was first ascribed to Cozzarelli by Edgell (1935), an attribution repeated without comment by van Marle (1937). It is omitted from Berenson's lists of that painter's works and was described by Fredericksen and Zeri (1972) as a studio production, a classification accepted by Laclotte and Mognetti (1977). Fahy (oral communication, 1985) accepted Laclotte's and Mognetti's association of the Boston Madonna with paintings at Avignon (Campana collection, inv. 20200; fig. 44) and formerly in the Barzelotti Camaiori collection, Siena (Berenson, 1968, fig. 919), labeling them either forgeries or simply Sienese fifteenth-century.

The three paintings grouped by Laclotte, Mognetti, and Fahy represent variations on a single cartoon and are clearly by a single artist, one who may have been active within Guidoccio Cozzarelli's workshop since he was able to distinguish between and imitate Cozzarelli's style from both the 1480s (Boston, Avignon) and 1490s (ex-Barzelotti Camaiori collection). Other works by the same artist include two panels of the Madonna and Child with two angels, again elaborated from a single cartoon, in Siena (Pinacoteca Nazionale, no. 337) and at Christ Church, Oxford (Byam Shaw, 1967, no. 40, pp. 51-52), and two

images of the Madonna and Child with two saints: in the Johnson Collection, Philadelphia (*Johnson Collection*, no. 112, pp. 25, 179), and formerly (1936) with the dealer Aldo Jandolo. An altarpiece formerly with the dealer Lazzaroni in Rome, showing the Virgin and Child enthroned with Saints Nicholas and Bartholomew (van Marle [1937], pp. 380-381, fig. 219), which also appears to be by the same artist, is as much an imitation of Matteo di Giovanni's late style as of Guidoccio Cozzarelli.

All these paintings seem to have been executed as independent works, not as products of Cozzarelli's studio. Their as yet unidentified author may have been primarily active as a miniaturist, judging from his exceptionally linear, thin-brushed technique which owes more to the practice of limning with inks than with tempera-based paints. Similar paintings exist executed in the styles of other prominent painters in Siena at the end of the fifteenth and beginning of the sixteenth centuries, notably Benvenuto di Giovannni (Siena, Pinacoteca Nazionale, no. 380), Pietro di Domenico, and Bernardino Fungai (Walters Art Gallery, Baltimore, inv. no. 37.1033: Zeri, vol. 1, 1976, p. 131 for a list and discussion of these paintings). It is not clear, however, whether all these works are the responsibility of one artist or if they represent the efforts of a minor if productive workshop active in Siena at the turn of the sixteenth century.

Pellegrino di Giovanni di Antonio da Perugia

THE FEW DOCUMENTS pertaining to this little-known Perugian painter (Gnoli, 1923, p. 237) reveal little more than that he was active before 1425, at which time he seems to have been associated in a partnership with the son of Cola di Petrucciolo of Orvieto, Policleto, and that he died in 1437. In 1428 he signed and dated a large panel of the Virgin and Child, perhaps the center panel of a dispersed polyptych, now in the Victoria and Albert Museum, London (Parronchi, 1975), and in 1434 he was paid by a certain Giovanni di Martino for an as yet unidentified altarpiece. Pellegrino di Giovanni must have been a leading member of the generation of artists active in Perugia following the departure of Gentile da Fabriano for Venice around 1408. His signed Madonna in the Victoria and Albert Museum is in fact a partial copy of Gentile's early Madonna and Child in the Galleria Nazionale dell'Umbria, Perugia, and the Boston Saint Michael catalogued below was long attributed to Gentile himself. The paucity of his surviving works, as of those of his contemporary Lello da Valletri, makes a more accurate assessment of his artistic personality impossible.

65

Saint Michael

Tempera on panel
Overall: 100 x 37.5 (39⅜ x 14¾)
Picture surface: 98.9 x 37.5 (38⅞ x 14¾)

Charles Potter Kling Fund. 68.22

Provenance: Vicomte Bernard d'Hendecourt, Paris, by 1914; Adolphe Stoclet, Brussels, by 1924; Mme. Michele Stoclet, Brussels (sale, Sotheby's, London, 30 June 1965, lot 19); Thos. Agnew & Sons, London

Literature: Perkins, 1914, p. 100; van Marle, vol. 2, 1924, pp. 574-575; idem, vol. 9, 1927, pp. 332-333; Longhi, 1928, pp. 71-75; Berenson, 1930, p. 350; idem, 1931, pp. 31-32; idem, 1932, p. 9; Pope-Hennessy, 1939, pp. 182-183; idem, 1939a, p. 119; idem, 1944; Brandi, 1949, pp. 208-209, fn. 71; Grassi, 1953, p. 69; Berenson, 1968, p. 6; Faison, 1970, pp. 28-31; idem, 1970a, p. 55; Witthoft, 1974, pp. 43-50; Huter, 1974, pp. 18-20; Micheletti, 1976, no. 25; Christiansen, 1981, pp. 353-355; idem, 1982, pp. 115-116; De Marchi, 1992, pp.123, 125, 215 fn. 108.

Condition: The image, which is in poor condition, is executed on a single plank of poplar 4.3 cm thick, with a vertical grain and light convex warp. A 7-cm-long gouge near the top of the right edge and a 5-cm long gouge with a large nail in it near the top of the left edge appear to be points where the panel was joined to the rest of the altarpiece. The gesso ground exhibits an extensive and pronounced horizontal cracking pattern with associated small losses in the paint surface. There is also a large area of loss along the left half of the bottom edge, a loss below the neck of the dragon and a small loss in the handle of the sword. Barbs along the top edges of the gilt background on either side of the archangel's head indicate that an engaged frame molding was detached when the panel was cut out of its altarpiece. The gilt background is slightly worn along the cracks but the punchwork in the halo is very well preserved as is the mordant gilding in the feathers. The silver gilt armor and sword, however, are badly abraded and worn. The dragon's body is also worn. The face, cap, painted feathers, and grass meadow are worn in places but otherwise are fairly well preserved.

THE ARMED FIGURE of the saint stands full-length in a meadow of flowers, silhouetted against the gold ground of the panel. His three pair of wings are painted blue, red, green, and white in alternating layers, each feather highlighted in mordant gilding. His armor is silver with gilt bosses on the epaulettes, and in his right hand he holds a silver sword with a gilt pommel and hilt. In his left hand he holds the shaft of a spear which rests on the beheaded corpse of a coiled dragon beneath his feet. His blond hair is covered with an elaborate cap made of peacock feathers (?), and his halo is inscribed: SANTVS [ANGE]LVS.

This much-discussed panel was initially believed to be a work by the then-recently discovered Sienese painter

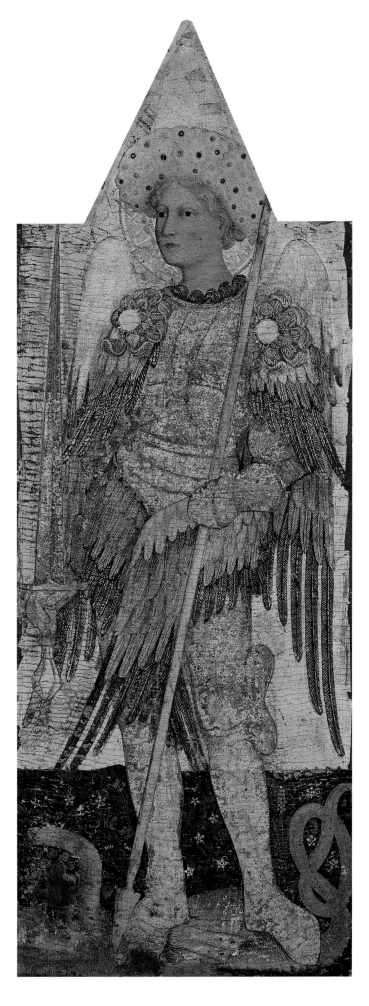

Andrea di Bartolo (Perkins, 1914; van Marle, 1924; Berenson, 1930, 1931, 1932, 1968), before it was recognized as a later, and yet more innovative effort than that artist, who died in 1428, was capable of producing. Subsequently, it was attributed to the Sienese painters Sassetta (van Marle, 1927), Domenico di Bartolo (Pope-Hennessy, 1944), Gualtieri di Giovanni (Grassi, 1953), and Pietro di Giovanni d'Ambrogio (Boskovits, oral communication, 1978), and to the North Italian masters Antonio Alberti da Ferrara (Brandi, 1949), Bonifacio Bembo (Witthoft, 1974), and Jacopo Bellini (Huter, 1974). All these ascriptions recognized the evident influence of Gentile da Fabriano in the painting's conception. Saint Michael's pose and such details of his costume as the extravagant hat seem to derive from the figure of the youngest magus in Gentile's *Adoration of the Magi* (Florence, Uffizi), painted in 1423 for Palla Strozzi, while the peculiarity of representing an archangel with three pairs of wings also appears in the lunette to that altarpiece. These similarities, coupled with the extremely high quality of the *Saint Michael*, induced Roberto Longhi (1928, followed by Faison, 1970, and Micheletti, 1976) to attribute the panel directly to Gentile, and it was as an autograph work by that artist that it was acquired by the Museum of Fine Arts in 1968.

The correct identification of the *Saint Michael* as a rare surviving work by the Perugian master Pellegrino di Giovanni di Antonio is due to Keith Christiansen (1981, 1982; Francis Russell, in an oral communication of 1979, agreed with Christiansen's then-unpublished opinion), who compared the painting with a *Madonna and Child* in the Victoria and Albert Museum, London, signed "Peregrinus pinsit MCC[C]CXXVIII" (Kauffmann, 1973, pp. 215-216). This identification is wholly convincing and is accepted by De Marchi (1992). The Victoria and Albert Museum Madonna, like the *Saint Michael*, is based on a prototype by Gentile da Fabriano, the early *Madonna and Child* in the Galleria Nazionale dell'Umbria at Perugia, and like the *Saint Michael* has been attributed to various Sienese (Pellegrino di Mariano: Pope-Hennessy, 1939, pp. 213-218) and North Italian (Pellegrino da Modena: Venturi, vol. 1, 1911, p. 191, fn. 2) masters under Gentile's influence. The suggestion that the "Peregrinus" who signed this painting may be identified with the Perugian painter Pellegrino di Giovanni is due in the first instance to Alessandro Parronchi (1975, pp. 3-13), and was confirmed by Francis Russell (1978, pp. 152-155) and by Christiansen (1981). This identification is undoubtedly correct.

No other panels that may have been excised from the same altarpiece as the *Saint Michael* have as yet been identified. Christiansen plausibly dated the panel later than the Victoria and Albert Madonna (1428) as being compositionally more sophisticated. Between that date and the artist's death in 1437, Pellegrino di Giovanni is documented as having painted an altarpiece for a certain Giovanni di Martino (Gnoli, 1923, p. 237), but there is no evidence for associating the present panel with that commission.

Bartolomeo di Giovanni Coradini, called Fra Carnevale

SAID BY VASARI (IV, 147-148) to have been the master of the young Bramante in Urbino, Bartolomeo Coradini is first recorded in a document of 1445, in Florence, where he was employed in the studio of Fra Filippo Lippi. By 1451, he had returned to Urbino and taken Dominican orders, and as Fra Carnevale he is recorded disbursing payments for the doorway and glazed terracotta lunette by Maso di Bartolomeo and Luca Della Robbia on the facade of San Domenico. In 1456, Fra Carnevale was excused from an obligation to paint an altarpiece for the Confraternity of the Corpus Domini, later executed by Joos van Ghent, and in 1467 he was paid for painting the high altarpiece of Santa Maria della Bella. Notices of Fra Carnevale, who was also parish priest at San Casciano di Cavallino, continue until 1484, presumably the year of his death.

The recent identification of Fra Carnevale with the long-admired but historically elusive figure of the so-called Master of the Barberini Panels (see Christiansen, 1979), establishes him as a major artistic presence in Urbino in the third quarter of the fifteenth century, fully consonant with the status implied by documents referring to him. Trained by Filippo Lippi, he fully integrated influences of Piero della Francesca and Giovanni Boccati into a highly intellectual and exquisitely crafted style. It is unclear whether he was in fact the teacher of Bramante, or whether Vasari simply deduced such a relationship from the two artists' mutual interest in architecture and the mathematical projection of space, of which the Boston Presentation in the Temple is a singular example.

66

Presentation of the Virgin in the Temple (?)

Tempera on panel
146.5 x 96.5 (57⅝ x 38)

Charles Potter Kling Fund. 37.108

Provenance: Santa Maria della Bella, Urbino, 1467; Cardinal Antonio Barberini, Rome, by 1644 (Lavin, 1975), possibly as early as 1631 (della Chiesa, 1969); Prince Maffeo Barberini, Rome, 1672 (?)-1685; Palazzo Barberini, Rome, 1685-1934; Marchesa Eleanora Corsini Antinori and Baronessa Giuliana Corsini Ricasoli, Florence, 1935; M. Knoedler and Co., New York, 1935

Literature: Vasari, 1567 (vol. 4, 1906), pp. 147-148; Colucci, 1796, p. 31; Lazzari, 1801, p. 73; Camuccini, 1817, no. 29; Dennistoun, 1851, vol. 2, p. 208ff.; Crowe and Cavalcaselle, vol. 1, 1871, p. 350; Schmarsow, 1886, p. 107; Mariotti, 1892, p. 127ff.; Venturi, 1893, pp. 416-418; idem, vol. 1, 1894, p. 85; Frizzoni, 1895, pp. 396, 400; Crowe and Cavalcaselle, vol. 8, 1898, p. 268; Budinich, 1904, p. 107; Burckhardt, pt. II, sect. iii, 1904, p. 678; Lafenestre and Richtenberger, 1905, p. 155; Frizzoni, 1905, p. 393; Rusconi, 1909, pp. 402-404; Bombe 1912, pp. 470-71; idem, 1912a, p. 20; Thieme, Becker, eds., vol. 6, 1912, p. 20; idem, 1912, pp. 470-471; Schmarsow, 1912, pp. 207-210; Crowe and Cavalcaselle, vol. 2, 1912, p. 53; Mandach, 1913, pp. 53-70; Venturi vol. 7, pt. ii, 1913, pp. 108-110; Witting, 1915, pp. 208-209; Escher, 1922, p. 110; Kimball, 1927, p. 131, fn. 22; van Marle, vol. 9, 1929, pp. 108-110; Burlington House, 1930, no. 124; Wittgens, 1930, p. 78; Holmes, 1930, p. 56; Berenson, 1932, p. 342; Colassanti, 1932, p. 79f.; Serra, vol. 2, 1934, p. 331; Berenson, 1936, p. 279; Wehle, 1936, pp. 59-66; Cunningham, 1937, pp. 214-215; idem, 1937a, pp. 3-9, 20, 23; Offner, vol. 1, 1939, pp. 205-253; Richter, 1940, pp. 311ff.; Swarzenski, 1940, pp. 90-97; Richter, 1943, pp. 5, 18; Papini, vol. 1, 1946, p. 150; Longhi, 1947, pp. 158-159; Zeri, 1948, p. 170, fn. 4; Rotondi, 1951, pp. 120, 122; Longhi, 1952, p. 19; Suida, 1953, pp. 24, 141; Zeri, 1953, pp. 130-131; idem, 1958c, p. 38; Chastel, 1958, p. 290; Meiss, 1961, pp. 61-66; Zeri, 1961, pp. 89ff.; Parronchi, 1962, pp. 280-286; Berenson, 1963, p. 141; Longhi, 1963, pp. 199, 204; Parronchi, 1964, pp. 437ff.; Chastel, 1966, p. 178; Wildenstein Galleries, 1967, fig. 5b; Stubblebine, 1967, p. 487; Licht, 1967, pp. 44, 47; Shapley, 1968, p. 3; Bruschi, 1969, pp. 71-73, n. 43; della Chiesa, 1969, p. 87; Zampetti, 1969, pp. 86ff.; Faison, 1970, pp. 31-32; Battisti, vol. 1, 1971, pp. 314ff., 501ff., vol. 2, pp. 53ff., 56, 100; Zampetti, 1971, pp. 12, 19, 194; Fredericksen and Zeri, 1972, pp. 125, 564; Alberti, 1972, pp. 153ff.; Lavin, 1975, pp. 158, 312, 349, 369, 474, 716; Conti, 1976, pp. 105ff.; Bruschi, 1977, p. 23; Hale, 1977, p. 253; Bernini, 1977, p. 89; Christiansen, 1979, pp. 198-201; Shapley, vol. 1, 1979, pp. 309-311; Zeri and Gardner, 1980, pp. 36-40; Meller and Hokin, 1982, pp. 239-246; Zeri, vol. 1, 1983, p. 553; Ciardi Dupre dal Pogetto, 1983, pp. 45-48; Alessi, vol. 1, 1987, p. 319; Battistini, vol. 2, 1987, pp. 398-401; Sangiorgi, 1989, p. 15 -21; Bellosi, 1990, p. 205; Zampetti,vol.1, 1991, pp. 393-396, 399, 419-420; Dal Poggetto, 1991, pp. 71-78; idem, 1992, pp. 301-315; De Marchi, 1992, p. 189 fn. 61; Lightbown, 1992, p. 262.

Condition: The panel, of a vertical wood grain and comprising three planks of approximately equal width, has been thinned and cradled but does not appear to have been reduced in height

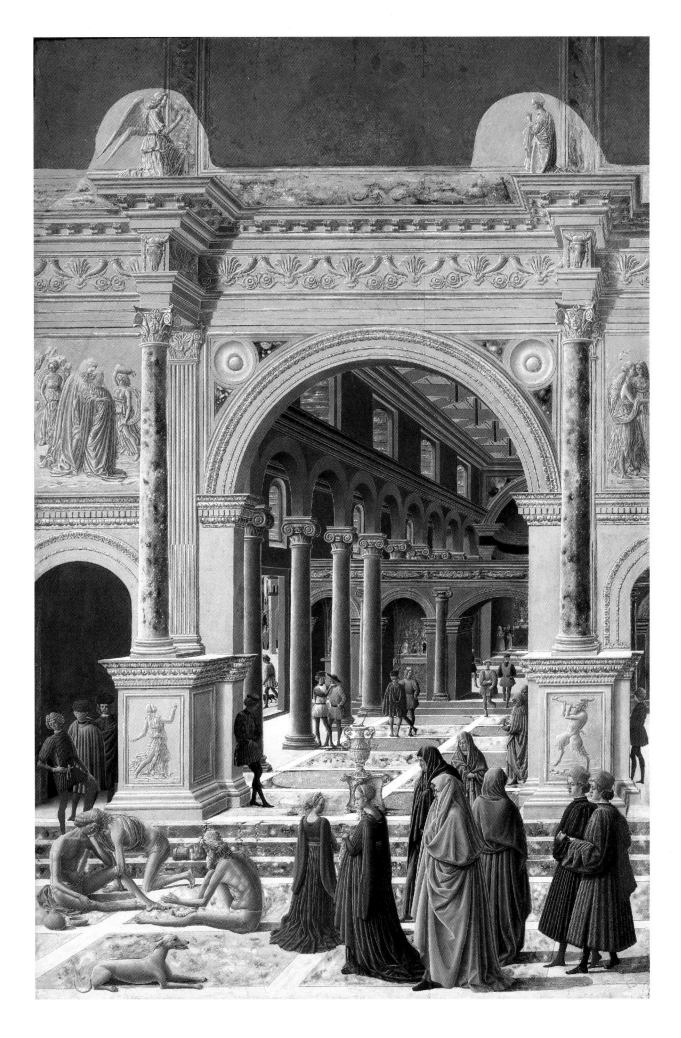

or width. Extensive damage and repainting along the top edge indicates an area originally covered by a now-missing engaged frame in the shape of a corbelled arcade. The paint surface otherwise is exceptionally well preserved, showing only minor scattered pinpoint flaking losses minimally inpainted.

THE SUBJECT of this painting is not immediately discernible. The scene is set before the elaborate facade of a classical basilica, its central arch supported on piers and flanked by Corinthian pilasters and free-standing porphyry columns, the latter supporting an entablature ornamented in the frieze with bucrania and an anthemion of cornucopias and honeysuckle. Atop the cornice are carved figures of the Angel and Virgin of the Annunciation; over the left side arch is a relief of the Visitation; and over the right side arch is a relief whose subject, cropped at the right edge of the panel, is unclear. Adorning the face of the plinths beneath the columns are reliefs of a satyr (right) and nymph (left). The basilica is preceded by three red marble steps, and seated on the ground before these at the left are three nearly nude beggars and a greyhound. In the right foreground is a procession of four women wrapped in blue, gray, black, and red cloaks; two fashionably dressed girls, the younger in blue and the elder in green, red, and blue; and two young men dressed in red and green. All these figures cast shadows toward the right. Inside the basilica, which is paved in variegated marbles, is an Ionic colonnade dividing the nave from the left side aisle, crossed by a rood screen forming transept chapels. Two such chapels are visible at the left, each containing a painted altarpiece. Another altarpiece is visible on the table of the high altar in the apse, with three monks (?) standing alongside. Twelve young men and two elderly pilgrims lounge or walk about inside the basilica, and two more young men are visible through a doorway in the left side aisle, opening onto a view of a city street.

A pendant to this panel, in the Metropolitan Museum of Art, New York, (fig. 45), shows a birth scene in an elaborate Renaissance palazzo. Haloes are faintly discernible on the figures of the mother and the newborn, and that scene is reasonably identified as the Birth of the Virgin. Reliefs of the Visitation and Annunciation on the facade of the basilica in the present picture confirm that both it and its pendant portray Marian subjects, and this is traditionally identified, therefore, as the Presentation of the Virgin in the Temple. Given the implicit references in the Annunciation and Visitation reliefs to the proximate birth of Christ, however, and the difficulty of identifying any of

Fig. 45. Fra Carnevale, *Birth of the Virgin*. The Metropolitan Museum of Art, New York

the foreground figures as Joachim, who should be in attendance at the Presentation (see Mandach, 1913), it is equally possible that this scene is meant to represent the Marriage of the Virgin. Joseph might therefore be any of the older figures standing within the temple, while the younger men might all be the Virgin's disappointed suitors.

The two panels in Boston and New York are among the most discussed Italian paintings surviving from the fifteenth century, primarily on account of their peculiarly secular treatment of religious narrative, their unusually accomplished mastery of perspectival rendering, and the spectacular compendium of Renaissance architectural motifs they incorporate. They have at various times been attributed to important architects known to have also worked as painters, specifically Luciano Laurana (Schmarsow, 1886; Witting, 1915), Donato Bramante (Swarzenski, 1940; Rotondi, 1951), and Leon Battista Alberti (Parronchi, 1962, 1964). The primary architectural references in these panels are indeed to the work of Leon Battista Alberti, in particular the Tempio Malatestiano at Rimini, whereas associations with Laurana and Bramante are suggested by the presence on the facade of the palazzo in the New York painting of heraldic eagles – emblems of the Montefeltro – reminiscent of carvings in the Palazzo Ducale, Urbino.

Of the numerous writers to have discussed these two panels, three have made particularly important contributions to unraveling their significance, authorship, dating, and context. Richard

Offner (1939) was the first to identify other paintings by the same hand, an Annunciation now in the National Gallery of Art, Washington, and a Crucifixion now in the Cini collection, Venice. He characterized their author – whom he styled the Master of the Barberini Panels after the Boston and New York paintings, formerly in the Barberini collection, Rome – as probably trained in Florence in the workshop of Filippo Lippi, undoubtedly before 1450, and later influenced by Piero della Francesca and the court of Federigo da Montefeltro at Urbino. Federico Zeri (1953, 1961, 1980) added several more panels to the Master's oeuvre, and proposed identifying him with a certain Giovanni Angelo di Antonio da Camerino, a painter known to have been in Florence in 1451, a companion of Giovanni Boccati (who worked in the Palazzo Ducale, Urbino), and a familiar of both the Malatesta at Rimini and the Montefeltro at Urbino. He dated the Boston and New York panels between 1470 and 1480, citing in them a knowledge of Piero della Francesca's frescoes in San Francesco, Arezzo (completed 1466) and Filippo Lippi's frescoes in the Cathedral at Spoleto (ca. 1468).

On the basis of documents discovered by Lavin (1975), which cite the Boston and New York panels in inventories of Cardinal Antonio Barberini's collection as early as 1644, Zeri presumed that they were among the spoils the Cardinal sent to Rome in 1631-33, when he was Papal Legate at Urbino, but rejected the suggestion, first raised by Venturi (1893), that they might have been part of the high altarpiece of Santa Maria della Bella in Urbino. Vasari (1567) had mentioned the Santa Maria della Bella altarpiece as the work of Fra Carnevale, and Pope Clement XI, in his diary of 1703 (published in della Chiesa, 1969), claimed that Antonio Barberini had appropriated this altarpiece, substituting for it a copy by Claudio Ridolfi. Lazzari (in Colucci, 1796) published a document of 31 October 1467, recording payment of 144 florins to Fra Carnevale for the altarpiece by the syndics of the Fraternità dei Disciplinati di Santa Maria della Bella, and later (1801) discovered Ridolfi's copy, now in Gropello d'Adda, which shows the Birth of the Virgin only and does not resemble the picture supposedly of that subject (New York) by the Master of the Barberini Panels. Primarily because of this discrepancy, Venturi himself (1913) was induced to withdraw his identification of the Barberini panels with the Santa Maria della Bella altarpiece, though the possiblility has been raised, most forcibly by E. Battisti (1971), and rejected numerous times since. Finally, Keith Christiansen (1979)

advanced incontrovertible arguments not only for identifying the Master of the Barberini panels with Fra Carnevale but also for considering the New York and Boston panels as the surviving fragments of the Santa Maria della Bella altarpiece.

A document of 28 November 1445 (Conti, 1976), records the disbursal of money on Filippo Lippi's behalf to Fra Carnavale: "Bartolomeo di Giovanni Coradini da Urbino dipintore et disciepolo di frate Filippo." Christiansen recognized the Barberini Master's hand among the subsidiary figures of an altarpiece by Filippo Lippi of approximately this date, the *Coronation of the Virgin* in the Vatican Pinacoteca, firmly establishing that artist's presence in Lippi's shop, which had earlier been intuited by Offner. Christiansen also noted Pope Clement's contention that Antonio Barberini confiscated the Santa Maria della Bella altarpiece by Fra Carnevale, and the fact that the Boston and New York panels are the only two items in the Cardinal's inventory of 1644 attributable to Fra Carnevale. To the objections that these panels are of an inappropriate format, both for their size and shape, to have been part of an altarpiece, he adduced the evidence of altarpieces by Paolo da Visso in the Pinacoteca at Ascoli Piceno and Niccolò Alunno in the Cathedral at Foligno, both of which are framed with a cusped arcade over a rectangular picture field similar to that implied by the shape of the void areas at the top of both the Boston and New York panels, and the example of a Venetian altarpiece recorded in a drawing in the Robert Lehman Collection at the Metropolitan Museum of Art, New York, in which monumental narrative scenes flank a full-scale image of the Virgin. The Santa Maria della Bella altarpiece must have followed a similar pattern, with the Boston and New York panels at the right and left, respectively, of a lost central image, painted or carved, of the Virgin.

Several recent attempts (Zampetti, 1991; Dal Poggetto, 1992) to revive the identification of the Master of the Barberini Panels with Giovanni Angelo di Antonio da Camerino, and to dissociate the Santa Maria della Bella altarpiece with any of his works, are groundless, based entirely on specious philological arguments. Christiansen's reconstruction of Fra Carnevale's career, subsequently summarized and reformulated by Sangiorgi (1989), is not open to dispute and cannot be added to here. It is only appropriate to conclude by following him in quoting Lazzari's appreciation of the Santa Maria della Bella altarpiece in 1801, which must have been based on an uncited written source since the altarpiece itself had already been missing for 170 years: "nel rappresentare al vivo le figure, e da profane ridurle a Sagre e stato assai valente," precisely those qualities which have intrigued writers about the Boston and New York panels since Vasari first mentioned them nearly 450 years ago.

Niccolò di Liberatore di Giacomo di Mariano da Foligno

NICCOLÒ DA FOLIGNO, also known as l'Alunno, is first documented in 1456, when he painted a fresco of the Crucifixion in the church of S. Maria in Campo near Foligno in central Umbria. From that date until his death in 1502, he received a steady stream of important commissions from towns throughout Umbria and the Marches, including frescoes and altarpieces in Deruta (1458), Spello (1461), Assisi (1468-1470), Gualdo Tadino (1470), Arcevia (1482), Nocera Umbra (1483), Aquila (1487), Todi (1491-92), and Terni (1497), as well as for major works in his native Foligno. The most accomplished Umbrian painter of the third quarter of the fifteenth century, Niccolò da Foligno's style is compounded from the experience of a local school in which he was trained, probably in the workshop of his father-in-law, Pietro Mazzaforte, and the decisive influence of Benozzo Gozzoli's frescoes in Montefalco (1450-52). From the 1460s on, his works reveal a thorough understanding of contemporary Venetian style as exemplified by the Vivarini and Carlo Crivelli, even to a preference for elaborate Venetian-style carved frames and an experimentation with a Venetian technique of oil glazes over his tempera surfaces. Though Niccolò never achieved the wide-spread recognition of Perugino or Pintoricchio, he remained the most significant artist of his generation in Umbria and one of the principal contributors to the development of a recognizable regional style later in the century.

67a

Saint Victorinus, Saint Sebastian, Saint Jerome

Tempera on panel
Overall: 41.8 x 32 (16⅜ x 12⅝)
Picture surface: *S. Victorinus:* 33 x 9.6
(13 x 3¾); *S. Sebastian:* 33 x 9.5 (13 x 3¾);
S. Jerome: 33.3 x 9.7 (13⅛ x 3⅞)

Gift of Mrs. Thomas O. Richardson.
20.1858

Provenance: see no. 20.1859 below

Literature: see no. 20.1859 below

Condition: The panel is composed of three separate wood planks and their original engaged frames which have been glued together to form a single trilobate arcade. The panels have not been glued flush along the front edges where they meet. The engaged frames have been cut away along the sides except for the outer edges of the left and right panels and they have also been regilt along the front and outer edges in order to cover the joins. The sight edges of the frames are mostly intact with the original gilding visible. There is a 13-cm long vertical split in the bottom center of the left panel, 6.5 cm from the left edge. The painted and gilt surfaces of the image are in excellent condition with only minor abrasions and losses along the joins, the split, and in the grass around the feet of St. Sebastian. Minor retouching can be found in these areas of damage.

VICTORINUS wears a robe of woven reeds and hangs by his arms from the cleft branch of a tree. The tree is painted green and grows from a rocky foreground. Sebastian is clothed only in a loincloth, his body pierced by six arrows. His arms are bound behind him to a gray tree trunk growing in a grassy meadow. Jerome is dressed in purple Cardinal's robes and berretta. He reads from a green book open in his left hand and is, like Sebastian, standing in a grassy meadow.
See no. 20.1859 below.

67b

Saint Lawrence, Saint Gregory, and a Bishop Saint

Tempera on panel
Overall: 41.8 x 32.3 (16⁷⁄₁₀ x 12¾)
Picture surface: *S. Lawrence:* 33.4 x 9.8
(13⅛ x 3⅞); *S. Gregory:* 33.2 x 9.9
(13⁷⁄₁₀ x 3⅞); *Bishop Saint:* 33.4 x 9.8
(13⅛ x 3⅞)

Gift of Mrs. Thomas O. Richardson.
20.1859

Provenance: S. Venanzio, Camerino, until 1808; Don Anastasio Tacchi, Camerino, 1828-1866 (?); Marchese Ranghiasci-Brancaleoni, Gubbio, until 1882; Mrs. Thomas O. Richardson, Florence

Literature: Servanzi-Collio, 1858, pp. 298-299; Piceller, 1882, p. 22, no. 380; Gnoli, 1912, p. 252; idem, 1921, pp. 41-43; idem, 1923, p. 214; Berenson, 1932, p. 392; van Marle, vol. 14, 1933, p. 38; Rinaldi, 1946-47, p. 97; Laclotte, 1956, pp. 76-77; Berenson, vol. 1, 1968, p. 295; Fredericksen and Zeri, 1972, pp. 125, 564; Laclotte and Mognetti, 1977, nos. 187-197; Pacciaroni, 1984, p. 45 fn. 72; Todini and Lunghi, 1987, n. p.; Todini, vol. 1, 1989, p. 241.

Condition: The complex is made up of three separate panels, complete with engaged moldings from the original framing members, shaved along the sides (except for the outer edges of the left and right panels) to just within the picture field and glued together to form a single, trilobate arcade. The front surface of the frames have been regilt to mask the joins, but the inner edges are largely preserved intact with the original gilding. The gold and paint surfaces are exceptionally well preserved, except for scattered minor flaking losses and an area of modern gilding, approximately 4 x 2 cm, at the right edge of the right panel, at the height of the bishop's shoulder.

SAINT LAWRENCE, at the left, wears a green dalmatic with red apparels; he holds a red book in his left hand and in his right a palm and the grill of his martyrdom. In the center, Saint Gregory wears a papal tiara and a red chasuble with pallium, and reads from a green book which he holds open before him. The bishop saint at the right wears a mitre and purple cloak; he holds a red book in his left hand and a crozier in his right. All three saints are shown standing in a grassy meadow and turned slightly to the viewer's left.

These three saints, and those in no. 20.1858 above, are fragments of the framing pilasters from an altarpiece painted by Niccolò da Foligno for the church of S. Venanzio in Camerino. Six more saints, identical to these in format but not joined into groups of three and therefore retaining their original moldings intact, are in the Musée du Petit Palais in Avignon (figs. 46-51). These represent Saint Paul (Laclotte and Mognetti, 1977, no. 189), a bishop saint (ibid., no. 190), Saint Anthony Abbot (ibid., no. 191), Saint Victor (?) (ibid., no. 192), Saint Stephen (ibid., no. 193), and a second bishop saint (ibid., no. 194). The six Avignon saints were identified by Gnoli (1912) as parts of the S. Venanzio altarpiece, together with two pinnacle panels representing the Annunciation and two predella panels showing the Nativity and the Ascension also now in Avignon (figs. 52, 53), and a third predella panel showing the Pentecost (Museo Diocesano, Camerino). Gnoli later (1921) recognized the six saints in Boston as parts of the same complex. The main tier of the S.

Venanzio altarpiece, representing the Crucifixion between Saints Peter, Venanzio, John the Baptist, and Porfirio with angels and prophets, and a central pinnacle representing the Resurrection, is today in the Vatican Pinacoteca.

The basis for Gnoli's reconstruction of the altarpiece was a detailed description of it compiled by Conte Severino Servanzi-Collio in 1858, who in part drew upon earlier descriptions contained in G. Ranaldi, *Memorie di belle arti*, ms., II, 18, p. 265, and in G. C. Gentili, *De Ecclesia Septempedana*, III, 18, p. 26. According to Servanzi-Collio, the elaborate frame that surrounded the altarpiece was destroyed at the time of the Napoleonic suppressions (1808), but the painted figures that adorned the pilasters were saved. He was informed that Count Francesco Morelli of Camerino had sold four of these figures in Rome in 1843, and he himself had seen six, joined into two sets of three, in the collection of Don Anastasio Tacchi. The latter were clearly the Boston saints, but it is uncertain whether the four sold by Count Morelli are among those now in Avignon, which entered the Campana collection before 1862, or whether there might not originally have been sixteen saints, four of which are missing today.

The disposition of the twelve known pilaster saints around the three panels of the principal tier of the altarpiece is difficult to reconstruct. They are evenly divided amongst themselves between figures oriented to the left and oriented to the right. They are, however, too large to have stood in four columns of three, one on either end of the structure and one separating the center panel from the laterals on each side. Probably the outermost columns contained only two saints while the two inner columns each had four: two in a lower tier corresponding to those in the outer pilasters and two in an upper tier, at the level of the upper half of the central Crucifixion and the chorus of weeping angels in its spandrel.

The S. Venanzio altarpiece is thought to have been commissioned by the prior Ansovino di Angeluccio Baraciani da Pierleone, who was also responsible for the provision of wooden choir stalls, the bell, and many of the liturgical instruments of the church, as well as providing 300 florins in his will (14 September 1477) towards the completion of the facade of the basilica. No documents specifically connect him with the painting of the altarpiece, but his heirs in the nineteenth century brought suit for the recovery of fragments of an altarpiece from the church (Santoni and Aleandri, 1906, p. 150 fn. 4). It has been suggested that Niccolò da Foligno's altarpiece stood in the

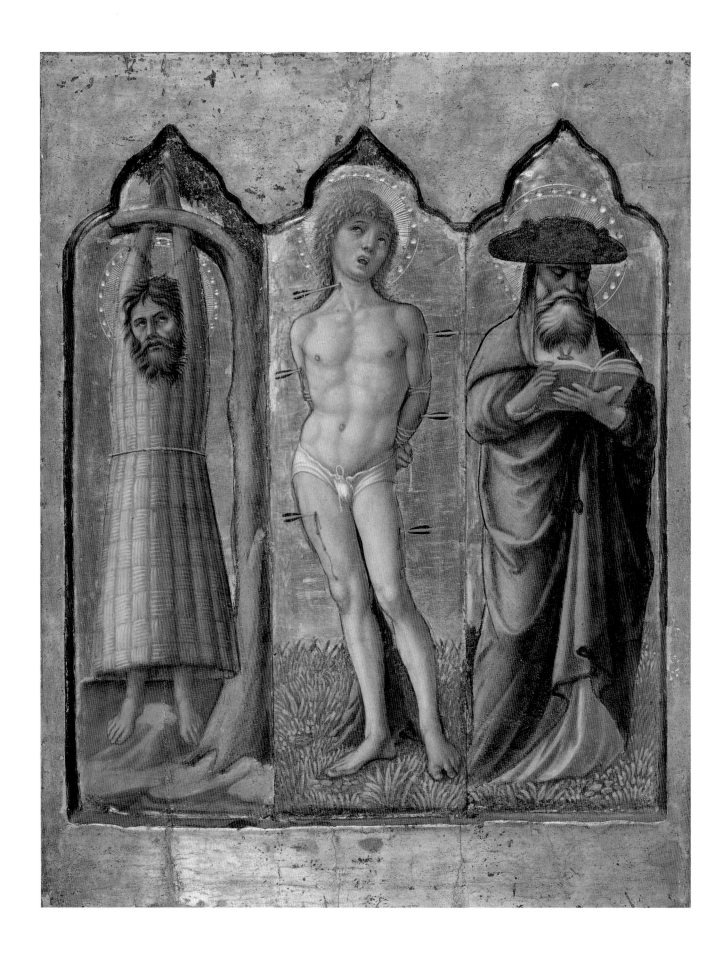

216 (cat. 67a)

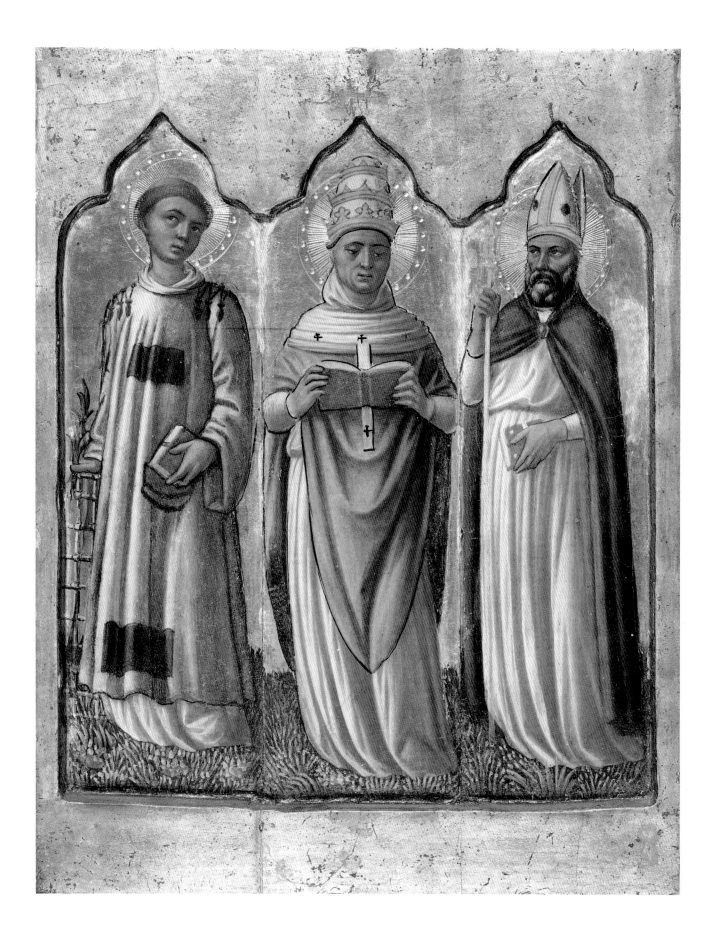

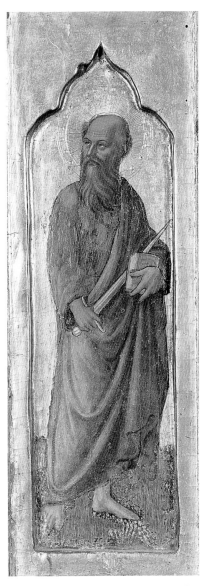

Fig. 46. Niccolò da Foligno, *Saint Paul*. Musée du Petit Palais, Avignon

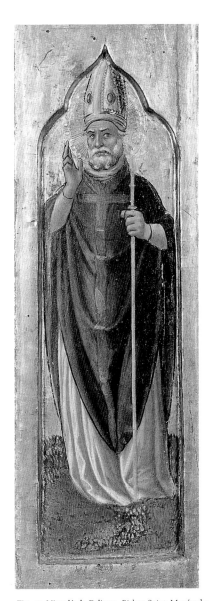

Fig. 47. Niccolò da Foligno, *Bishop Saint*. Musée du Petit Palais, Avignon

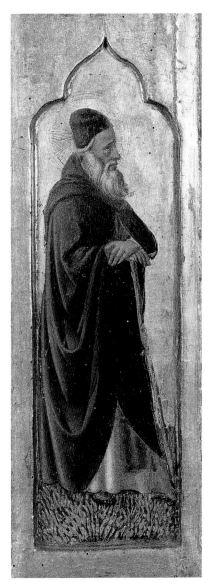

Fig. 48. Niccolò da Foligno, *Saint Anthony Abbot*. Musée du Petit Palais, Avignon

chapel of Saint Michael in S. Venanzio, since the Archangel is portrayed twice in the predella (Gnoli, 1912). Only one figure in the predella, however, can unequivocally be indentified as Saint Michael, and Lunghi's (1987) contention that the complex stood on the high altar of the church is more likely if Ansovino Baraciani was indeed its patron.

Various opinions have been expressed over the dating of the complex, ranging from the earliest to the latest part of Niccolò da Foligno's career. A record of it intact in the church of S. Venanzio, however, verifies that it was completed and installed in 1480 and leaves open the likelihood that it was begun shortly after the death of Ansovino Baraciani in 1478: "A. S. Venanzio di Camerino e una gran

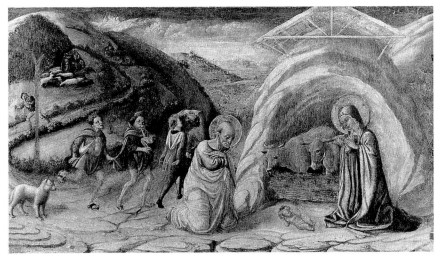

Fig. 52. Niccolò da Foligno, *Nativity*. Musée du Petit Palais, Avignon

218

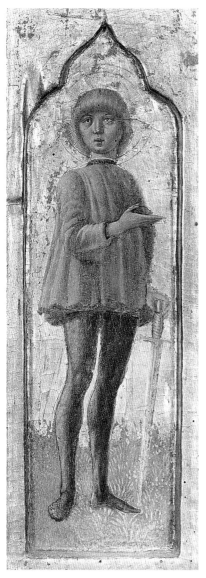

Fig. 49. Niccolò da Foligno, *Saint Victor*. Musée du Petit Palais, Avignon

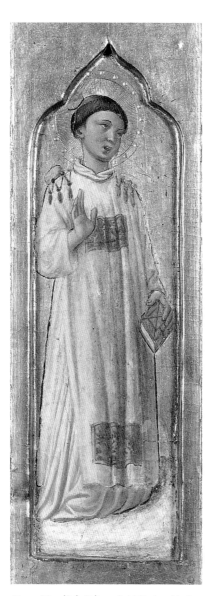

Fig. 50. Niccolò da Foligno, *Saint Stephen*. Musée du Petit Palais, Avignon

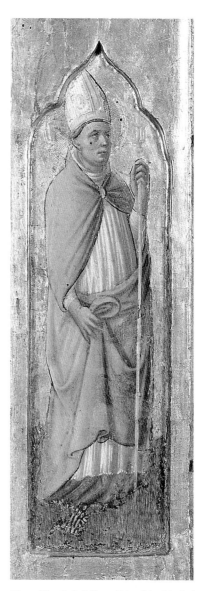

Fig. 51. Niccolò da Foligno, *Bishop Saint*. Musée du Petit Palais, Avignon

tavola d'altare tutta con fondo d'oro, ov'e espresso Gesù in croce fra varj SS., aggiuntevi tre picciole istorie evangeliche. La iscrizione E OPUS NICOLAI FULGINATIS, 1480" (Lanzi, 1809, p. 22).

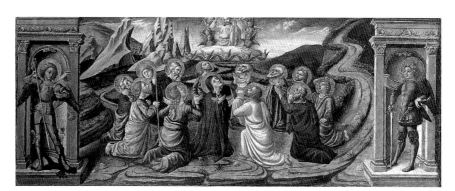

Fig. 53. Niccolò da Foligno, *Ascension*. Musée du Petit Palais, Avignon

Bernardino di Betto di Biagio, called Il Pintoricchio

BORN IN PERUGIA about 1454, Pintoricchio is first mentioned in a document of 1481, when he registered in the painters' guild there. He may have been active as much as a decade before that, however, first as an apprentice and then as an associate of Pietro Perugino, by whom he appears to have been employed in executing the wall frescoes in the Sistine Chapel in 1481/82. Following completion of a fresco cycle in the Bufalini chapel in S. Maria in Aracoeli, Pintoricchio was recognized as the preeminent monumental painter in Rome, where for the next two decades he enjoyed the almost exclusive patronage of Alexander VI Borgia, for whom he painted a series of private apartments in the Vatican and several rooms in the Castel Sant'Angelo, and the Della Rovere, whose commissions included three chapels in Santa Maria del Popolo and the initial work in the Vatican Stanze, interrupted by the arrival of Raphael in 1508. Pintoricchio also undertook major fresco projects in Orvieto and Spello, and in 1503 he was called to Siena by the nephews of Pope Pius III Todeschini-Piccolomini to decorate the Cathedral Library, completed in 1508. Pintoricchio spent the last ten years of his life in Siena, where he also painted frescoes in the Baptismal chapel in the Cathedral and in the palace of the Magnifico Pandolfo Petrucci, and where his work exerted a profound influence on the younger generation of Sienese artists. He died in 1513.

Pintoricchio's quintessentially Umbrian style, formed under the tutelage of Perugino and at times barely distinguishable from that of Fiorenzo di Lorenzo, is characterized – in his monumental frescoes, his altarpieces, and his intimate devotional panels – by an accomplished, almost miniaturist sense of naturalistic detail coupled with a lyrical palette of saturate colors and a lavish use of gold and gilt pastiglia appliques for highlights and decorative arabesques. In Rome, he became the earliest exponent of a literal revival of antique style in adopting the use of so-called grotesque ornament and illusionistic, architectonic framing structures, imitating the fresco decoration of the then-recently discovered Golden House of Nero. Though he is perhaps less highly regarded today than are many of his contemporaries, he was during his lifetime the most influential painter in Central Italy, excepting only Perugino and Signorelli.

Virgin and Child with Saint Jerome

Oil on panel
Overall: 52.6 x 39.0 (20¾ x 15⅜)
Picture surface: 51.0 x 37.4 (20⅛ x 14¾)

Gift of Mrs. W. Scott Fitz. 20.431

Provenance: Bacchettoni, San Gemini (Narni); Duveen, New York, 1920

Literature: Hawes, 1920, pp. 26-27; Gnoli, 1920, pp. 357-360; idem, 1923, p. 116; Lazarev, 1926, pp. 220-223; Berenson, 1932, p. 459; Venturi, 1933, vol. 2, pl. 324; van Marle, vol. 14, 1933, pp. 181-182; Berenson, 1936, p. 394; Zeri, 1953, p. 136; Fumarola, 195-?, pp. 5-18; Davies, 1961, p. 183; Berenson, 1968, vol. 1, p. 134; Fredericksen and Zeri, 1972, pp. 71, 564; Steinberg, 1986, pp. 150, 154; Todini, vol. 2, 1989, p. 67, vol. 1, pl. 1132.

Condition: The panel, composed of two vertical planks joined 1.5 cm from the right edge, has been thinned to a depth of 1.5 cm and was formerly cradled. The cradle was removed in a recent restoration (1989) and replaced with two thin movable battens. A gesso beard is preserved along all four edges of the paint surface, indicating the removal of an engaged frame, and a thin red painted border, which would have continued up onto this frame, remains just inside the beard. Aside from scattered pinpoint flaking, the paint surface is extremely well preserved, with only minor abrasions and minimal retouching. The gold of the haloes and of the star on the Virgin's shoulder is worn, and an uneven residue of old varnish covers the haloes of all three figures and the Virgin's mantle. Several vertical, partial splits in the upper half of the panel are visible through the paint surface, most notably in the faces of the Virgin and the Christ Child, but these have resulted in minimal paint loss.

THE VIRGIN is shown half-length behind a marble parapet in a high-waisted red dress bound with a green sash, covered by a heavy blue mantle highlighted with gold. She holds a closed book in her left hand, resting on a fold of her mantle, and with her right she supports the Christ Child, naked, standing on the parapet before her and looking back over his right shoulder out of the picture. Behind the Virgin at the upper right appears the bust-length figure of Saint Jerome, in red Cardinal's robes and hat, while a view of a distant landscape fills out the composition at the left.

Through most of its known history, the Boston Virgin and Child with Saint Jerome has been considered a prime example of the mature style of Fiorenzo di Lorenzo, and has been adduced (Lazarev, 1926; Fumarola, 195[?]) as evidence that Fiorenzo was at least as influential on his contemporaries Perugino and Pintoricchio as they were on him. Berenson (1932) first suggested that the Boston painting might instead be an early work by Pintoricchio, though he subsequently (1936, 1968) listed it as by

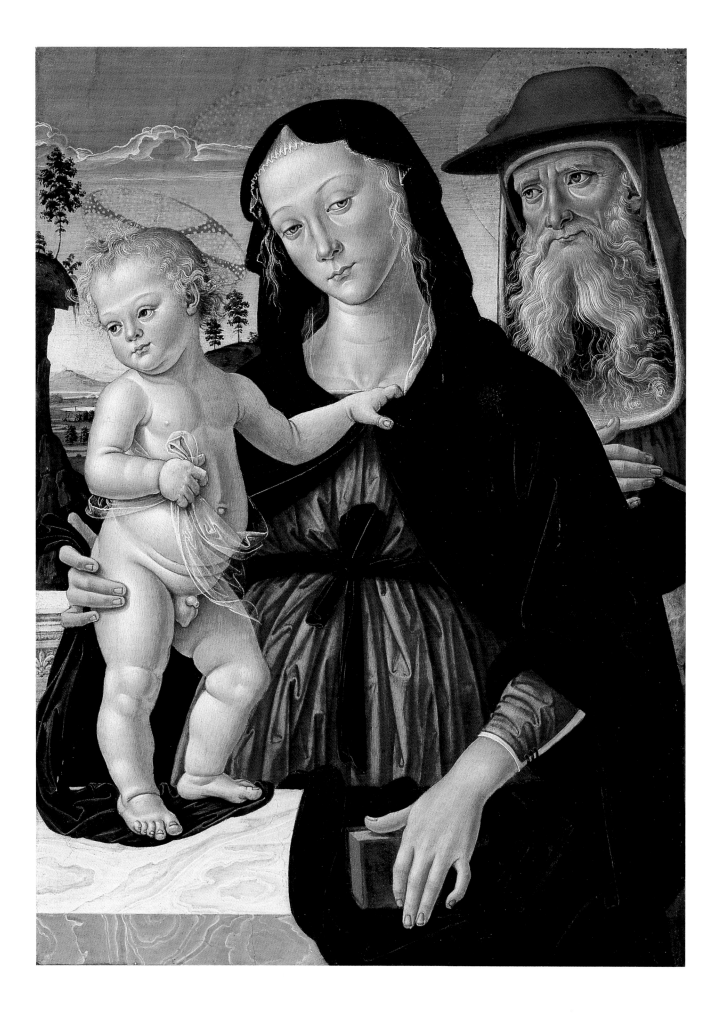

Fiorenzo di Lorenzo. Berenson's suggestion was directly rejected by Zeri (1953: "inesattamente elencata dal Berenson sotto l'elenco del Pinturicchio"), who contrasted the Boston painting with a related *Virgin and Child* in the National Gallery, London (Salting Bequest), also generally considered the work of Fiorenzo di Lorenzo but for which he accepted Berenson's attribution to Pintoricchio. Everett Fahy (manuscript opinions 1967, 1985), has recently returned to Berenson's initial pronouncement, describing the Boston painting as an important early work by Pintoricchio, painted about 1480.

The Virgin and Child in the Boston painting are very evidently related in type and composition to the same two figures in the lunette above the so-called "nicchia di S. Francesco" by Fiorenzo di Lorenzo (Galleria Nazionale dell'Umbria, Perugia, inv. no. 235; F. Santi, 1985, pp. 69-71), dated 1487, and the two works have been assumed not only to be by the same artist but also to be roughly contemporary. It is, however, only possible to accept 1487 as the date by which this particular grouping of the Virgin and Child was current in Umbria: it appears as well in a fresco of 1489 by the Eugubine painter Orlando Merlini (Casa Castalda, Madonna dell'Olmo; Todini, 1989, vol. 2, pl. 850) and in numerous Peruginesque Madonnas (Rome, Galleria Borghese; Moscow, Puschkin Museum; Cambridge, Fitzwilliam Museum; etc.). The handling of paint and the modeling of forms in the "nicchia" are much heavier and more schematic than in the Boston painting, revealed by a recent cleaning to be a tour-de-force of surface detail unmatched in delicacy or refinement in any known painting by Fiorenzo di Lorenzo. In this respect, the Boston painting compares favorably to the Salting Madonna in London and to a Saint Jerome in the Walters Art Gallery, Baltimore (Zeri, 1976, vol. 1, pp. 168-170), both attributed convincingly by Zeri to Pintoricchio. The Pintoricchiesque character of the Boston painting has been remarked by every author to have discussed it, but it has in every instance been explained either as evidence of Fiorenzo's influence on Pintoricchio or of Pintoricchio's influence on Fiorenzo.

The composition of both the Salting Madonna and the Boston Madonna are loosely derived from Perugino's early experiments in this genre, notably the Virgin and Child in the Musée Jacquemart-André, Paris, and that in the Staatliche Muséen, Berlin-Dahlem, generally dated to the early 1470s. The figure types, landscape, lighting effects, and drapery forms in the Boston painting all consciously imitate similar details in early paintings by Perugino, but without the latter's characteristic sense of volume and plasticity, relying instead on a miniaturist, decorative touch which can also be found in works plausibly attributed to the young Pintoricchio working as Perugino's assistant. Foremost among these are two of the panels showing miracles of Saint Bernardino, painted in 1473 for S. Francesco al Prato, Perugia – Saint Bernardino freeing a prisoner and Saint Bernardino restoring to life a man killed and found beneath a tree (Santi, 1985, pp. 86-90). Similarities between these panels, especially the second of them, and the Boston painting are so compelling as to suggest a common authorship and approximate contemporaneity, though attributions for the entire series of Saint Bernardino panels are too much a subject of contention to provide a reliable basis for identification. In the present, limited state of knowledge of Umbrian painting in the 1470s and 1480s, it is safe only to propose a tentative attribution for the Boston panel to the young Pintoricchio, probably painted shortly after the Saint Bernardino panels of 1473 and certainly before the artist's first commonly accepted independent works, the frescoes in the Bufalini chapel in Santa Maria in Aracoeli, Rome, of the early 1480s.

Bernardino di Lorenzo di Cecco

BROTHER and collaborator of the better-known Fiorenzo di Lorenzo, Bernardino is first certainly mentioned in a document of 1477, when he matriculated in the painters' guild of Perugia, though he may be identical with a certain Bernardino da Perugia mentioned in notices of 1471 and 1474 (Gnoli, 1923, pp. 67-68). Known through a single signed work, a processional standard of 1498 representing the Trinity with Saints Peter and Roch formerly in the Briganti collection, Perugia (reproduced in Todini, vol. 2, 1989, fig. 1138), Bernardino's artistic identity has been only partially reconstructed. The handful of paintings attributed to him on the basis of this standard reveal him to have been a conservative master strongly dependent on his brother's example, tempered slightly by the influence of Bartolomeo Caporali and Niccolò da Foligno. Bernardino di Lorenzo died in 1530.

69

Saint Sebastian

Fresco, transferred to canvas
Overall: 179 x 62.9 (70½ x 24¾)

Charles Potter Kling Fund. 47.232

Provenance: Robert I. Nevin, Rome, (sale, Galleria Sangiorgi in Palazzo Borghese, Rome, 22 April 1907, lot 356); Mrs. Robert Bonner (sale, American Art Association, New York, 5 May 1928, lot 716); Seligman & Brummer, New York

Literature: Edgell, 1947, pp. 70-74; Berenson, vol. 1, 1968, p. 134; Fredericksen and Zeri, 1972, pp. 71, 565; Todini, vol. 1, 1989, p. 32.

Condition: The fresco has been transferred to a canvas support, causing numerous cracks, losses, and small distortions in the paint surface. Additionally, numerous large losses, especially along the edges and near the bottom, have been coarsely restored and inpainted, and are now discolored. The red border at the right is modern. A few white patches have come to the surface in the bottom half of the painting.

THE SAINT is shown full length standing on a green marble pavement, wearing only a loin cloth, and facing in three-quarters profile to the right. He is bound with his hands behind him to a porphyry column, the shafts of ten arrows bristling from his body. The background of the painting is red with a superimposed pattern of black lozenges, and is closed off on the left by a painted yellow molding, perhaps the front edge of a niche or architectural surround now cropped at the top and right edges of the composition.

This little-known fresco was first published by Edgell (1947), when it entered the collection of the Museum of Fine Arts, with an attribution to Fiorenzo di Lorenzo, an attribution repeated in the Berenson lists of 1968 with a qualifying "(?)." Edgell's attribution was based on generic similarities to paintings by Fiorenzo such as the Saint Sebastian in the Galleria Nazionale dell'Umbria, Perugia (no. 231), and on specific similarities to another Saint Sebastian which he published as the left wing of a triptych formerly in the Galleria Sangiorgi in the Palazzo Borghese, Rome: "here attitude, drawing, setting, and composition are so similar as to produce almost an exact replica. Indeed, I should have used only the Borghese piece to prove the authorship of the Boston panel, were it not for the fact that the Borghese painting is so badly damaged and the photograph so poor." Edgell was unaware that the Boston fresco is the ex-Galleria Sangiorgi picture, and that the photograph he published simply showed the work in its unrestored state.

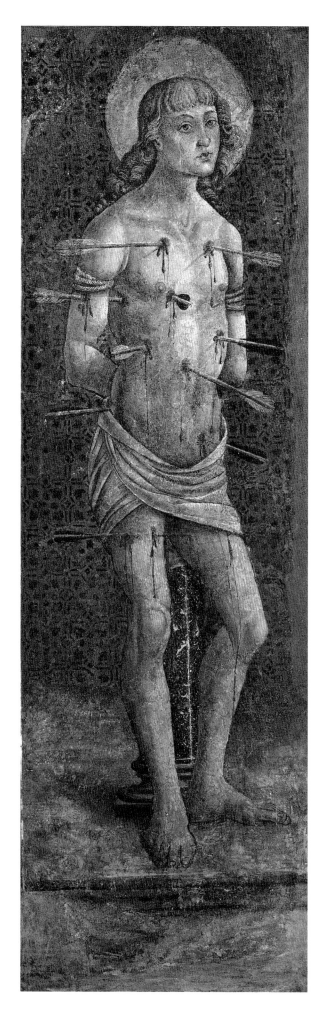

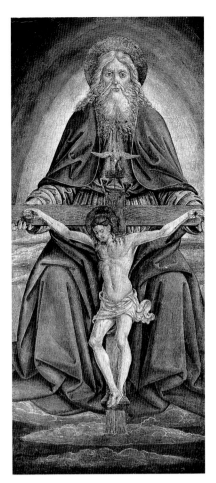

Fig. 54. Bernardino di Lorenzo, *Holy Trinity*. Formerly Galleria Sangiorgi, Rome

The Boston fresco appeared at the Nevin sale at the Galleria Sangiorgi (1907) as one of a set of three frescoes, attributed there to the school of Fiorenzo di Lorenzo, representing in the center the Trinity (178 x 87 cm) with a Saint Sebastian at either side (178 x 75 cm each). The three frescoes are reproduced in Galleria Sangiorgi, Rome, *Catalogue des Objets d'Art Ancien pour l'année 1913*, Venice, 1913, pl. 4. The central Trinity recently reappeared at auction (Sotheby's, Florence, 6 May 1980, lot 528; fig. 54), and was identified and published by Todini (1989, p. 32) with a convincing attribution to Bernardino di Lorenzo. The Boston fresco is also attributed by Todini to Bernardino di Lorenzo, but not associated with the Trinity. The third fresco from the Nevin sale is to be identified with the Saint Sebastian in the Contini-Bonacossi bequest at the Castel Sant'Angelo (fig. 55), also attributed by Todini to Bernardino di Lorenzo.

The cartoon for the Boston fresco is in most essentials a reversal of Fiorenzo di Lorenzo's design for the Saint Sebastian now in the Staedel Institut, Frankfurt (ill. Berenson, vol. 2, 1968, fig. 1067). This and the related image in Perugia (Galleria Nazionale, no. 231) are based on Mantegnesque prototypes, probably known

to Fiorenzo through the intermediation of Gerolamo da Cremona, and are generally considered early works. By the 1490s, Fiorenzo demonstrated a preference for a Peruginesque type of Saint Sebastian, as in the San Giorgio dei Tessitori frescoes (1498) or the painting in the Palazzo Spada, Rome. It is reasonable to assume that Bernardino's dependence on his brother's designs would not have been exaggeratedly retardataire and that the Boston fresco therefore may be dated to the 1480s or the late 1470s, an assumption supported by close stylistic similarities to the work of Bartolomeo Caporali (Bury, 1990, pp. 469, 475) in those decades, by whom Bernardino di Lorenzo is supposed to have been influenced in his early career. If the Boston Saint Sebastian was commissioned as an ex-voto for deliverance from the plague, it may be possible to associate it either with the epidemic of 1475-79 or with that of 1486.

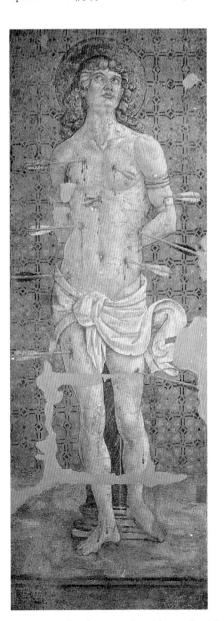

Fig. 55. Bernardino di Lorenzo, *Saint Sebastian*. Contini-Bonacossi Bequest, Castel Sant'Angelo, Rome

Luca d'Egidio di Ventura Signorelli

THE DATE of Luca Signorelli's birth is uncertain. Given by Vasari as 1441, he may actually have been born as late as 1450-55. According to contemporary sources, Signorelli was apprenticed to Piero della Francesca, perhaps while that artist was finishing work on the fresco cycle of the True Cross in San Francesco, Arezzo (Signorelli was born in nearby Cortona), and he appears to have worked with Piero in Perugia, San Sepolcro, and Città di Castello in the late 1460s and early 1470s. After a probable period of employment in the shop of Pietro Perugino in Florence and Rome, including work on the wall frescoes in the Sistine Chapel, Signorelli is first recognizable as an independent artist in an altarpiece of 1484 (Perugia, Museo dell' Opera). From that date until the first decade of the sixteenth century, Signorelli received and executed major commissions throughout Tuscany, Umbria, and the Marches, culminating in the fresco cycle of the Last Judgment in Orvieto Cathedral (1499-1504) and the commission from Pope Julius II to paint alongside Perugino and Pintoricchio in the Vatican Stanze (1507), a work destroyed shortly afterward and replaced by Raphael. From about 1510 until his death in 1523, Signorelli remained active primarily in his native Cortona, supplying altarpieces to a provincial, relatively conservative clientele, many painted with extensive assistance from his nephew, Francesco Signorelli.

Vasari says of Signorelli that his heroic narrative style and his mastery of rendering the nude brought to a close the "second period" of the revival of the arts in the modern age, and paved the way for the perfection of the "third period," i.e. for the advent of Michelangelo. The Last Judgment frescoes in Orvieto, Signorelli's masterpiece and one of the great accomplishments of the Italian Renaissance, inspired numerous painters in the sixteenth century and later, and many of his lesser commissions – in Siena, Città di Castello, Cortona, and Arcevia, for example – indelibly altered the development of local schools of painting. Though his

reputation declined in his later years, he may be considered alongside Perugino as the most important central Italian painter outside Florence in the last two decades of the fifteenth century.

Virgin and Child with an Angel

Tempera and oil on panel
59 x 40.5 (23¼ x 16)

Maria Antoinette Evans Fund. 22.697

Provenance: Menchetti collection, Rome (?); Private collection, England; Lino Pesaro, Milan

Literature: Venturi, 1921-22, pp. 71-72; Hawes, 1923, p. 48; Berenson, 1926, pp. 105-117; van Marle, vol. 11, 1929, pp. 90-91, vol. 16, 1937, pp. 5-7; Longhi, 1930, p. 155; Meiss, 1941, pp. 53ff.; Zeri, 1953, pp. 130, 132-134, 139 fn. 13; Salmi, 1953, p. 45; Briganti, 1954, no. 21, p. 3; Martini, 1960, pp. 139-140; Scarpellini, 1964, pp. 11, 146; Byam Shaw, 1967, p. 48; Battisti, 1971, p. 92; Fredericksen and Zeri, 1972, pp. 164, 564; Kury, 1978, pp. 303-315; Zeri and Natale, 1984, pp. 24-26; Kanter, 1990, pp. 95-111; Paolucci, 1990, p. 5; Lightbown, 1992, p. 262-3; Berti, 1992, pp. 30-32, 97, 108, 116, 118.

Condition: The wood panel support has been thinned to a depth of 1.3 cm and cradled. Exposed worm channels along the left edge indicate that it has been trimmed somewhat on that side. A split, 18 cm from the right edge, is held together by metal joins at the top and bottom. The paint layers exhibit an extensive craquelure that is most pronounced in the sky and figures. Associated with the cracking pattern are numerous small losses that have been extensively retouched. The painting is badly abraded and much of the modeling is worn away from solvent damage in past restorations. The most significant losses have occurred in the figure of the Christ Child and in the hands of the Virgin.

THE VIRGIN, wearing a soft blue dress with red sleeves beneath a blue cloak with a green lining, is shown half-length behind a parapet which is draped with red brocade. She supports the Christ Child, who is seated naked on a cushion placed on a small marble throne. The throne is set atop the parapet and is covered with a red and gold cloth of honor. The Child holds a finch in his right hand and raises one finger of his left hand in benediction. Behind the Virgin at the left stands an angel, and behind that figure is a low white marble wall inlaid with porphyry. A single cloud hovers in the blue sky above the head of the Christ Child.

This well-known and controversial painting was first brought to public attention by A. Venturi in 1921, who included it in his monograph on Piero della Francesca as a fully autograph work of about the same date as the Misericordia altarpiece in San Sepolcro. Venturi (followed by Hawes, 1923) is the only author to have attributed the painting directly to Piero, however. Berenson (1926) first proposed associating it with two other devotional panels of the Madonna and Child, one at Christ Church, Oxford, and one then in the Villamarina collection, Rome (now Cini collection, Venice), which had earlier been identified by Gnoli (1923, p. 319) as juvenile works by Luca Signorelli on the basis of their strong resemblance to the remains of a purportedly documented fresco of 1474 in Città di Castello. All subsequent discussion of the picture's attribution or significance has centered around the validity of this grouping and its relationship to the late works of Piero della Francesca and the known earlier works of Luca Signorelli.

Notwithstanding a number of opinions to the contrary (e.g., Meiss, 1941; Zeri, 1953; Scarpellini, 1964; Kury, 1978; Zeri and Natale, 1984; Berti, 1992), there can be little doubt that the present picture is by the same artist who painted the Christ Church and Cini Madonnas and the fresco at Città di Castello. Presumed differences between them are all to be ascribed to the seriously deteriorated condition of the Boston panel and the sequence of restorations it has undergone (fully documented in Kanter, 1990), and to the abraded and partially repainted state of the Cini Madonna. A recent campaign of restoration (1988) intended to free the Boston panel of its opaque varnish and of the additions made to it in 1940 bears this out. A processional standard showing the Circumcision of Christ formerly in the Cook collection, Richmond (now in a private collection, Italy), has also been associated with these paintings on stylistic grounds (Salmi, 1953; Briganti, 1954; Martini, 1960). This painting, too survives in severely compromised condition, but appears, despite differences in medium and support, also to be by the author of the Boston Madonna, notwithstanding repeated attributions for it to the young Pietro Perugino (Zeri, 1953; Berti, 1992).

While it seems clear that these paintings are all by a single artist, the identity of that artist has been hotly debated. It was established by Battisti (1971), though his observation was ignored by subsequent writers, that the documentation for the fresco fragments in Città di Castello, in the form of a description in a contemporary chronicle, refers only to their date, 1474, and is silent in regard to their authorship. Authority for an attribution to Luca Signorelli goes no further back than a local tradition of the eighteenth century. Signorelli had strong ties to Città di Castello, where he was made a citizen in 1488 and where he painted five surviving altarpieces, a processional standard, and three portraits of members of the Vitelli family.

Morphological similarities between any of this group of supposed early works and the known paintings of Luca Signorelli are also tenuous, but it can be shown (see Kanter, 1990, p. 100) that their

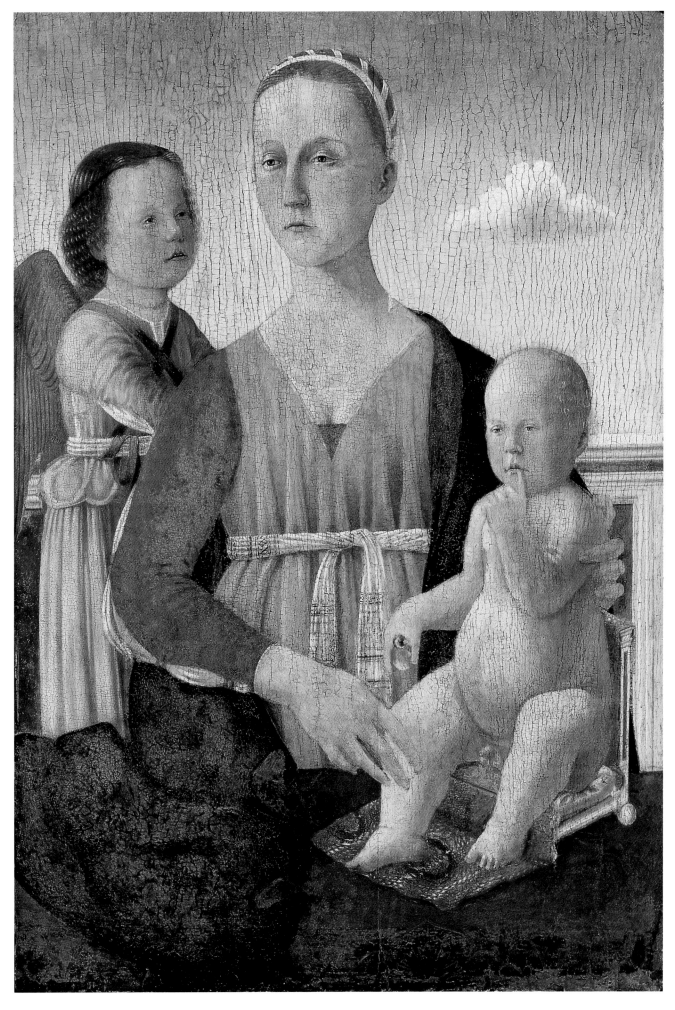

226 (cat. 70)

technique exactly conforms to Luca Signorelli's handling of paint, which is unique among Central Italian painters of the fifteenth century. It can also be shown that they present tangible stylistic links to another group of works attributable to Luca Signorelli (in collaboration with Pietro Perugino) from the late 1470s or around 1480, including a Crucifixion altarpiece in the Uffizi, Florence, and an altarpiece of the Adoration of the Magi in the Galleria Nazionale dell'Umbria, Perugia (ibid., pp. 98-99). The Boston Madonna was in all likelihood painted by Signorelli presumably while the artist was still a member of Piero della Francesca's shop, around 1470-75.

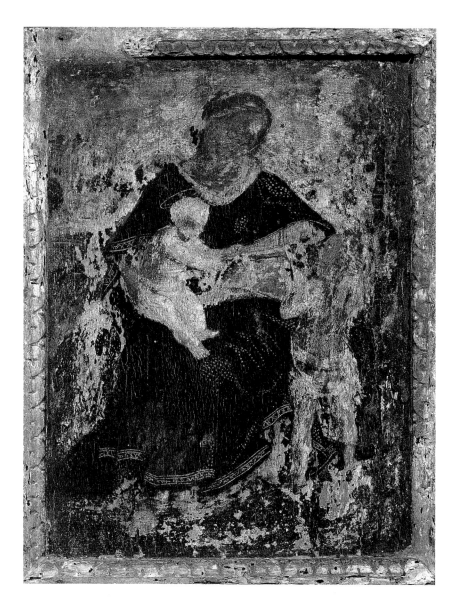

71

Virgin and Child with the Infant Saint John the Baptist

Oil on panel
Overall: 43.8 x 33 (17¼ x 13)
Picture surface: 38.7 x 28.9 (15¼ x 11⅜)

Gift of Mr. and Mrs. W deForest Thomson. 19.131

Provenance: Unknown; Mr. and Mrs. W. deForest Thomson, by 1919

Condition: Ruinous. The painting, with the exception of the Virgin's mantle, has been effaced by solvents. Fragments of the original engaged molding survive on all four sides and the panel support has not been thinned or altered in any way.

THE VIRGIN in a blue (?) mantle, is seated in a landscape (?) with the Christ Child on her lap. The Child reaches across his mother's body toward the nearly obliterated figure of the young Baptist standing to the right.

This unpublished painting has never borne a specific attribution since entering the Museum of Fine Arts, nor perhaps does its ruinous condition warrant one. The composition, however, and the underdrawing now clearly visible beneath the missing pigments reveal that it was once an autograph late work by Luca Signorelli, approximately contemporary to his tondo of the two Holy Families in Berlin (ca. 1513). At this period in his career, Luca Signorelli was active almost exclusively in Cortona, and the fact that this panel was accompanied in the Thomson collection by a panel by a Cortonese follower of Signorelli (Res. 19.134), implies that both pictures may have been purchased either in Cortona or from a Florentine dealer who would have acquired them there.

Matteo di Pietro di Giovanni da Gualdo Tadino

MATTEO DA GUALDO, the dominant artistic personality in southern Umbria in the last third of the fifteenth century, is documented at frequent intervals of activity in his native town of Gualdo Tadino between 1462 and 1503, though he is also known to have worked nearby in Nocera Umbra and in Assisi. A provincial artist receptive to an eclectic range of influences, he forged a distinctively individual style from the combined examples of the Marchigian painters Giovanni Boccati and Girolamo di Giovanni da Camerino and the Umbrians Niccolò da Foligno (q.v.) and Bartolomeo di Tommaso. Matteo was also clearly aware of Benozzo Gozzoli's Umbrian frescoes, and it appears he may also have been familiar with contemporary artistic endeavors as far away as Siena and Padua, with which his work often exhibits superficial similarities.

72

Madonna and Child Enthroned

Fresco, transferred to canvas
Overall: 172 x 108 (67¾ x 42½)

Charles Potter Kling Fund. 47.234

Provenance: Casa Ferri, Acciano (Nocera Umbra), 1907; Count Gentile, Foligno; Joseph Brummer, New York, 1925; William Randolph Hearst; Joseph Brummer, New York

Literature: *Corriere*, 1907; Massei, 1908, p. IV, V; Gnoli, 1923, p. 198; Perkins, 257; van Marle, vol. 14, 1933, p. 98; Edgell, 1947, pp. 70-71; Berenson, vol. I, 1968, p. 262; Fredericksen and Zeri, 1972, pp. 139, 565; Donnini, 1974, pp. 4, 9 fn. 11; Zeri, vol. I, 1976, p. 162; Todini, vol. I, 1989, p. 211, vol. 2, p. 384.

Condition: The fresco painting was transferred onto a coarse canvas support. Large undulating sags and planar distortions have formed over the surface, caused by the weight of the plaster layer. The painting is in poor condition from weathering, exhibiting numerous losses and cracks, especially in the four corners. All losses have been extensively retouched and in some areas completely repainted.

THE MADONNA is seated frontally on a carved marble throne draped with a brocade cloth of honor. She holds an open book in front of her in her left hand, and with her right supports the Christ Child standing on her lap. The Child inclines his head slightly to the left, raises his right hand in benediction, and rests his left hand on the open book held by his mother. Behind the throne at either side appear the rudiments of a low brick or stone wall. The fresco is completed by a painted frame, in the predella of which are the remains of a mutilated three-line inscription.

This fresco was first described *in situ* in 1907 (Massei, 1908) on the east facade of the Casa Ferri in Acciano, near Nocera Umbra. At that time it was enclosed in a wooden tabernacle which lacked shutters, and the inscription at its base was at least partly legible. Massei recorded the first line: "Questa è la Matre de li peccaturi ..."; and the few surviving characters still legible today confirm the accuracy of this transcription. Massei read the date at the right in the inscription as 1497. Only the first two digits are legible today.

The fresco had been removed from the facade of the Casa Ferri and sold by 1923, when Umberto Gnoli listed it as "staccato e disperso." Unaccountably, Gnoli recorded its date as 1487, and it has been assumed to be a work of that year by all subsequent writers. It entered the Museum of Fine Arts with no indication of provenance, date, or previous published history, and was attributed to Matteo da Gualdo by Edgell (1947) on the basis of its resemblance to Matteo's fresco from Colle Aprico near Nocera Umbra, now in the Galleria Nazionale dell'Umbria, Perugia. Berenson (1968) was the first to identify the Boston fresco with the missing fresco from Acciano.

The date commonly assumed for this fresco, 1487, is likely to be incorrect and may be based on a simple typographical error by Gnoli. There is little reason to question Massei, the only author to have seen the fresco prior to its transfer to canvas, who claimed instead that it dated to 1497. The cartoon of the Madonna and Child is clearly based directly on that of the Colle Aprico fresco, which was also employed with variations in a smaller painting in the collection of Federico Zeri at Mentana (Todini, vol. 2, 1989, p. 385). The date of the Colle Aprico fresco has traditionally been read as 1488, but Francesco Santi (1985, pp. 38-39) has recently proposed that this date be read as 1493, a terminus post quem for the Boston fresco. The same conclusion is suggested by stylistic comparison to Matteo's altarpiece of the Meeting at the Golden Gate in the Pinacoteca at Nocera Umbra, which employs the same eccentric, desiccated figure style – typical of the artist's late career but especially close in these two works – and similar classical motifs in the candelabra and anthemia decorating the painted architecture. The *Meeting at the Golden Gate* is inscribed "Sedente Alessandro VI," and was therefore painted between 1492 and 1503. Furthermore, Matteo da Gualdo is otherwise known to have been active in Nocera Umbra in 1497, when he painted a cycle of votive frescoes in the church of San Francesco there.

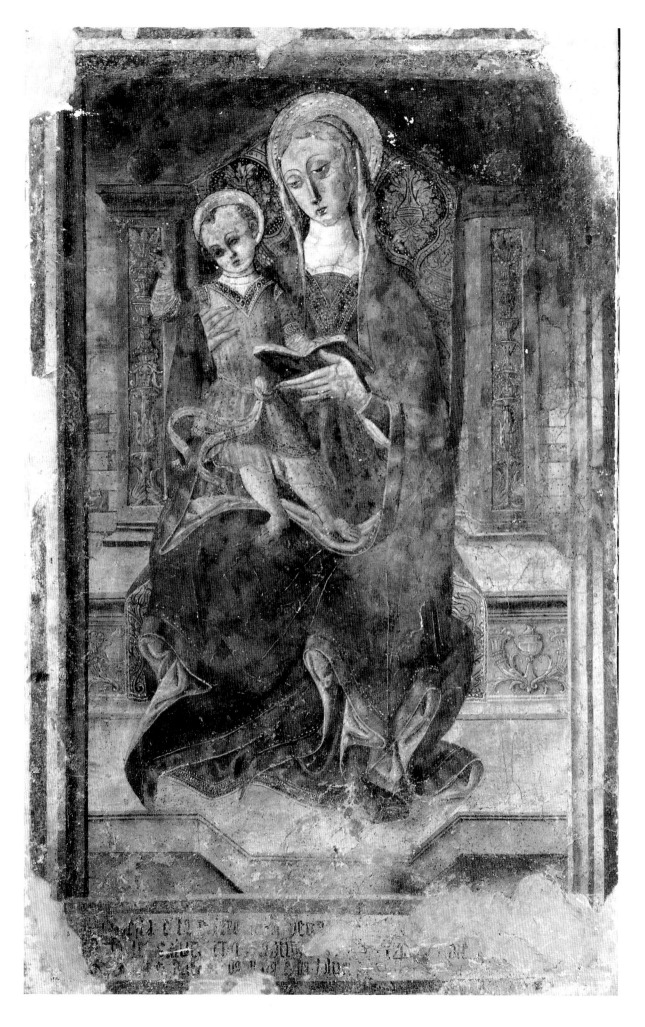

Carlo Crivelli

BORN, PROBABLY AROUND 1435, and trained in Venice, where he is mentioned as a painter in a document of 1457, Carlo Crivelli spent his entire mature career in the Marches, first at Fermo, where he maintained a workshop until at least 1470, and subsequently at Ascoli Piceno. His earliest signed and dated work, an altarpiece of 1468 at Massa Fermana, reveals him to have been trained in the Venetian style typified by Antonio and Bartolomeo Vivarini and the Bellini workshop, though the salient influence on his art was that of the Paduan Squarcione and his pupils, Mantegna, Giorgio Schiavone, and Marco Zoppo. A highly sophisticated and painstaking craftsman, Crivelli combined a deliberately archaizing, Gothic taste with an acute sense of naturalistic detail to produce images of an intense emotional pathos and astonishing visual immediacy. His elaborately constructed polyptychs, frequently enlivened with trompe-l'oeil or gilt pastiglia decorative and symbolic objects, were in demand throughout the Marches, and earned him a knighthood from Ferdinando di Capua in 1490. In addition to Fermo and Ascoli, Crivelli painted altarpieces for Camerino (1482, 1488), Ancona (1490), Matelica (1490), and Fabriano (1491, 1493-94), a large portion of them for a network of Franciscan patrons. The last preserved notice of Crivelli is of 1494; he appears to have died in or around 1495.

73

Lamentation over the Dead Christ

Tempera on panel
Overall: 88.7 x 53 (34¾ x 20⅞)
Picture surface: 86.6 x 51.1 (34⅛ x 20⅛)

James Fund and Anonymous Gift. 02.4

Provenance: Panciatichi collection, Florence; John Marshall, 1900; Warren Family collection, Boston

Literature: Berenson, 1894, p. 99; Rushforth, 1900, pp. 52, 66, 103, 120; Berenson, 1901, p. 103; Rankin, 1905, p. 15; Reinach, 1905, p. 466; Berenson, 1907, p. 106; Colasanti, 1907, p. 418; Rankin, 1907, p. 103; Venturi, 1907, pp. 205, 207; Crowe and Cavalcaselle, vol. 1, 1912, p. 89; Burroughs, 1913, p. 262; Geiger, vol. 13, 1913, p. 131; Venturi, vol. 7, 3, 1914, p. 392, fig. 301; Testi, vol. 2, 1915, pp. 559, 638-639, 678; Berenson, 1916, p. 23; Drey, 1927, pp. 72, 73, 93, 139, pl. liv; van Vechten Brown and Rankin, 1930, p. 357; Berenson, 1932, p. 161; Venturi, vol. 2, 1933, no. 370; Serra, vol. 2, 1934, p. 389; Tietze, 1935, p. 328, pl. 69; Berenson, 1936, p. 138; van Varle, vol. 28, 1936, pp. 37-38; Mather, vol. 6, 1936, p. 137; Tietze, 1939, p. 312, pl. 69; Galetti and Camesasca, vol. 1, 1950, p. 760; Zampetti, 1952, p. 66; Coletti, p. xlvi, pl. 95b; Berenson, vol. 1, 1957, p. 69, pl. 154; Pallucchini, vol. 2, 1957-58, pp. 25, 29-30; Bovero, 1961, pp. 38, 78; Davies, 1961, p. 154; Zampetti, 1961, pp. 46, 90, pl. 102, xix; Longhi, 1962, p. 15; Chastel, 1966, pp. 196-197; Zampetti, vol. 1, 1969a, p. 43; Faison, 1970, p. 33; Fredericksen and Zeri, 1972, pp. 60, 563; Bovero, 1975, pp. 96, 563; Levi d'Ancona, 1977, pp. 171, 249; Hadley, 1987, pp. 219, 291-293; Hirshler, 1988, pp. 49-50, p. 54 fn. 17; Steinberg, 1989, pp. 494-498.

Condition: The panel support, of a vertical wood grain, has been thinned to a depth of 2.4 cm. Two horizontal battens have been attached to the back and six rectangular wood buttons have been attached along a 7.3 cm long curved split that runs vertically through the center of the panel, apparently caused by attempts to flatten the panel's warpage. The edges of the panel have been trimmed by at least 2 cm on the sides and an uncertain amount along the curve of the arch, which has been altered in profile by the addition of an 0.8 x 16.3 cm capping strip across the top. A 14 x 2 cm wedge has been split from the panel at the lower left corner and been reattached. The gold ground is exceptionally well preserved, as is the gold tooling and the mordant gilt decoration in the hair and drapery of the figures. The pastiglia haloes and patterns in Mary Magdalene's dress are also in excellent condition, as are the paint surfaces generally, except for a few small losses scattered along the edges of the panel, around the figure of Christ, and along a series of fine, parallel diagonal crackle lines running through the center of the composition the full height of the panel. Retouches in these losses are minimal. The left edge of the painted cornice, to the left of the artist's signature, is repaired. The dark glazes of shadow over the body of Christ and the Virgin's head have become transparent, impairing slightly these figures' legibility but revealing the artist's complex and beautifully delicate underdrawing.

THE NAKED BODY of the Dead Christ is supported above a marble parapet by the mourning figures of the Virgin and Saint Mary Magdalene in half-length at the left and Saint John the Evangelist at the right. The Virgin, wearing a blue cloak turned back at her ear to reveal a green lining, has her son's arm around her shoulder as she tenderly reaches for the wound in his side. The Magdalene, wearing a red dress with slit gold sleeves rendered in gilt pastiglia, holds Christ's right leg, which projects forward above a crimson and gilt cloth of honor draped over the parapet. Saint John the Evangelist, standing with one foot braced on the parapet, wears a red cloak lined with dark green over a yellow robe. He supports most of the weight of Christ's body against his chest, and cradles the Savior's rigid left hand on his arm. A gold damask cloth of honor hangs behind the figures, whose haloes are decorated with raised pastiglia borders, and the gold background of the panel is punched in imitation of Lucchese silks or velvets. Stretched across the top of the panel is a swag of oversized fruit, including a peach, a cucumber, plums, cherries, hazlenuts, and quince. The parapet, the frieze of which is decorated with an elaborate acanthus rinceau, bears an inscription on the front face of its cornice at the left: OPUS CAROLI CRIVELLI VENETI 1485. A shield with a coat of arms is painted before the cloth of honor at the bottom center of the panel.

One of the best-known and most frequently cited paintings by Carlo Crivelli in any public collection, the Boston *Lamentation over the Dead Christ* is justly admired for the sophistication of its composition, the pathos of its expression, and the richness and refinement of its decorative details. It was described by Berenson (1916) as "the most original of all [Crivelli's] treatments of this sublime subject," which include examples in the National Gallery, London; the Metropolitan Museum of Art, New York; the John G. Johnson Collection, Philadelphia; the Fogg Art Museum, Cambridge; the Detroit Institute of Art; the Louvre, Paris; the Pinacoteca di Brera, Milan; the Cathedral of Sant'Emidio, Ascoli Piceno; the Vatican Pinacoteca; and elsewhere. All of these paintings are presumed to have been intended for (or are still situated in) the center of the upper tier of an altarpiece, whether Gothic or classical in form, and they all share the device of a low viewing-point with a stone parapet – frequently with figures or objects resting on its top edge and limbs or draperies projecting over and in front of it – closing off the foreground.

In this context, the London, Boston, and Vatican Lamentations are anomalous in being signed by the artist, a distinction usually reserved for the center panel of the main tier of an altarpiece. The prove-

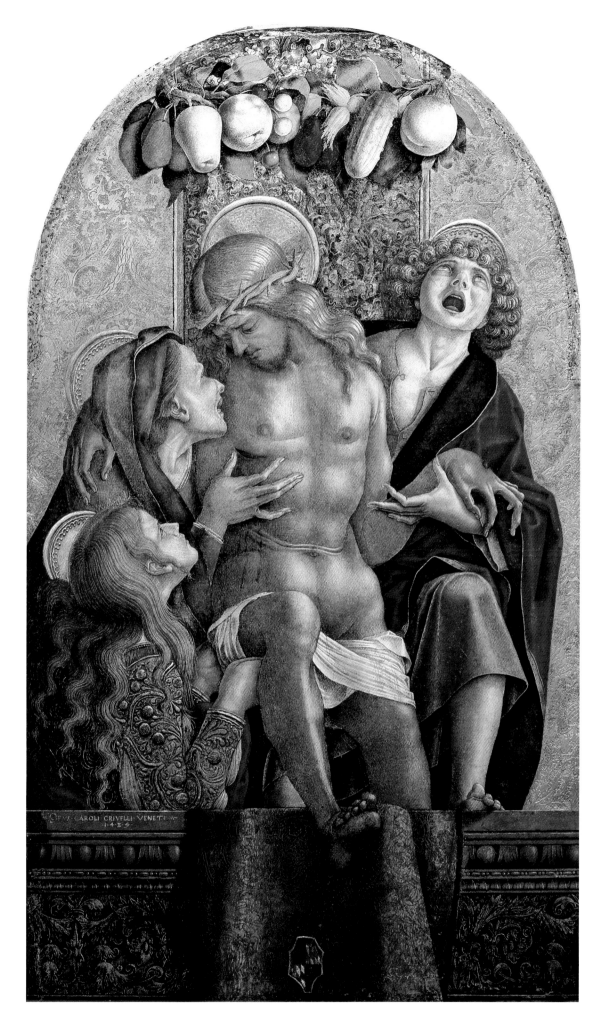

nance of the Vatican Lamentation is unknown, and though it certainly formed the lunette of an altarpiece, the main panel of that structure has not been securely identified. The London Lamentation is reasonably assumed (see Bovero, 1975, pp. 87-88) to have been the central pinnacle of the Montefiore dell'Aso altarpiece, where it would have stood above a panel of the Madonna and Child Enthroned now in the Musées Royaux des Beaux-Arts, Brussels, which is fully signed. It has been postulated that the signature on the London panel was faithfully copied from that on the Brussels panel, perhaps at the time of the dismantling of the altarpiece. No such "copied signatures" appear on any other of the dispersed panels from this altarpiece, however, and no technical evidence has been produced suggesting that the inscription is anything but contemporary with the rest of the picture surface (Davies, 1961). Similarly, the signature on the Boston Lamentation has been questioned as possibly replicating an inscription on the missing or as yet unidentified main panel of the altarpiece from which it was excised (Venturi, 1933), but technical examination reveals this signature to be entirely original.[1]

No other panels by Crivelli of the date (1485) of the Boston Lamentation are known that may be associated with it in a single complex. The two paintings most closely related to it stylistically are the Annunciation altarpiece in the National Gallery, London, of 1486, in which the lappets at the sleeves of the Annunciatory Angel closely approximate the spiky forms of the acanthus rinceau carved on the parapet in the Boston panel, and the signed but undated Saint Mary Magdalene in the Rijksmuseum, Amsterdam, where the decoration of the Magdalene's bodice may be favorably compared with the glazed decoration of the gold cloth of honor at the back of the Boston panel. It should also be noted that, unusually for Crivelli, simulated architectural relief carvings in both the London and Amsterdam paintings are set off against a densely hatched background, precisely as in the Boston Lamentation. Both the London Annunciation altarpiece and the Amsterdam Magdalene were painted for patrons in Ascoli Piceno. There is a strong presumption that the Boston Lamentation also originated from Ascoli Piceno. The coat of arms painted at the center of its bottom edge has been identified (Zampetti, 1961) as that of the Bonacossi and Malatesta of Ascoli, quartered.

Although its format is that of a lateral panel from a Gothic polyptych, it has been argued (Zampetti, 1961) that the Amsterdam Saint Mary Magdalene may have been conceived either as the center panel of an altarpiece or, more likely, as an independent devotional image. The argument is based in part on the presence of Crivelli's signature on the front of the parapet at the Magdalene's feet, and on the fact that no similar panels can now be associated with it or have ever been known to have been associated with it. Additionally, a swag of flowers is painted across the top of the Amsterdam panel, a symbolic and decorative device usually reserved by Crivelli, generally in the form of fruit rather than flowers, for independent devotional images or the central panels of polyptychs. As all the same observations may be made of the Boston Lamentation, which is unique among the many representations of that subject by Crivelli for the inclusion of a symbolic swag of fruit across the top, it is possible that it was intended from the first as an independent devotional image rather than as part of a larger liturgical structure. The present shape of the picture field has been modified slightly, but its scale and proportions are consistent with those of standard Central Italian tabernacle frames of the 1480s. The presence of a signature and coat of arms on the painting would be less unusual in such a context than if the panel had formed the central pinnacle of a large altarpiece.

Each of the fruits bound into a swag across the top of the panel is subject to various symbolic interpretations (cf. Levi d'Ancona, 1977, passim). Taken together, and in conjunction with the painting's subject, they seem all to allude to Christ's Passion (plum, cherries) and Resurrection (quince, cucumber), and mankind's consequent salvation (peach, hazlenut). The peach is also sometimes symbolic of the Trinity, but such an interpretation is marginal or inappropriate to the present context.

1. Berenson's representation to Mrs. Gardner (Hadley, 1987) that the Boston Crivelli, then in the Warren collection, was entirely regilt and overpainted and had been "improved" by the restorer Cavenaghi, was greatly exaggerated. Berenson was undoubtedly misled by the near-perfect state of the gold ground and the unusual pattern of its punched decoration. Cavenaghi's intervention seems to be restricted to repainting the end of the cornice to the left of Crivelli's signature, and probably to repairing the split in the center of the panel.

ABBREVIATIONS

Addison, 1910
J. W. Addison, *The Boston Museum of Fine Arts* (1910).

Alberti, 1972
L. B. Alberti, *On Painting and Sculpture*, C. Grayson, ed. (1972).

Aleandri, 1908
V. Aleandri, "Il Palazzo in Roma, la famiglia e il ritratto di Giambattista Caccialupi Sanseverinate," *Arte e storia*, 27 (1908).

Alessi, 1987
C. Alessi, "La Pittura a Siena nel primo Quattrocento," *La Pittura in Italia. Il Quattrocento*, F. Zeri, ed. (1987).

Alessi and Scapecchi, 1985
C. Alessi and P. Scapecchi, "Il 'Maestro dell'Osservanza': Sano di Pietro o Francesco di Bartolomeo?," *Prospettiva* 42 (1985).

Algeri, 1989
G. Algeri, "L'attività tarda di Barnaba da Modena: una nova ipotesi di riconstruzione," *Arte cristiana* 732 (1989).

Amico, 1979
L. N. Amico, "Reconstructing an Early Fourteenth-Century Pentaptych by Ugolino di Nerio: St. Catherine Finds Her Niche," *Bulletin of the Krannert Art Museum* 5 (1979).

Angelini, 1988
A. Angelini, "Francesco di Giorgio pittore e la sua bottega. Alcune osservazioni su una recente monografia," *Prospettiva* 52 (1988).

Antal, 1948
F. Antal, *Florentine Painting and Its Social Background* (1948).

Arb, 1959
R. Arb, "A Reappraisal of the Boston Museum's Duccio," *The Art Bulletin* 41 (1959).

Bacci, 1927
P. Bacci, "Il Barna o Berna, pittore della Collegiata di San Gimignano, e mai esistito?," *La Balzana* 1 (1927).

Bacci, 1939
P. Bacci, "L'Elenco della pitture, sculture e architeture di Siena, compilato nel 1625-26 da mons. Fabio Chigi, poi Alessandro VII secondo il ms. chigiano I.I.ll," *Bolletino senese di storia Patria* 10 (1939).

Bacci, 1944
P. Bacci, *Fonti e commenti per la storia dell'arte senese* (1944).

Baldini, 1953
U. Baldini, "Note brevi su inediti toscani," *Bolletino d'arte* 38 (1953).

Baldini, 1970
U. Baldini, *L'Opera completa dell'Angelico* (1970).

Bandera, 1974
M. C. Bandera, "Qualche osservazione su Benvenuto di Giovanni," *Antichità viva* 12, 1 (1974).

Bandera, 1977
M.C. Bandera, "Variazioni ai cataloghi Berensoniani di Benvenuto di Giovanni," *Scritti di storia dell'arte in onore di Ugo Procacci*, 2 vols. (1977).

Battisti, 1971
G. Battisti, *Piero della Francesca*, 2 vols. (1971).

Battistini, 1925
M. Battistini, "Francesco di Neri da Volterra," *L'Arte* 28 (1925).

Battistini, 1931
M. Battistini, *La Confrérie de Sainte Barbre des Flamands à Florence* (1931).

Battistini, 1987
R. Battistini, "La pittura del Quattrocento nelle Marche," *La pittura in Italia. Il Quattrocento*, F. Zeri, ed. (1987).

"Battle Scene," 1913
M. C., "Battle Scene by Paolo Ucello," *Bulletin of the Museum of Fine Arts* 13 (1915).

Beatson et al., 1986
E. H. Beatson, N. E. Muller, and J. B. Steinhoff, "The St. Victor Altarpiece in Siena Cathedral: A Reconstruction," *The Art Bulletin* 68 (1986).

Beissel, 1909
G. Beissel, *Geschichte der Verehrung Marias in Deutschland wahrend des Mittelalters* (1909).

Bellosi, 1974
L. Bellosi, *Buffalmacco e il trionfo della morte* (1974).

Bellosi, 1985
L. Bellosi, "Su alcune disegni italiana tra la fine del Due e la metà del Quattrocento. X: Un'illustrazione dantesca del Maestro della Cappella Bracciolini," *Bolletino d'arte* 70 (1985).

Bellosi, 1990
L. Bellosi, ed., *Pittura di luce. Giovanni di Francesco e l'arte fiorentina di metà Quattrocento* (1990).

Bellosi, 1992
L. Bellosi, "Miniature del 'Maestro della Carita,'" *Prospettiva* 65 (1992).

Bellosi and Angelini, 1986
L. Bellosi and A. Angelini, *Collezione Chigi-Saracini, I. Sassetta e i pittori toscani tra XIII e XV secolo* (1986).

Bellosi et al., 1993
L. Bellosi, *Francesco di Giorgio il Rinascimento a Siena* (1993).

Benedictis, 1974
C. de Benedictis, "Naddo Ceccarelli," *Commentari* 25 (1974).

Benedictis, 1974a
C. de Benedictis, "Sull'attività giovanile di Niccolò Tegliacci," *Paragone* 291 (1974).

Benedictis, 1976
C. de Benedictis "I corali di San Gimignano, I: Le miniature di Niccolò Tegliacci," *Paragone* 313 (1976).

Benedictis, 1976a
C. de Benedictis, "I Corali di San Gimignano, Il secondo miniatori," *Paragone* 315 (1976).

Benedictis, 1976b
C. de Benedictis, "Il polittico della Passione di Simone Martini e una proposta per Donato," *Antichità viva* 15 (1976).

Benedictis, 1979
C. de Benedictis, *La Pittura senese 1330-1370* (1979).

Berenson, 1894
B. Berenson, *The Venetian Painters of the Renaissance* (1894).

Berenson, 1897
B. Berenson, *The Central Italian Painters of the Renaissance* (1897).

Berenson, 1901
B. Berenson, *The Study and Criticism of Italian Art* (1901).

Berenson, 1907
B. Berenson, *The Venetian Painters of the Renaissance* (1907).

Berenson, 1909
B. Berenson, *The Central Italian Painters of the Renaissance* (1909).

Berenson, 1909a
B. Berenson, *The Florentine Painters of the Renaissance* (1909).

Berenson, 1913
B. Berenson, *Catalogue of a Collection of Paintings and Some Art Objects, I: Italian Paintings, John G. Johnson* (1913).

Berenson, 1916
B. Berenson, *Venetian Painting in America* (1916).

Berenson, 1918
B. Berenson, "Guidoccio Cozzarelli and Matteo di Giovanni," *Essays in the Study of Sienese Painting* (1918).

Berenson, 1926
B. Berenson, "An Early Signorelli in Boston," *Art in America* 14 (1926).

Berenson, 1926a
B. Berenson, "Due illustratori italiana dello Speculum Humanae Salvationis," *Bolletino d'arte* 5 (1926).

Berenson, 1930
B. Berenson, "Quadri senza casa – il trecento senese, II," *Dedalo* 11 (1930).

Berenson, 1930a
B. Berenson, "Italian Illustrators of the Speculum Humanae Salvationis," *Studies in Medieval Painting* (1930).

Berenson, 1931
B. Berenson, "Lost Sienese Trecento Paintings – Part IV," *International Studio* 93 (1931).

Berenson, 1932
B. Berenson, *Italian Pictures of the Renaissance: a List of the Principal Artists and Their Works, with an Index of Places* (1932).

Berenson, 1932a
B. Berenson, "Quadri senza casa – il Quattrocento Fiorentino," *Dedalo* 12 (1932).

Berenson, 1936
B. Berenson, *Pitture italiane del Rinascimento: Catalogo dei principali artisti e delle loro opere con un indice dei luogi* (1936).

Berenson, 1957
B. Berenson, *Italian Pictures of the Renaissance: a List of the Principal Artists and Their Works, with an Index of Places: Venetian School*, 2 vols. (1957).

Berenson, 1963
B. Berenson, *Italian Pictures of the Renaissance: a List of the Principal Artists and Their Works, with an Index of Places: Florentine School*, 2 vols. (1963).

Berenson, 1968
B. Berenson, *Italian Pictures of the Renaissance: a List of the Principal Artists and Their Works, with an Index of Places: Central Italian and North Italian Schools*, 3 vols. (1968).

Bernacchioni, 1990
A. Bernacchioni, "Documenti e precisazioni sull'attività tarda di Domenico di Michelino: la sua bottega in via delle Terme," *Antichità viva*, XXIX, 6, 1990.

Bernini, 1977
D. Bernini, *Palazzo Ducale di Urbino – Storia di un museo* (1977).

Bertelli, 1970
C. Bertelli, "Un Codice della Badia a Settimo scritto nel 1315," *Paragone* 249 (1970).

Berti, 1963
L. Berti, "Miniature dell'Angelico (e l'altro) – II," *Acropoli* 3 (1963).

Berti, 1992
L. Berti, Roberto Bartalani, Luciano Bellosi, Stefano Casciu, Giovanna DaMiani, et al., *Nel raggio di Piero*, 1992

Bichi, 1724
G. Bichi, *Copia dell'Arme gentilizie e dell'Inscrizioni, che sono espresse nelle tavolette, che gia servirono per Coperte de'Libri Magistrato della Magnifica Biccherna di Siena* (1724).

Bo and Mandel, 1978
C. Bo and G. Mandel, *L'Opera completa del Botticelli* (1978).

Bologna, 1954
F. Bologna, "Miniature di Benvenuto di Giovanni," *Paragone* 51 (1954).

Bologna, 1962
F. Bologna, *La Pittura Italiana delle origini* (1962).

Bologna, 1964
F. Bologna, *Early Italian Painting: Romanesque and Early Medieval Art* (1964)

Bologna and Castris, 1984
F. Bologna and P. Leone di Castris, "Percorso del Maestro di Offica," *Studi di storia dell'arte in memoria di Mario Rotili* (1984).

Bombe, 1912
W. Bombe, "Die Kunst am Hofe Federigos von Urbino," *Monatsheft fur Kunstwissenschaft* 5 (1912).

Bombe, 1912a
W. Bombe, "Fra Carnevale," *Algemeines Lexikon der bildenden Künstler*, U. Thieme and F. Becker, eds., vol. 6 (1912a).

Bomford et al., 1989
D. Bomford, D. Dunkerton, D. Gordon, and A. Roy, et al., *Art in the Making: Italian Painting before 1400* (1989).

Borgia et al., 1984
L. Borgia, E. Carli, M. A. Ceppari, U. Morandi, P. Sinibaldi, and C. Zarrilli, *Le Biccherne* (1984).

Borsook, 1966
E. Borsook, *Ambrogio Lorenzetti* (1966).

Boskovits, 1962
M. Boskovits, "Une Madonne de l'atelier de Niccolò di Pietro Gerini," *Bulletin du Musée hongrois des Beaux-Arts* 21 (1962).

Boskovits, 1967
M. Boskovits, "Un apertura per Francesco Neri da Volterra," *Antichità viva* 6 (1967).

Boskovits, 1974
M. Boskovits, "A Dismembered Polyptych, Lippo Vanni and Simone Martini," *The Burlington Magazine* 116 (1974).

Boskovits, 1975
M. Boskovits, *Pittura fiorentina alla vigilia del Rinascimento* (1975).

Boskovits, 1975a
M. Boskovits, "Il Maestro del Bambino Vispo: Gherardo Starnina o Miguel Alcaniz?," *Paragone* 307 (1975).

Boskovits, 1980
M. Boskovits, "Su Niccolò di Buonaccorso, Benedetto di Bindo, e la pittura senese del primo Quattrocento," *Paragone* 359-361 (1980).

Boskovits, 1983
M. Boskovits, "La fasa tarda del Beato Angelico: una proposta di interpretazione," *Arte cristiana* 694 (1983).

Boskovits, 1984
M. Boskovits, *A Critical and Historical Corpus of Florentine Painting, 3, the Fourteenth Century, ix, The Painters of the Miniaturist Tendency* (1984).

Boskovits, 1988
M. Boskovits, *Fruhe italienische malerei, Gemäldegalerie Berlin*, E. Schleier, ed. (1988).

Boskovits, 1989
Boskovits, *A Critical and Historical Corpus of Florentine Painting, III., iii, The Fourteenth Century. The Works of Bernardo Daddi*, M. Boskovits, ed. (1989).

Boskovits, 1991
Boskovits, *A Critical and Historical Corpus of Florentine Painting, III., iv, The Fourteenth Century. Bernardo Daddi, His Shop and Following*, M. Boskovits, ed. (1991).

Boskovits et al., 1964
M. Boskovits, M. Mojzer and A. Mucsi, *Az Esztergomi Kereszteny Múzeum Keptara* (1964).

Bottari, 1958
S. Bottari, "I grandi cicli di affreschi riminesi," *Arte antica e moderna* 2 (1958).

Bovero, 1961
A. Bovero, *Tutta la pittura di Crivelli* (1961).

Bovero, 1975
A. Bovero, *L'opera completa di Carlo Crivelli* (1975).

Brandi, 1928
C. Brandi, "Barna e Giovanni d'Asciano," *La Balzana* 2 (1928).

Brandi, 1931
C. Brandi, "Niccolò di Buonaccorso," *Algemeines Lexikon der bildenden Künstler*, U. Thieme and F. Becker, eds., vol. 25 (1931).

Brandi, 1933
C. Brandi, *La Regia pinacoteca di Siena* (1933).

Brandi, 1935
C. Brandi, *Mostra della pittura riminesi del Trecento, Catalogo* (1935).

Brandi, 1941
C. Brandi, "Giovanni di Paolo," *Le Arti* 4 (1941).

Brandi, 1947
C. Brandi, *Giovanni di Paolo* (1947).

Brandi, 1949
C. Brandi, *Quattrocentisti senesi* (1949).

Brandi, 1951
C. Brandi, *Duccio* (1951).

Breck, 1913
J. Breck, "A Trecento Painting in Chicago," *Art in America* 1 (1913).

Briganti, 1954
G. Briganti, "Piero della Francesca Werkstatt, 'Darstellung im Temple,'" *Die Weltkunst* 24 (1954).

Bronowski, 1978
J. Bronowski, *The Visionary Eye: Essays in the Arts, Literature and Science* (1978).

Brunetti, 1935
G. Brunetti, "Gli affreschi della cappella Bracciolini in San Francesco a Pistoia," *Rivista d'arte* 17 (1935).

Bruschi, 1969
A. Bruschi, *Bramante Architetto* (1969).

Bruschi, 1977
A. Bruschi, *Bramante* (1977).

Budinich, 1904
C. Budinich, *Il Palazzo Ducale d'Urbino* (1904).

Burckhardt, 1884
J. Burckhardt, *Der Ciceroni*, W. Bode, ed. (1884).

Burckhardt, 1904
J. Burckhardt, *De Ciceroni*, W. Bode and C. von Fabriczy, eds. (1904).

Burlington House, 1880
"Eleventh Exhibition of Old Masters," Burlington House, London (1880).

Burlington House, 1896
"Twenty-seventh Exhibition of Old Masters," Burlington House, London (1896).

Burlington House, 1930
"Exhibition of Italian Art," Burlington House, London (1930).

Burroughs, 1913
B. Burroughs, "Venetian Paintings," *Bulletin of the Metropolitan Museum of Art* 8 (1913).

Bury, 1990
M. Bury, "Bartolomeo Caporali: A New Document and Its Implications," *The Burlington Magazine* 132 (1990).

Busignani, 1962
A. Busignani, "Cosimo Rosselli a il gusto della Tarsia," *Antichità viva* 1 (1962).

Byam Shaw, 1967
J. Byam Shaw, *Paintings by Old Masters at Christ Church, Oxford* (1967).

Cadogan et al., 1991
J. Cadogan, R.T. Mahoney, G. Kubler, and C. Felton, et al., *Wadsworth Athenum Paintings II, Italy and Spain, Fourteenth through Nineteenth Centuries* (1991).

Caleca, 1977
A. Caleca, "Tre polittici di Lippo Memmi, Un'ipotesi sul Barna e la bottega di Simone e Lippo, 2," *Critica d'arte* 42 (1977).

Callmann, 1974
E. Callman, *Apollonio di Giovanni* (1974).

Camuccini, 1817
V. Camuccini, *Oggetti di pittura dell'eccellentissima casa Barberini* (1817).

Cannon, 1980
J. Cannon, "Dominican Patronage of the Arts in Central Italy: the Provincia Romana c. 1220 – c. 1320," Ph.D. diss., Courtauld Institute of Art, University of London (1980).

Carli, 1950
E. Carli, *Le Tavolette di Biccherna e di altri uffici dello Stato di Siena* (1950).

Carli, 1952
E. Carli, *Duccio* (1952).

Carli, 1955
E. Carli, *La Pittura senese* (1955).

Carli, 1956
E. Carli, *Sienese Painting* (1956)

Carli, 1957
E. Carli, *Sassetta e il Maestro dell'Osservanza* (1957).

Carli, 1963
E. Carli, "Ancora dei Memmi a San Gimignano," *Paragone* 159 (1963).

Carli, 1972
E. Carli, *Montalcino, museo civico, museo diocesano d'arte sacra* (1972).

Carli, 1972a
E. Carli, "Chi e lo 'Pseudo-Ambrogio di Baldese?,'" *Studi di storia dell'arte in onore di Valerio Mariani* (1972).

Carli, 1981
E. Carli, *La pittura senese nel Trecento* (1981).

Carpegna, 1973
N. di Carpegna, *Catalogo della Galleria Nazionale, Palazzo Barberini, Roma* (1973).

Casalini, 1962
E. M. Casalini, O.S.M., "Una Tavola di Taddeo Gaddi gia alla Ss.ma Annunziata di Firenze," *Studi storici dell'Ordine dei Servi di Maria* 12 (1962).

Castris, 1988
P. L. de Castris, "Problemi Martiniani avignonesi: il 'Maestro degli Angeli Ribelli,' i due Ceccarelli ed altro," in *Simone Martini: atti del convegno*, L. Bellosi, ed. (1988).

Catroux, 1921
R. C. Catroux, "Les Collections du Château de Ripaille," *Revue de l'art ancien et moderne* 39 (1921).

Cattaneo, 1972
G. Cattaneo, *L'Opera completa di Duccio* (1972).

Cecci, 1931
E. Cecci, *The Sienese Painters of the Trecento* (1931).

Cecci, 1948
E. Cecci, *Trencentisti senesi*, 2nd. ed. (1948).

Chastel, 1958
A. Chastel, *L'Arte italiana* (1958).

Chastel, 1966
A. Chastel, *Studios and Styles of the Italian Renaissance* (1966).

Chelazzi-Dini, 1982
G. Chelazzi-Dini in *Il Gotica a Siena* (1982).

Chelazzi-Dini, 1988
G. Chelazzi-Dini, "I riflessi di Simone Martini sulla pittura pisana," in *Simone Martini: atti del convegno*, L. Bellosi, ed. (1988).

Chiti, 1931
A. Chiti, *Pistoia* (1931).

Christiansen, 1979
K. Christiansen, "For Fra Carnevale," *Apollo* 109 (1979).

Christiansen, 1981
K. Christiansen, "'Peregrinus' and Perugian Painting in the Fifteenth Century," *The Burlington Magazine* 123 (1981).

Christiansen, 1982
K. Christiansen, *Gentile da Fabriano* (1982).

Christiansen, 1989
K. Christiansen, "Three Dates for Sassetta," *Gazette des Beaux-Arts* 114 (1989).

Christiansen et al., 1989
K. Christiansen, L. Kanter, and C. B. Strehlke, *Painting in Renaissance Siena 1420-1500*, exh. cat. (1989).

Christiansen, 1990
K. Christiansen, "Notes on 'Painting in Renaissance Siena,'" *The Burlington Magazine* 132 (1990).

Christiansen, 1991
K. Christiansen, "Sano di Pietro's Saint Bernardino Panels," *The Burlington Magazine* 133 (1991).

Ciardi Dupre dal Pogetto, 1983
M. G. Ciardi Dupre dal Pogetto and P. dal Poggetto, eds., *Urbino e le Marche prima e dopo Raffaello* (1983).

City Museum, 1960
Catalogue of Paintings, City Museum and Art Gallery, Birmingham, 1960.

Cohn, 1956
W. Cohn, "Notizie storiche intorno ad alcune tavole fiorentine del trecento e Quattrocento," *Rivista d'arte* 31 (1956).

Cole, 1968
B. Cole, "A New Work by the Master of the Arte della Lana Coronation," *The Burlington Magazine* 110 (1968).

Cole, 1977
B. Cole, *Agnolo Gaddi* (1977).

Cole, 1980
B. Cole, "Circle of Niccolò di Pietro Gerini," *Italian Paintings XIV – XVIII Centuries from the Collection of the Baltimore Museum of Art*, G. Rosenthal, ed. (1980).

Cole, 1985
B. Cole, *Sienese Painting in the Age of the Renaissance* (1985).

Cole, 1987
B. Cole, *Italian Art 1250-1550* (1987).

Cole and Gealt, 1977
B. Cole and A. Gealt, "A New Triptych by Niccolò di Buonaccorso and a Problem," *The Burlington Magazine* 119 (1977).

Colasanti, 1907
A. Colasanti, "Per la storia dell'arte nelle Marche," *L'Arte* 10 (1907).

Colasanti, 1932
A. Colasanti, *Die Malerei des XV Jahrhunderts in den italienischen Marken* (1932).

Coletti, 1946
L. Coletti, *Storia della pittura italiana* (1946).

Coletti, 1949
L. Coletti, "The Early Works of Simone Martini," *Art Quarterly* 12 (1949).

Coletti, 1953
L. Coletti, *Pittura veneta del Quattrocento* (1953).

Collection Toscanelli, 1883
Collection Toscanelli, album contenant la reproduction des tableaux et meuble anciens (1883).

Colucci, 1796
G. Colucci, *Antichità Picene*, XXXI (1796)

Comstock, 1928
H. Comstock, "The Bernardo Daddis in America," *The International Studio*, February 1928, March 1928.

Comstock, 1928a
H. Comstock, "Three Paintings by Francesco di Giorgio," *The International Studio*, April 1928.

Constable, 1925
W. G. Constable, "Paintings in the Marlay Collection at Cambridge," *The Burlington Magazine* 47 (1925).

Constable, 1927
W. G. Constable, *Catalogue of Pictures in the Marlay Bequest, Fitzwilliam Museum, Cambridge* (1927).

Constable, 1941
W. G. Constable, "A Fresco of the School of Rimini," *Bulletin of the Museum of Fine Arts* 39 (1941).

Conti, 1976
A. Conti, "Un libro della sagrestia di Sant'Ambrogio," *Annali della Scuola Normale Superiore di Pisa* 6 (1976).

Contini and Gozzoli, 1970
G. Contini and M. C. Gozzoli, *L'opera completa di Simone Martini* (1970).

Cooper, 1965
F. Cooper, "A Reconstruction of Duccio's *Maestà*," *The Art Bulletin* 47 (1965).

Coor-Achenbach, 1949
G. Coor-Achenbach, "A New Attribution for the Dugento Crucifixion in the Museum of Fine Arts, Boston," *Bulletin of the Museum of Fine Arts* 47 (1949).

Coor-Achenbach, 1953
G. Coor-Achenbach, "A Fresco Fragment of a Nativity and Some Related Presentations," *Bulletin of the Museum of Fine Arts* 51 (1953).

Coor-Achenbach, 1955
G. Coor-Achenbach, "Contributions to the Study of Ugolino di Nerio's Art," *The Art Bulletin* 37 (1955).

Coor-Achenbach, 1956
G. Coor-Achenbach, "Trecento-gemälde aus der Sammlung Ramboux," *Wallraf-Richartz Jahrbuch* 18 (1956).

Coor-Achenbach, 1961
G. Coor-Achenbach, *Neroccio de'Landi* (1961).

Coor-Achenbach, 1961a
G. Coor-Achenbach, "Two Unknown Paintings by the Master of the Glorification of St. Thomas and Some Closely Related Works," *Pantheon* 19 (1961).

Corriere, 1907
Corriere d'Italia, 10 December 1907.

Corsini, 1984
Pietro Corsini, Inc., *Italian Old Master Paintings* (1984).

Crowe and Cavalcaselle
J. A. Crowe and G. B. Cavalcaselle, *A History of Painting in Italy*, L. Douglas (vols. 1-4), T. Borenius (vols. 5-6), eds.

Crowe and Cavalcaselle, 1864
J. A. Crowe and G. B. Cavalcaselle, *A New History of Painting in Italy* (1864).

Crowe and Cavalcaselle, 1869
J. A. Crowe and G. B. Cavalcaselle, *Geschicte der italianischen Malerei*, 2 vols. (1869).

Crowe and Cavalcaselle, 1871
J. A. Crowe and G. B. Cavalcaselle, *A History of Painting in North Italy* (1871).

Crowe and Cavalcaselle, 1883
J. A. Crowe and G. B. Cavalcaselle, *Storia della pittura itialiana dal secolo II al secolo XVI*, 2 vols. (1883).

Crowe and Cavalcaselle, 1898
J. A. Crowe and G. B. Cavalcaselle, *Storia della pittura italiana* (1898).

Crowe and Cavalcaselle, 1909
J. A. Crowe and G. B. Cavalcaselle, *A New History of Painting in Italy from the II to the XVI Century*, E. Hutton, ed. (1909).

"Crucifixion," 1916
"The Crucifixion," *Bulletin of the Museum of Fine Arts* 14 (1916).

Cunningham, 1937
C. Cunningham, "A Great Renaissance Panel," *Bulletin of the Museum of Fine Arts* 35 (1937).

Cunningham, 1937a
C. Cunningham, "An Italian Masterpiece for Boston," *Art News* 35 (1937).

Cust and Douglas, 1904
L. Cust and R. L. Douglas, "Pictures in the Royal Collection," *The Burlington Magazine* 5 (1904).

Cust and Douglas, 1911
L. Cust and R. L. Douglas, *Notes on Pictures in the Royal Collections* (1911).

Czarnecki, 1978
J. Czarnecki, *Antonio Venziano: A Florentine Painter of the Late Trecento*, Ph.D. diss., Indiana University, 1978.

Dalli Regoli, 1988
G. Dalli Regoli, ed., *Il 'Maestro di San Miniato,' lo stato degli studi, i problemi, le risposte della filologia* (1988).

Dalli Regoli, 1989
G. Dalli Regoli, ed., *Il Maestro di San Miniato* (1989).

Dal Poggetto, 1991
P. Dal Poggetto, "Cio che era finora invisibile nella 'camera picta' del Palazzo Ducale di Urbino," *Bolletino d'Arte*, (78) 1991.

Dal Poggetto, 1992
P. Dal Poggetto, Enrico Gamba, Mario Luni, Vico Montebelli, Gabriele Morolli, *Piero e Urbino, Piero e le corti rinascimentali*, 1992.

d'Argenio, 1982
S. d'Argenio in *Il Gotica a Siena* (1982).

Davies, 1961
M. Davies, *National Gallery Catalogues, the Early Italian School* (1961).

Davies, 1974
M. Davies, *European Paintings in the Collection of the Worcester Art Museum* (1974).

Della Chiesa, 1969
A. della Chiesa, *Dipinti della Pinacoteca di Brera in deposito nelle chiese della Lombardia* (1969).

Della Pergola, 1959
P. Della Pergola, *Galleria Borghese, I Dipinti* (1959).

Del Migliore, 1684
F. L. Del Migliore, *Firenze città nobilissima* (1684).

Delogu Ventroni, 1972
S. Delogu Ventroni, *Barna da Siena* (1972).

De Marchi, 1987
A. De Marchi, *Antichi maestri pittori: 18 opere del 1350 al 1520* (1987).

De Marchi, 1990
A. De Marchi, *Pitture di luce, Giovanni di Francesco e l'arte fiorentina di metà Quattrocento*, L. Bellosi, ed. (1990).

De Marchi, 1992
A. De Marchi, *Gentile da Fabriano. Un viaggio nella pittura italiana alla fine del gotico* (1992).

De Marchi, 1992
A. G. De Marchi, "Il maestro della cappella Bracciolini e l'avvio del tardogotico a Pistoia," *Storia dell'Arte* 74 (1992).

Dennistoun, 1851
J. Dennistoun, *Memoirs of the Dukes of Urbino* (1851; ed. E. Hutton 1909).

Deuchler, 1984
F. Deuchler, *Duccio* (1984).

De Wald, 1930
E. T. De Wald, *Pietro Lorenzetti* (1930).

Donnini, 1974
G. P. Donnini, "Aggiunte a Matteo da Gualdo," *Antichità viva* 13 (1974).

Drey, 1927
F. Drey, *Carlo Crivelli und seine Schule* (1927).

Dunkerton et al., 1991
J. Dunkerton, S. Foister, D. Gordan, and N. Penny, *Giotto to Dürer: Early Renaissance Painting in the National Gallery London* (1991).

Edgell, 1924
G. H. Edgell, "The Boston 'Mystic Marriage of St. Catherine' and Five More Panels by Barna Senese," *Art in America* 11 (1924).

Edgell, 1932
G. H. Edgell, *History of Sienese Painting* (1932).

Edgell, 1935
G. H. Edgell, "Un Nuovo Cozzarelli," *Bolletino d'arte* 29 (1935).

Edgell, 1935a
G. H. Edgell, "A Hitherto Unpublished Cozzarelli," *Bulletin of the Museum of Fine Arts* 33 (1935).

Edgell, 1939
G. H. Edgell, "A Newly Acquired Panel by Ambrogio Lorenzetti," *Bulletin of the Museum of Fine Arts* 37 (1939).

Edgell, 1940
G. H. Edgell, "Six Unpublished Sienese Paintings in Boston," *Art in America* 28 (1940).

Edgell, 1942
G. H. Edgell, "A Madonna, Saints and Angels by Francesco di Giorgio Martini," *Bulletin of the Museum of Fine Arts* 40 (1942).

Edgell, 1944
G. H. Edgell, "A Tabernacle by Gregorio di Cecco," *Bulletin of the Museum of Fine Arts* 42 (1944).

Edgell, 1946
G. H. Edgell, "A Crucifixion by Duccio with Wings by Simone Martini," *The Burlington Magazine* 88 (1946).

Edgell, 1946a
G. H. Edgell, "An Important Triptych of the Sienese Trecento," *Bulletin of the Museum of Fine Arts* 44 (1946).

Edgell, 1947
G. H. Edgell, "Three Newly Acquired Frescoes," *Bulletin of the Museum of Fine Arts* 45 (1947).

Edgell, 1947a
G. H. Edgell, "A Madonna by Bernardino di Mariotto," *Bulletin of the Museum of Fine Arts* 51 (1947).

Edgell, 1953
G. H. Edgell, "Two Recently Acquired Sienese Paintings in the Museum of Fine Arts," *Bulletin of the Museum of Fine Arts* 51 (1953).

Escher, 1922
K. Escher, *Malerei der Renaissance in Italien* (1922).

Fahy, 1966
E. Fahy, "Some Notes on the Stratonice Master," *Paragone* 197 (1966).

Fahy, 1974
E. Fahy, "A 'Holy Family' by Fra Bartolomeo," *Los Angeles County Museum of Art Bulletin* 20, 2 (1974).

Fahy, 1976
E. Fahy, *Some Followers of Domenico Ghirlandaio* (1976).

Fahy, 1978
E. Fahy, "A Madonna by Spinello Aretino," *Bulletin of the Cleveland Museum of Art* 65 (1978).

Fahy, 1978a
E. Fahy, "On Lorenzo di Niccolò," *Apollo* 108 (1978).

Fahy, 1989
E. Fahy, "The Argonaut Master," *Gazette des Beaux-Arts* 114 (1989).

Faison, 1932
S. L. Faison, Jr., "Barna and Bartolo di Fredi," *The Art Bulletin* 14 (1932).

Faison, 1970
S. L. Faison, Jr., "Early Spanish and Italian Paintings," *Apollo* 91 (1970).

Faison, 1970a
S. L. Faison, Jr., "Centennial Acquisitions," *Bulletin of the Museum of Fine Arts* 68 (1970).

Fallani, 1984
G. Fallani, *Vita e opera di Fra Giovanni Angelico* (1974).

Fehm, 1973
S. A. Fehm, Jr., *The Collaboration of Niccolò Tegliacci aud Luca di Tommè* (1973).

Fehm, 1978
S. A. Fehm, Jr., "Simone and the Franciscan Zelanti," *Fenway Court* (1978).

Fehm, 1978a
S. A. Fehm, Jr., "Attributional Problems Surrounding Luca di Tommè," *Essays Presented to Myron P. Gilmore* (1978).

Fehm, 1986
S. A. Fehm, Jr., *Lucca di Tommè* (1986).

Fischel, 1929
O. Fischel, *Die Sammlung Joseph Spiridon, Paris* (1929).

Fleming, 1979
J. Fleming, "Art Dealing in the Risorgimento, II," *The Burlington Magazine* 121 (1979).

Foester, 1895
R. Foester, "Amor und Psyche vor Raphael," *Jahrbuch der koniglich preussischen Kunstsammlungen* 16 (1895).

Fogg Art Museum, 1919
Collection of Mediaeval and Renaissance Paintings (1919).

Foucart, 1988
B. Foucart, P. Amato, G. Chazal, C. Mariani, M. Stella, *Imago Mariae: tesori d'arte della civiltà cristiana*, (1988).

Francovich, 1926-27
G. de Francovich, "Appunti su alcuni minori pittori

fiorentini della seconda metà del secolo XV," *Bolletino d'arte* 6 (1926-27).

Francovich, 1927
G. de Francovich, "Sebastiano Mainardi," *Cronache d'arte* 3 (1927).

Fredericksen and Davisson, 1966
B. B. Frederickson and D. D. Davisson, *Benvenuto di Giovanni, Girolamo di Benvenuto, Their Altarpieces in the J. Paul Getty Museum and a Summary Catalogue of Their Paintings in America* (1966).

Fredericksen and Zeri, 1972
B. B. Fredericksen and F. Zeri, *Census of Pre-Nineteenth-Century Italian Paintings in North American Collections* (1972).

Fremantle, 1975
R. Fremantle, *Florentine Gothic Painters from Giotto to Masaccio* (1975).

Freuler, 1985
G. Freuler, "Bartolo di Fredis Alter fur die Annunziata-Kappele in S. Francesco in Montalcino," *Pantheon* 43 (1985).

Freuler, 1986
G. Freuler, "L'Altare Cacciati di Bartolo di Fredi nella chiesa di San Francesco a Montalcino," *Arte cristiana* 708 (1986).

Freuler, 1991
G. Freuler, *Manifestatori delle cose miracolose* (1991).

Freuler and Wainwright, 1986
G. Freuler and V. Wainwright, "On Some Altarpieces by Bartolo di Fredi," *The Art Bulletin* 68 (1986).

Friedländer, 1917
M. J. Friedländer, *Die Sammlung Richard von Kaufmann Berlin, I die italienischen Gemalde* (1917).

Friedländer, 1930
M. J. Friedländer, *Die Sammlung Dr. Albert Figdor, Wien*, vols. 1, 3 (1930).

Frinta, 1965
M. Frinta, "An Investigation of the Punched Decoration of Medieval Italian and Non-Italian Panel Paintings," *The Art Bulletin* 47 (1965).

Frinta, 1971
M. S. Frinta, "Notes on the Punched Decorations of Two Early Panels at the Fogg Art Museum: 'St. Dominic' and the 'Crucifixion,'" *The Art Bulletin* 53 (1971).

Frinta, 1976
M. Frinta, "Deletions from the Work of Pietro Lorenzetti," *Mitteilungen des Kunsthistorischen Instituts in Florenz* 20 (1976).

Frinta, 1982
M. Frinta, "Drawing the Net Closer: The Case of Ilicio [sic] Federico Ioni, Painter of Antique Pictures," *Pantheon* 40 (1982).

Frinta, 1983
M. Frinta, "Unsettling Evidence in Some Panel Paintings by Simone Martini," *La pittura nel XIV e XV secolo, il contributo dell'analisi tecnica alla storia dell'arte*, van Os, ed. (1983).

Frizzoni, 1895
G. Frizzoni, "Notizie concernenti oggetti d'arte, Musei e Gallerie del Regno," *Archivo storico dell'arte* n. s. 1 (1895).

Frizzoni, 1905
G. Frizzoni, "Recensioni," *L'Arte* 8 (1905).

Frosinini, 1987
C. Frosinini, "Il Passaggio di gestione in una bottega pitorica fiorentino del primo '400: Bicci di Lorenzo e Neri di Bicci," *Antichità viva* 26 (1987).

Fumarola, 195?
A. Fumarola, *Fiorenzo di Lorenzo e la sua presunta "bottega"* (195?).

Gabrielli, 1936
A. M. Gabrielli, "Ancora del Barna pittore delle sto-

rie del Nuovo Testamento nella Collegiata di San Gimignano," *Bolletino senese di storia patria* 7 (1936).

Gaillard, 1922
E. Gaillard, "Le Pretendu Girolamo di Benvenuto de l'ex-collection Engel-Gros," *Revue de l'art ancien et moderne* 41 (1922).

Gaillard, 1923
E. Gaillard, *Sano di Pietro* (1923).

Galetti and Camesasca, 1950
U. Galetti and E. Camesasca, *Enciclopedia della pittura italiana*, 2 vols. (1950).

Ganz, 1921
P. Ganz, *L'Oeuvre d'un amateur d'art – la collection de M. F. Engel-Gros*, 2 vols. (1921)

Gardner, 1990
J. Gardner, "The Back of the Panel of 'Christ Discovered in the Temple' by Simone Martini," *Arte cristiana* 741 (1990).

Garrison, 1949
E. B. Garrison, *Italian Romanesque Panel Paintings* (1949).

Geiger, 1913
B. Geiger, "Carlo Crivelli," *Algemeines Lexikon der bildenden Künstler*, U. Thieme and F. Becker, eds. (1913).

Gengaro, 1932
M. L. Gengaro, "Eclesttismo e arte nel Quattrocento senese," *La Diana* 7 (1932).

Georges Petit, 1900
Galerie Georges Petit, *Collection de M. Eugene de Miller Aicholz*, 18-22 May 1900.

Ghiberti, 1947
L. Ghiberti, *Commentari*, O. Morisani, ed. (1947).

Gielly, 1912
L. Gielly, "Les Trecentistes siennois: Ambrogio Lorenzetti," *Revue de l'arte ancien et moderne* 31 (1912).

Gielly, 1926
L. Geilly, *Les primitifs siennois* (1926).

Gnoli, 1911
U. Gnoli, "Cronique," *Revue de l'arte chrétien* (1911).

Gnoli, 1912
U. Gnoli, "Opere inedite e opere smarrite di Niccolò da Foligno," *Bollettino d'arte* 6 (1912).

Gnoli, 1920
U. Gnoli, "Madonne di Fiorenzo di Lorenzo," *Dedalo* 1 (1920).

Gnoli, 1921
U. Gnoli, "Ancora sull'Alunno," *Rassegna d'arte umbra* 3 (1921).

Gnoli, 1923
U. Gnoli, *Pittori e miniatori nell'Umbria* (1923).

Gnudi, 1977
C. Gnudi, "Il Restauro degli affreschi di San Pietro in Sylvis a Bagnacavallo," *Scritti di storia dell'arte in onore di Ugo Procacci*, 2 vols. (1977).

Gnudi, 1978
C. Gnudi, "Crocefissione ignoto di Pietro da Rimini," *Acta historiae artium* 24 (1978).

Gonzales-Palacios, 1971
A. Gonzales-Palacios, "Percorso di Giuliano di Simone," *Arte illustra* 45/46 (1971).

Gonzales-Palacios, 1971a
A. Gonzales-Palacios, "Posizione di Angelo Puccinelli," *Antichità viva* 10 (1971).

Goodison and Robertson, 1967
J. W. Goodison and G. H. Robertson, *Fitzwilliam Museum, Cambridge, Catalogue of Paintings, II, Italian Schools* (1967).

Grassi, 1953
L. Grassi, *Tutta la pittura di Gentile da Fabriano* (1953).

Graves, 1912
A. Graves, *Summary and Index to Waagen* (1912).

Gregori, 1992
M. Gregori, et al., *Maestri e botteghe, pittura a Firenze alla fine del Quattrocento* (1992).

Grieg, 1944
T. P. Grieg, "In the Auction Room," *The Connoisseur* 113 (1944).

Gronau, 1950
H. Gronau, "The Earliest Work of Lorenzo Monaco," *The Burlington Magazine* 92 (1950).

Guidotti, 1979
A. Guidotti, "Precisazioni sul Maestro Daddesco in alcuni codici miniati della Badia a Settimo," *La Miniatura italiana in età Romanica e Gotica* (1979).

Hadley, 1987
R. van N. Hadley, *The Letters of Bernard Berenson and Isabella Stewart Gardner 1887-1924* (1987).

Hale, 1977
J. Hale, *Italian Renaissance Painting from Masaccio to Titian* (1977).

Harpring, 1993
P. Harpring, *The Sienese Trecento Painter Bartolo di Fredi* (1993).

Hartt, 1971
F. Hartt, *History of Italian Renaissance Art* (1971).

Hawes, 1920
C. H. Hawes, "The Madonna and Child with Saint Jerome by Fiorenzo di Lorenzo," *Bulletin of the Museum of Fine Arts* 18 (1920).

Hawes, 1923
C. H. Hawes, "Madonna and Child with an Angel, Piero della Francesca," *Bulletin of the Museum of Fine Arts* 21 (1923).

Hendy, 1930
P. Hendy, "Giovanni di Paolo," *Bulletin of the Museum of Fine Arts* 28 (1930).

Hendy, 1932
P. Hendy, "An Altarpiece by Botticelli," *The Burlington Magazine* 40 (1932).

Herzner, 1985
V. Herzner, *Italian Renaissance Sculpture in the Time of Donatello* (1985).

Heywood and Olcott, 1901
W. Heywood and L. Olcott, *Guide to Siena* (1901).

Hirshler, 1988
E. Hirshler, "Mrs. Gardner's Rival: Susan Cornelia Warren and Her Art Collection," *Fenway Court* (1988).

Holmes, 1930
C. Holmes, "The Italian Exhibition," *The Burlington Magazine* 56 (1930).

Horne, 1987
H. P. Horne, *Alessandro Filipepi, Commonly Called Sandro Botticelli, Painter of Florence* (1908, rev. ed. 1987).

Hovey, 1975
W. R. Hovey, *Treasures of the Frick Art Museum* (1975).

Huter, 1974
C. Huter, "Early Works by Jacopo Bellini," *Arte veneta* 28 (1974).

Huter, 1975
C. Huter, "Panel Paintings by Illuminators. Remarks on a Crisis of Venetian Style," *Arte veneta* 29 (1975).

Hutton, 1910
E. Hutton, *Siena and Southern Tuscany* (1910).

Jacobson, 1907
E. Jacobson, *Sienesische Meister des Trecento in der Gemäldegalerie zu Siena* (1907).

Johnson Collection
John G. Johnson Collection of Italian Paintings (1966).

Kaftal, 1965
G. Kaftal, *The Iconography of the Saints in Central and South Italian Schools of Painting* (1965).

Kanter, 1981-82
L. B. Kanter, "Ugolino di Nerio: Saint Anne and the Virgin," *National Gallery of Canada Annual Bulletin* 5 (1981-82).

Kanter, 1983
L. Kanter, "A 'Massacre of the Innocents' in the Walters Art Gallery," *Journal of the Walters Art Gallery* 41 (1983).

Kanter, 1983a
L. Kanter, "Trittico di Benvenuto di Giovanni alla National Gallery di Londra," *Arte cristiana* 71 (1983).

Kanter, 1990
L. Kanter, "Luca Signorelli, Piero della Francesca, and Pietro Perugino," *Studi di storia dell'arte* 1 (1990).

Kauffmann, 1973
C. M. Kauffmann, *Victoria and Albert Museum, Catalogue of Foreign Paintings, I. Before 1800* (1973).

Keith, 1966
H. Keith, "A Fourteenth-Century Italian Work: Saint Bartholomew," *Auckland City Art Gallery Quarterly* 34 (1966).

Kent, 1989
F. W. Kent, "The Cederni Altarpiece by Neri di Bicci in Parma," *Mitteilungen des Kunsthistorischen Instituts in Florenz* 33 (1989).

Kimball, 1927
F. Kimball, "Luciano Laurana and the High Renaissance" *The Art Bulletin* 10 (1927).

Klesse, 1967
B. Klesse, *Seidenstoffe in der italienischen Malerei des vierzehnten Jahrhunderts* (1967).

Kreplin, 1929
B. C. Kreplin, "Zanobi Machiavelli," *Algemeines Lexikon der bildenden Künstler*, U. Thiemer and F. Becker, eds. (1929).

Kury, 1978
G. Kury, *The Early Work of Luca Signorelli* (1978).

Laclotte, 1956
M. Laclotte, *De Giotto à Bellini* (1956).

Laclotte, 1969
M. Laclotte, "Le Maître des Anges Rebelles," *Paragone* 237 (1969).

Laclotte and Mognetti, 1977
M. Laclotte and E. Mognetti, *Avignon-Musée du Petit Palais Peinture italienne* (1977).

Laclotte, 1986
Musée du Louvre, Nouvelles acquisitions du Department des Peintures, 1983-1986

Laclotte, 1987
M. Laclotte, "Une Madone d'Ugolino da Siena," *Homage à Hubert Landais, Art, Objets d'art Collection*, Blanchard, ed. (1987)

Lafenestre and Richtenberger, 1905
G. Lafenestre and E. Richtenberger, *Rome* (1905).

Land, 1978
N. E. Land, "Cristoforo Cortese and an Important Antiphonary in the Bodleian Library, Oxford," *The Burlington Magazine* 120 (1978).

Landolfi, 1988
G. Landolfi, "Il Maestro della Natività Johnson," in *Il 'Maestro di San Miniato,' lo stato degli studi, i problemi, le risposte della filologia* (1988).

Lanzi, 1809
Abbate Luigi Lanzi, *Storia pittorica della Italia*, 2 vols. (1809).

Lavin, 1975
M. Lavin, *Seventeenth-Century Barberini Documents and Inventories of Art* (1975).

Lazarev, 1926
V. Lazarev, "A Newly Discovered Fiorenzo di Lorenzo," *The Burlington Magazine* 48 (1926).

Lazarev, 1928
V. Lazarev, "Some Florentine Pictures of the Trecento in Russia," *Art in America* 16 (1928).

Lazzari, 1801
A. Lazzari, *Delle Chiese di Urbino* (1801).

Lehman, 1928
R. Lehman, *The Philip Lehman Collection* (1928).

Leoni de Castris, 1989
P. Leoni de Castris, *Simone Martini, catalogo completo* (1989).

Levi d'Ancona, 1977
M. Levi d'Ancona, *The Garden of the Renaissance: Botanical Symbolism in Italian Painting* (1977).

Licht, 1967
F. Licht, "For Florence, From Florence," *Art News* 66 (1967).

Lightbown, 1978
R. Lightbown, *Sandro Botticelli* (1978).

Lightbown, 1992
R. Lightbown, *Piero della Francesca* (1992).

Lisini, 1903
A. Lisini, *Le Tavolette dipinte di Biccherna e di Gabella del R. Archivo di Stato* (1903).

Lloyd, 1977
C. Lloyd, *A Catalogue of the Earlier Italian Paintings in the Ashmolean Museum* (1977).

Locko Park, 1968
Nottingham University Art Gallery, *Pictures from Locko Park* (1968).

Longhi, 1928
R. Longhi, "Me pinxit: un San Michele Archangelo di Gentile da Fabriano," *Pinacoteca* 1 (1928).

Longhi, 1930
R. Longhi, *Piero della Francesca* (1930).

Longhi, 1940
R. Longhi, "Fatti di Masolino e di Masaccio," *Critica d'arte* 25-26 (1940).

Longhi, 1947
R. Longhi, *Piero della Francesco*, 2nd ed. (1947).

Longhi, 1948
R. Longhi, "Il Maestro della predella Sherman," *Proporzioni* 2 (1948).

Longhi, 1952
R. Longhi, "Il Maestro di Pratovecchio," *Paragone* 35 (1952).

Longhi, 1953
R. Longhi, "Frammento siciliano," *Paragone* 47 (1953).

Longhi, 1959
R. Longhi, "Qualità e industria in Taddeo Gaddi," *Paragone* 109 (1959).

Longhi, 1962
R. Longhi, "Crivelli e Mantegna: due mostre interferenti e la cultura artistica nel 1961," *Paragone* 145 (1962).

Longhi, 1963
R. Longhi, *Piero della Francesca*, 3rd ed. (1963).

Longhi, 1967
R. Longhi, "Un nuovo numero del 'Maestro della Predella Sherman,'" *Paragone* 211 (1967).

"Lorenzo il Magnifico," 1949
Lorenzo il Magnifico e le arti: catalogo della mostra d'arte antica (1949).

Mackowsky, 1899
H. Mackowsky, "Jacopo del Sellaio," *Jahrbuch der koniglich preussischen Kunstsammlungen* 20 (1899).

Maginnis, 1977
H. B. J. Maginnis, "The Literature of Sienese

Trecento Painting, 1945-1975," *Zeitschrift fur Kunstgeschichte* 40 (1977).

Maginnis, 1981
H. B. J. Maginnis, ed., *A Legacy of Attributions*, supp. to R. Offner, *A Critical and Historical Corpus of Florentine Painting* (1981).

Malaguzzi-Valeri, 1903
F. Malaguzzi-Valeri, "L'Ordinamento e i nuovi acquisti della pinacoteca di Brera," *Emporium* 17 (1903).

Mallory, 1974
M. Mallory, "An Altarpiece by Lippo Memmi Reconsidered," *Metropolitan Museum of Art Journal* 9 (1974).

Mallory, 1975
M. Mallory, "Thoughts Concerning the 'Master of the Glorification of St. Thomas,'" *The Art Bulletin* 57 (1975).

Malvano, 1969
L. Malvano, "Une Vierge à l'Enfant de Barnaba da Modena au Louvre," *La Revue du Louvre* 19 (1969).

Mandach, 1913
C. de Mandach, "L'importance de Jacopo Bellini dans le developpment de la peinture italienne," *Archives de l'art français* 7 (1913).

Mandel, 1967
G. Mandel, *The Complete Paintings of Botticelli* (1967).

Marcuci, 1965
L. Marcuci, *Gallerie Nazionali di Firenze, i dipinti toscani del secolo XIV* (1965).

Mariotti, 1892
F. Mariotti, *La legislazione delle belle arti* (1892).

Martindale, 1988
A. Martindale, *Simone Martini* (1988).

Martini, 1960
A. Martini, "The Early Work of Bartolomeo della Gatta," *The Art Bulletin* 42 (1960).

Massei, 1908
D. R. Massei, "Alcuni affreschi di Matteo da Gualdo scoperti recentemente nelle valli del monte Pennino," *Rassegna d'arte antica e moderna* 8 (1908).

Mather, 1923
F. J. Mather, Jr., *A History of Italian Paintings* (1923).

Mather, 1936
F. J. Mather, Jr., *Venetian Painters* (1936).

Matteoli, 1972
A. Matteoli, "Aggiunte a Zanobi Machiavelli," *Bolletino degli Euteleti* 42 (1972).

Mattheisen, 1983
Matthiesen Fine Art Ltd., *Early Italian Paintings and Works of Art, 1300-1480* (1983).

Maytham, 1957
T. N. Maytham, "An Expulsion from Paradise by Benvento di Giovanni," *Bulletin of the Museum of Fine Arts* 40 (1957).

Meiss, 1941
M. Meiss, "A Documented Altarpiece by Piero della Francesca," *The Art Bulletin* 23 (1941).

Meiss, 1946
M. Meiss, "Italian Primitives at Kŏnŏpiste," *The Art Bulletin* 28 (1946).

Meiss, 1951
M. Meiss, *Painting in Florence and Siena after the Black Death* (1951).

Meiss, 1955
M. Meiss, "Nuovi dipinti e vecchi problemi," *Rivista d'arte* 30 (1955).

Meiss, 1955-56
M. Meiss, "Saint John the Evangelist by Andrea Vanni," *Fogg Art Museum Annual Report* (1955-56).

Meiss, 1961
M. Meiss, "Contributions to Two Elusive Masters," *The Burlington Magazine* 103 (1961).

Meller and Hokin, 1982
P. Meller and J. Hokin, "The Barberini Master as a Draftsman?," *Master Drawings* 20 (1982).

Meloni Trkulja, 1971
S. Meloni Trkulja, "Una Madonna e mezzo affresco di Giuliano di Simone lucchese," *Paragone* 255 (1971).

Meyenburg, 1903
E. von Meyenburg, *Ambrogio Lorenzetti. Ein Beitrag zur Geschichte der sienesischen Malerei in vierzehenten Jahrhundert* (1903).

Micheletti, 1976
E. Micheletti, *L'Opera completa di Gentile da Fabriano* (1976).

Milanesi, 1854
G. Milanesi, *Documenti per la storia dell'arte senese* (1854).

Milanesi, 1883
G. Milanesi, *Catalogue des tableaux, meubles, et objets d'art formant la galerie de M.r le Chev. Toscanelli* (1883).

Molajoli, 1934
B. Molajoli, "Gli affreschi riminesi in S. Agostino di Fabriano," *Rivista d'Arte* 16 (1934).

Molajoli, 1936
B. Molajoli, *Guida artistica di Fabriano* (1936).

Mongan et al., 1983
A. Mongan, C. Gould, E. Mongan, M. Quick, foreword by N. A. Peterson, *Timken Art Gallery, European and American Works of Art in the Putnam Foundation Collection* (1983).

Moran, 1976
G. Moran, "Bartolo di Fredi e l'altare Fornai del 1368," *Prospettiva* 4 (1976).

Moran, 1976a
G. Moran, "Is the Name Barna an Incorrect Transcription of the Name Bartolo?," *Paragone* 311 (1976).

Moran and Mallory, 1972
G. Moran and M. Mallory, "Yale's Virgin of the Annunciation from the Circle of Bartolo di Fredi," *Yale University Art Gallery Bulletin* 35 (1972).

Mostra, 1904
Mostra dell'antica arte senese (1904).

Muller, 1977
N. E. Muller, "A Newly Discovered Panel from Bartolo di Fredi's 'Adoration of the Magi,'" *Simiolus* 9 (1977).

Muller, 1978
N. E. Muller, "Three Methods of Modelling the Virgin's Mantle in Early Italian Painting," *Journal of the American Institute for Conservation* 17 (1978).

Muratoff, 1930
P. Muratoff, *Fra Angelico* (1930).

Musatti, 1950
R. Musatti, "Catalogo giovanile di Cosimo Rosselli," *Rivista d'arte*, n. s. 1 (1950).

Neri di Bicci
Neri di Bicci: Le Ricordanze, B. Santi, ed. (1976).

New Gallery, 1893-94
"Exhibition of Early Italian Art," New Gallery, London (1893-94).

Nicola, 1919
G. de Nicola, "Studi sull'arte senese," *Rassegna d'arte* 6 (1919).

Norton, 1908
R. Norton, "Painting by Sano di Pietro," *Bulletin of the Museum of Fine Arts* 6 (1908).

Nuttal, 1985
P. Nuttal, "'La Tavele Sinte Barberen': New Documents for Cosimo Rosselli and Giuliano da Maiano," *The Burlington Magazine* 127 (1985).

Oberhuber, 1973
K. Oberhuber, in *Early Italian Engravings from the National Gallery of Art* (1973).

Offner, 1920
R. Offner, "A Panel by Antonio Veneziano," *Art in America* 8 (1920).

Offner, 1921
R. Offner, "Niccolò di Pietro Gerini," *Art in America* 9 (1921).

Offner, 1923
R. Offner, "Five More Panels by Antonio Veneziano," *Art in America* 11 (1923).

Offner, 1925
R. Offner, "Niccolò di Tommaso," *Art in America* 13 (1925).

Offner, 1927
R. Offner, *Italian Primitives at Yale University* (1927).

Offner, 1927a
R. Offner, *Studies in Florentine Painting* (1927).

Offner, 1939
R. Offner, "The Barberini Panels and Their History," *Medieval Studies in Honor of Kingsley Porter* (1939).

Offner
R. Offner, *A Critical and Historical Corpus of Florentine Painting* (1930-1984).

Offner, 1960
R. Offner, "Reflections on Ambrogio Lorenzetti," *Gazette des Beaux-Arts* 56 (1960).

Orlandi, 1964
S. Orlandi, *Beato Angelico* (1964).

Paccagnini, 1955
G. Paccagnini, *Simone Martini* (1955).

Pacciaroni, 1984
R. Pacciaroni, *Un Dipinto sanseverinate in America* (1984).

Padoa Rizzo, 1977
A. Padoa Rizzo, "La Cappella Salutati nel Duomo di Fiesole e l'attività giovanile di Cosimo Rosselli," *Antichità viva* 16 (1977).

Padoa Rizzo, 1986
A. Padoa Rizzo, "Pittori e miniatore a Firenze nel Quattrocento," *Antichità viva* 25, 5-6 (1986).

Padoa Rizzo, 1987
A. Padoa Rizzo, "La Cappella della Compagnia di Santa Barbara della 'Nazione Tedesca' all Santissima Annunziata di Firenze nel secolo XV. Cosimo Rosselli e la sua 'impressa' artistica," *Antichità viva* 26, 3 (1987).

Padoa Rizzo, 1987a
A. Padoa Rizzo, "Ricerche sulla pittura del' 400 nel territorio fiorentino: Bernardo di Stefano Rosselli," *Antichità viva* 26, 5-6, (1987).

Padovani, 1972
S. Padovani, "Barnaba Agocchiari da Modena," *Dizionario enciclopedico Bolaffi dei pittori e degli incisori Italiani* vol. 1 (1972).

Padovani, 1979
S. Padovani, *Tesori d'arte antica a San Miniato* (1979).

Padovani, Trkulja, 1982
S. Padovani, S. Meloni Trkulja, *Il Cenacolo di Andrea del Sarto a San Salvi* (1982).

Pallucchini, 1957-58
R. Pallucchini, *La pittura veneta del Quattrocento* (1957-58).

Palumbo, 1973
G. Palumbo, *Collezione Federico Mason Perkins, Sacro Convento di S. Francesco Assisi* (1973).

Paolucci, 1971
A. Paolucci, "Per Bernardino di Mariotto," *Paragone* 255 (1971).

Paolucci, 1990
A. Paolucci, *Luca Signorelli* (1990)

Papini, 1946
R. Papini, *Francesco di Giorgio architetto* (1946).

Parronchi, 1962
A. Parronchi, "Leon Battista Alberti as a Painter," *The Burlington Magazine* 104 (1962).

Parronchi, 1964
A. Parronchi, *Studi su la dolce prospettiva* (1964).

Parronchi, 1975
A. Parronchi, "Peregrinus pinsit," *Commentari* 26 (1975).

Perkins, 1904
F. M. Perkins, "La Pittura all mostra d'arte antica in Siena," *Rassegna d'arte* 4 (1904).

Perkins, 1904a
F. M. Perkins, "Di alcune opere poco note di Ambrogio Lorenzetti," *Rassegna d'arte* 4 (1904).

Perkins, 1904b
F. M. Perkins, "The Forgotten Masterpiece of Ambrogio Lorenzetti," *The Burlington Magazine* 5 (1904).

Perkins, 1904c
F. M. Perkins, "The Sienese Exhibition of Ancient Art," *The Burlington Magazine* 5 (1904).

Perkins, 1905
F. M. Perkins, "Pitture senese negli Stati Uniti," *Rassegna d'arte senese* 1 (1905).

Perkins, 1907
F. M. Perkins, "Ancora dei dipinti sconosciuti della sculoa senese," *Rassegna d'arte senese* 3 (1907).

Perkins, 1910
F. M. Perkins, "Dipinti italiani nella raccolta Platt," *Rassegna d'arte* 11 (1910).

Perkins, 1913
F. M. Perkins, "Un quadro di Jacopo del Sellajo a Boston," *Rassegna d'arte* 13 (1913).

Perkins, 1914
F. M. Perkins, "Dipinti senesi sconosciuti o inediti," *Rassegna d'arte* 14 (1914).

Perkins, 1915
F. M. Perkins, "Un dipinto ignorato di Barnaba da Modena," *L'Arte* 18 (1915).

Perkins, 1920
F. M. Perkins, "Un Dipinto inedito di Niccolò di Buonaccorso," *Rassegna d'arte senese* 13 (1920).

Perkins, 1920a
F. M. Perkins, "Some Sienese Paintings in American Collections, Part One," *Art in America* 8 (1920).

Perkins, 1922
F. M. Perkins, "Some Recent Acquisitions of the Fogg Art Museum," *Art in America* 10 (1922).

Perkins, 1928
F. M. Perkins, "Three Paintings by Francesco di Giorgio," *Art in America* 16 (1928).

Perkins, 1930
F. M. Perkins, "Matteo da Gualdo," *Allegmeines Lexikon des bildenden Künstler*, U. Thieme and F. Becker, eds., vol. 24 (1930).

Perkins, 1931
F. M. Perkins, "Pitture senesi poco conosciute," *La Diana* 6 (1931).

Pesenti, 1968
F. R. Pesenti, "'Barnaba de Mutina pinxit in Janua': i polittici di Murcia," *Bolletino d'arte* 53 (1968).

Pesenti, 1970
F. R. Pesenti, "Un apporto emiliano e la situazione figurativa locale," in *La Pittura a Genova e in Liguria* (1970).

Peters, 1988
S. D. Peters, ed., *Memorial Art Gallery. An Introduction to the Collection* (1988).

Piceller, 1882
A. Piceller, *Catalogue du Musée appartenant aux nobles heritiers du feu Marquis Ranghiasci-Brancaleoni* (1882).

Pigler, 1947
A. Pigler, "Reminiscenze trecentesche a Firenze nel-l'ultimo quarto del secolo XV," *Annuario dell'Istituto ungherese di storia dell'arte di Firenze* (1947).

Poggi, 1904
G. Poggi, "La mostra d'antica arta senese," *Emporium* 2 (1904).

Polzer, 1981
J. Polzer, "The 'Master of the Rebel Angels' Reconsidered," *The Art Bulletin* 63 (1981).

Pope-Hennessy, 1938
J. Pope-Hennessy, *Giovanni di Paolo* (1938).

Pope-Hennessy, 1939
J. Pope-Hennessy, *Sassetta* (1939).

Pope-Hennessy, 1939a
J. Pope-Hennessy, "The Panel Paintings of Pellegrino di Mariano," *The Burlington Magazine* 74 (1939).

Pope-Hennessy, 1944
J. Pope-Hennessy, "The Development of Realistic Painting in Siena," *The Burlington Magazine* 84 (1944).

Pope-Hennessy, 1946
J. Pope-Hennessy, "Barna, the Pseudo-Barna and Giovanni d'Asciano," *The Burlington Magazine* 88 (1946).

Pope-Hennessy, 1947
J. Pope-Hennessy, *Sienese Quattrocento Painting* (1947).

Pope-Hennessy, 1950
J. Pope-Hennessy, *Paolo Uccello* (1950).

Pope-Hennessy, 1952
J. Pope-Hennessy, *Fra Angelico* (1952).

Pope-Hennessy, 1974
J. Pope-Hennessy, *Fra Angelico*, 2nd ed. (1974).

Pope-Hennessy, 1988
J. Pope-Hennessy, "Giovanni di Paolo," *The Metropolitan Museum of Art Bulletin* 46 (1988).

Pope-Hennessy and Kanter, 1987
J. Pope-Hennessy and L. Kanter, *The Robert Lehman Collection, I. Italian Paintings* (1987).

Post, 1914
C. R. Post, "Madonna and Child with Angels, Saints and a Donor," *Bulletin of the Museum of Fine Arts* 12 (1914).

Preiser, 1973
A. Preiser, *Das Entstehen und die Entwicklung der Predella in der italienische Malerei* (1973).

Previtali, 1985
G. Previtali, in *Simone Martini e 'chompagni'* (1985).

Procacci, 1933
U. Procacci, "Gherardo Starnina," *Rivista d'arte* 15 (1933).

Procacci, 1935
U. Procacci, "Gherardo Starnina," *Rivista d'arte* 17 (1935).

Procacci, 1936
U. Procacci, "Gherardo Starnina," *Rivista d'arte* 18 (1936).

Procacci, 1961
U. Procacci, "Di Iacopo d'Antonio e delle compagnie di pittori del corso degli Adimari nel XV secolo," *Rivista d'arte*, n. s. 11 (1961).

Procacci, 1984
U. Procacci, "Lettere a Roberto Salvini con vecchi ricordi e con alcune notizie su Lippo di Andrea modesto pittore del primo Quattrocento," *Scritti di storia dell'arte in onore di Roberto Salvini* (1984).

Pudelko, 1935
G. Pudelko, "The Minor Masters of the Chiostro Verde," *The Art Bulletin* 17 (1935).

Pudelko, 1938
G. Pudelko, "Il Maestro del Bambino Vispo," *Art in America* 26 (1938).

Quintavalle, 1939
A. O. Quintavalle, *La Regia Galleria di Parma* (1939).

Ragghianti, 1953
C. Ragghianti, ed., *Sele Arte* (1953).

Ragionieri, 1989
G. Ragionieri, *Duccio: Catalogo completo dei dipinti* (1989).

Ramboux, 1862
J. A. Ramboux, *Katalog der Gemälde alter italienischer Meister (1221-1640) in der Sammlung des Conservator J. A. Ramboux* (1862).

Rankin, 1905
W. Rankin, "Notes on the Collections of Old Masters at Yale University, the Boston Museum of Fine Arts, the Fogg Museum of Harvard University," *Wellesley College* (1905).

Rankin, 1907
W. Rankin, "Primitives in the Boston Museum," *The Scrip* (January 1907).

Réau, 1958
L. Réau, *Iconographie de l'art chretien*, 3 vols. (1958).

"Recent Gifts," 1915
"Recent Gifts," *Bulletin of the Museum of Fine Arts* 13 (1915).

Reinach, 1905
S. Reinach, *Repertoire des peintures du moyen âge et de la renaissance* (1905).

Ricci, 1834
A. Ricci, *Memoire storiche della arti e degli artisti della Marca di Ancona* (1834).

Richter, 1940
G. M. Richter, "Rehabilitation of Fra Carnevale," *Art Quarterly* 3 (1940).

Richter, 1943
G. M. Richter, "Architectural Fantasies by Bramante," *Gazette des Beaux-Arts* 23 (1943).

Rinaldi, 1946-47
E. Rinaldi, *Niccolò da Foligno (detto l'Alunno)*, Ph.D. diss., Università degli Studi di Firenze, 1946-47.

Robinson, 1979
J. M. Robinson, "The Ruin of Historic English Collections," *Connoisseur* 805 (1979).

Rocchi, 1911
Collection of Objects of Art and Antiquities of chev. Prof. Mariano Rocchi (1911).

Rosini, 1839
G. Rosini, *Storia della pittura italiana*, 2 vols. (1839).

Rossi, 1875
A. Rossi, "Maestro Lorenzo di Maestro Alessandro pittore severinate, commentario," *Giornale di erudizione artistica* 4 (1875).

Rotondi, 1951
P. Rotondi, "Contributi Urbinati al Bramante pittore," *Emporium* 57 (1951).

Rowland, 1931
B. Rowland, "A Fresco Cycle from Spoleto," *Art in America* 19 (1931).

Rowlands, 1960
J. Rowlands, "A Hitherto Unknown Panel by Simone Martini," *The Burlington Magazine* 102 (1960).

Rowley, 1927
G. Rowley, "Ambrogio Lorenzetti, il Pensatore," *La Balzana* 5 (1927).

Rusconi, 1909
A. J. Rusconi, "Novi quadri nella Galleria Barberini," *Vita d'arte* 4 (1909).

Rushforth, 1900
G. M. Rushforth, *Carlo Crivelli* (1900).

Russell, 1973
F. Russell, "The Evolution of a Sienese Painter: Some Early Madonnas of Pacchiarotto," *The Burlington Magazine* 115 (1973).

Russell, 1978
F. Russell, "Two Italian Madonnas," *The Burlington Magazine* 120 (1978).

Salmi, 1928-29
M. Salmi, "Antonio Veneziano," *Bolletino d'arte* 8 (1928-29).

Salmi, 1931-32
M. Salmi, "La Scuola di Rimini, I," *Rivista del Reggio Istituto di archeologia e storia dell'arte* (1931-32).

Salmi, 1935
M. Salmi, "Bibliografia," *Rivista d'arte* 7 (1935).

Salmi, 1952
M. Salmi, "La Miniatura fiorentino medievale," *Accademie e biblioteche d'Italia* 20 (1952).

Salmi, 1953
M. Salmi, *Luca Signorelli* (1953).

Salmi, 1958
M. Salmi, *Il Beato Angelico* (1958).

Salvini, 1958
R. Salvini, *Tutta la pittura del Botticelli* (1958).

Salvini, 1965
R. Salvini, *All the Paintings of Botticelli* (1965).

Sandberg-Vavalà, 1953
E. Sandberg-Vavala, *Sienese Studies* (1953).

Sangiorgi, 1989
F. Sangiorgi, "Fra Carnevale e la tavola di Santa Maria della Bella di Urbino," *Notizie da Palazzo Albani* 18, 2 (1989).

Sani, 1985
B. Sani in *Simone Martini e 'chompagni'* (1985).

Santangelo, 1948
A. Santangelo, *Museo di Palazzo Venezia, Catalogo* (1948).

Santangelo, 1974
A. Santangelo, *Catalogo di Museo di Palazzo Venezia, I, i dipinti* (1974).

Santi, 1985
F. Santi, *Galleria Nazionale dell'Umbria, dipinti, sculture e oggetti dei secoli XV-XVI* (1985).

Santoni and Aleandri, 1906
M. Santoni and V. Aleandri, "La Chiesa di S. Venanzio in Camerino rinnovata nel secolo XV," *Rassegna bibliografica dell'arte italiana* 9 (1906).

Saslow, 1986
J. M. Saslow, *Ganymede in the Renaissance* (1986).

Scarpellini, 1964
P. Scarpellini, *Luca Signorelli* (1964).

Schmarsow, 1886
A. Schmarsow, *Melozzo da Forli* (1886).

Schmarsow, 1912
A. Schmarsow, *Joos van Ghent und Melozzo da Forli in Rom und Urbino* (1912).

Schorr, 1940
D. C. Schorr, "The Mourning Virgin and Saint John," *The Art Bulletin* 22 (1940).

Schorr, 1954
D. C. Schorr, *The Christ Child in Devotional Images in Italy during the XIV Century* (1954).

Schottmuler, 1924
F. Schottmuler, *Fra Angelico* (1924).

Schubring, 1915
P. Schubring, *Cassone* (1915).

Seidel, 1989
M. Seidel, "Sozialgeschichte des sieneser Renaissance-bildes, studien zu Francesco di Giorgio, Neroccio de'Landi, Benvenuto di Giovanni, Matteo di Giovanni und Bernardo Fungai," *Städel Jahrbuch*, n. f. (1989).

Serra, 1934
L. Serra, *L'Arte nelle Marche*, 2 vols. (1934).

Servanzi-Collio, 1858
S. Servanzi-Collio, "Dipinto in tavola nella chiesa collegiata di S. Venanzio e quindi nel Museo Vaticano in Roma," *L'Album* 25, no. 37 (1858).

Seymour, 1952-53
C. Seymour, "The Jarves Sassettas and the Saint Anthony Altarpiece," *Journal of the Walters Art Gallery* 15-16 (1952-53).

Seymour, 1970
C. Seymour, *Early Italian Paintings in the Yale University Art Gallery* (1970).

Shapley, 1966
F. R. Shapley, *Paintings from the Samuel H. Kress Collection. Italian Schools, XIII-XV Century* (1966).

Shapley, 1968
F. R. Shapely, *Paintings from the Samuel H. Kress Collection. Italian Schools XV-XVI Centuries* (1968).

Shapely, 1979
F. R. Shapely, *Catalogue of the Italian Paintings, National Gallery of Art* (1979).

Shearman, 1983
J. Shearman, *The Early Italian Pictures in the Collection of Her Majesty the Queen* (1983).

"Sherman Collection," 1922
"The Henry H. and Zoe Oliver Sherman Collection," *Bulletin of the Museum of Fine Arts* 20 (1922).

"Sienese Primitive," 1916
"A Sienese Primitive," *Bulletin of the Museum of Fine Arts* 14 (1916).

Sinibaldi, 1933
G. Sinibaldi, *I Lorenzetti* (1933).

Sirén, 1904
O. Sirén, "Di alcuni pittori fiorentini che subirono l'influenza di Lorenzo Monaco," *L'Arte* 7 (1904).

Sirén, 1907
O. Sirén, *Giotto and Some of His Followers* (1907).

Sirén, 1916
O. Sirén, *A Descriptive Catalogue of the Pictures of the Jarves Collection Belonging to Yale University* (1916).

Sirén, 1916a
O. Sirén, "Some Early Italian Paintings in the Museum Collection," *Bulletin of the Museum of Fine Arts* 14 (1916).

Sirén, 1920
O. Sirén, "Gerini, Niccolò di Petro," *Algemeines Lexikon der bildenden Künstler*, U. Thieme and F. Becker, eds., vol. 13 (1920).

Sirén, 1920a
O. Sirén, "Lorenzo di Niccolò," *The Burlington Magazine* 36 (1920).

Sirén and Brockwell, 1917
O. Sirén and M. W. Brockwell, *Catalogue of a Loan Exhibition of Italian Primitives* (Kleinberger, New York, 1917).

Skaug, 1971
E. Skaug, "Contributions to Giotto's Workshop," *Mitteilungen des Kunsthistorischen Instituts in Florenz* 15 (1971).

Skaug, 1975
E. Skaug, "The St. Anthony Abbot Ascribed to Bartolo di Fredi in the National Gallery, London," *Institutam Romanum Norvegiae, Acta ad archaeologiam et artium historiam pertinentia* 6 (1975).

Skaug, 1976
E. Skaug, "Notes on the Chronology of Ambrogio Lorenzetti and a New Painting from His Shop," *Mitteilungen des Kunsthistorischen Instituts in Florenz* 20 (1976).

Skaug, 1983
E. Skaug, "Punch Marks – What Are They Worth? Problems of Tuscan Workshop Interrelationships in Mid-Fourteenth Century: the Ovile Master and Giovanni da Milano," *La pittura nel XIV e XV secolo: il contributo dell'analisi tecnica alla storia dell'arte* (1983).

Sricchia Santoro, 1976
F. Sricchia Santoro, "Sul soggiorno spagnolo di Gherardo Starnina e sull'identà del 'Maestro del Bambino Vispo,'" *Prospettiva* 6 (1976).

Stefaniak, 1992
R. Stefaniak, "Replicating Mysteries of the Passion: Rosso's *Dead Christ with Angels*," *Renaissance Quarterly* 45 no. 4 (winter 1992).

Stechow, 1944
W. Stechow, "Marco del Buono and Apollonio di Giovanni, Cassone Painters," *Allen Memorial Art Museum Bulletin* 1 (1944).

Stechow, 1967
W. Stechow, *Catalogue of European and American Paintings and Sculpture in the Allen Memorial Art Museum* (1967).

Steinberg, 1986
L. Steinberg, *The Sexuality of Christ in Renaissance Art and in Modern Oblivion* (1986).

Steinberg, 1989
L. Steinberg, "Michelangelo's Florentine Pietà: the Missing Leg Twenty Years Later," *The Art Bulletin* 71 (1989).

Steinweg, 1965
K. Steinweg, "Eine Verkundigung des Antonio Veneziano," *Berichte aus den Staatlichen Museen der Stiftung preussischer Kulturbesitz*, n. f. 15 (1965).

Stiavelli, 1909
G. Stiavelli, *Ars et Labor* (1909).

Strehlke, 1988
C. Strehlke in *Painting in Renaissance Siena 1420-1500* (1988).

Strehlke, 1984
C. Strehlke, "La 'Madonna dell'Umilita' di Domenco di Bartolo e San Bernardino," *Arte cristiana* 772 (1984).

Strehlke, 1991
C. Strehlke, "The Early Sienese Paintings in Holland," *The Burlington Magazine* 133 (1991).

Stubblebine, 1964
J. H. Stubblebine, *Guido da Siena* (1964).

Stubblebine, 1967
J. H. Stubblebine, "The Italian Heritage," *The Burlington Magazine* 109 (1967).

Stubblebine, 1969
J. H. Stubblebine, "Segna di Bonaventura and the Image of the Man of Sorrows," *Gesta* 8 (1969).

Stubblebine, 1969a
J. H. Stubblebine, "The Angel Pinnacles on Duccio's Maestà," *The Art Quarterly* 32 (1969).

Stubblebine, 1973
J. H. Stubblebine, "Duccio and His Collaborators on the Cathedral Maestà, *The Art Bulletin* 55 (1973).

Stubblebine, 1978
J. H. Stubblebine, "The Boston Ducciesque Tabernacle, a Collaboration," in *Collaboration in Italian Renaissance Art*, W. S. Sheard and J. T. Paoletti, eds. (1978).

Stubblebine, 1978a
J. H. Stubblebine, "The Face in the Crowd: Some Early Sienese Self-Portraits," *Apollo* 108 (1978).

Stubblebine, 1979
J. H. Stubblebine, *Duccio di Buoninsegna and His School*, 2 vols. (1979).

Stubblebine, 1985
J. H. Stubblebine, "Ugolino di Nerio: Old and New in an Early Madonna," *Apollo* 121 (1985).

Suida, 1952
W. E. Suida, *The Samuel H. Kress Collection Birmingham Museum of Art* (1952).

Suida, 1953
W. E. Suida, *Bramante pittore e il Bramantino* (1953).

Sutton, 1979
D. Sutton, "Robert Langton Douglas, part III: Commerce and Connoisseurship," *Apollo* 109 (1979).

Sutton, 1979a
D. Sutton, "Robert Langton Douglas, part IV: 'A Fresh Start,'" *Apollo*, 110 (1979).

Sutton, 1979b
D. Sutton, "Robert Langton Douglas, part V: Sunset at Fiesole," *Apollo* 110 (1979).

Sutton, 1983
D. Sutton, "Piety and Restraint: Two Centuries of Italian Art in London," *Apollo* 118 (1983).

Swarzenski, 1940
G. Swarzenski, "The Master of the Barberini Panels: Bramante," *Bulletin of the Museum of Fine Arts* 38 (1940).

Swarzenski, 1950
G. Swarzenski, "A Sienese Bookcover of 1364," *Bulletin of the Museum of Fine Arts* 48 (1950).

Syre, 1979
C. Syre, *Studien zum 'Maestro del Bambino Vispo' und Starnina* (1979).

Tartuferi, 1983
A. Tartuferi, "Spinello Aretino in San Michele Visdomini (e alcune osservazioni su Loranzo di Niccolò)," *Paragone* 395 (1983).

Tartuferi, 1987
A. Tartuferi, *Dipinti italiani del XIV e XV secolo in una raccolta milanesi*, M. Boskovits, ed. (1987).

Tartuferi, 1990
A. Tartuferi, *Paintings and Miniatures from the XIV to the XVII Centuries* (Galerie Adriano Ribolzi, Monte Carlo, 1990).

Tatlock, 1930
R. R. Tatlock, "A Giottesque Panel for Boston," *The Burlington Magazine* 56 (1930).

Taylor, 1932
F. H. Taylor, "Rainaldictus Fresco Painter of Spoleto," *Worcester Art Museum Bulletin* 22 (1932).

Testi, 1915
L. Testi, *Storia della pittura veneziana* (1915).

Tietze, 1935
H. Tietze, *Meisterwerke europaischer Malerei in America* (1935).

Tietze, 1939
H. Tietze, *Masterpieces of European Painting in America* (1939).

Todini, 1986
F. Todini, "Pittura del Duecento e del Trecento in Umbria e il cantieri di Assisi," *La Pittura in Italia. Il Duecento e Trecento*, 2 vols. (1986).

Todini, 1989
F. Todini, *La Pittura umbra dal Duecento al primo Cinquecento*, 2 vols. (1989).

Todini and Lunghi, 1987
F. Todini and E. Lunghi, *Niccolò di Liberatore detto l'Alunno* (1987).

Toesca, 1927
P. Toesca, *Storia dell'arte italiana* (1927).

Toesca, 1951
P. Toesca, *Il Trecento* (1951).

Toledano, 1987
R. Toledano, *Francesco di Giorgio Martini* (1987).

Tonini, 1876
P. Tonini, *Il Santuario della SS. Annunziata di Firenze* (1876).

Torriti, 1977
P. Torriti, *La Pinacoteca Nazionale di Siena, i dipinti dal XII al XV secolo* (1977).

Toscano, 1974
B. Toscano, "Il Maestro delle Palazze e il suo ambiente," *Paragone* 291 (1974).

Traldi, 1977
R. Traldi, "Due precisazioni per Bartolo di Fredi," *Prospettiva* 10 (1977).

Ullman, 1893
H. Ullman, *Sandro Botticelli* (1893).

Valentiner, 1933
W. R. Valentiner in *The Sixteenth Loan Exhibition of Old Masters* (Detroit Institute of Arts, 1933).

van Marle
R. van Marle, *The Development of the Italian Schools of Paintings*, 19 vols. (1923-38).

van Marle, 1920
R. van Marle, *Simone Martini et les peintres de son école* (1920).

van Marle, 1922
R. van Marle, "An Early and a Late Work of Andrea Vanni," *Art in America* 10 (1922).

van Marle, 1922a
R. van Marle, "Opera giovanili di Barna da Siena," *Rassegna d'arte senese* 15 (1922).

van Marle, 1925
R. van Marle, "Nuove attribuzioni a Barna da Siena," *Rassegna d'arte senese* 18 (1925).

van Marle, 1929
R. van Marle, "Quadri senesi sconosciuti," *La Diana* 4 (1929).

van Marle, 1929a
R. van Marle, "Die Sammlung Joseph Spiridon," *Der Cicerone* 21 (1929).

van Marle, 1930
R. van Marle, "Minor Simonesque Masters," *Apollo* 14 (1930).

van Marle, 1931
R. van Marle, "Quadri ducceschi ignorati," *La Diana* 6 (1931).

van Marle, 1931a
R. van Marle, "Ancora quadri senese," *La Diana* 6 (1931).

van Marle, 1935
R. van Marle, "Contributo allo studio della scuola pictorica del Trecento a Rimini," *Rimini* (July-August, 1935).

van Os, 1969
H. W. van Os, *Sienese Painting in Holland* (1969).

van Os, 1969a
H. W. van Os, *Marias Demut und Verherrlichung in der sienesischen Malerei 1300-1450* (1969).

van Os, 1971
H. W. van Os, "Problemi senesi, a proposito della mostra 'Pitture senesi in Olanda,'" *Commentari* 22 (1971).

van Os, 1974
H. W. van Os, "Andrea di Bartolo's 'Madonna of Humility,'" *Montreal Museum of Fine Arts Bulletin* 6 (1974).

van Os, 1983
H. W. van Os, "Discoveries and Rediscoveries in Early Italian Painting," *Arte cristiana* 695 (1983).

van Os, 1984
H. W. van Os, *Sienese Altarpieces 1215-1344* 1 (1984).

van Os, 1985
H. W. van Os, "Tradition and Innovation in Some Altarpieces by Bartolo di Fredi," *The Art Bulletin* 67 (1985).

van Os, 1990
H. W. van Os, *Sienese Altarpieces 1344-1460* 2 (1990).

van Os et al., 1974
H. W. van Os, *The Florentine Paintings in Holland, 1300-1500* (1974).

van Vechten Brown and Rankin, 1930
A. van Vechten Brown and W. Rankin, *A Short History of Italian Painting* (1930).

van Waadejen, 1983
J. van Waadejen, *Starnina e il gotico internazionale a Firenze* (1983).

van Waadenoijen, 1974
J. van Waadenoijen, "A Proposal for Starnina: Exit the Maestro del Bambino Vispo?" *The Burlington Magazine* 116 (1974).

Vasari, 1567 (1906)
G. Vasari, *Le Vite de'piu eccellenti pittori, scultori ed architettori* (1567; ed. G. Milanese, 1906).

Venchi, 1984
I. Venchi, "Cronologia del Beato Angelico," *Beato Angelico, miscellanea di studi* (1984).

Venturi, 1893
A. Venturi, "Nelle pinacoteche minori d'Italia," *Archivo storico dell'arte* 6 (1893).

Venturi, 1894
A. Venturi, *Gallerie nazionale* (1894).

Venturi, 1907
A. Venturi, *Le origine della pittura veneziana* (1907).

Venturi, 1911
A. Venturi, *Storia dell'arte italiana* (1911).

Venturi, 1914
A. Venturi, *Storia dell'arte italiana* (1914).

Venturi, 1933
L. Venturi, *Italian Paintings in America*, 2 vols. (1933).

Vermeule, 1960
C. Vermeule, "Review," *Speculum* 25 (1960).

Vertova, 1979
L. Vertova, "Cupid and Psyche in Renaissance Painting before Raphael," *Journal of the Warburg aud Courtauld Institutes* 42 (1979).

Vigni, 1949
G. Vigni, "Il 'Maestro del Trionfo di San Tommaso,'" *Bolletino d'arte* 34 (1949).

Vitalini Sacconi, 1968
G. Vitalini Sacconi, *Pittura marchigiana, la scuola camerinese* (1968).

Volpe, 1960
C. Volpe, "Precisazioni sul 'Barna' e sul 'Maestro di Palazzo Venezia,'" *Arte antica e moderna* 10 (1960).

Volpe, 1965
C. Volpe, *La Pittura riminese del Trecento* (1965)

Volpe, 1982
C. Volpe in *Il Gotico a Siena* (1982).

Volpe, 1983
C. Volpe, "Il lungo percorso del 'dipingere dolcissimo e tanto unito,'" *Storia dell'arte italiana* 5 (1983).

von Baldass, 1929
L. von Baldass, "Die Gemälde der Sammlung Figdor," *Pantheon* 4 (1929).

von Erffa, 1976
H. M. von Erffa, "Der Nürnberger Stadtpatron auf Italienischen Gemälden," *Mitteilungen des Kunsthistorichen Institutes in Florenz* 20 (1976).

Waagen, 1837
G. F. Waagen, *Kunstwerke und Künstler in England* (1837).

Waagen, 1854
G. F. Waagen, *Treasures of Art in Great Britain* (1854).

Waagen, 1857
G. F. Waagen, *Galleries and Cabinets of Art in Great Britain* (1857).

Wagstaff, 1965
S. Wagstaff, *An Exhibition of Panels and Manuscripts from the Thirteenth and Fourteenth Centuries in Honor of Richard Offner* (Wadsworth Atheneum, 1965).

Wehle, 1936
H. B. Wehle, "A Painting Attributed to Fra Carnevale," *Metropolitan Museum of Art Bulletin* 31 (1936).

Wehle, 1940
H. B. Wehle, *The Metropolitan Museum of Art: A Catalogue of Italian, Spanish, and Byzantine Paintings* (1940).

Weigelt, 1909
C. H. Weigelt, "Contributo alla reconstruzione della Maestà di Duccio di Buoninsegna," *Bolletino senese di storia patria* 16 (1909).

Weigelt, 1911
C. H. Weigelt, *Duccio di Buoninsegna* (1911).

Weigelt, 1921
C. H. Weigelt, "Girolamo di Benvenuto," *Algemeines Lexikon der bildenden Künstler*, U. Thieme and F. Becker, eds., vol. 14 (1921).

Weigelt, 1930
C. H. Weigelt, *Sienese Painting of the Trecento* (1930).

Weigelt, 1931
C. H. Weigelt, "Minor Simonesque Masters," *Apollo* 14 (1931).

Weisbach, 1901
W. Weisbach, *Francesco Pesellino und die Romantik der Renaissance* (1901).

Weller, 1943
A. S. Weller, *Francesco di Giorgio 1439-1501* (1943).

White, 1966
J. White, *Art and Architecture in Italy: 1250-1400* (1966).

White, 1973
J. White, "Carpentry and Design in Duccio's Workshop: The London and Boston Triptychs," *The Journal of the Warburg and Courtauld Institutes* 36 (1973).

White, 1979
J. White, *Duccio: Tuscan Art and the Medieval Workshop* (1979).

Whitehill, 1970
W. M. Whitehill, *The Museum of Fine Arts, Boston. A Centennial History* (1970).

Wildenstein Galleries, 1967
The Italian Heritage, Wildenstein Galleries, New York (1967).

Wittgens, 1930
F. Wittgens, "The Contribution of Italian Private Collections to the Exhibition at Burlington House," *Apollo* 11 (1930).

Witthoft, 1974
B. Witthoft, "A Saint Michael by Bonifacio Bembo," *Arte lombarda* 41 (1974).

Witting, 1915
F. Witting, "Luciano Lauranna als Maler," *Jahrbuch de koniglich preussischen Kunstammlungen* 36 (1915).

Wixom, 1974
W. D. Wixom, *The Cleveland Museum of Art, European Paintings before 1500* (1974).

Wolf, 1946
B. Wolf, "Boston Acquires America's Seventh Duccio," *Art Digest* 20 (1946).

Yashiro, 1925
Y. Yashiro, *Sandro Botticelli* (1925).

Young, 1970
E. Young, *Catalogue of Spanish and Italian Paintings, Bowes Museum, Barnard Castle* (1970).

Young, 1985
E. Young, "Old Master Paintings in the Collection of the Fellowship of Friends at Renaissance, California," *Apollo* 121 (1985).

Zampetti, 1952
P. Zampetti, *Carlo Crivelli nelle Marche* (1952).

Zampetti, 1961
P. Zampetti, *Carlo Crivelli* (1961).

Zampetti, 1969
P. Zampetti, *La Pittura marchigiana* (1969).

Zampetti, 1969a
P. Zampetti, *A Dictionary of Venetian Painters* (1969).

Zampetti, 1971
P. Zampetti, *Giovanni Boccati* (1971).

Zampetti, 1971a
P. Zampetti, *Paintings from the Marches* (1971)

Zampetti, 1991
P. Zampetti, *Pittura nelle Marche*, I (1991).

Zdekauer, 1894
L. Zdekauer, *Lo Studio di Siena nel Rinasciamento* (1894).

Zeri, 1948
F. Zeri, "Me Pinxit," *Proporzione* 2 (1948).

Zeri, 1950
F. Zeri, "Un Affresco del Maestro dell'Incoronazione d'Urbino," *Proporzione* 3 (1950).

Zeri, 1953
F. Zeri, "Il Maestro dell'Annunziazione Gardner," *Bolletino d'arte* 38 (1953).

Zeri, 1957
F. Zeri, "La riapertura della Alte Pinakothek di Monaco," *Paragone* 95 (1957).

Zeri, 1958
F. Zeri, "Una Deposizione di scuola riminese," *Paragone* 99 (1958).

Zeri, 1958a
F. Zeri, "Un Polittico di Segna di Bonaventura," *Paragone* 103 (1958).

Zeri, 1958b
F. Zeri, "Sul problema di Nicolò di Ser Sozzo Tegliacci e Luca di Tommè," *Paragone* 105 (1958).

Zeri, 1958c
F. Zeri, "Qualcosa su Nicola di Maestro Antonio," *Paragone* 107 (1958).

Zeri, 1961
F. Zeri, *Due dipinti, la filologia e un nome* (1961).

Zeri, 1964
F. Zeri, "Investigations into the Early Period of Lorenzo Monaco – I," *The Burlington Magazine* 106 (1964).

Zeri, 1965
F. Zeri, "Italian Primitives at Messrs Wildenstein," *The Burlington Magazine* 107 (1965).

Zeri, 1973
F. Zeri, "Sull'ipotesi pisana del Tegliacci," *Quaderni di Emblema* 2 (1973).

Zeri, 1976
F. Zeri, *Italian Paintings in the Walters Art Gallery*, 2 vols. (1976).

Zeri, 1980
F. Zeri, "Neri di Bicchi: Reintegrazione di un dipinto già nella Santissima Annunziata di Firenze," *Antologia di bella arti* 6 (1980).

Zeri, 1983
F. Zeri, "Rinascimento e Pseudo-Rinascimento," *Storia dell'arte italiana* part ii (1983).

Zeri, 1988
F. Zeri, *La Collezione Federico Mason Perkins* (1988).

Zeri and Gardner, 1980
F. Zeri and E. E. Gardner, *Italian Paintings Sienese and Central Italian Schools, A Catalogue of the Metropolitan Museum of Art* (1980).

Zeri and Natale, 1984
F. Zeri and M. Natale, *Dipinti toscani e oggetti d'arte dalla collezione Vittorio Cini* (1984).

Ziff, 1957
J. Ziff, "The Reconstruction of an Altarpiece by Andrea Vanni," *The Art Bulletin* 39 (1957).

❧ CONCORDANCE

Accession No.:	Catalogue no.:	Accession No.:	Catalogue no.:
83.175.a, b, c	19	30.772	53
84.293	6	36.144	14
95.1372	52	37.108	66
97.229	58	37.409	5
02.4	73	38.1840	3
03.562	47	39.536	15
03.563	32	39.801	56
03.564	33	39.802	60
04.237	30	40.91	27
06.121	63	41.921	59
06.2441a	42a	44.831	62a
06.2441b, c	42b, c	44.832	62b
07.78	55	45.514	34
07.515	57	45.515	8
10.37	4	45.880	9
12.1049	50	46.1429	49
14.416	36	47.232	69
15.910	41	47.234	72
15.951	28	48.297	38
15.952	10	50.5	20
15.953	22	51.738	17
15.1145	16	51.2397	13
16.64	29	56.512	61
16.65	11	60.536	54
16.117	18	63.3053	51
17.3223	46	64.2077	44
19.131	71	64.2379	43
20.431	68	68.22	65
20.1855a	31a	1978.466	12
20.1855b	31b	1983.300	37
20.1856	31c	222.1986	2
20.1857	31d		
20.1858	67a		
20.1859	67b		
20.1860	21		
21.1460	64		
22.3	23a		
22.4	23b		
22.5	48		
22.403	7		
22.635	35		
22.651	45		
22.697	70		
23.211	1		
23.252	39		
24.115	25		
28.886	24		
28.887	26		
30.495	40		

INDEX
of Collectors and Dealers